FLORENCE

FLOR

ENCE

A PORTRAIT

BY

MICHAEL LEVEY

HARVARD UNIVERSITY PRESS

CAMBRIDGE, MASSACHUSETTS

1996

First published in the United Kingdom in 1996
by Jonathan Cape

LIBRARY OF CONGRESS CATALOGING-IN-PUBLICATION DATA

Levey, Michael.
 Florence: a portrait/Michael Levey
 p. cm.
 Includes bibliographical references and index.
 ISBN 0-674-30657-0
 1. Florence (Italy) — Description and travel.
 2. Florence (Italy) — Civilization.
 3. Art, Italian — Italy — Florence.
I. Title.
DG734.23L 1996
945'.51—dc20 95-31215

Printed and bound in Great Britain by
Butler and Tanner Ltd, Frome, Somerset

. . . Do you feel thankful, ay or no,
For this fair town's face, yonder river's line,
The mountain round it and the sky above,
Much more the figures of man, woman, child,
These are the frame to? What's it all about?

Robert Browning, 'Fra Lippo Lippi'

CONTENTS

ILLUSTRATIONS

BLACK AND WHITE ILLUSTRATIONS

between pages 418 and 419

BLACK AND WHITE ILLUSTRATIONS

The author and publishers are grateful for permission to reproduce the illustrations in this book.

Foreword

THERE IS PERHAPS no city in the world which offers keener attraction – and keener challenge – to a writer than does Florence.

The attraction and the challenge lie in the extraordinary combination represented by the city, its history, its culture and its art. In one sense it seems familiar: Florence as the 'cradle' of the Renaissance, the republican home of humanism, fostering some of the greatest achievements of Western painting, sculpture and architecture. Yet if that suggests a climate of civilised enlightenment, it is misleading in historical terms, for the city was the site of often violent events, frequent frenetic revisions of constitution and abrupt alterations in the very character of government. By the time a settled and autocratic regime had been established, the Renaissance, at least as conventionally understood, was largely over. A new Florence developed, one that has not gained much repute in accounts of either art or civilisation. Nevertheless, that later city has a surprising number of artistic achievements to its credit, especially in architecture. And when there came a total change of ruling dynasty further changes came to the city. Then, with the nineteenth century and the establishment of Florence as the capital of Italy for a period, there came a new and dramatic and rapid programme of change, which was to alter the city irreparably.

The result has left Florence a highly complex entity. To try to seize something of that entity and trace its evolution over the centuries, from medieval times into the full nineteenth century, is the purpose of this 'portrait'. It is deliberately not purely an historical account, nor is it offered as an outline of Florentine art through the ages, and still less is it a guide-book. But it partakes of all three categories of approach, mingling them as history and art are mingled in the city. I recognise that at times such mingling may create some bewilderment, but a firm handrail is provided by the Selective Chronology on pages xxi–xxvi. And so much has already been written on the subject that a fresh if ambitious treatment seems legitimate (in a way it would not were the subject, say, Lisbon). To some extent, I attempt to answer the question posed by the speaker in the epigraph to this book. Much of my emphasis is on portrayal of the changing lineaments of the physical face of Florence.

The portrait is one delineated not for scholars and specialists but for the intelligent, interested, general reader, to whom some of the facts and some of the works of art may well be unfamiliar. I have concentrated on the city and its monuments as they can be seen today by any visitor, without discussing, for example, the interiors of palaces which are for most people inaccessible. There is plenty to see and enjoy from every century, without the tedious business of negotiating entry into private or civic and state buildings not normally open to the public. And because there is a wealth of material available within the city, I have made no attempt to take the reader out into the environs, alluring though they are.

The book does not start at the beginning of the city's history and it stops well short of the twentieth century. Yet it deliberately continues the story of Florence, historically and artistically, far beyond any period that can be interpreted as 'Renaissance'. Because of the vast fame and glamour that period has acquired in that city of all cities, later ages there tend still to be overshadowed and their own authentic artistic contributions left undiscussed or unsignposted. I have done what I can to redress the balance, openly championing certain achievements, whether a large-scale building or a small-scale reliquary, which traditionally disconcert British and American taste, partly – if we are frank – because of their strong religious connotations.

To pretend that such works are not typical of Florence, when one means merely they do not meet one's preconceptions of Florence, is bad history and also a loss of valid, often exciting visual experience. Part of the uniqueness of the city is that it can offer a succession of completely different yet equally authentic aesthetic encounters: from the familiar idiom of some grey-toned, restrained church interior of the *quattrocento* to the unexpected one in white and gold from the early eighteenth century. My hope for this book may be summed up by saying that I should like to think of the reader or visitor associating the Palazzo Medici-Riccardi in future not only with the chapel of Gozzoli's celebrated frescoes of the *Journey of the Magi* but also with the *galleria*, frescoed no less exuberantly in homage to the Medici, centuries later, by Luca Giordano.

In covering such a wide subject, the book may contain some factual errors, despite the author's best endeavours. I did not always find expert agreement on a number of relevant points. Dates are sometimes given variously by acknowledged authorities. To establish the basis of each of them would require research in libraries and archives which I have not carried out. My time in Florence has usually been spent in looking at what I describe, and I believe that was the right priority for this book. As well as apologising for any errors, I should also apologise if my descriptions occasionally deal with works of art

which ultimately could not be reproduced within the necessary publishing limitations. Choices had to be made, not least in terms of overall balance.

During the gestation of this book I have incurred many pleasant debts. A number of people contributed to its eventual existence, and I am warmly grateful to them all. To my agent, Giles Gordon, I already owe much, but on this occasion his initiative and his generous, sustained interest were fundamental. I am particularly grateful to David Godwin, who commissioned this book when he was at Jonathan Cape; I recall a stimulating discussion at a time when it was barely a twinkle in the author's eye, and I recall yet more gratefully his continued faith in the project and in me.

I must express my thanks also to the keen, perceptive and encouraging response given to the book by David Godwin's successor at Cape, Dan Franklin. The text has gained greatly from the care and attention of my zealous editor, Pascal Cariss. I should also mention gratefully the work of Cathie Arrington in gathering the illustrations with both persistence and flair, and that of Peter Ward in his sensitive design of the book.

While engaged on the arduous task of writing, I had much affectionate support and encouragement from Anne Graham Bell. Professor Christopher White found time in a busy, official life to read and comment pertinently on some chapters, and he was particularly helpful at a critical moment in the book's genesis. Professor Nicolai Rubinstein generously responded to an appeal for scholarly guidance on a specific point, but I owe it to him to underline his total lack of responsibility for any of my statements.

Very great help was given in deciphering and coping with a crabbed, untidy manuscript by Mrs Colette Bates, to whom I am additionally grateful for her kind interest in my subject. To Richard Bates at Discript I am indebted for the conversion of copy into elegantly printed pages, and again I appreciated his personal interest in my subject. I want to express my thanks to Mrs Shirley Dent, for some invaluable last-minute typing, and I must also acknowledge, with fond gratitude, a family debt to Elizabeth Bussell, herself yet one more devotee of Florence, who so thoughtfully gave up time to permit me to be absent more easily from England.

It would not have been possible to write this book away from major libraries in Britain without the unremitting assistance I received during that considerable period of time from Alyson Wilson. Assistance is really too passive a word to define her active, ever-alert pursuit of books, catalogues and articles which she thought might be of use; I have also benefited greatly from her knowledgeable observations on a city already a focus of interest to her. Her expertise improved the list of books for further reading, and she has crowned her unselfish help by kindly reading a proof of the whole text.

The most pleasant requirement of my task was, naturally, to revisit Florence, walk its streets and make my own discoveries, while not failing to look again at familiar objects. On recent visits I have greatly appreciated the companionship of David Rodgers, and I thank him warmly for his patience, his observations and his photographs, in addition to his presence.

But my deepest debt of gratitude is to the quartet of dedicatees of this book. I can say only that without their affection I am sure there would have been no book — nor, I suspect, its writer.

Michael Levey
Louth, Lincolnshire, 1996

Selective Chronology
1000–1900

1000: Florence established on the river Arno as a small walled city of the Holy Roman Empire, held by the Marquis of Tuscany. Its major buildings included the Baptistery, the cathedral (of Santa Reparata), a church of San Lorenzo and the Badia (abbey), founded in 978 by Willa, mother of Ugo, Marquis of Tuscany.

1018: Foundation of the church of San Miniato al Monte.

1078: Matilda, Countess of Tuscany, initiates a new circle of walls for the city.

1115: Death of Matilda and establishment of the Commune as governing body of Florence (effectively recognised by the Emperor Henry VI in 1187).

1173–5: A new, more extensive circle of walls, built by the Commune. By now the city densely populated around the Ponte Vecchio, sole bridge across the Arno.

1216: Assassination of Buondelmonte dei Buondelmonti, traditional starting point for feuds between Florentine families, developing into violent opposition parties of the Guelphs (supporters of the Papacy) and the Ghibellines (supporters of the Empire).

1246: The existing Dominican church of Santa Maria Novella founded.

1252: First coining of the Florentine florin.

1265: Birth of Dante.

1267: Charles of Anjou, King of Sicily, accepted as the city's overlord.

1294/5: The existing Franciscan church of Santa Croce founded.

1299: Work begins on the Palazzo dei Priori (Palazzo Vecchio), in use by 1302.

1300: Arnolfo di Cambio *capomaestro* of the new cathedral (Santa Maria del Fiore); Giovanni Villani commences his chronicle of Florence.

1302: Exile of Dante, along with other 'White' Guelphs.

1313: Birth of Giovanni Boccaccio (d. 1375) in or around Florence.

1333: Severe flooding of the Arno destroys the bridges (by then three) and generally damages the city.

1334: Campanile of the cathedral (designed by Giotto) begun.

1337: Founding of the existing church of Orsanmichele.

1342: Walter de Brienne, Duke of Athens, nominated 'perpetual' lord of Florence.

1343: St Anne's Day (26 July), expulsion of the Duke of Athens.

1348: Grave outbreak of plague, the 'Black Death', in Florence, Villani among the many victims; the plague situation utilised by Boccaccio for the opening of the *Decameron*.

1350: Decision by the *Signoria* to build a loggia (the Loggia 'dei Lanzi') for official receptions, etc.; work begun 1376.

1378: Revolt of the 'Ciompi', day-labourers chiefly in the woollen industry, only briefly successful before being suppressed.

1400: Florence and its territories (Prato, Arezzo, etc.) threatened by Gian Galeazzo Visconti, Duke of Milan (d. 1402).

1401: Competition organised for the second pair of bronze doors for the Baptistery; Brunelleschi and Ghiberti the leading Florentine competitors, Ghiberti finally chosen.

1418: Brunelleschi wins the commission to build the cupola of the cathedral.

1425: Ghiberti assigned the commission for the third pair of Baptistery doors (the 'Doors of Paradise'); Masaccio and Masolino probably working on the frescoes in the Brancacci Chapel of Santa Maria del Carmine; Donatello, in collaboration with Michelozzo, at work on the tomb of the deposed Pope John XXIII in the Baptistery.

1427: Institution of the '*catasto*' (civic tax) in Florence.

1429: Death of Giovanni di Bicci de' Medici, founder of the family's fortune, leaving two sons, Cosimo and Lorenzo, from whom descended two main branches of the family.

1433: Banishment of Cosimo (and Lorenzo) de' Medici from Florence by the oligarchic faction headed by Rinaldo degli Albizzi.

1434: Return of Cosimo from exile; thenceforward the Medici party, and he personally but unofficially, dominates the republican government.

1444: Michelozzo begins a new imposing palace for Cosimo and his family (the Palazzo Medici-Riccardi).

1449: Birth of Lorenzo 'the Magnificent', son of Cosimo de' Medici's elder son, Piero.

1450: The apothecary Luca Landucci begins keeping his diary of events.

1464: Death of Cosimo de' Medici and succession of Piero as first citizen in Florence.

1469: Death of Piero de' Medici; Lorenzo confirmed as his successor by a group of leading citizens. Birth of Machiavelli.

1478: The Pazzi conspiracy against the Medici fails politically; Florence is placed under edict by Pope Sixtus IV.

1480: Lorenzo 'the Magnificent' negotiates peace and an accord with the Pope. A period of peace in Italy generally follows.

1483: Birth of Francesco Guicciardini, historian and man of affairs.

1489: The Ferarrese-born Dominican Fra Girolamo Savonarola attracts attention by his preaching. The foundations of the Palazzo Strozzi are laid, and Lorenzo 'the Magnificent' begins his villa at Poggio a Caiano.

1492: Death of Lorenzo; his position in Florence assumed by his eldest son, Piero (d. 1503).

1494: Invasion of Italy by Charles VIII of France. Flight and subsequent banishment of Piero de' Medici from Florence; entry of Charles VIII into the city. Florence a reformed republic under the emotional sway of Savonarola.

1496: The hall of the new governing body, the Great Council, inaugurated in the Palazzo Vecchio, although not finished.

1498: Savonarola and two fellow-Dominicans convicted of heresy at the instigation of Pope Alexander VI (Borgia) and publicly burnt on the Piazza della Signoria.

1502: Under a new constitution the head of government in the republic to be the *Gonfaloniere di Giustizia* (Standard-bearer of Justice), who would hold office for life. Piero Soderini was the first – and, as it proved, the last – to be so appointed.

1504: Michelangelo's *David* set up outside the Palazzo Vecchio. Under Soderini, he and Leonardo da Vinci each received a commission to execute a battle-picture in the Hall of the Great Council.

1509: The city of Pisa surrenders to Florence.

1510: Publication of Albertini's *Memoriale di molte statue e pitture . . . di Firenze*, the city's first printed guide-book.

1512: The republic threatened by pro-Medici Papal forces; Prato sacked and Florence compelled to accept reinstatement of the Medici.

1513: Election of Cardinal Giovanni de' Medici, son of Lorenzo 'the Magnificent', as Pope Leo X.

1515: Triumphal entry of Leo X into Florence.

1519: Cardinal Giulio de' Medici created Archbishop of Florence and effectively its governor. Birth of Cosimo de' Medici, future first Grand Duke of Tuscany.

1520: Cardinal Giulio initiates building of a new Medici sacristy at San Lorenzo, its architecture and sculpture to be designed by Michelangelo.

1522: Election of Cardinal Giulio de' Medici as Pope Clement VII (d. 1534)

1527: Sack of Rome by imperial troops of the Emperor Charles V. The Medici expelled from Florence and the republic restored.

1529: Peace between the emperor and pope, whose combined forces besiege Florence in the Medici cause.

1530: Florence eventually surrenders.

1531: Charles V declares the illegitimate Alessandro de' Medici head of government in Florence and in the next year creates him 'Duke of the Florentine Republic'.

1537: Assassination of Duke Alessandro. The ruling circle in Florence nominates the young Cosimo de' Medici as head of government, and he is subsequently confirmed by Charles V as Duke.

1539: Duke Cosimo marries the younger daughter of the Spanish viceroy of Naples, Eleonora di Toledo.

1540: The duke and duchess leave the Medici palace to live in the Palazzo Vecchio.

1541: Birth of the eldest son of the ducal pair, the future Grand Duke Francesco de' Medici.

1549(?): Purchase by the duchess of the Palazzo Pitti, subsequently the residence of all the grand dukes.

1550: Vasari publishes the first edition of his *Lives* of the artists, dedicated to Duke Cosimo (second, much expanded edition, 1568).

1555: Imperial and Florentine troops capture Siena.

1560: Vasari directs the start of building the state offices, the Uffizi.

1562: Death of the duchess and two of her sons.

1564: Abdication of Duke Cosimo in favour of his eldest son, Francesco.

1565: Marriage of Francesco de' Medici and Archduchess Joanna of Austria.

1569: Pope Paul V grants Cosimo the title of Grand Duke of Tuscany.

1574: Death of Grand Duke Cosimo I.

1584: Publication of Stefano Bonsignori's huge, detailed map of Florence, dedicated to Grand Duke Francesco.

1587: Death of Grand Duke Francesco, succeeded by his brother, Cardinal Ferdinando.

1588: Grand Duke Ferdinando I issues letters patent concerning marbles for a new (Medici) sepulchral chapel at San Lorenzo.

1591: Publication of F. Bocchi's guide-book, *Le bellezze della città di Fiorenza*.

1594: Giambologna's equestrian statue of Grand Duke Cosimo I set up in Piazza della Signoria.

1600: Peri's opera, *Euridice*, performed in Florence in celebration of the marriage of the grand duke's niece, Maria de' Medici, to Henri IV of France.

1604: First stone laid of the church of Santi Michele e Gaetano, and of the Chapel of the Princes at San Lorenzo.

1608: Giambologna's equestrian statue of Ferdinando I set up in the Piazza Santissima Annunziata.

1609: Death of Grand Duke Ferdinando I, succeeded by his son, Cosimo II.

1610: Galileo publishes at Venice his study of the stars, *Siderius Nuncius*, dedicated to the Medici grand duke.

1621: Premature death of Grand Duke Cosimo II, succeeded by his son, Ferdinando II, a minor, under a regency of the widowed grand duchesses, his mother and grandmother.

1628: Ferdinando II assumes power.

1641: First employment of Pietro da Cortona in decoration of the Palazzo Pitti.

1650: The Corsini family begin extensive enlargement, to continue into the following century, of their palace on the Lungarno.

1670: Death of Grand Duke Ferdinando II, succeeded by his son Cosimo III.

1682–3: Luca Giordano frescoes the ceiling of the galleria in the Medici palace which had been acquired by the Marchese Riccardi.

1683: Inauguration of the Corsini chapel in Santa Maria del Carmine.

1713: Death of Grand Prince Ferdinando de' Medici, Cosimo III's heir.

1718: The chief European powers (including England) choose Don Carlos, son of the King of Spain, to succeed eventually to the Grand Duchy of Tuscany.

1723: Death of Cosimo III, succeeded by his childless son, Gian Gastone, the last Medici grand duke.

1735: The Treaty of Aix-la-Chapelle assigns succession of the Grand Duchy to Francis Stephen, Duke of Lorraine (husband of Maria Theresa, future Empress of Austria).

1737: Death of Grand Duke Gian Gastone.

1738: A triumphal arch erected outside the Porta di San Gallo, designed by J.-N. Jadot, for the entry into Florence of the new grand duke.

1739: Entry of Francis Stephen and his wife into Florence, and their departure, leaving the city governed by a Regency Council.

1743: Death in Florence of the widowed Electress Palatine, Anna Maria Luisa de' Medici, Cosimo III's daughter, who bequeathed the vast Medici collections to the new line of grand dukes as inalienable property of the state.

1765: Death of Francis Stephen, succeeded as grand duke by his second surviving son, Pietro Leopoldo (in Italy), who rapidly established an enlightened, reformist regime throughout Tuscany.

1769: The Uffizi gallery opened to the public.

1784: Founding of the Accademia di Belle Arti.

1790: Death of the childless Austrian Emperor, Joseph II, succeeded by his brother Pietro Leopoldo as Leopold II (d. 1792), who assigns rule of Tuscany to his second son, Ferdinando III.

1799: French troops occupy Florence; Ferdinando III retreats to Vienna.

1801: By the treaty of Lunéville, the Grand Duchy of Tuscany is assigned to the Infante Don Lodovico, Prince of Parma, and soon after constituted as the kingdom of Etruria.

1808: Napoleon as Emperor adds Tuscany to French possessions and installs his sister, Elisa Baciocchi, in Florence as Grand Duchess.

1815: Following the defeat of Napoleon, Ferdinando III returns as Grand Duke.

1816: Return to Florence of most of the art treasures removed by the French.

1824: Death of Ferdinando III and succession of his son, Leopoldo II.

1841–8: Railway line from Florence to Livorno, via Pisa, constructed.

1848–9: Leopoldo II temporarily abandons Florence in the face of popular uprising.

1854: The Alinari brothers open their photographic studio in the city.

1859: Final departure of Leopoldo II from Florence after renewed popular demonstrations.

1860: A plebiscite favours Florence and Tuscany joining the kingdom of Sardinia (as part of the emerging kingdom of Italy); King Vittorio Emanuele II arrives in Florence.

1861: The king opens the large *Esposizione Italiana* in Florence.

1865–70: Florence established as the capital of Italy; Giuseppe Poggi begins a radical redevelopment of the city.

1870: Bartolini's monument to Nicholas Demidoff inaugurated; arrival and death in Florence of the Maharajah of Kohlapur.

1888: First visit to Florence by Queen Victoria.

1890: The equestrian statue of Vittorio Emanuele II set up in the eponymous piazza (now della Repubblica).

1895: Date of restitution of 'new life' to the city centre, as inscribed on the triumphal arch in the Piazza della Repubblica.

1899: Construction begun of the Russian Orthodox church.

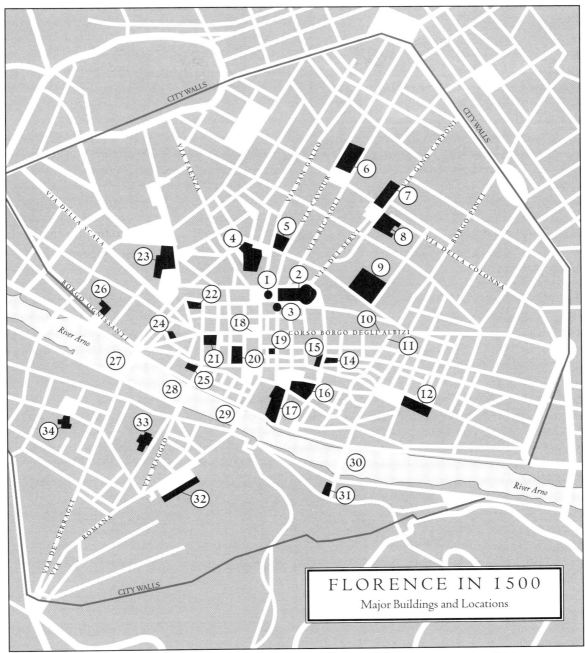

FLORENCE IN 1500
Major Buildings and Locations

1. The Baptistery
2. The Duomo
3. The Campanile
4. San Lorenzo
5. Palazzo Medici
6. The church and convent of San Marco
7. Santissima Annunziata
8. The Ospedale degli Innocenti
9. The Ospedale di Santa Maria Nuova
10. Palazzo Albizzi
11. San Pier Maggiore
12. Santa Croce
13. Palazzo dei Pazzi
14. The Palazzo del Podestà (The Bargello)
15. The Badia
16. The Palazzo dei Signori (Palazzo Vecchio)
17. The Loggia 'dei Lanzi'
18. The Mercato Vecchio
19. Orsanmichele
20. Palazzo Davanzati
21. Palazzo Strozzi
22. Palazzo Antinori
23. Santa Maria Novella
24. Palazzo Rucellai
25. Santa Trinita
26. Ognissanti
27. The Ponte alla Carraia
28. The Ponte Santa Trinita
29. The Ponte Vecchio
30. The Ponte alle Grazie
31. Palazzo Mozzi
32. Palazzo Luca Pitti
33. Santo Spirito
34. Santa Maria del Carmine

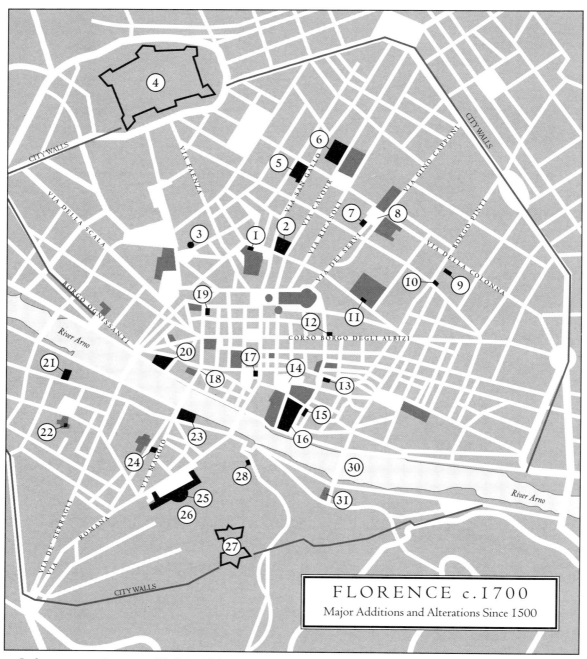

FLORENCE c. 1700
Major Additions and Alterations Since 1500

1. San Lorenzo: new sacristy, Chapel of the Princes and Biblioteca Laurenziana
2. Palazzo Medici-Riccardi (Palazzo Medici, enlarged and renamed)
3. The house of Vincenzo Viviani
4. The Fortezza da Basso
5. Palazzo Castelli-Fenzi
6. The Casino Mediceo
7. Palazzo Grifoni
8. Equestrian statue of Grand Duke Ferdinando II
9. High altar area of Santa Maria Maddalena dei Pazzi
10. Santa Maria di Candeli (1703)
11. Portico of the Ospedale di Santa Maria Nuova
12. Palazzo Nonfinito
13. San Filippo Neri
14. Equestrian statue of Grand Duke Cosimo I
15. The Grain Loggia of Grand Duke Cosimo II
16. The Uffizi
17. The Loggia of the Mercato Nuovo
18. The Column of Justice
19. Santi Michele e Gaetano
20. Palazzo Corsini
21. San Frediano in Cestello
22. Corsini Chapel, Santa Maria del Carmine
23. The 'Palazzo delle Missioni'
24. The house of Bianca Capello
25. Palazzo Pitti (enlarged)
26. The Boboli Gardens
27. The Fortezza del Belvedere
28. San Giorgio e Spirito Santo (1705)

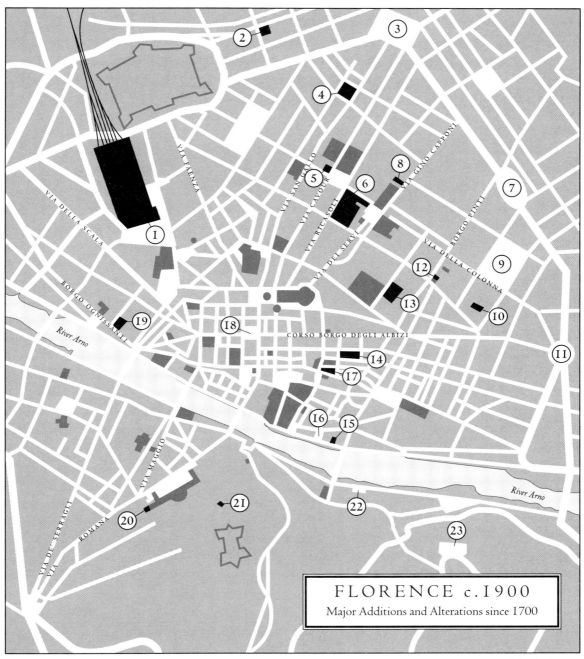

FLORENCE c.1900

Major Additions and Alterations since 1700

THE CITY WALLS HAVE
BEEN REMOVED

1. The main station (originally
 Stazione Maria Antonia)
2. The Russian Orthodox
 Church
3. Triumphal Arch to Francis
 Stephen of Lorraine and
 Piazza (della Libertà)

4. The Ospedale di Bonifacio
 (Questura)
5. The Casino della Livia
6. The Accademia di Belle Arti
7. Piazzale Donatello and the
 'English' Cemetery
8. The Palazzina de' Servi
9. Piazza d'Azeglio
10. The Synagogue
11. Piazza Beccaria

12. The ex-Liceo Regio
13. The Teatro della Pergola (as
 public theatre)
14. Palazzo Borghese
15. The Borsa Merci
16. Piazza Mentana and the
 monument to the fallen (1902)
17. The complex of San Firenze
18. Triumphal Arch and rebuilt
 Piazza (della Repubblica)

19. Atrium and church of San
 Giovanni di Dio
20. The Meridiana (Costume
 Museum)
21. The Kaffeehaus
22. Piazza Demidoff
23. Piazzale Michelangelo

SERIOUSLY SEEKING FLORENCE

F OR CENTURIES ROME and Venice have been attracting crowds of visitors, varied in every possible way and with every possible purpose. Native or foreign, there were — as there continue to be — the casual tourist, the artist, connoisseur, historian, antiquarian, the devout pilgrim and the devoted pleasure-lover, all travelling to one or both cities conscious of treading a path taken by generations of their predecessors.

None of that applies to Florence, but you would scarcely guess as much, seeing the city today. At most seasons it is virtually under siege from polyglot, eager, patient or occasionally half-recalcitrant crowds, queuing like cattle — and penned-in like cattle — to enter the Uffizi, surging around though not always across the Ponte Vecchio, gazing respectfully at the 'Doors of Paradise' of the Baptistery, turning over the tourist tat in one or other market and smiling sophisticatedly at the ubiquitous image of Michelangelo's *David*, openly treated as a gay icon.

While a few isolated foreign students may take advantage of a sunny afternoon to sprawl along the pavement of the Piazza della Signoria, scribbling a postcard home close to the spot where Savonarola was burnt, a band of native visitors will probably still be tramping the streets, dutifully wheeling and halting at the signal of its guide's upraised stick, often with flower attached, to imbibe with fraying attention a last dose of instruction about yet one more famous Florentine sight.

Florence has been transformed from a city into a shrine, the end of a journey made by pilgrims from all over the world, impelled by belief in, or acceptance of, a cultural faith as intense and ardent as any religious one. Like true pilgrims, they have not come to Florence for 'fun' or for a magnificent urban spectacle — or, if any have, they will, in both cases, be disappointed. Nor are they expecting to see the ruins of an antique civilisation or to receive a papal benediction. Almost too well do they know that they have come to encounter a unique, narrow but tremendous experience, the explosion of art and culture which we call the Renaissance and which detonated first or most patently in Florence. It

was, or it has conventionally been treated as, a hugely important stage in the development of Western civilisation, and though its literary manifestations may not be immediately accessible, its artistic ones are. In one sense, there is no need to write books explaining what the Florentine Renaissance was, in so far as the visual arts are concerned. Florence is filled with buildings, sculpture and paintings which 'explain' the phenomenon better than any words. At least, they remain broadly untouched and often *in situ*, even if only in replica, as so many shrines contained within the larger shrine of the city itself.

Where else but in Florence can one have that experience in such a powerful, concentrated and indeed overwhelming way? The Renaissance was by no means a purely Florentine phenomenon, but one might well assume it had been, having read a typical book on the subject and having visited the city. At every turn, a Renaissance achievement is apparent — and that is to treat the Renaissance solely in terms of the visual arts. It has probably been a long-standing Florentine belief that the Renaissance, in the fullest cultural sense, occurred there, and nowhere else. Although any such belief is not in accord with the facts, for the Renaissance was a European phenomenon, not restricted to any single country, never mind city, it is a thoroughly understandable one.

Despite the additions and alterations of later centuries, Florence still looks essentially an early Renaissance city. The great and famous artistic figures in the city at that period — Brunelleschi, Donatello, Masaccio, Ghiberti — could return tomorrow and find much of what they knew and what they had contributed to it surviving (even when moved into a museum environment). Their achievements were profoundly admired by their fellow-citizens, and it would probably be a considerable mistake to suppose they would be astonished that the admiration was now world-wide. Of them only Ghiberti has left any written record to convey personality (and what he wrote as a form of autobiography is remarkably 'Renaissance' in its vivid picturing of his life and achievements, at an unprecedentedly early date), but he asserted that he had done a great deal to embellish Florence. On his 'Doors of Paradise' he included a self-portrait in bronze (see Plate 2), poking his bald head out as if to catch a stream of praise down the ages.

Veneration for his fifteenth-century Florence, its popularity, its particular appeal and its colossal prestige — all is of comparatively recent origin. The somewhat romantic historicism of the nineteenth century brought into fresh focus a period previously regarded generally as inferior to the subsequent High Renaissance, associated as it was with such geniuses as Michelangelo and Raphael, and located largely at Rome. Thus the tourists of the eighteenth century are rarely ecstatic about Ghiberti or Donatello or Masaccio. Florence was far from being an obligatory stop on the typical tour, and what

it had to offer were such sights as Michelangelo's Medici chapel. The Uffizi was a princely gallery open to the public in a thoroughly enlightened way (and with a first attempt at a guide-book as early as 1762), but it was paintings by Titian and Raphael, and other High Renaissance artists, that were the prime attraction, along with classical antique statues such as the Medici Venus.

There could be no question of a Botticelli room, for until the nineteenth century he was a painter little prized or appreciated, and the masterpieces of the *Primavera* and *The Birth of Venus* were not yet in the Uffizi collection. The rediscovery of him epitomises the revolution of taste which the nineteenth century brought about in attitudes to Florence. It is one in which the British played an influential part, and it seems quite right that there should be an 'English' cemetery in Florence (where are buried, among others, Clough, Landor and Elizabeth Barrett Browning), a charming, evocative, unmelancholy place in which to wander, half-expecting to come on a memorial to Ruskin or even Pater. In fact, the cemetery was for Protestant burials of all nations, with Swiss and German and American tombs amid the British ones.

The nineteenth century invested Florence with a semi-sacred aura, to some extent in reaction against the cool, secular, even anti-clerical tone the city had had during the previous century, notably under its most able, rational-philosophical ruler, the Grand Duke Pietro Leopoldo of Austria. Sometimes, it dutifully carried out the intentions of much earlier times in embodying history in sculpture. It had been Duke Cosimo I's plan that statues of famous Tuscans should fill the niches in the loggia of the Uffizi. From 1835 onwards a comparable project was initiated, one which would include both Galileo and Masaccio. Flanking the entrance to the Uffizi were placed the two famous early Medici, the elder Cosimo and Lorenzo 'the Magnificent'.

Similarly, on the façade of the Canons' modest palace in the Piazza del Duomo two large-scale statues were placed, facing the side of it, in honour of the two architects who had contributed most to its existence: Arnolfo di Cambio, under whom it had been begun, and Brunelleschi, who had famously solved the problem of creating its vast cupola. If most people hurrying by, or looking in other directions, miss that piece of homage, it is probably because of such distractions as the marble façade of the Duomo itself, completed in 1887, in pedantically correct yet utterly lifeless Gothic detail. Nevertheless, that finishing, so many centuries later, of Arnolfo's great concept has its own significance. It shows the determination of nineteenth-century Florence to confront and meet the world's expectations of it as a supreme artistic capital. And the spirit in which the façade was built was, or was meant to be, a religious one. It was explicitly

designed to celebrate 'the greatness of Christianity and the significance of Mary' (the Madonna).

To some such ends, we may presume, Fra Angelico had worked during the first half of the fifteenth century, but with very different results. Fra Angelico is almost a patron saint of the Florence re-emphasised by the nineteenth century, and it was then that his Dominican monastery became a museum. Pious and (to some extent) cloistered, he was, however, no naive or unworldly painter as far as awareness of contemporary artistic developments was concerned. Nor was his work restricted to Florence: he left a last masterpiece of fresco decoration, as lucid in colour as in organisation, in the small chapel of Nicholas V in the Vatican at Rome.

Nothing comparable exists in the Museo di San Marco at Florence, but it is there that Fra Angelico presides, though the word is too grandiose for the exercise of his spell in its frescoed corridors and cells. Never, perhaps, were the attractions of monastic life set out more persuasively in paint. Some credit should go, too, to the calm, airy architecture of Michelozzo, casting its own contemplative spell. In such a setting, even today, or perhaps especially today, the Florence of the fifteenth century takes on an ideal aspect: human and humane, logical, thoughtful, unfevered, and somehow 'better' — almost in a moral sense — than any other city.

This ideal is at odds with the truth, but dreams of Florence in some vague, half-confused Renaissance period already haunted Samuel Rogers, a cultured and enthusiastic English visitor of as early as 1814. 'What a life was a life passed in such a city,' he wrote in his Italian Journal, '— in such a valley — in such a country — with such people in the golden days of Florence! Here came in succession Dante, Petrarch, Boccaccio, Machiavel, Gallileo [sic], M. Angelo, Raphael, Milton.'

The actual Florence known to Fra Angelico (who died in 1455) was certainly rich in artistic creativity but also in political tension. It had come through threatening storms from outside enemies and from internal factions, for and against the Medici family, whose chief representative, Cosimo de' Medici, had achieved a dominant personal position in governance of a city which was, and prided itself on being, a republic.

Republican Florence had its appeal to the nineteenth century, quite apart from coinciding in the Renaissance with a great age of art. With its guild structure and citizen government and councils of the 'people', it appeared to have been a democracy, or at least not an autocracy. At a time (in the earlier half of the century especially) of fervent striving towards a united Italy, free from foreign princes and kings, the story of how the Florentine republic fought yet failed to preserve freedom from Medici princely rule was

inspiring and rousing. Fanatical monk as he might be, Savonarola took on *Risorgimento* associations when he was seen championing 'civic freedom and law against tyranny and absolute personal rule', as Mrs Oliphant put it in her much-read and re-issued book *The Makers of Florence* (first published in 1876), though she also added his championship of 'Christianity against Paganism, of moral purity against vice'. Not unexpectedly, a large nineteenth-century statue of Savonarola was sculpted for the Salone dei Cinquecento, the main hall of the Palazzo Vecchio (it has since been removed).

In the fresh perspective, which so valuably if over-enthusiastically restored a century of greatness to the popular history of Florence and of Florentine art, it was inevitable that the sixteenth century there should diminish sharply in esteem, taking all later centuries with it. Medici domination had robbed the city of its liberty, and except for Michelangelo (a believer in republican liberty yet compelled to work for the very Medici who had destroyed it), art seemed to have fled, along with freedom. 'What', asked Mrs Oliphant, 'has Florence done more in Art?' She answered her own rhetorical question in a confidently sweeping way, long accepted as virtually a commonplace: 'except effete Dukes and Renaissance Cupids entangled in chains of roses, and a people without life and hope – nothing more'.

Nobody writing on Florence should smile at Mrs Oliphant's way of putting things until they are sure they have not, however unwittingly, reinforced her assumptions. As the Foreword to this book implies, there is no single city – 'Florence' – to be discovered by the visitor, leaving aside the still developing city we see at the end of the twentieth century. And the prime reason for that lies in the restless, changing history of Florence.

Once again, the contrast with Rome and Venice is marked. Declining though it might be by the eighteenth century, Venice remained a republic until 1797 – a matter of impressive record and intense local pride. Not until Napoleon did anyone conquer Venice. Rome too had its proud tradition of continuity in the papacy, which once established, or re-established, ruled there as had once the Roman emperors. And from Vatican City the pope is still ruling, less Rome than a large portion of the world, no longer temporally but spiritually. His greatest predecessors, like Pope Boniface VIII, the first pope to declare a jubilee year, in 1300, and a figure destined to appear in effigy on the original façade of Arnolfo di Cambio's Duomo in Florence, might feel that their global vision had been not only justified but sustained.

It was on an altogether smaller stage, though one which might be termed 'revolving', or frequently even giving way, that Florence performed. It was never of much political moment in the larger European world. It never possessed an empire like that of

Venice. The Florentine chronicler Giovanni Villani made a neat story out of visiting Rome in 1300 and returning to his native city aware of its ascendancy; he would decide in that very year to begin compiling his chronicle. Florence he saw as the 'daughter and creature of Rome', a pedigree she needed. If there were ways in which the daughter could challenge her parent — financially and commercially, intellectually and artistically — yet it remained apparent that Florence would never replace Rome as the notional capital of Italy, for centuries before that became accomplished fact.

The very first Florence, the Roman colony, is a fairly elusive entity. By tradition it was founded by Julius Caesar. Before that, there had been an Etruscan city up on the hill of Fiesole, where there lingers a strong sense of deep-rooted, primeval, mysterious antiquity. The Romans built their town down in the valley, to guard and benefit from the river Arno. They ruled out a roughly rectangular plan, creating an urban area on the north bank, within the walls of which were contained the present-day sites of the Duomo, the Piazza della Repubblica and the Baptistery. Under the Baptistery survives an ancient mosaic pavement, once presumed almost too patly part of some Roman baths but possibly of a bakery. The space approximately of the Piazza della Repubblica was the ancient forum or market-place, and would from early medieval times onwards be the main market-place of the city, the Mercato Vecchio (see p. 8), until it was destroyed in the 1880s, in a wanton scheme of 'improvement', of a kind more often and rightly associated with Britain. For centuries the market had been an evocative if increasingly squalid focal point of ordinary daily life. It was there that the fifteenth-century Commune had set up a rare item in Renaissance Florence, a column on which was placed Donatello's sculpture of *Abundance*, a Roman-style goddess standing suitably enough on a Roman site. The statue perished, to be replaced by one by the Bernini of Florence: the highly gifted seventeenth-century sculptor and architect Foggini. The column itself is still there today, so modest in its dimensions in the huge, ugly piazza that it probably seldom gets noticed.

Roman Florence left little trace of itself above ground but later times soon remedied that by treating the Baptistery as a Roman temple, built by Julius Caesar and dedicated to the god of war, Mars (' 'l primo padrone' of the city, as one citizen calls him in Dante's *Inferno*). More perhaps than the Duomo in any form, or the town hall of the Palazzo Vecchio, was the Baptistery from very early on the emotional, pagan-cum-Christian, semi-patriotic core of Florence (see Plate 4). To the font there, every Florentine baby was brought for baptism, pauper's child or prince's. As late as 1965 the

Opposite: *Lorenzo Ghiberti:* The 'Doors of Paradise', *Baptistery.*

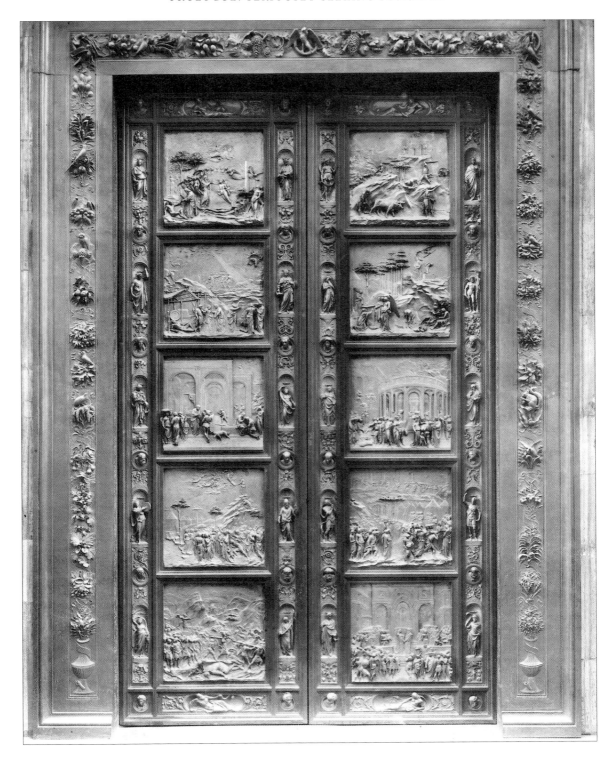

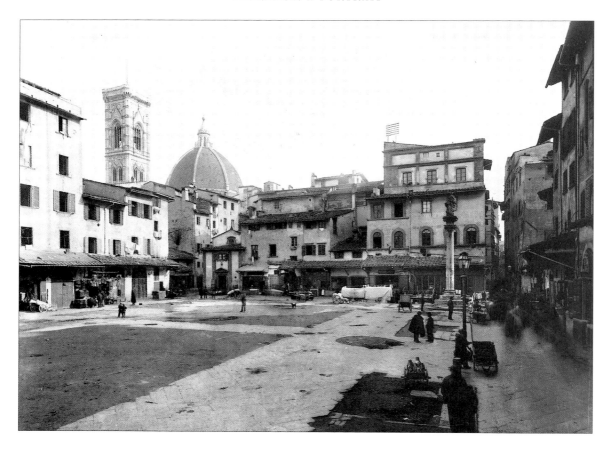

The Mercato Vecchio in the nineteenth century.

Cardinal-Archbishop of Florence was expressing the view that while infants born within his see should normally be baptised in the relevant parish church, the custom should continue of Florentine infants being baptised in the Baptistery of St John, patron saint of the city.

The history of the Baptistery is an epitome of the city's history or at least of its art. In terms of its embellishment we may think primarily of the three sets of bronze doors – Ghiberti's two pairs particularly (see p. 7) – still there to be gazed at (though the panels of his 'Paradise' doors are now there only in replica). Almost as a form of Roman tribute were two porphyry columns added to the east entrance in the twelfth century, gifts of then grateful Pisa. In the thirteenth century the marvellous mosaics of the interior were begun. A significant fifteenth-century contribution was made by the tomb of ex-Pope John XXIII, with its bronze effigy of the dead man, a work of collaboration between

Donatello and Michelozzo carried out at the instigation of Cosimo de' Medici. Early sixteenth-century republican-cum-civic pride added to the outside a sculptural group of the Baptist preaching.

The process of embellishment did not stop there, although today it may need an act of imagination to grasp the facts. Later in the sixteenth century, when a male heir was born to the second Cosimo de' Medici, Duke of Florence, the occasion of the boy's baptism was turned into a public, state event — of a kind to cause any surviving citizens of the old republican city to stare in amazement and disgust. The duke had the Baptistery refurbished, with contemporary artists' decorations, including a large canvas of the *Baptism of Christ*, painted in six days by the young courtier-artist Giorgio Vasari. The duke himself visited the Baptistery to inspect

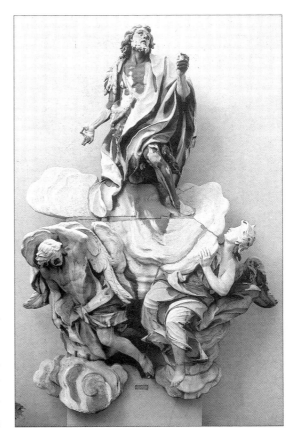

Girolamo Ticciati: St John the Baptist in Glory, *Museo dell'Opera del Duomo.*

the decorations (a thoroughly proto-Napoleonic piece of behaviour), and it was he who required the execution of the large canvas which served to conceal the altar area of the Baptistery. The celebration was only in part a religious rite. The public ceremony, the procession of noble youths through the streets from the Palazzo Vecchio to the Baptistery, proclaimed the establishment of a dynasty. Cosimo's eldest son would grow up to be the second Grand Duke of Tuscany, and though he left no son to succeed him, the direct heirs of Cosimo would reign as grand dukes until 1737.

The décor for Prince Francesco's baptism in 1541 was only temporary. A would-be permanent and major addition was made to the interior of the Baptistery in the eighteenth century, when the sculptor Girolamo Ticciati executed a large, visionary, marble 'glory' of St John the Baptist ascending to heaven, supported by angels and encircled with

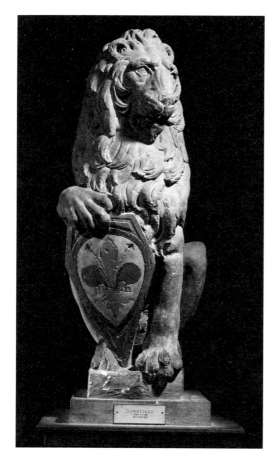

Donatello: The 'Marzocco',
Museo nazionale del Bargello.

clouds, ingeniously fitted in around the high altar, which was also given a new choir-area.

It was a tribute as religiously and artistically serious as any previous contribution to the beauty of the Baptistery. It must have made a particularly dramatic, illusionistic impact when seen from a distance, through the open east doorway. Yet the taste of 1912 not merely failed to appreciate it, but on some impulse of false purism removed the whole sculptured apparatus, banishing it to the limbo of the Museo dell'Opera del Duomo, ironically near yet so far from the Baptistery for which it was planned and where it had remained for nearly two centuries.

The tale of Ticciati's minor masterpiece is a salutary one. If the worn and dismembered work had been better preserved, it ought by now to have gone back into the Baptistery, for it is part of the building's history, regardless of its aesthetic quality. In its way and for its date it is as much a symbol of Florence — the ostentatious, baroque, pietistic yet artistically exuberant Florence in the last days of the Medici grand dukes — as is Donatello's 'Marzocco', the anthropomorphic lion-statue with one great paw clasping the civic shield bearing the Florentine lily, a symbol of the sober, wary, fifteenth-century republic.

It is not too fanciful to say that the Baptistery is where the Florence we know best had its birth. Certainly in the thirteenth and fourteenth centuries the area surrounding it was the space to watch in physical development of the city, although from the first the area was insufficiently commodious. A clutter of miscellaneous buildings had to be removed when it was decided to replace the cathedral dedicated to a female patron saint of the city, St Reparata, by a larger, much more ambitious building. The cornerstone of

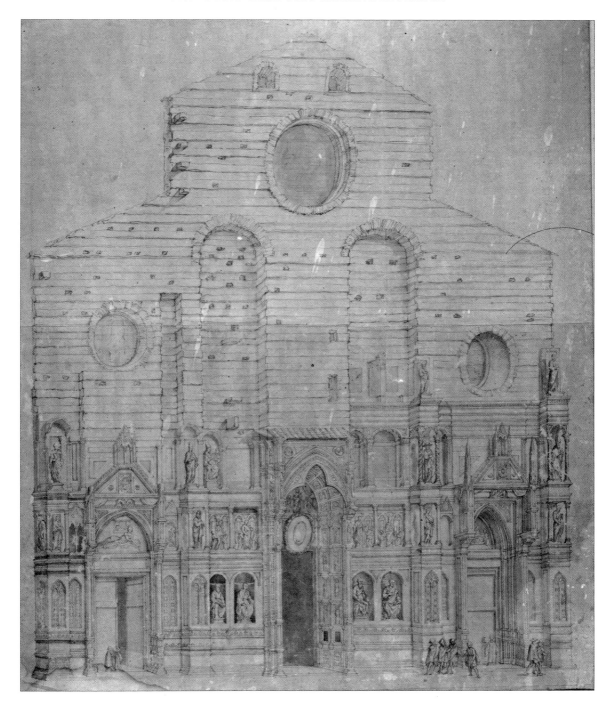

Bernardino Pocetti: Drawing of the Unfinished Façade of the Duomo,
Museo dell'Opera del Duomo.

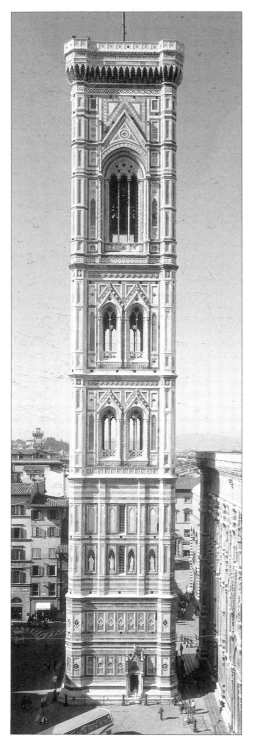

that church, the Duomo of today, was laid in 1294. It was designed by Arnolfo di Cambio, by training a sculptor, and he began the impressive, statue-filled façade that rose excitingly in its day but which was doomed to remain for centuries incomplete. We are fortunate to have a late sixteenth-century drawing that records the incompleteness, though also the rich animation, of Arnolfo's concept (see p. 11).

It was a standing reproach to a city with such a tradition of sustained artistic vigour that the façade of its Duomo should be left in such a condition. Virtually every period had plans for a façade, in the style that was then contemporary. Only the nineteenth century lacked one dominant authentic style. It was that century which completed the façade, but in fairly deadly pastiche Gothic, not improved by being juxtaposed to the genuine Gothic of the campanile, designed largely by a painter, Giotto, and solemnly founded in the summer of 1334. By that date one might term what was happening in Florence a renaissance of sorts, an expression certainly of civic as much as artistic purpose. When Giotto died in 1337 he was buried in the new, very much bigger if unfinished Duomo. That building had a new dedication, a specially Florentine one, not to an obscure female martyr but to

Giotto (and others): The Campanile of the Duomo.

the Virgin, as Santa Maria del Fiore (the flower being the lily, most enduring and ubiquitous of the city's several adopted symbols).

However, expansion was not restricted to the area around the Baptistery. Giotto's city, which was that of Dante too, was a thriving commercial and financial centre, ringed by a new and much wider set of walls. There were big new churches, such as those of Santa Croce, Santa Maria Novella and Santissima Annunziata, each at a fair, discreet distance from the other, built respectively by the Franciscans, the Dominicans and the Servites — all orders which were themselves comparatively new. Giotto's city also had its important civic-official centre: in its town hall and seat of government, the fortress-like Palazzo Vecchio, originally the palace of the 'People' or of the 'Priors', the regularly elected members of government, of whom Dante was one.

On those sturdy foundations, the early Renaissance was able, literally and metaphorically, to build. The Florence of pre-1400 has its own fascination, and the chief areas of sacred and secular it had defined — of cathedral complex, of government, and of market-place — remained the cardinal points of every citizen's existence. It is broadly the first Florence to survive, the one from which the visitor of today may start to seek the complex experience of the city.

As one looks with a sharpened, increasingly eager eye, one sees that despite political discontinuity, and the often violent upheavals, a strong sense of tradition binds together the apparently disparate aspects of Florence. Regardless of individual and dynastic pride, most ages have tended to add to its greater glory. Each has accepted a splendid inheritance from the past and in its own way, effectively or clumsily, has aspired to enhance that inheritance.

It becomes right to remark, in the fourteenth-century interior of Santa Croce, a monument of the mid-nineteenth century to Leon Battista Alberti, the brilliant, versatile early Renaissance personality. Santa Croce certainly houses a number of disparate monuments, some of no more than mild historical curiosity, rather as does Westminster Abbey. But the Alberti monument is the work of a distinguished sculptor, Lorenzo Bartolini. It was commissioned by the last representative of the Alberti, a family whose connection with the church goes back to its early days. Rich local banking families like the Alberti, and the Bardi and the Peruzzi, favoured Santa Croce, and the church which took shape, designed possibly by Arnolfo di Cambio, must have seemed as grand inside as the new Duomo, perhaps grander. It is a vast, luminous, pillared hall of a church, Gothic in its style yet classical in its air of calmness.

Steps in history are more patent and regular at San Lorenzo where one can advance

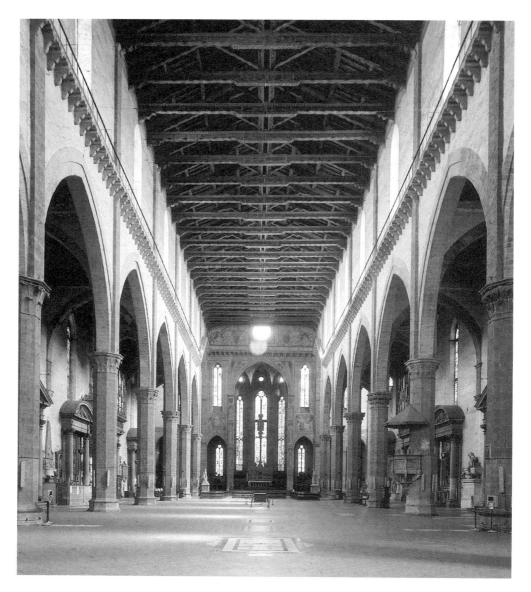

Arnolfo di Cambio (?): Interior of Santa Croce.

— imaginatively — from the fifteenth-century sacristy designed by Brunelleschi for the early, unostentatious Medici, to Michelangelo's princely one for the first ducal Medici, and then to the huge chapel of the Medici grand dukes, a marvel of a thoroughly Florentine medium, *pietre dure*, precious or semi-precious 'hard stones', there cut and polished and juxtaposed in a cold, bravura blaze no less authentic, in its fashion, than the

14

art of Brunelleschi's interior. The very development of *pietre dure* in Florence is an instructive, valuable quest. Monumentally, it ends appropriately in San Lorenzo itself, though with something of an artistic whimper, in the obscurely sited tomb of Maria Carolina of Saxony, first wife of the Grand Duke Leopold II (Austrian by descent). The Medici grand dukes first established an official workshop of *pietre dure*, and it was that workshop which in 1857 produced this modest, miniature echo of their tombs, with its slab of basalt, its crown, its coats-of-arms and bronze inscription, from which, in its currently neglected state, some letters have fallen away. But the craft of *pietre dure* has declined to die, and examples good as well as appallingly bad, by any standard, can be seen on display in expensive shops along the north bank of the Arno.

Does their opulent elaboration represent a Florence less 'true' than that suggested by the naked brick façade of San Lorenzo? It is a façade the more misleading for concealing behind it the various splendours of the three sacristies, not to speak of the actual church. In that very bareness it seems characteristically Florentine, and one might be encouraged sentimentally to think that such a condition conveys stern, unsensuous, almost puritan Florence, whereas its appearance — like the similar condition of several other important churches in the city — was never intended to be permanent. Under the first Medici pope, Leo X, Michelangelo prepared designs for a highly dignified façade (a model exists in the Casa Buonarroti). Nothing came of that, but the question of giving the church deserved completion was still an issue in the nineteenth century, when Grand Duke Leopold II had an imposing neo-classic design prepared by the architect Pasquale Poccianti. It too was never started. In some ways that is a cause for regret, rather than relief. Poccianti's façade would have been an undoubted oddity in Florence, but it would have given great exterior presence to San Lorenzo. And thus, even in the nineteenth-century grand duke's interest, we see the continuation, by a Habsburg, of Medici concern for the church.

Again and again, the off-putting, unfinished appearance of a Florentine church acts almost teasingly on the visitor. Experience teaches that the interior may in fact be more startling, possibly more sumptuous or simply more graceful than one expects — as happens in the prominent church of San Frediano and, more surprisingly, in the small, obscure one of San Giorgio alla Costa. Nobody can fail to remark on the bold silhouette of San Frediano's cupola, even if the building remains distant and unsampled, but San Giorgio is more of a challenge, for it lies off any obvious tourist route, up the hillside on the south bank of the Arno, and its exterior is plain and unalluring. It looks closed and it usually is, except for the two or three times a week when a service takes place (the

timetable of which is, to its credit, displayed outside). Yet even if it were open daily, and visitors were encouraged, it would still provide an environment enchanting and astonishing.

In the comparatively restricted space, the white and gold of its stucco and wood create a shimmering, celestial effect, suitable enough for a church whose full dedication is to the Holy Spirit as well as to St George. The church was a medieval foundation, the convent church of nuns, whose choir loft is one further surprising feature in the ingenious manipulation of the interior. The transformation of that into carefully calculated and controlled elegance, less profane than may at first appear, was achieved by Foggini at the beginning of the eighteenth century (see Plate 39). San Giorgio is merely one of Foggini's ecclesiastical masterpieces in Florence, but – along with the Corsini Chapel in Santa Maria del Carmine – it is one that radically revises any notions of a city artistically exhausted after the Renaissance had finally closed.

It is a steep walk up to San Giorgio alla Costa, and it can be a frustrating one, too. The visitor who persists, however, and who manages to get into the church, not only enjoys an intense aesthetic experience but is on the right road for serious discovery of Florence in all its complexity.

CHAPTER ONE

'St John's Sheep-fold': The City Emergent

E ARLY RENAISSANCE FLORENCE — the composite city symbolised by Brunelleschi's dome of the Duomo and Ghiberti's bronze doors for the Baptistery, with 'Giotto's campanile' vaguely thrown in as conveniently at hand and as prominently visible – forms so famous and alluring a concept that the armchair visitor, as much as the actual one, is tempted to rush on to experience it, not pausing over nascent Florence.

That latter city is indeed less obviously accessible, even or particularly on the spot. Much of it has to be read about and re-created. Where the monuments do physically survive, few or none have been left unadulterated, often by improvements and additions of Renaissance devising. There are too, if one is honest, other difficulties. No glittering myth but a mist tends to obscure the culture and the artistic achievements of that truly early city, taking shape and identity during the thirteenth century. Among both artists and patrons there appears to be a lack of those dominant personalities whose human aura enhances aesthetic quality. About the very dates of some buildings, as about the lives of those who built them, or are presumed to have built them, there is little certain record. Before Giotto, the medium of painting – normally thought of today as the most immediately assimilable of all visual media – tends in Florence to seem stylistically homogeneous and anonymous, if not positively monotonous: a matter of crucifixes and dim bits of fresco which can pass as just the inevitable religious furnishing of chapels and churches.

Moreover, the political picture of Florence in the decades leading up to 1300, in so far as it can be described by anybody not an expert, is one profoundly dark in hue – in fact painted largely black. It is generally devoid of appeal, though certainly not of incident. Any dreams of agreeably civilised, learned, religious, cultured Florence – a Christian Athens on the Arno – are brutally invaded and dispersed by the din of the reality: an incessant clash of factions and feuds, constantly fomented unrest, fiercely divisive but often pointless vendettas and a considerable measure of disregard for any-

thing except personal or family advantage. Understandably, the chroniclers of the time find it worth stressing when there occurs a brief interval of civic calm.

It may all make fascinating material for modern historians to burrow into and explicate (from a safe distance), but for most of us the spectacle of the Guelphs battling it out with the Ghibellines looks like the fight of Tweedledum and Tweedledee as far as a sensible way of governing a city is concerned. The nuances of colour-coding between 'Black' Guelphs and 'White' ones, the nature of the post of *Podestà*, the succession of the Priors, and the general futility – not to mention the bloodshed – tend to induce little except weariness. The Florence of that period is no shining example of the virtues of republicanism. If anything endemic was then being born, it was the activity of the Mafia.

No doubt it can be interpreted as a triumph of individualism – showing how lively-minded the Florentines always were – but a measure of pragmatic, possibly dull, conformity would have made for a more peaceful existence. Florence fostered theorists who eloquently and elegantly discoursed on the benefits of the republican form of government, and it went on tinkering with its own constitution like a demented hypochondriac. But Venice was the city which early put into successful practice, without rhetoric, a system of republican government (remote from anything particularly democratic, of course) that lasted for centuries.

The efforts of Florence to be stable, independent and republican – and perhaps also democratic, in a fashion – look doomed all along. The liberty it lost conclusively in 1537 when Cosimo de' Medici, the future Grand Duke of Tuscany, was chosen as head of government, was partly a legend and had already proved a dubious blessing. No outside enemy, no pope or emperor, did more than the Florentines themselves to jeopardise and debase liberty as a principle. In his *History of Florence*, Machiavelli summed up the situation tersely: 'The evil . . . which external powers could not effect, was brought about by those within.' A rich irony of history is that the Florentines were to live thenceforward under an autocracy – into the nineteenth century – in virtually total peace.

Yet it would be a pity, indeed a serious mistake, to allow the depressing confusion of the politics, the violence of the vendettas and a general feeling of remoteness, to conceal the clear fact that by the beginning of the fourteenth century Florence had emerged as one of the major cities of Europe. By the standards of the age it was huge in terms of population alone. Between 1200 and 1300 the number of its inhabitants almost doubled, to reach a figure around 95,000 or more. Physically too, the city had evolved significantly over the same time-span. Several of the great and most familiar buildings and other monuments – bridges and palaces, as well as churches – were by then planned if not

actually in existence. The city might be magnificently embellished by later, Renaissance artists but the nucleus of Florence as we know it was already established, and in certain ways its basic character would change little, although it assumed different clothes.

Above all, the Florence of 1300 was famous and important not for its culture or its beauty but for its commerce (which can be interpreted in the strict dictionary sense of 'buying and selling, all forms of trading, including banking'). Asked to name the chief artefacts associated with Florence, an average European of the fourteenth century would have named money and textiles, especially woollen cloth. An admittedly unaverage European, Petrarch, Italian-born but an international figure, was to express succinctly what Florence was: 'a commercial and cloth-making city'.

 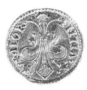

Medieval gold florin of Florence, Museo nazionale del Bargello.

The most beautiful object the city had produced, as far as the outside world was concerned, was its gold coin, the florin, issued first in 1252. Other Italian cities had their own gold coins. Genoa's was the *genovino* and Milan's the *ambrogino*, but the Florentine florin was the one that became a sought-after, standard currency throughout Europe. The coin was stamped on one side with the device of the lily, and on the other with an image of the city's patron saint, St John. It was, as Dante refers to it in the *Inferno*, 'sealed by the Baptist'; and the saint, with his costume of skins and fleecy symbol of the Lamb, seems a highly appropriate protector – almost an advertisement – of the basis of flourishing, mercantile Florence.

In 1300 a remarkable tribute was paid to the Florentines by the reigning pope, Boniface VIII, a dynamic, dictatorial ruler whose conviction of the universal supremacy of the papacy over temporal power makes his words the more impressive. To the four elements of earth, water, air and fire, he declared he added a fifth one, the Florentines, 'who seem to rule the world'. He himself had been only too pleased to borrow quantities of florins from the city's bankers (at considerable rates of interest). Well might Florence find a place for such a pope on the façade of the new cathedral it was in the process of building. The imposing surviving statue associated with Arnolfo di Cambio (in the

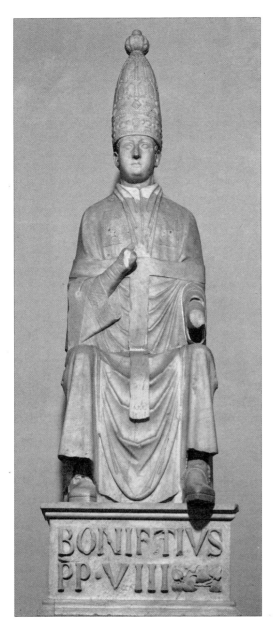

Arnolfo di Cambio: Pope Boniface VIII,
Museo dell'Opera del Duomo.

Museo dell'Opera del Duomo), with its tall, elongated tiara that might have been designed by Giacometti, seems a reciprocal compliment from the city to Boniface VIII.

To help recover something of that city, its appearance, its age, its culture and its constitution, there fortunately exists a human guide, or at least a focus: no imaginary person but a citizen involved with its affairs who was also to be its greatest literary genius, Dante. He is really the best argument for trying to comprehend something of the political situation, and any impatience or distaste felt in retrospect for what was going on pales before his own inspired, eventual fury with his fellow-citizens, many of whom he was firmly to consign to the *Inferno* of the *Divina Commedia*. A place is allotted there for the arrival of Boniface VIII. Dante's fury was itself provoked by profound, nostalgic patriotism: a vision of what Florence had been and could yet be. Less generally celebrated than the vision of the wretches in Hell is Dante's meeting in the *Paradiso* with his ancestor Cacciaguida, which prompts the poet to speak of Florence as 'St John's sheep-fold' (*'l'ovil di San Giovanni'*), a place he later recalls wistfully as the lovely fold where once he slept lamb-like but from which he is cruelly shut out. Should he ever return to be crowned as poet, it will be in the very Baptistery where he was christened (*'in sul fonte / del mio battesimo'*).

Dante was born in 1265. He was formally banished from Florence in 1302 and never again saw the city. From the moment of his death at Ravenna in 1321, his remains were fought over between the two cities, but Ravenna always managed to retain them. Florence had to be content with planning a cenotaph in the Duomo and erecting outside Santa Croce a huge, lard-white marble statue of Dante, put up 600 years after his birth, a bland piece of work despite its frowning demeanour, and probably unseen, for all its prominence, by most visitors entering or leaving the church.

The city into the heart of which Dante was born (apparently not far from the Baptistery) was physically altering and expanding decade by decade. Its central core, however, remained – as it still remains – compact. When the third and final ring of walls was going up, at the end of the thirteenth century, at a time when the real threat to Florence lay largely not outside but within the city, among its brawling and bloodthirsty upper- or middle-class citizens, that ring embraced an optimistically wide area north of the Arno which for a long time remained scarcely developed. The fields and gardens that continued for centuries to extend their fat green fingers to just behind Santa Maria Novella and Santissima Annunziata, for example, were not exploited until the expansionist schemes of the mid-nineteenth century, and a largeness of scale and space can be detected even today in such areas, which are untrodden by tourists and hardly seem to typify Florence at all.

The site of Florence selected by the Romans had no particular physical allure or grandeur. It had none of the rocky, eyrie-like effect of hill-top Fiesole, or of many Tuscan towns, exemplified by Volterra and San Gimignano. The naturally picturesque, marine setting of Naples was lacking, as were the opportunities offered by the seven hills of Rome. The human ingenuity which created the wonder of Venice in an unpromising marshy location was not required. In essence Florence occupied a flat area – as flat as that of any Dutch seventeenth-century city – beside the Arno, and the river proved its greatest geographical advantage. It did not provide adequate access to the sea (for that Florence needed to acquire both Pisa and the Pisan port of Livorno) but it gave running-water facilities which could be harnessed for the washing and treatment of wool. Along its banks were built mills and drying-houses (governed by guild ordinances). Aspects of the whole process of turning raw fleece into exportable cloth are commemorated by street-names in the vicinity of the river, now sounding quaint perhaps but indicative of the complex industry which employed hundreds of artisans in painful, poorly paid day labour, washing, drying and dyeing.

The Arno has seldom been a satisfactory, calmly flowing river. Its extremes of

flooding and drying-up have a long history, but even when it dwindled to a trickle it continued to supply plentiful sand and gravel, valuable resources for the building trade (and rights of access by builders were early controlled and guaranteed by legislation).

While the northern side of the Arno allowed for embarrassingly generous expansion of the city, the southern side, the region of Oltrarno, was always smaller and more restricted, partly because the ground became hillier much sooner. Only a few great families cared to build palaces there before Luca Pitti chose to do so, on an extremely effective, highly exploitable site, in the fifteenth century. On the north bank the old city centre remained roughly a rectangle. On the south was formed an approximate triangle, its apex the present Porta Romana. Until 1220 the two sides of the city were connected by a single bridge, the Ponte 'Vecchio' (as it became known, with the building of a new one). By the time of Dante's birth there were no fewer than four bridges.

Dante's city was not only compact but visually harmonious in its reserved, even severe, somewhat embattled, business-like way. Its streets were straight but narrow, lined by tall, fortress-style houses of a proto-skyscraper kind for which 'palace' seems too grandiose a word. It was essentially a city of brick, brick more than stone — which probably gave it already a sober, dun-coloured appearance. There were few large public spaces, although orchards and gardens, and gardens enclosed by cloisters, were surprisingly prevalent. Literally thousands of orange and lemon trees are mentioned as planted in just one garden towards the end of the thirteenth century, and the way greenery can magically enhance a stony site in modern Florence is seen when a 'garden centre' is temporarily installed in a piazza, such as that of Santissima Annunziata.

That space was itself probably no area of coherence or specific beauty in Dante's day. It awaited the genius of Brunelleschi to create the low, graceful façade and open loggia of the Ospedale degli Innocenti on one side. It was enhanced by later additions and given the final refinement of Tacca's pair of fountains only in 1643. Far more closed than open, the façades of most Florentine buildings of the thirteenth century, sacred as well as secular, must have tended to look grim. On many buildings there was no place for decoration or colour. Even patterning in brick, as on the Doges' Palace at Venice, was not a popular idiom, and it is impossible to conceive of such a fantastic, elaborately wrought, gilded and jewelled façade as that of St Mark's being thought desirable — still less executed — in contemporary Florence.

From any picture of the city in which Dante grew up we must banish several of the most famous and familiar buildings which now seem the very quintessence of Florence, beginning with the Duomo and its campanile. The Palazzo Vecchio had been started not

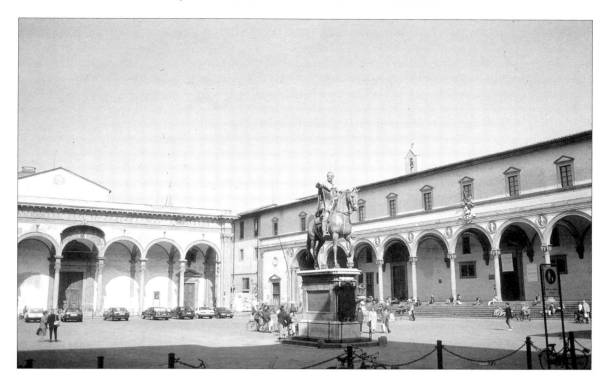

View of the Piazza Santissima Annunziata.

long before his banishment, but there was as yet no Loggia dei Lanzi. There would have been virtually no exterior sculpture to be seen anywhere, and little or none in churches. The wonderfully sculpted pulpits of Nicola and Giovanni Pisano occur at Siena, Pisa and Pistoia. There is nothing comparable at Florence. No sculpted public fountain like that in Perugia was planned.

Yet the city must have exuded an air of being impressively old, indeed ancient, richly endowed with churches, redolent of tradition and under heaven's protection ultimately – whatever the current civic crisis or the larger problems of the Italian peninsula. In the *Paradiso* Dante has Cacciaguida evoke an ideal Florence of the past, when it was still contained within the older, narrower circle of its walls and lived 'in peace, sobriety and decency'. The evocation is tinted with a good deal of rose colour, since Dante wishes to contrast sharply those simple frugal times, when ladies dressed plainly (a familiar dream of male moralists at all periods and in all countries), rocked the cradle and spun flax, with the degenerate Florence of his own day. Women there with painted faces and elaborate costumes seem a very minor aspect of degeneration, it must be said, amid the real fights

and feuds the city had had to suffer, and about which Dante made Cacciaguida rightly gloomy.

At the same time, this ancestral figment proudly stresses the nativeness of Dante's family, for generations established in the centre of the old city, around the corner from the abbey church, the Badia, whose chimes Dante has Cacciaguida recall as still regularly sounding out; but the nostalgia is the poet's, conscious that he himself is unlikely to hear them ever again.

No building in Florence could compete with the fusion of antiquity, esteem, emotional importance and beauty in the Baptistery, at once core and symbol of St John's sheep-fold – simply 'San Giovanni' to every Florentine, other churches of the saint being referred to as lesser, as of 'San Giovannino'. It is the building to which Dante's thoughts constantly return, and without the competition of the campanile and the distraction of the Duomo façade it must have stood out the more prominently in its almost flamboyant display of green and white marble outside and golden mosaic dome inside – a combination that remained unique in the city. The scheme of the mosaic is a cosmic one, of heaven and hell, of the Lamb of God and of Christ as Judge, which has its Dantean echoes or anticipations and which was well under way before his banishment. Until the addition of those mosaics, the work maybe of non-native, perhaps Venetian craftsmen, the Baptistery must have lacked any very marked Christian connotations, apart from its central font.

Stylistically and aesthetically, one building alone complemented the Baptistery, the church of San Miniato, superbly sited on its hill far across the Arno and looking down on the city. That the same powerful guild, the Calimala, became responsible for both buildings seems appropriate. Like St Reparata, the patron saint of the old Duomo, St Minias is an obscure early martyr. Unlike her, however, he was traditionally executed outside the city walls, on the hill where his body was afterwards buried. To that chance is owed the setting of the church, which remained alone on its eminence, deep in the countryside and yet visible and near at hand, until the fifteenth century, when another church was built nearby, San Salvatore al Monte. Not until the skilful and effective, if romantically conceived, creation of the Piazzale Michelangelo in the later nineteenth century did any urbanisation touch the hillside. Even now San Miniato is invested with a calm, slightly rustic apartness and quietness. No less a marble shrine than the Baptistery, though a far less busy one, it equally speaks of the Florence that was old when Dante was born. It seems the ideal temple to a saint martyred under the Roman empire, and some of the columns of its truly Romanesque, classically lucid interior, are antique.

That tripartite interior leads on logically — skipping the intervening centuries — to the classically lucid, pillared interiors of Renaissance churches such as Brunelleschi's Santo Spirito on the Oltrarno.

The façade of San Miniato is equally forward-looking. Its patterned white and black-green marble is applied not in dazzling, delightful, semi-abstract zebra-style striping, of the kind seen at Pistoia and at Siena, but to suggest three-dimensional architecture, beginning with a five-arched portico, outlined on the façade, above which rises a strongly emphasised pediment (see Plate 3). Apart from the special case of the Baptistery, no church down in the city had such a comparably finished — as well as handsome — façade until that of Santa Maria Novella, designed by Alberti in the mid-fifteenth century: a façade which consciously takes its inspiration from that of San Miniato.

Of the old city churches San Lorenzo could claim to be oldest, founded by St Ambrose of Milan in the fourth century. More venerated, probably, was the Badia, for it had been founded by Willa, mother of Ugo, Margrave of Tuscany, the *'gran barone'* mentioned in the *Paradiso*, who had preferred Florence to Lucca as his residence and who had died on 21 December (the feast-day of St Thomas) 1001. By a tradition to which Dante refers, he was — and still is — annually commemorated by a mass on that day. He was also commemorated in the fifteenth century by the setting up in the Badia of an elaborate tomb (presumably previously lacking) by Mino da Fiesole: a monument rather too obviously indebted to the finer Renaissance tombs of Leonardo Bruni and Carlo Marsuppini in Santa Croce, but even in borrowing from them the tomb absorbs the margrave into a patriotic Florentine ethos and gives him an honourable place in the city's history.

Old as the Badia's brickwork may appear today, the church was one of those being rebuilt in the years when Dante was growing up nearby. Like several other truly old Florentine churches, it remained nevertheless modestly tucked away, to some extent, at street level, imposing itself more by its tall, pointed campanile than by any assertive façade or spacious approach. Even when work soon began on the new and greatly enlarged Duomo (rededicated to an entirely new, peculiarly Florentine aspect of the Virgin, Santa Maria 'del Giglio'), the piazza surrounding it was only very tentatively extended, with the result that neither it, nor Giotto's campanile, enjoys sufficient space around it for full appreciation. Perhaps it is as well, from that point of view, that the eventual façade of the Duomo was no masterpiece.

In addition to old, sacred edifices, the Florence Dante knew had recently been enriched — effectively, enringed — by a number of important churches, each founded by a religious order and built with very large spaces in front of them, as was possible on what

then ranked as the periphery. To posterity the effect is of a series of aesthetic bulls' eyes scored in rapid succession on the target of Florence, beginning with the earliest manifestation of the Dominicans at Santa Maria Novella (from 1221), followed by the Franciscans at Santa Croce (1226–8), the Servites at Santissima Annunziata (1248), the Augustinians with Santo Spirito on the Oltrarno (1250), the Umiliati with Ognissanti (1256), and the Carmelites, again on the Oltrarno, with the church of the Carmine (1268).

While it is true that each of these foundations resulted in a complex, augmented over the centuries, which contained or incarnated work of the greatest artistic importance and beauty, their fundamental purpose was quite otherwise. They were built as expressions of faith and means of salvation, so many spiritual sheep-folds for the population of Florence (which might well look forward to the peace of heaven after the hellish hurly-burly of thirteenth-century life on earth). The huge spaces in front of each church — today's piazzas — are frequently explained as originating in the urge to preach outdoors to the people (and outdoor large-scale preaching occurred, though few of the congregation can have heard much), but these spaces probably served no less for processions and also, as urban planning concepts increased, for the general dignity of the church and its immediate environment. It is known that in 1317 (about the time Dante moved to Ravenna) the Carmelites petitioned the Commune of Florence for the cleaning up of the squalid conditions around their church, and in response the authorities established what is now the piazza, as an amenity equally for the city as for the church.

Many of the steady improvements to Florence during the thirteenth and early fourteenth centuries, deepening its air of being a truly advanced and essentially organised, practical place in which to live and work, represent nothing notably artistic as such. No artist or architect — or town planner — is credited with the important action of paving the streets with stone, undertaken from 1237, according to the chronicler Villani, with the triple result of the city becoming, as he says, 'cleaner, more beautiful and more healthy'. The straightening of streets, too, sometimes prompted by the building of the new bridges (themselves a sign of increased volume of traffic) is credited to no individual, and the decisions themselves were effectively anonymous ones by 'local government'. In many ways these corporate initiatives (of a kind undertaken in other great Italian cities, such as Siena) are as remarkable and as enlightened as any famous Renaissance acts of collaboration involving individual artists and patrons. The latter are now the more obvious and appreciated, but nobody who walks the streets of central Florence should forget Villani's tribute to the first proper paving of them.

Secular concerns also played their part in adding to the monuments in the city.

Some leading families built palaces on a big, novel scale, for which almost inevitably new and somewhat distant sites had to be chosen. In contrast to the central northern side, the Oltrarno offered scope. Close to the Ponte Santa Trinita the powerful, mill-owning Frescobaldi family built their palace, having already instigated the building of the bridge, first constructed in 1252. When the French king's brother, Charles of Valois, entered Florence in November 1301, he stayed not at the neutral, usual and safe location of Santa Maria Novella but in the Frescobaldi house. That was largely a matter of political manoeuvring, but it also suggests the premises could accommodate a prince.

A grander palace was built by another powerful family, the Mozzi, in a more daring and partly unsavoury site on the Oltrarno, facing the Ponte alle Grazie (as it became). Its bulk and dominance can still be appreciated, though the building is much restored. Both palaces had their gardens, that of the Palazzo Mozzi including an orchard, and even today it has a sense of being on the rural, or semi-rural, fringe of Florence. It ranked in Dante's time as the finest of all the city's new private palaces and was thus apparently judged suitable to lodge the pope, Gregory X, when he visited Florence in 1273, with the intention of quelling the strife between Guelphs and Ghibellines. The Mozzi were prominent bankers, and perhaps the pope's residence with them had a less advertised financial explanation. That he failed to settle in any permanent way the strife between Guelphs and Ghibellines is not unexpected. In his chagrin, he interdicted the city, but was actually compelled to pass through it under that ban, shortly before his death, because of the swollen nature of the Arno elsewhere. He was perhaps lucky not to die on the spot, for he was already ill and died while still in Tuscany, at Arezzo.

It was not individuals but the Commune which built the two great palaces that had begun to rise in Florence before Dante's exile: the Bargello (see p. 28) and the Palazzo Vecchio, as they are generally known, although those names obscure the original purposes for which each was built. In themselves they are monuments and indeed museums to profane, polit-ical Florence. Their bell-towers are campanili less for summoning the faithful to prayer than the citizens to assemble, and on occasion to be armed. The late fifteenth-century diarist Luca Landucci records how the bell of the '*Palagio*' (Vecchio), ringing out at the dramatic time of the Pazzi conspiracy, roused the city.

Solid, assertive, impregnable-looking, though now tamed and grown merely picturesque, the two buildings — significantly not far from each other — are as good an introduction as any to the Florentine system of government which seemed so admirable in principle and proved so ineffectual in practice. The Bargello is the older of the two, and its tower, rising as something of a square, secular 'answer' to the pointed campanile of the

View of the Bargello and the campanile of the Badia.

Badia across the street, was probably incorporated from an existing private dwelling when the battlemented palace was begun, a decade before Dante's birth. Its bulk is greater than can easily be realised on the ground from any single angle, and its façades turn an uncompromisingly bleak, defensive stare on the closely-surrounding buildings, as though anticipating trouble.

That was only wise in Florence. The Bargello was intended to be the seat of corporate government and it became the first permanent physical expression of the Florentine state. Considering the fluctuations of that entity, however, its sturdy air of survival is misleading. Its purpose was to accommodate officially the Captain of the *Popolo*, a post newly created in 1250, after revolt, to represent the 'people', as opposed to the great patrician magnates (landowners, incidentally, as well as the commercially active), who had previously been the city's masters. The 'people' he represented were an amalgam of prosperous, non-noble merchants and so on (a sort of upper middle-class, typified later by the Medici), with a lower stratum of shopkeepers, minor merchants and artisans — but exclusive of the labouring population in major trades such as wool-working and building. That the franchise did not extend to them is neither surprising nor shocking. After all, the English working-class was not enfranchised until the later nineteenth century, and the proposals for so doing alarmed a considerable body of not just reactionary aristocrats.

Before the post of the Captain of the *Popolo* came into being, there had existed a chief magistrate in Florence, the *Podestà*, who governed, as did the captain, with the advice of councillors. It had appeared a guarantee of his impartiality that he should always be non-native to the city (the first, in 1207, was a Lombard), and in theory a nice constitutional balance may be envisaged between two such leading officials representative of the major social forces: the magnates and the *popolo*. In reality, it was less simple. Fresh revolts and fresh regimes affected the office of Captain. What had been his palace became that of the *Podestà*, whose own position soon ceased to be of significance. A sort of miniature storming of the Bastille occurred in the fourteenth century, when the palace-cum-prison was sacked. In the reign of Duke Cosimo I de' Medici it became the residence of the chief of police (for which it seems indeed well-suited), who was called the Bargello. In the nineteenth century it became a museum.

By the time Dante grew to manhood, the government of Florence was — or was meant to be — in the hands of a new body, the Priors (priors of the several major *Arti* or guilds), also known as the *Signori*. There were seven of them, elected, unbelievably, for no longer than a period of two months — a precaution worse for stability than almost any

dangers of long-serving corruption. Dante himself (then no more than a local citizen-poet, not yet the author of the *Commedia*) was a Prior in June–August 1300. Another Prior at precisely the same period remained a wholly obscure literary figure for centuries. He was a merchant, Dino Compagni, a modest, middling type of man, anxious for the good of his city and appalled by the happenings around him. In straightforward prose he wrote a *Chronicle* of events as he had experienced them and been involved with them. It is an indictment as damning as any anathema of Dante, and inevitably more detailed. At the close of his recital of the constant factional conflicts which represents the 'political' history of Florence, Compagni concludes with an almost audible wail: 'Such is our troubled city! Such are our citizens, obstinate in evil-doing!'

That was the city which had meanwhile proceeded with two great building projects: the new Duomo and – more urgently and rapidly – a building for the Priors. It was as the Palazzo of the Priors, or of the *Signoria*, that in 1299 work began on the vast, dominating castle, as it effectively is, of what is now known as the Palazzo Vecchio, not merely larger and far grander than the Bargello but made the more memorable in its towering impact by the huge surrounding space of its piazza. The new palace and the new cathedral would eclipse the Bargello and the Badia, both on the ground and in the profile and panorama of the city for the future. Nothing – not even Giotto's campanile – was better anticipatory complement to Brunelleschi's dome of the cathedral than the tall, tawny-yellow, crenellated tower of the Palazzo Vecchio, surveying and symbolising the state of Florence and expressive of colossal civic pride (see Plate 6). Like a mailed arm and fist in masonry, it stretches towards the sky, very much contributing a 'fifth element' to the cosmos.

The high-minded system of government which had brought it into existence would proliferate in councils and committees, and would-be democracy, of a limited kind, and lead to oligarchy and finally to autocracy. The palace built for the Priors to live out a quasi-monastical period of office (perhaps fortunately brief, from that point of view), eating and sleeping there, as well as deliberating, continued to be the seat of government (as well as family home for a period) when Cosimo de' Medici became Duke of Florence, changing its outside appearance comparatively little. And that the Mayor of Florence should today be the chief occupant of the palace, which serves as the town hall in addition to being a museum, is something of which its instigators would surely approve, for it had been solemnly voted into existence '*pro Comuni Florentiae*'.

The piazza that is fundamental to the building's impact at ground level was, and partly remains, a more haphazard affair, not much helped by a motley collection of sur-

rounding buildings. But space in Florence was often haphazard, if not capricious. There is too little space around the Duomo, too much in front of Santa Croce. The chief big public space which could have been made use of for the palace of government was in the centre of the city, in the (old) Market-Place. That a site there was not chosen may have been a matter of chance or perhaps policy. A market environment might have seemed insufficiently dignified, even dangerously 'popular' and certainly liable to congestion if the citizens were summoned to fill it while stall-holders occupied it.

At Siena, however, the market-place was so selected, virtually at the same date. The result is unmatched, unforgettable, as a piece of inspired urban planning – almost literally at the heart of the city – whereby the great dipping, semi-circular sweep of the Piazza del Campo curves round like an auditorium to meet the great stage-set of the extensive yet graceful Palazzo Pubblico, the tower of which launches itself, slim-seeming and rocket-like, high over city and countryside (higher than that of the Florentine Palazzo Vecchio).

Nothing so stunningly integrated and effective – and unspoilt – as a civic setting was ever achieved in Florence. Some of the profound endemic hatred between the two cities might be traced to cultural rivalry, and though the fourteenth-century Florentine versifier and town crier Antonio Pucci mocked the spaciousness of the Campo at Siena (too hot in summer, too cold in winter), his patriotism had outrun any visual sense.

Both republics were rather similarly governed at the end of the thirteenth century, but under its 'Nine', the representatives and defenders of the Commune, Siena was not only at peace – for a period – but seems to have been much more concerned to employ all the arts, especially painting, to preach to its own citizens about the benefits of life in a good, God-fearing city. Like the Venetians, the Sienese failed to produce those learned treatises on republican ideals and the importance of liberty which typify Florence; but, again like the Venetians, they made a better show of putting such ideals into practice.

A stern, Sienese-style edict might have tidied up the Piazza della Signoria in Florence once and for all – or at least seen to it that the site of the new civic palazzo was a regular one. That did not occur, and the Palazzo Vecchio got built where it did largely, it seems, because a space was available. The piazza remained an odd shape, while the exterior of the palace never shook off its appearance of brutality when compared with the regular, triple-windowed, handsome façade of the Palazzo Pubblico at Siena.

As well as the spate of buildings that went up in thirteenth-century Florence, there was considerable demolition of buildings. Some disappeared in the course of urban development, but many more were deliberately destroyed. That is what had created the

space on which the Palazzo Vecchio was built, though at least one other comparable space would have been available. In the area of the market-place a great palace – 'the palace', it was called – belonging to the Tosinghi family was among the thirty-six houses and towers pulled down in 1248. Not only had that palace its own tower, but a façade which was, according to Villani, decorated with small marble columns, a style more Venetian than Florentine and certainly unlike the familiar, plain stone façades of medieval-Renaissance palaces in the city.

The reason why this handsome-sounding building – along with so many other private houses – had to be destroyed was political. The politics involved two violently opposed groups of adherents: the Guelphs, who allied themselves with the papacy, and the Ghibellines, who allied themselves with the Holy Roman Emperor. In 1248 the Ghibellines were in the ascendant in Florence. The Guelphs were banished and their property taken over or razed, regardless of the damage to the city's appearance. Two years later the Guelphs swept back triumphantly, and it was the turn of the Ghibelline families to be banished. A decade later, following the savage battle of Montaperti in 1260, the exiled Ghibellines were victorious, with the aid of Siena (which celebrated its success and freedom from Florentine domination by, among other things, a series of artistic religious commissions). Florence became again a Ghibelline city, but not for long. Another swing of the political pendulum – not so much swinging as given a hefty push by events and personalities outside the city – brought re-entry of the Guelphs in 1267. Among the lesser Guelph families was Dante's. The fate of Ghibelline families was banishment of a drastic, would-be permanent kind. They had to endure the bitter lot of the refugee which would later be Dante's own, and which he expressed in the famous lines of the *Paradiso* (canto xvii) about being separated from everything dear and learning how bitter is the bread of strangers and how painful the path of going up and down their stairs:

> *Tu proverai sì come sa di sale*
> *lo pane altrui, e come è duro calle*
> *lo scendere e'l salir per l'altrui scale.*

An era of peace in Florence might have been envisaged following the settled Guelph return. The sheer ding-dong contest of the preceding twenty or so years would have given most cities a wish for respite. But the Florentines were soon again at each other's throats, often literally. These were the years when the Guelphs split into the two factions of Black and White, who naturally began to fight each other (the Ghibellines being out of the running) with fratricidal venom. The city's patron seemed to have reverted from the

Baptist to its old pagan protector, Mars, god of war. More Black wolves than White lambs flourished in the sheep-fold, and when Blacks defeated Whites, the lambs sentenced to exile included Dante.

This extraordinarily unsettled, confused and largely disagreeable situation was the background to the emergence of Florence as a great and prosperous European city. This has often been deemed a paradox, but it probably simply shows the comparative contemporary detachment of politics from economics. The commercial sinews of the city were not necessarily damaged by feuding in its streets, however violent. International banking and trading links were not broken, and the major foreign clients and firms involved with Florence were no doubt little concerned about its constitutional volatility (and what the Black Guelphs were doing at any given moment to the White Guelphs, or vice-versa) as long as money and goods travelled freely.

To Edward I of England, who reigned until 1307, it must have been a matter of indifference whether the Frescobaldi family pursued some local vendetta or practised poetry (two of the family were in fact poets). The importance for him lay in their proven mercantile abilities and their capacity to lend large sums of money, and the kings of Naples would have agreed with him. Florence had the advantage over several other great trading centres of dual strength: finance and industry. When, at a later date, in the years 1376 to 1378, the city came under a fresh papal interdict, its economy appears to have been relatively unscathed, though its bankers lost in the pope an important client. Dino Compagni might in the privacy of his *Chronicle* upbraid Berto Frescobaldi for mediating in a political matter to earn 12,000 florins, but such self-advantage is hardly unknown among mercantile and financial organisations in today's world. Commercial interest in politics is usually restricted to what affects commerce, or can be interpreted as doing so. Patriotism tends to stop there.

The Guelphs and the Ghibellines were a form of political plague afflicting not just Florence but a good deal of Italy. It was the price paid by a country disunited and anti-monarchical, unlike France and England, but the battleground for two super-powers, the papacy and the Holy Roman Empire.

In the very existence of those two mighty rivals lay an admission that an Italian city-state would have difficulty in asserting its independent status. At times the reigning pope seemed the best ally Florence could have, at times the emperor. Long after the Guelphs and the Ghibellines had faded from the scene, the papacy and the empire continued to be often painful political realities for Florence and its government. Cosimo I de' Medici became Grand Duke of Tuscany only by the sacred authority of the pope, Pius V, and

that title needed the ratification of the secular authority, Philip II of Spain, son of the Holy Roman Emperor, Charles V.

Both Dante and Dino Compagni, moderate 'White' Guelphs and profound patriots, saw Florence as requiring some outside saviour – a ruler, in effect, of a kind that ultimately Cosimo I de' Medici proved. Their experience of events did not lead them to suppose that the city could achieve political peace otherwise, or 'go it alone' as a republic.

Guelph and Ghibelline conflict in Florence was given additional, local virulence by a long-standing feud between families which by tradition goes back to 1216, when a certain Buondelmonte de' Buondelmonti was murdered near the Ponte Vecchio. He was killed by the aggrieved relations of a girl from a good family, whom he had jilted after being attracted by the beauty of another girl, of the Donati family (into which Dante would marry).

This Florentine variation and anticipation of the Romeo and Juliet story, with all its associations of ancient hatred and sustained feuding ('Where civil blood makes civil hands unclean'), seems more of an excuse than an explanation. As the serious origin of the jostling for power several decades later, it has a dubious, folklore-like air. In the very telling of the story by Villani, for example, there can be detected perhaps unconscious pleasure in a vivid and human, if horrible, anecdote. Rather similarly, he traces the split in the Guelph party to a scuffle among young bloods on horseback who were watching ladies at an open-air dance. Yet the traditional explanation offered for the terms 'Black' and 'White' is equally and perhaps dubiously 'human', relating them to the two wives of a member of the leading family of Cancelliere in Pistoia, who were called Nera and Bianca.

These stories suggest a small-town atmosphere and possibly a concomitant sense of boredom or frustration. Substituting motor-cycles for horses, one can see a couple of gangs – in modern England more easily than in modern Florence – egging each other on to an ugly fight with girls present. Then as now, the more prudent or elderly citizens may have stepped aside, gone about their own business and deplored the current hooliganism, so different from things in their own youth.

However it is all to be explained, the entity of Florence survived remarkably well. Compagni's *Chronicle* may have ended with a whimper but it opens with a loud boast. The inhabitants of Florence are splendid and its buildings are beautiful. Many people come from distant lands (tourists, we would call them) just to see Florence – not because they have to, but because of its crafts and its guilds and the beauty of the city.

Compagni's juxtaposed mention of 'guilds' to the city's beauty is perhaps fortuitous but it is remarkably prophetic. The existence of the Florentine guilds not only has

its political aspect but gives body to the social scene. The Priors for whom the Palazzo Vecchio was built were chosen at first from members of the greater guilds, whose activities were fundamental to the city's prosperity. They included the Calimala, importers of cloth; the Cambio, the bankers; the silk merchants' guild of Por Santa Maria (Compagni's guild); that of the wool-manufacturers, the Lana; the doctors' and apothecaries' guild; and the guild of lawyers and notaries.

Those represented the élite of professional Florence, and to them were gradually added for the purposes of political representation groups of lesser guilds which served the city in more immediate, practical ways, from shoemakers and master-builders to tanners, innkeepers and bakers. The bakers caused a sensation in the general council called in 1301 to consider whether Charles of Valois should be invited to enter the city. Alone of the guilds, they opposed his being received or honoured; they believed he came to destroy Florence, and, though unheeded, they were broadly correct.

How intensely organised work of every kind was in the city is shown by the fact that at that date there existed 72 craft guilds, virtual trade unions, jealously controlling admission and regulations affecting their status and their skill. There was an almost club-like aspect to the guilds from which the Priors were elected, for nobody could be elected who did not belong to one of them (and hence the enrolment in such guilds of magnates anxious to exercise power). At the same time, the social-cum-welfare nature of the guilds seems always to have been fairly slight in Florence, unlike some other Italian cities. A number of activities did not justify a guild in themselves and had to find shelter, as it were, within an existing guild. Part of the prestige and wealth of a leading Florentine guild, the Lana, arose from the fact that – unlike the situation in Flanders – all the branches of the wool industry became united in the one organisation.

Artists in Florence – those who might begin training as goldsmiths, then work as painters or sculptors, and possibly get involved too with a building project – never established a specific guild. The painters were simply part of the guild of Physicians and Apothecaries, and though they had formed within it their own confraternity of St Luke, that did not occur in the lifetime of Giotto.

The great era of creative guild patronage – less of art generally than of particular buildings and schemes – came subsequently and by a period when their political importance had declined. Yet it is the corporate nature of undertakings that is characteristic of Dante's city, and there is also a certain more metaphysical corporateness at the period, uniting the social, the cultural and the artistic (at least as far as the visual arts are concerned), all broadly within a religious framework.

Artists were not a dominant class of personalities, to be treated as occupying a special place in society as geniuses. For some of the great artistic achievements of Italy in the thirteenth century (such as the series of fresco decorations in the basilica of St Francis at Assisi) no artists' names are documented. And although Compagni, for example, praises the beauty of Florence, he fails to be specific about even an individual building. It is true that the new cathedral of Santa Maria del Fiore can be connected with a particular architect and sculptor, Arnolfo di Cambio, who is described in a contemporary document as a 'famous master', but it is tradition alone that connects him with the building of the Palazzo Vecchio, the rebuilding of the Badia and Santa Croce, and so on. There exists remarkably little information about even Giotto; and out of one fleeting mention of him by Dante rather too much is often made. Evidence for their close friendship, as it is sometimes called, has yet to come to light, though it is understandable that in later myth-making around the culture of Florence the fact of their being contemporaries cried out for exploitation. Neatest of all legends binding the two men together was that which had the exiled Dante helping Giotto paint the *Apocalypse* in a church at Naples.

The Florentines worked hard and extremely successfully to perpetuate the idea of the greatness and superiority of everything Florentine. To that generalisation Dante is a superb exception. He would have made a good reviewer of books which automatically assume the highest levels of culture, art and intellect as somehow developing naturally and uniquely in Florence, with assumptions covert or open that – to take one instance – Giotto is a better artist, being a more 'advanced' one, than Duccio.

Dante's Florence possessed no university, and although even that can be turned to Florentine advantage as showing the city's freedom from any academic constraints, it remains a striking fact. Book-keeping, one may surmise, was at least as important as book-learning in the average merchant's view of education for his sons. The great, or at least influential, teachers at the great universities of Bologna and Padua – not to mention Paris – had no comparable colleagues in Florence. Most erudition of a specialised kind must have come with a strong clerical tinge. One respected secular Florentine *savant* of the period was Brunetto Latini, from whom Dante probably gained something. Latini was the author of a typical medieval compilation of unoriginal, miscellaneous knowledge, but to Villani – noting his death in 1291 – he was 'a great philosopher', which suggests that philosophers cannot have been thick on the ground. Latini was also a notorious homosexual, and though Dante expresses gratitude to him in the *Commedia* (as well as giving him a splendid diatribe against the Florentines as people ungrateful, malignant and hard-hearted), he assigns him to the *Inferno* and to the circle reserved for sodomites.

The visual arts of and in Florence were in subject-matter alone far less sophistic-ated and varied than literature – above all, poetry. The Tuscan love-poets (popularised in England and put into English by a poet himself called Dante, Dante Gabriel Rossetti) have no painterly equivalents at the period. Pictures of religious subjects not merely pre-dominated but constituted virtually the whole output of painting. Had Dante wished to take a portrait of Beatrice into exile with him, he might not have found it easy in his native city to commission a painter specialising in that category of picture. Latini vividly described his poetic vision of Love – not surprisingly, a naked boy – in a way that seems to anticipate many a subsequent Florentine decorative painting, but which the ethos of his own age perhaps prevented being realised in the pictorial medium. Yet, a century before Latini was writing, two naked cupids had been carved by Master Wiligelmus among the figures on the façade of the cathedral at Modena.

There are no records of any talks by Dante with Giotto, though Landor might have devised one in his series of *Imaginary Conversations*. In the *Commedia* it is not painting but sculpture that is imaginatively utilised to create visual works of art. The two famous Florentine painters whom Dante mentions – Cimabue and Giotto – gained their fame partly outside Florence, by activity at Assisi, Pisa, Padua and Rome. Giotto's most cel-ebrated surviving frescoes are those in the Scrovegni chapel at Padua, never Tuscan territory. Neither Cimabue nor Giotto appears to have received state commissions in Florence comparable in importance to those given to painters at Siena (beginning around 1290) for decoration of the Duomo and, more significantly, the civic centre of the Palazzo Pubblico.

Far from seeming particularly laudatory, Dante's coupled reference to Cimabue and Giotto has a moralistic and faintly sardonic tone. In the *Purgatorio* (canto xi) he meets a non-Florentine painter of illuminated manuscripts, Oderisi, who is being punished for the sin of pride, and it is Oderisi who draws the moral about the swift passage of human renown, citing as example the eclipse of Cimabue's pre-eminence by Giotto's popularity:

> Once Cimabue thought to hold the field
> In painting; Giotto's all the rage today;
> The other's fame lies in the dust concealed.
>
> (*Dorothy L. Sayers's translation*)

Even while Cimabue's notorious pride is implicitly rebuked, there is a hint that the fame of Giotto may in turn decline, since fame is as changeable as the wind. About Giotto's revolutionary naturalism and his artistic achievements generally, Dante is silent.

When Dante wrote, he was probably better acquainted with Giotto's fame than with his work. As far as the embellishment of Florence was concerned, that would have remained largely true even had he not been banished. Giotto's involvement with the new Duomo and the creation of the campanile came only in 1334, more than a decade after Dante's death and just three years before his own. About that involvement there is a double corporateness, for administration of the funds raised for the new projects was a guild responsibility, that first of the Calimala but transferred to the Lana by the time of Giotto's appointment, and Giotto himself was appointed overseer, *capomaestro*, of what was necessarily a large building workshop.

With the Palazzo Vecchio built, the great outstanding communal project was the cathedral, which originally had perhaps been envisaged as going up contemporaneously. The delays on it would have their happy aspect. Not only did the plans expand, following the building of the campanile, but just within a century of Dante's death competing solutions for the daunting problem of vaulting what had become the enormous central crossing would conclude with the choice of Brunelleschi's. His dome would at once transform and dominate 'St John's Sheep-fold' and invest it with unforeseen grandeur.

In a way, the city ceased to be St John's, exclusively at least, profoundly though it continued to honour him. Like its detested rival Siena, and possibly in deliberate rivalry, it asserted that it was under the patronage of the Virgin. Its cathedral, like that of Siena, would be dedicated to her. In fact, the Badia was already dedicated to the Virgin of the Assumption, an unfortunate dedication by the early fourteenth century because Siena had instituted a public festival on that very feast-day. Among the triumphal items in the Assumption Day procession there was a painted cart captured from the Florentines at the battle of Montaperti, a victory which Sienese piety and history – and art – emphasised as gained through intercession to the Virgin, Queen of heaven and protectress of Siena.

In Florence the Virgin was reclaimed, made virtually an honorary citizen with the title of Santa Maria del Fiore. The church dedicated uniquely to her was planned to be unsurpassed in its scale and splendour – to be one of the largest in Christendom. It was set in hand at a prosperous late medieval moment and crowned with its cupola in the cultural ferment of the early Renaissance. But work on it, and thought around it, would continue over the centuries, and the piazza where it stood, with the Baptistery and the campanile, was emotionally reinforced as the focus of the city. Artistically, there was however to be no straightforward story of evolution, and socially and politically, in the decades following the foundation of Santa Maria del Fiore, the Florentines were to need all the protection the Virgin could give.

CHAPTER TWO

Fire, Flood, Plague, War and Art: The City Renascent

F OR A VISITOR to Florence at the beginning of the fourteenth century – slipping into it perhaps on a rare day when the place was at peace – there was much to see, marvel at and even envy in an obviously thriving, thoroughly up-to-date city which was assuming something of the character of a metropolis.

Its commercial prosperity seemed assured. An economist of the period would probably have prophesied, with the usual accuracy of his kind, that the market was buoyant and that the upward spiral would continue. The extraordinary building achievements of the previous fifty or so years needed no duplication, though scope existed for refinement, additions and enrichment, not least by mural decoration. Two large, prominent palaces proclaimed the pride and strength of the republican form of government – a form alien to visitors from France, England and Flanders, and one rejected or lost in Northern Italy at, for example, Verona, Ferrara and Milan, itself a city already established as a centre of commerce.

Physically, Florence offered the spectacle of the old and the beautiful in one idiom juxtaposed to the new and would-be beautiful in fresh idioms: the smooth-walled, neat and abstract marble octagon of the Baptistery in harmony with the huge, highly wrought, animated façade of the Duomo, conceived as a strongly vertical screen of niches and miniature columns and statues, taking their place gradually on a building which promised to be a wonder of the world when it was completed. Certainly nothing similar in style had ever been attempted before in Florence.

There were other great if less obvious sights to gaze at and visit, such as the major mendicant churches of Santa Maria Novella and Santa Croce, each with an impressive expanse of piazza before it. If Florence had as yet no university, it was well-equipped with schools. It had also a good supply of hospitals, often connected with the mendicant orders. In a gesture of proto-Renaissance munificence, a rich private citizen had founded a new one, that of Santa Maria Nuova, in 1286. The hospital (totally altered and vastly

The Torre della Pagliazza, Piazza Santa Elisabetta.

expanded) survives today, though its founder, Folco Portinari, is more often recalled as the father of Dante's Beatrice, an irony he might not have altogether relished. But grateful Florence has at least preserved his name in the street that leads directly to the existing complex of buildings.

As well as manifestations of charity, care of the sick and concern for the poor, there was provision for criminals, with the main state prison, the *Stinche*. Conveniently situated near the Bargello and the Palazzo Vecchio, it was an uncompromising mass of masonry that survived (on the site of the present Teatro Verdi) until the nineteenth century. Other prisons occupied towers in the city, and these towers, built by families primarily for defence, would have been a striking aspect of the city, especially when we realise that prominent *campanili* of churches would then have been comparatively few. Nearly all the towers that survive are rectangular in shape (a typical and impressive, though partly reconstructed, group can be seen in the Borgo San Jacopo on the Oltrarno). Unusual if not unique in its semi-circular form is the tower, also once a prison, in the minute Piazza Santa Elisabetta, close to the Duomo, which has been ingeniously incorporated into the most un-prison-like ambience of a modern hotel. Its form seems explicable through its having been adapted and expanded from the remains of a Roman building, so it was already ancient in medieval times.

What by then would probably have struck the visitor most would have been not so much the architecture as the activity of Florence, itself a matter of order and ordinances. For while the state might be well or badly governed — with a hectic succession of differ-ent, often ineffective, sometimes conflicting solutions — the city as such continued to be administered steadily and efficiently. Regulations were necessary for civic life to con-tinue, settling, for example, whether butchers might practise butchery in the streets and where precisely — and solely — fish might be put on sale.

Certain quarters of the city were associated with specific professions and trades: the prosperous bankers congregated in one 'stock exchange' area (a central one, inevitably), that of the Mercato Nuovo, while the humble dyers, tanners and weavers lived around Santa Croce. Yet there seems to have been a remarkable mixture, at least socially, for there were also very grand families living near Santa Croce, among them the Bardi and the Peruzzi, whose chapels in the church were to be frescoed by Giotto. In the district of Santa Maria Novella could be found a complete conspectus of Florentine society, run-ning from wealthy merchants to servants and market women, via artisans and shopkeep-ers. There is something symbolic in the fact that so many shops in the city were, as they often still are, small rooms, in effect, occupying the ground-floor loggias of what were otherwise domestic palaces.

Amid the sheer noise and the traffic — the volume of both of which would proba-bly shock even a modern visitor inured to the diurnally celebrated feast, Italian as much as specifically Florentine, of pandemonium — the fourteenth-century visitor might have

detected, or been persuaded to detect, evidence of the city not only as a physical entity but as an ideal republic. No private palace could compete with the imposing ones raised by the Commune, and soon there would be several other striking or handsome, if more modest, secular buildings that were halls for the greater guilds or, like the Palazzo di Parte Guelfa, housed the dominant political party.

In the clearly defined layout of the main streets connecting the centre of government, the Palazzo Vecchio, to the religious centre of the Piazza del Duomo, taking in *en route* the (old) market-place, might be seen an expression of corporate coherence. Passing and mingling along those busy thoroughfares were the citizens (the male ones, anyway) of all social levels, little distinguished from each other in dress, itself sober rather than showy, and all notionally equal before the law. For hundreds of them, government was not remote, however abstruse or even impotent, because they would have an opportunity, however brief, for some sort of involvement with the governing process. A quite un-grand figure such as Dino Compagni could as a Prior summon his fellow-citizens to a meeting (skilfully selecting for it the emotive 'cradle' of the Baptistery), and they came.

The Florentines might not in fact be very good at governing themselves. The commercial acumen that brought the city prosperity did not necessarily result in political wisdom. Florence was, however, free from a prince, a 'tyrant', a reigning dynasty and the cost and caprices of a princely court. Ostentatious feasts and public shows were normally instigated not by individuals but by the Church or the Commune. Breaking with that tradition caused envy and suspicion, and Machiavelli was no doubt echoing judgments of the period when he described the magnificent celebrations organised by a leading family, the Alberti, after the acquisition of Arezzo in 1384 as 'more suitable for a sovereign prince than for any private individuals'.

Ultimate homage was paid to the concept 'Florence', symbolised by the lily and by the lion (in a perhaps unconscious yoking of grace and strength) but above all enshrined in the visible city. On a calm evening, standing on the Ponte Vecchio, with the already existing break in its row of shops allowing for a vista down the river, a foreigner could easily have been lulled into assuming that he was experiencing a purer condition of civilisation than had been achieved by most European countries.

If that was not entirely true, it was also not entirely a myth. Florence did represent something which in principle was admirable and enlightened. It was not yet dependent on any one man's whim. It aspired to liberty, even if confused about how to achieve that and, even more, how to maintain it. It believed in an ordered commonwealth as it believed in an ordered city. Every citizen (within defined limits) had shared in decision-making

and must therefore democratically abide by the results, whether it was a matter of how to deal with emperors and popes or how to advance the building of the Duomo. The 'honour and the good and the welfare of your city' were constantly invoked terms, bordering on cliché, which nevertheless possessed real validity. Most people probably subscribed to them, simply out of natural self-interest. The phrases served as a reminder that affairs were in their own hands, not in those of God or a king. The problems arose with defining and agreeing about what constituted the city's welfare — a permanent problem in any democracy.

The honour and the good and the welfare of Florence, and its very fabric too, were to be terribly tested in the years between 1300 and 1400. Any visitor's vision of the handsome and prosperous city, the flower of civilisation, would rapidly be swept away, as was the Ponte Vecchio itself, under the pressure of repeated disasters, some man-made but others acts of God. A superstitious Florentine might have concluded that St Reparata was not pleased at being superseded as titular patron of the Duomo, a building which obstinately did not get completed and which must increasingly have seemed in danger of becoming not a boast but an embarrassment. Even a much less grandiose project, that of constructing a fifth bridge over the Arno, was begun only to be left unfinished. It had been intended to call it the 'Ponte Reale', in honour of the city's 'protector' for a period, King Robert of Naples, but the name seems ominous in such a sturdily republican ethos.

The commune of Florence in the fourteenth century has sometimes been compared to a mosaic, to indicate something of its assembly and complexity. Yet no mosaic could possibly be as eddying, fragile and unstable as the government of Florence, which is better likened to a tattered piece of needlework, as full of holes as of stitches, and frequently torn further in internal power struggles. Florence had become a Guelph city, which was chiefly defined as anti-Ghibelline. Whatever a Guelph might be, to be called a Ghibelline was to suffer a sinister form of denunciation, to become almost a non-person. There is a distinctly proto-Fascist air to the activities of the Parte Guelfa, with its own headquarters representing virtually a rival seat of government, its own partisan interpretation of 'patriotism', its purges of opponents and its papal-conservative policies.

The fourteenth century opened for Florence in political chaos, and it closed in grave crisis, with the city under threat from Giangaleazzo Visconti, Duke of Milan, and from a renewed outbreak of plague. For each decade there seems a disaster to record, inflicted on a city which by 1342 had reached such a nadir, economically as well as politically, that it compromised its own status and adopted one-man government, making

Walter de Brienne, the splendidly titled Duke of Athens, sole *signore*. Admittedly, Florence tolerated his reign for only a year (though he had been proclaimed *signore* for life). His chief success was in uniting the citizens — against him. After witnessing his son hacked to pieces by the populace, the Duke of Athens was expelled from Florence for ever, and soon the citizens were again indulging in their favourite pastime of street-fighting.

In the first half of the century, Florence had suffered an extensive fire (in 1304), and a series of dramatic banking and commercial failures, linked to a general European slump. In 1333 there came a great flood, washing away the Ponte Vecchio. New banking failures were followed a few years later by the arrival of the 'Black Death', part of the epidemic of bubonic plague that was sweeping Europe. Fresh outbreaks of plague occurred in Florence during the second half of the century, but none equalled the catastrophe of 1348. It more than halved the population of the city, notably killing the poor and poorly housed inhabitants but not sparing the religious congregations.

As if these were not sufficient disasters for one century (and there were several famines), Florence embarked on a war with the papacy in 1375 (a war which it might better have fought decades before), to assert its independence. The war ended ingloriously in 1378, though Florence could claim to have remained unconquered. In the same year came the uprising associated with the Ciompi, the day-labourers of the cloth industry, some of whom had made a few pathetic and fiercely punished efforts in the 1340s to organise labour as a force and occasionally to strike. Abetted by certain sympathetic yet perhaps not disinterested upper middle-class citizens — among them a Medici — the Ciompi achieved a largely bloodless coup. For a heady moment a wool-carder named Michele di Lando found himself *signore* and standard-bearer of justice in the city, but the government passed out of popular control. Michele di Lando faced the familiar fate of exile; and Florence, which within four decades had gone from dictatorship to semi-plebeian democracy, adopted one of the few alternatives previously untried, an oligarchy.

That in such a switchback of a century the city had survived at all might seem achievement enough. Yet not only had Florence survived, it had valiantly fought back in cultural and artistic terms. The success of the fight is symbolised by the Ponte Vecchio, firmly reconstructed following the great flood and designed (according to Vasari) by Taddeo Gaddi, now thought of chiefly as a painter. The bridge endured, and when in Vasari's own day there was one more devastating flood, it continued to stand, while other bridges were severely damaged. And it still stands. The very battering by dire events which Florence underwent in the fourteenth century perhaps helped to temper the city,

knocking it into shape, as it were, and deepening its consciousness of having a special destiny.

With its population cruelly slimmed down by the plague, it was probably better placed to recover economically. There were fewer people to be housed and fed – fewer 'mouths' in the vivid term used at the period for numbering the population – and a much reduced pool of labour might, at least in theory, look for a rise in wages.

Something vital and unquenchable seems inherent in the spirit of a city which could survive a succession of catastrophes and rally to defend itself against yet one more threat, posed by the aggressive ambition of the ruler of Milan, Giangaleazzo Visconti. He might well have captured Florence in 1402, had he not suddenly died of plague. 'Death', observed Machiavelli sardonically and not quite fairly, in recounting the unexpected reprieve, 'has always done more for the Florentines than their own valour.' At the time it no doubt seemed, rather, that an act of God had proved beneficial – for once.

What is unmistakeable in assessing Florence in the fourteenth century is how much more clearly it comes into focus than in preceding times. Its documentation of itself is far more detailed, not least thanks to Giovanni Villani and his chronicle. If it was really in the year 1300 that he decided to start writing an account of his native city, he was remarkably prescient. The following years provided constant dramatic material for his pen. And even when he himself was carried off by the plague in 1348, his chronicle went on, continued by his brother, Matteo, and then his nephew, Filippo.

Physical and political disasters are only one aspect of the century, and, though grave, they were not irreparable. For Florence as a city the decades can be charted in terms much more positive and lasting. Leaving aside the massive contribution made by painting to existing buildings, there are the new buildings and monuments themselves. The first bronze doors for the Baptistery were commissioned from Andrea Pisano in 1330. In 1334 the campanile designed by Giotto was started. Two years later the Commune set in hand the present structure of the oratory-cum-granary of Orsanmichele, a building which soon became the quintessential expression of guild patronage, and a thoroughly Florentine affair in its combined provision of food for body and soul.

The Piazza del Duomo received a further addition with the house, and notably the graceful loggia, of the Bigallo, the charitable foundation of the confraternity of the Virgin Mary. The piazza also received less obvious yet sensitive attention, for as work on the new Duomo resumed there became apparent a problem of the piazza's low level, causing the buildings in it to seem sunken. That was partly corrected by lowering the level of the surrounding streets.

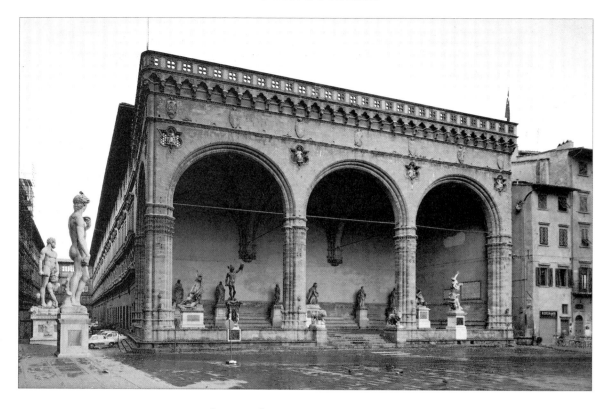

The Loggia dei Lanzi, Piazza della Signoria.

In the Piazza della Signoria, the most famous of all loggias, the long-projected Loggia 'dei Lanzi' (as it was later to be called) was completed by 1382. It was built by the Commune for the Commune, as a place for official reception of visitors (useful not least when it rained, no infrequent occurrence in Florence) and yet usable also as a lounging-place by the citizens, old or young. Houses of impressive layout — in domestic design as well as in scale — began to be built. Surviving and visitable is the Palazzo Davanzati (built for the Davizzi family, today a museum), which may have possessed no particular fame at the time but which is now the supreme building in Florence for conveying a convincing feel of how a large household actually lived during the fourteenth and fifteenth centuries (see Plate 7). From the well in the courtyard, making unnecessary any journeys for water beyond the palace confines, to the kitchens installed on the topmost floor — not omitting the lavatories conveniently off the main reception-bedrooms — the palace is organised as a habitation civilised and practical. The Davizzi had been one of the families denounced by the Parte Guelfa as Ghibelline, as they complained in 1349 to the *Signoria*. They

successfully petitioned to be recognised as Guelphs – in effect, to recover acceptable status again in the city, and, accidentally or not, the palace dates from around that year.

While Giovanni Villani was composing his picture in words of Florence during the 1330s, the first factual-sounding, highly detailed map of the city (now lost) was produced. Some of the famous buildings of Florence began to be depicted – not as mere symbols but with a sense of the three-dimensional – in paintings. The secular commissioners of some of the great mural schemes in the churches began to appear portrayed in them, as for instance is Buonamico di Lapo Guidalotti in the 'Spanish Chapel' of Santa Maria Novella.

Only wealthy individuals were in a position to build or have decorated a complete family chapel. Some of the great and prominent families of Florence, such as the Strozzi, were particularly active and assertive. Portraits of them were included in the frescoes by Jacopo di Cione, a younger brother of the better-known artist, Orcagna, for their chapel at Santa Maria Novella, which they founded in 1319. Not every prominent family was prominent artistically, and conversely the history of Florence unfolds without the involvement of a Buonamico di Lapo Guidalotti.

A number of prosperous individuals, as also less prosperous ones, were content with the exercise of corporate patronage through their guild. The humbler ranks of society could hardly expect to appear in paintings at all except in a generalised sense, usually at this date in Florence as part of a religious scene. Builders and masons might be depicted when a saint had directed building operations. Domestic servants and midwives are other humble people introduced into scenes such as the Virgin's birth.

Florentine society probably took no cognisance of the servant class, and certainly not of slaves who were bought and sold – and maltreated – as so much cattle (or worse). The lowest level of society was that of the largely faceless, propertyless, labouring class – that which became so abruptly vocal in the revolt of the Ciompi. Next came the *petitbourgeois*, shopkeepers and so on, probably not very different in outlook from the major mercantile class above them, the *gente nuova*, who with the old patrician families usually took the lead in artistic patronage, as in politics.

Yet the character of Florentine people – and not solely the grand, the prosperous and the influential – was becoming thought of as of 'human' interest, worthy of recording. Of great men in most fields Florence was in any case rather short. In literature, it had, of course, Dante, although it had not treated him very well and might justifiably experience mixed feelings in reading what he wrote about his fellow-citizens. In the visual arts it had had Cimabue (who died around 1302). It had, incidentally, also had Arnolfo di

Cambio, a great sculptor as well as architect, but someone who left no trace of personality.

The various needs of Florentine origin, great genius and considerable personality were happily fused in Giotto, overtaking Cimabue and introduced into literature in his lifetime by Dante's reference in the *Purgatorio*. Soon he was an established character, ugly, modest and witty in a pungent 'Florentine' way (being portrayed thus already in Boccaccio's *Decameron*). And though several admiring tributes were to be paid to Giotto by Florentine writers, they tend to be unspecific about his art, except that his pictures are wonderfully lifelike. There may even have been a suspicion that the city was less rich in his work than some other cities, but then part of Giotto's fame for Florence lay in the fact that he was in such demand elsewhere. Perhaps the city had been rather slow in its employment of its genius: when he was appointed *capomaestro* of the Duomo and its workshops in 1334, he was most probably in his mid sixties. He died in January 1337.

Both as artist and as personality, Giotto could be interpreted as fitting neatly into his century's fresh interest and emphasis on the factual and the natural. Although his role as a painter might be presented as learned and significant, as that of an artist regenerator who had recovered truths misplaced in earlier, dark ages, he could be seen less loftily as a painter whose prime achievement was in depicting figures and attitudes '*al naturale*', as Giovanni Villani put it. All of us, runs the implication, can appreciate the natural in art: 'people weeping, rejoicing and doing other things', in the words of Villani's nephew's praise of Giotto. Seeds of a certain kind of philistinism lie there, or at least of a duality. The less 'natural' painter (such as Duccio, for instance) risks being underestimated. When one looks deeper into the fourteenth century, and beyond, that is indeed what happened.

Giotto's vivid artistic naturalism, as it seemed, was complemented by his own unvarnished character, itself *al naturale* and vivid. It must have appeared all of a piece, as if he were an unidealised figure in one of his own compositions. He was a jewel in the crown of Florence, 'one of the lights in the glory' of the city (in Boccaccio's phrase). Definitely its first renascence if not Renaissance artist, he personified its fourteenth-century achievements in the visual arts, loosely yet openly linked to Dante who stood for literature. That Giotto had painted Dante along with himself was almost a *sine qua non*, regardless of whether it was he who had portrayed them both in a fresco in the Palazzo del Podestà. A pictorial complement-cum-compliment was needed to Dante's mention of him.

Yet, at the same time as being a glorious light, Giotto had been a plain citizen: 'one of us', it could have been said by some of the ordinary local people who were beginning

to occur in poems and stories, written not in Latin but in the accessible vernacular. The tricks and traits and simple humorous doings of such people comprise most of the *Trecentonovelle* (*Three Hundred Tales*) of Franco Sacchetti, in some ways a Florentine Chaucer and Chaucer's close contemporary. The two men might conceivably have met, for Chaucer was in Italy and possibly visited Florence in the 1370s. Like his more famous, more ostensibly erudite and older fellow-citizen, Boccaccio, Sacchetti was the son of a merchant, and the voices of individual Florentine merchants become audible in the century, not only in fiction but in letters and family memoranda and advice to their sons — in a vein more pithy than, but as worldly-wise as, that of Polonius.

A civilised and social sound can also be heard, amid the din of great, dignified and often terrible events, and that is the sound of men and women laughing. Words such as 'society' and 'demographic trend' take on human significance, and Florence begins to be peopled by a lively crowd of inhabitants — not punished in hell and exalted in heaven, but talking and jostling and joking on earth. They seem newly arrived in literature of the period, and they are very welcome.

Antonio Pucci, the Florentine bell-ringer, town-crier, versifier and survivor (dying only in 1388, probably in his late seventies) himself may have been a 'character' verging on the type of ubiquitous small-town bore, but his eye is keen for the give-and-take of daily life. His verses about the market place of Florence are — in several senses — broad, ranging through the tempting variety of food on offer and the variety of vendors, from tough old women to pert country girls. Yet these people all have their place, as it happens, in the city's basic economy, for their trade and produce help to fill those 'mouths' that are the citizens.

Far more sophisticated and central a literary figure — as well of course as far greater — is Boccaccio, a highly complex personality who, like many another writer, may have felt that his most famous work was not his best. But the *Decameron* became famous early on, and was avidly read and frequently translated throughout Europe. Today, only scholars settle down to read his more high-flown romances and classical compilations, or even his 'life' of Dante, whom he profoundly admired.

The *Decameron* is a thoroughly Florentine book and a thoroughly social one, down to its structure. After the poetry of the *Divine Comedy*, it is very much prose, in every way. It glories in being undidactic, entertaining and openly — though by no means totally — scabrous. Eventually it shocked and frightened its creator, who thus wittingly or not recognised the force of its literary power. He repented and turned moralist and academic, leaving Florence for the small Tuscan town of Certaldo where he had probably been born

and where in 1375 he died. Part of his religious repentance was perhaps expressed by commissioning two altarpieces (sadly, not extant) for a local church.

Whatever the medievalism enshrined in the *Divine Comedy*, the *Decameron* speaks for a robustly changed, relaxed vision, one set firmly upon earth. It is the opposite of lonely and ecstatic. It is a vision closer to that of the *Canterbury Tales* than to the spiritual one of *Piers Plowman*. It has female protagonists who seem *mondaine* if not precisely modern compared with the real women mystics and saints of central Italy of a few generations before, women whose fierce, intense, sometimes horrifyingly palpable and semi-erotic visions read like real-life cantos from Dante's poem. It is Boccaccio who should more correctly have been painted beside Giotto, for in a certain sense they share standards that are *al naturale*.

Boccaccio's *donnée* is of an upper middle-class milieu where girls and young men can meet socially at ease and move — thanks to wealth — out of plague-stricken Florence. In fact, it daringly reverses the standard form of morality, well summed up nearly contemporaneously by Traini's famous *Triumph of Death* fresco in the Campo Santo at Pisa. There, an upper-class, amorous, hedonistic group of young people is depicted as doomed to die. Boccaccio's group consists very much of stylish survivors. Almost more scandalous than any of the tales they tell among themselves, is their clear-eyed common sense. Since they can do nothing about the plague, they seize the chance of the general disruption of normal *convenances* and the absence — or loss — of parents and guardians, to go off and enjoy themselves, for which they are not punished.

The code of behaviour they assume and also promulgate is impressively liberal, civilised and un-prudish. Love is a natural bond between them, neither coarse nor etherealised. Seven girls who have met by chance at mass at Santa Maria Novella plan their adventure and then co-opt three young men who happen to enter the church. The three are already known to them, but it is the girls who take the initiative, in a tactful, well-bred way, making it clear from the start that this is no invitation to rape.

One has only to try to imagine Victorian girls — in fiction or in fact — behaving with such a degree of sophistication to see that society by no means advances century by century. No doubt Boccaccio has idealised a little, but he puts forward a calm, sane case for freedom and humour and good manners between the sexes which, however palely, foreshadows the Shakespearian world of Beatrice and Benedick.

The theme of the stories his group exchanges is human behaviour — often as it is manifested under the pressure of lust or love. But the group is also shown indulging in chess and music and dancing (even bathing, though separated by sex). The ladies fre-

quently laugh and occasionally blush, while never losing their self-possession and their implicit command of the situation. Never could they be mistaken for allegorical nymphs or bloodless abstractions.

That the diversions of the *Decameron* are set brightly against the gruesome darkness of the Black Death is effective and also realistic. The plague begins the book. It is seen working psychologically as well as physically, horribly corrupting manners and morals, in addition to destroying life. Neither prayer nor practical measures can check it — a grim further reality. Diversion and escape seem not frivolous but prudent, especially when provided by a pleasantly sited, well-stocked villa outside Florence, with amenities that extend to agreeable pictures in its rooms. In sharing the group's diversions the reader should be diverted, and Boccaccio says that he is thinking particularly of women, love-lorn women. Their lives are restricted: in love they cannot, unlike men, find relief in sport, travel and business. It adds another, non-idealistic touch to his portrait of society, just as the retreat to the country is no literary convention but a reminder of the pleasant villas in the hills around the city.

Both Boccaccio and Sacchetti were, as men, involved directly in Florentine affairs, critical of much that went on, in the way justice was administered (to the detriment of the poor), for example, and in the way churchmen behaved. Sacchetti penned a poetic diatribe specifically against Pope Gregory XI, with whom Florence was at war from 1375–8, and he could be keenly satiric about other prominent contemporaries, but his *novelle* are frequently amusing, in an informal, anecdotal manner, although more interesting, at times, for their social context than for their humour.

Thus Sacchetti tells of a group of Florentine painters and sculptors enjoying a discussion up at San Miniato, after a substantial meal, about who (apart from Giotto) was the greatest artist. Before the whole thing dissolves into a tipsy, mildly misogynistic joke (for one of the bunch triumphantly cites Florentine women as the greatest of artists in their use of cosmetics and corsets), individual established artists — including Taddeo Gaddi and Orcagna — are named and speak. The conversation may not be very elevated but even in its slightly stale studio-cum-tavern humour it is convincing, more so than would be an abstruse discussion of theory or technique. Most lifelike of all is Gaddi's lament that art is declining daily (the meal had perhaps not agreed with him).

However induced, Gaddi's gloom was misplaced. (It certainly cannot have been very encouraging for the morale of his two painter sons, of whom Agnolo was later himself to work at San Miniato.) Taken *in toto*, his century was one of unprecedented, widespread manifestation of painterly activity in Florence, though by no means all the

resulting art was in the style of Giotto, the master of Gaddi (and that may have troubled him). The interiors of Santa Croce and Santa Maria Novella alone reveal how much use of painting was being made to serve both as adornment of the walls and as instruction for the faithful. The style associated with Orcagna and his two painter brothers (each with a flourishing workshop) is far more obviously linear and decorative than Giotto's but perhaps more appealing to, and more easily appreciated by, the average worshipper of the period.

Some of the Florentine altarpieces in Orcagnesque style, though very much collaborative productions, are masterpieces of craft and art: great gilded and fretted semi-architectural screens of numerous highly wrought, subtly coloured panels, in emphasis narrative and meditative, which must have dazzled and captivated those who first saw them. In pictorial terms such altarpieces are the equivalent of Arnolfo di Cambio's design for the façade of the Duomo. Although their message may be an assertion of Christian doctrine, they tell it on several levels, often literally, and with an amount of rich detail which would require a lot of time to absorb. It is, indeed, a question as to who was privileged enough, and learned enough, to draw sufficiently near and comprehend each saint and symbol that was depicted. Yet the power of painting to present images not only of heaven (which was, after all, anyone's guess) but of earth must have seemed almost magical.

From about 1370, anyone could go into the ancient church of San Pier Maggiore and see its huge, new, multi-panelled high altarpiece of the Coronation of the Virgin, with small scenes of St Peter's life below and the Crucifixion crowning the whole above. Near to, St Peter was visible prominently kneeling in heaven, to the left of the Virgin, balancing on his knee a solid-looking, recognisable model of the church itself, with its cupola and campanile and its steps up which one walked to enter the building. The message might be that St Peter had San Pier Maggiore under his protection, but the wonder lay surely in seeing realised in art a miniature image of a familiar Florentine landmark. Today, the church has gone, but fixed in paint that image of it remains.

The city where such complex and refined works of art could be commissioned and created was obviously in no parlous state. A wealthy, leading mercantile family, possibly the Albizzi (who lived nearby, and were connected with the church, and whose politically prominent head then happened to be called Piero), instigated that particular altarpiece, which will have been a costly affair. The style in which it is painted is no less characteristically Florentine for not sharing Giotto's sober, solid and sculptural-seeming vision — and nor should there be any question of which style is the advanced one, for art never

Attributed to Jacopo del Cione: The Coronation of the Virgin, *National Gallery, London.*

does 'advance', not being a branch of scientific research. Even nowadays some art history represents the Renaissance discovery of the laws of perspective as if it were virtually the equivalent of the discovery of radium, and often tacitly fosters the assumption that there is something superior, as well as more truly Florentine, in the grave, graven images moulded by Giotto, and subsequently by Masaccio, compared to the more delicate and delicately coloured, barely shadowed ones which painters like Orcagna do not so much sculpt as embroider. It occasionally seems as though even the fourteenth century must be assessed retrospectively by the standards of Cézanne (or at least Roger Fry), and pictures from which volume is absent condemned for their lack of 'significant form'.

It may not suit simplistic ideas of cerebral, intellectual Florence (as opposed to sensuous, voluptuous Venice) to think of painting there pursuing colourful, goldsmith-like elaboration of effect and ignoring volume, even perspective, while delighting in what can be achieved by line. But the emphases of Orcagna and his generation express profoundly

Florentine tendencies to be taken up and exulted in by Botticelli – in a mood almost joy-fully anti-realistic – and still very much present in the sixteenth century in the art of Bronzino.

That the Black Death had anything to do with the exquisite yet luxurious linear and pattern-making style of later fourteenth-century Florentine pictures, chiefly religious though they are, is difficult to accept. And to suppose that painters were at fault in not following the 'lessons' of Giotto is somewhat comparable to complaining that Matisse failed to follow Picasso. Any belief that sober, hard-headed bankers and merchants in Florence would prefer sober, hard-headed art is constantly given the lie by what was enthusiastically commissioned. All the tendencies towards blazing gold and sumptuous colour, with a maximum of physical display and a minimum of intellectual content, culminate in Benozzo Gozzoli's frescoes of the *Procession of the Magi*, commissioned in the fifteenth century by the Medici for their palace chapel (see Plate 9). The huge fame and popularity of those paintings today may be an irritant to sober, hard-headed art historians (by whom Gozzoli is usually tacitly relegated to the level of the second or third rate) but suggest that the Medici were admirably far-sighted in their taste.

Even if fourteenth-century Florentine merchants would have admitted they knew little about art, they definitely knew about driving bargains and getting value for money and were in the main good judges of textiles. We may be inclined to smile at contracts for altarpieces which stipulate that real gold and ultramarine shall be used in their execution (knowing that the best pigments do not in themselves make the best pictures), but if one thinks of the commissioning of a piece of jewellery, it would seem only sensible to stip-ulate that the stones used be diamonds not glass. Painter and patron probably agreed amicably that for certain brilliant effects – and brilliance was a requisite in most four-teenth-century Florentine altarpieces – there were no substitutes for gold leaf and the ultramarine blue extracted from lapis lazuli, a pigment which came literally 'ultramarine', from across the seas (from as far away in origin as Afghanistan).

The paintings of the period are rich not simply in colour and gold but in wonder-fully variegated fabrics, now soft, now stiff and encrusted, which are worn by sacred per-sonages, hang in heaven or serve as carpets of almost bristling, tactile feel under a saint's bare feet. Heaven indeed is seen largely as a textile emporium, where even a throne serves to display a bolt of artfully arranged, precious-looking fabric.

A silk merchant's mouth might well water at witnessing, created in paint, metres of rose-pink or milk-white material delicately covered with a cobweb-like tracery of thin gold, and only the more exquisite for being set against a heavy hanging as dark as the mid-

night sky and sprinkled with stars. Skilfully alternating plain and patterned draperies in front of the sheet of gold – not open sky – that fell like a shutter at the back of the composition, severing it from 'reality', the painter became a weaver-dealer himself in choice and exotic stuffs. At times, he was content with applying pigment straightforwardly but at others, by incising and pouncing and scraping an area of simulated fabric, he gave it a surface comparable to that of an actual textile interwoven with gold thread. Enhanced by candlelight on an altar, the illusion must have been of some real, rare, glittering fabric suspended within the picture.

For such altarpieces, subjects that offered opportunities for opulent effects were popular. Few offered greater opportunities than that of the Coronation of the Virgin in heaven (see p. 53) – a matter not of dogma but of pious devotion, and never kept as a feast-day of the Church. That this subject became so popular in republican Florence may seem a mild paradox, akin to Communist fascination with royalty, but it lent itself to splendid scale as well as representation, extending from the Virgin's coronation to the court of heaven assembled around, and is at once pleasant and placid in a way no treatment of the Crucifixion can be. It honours the Mother of Christ, but as a bride rather than in her maternal role – and to an uninstructed, non-Christian eye many of the compositions would suggest that a king is crowning his consort. By identifying the Virgin with the Church, that can indeed be explained, though it is doubtful if such theological niceties preoccupied the average secular Florentine patron, who was no doubt more concerned with a sumptuous, cheerful, colourful vision of eternity and an eternal monument to his piety and munificence.

Whether the city was tranquil or disturbed, the durability of paintings paid for and set up in churches was an essential aspect of their commissioning. There needed to be some promise that they were so admirably crafted, painted and burnished that they would last many lifetimes, largely undimmed. That constituted ultimate, if unproven, value for money. And at a period when architecture, sculpture and painting were closely allied (painters often predominating as designers of both architecture and sculpture), and with goldsmiths' work connected too, the crocketed, gilded, many-panelled altarpiece partook of some of the qualities of a portal (like the Porta della Mandorla of the Duomo), as well as of a metal monstrance or ciborium.

In their day, the elaborately carpentered altarpieces were miracles of modern art. It was to be a development, not automatically progress, when more naturalistic, rational, would-be scientific modes of painting – following from Giotto – were formulated in Florence at the beginning of the subsequent century. The enthusiastic propaganda which

accompanied that development – especially the support given to it in writing – has probably continued to have its effect. Painters such as Orcagna lacked contemporary literary champions, and it has taken a long time for such artists to recover – if indeed they have – deserved repute.

Something was lost in all the apparent, much-applauded gains of the fifteenth century. A certain fervour and fantasy dwindled and cooled and became old-fashioned. Calm, aerial perspective replaced the flat yet patterned, glistening gold backgrounds which, in their own convention, had been equally artful and beautiful. The very frames of pictures began to be conceived of more rationally: quieter and more compact shapes surrounded more compact compositions. Gradually, the demand for the wondrous multi-panelled altarpieces, framed within forests of crockets and pinnacles, ceased.

It was not only the altarpieces that had induced wonder. By the end of the century the two great, tacitly rival churches of Santa Croce and Santa Maria Novella possessed huge mural decorations on a scale not seen before in Florence. At Santa Croce the Franciscans inevitably celebrated their founder St Francis, other Franciscan saints and the Cross itself, culminating not in the church, however, but in the adjoining refectory – a less public place – where Taddeo Gaddi filled a complete end wall with ordered, 'realistic' scenes of double, if not triple, illusionism. Christ's Last Supper appears taking place there at the lowest level, below which will have run a real table for the friars. Above are four smaller, saintly narrative scenes with landscapes and interiors, flanking a central, dominating vision of the mystic Crucifixion, which rises immediately over the head of Christ seated at the Last Supper. Not even in the basilica of St Francis at Assisi is the Franciscan founder and the order so glorified, for although the Virgin and St John appear at the Crucifixion, along with selected saints, the foot of the Cross is occupied, and clasped, by St Francis alone.

To the art and assertion of that mural the Dominican 'reply' at Santa Maria Novella lies again not in the church as such but in the original chapter-house (now known as the Spanish Chapel), where from 1365 Andrea Bonaiuti covered with frescoes the vault and the walls of what was then a recently built room (see p. 58). This took place some twenty years after Gaddi's mural in the refectory at Santa Croce, and the Giotto-Gaddi style of sober realism has been replaced by a style much more linear, fluid and overtly graceful.

As at Santa Croce, the Crucifixion is a central scene, high up on the arch facing the spectator entering the Spanish Chapel. But it hardly dominates the decorative scheme, for on either side are two unbroken walls of elaborate, far less familiar imagery, each a cosmic panorama. At the left St Thomas Aquinas (the Dominican saint who pictorially

at least challenged St Dominic for pre-eminence) is enthroned in theological triumph, the focal point for what is a sort of illusionistic mural altarpiece, the lower tier of which is filled by a series of slender, elegant women – ladies, in fact – justified as presences in a celibate, cloistered environment because they personify the Arts and Sciences. At the feet of each sits a masculine representative, as if to add respectability, but the women preside with a distinctly secular air, forming a court of beauty which might illustrate some chivalric romance rather than Dominican doctrine.

The opposite wall has a no less triumphant, assertive theme, that of the world seen through Dominican eyes. There is depicted the pathway from earth to paradise for those who follow the Order's precepts and are guided by St Dominic, St Thomas Aquinas and St Peter Martyr. Paradise is austerely apocalyptic (and for his vision of Christ the painter perhaps borrowed from the Baptistery mosaics), and earth is meant to be serious and admonitory. Yet it is very much Florentine earth, and behind the stern, judicial figures of pope and emperor, with their councillors, rises the pale, pinkish bulk of the Duomo – shown conveniently finished and complete even to the cupola. And all around is assembled a Chaucerian medley of life's pilgrims, male and female, religious and laity, the fashionable and the humble. Even the edifying black and white dogs (a punning illustration of the *Dominicanes*: dogs of the Lord) take on a delightful genre aspect; they might be fashionable pets of the day, evocative of those 'smale houndes' cherished by the Prioress in *The Canterbury Tales*.

It is partly the painter's failure to suppress his mundane, topical instincts that makes these scenes so enjoyable. To Christ's carrying of the Cross, and the Crucifixion itself, he brings a social, half-gossipy response. As interpreted by him, it was *the* event of the day, and simply everyone turned out for it. The Dominicans can scarcely have meant their programme to be reduced to that level. And yet, notably in the specifically Florentine scene, a pleasure must have existed for contemporaries (as it has subsequently) in remarking its 'Who's Who' air and its vivid, literal picture of society – regardless of any spiritual significance.

That the frescoes are 'merely second-rate' is the old, unusually vehement Baedeker judgment, often reiterated by art historians, although probably the work retains its popular appeal. The pity is that Andrea Bonaiuti was never given a wholly profane decorative commission. Had he been let loose on the walls of, say, Palazzo Davanzati (pleasantly though dimly painted as some of its rooms were), he might have produced a minor masterpiece, respected both as social document and as art.

But the Spanish Chapel decoration in itself celebrates the confident proliferation

Andrea Bonaiuti: Holy Church Enthroned, *Spanish Chapel, Santa Maria Novella.*

of painting in fourteenth-century Florence — across acres of wall, in large-scale and small schemes, quite apart from elaborate, many-tiered altarpieces. To say painting was ubiquitous is hardly an exaggeration, for it was in the very streets, in open-air tabernacles, as well as in the churches. By 1400 the great, basically severe, even gaunt, yet spacious interiors of Santa Maria Novella and Santa Croce had been transformed in a way that might have astonished their architects.

The changes would not have been apparent at first glance, for in each case the bare bones of the pillared nave stood clearly articulated, only partially painted and anyway far less cluttered than they were to become. The quality of the actual light, however, had changed and grown richer through the addition of stained glass, designed by painters such as Bonaiuti and Agnolo Gaddi. As one advanced towards the area of the choir and high altar around which clustered chapels, often with family tombs, the sheer scale and

illusionistic sense of the painted compositions spread across those chapel walls must have seemed — and still do seem — overwhelming. Within painted frames, scene after scene — like stills from silent films — emphatically and graphically narrates the story of the life of the Virgin or of some saint. Elsewhere, hell gapes and heaven beckons. Here, angel trumpeters announce the Last Judgment to the massed assemblies of the elect and the damned. There, more quietly and on a modest scale, a male member of some leading family is resurrected to enjoy — in privacy — his own personal vision of Christ the Redeemer. For the wealthy, even death has its privileged aspect.

The emphasis of most of the painting executed in Florence was religious. Religion would continue to be a potent force in the creation of art which also managed to convey a good deal about worldly status. Already adumbrated in the painted family chapels of the fourteenth century is that blend of piety and pride to be summed up in the seventeenth-century baroque splendours of the Corsini Chapel in Santa Maria del Carmine.

Perhaps the lack of a ruling prince or princely individual retarded secular painting as such. Salvation, especially after a lifetime engaged in business, possibly involving dubious activities such as usury, was a more urgent concern for merchants and bankers than ostentatious decoration of their homes. The Commune never seems to have commissioned major mural schemes comparable to its architectural ones. The contrast with the beautiful images and scenes clothing the town hall interior at Siena is painfully striking. And although the Palazzo Vecchio remained the Republic's seat of government, it never developed into a treasure-house of painting approaching that of the Doges' Palace at Venice. The Republic's boldest initiative came early in the sixteenth century when 'The Magnificent and Sublime Signori', as documents called them, commissioned rival murals from Leonardo da Vinci and Michelangelo for the Hall of the Great Council — ill-fated, never finished works (see Chapter 9).

A rare straightforward fourteenth-century reflection of ordinary life in Florence occurs in the fresco decoration of the Bigallo, where the brethren of the Misericordia are shown — in factual, proto-Ghirlandaio style — within the loggia of the building, at their self-appointed charitable task of caring for orphan children. And the Bigallo also houses a contemporary fresco, of the Misericordia Madonna, at the base of which is a compressed image of the oldest part of the city, showing clearly the Baptistery and the Palazzo Vecchio, the unfinished façade of the Duomo and the shaft of the Campanile as far as then advanced (less than half its eventual height).

In general, little non-religious painting survives from the period or is mentioned by the written sources before Vasari. Some sort of painted 'history' in the Palazzo di Parte

Guelfa is recorded as being by Giotto, and there is tantalising mention of 'many paintings' in the house of Taddeo and Agnolo Gaddi.

Perhaps it was the achievement and the fame of the mural decoration of the basilica of San Francesco at Assisi (set in train long before 1300) that prompted ideas of emulation at Florence. Giotto may very well have been one of the painters who worked at Assisi, and he was definitely the creator of a complete fresco scheme in a free-standing chapel, that of the Scrovegni family, which ought ideally to have been located in Florence. His frescoes there are a landmark not only in Florentine but in Western painting. It is a slightly inconvenient fact – at least for panegyrists of Florence – that the Scrovegni Chapel lies on Venetian territory, at Padua. (Another unprecedented Florentine masterpiece was to be added there in the fifteenth century with the equestrian statue of Gattemelata by Donatello.) The earliest (Florentine) commentators referring to Giotto's work were vague and confused about quite what he had done at Padua, as they would hardly have been had the frescoes been visible in his native city. And, as it is, the subsequent frescoes by him in the chapels of the Bardi and the Peruzzi in Santa Croce do not entirely compensate for the absence of the Scrovegni Chapel.

It was, however, in an altarpiece for a Florentine church that Giotto had around 1310 (and after finishing the Scrovegni Chapel) issued a manifesto of his revolutionary new art. That the subject of this painting was the traditional one of the Virgin and Child enthroned only served to emphasise his bold stylistic innovations, not necessarily foreseen or entirely agreeable to his patrons, the order of the Umiliati, who commissioned the picture for their church of Ognissanti. Alternatively, of course, they deliberately chose him as a painter who was the 'latest cry' and who would produce something novel. We do not know. What we do know is that before the fourteenth century was over the work had apparently been moved to make way for a polyptych by a lesser, more linear painter, Giovanni da Milano.

In the churches of Santa Maria Novella and Santa Trinita there were already larger altarpieces of the same subject and shape (with pointed top) by Duccio and Cimabue, respectively. Today they hang in the Uffizi beside Giotto's altarpiece, forming a silent but compulsive demonstration of differing artistic ideals and vision, with barely any difference in aesthetic quality. Duccio's picture, a Florentine religious confraternity commission of 1285, and Cimabue's, of a few years before, have much in common – to the point where, ironically, Duccio's picture passed for centuries as being by Cimabue.

Opposite: *Giotto:* The Ognissanti Madonna, *Galleria degli Uffizi.*

Almost roughly, Giotto has subjected the two earlier compositions to a radical overhaul, in the interests of space and volume and light, combining to give his altarpiece a much greater illusion of naturalism. Where Duccio and Cimabue design, he builds. That his Virgin and Child appear more solid-seeming, having something in common with sculpture, that especially of Arnolfo di Cambio, is clear.

But with a subject as hieratic as the enthroned Virgin and Child there were difficulties in interpreting it *al naturale*, at least within Giotto's vocabulary. He felt perhaps some doubt or division over how far he could go in bringing it down to earth without loss of its sacred significance. Duccio's pure and confident lyricism, of vision and tone as well as of line, was not his. The austere yet poignant concentrated power of the Scrovegni Chapel frescoes — where everything seems pared to absolute essentials, with no loss but an increase in profound humanity — was not so easily translated into an altarpiece for a church. Nevertheless, if Giotto has not been as fully daring as he might have wished in the Ognissanti altarpiece, he created in the Virgin alone a mighty maternal image, a woman with a body modelled out of light and shade and given the full weight of breasts.

When one looks at that figure, on whose lap sits a no less uncompromisingly solid Child, and compares it with the Virgins of Cimabue and Duccio, one senses how Giotto's achievement thrilled both simple and sophisticated contemporaries, stimulated a flock of pupils and followers and seemed to establish a standard of 'realism' by which all art should in future be judged.

The situation happily proved more complex. Not every Florentine painter became a follower of Giotto. Several of the most important commissions for altarpieces went to outside painters, from Siena, during Giotto's active lifetime. It was, for example, a close, gifted follower of Duccio, Ugolino di Nerio, who painted the high altarpiece of Santa Croce, pointedly adding to his signature on the latter that he was 'de Senis' (from Siena).

When Gaddi, Orcagna and fellow-Florentines discussed the rival merits of painters in the *Three Hundred Tales*, they remained silent about the claims of any of the Sienese, although they must have been aware of pictures by them in Florence. A Florentine exclusiveness was already growing up, a sort of artistic Guelphism by which painters from elsewhere were tacitly proscribed or excluded from consideration. Yet two other talented Sienese painters, the brothers Ambrogio and Pietro Lorenzetti (both probably dying of plague in Siena in 1348), had acknowledged the influence of Giotto, marvellously synthesising it with their Sienese linear inheritance. Ambrogio worked for Florence, and Pietro Lorenzetti painted a crisp glimpse of the city (one of the earliest of all images of

it) in one of the beautiful narrative scenes of his Blessed Umiltà altarpiece (now in the Uffizi), painted for a convent of Vallombrosan nuns.

In Florentine tributes to Giotto there is a further implied exclusiveness, which major pupils of his, such as Taddeo Gaddi, had perhaps fostered. Painters in Florence advanced as a body during the fourteenth century, first forming a confraternity of St Luke and then becoming affiliated with the Guild of the Physicians and Apothecaries. They were significant enough to receive a brief chapter in the book on Florence by Filippo Villani, Giovanni's nephew, which included accounts of its famous citizens. Writing around 1380, Villani was well placed to survey the century, but the surprise is that with the exception of Cimabue (introduced in the role virtually of John the Baptist), he omitted to mention any painters except Giotto and his immediate followers. There are, he ends, countless other painters, though he has no time to enumerate them. One feels a retrospective pang at least for Orcagna — a talented artist, who was also important in his day. Not to have painted like Giotto is clearly, by Villani's standards, to have failed in life.

Villani has another surprise in store, for at least the modern reader. His categories of famous Florentines are quite generous in their scope, taking in poets, jurists, orators, musicians and buffoons, but no space is assigned to sculptors or architects, despite the evidence all around him. A century later the omission of those categories from any Florentine biographical work would have become impossible, given the impact of Ghiberti, Donatello and Brunelleschi, to name only the most obvious examples.

It is true that for Villani's own century there were not such dynamic, dominant artistic personalities among sculptors and architects, and those who did exist lived ignored, it seems, by literary figures and without leaving any particular legend. Thus the Talenti father and son, the architects Francesco and Simone, have largely slipped from view. They barely get a mention even in Vasari's *Lives*. It is true that in a twentieth-century quarter of Florence, where artistic street-names abound, there runs the Viale Francesco Talenti (ending, somewhat anachronistically, in the piazza of the eighteenth-century painter Pompeo Batoni), but probably few people driving along it could say who Francesco Talenti was, still less what he built. Yet Francesco added the upper storeys to Giotto's campanile, and thus to the familiar profile of Florence, while Simone is credited with a share in a hardly less familiar if more modest monument, the Loggia dei Lanzi. Both father and son probably contributed to Orsanmichele, the quintessential building of fourteenth-century Florence: a phoenix which rose from the flames of the fire of 1304.

Apart from Arnolfo di Cambio, there had been one brilliantly gifted sculptor working in the city in the first half of the century, Andrea Pisano, the sculptor of the first

pair of bronze doors of the Baptistery (themselves to be shifted and then fatally over-shadowed because of Ghiberti's two subsequent pairs) and of wonderfully inventive reliefs around the lower storeys of the Campanile (replaced there today by replicas and to be appreciated, without external distractions, in the Museo dell'Opera del Duomo). He succeeded Giotto as *capomaestro* of the Duomo, taking over with it the Campanile, and was in turn succeeded by Francesco Talenti.

As his name implies, Pisano came from the region around Pisa, though he died an honoured citizen of Florence (according to Vasari). Florentine tradition held — almost, one might say, required — that a certain amount of his work was inspired by Giotto. There are clear affinities between them in fondness for clear-cut compositions, taut and economical as human dramas (there are just two guests, for example, in Andrea Pisano's interpretation of Herod's banquet at which Salome danced — a scene Ghiberti would, idiomatically speaking, definitely have made a meal of). And Giotto may indeed have influenced Andrea Pisano. The tendency for painters to assume a leading role in sculptural and architectural projects in Florence is characteristic of the fourteenth century. Possibly, although he did not express the fact, Villani understood as much. Yet in paying tribute to Giotto, he omitted any mention of his designing the Campanile. He did, however, point to one significant aspect of the mingling and interchange of the visual arts that was all around him, when he praised Taddeo Gaddi's skill in painting 'buildings and places'.

Gaddi is, in fact, only one among the painters of the period who rejoiced in devising buildings to fill their pictures — showing much greater response indeed to all the possibilities offered by architecture than to those of 'places' in the sense of the countryside. That location tends to be bleak and conventional, chiefly a matter of rocks and scrubby trees. How to organise a landscape had in any case its own pictorial problems, while the designing of buildings might be close to the painter's own experience and offered in paint possibilities for graceful, dream-like yet coherent structures, which possess a not quite logical but strong three-dimensional air. In contrast to untamed nature, these buildings show off the inventive, civilised achievements of man. The city was, after all, a more protected and far safer place to live in than the countryside.

Still, the time had not yet come when a city square — or a city — could be the sole subject for a picture. However much they obtrude and proliferate, the buildings appearing in fourteenth-century Florentine paintings — murals, chiefly — remain subordinated

Opposite: *The Loggia of the Bigallo.*

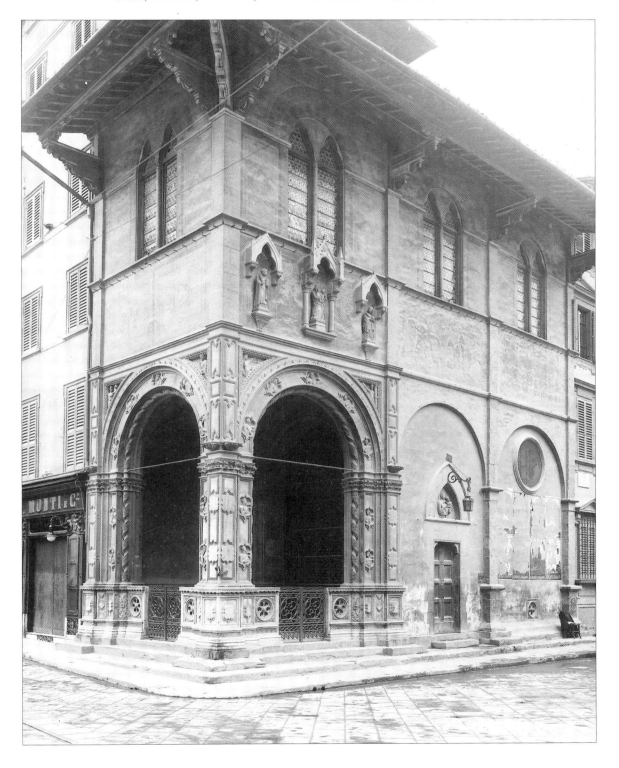

to the figure-subject, with the result that they had to be open and opened up, which made for a decorative lightness in accord with aesthetic ideals generally in the city. The paintings abound in loggias and arcades and open pavilions, with fretted, canopy-like roofs, supported on tall, slender, sometimes twisted columns, tinted in delicate tones and decorated with favourite motifs: bands of sparkling, mosaic-style chequer-work and patterns of lozenges and quatrefoils, simulated as shallowly incised or as inlaid with coloured enamels.

Pavilions as enchanting (and impractical) were not, it has to be admitted, erected in fourteenth-century Florence. Yet the architectural idiom in the paintings was translated into analogous facts, some of which have to be partly recovered in the mind's eye. Loggias and arcades of a literally picturesque kind, with surfaces sculpted and even in places coloured, were built, on a scale ranging from the grand one of the Loggia dei Lanzi to the minute one of the Loggia del Bigallo (see p. 65), a jewel-box of decoration in stone and metal, unmissable as it adorns a corner of the Piazza del Duomo, and which really might have appeared in some painting.

The famous pieces of sculpture which today occupy the Loggia dei Lanzi detract from appreciation of its graceful vaulting and of its main façade on which are carved the four Virtues most applicable to the city-state (Justice, Prudence, Fortitude and Temperance), designed by Agnolo Gaddi and set in niches of blue enamel patterned with gold stars.

Orsanmichele was originally arcaded on the ground floor, as markedly 'open' as it now appears walled-in and 'closed'. Inside, it contains the most exuberant of all semi-architectural shrines – an object more daringly fantastic and more richly ornamented than any painter included in a picture – the huge, carved and enamelled, pinnacled and pedimented tabernacle by Orcagna.

To a limited degree, despite its much larger scale, Giotto's Campanile belongs in the same decorative idiom. As a cathedral bell-tower, it is unprecedented and unrepeated. The lower portions are not merely inlaid and patterned with coral-pink and seaweed-green marbles but serve as a showcase for sculpture – sculpted reliefs and large-scale statuary. The whole shaft was eventually so patterned, pierced and adorned that its architectural character is in danger of disappearing, and a persistent, miniature preciousness hints at its ending up reproduced as a mantelpiece ornament under a transparent dome (a fate half anticipated by the Emperor Charles V's remark that it deserved to be kept under glass).

That the Campanile proceeded in stages is only too visible in its structure. Between

them Giotto and Andrea Pisano produced a giant podium (in detail much more fussy and fretted, incidentally, than the geometric-abstract patterns on the lower storeys recorded in a contemporary drawing) on which Talenti built three more graceful, fenes-trated storeys of spun-sugar refinement and seeming insubstantiality. They are topped not by the expected (perhaps originally intended) pinnacles and spire but by a cake-frill of balcony that seems not so much to develop organically out of the structure as to have been lowered onto it, like a miraculously suspended marble crown.

It is notable that such an extreme of refined ornamentation is based on and develops from what had been provided by Giotto. Because of the steady current of praise for Giotto the 'natural' painter, and because the following centuries saw him as a re-generator who sternly brought painting back to truthfulness, Giotto's own decorative emphases can even now be underestimated. The artist who devised the base of the Campanile had previously shown, in the Scrovegni Chapel, a predilection not only for introducing buildings into his mural scenes but for framing those scenes in borders of fantastic, semi-playful decoration often omitted in modern reproductions of the fres-coes. They are brightly coloured, rich in slabs of simulated marble and hexagonal and quatrefoil snowflake shapes, themselves fixed within long lines of *trompe l'œil*-encrusted patterns of mosaic or tile – all with a vitality that only a great and disciplined painter could keep from swamping the areas they surround.

Giotto had not been the initiator in Italy of any of these decorative devices, least of all of the framing-round of mural compositions with patterned borders, but by his fond, inspired use he sanctioned and popularised them – in Florence especially but also else-where (notably in Padua). Gaddi was following in the footsteps of the master when he executed his murals of the life of the Virgin in the Baroncelli Chapel at Santa Croce (the Baroncelli being a local great mercantile family like the Peruzzi and commercially con-nected with them). Where Giotto, however, had been visually terse, Gaddi was voluble, filling his scenes with enough architecture – complex in design, exiguous in bulk – to constitute a bid to succeed Giotto as *capomaestro* of the stalled Duomo scheme. Gaddi positively riots in painted, pseudo-architectural-cum-sculptural borders and niches, with a curly-columned tabernacle or two, pointing the way to Orcagna's real one in Orsanmichele.

To shake one's head and gravely deplore the dilution of Giotto's 'lesson' would be to miss the duality of his example and the fact that the Florentine visual arts were as bent on pleasure as Boccaccio's group of young people, in a way that was possibly novel and which has a certain spring-like ebullience. What came after was not exactly 'the deluge'

but a more sober, intellectualised reaction, a nipping of the extravagant and carefree, at times careless, flowers that had bloomed in the largely 'incorrect', unclassical fourteenth century. When Alberti, in his treatise on painting, condemns the use of gold for pictures, he seems to be pronouncing an aesthetic anathema on a large category of fourteenth-century Florentine art.

That a wiser, more knowledgeable and responsible age, the age of the Renaissance, was about to arrive – rather in the role of a nanny finding her charges rioting in the nursery – was not in the minds of artists or anyone else as 1400 approached. In Florence a mood of assertive official optimism about the city's status and its achievements hardened under the fresh threat from Milan after decades of threats and disasters, and found propagandist expression in the public declarations of its famous chancellor, Coluccio Salutati. 'What town,' Salutati asked histrionically, 'not only in Italy but in the whole world, has safer walls, more superb palaces, more ornate churches, more handsome buildings . . . ?'

That this is rhetoric, for a defiant purpose, has often been recognised. Salutati was very consciously making himself the mouthpiece of Florence, for which his post of chancellor admirably fitted him. The chancellor was a servant of the *Signoria*, a very superior civil servant in fact, approximately equivalent to a combination of Cabinet Secretary and Head of the Foreign Office with Public Orator. Among much else, he communicated with foreign powers in the name of the *Signoria* (not on his own initiative). When Florence was in danger, a high tone might be expected, especially from a learned letter-writer famed for his eloquence. Salutati had earlier taken a more pessimistic view of things in a moral treatise on withdrawing from active life (not that he did), finding the buildings of Florence in decay, though even then admitting their size and splendour.

Some of the greatest of those had been built before the fourteenth century, but the century could boast of having greatly embellished them. To its ancient, revered Baptistery the Guild of the Calimala had added – for all to see, at all times – a pair of modern bronze doors, facing the Duomo, which were unmatched in Florence. Whatever Andrea Pisano borrowed compositionally from the Baptistery mosaics of St John's life, and however influenced by Giotto, he and his goldsmith assistants created a narrative of tremendous punch and fierce, finely wrought concentration, stamping each of the twenty scenes from the saint's story with the clarity, authority and economy of a great coin. Giotto himself seems profuse compared with the absolute rigour of the few elements in each composition. Not the least of the merits of the doors is that they remain doubly readable – first as leaves of a strong and strongly rectangular doorway and second, with no diminution of that overall impression, as open pages imprinted with a series of clear-cut, compartmen-

talised, individual images. At a time when even those who could read had little at home in the way of reading-matter, here was a giant, gilded book permanently available.

Giotto's Campanile was the next embellishment, something of a welcome substitute perhaps for the delayed completion of the Duomo, which would — possibly already did — adjoin it uncomfortably closely (in Andrea Bonaiuti's Spanish Chapel mural he has removed the Campanile towards the rear of the Duomo, by no means a bad idea). And on that Campanile Andrea Pisano seems to have shown fresh creative flair in the series of reliefs around its two lower storeys. The reliefs at their best possess all the inventive economy apparent in the Baptistery doors, though

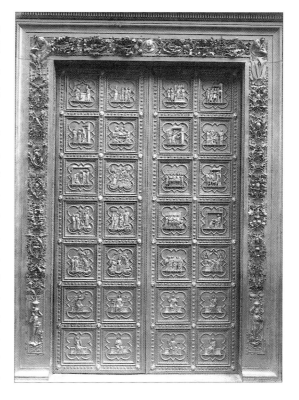

Andrea Pisano: Bronze Doors, *Baptistery.*

several of them are by, or designed by, Giotto — according to patriotic Antonio Pucci (who, one feels, would be bound to claim that). It may seem surprising that some local enthusiast did not ascribe Pisano's doors to Giotto (as at one point Vasari actually does).

As a commission, the Campanile reliefs presented a similar sort of challenge: the devising of a series of compositions each contained within a regular shape, hexagonal or diamond, and some of the most effective of the panels are those which manage to exploit the somewhat awkward format, especially of the hexagon. Fortunately, there was in compensation considerable freedom of subject matter and interpretation, beginning with Genesis and the creation of man but going on, more interestingly, to man's own creations and discoveries, ranging from the pastoral (stock-raising) to weaving, sculpture and music.

Some genius, who was most probably none other than Andrea Pisano, brought these subjects into terse, brilliant life, with vibrant touches of pure genre — such as the crisply modelled loom that almost hums in *Weaving* and the litter of tools at the bench of

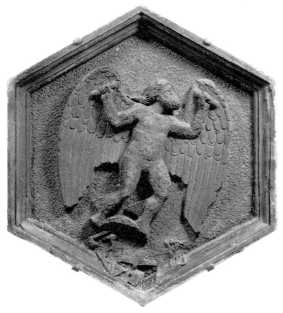

Andrea Pisano: Relief Plaque of Daedalus,
Museo dell'Opera del Duomo.

Sculpture. From a tent ingeniously echoing the hexagonal frame, the patriarch Jabal, seated cross-legged, gazes out benevolently in *Stock-raising,* while a ram and two sheep are guarded by an alert dog hardly more than a puppy. Perhaps most memorable of all is the single figure of Daedalus — the artist-inventor personified — bearded and muscular, his square body feathered as well as his huge, outspread wings, determinedly aspiring upwards. He is no bad symbol of fourteenth-century Florence.

These reliefs must definitely have become Andrea Pisano's responsibility after Giotto's death in 1337. And by that year work was in hand on the new loggia of Orsanmichele, a building whose associations went back deep into the past of Florence, and which the fifteenth and even the sixteenth century (as late as in Giambologna's career) would augment and enrich with art of historic, civic, specifically Florentine significance. Nevertheless, Orsanmichele is a unique temple to the ideals of the fourteenth century, a temple which must be entered to be understood.

T HE SMALL ORATORY of San Michele had been founded as far back as the eighth century in an *orto* (an orchard or garden). The old name lingered on, though by the time Dante reached adulthood the site was occupied by an open, pillared hall, serving as the grain market. No longer standing *in orto,* it was at a key point in the developing layout of the emergent city, near the main market-place and on the axis of the Piazza del Duomo and the Piazza della Signoria — metaphorically facing both ways, for it already combined a sacred and secular function.

An image of the Madonna was painted on one of its pillars, and Giovanni Villani tells how in July 1292 miracles began to occur before this painting.

Soon fame and devotion turned the area into a place of worship. People started to

come from all over Tuscany, to present wax votive objects and give money — and to pray. Here was an accessible, thoroughly public, wonder-working image suddenly enlivening and singling out the centre of Florence, and it comes as no surprise to learn from Villani that the 'preaching friars' and other orders showed hostile incredulity.

The important Dominican and Franciscan churches of Santa Maria Novella and Santa Croce were still in the course of being built. They required funds and prestige, and their *Frati* are bound to have disliked a rival, 'unofficial', lay establishment suddenly attracting popular attention. The mendicant orders are treated very solemnly in modern history — almost at times as though they were forces of nature, whereas they were made up of human beings (male ones as far as almost all the

Master of the Biadaiolo Fiorentino: The Corn Market, *Biblioteca Laurenziana.*

important activities and decisions were concerned). Just how human they tended to be as individuals, and how they could abuse religion for their own private ends, are commonplaces of the period, emphasised most amusingly though bitterly by Boccaccio and by Chaucer.

The Madonna's miracles at Orsanmichele manifested themselves at an unusual moment for the Church. There was no pope, and there remained none until late in 1294, following the death of the first Franciscan pope, Nicholas IV, earlier in 1292. The Holy Spirit failed to declare itself, or the cardinals were peculiarly deaf to heaven; they were certainly engaged in protracted, unedifying though not untypical rivalry and wrangling.

The fire of 1304 in Florence destroyed or irreparably damaged the pillared hall — news which must have been received in the local monasteries with more than pious resignation to God's will. After the first, tentative effort at rebuilding, a new and much stronger loggia was begun in 1336 — planned by the Commune, built of stone and very

much higher, serving the triple functions of grain-store, grain-market and shrine. Completed, the free-standing building had all the appearance of a palace. In fact, the triple functions proved too many and the grain-market was soon moved. The animation of that market, with its barrels of grain and its characterful buyers and sellers, happens to be vividly documented in the scenes illuminating the chronicle of an early fourteenth-century Florentine grain-dealer, Dominico Lenzi, though they might equally well illustrate the verses of Antonio Pucci.

Far from stripping Orsanmichele of importance, however, the move of the market left it the more numinous as a civic-religious centre, and its mercantile associations were to be reinforced when the greater and lesser guilds became involved with it, first by each adopting and having painted on the flank of a pilaster the guild's patron saint. Corporateness went hand in hand with reverence, and the secular — or, at least, non-monastic — aspect of the building seems underlined by the choice of no professional theologian but the *littérateur* Sacchetti, a member of the Marian lay confraternity there, to devise a programme for the murals in the vault.

It must already have been a mysterious environment, shadowy and quiet after the light and noise of the surrounding streets, that a worshipper encountered, stepping through the still-open arcades in the years around 1360, when Orcagna's tabernacle had just been completed.

Niches had been sculpted on the exterior pilasters, destined for sculpture but almost entirely unfilled until the following century. That absence, combined with the absence of walls as such, left the emphasis upon interior space, now additionally darkened and deepened by the late fourteenth-century stained glass which extends the mood of mystery.

Ideally, Orcagna would perhaps have liked his tabernacle to stand centrally in the space under the painted and patterned arches, and amid the concourse of patron saints. Because of the location of the supporting pilasters, that could not be. It was placed in the south-east corner, approximately as an altar. But it was conceived not merely as a frame for the painting it holds of the Virgin and Child (by Bernardo Daddi). It is virtually a building rising within the larger one, approachable from all sides and containing a large sculpted relief of the Assumption of the Virgin, signed by Orcagna himself, visible on what has perforce become the back of the tabernacle.

Guarded by angel-acolytes on pillars at the four corners, and kept holy and apart by

Opposite: *Andrea Orcagna:* Tabernacle, *Orsanmichele*

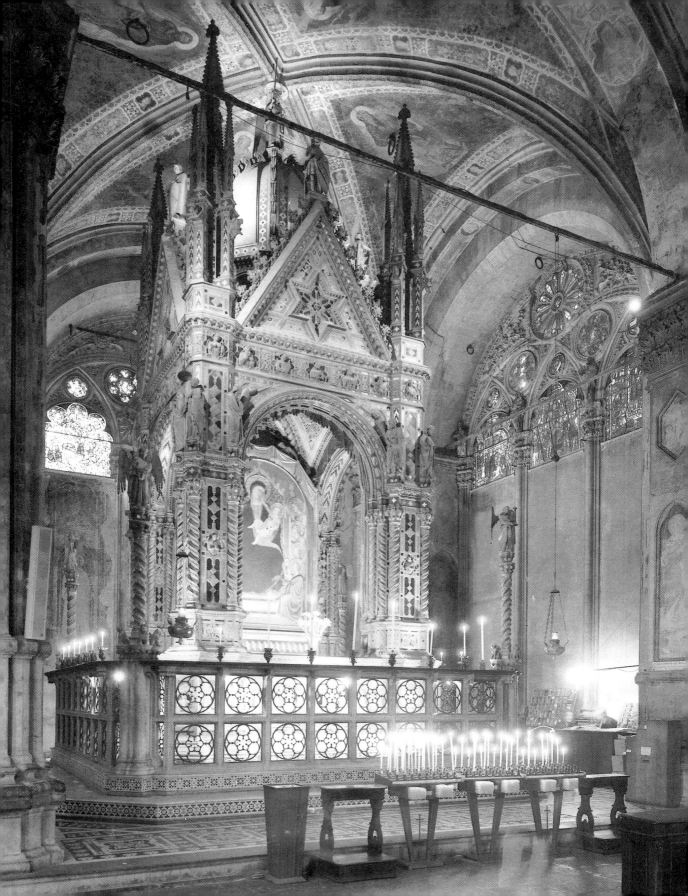

a low iron-grilled balustrade, there takes shape a gleaming, enamelled and inlaid, fairy-like structure, pedimented and pinnacled and even domed, its flamboyant, fanciful detail disappearing into the penumbra of the vault overhead. Compared with this great, glittering stalagmite, Giotto's Campanile becomes a model of restraint.

The tabernacle commemorates the miracles performed by the old image of the Madonna (none seems subsequently to have occurred) and was itself miraculous as a concentrated achievement of the latest art, fusing painting, sculpture and architecture, as well as metal-work and goldsmiths' work, into one complex, half-visionary entity, whose elaboration is intended to be endless, leaving the spectator gazing and wondering for ever.

To enter Orsanmichele today is to go back in time, as is unavoidable, but back unfortunately through the direct perspective of the early fifteenth century, its achievements asserted on every exterior wall of the building by magnificent statues which offer the worst possible context in which to do justice to Orcagna's tabernacle. It is as if one had to approach a Victorian monument through an avenue of Brancusi and Epstein. Perhaps it would in some ways be easier to explain or enjoy the tabernacle as the contribution to Orsanmichele by some wealthy nineteenth-century Russian living in Florence (such as Anatole Demidoff, Prince of San Donato, see Epilogue), so little does it accord with preconceived notions of what is typically Florentine. Yet its sumptuous intricacy and coloured inlay alone prepare one for the thoroughly native craft of *pietre dure*.

To build something may well have been Orcagna's ambition. It is as 'archimagister' of Orsanmichele, as well as *pictor florentinus*, that he signs his tabernacle. It is dated 1359, by which year he was closely concerned — as increasingly were numerous artists of all kinds in Florence — with advising over, and even executing, plans for the Duomo. Possibly yet more relevant was his appointment in 1358 as *capomaestro* of the cathedral at Orvieto, for in that pedimented and pinnacled façade he could certainly have found encouragement, if not inspiration. Inside the cathedral, too, similar refinement in the same style is expressed by its finely carved choir stalls and mesh of metal nave screen, and perhaps most pertinently of all by two exquisite, highly elaborate reliquaries by the Sienese goldsmith Ugolino di Vieri. Somewhere between their semi-architectural form and the semi-sculpted architecture of the Orvieto cathedral façade stands Orcagna's tabernacle, though its unrestrained fantasy and richness are — like its scale — ultimately unique. And in managing to fit in a dome on top, literally, of his whole confection (an Easter egg of a dome, patterned along its ribbing), Orcagna may be alluding to the dream-cupola long projected for the Duomo at Florence.

All his aspirations seem enshrined in the tabernacle, to the point where Daddi's placid devotional painting might appear threatened with eclipse. Yet by its clarity of composition and chromatic bravura blues and gold, it survives, complemented rather than crushed by the blue enamel and gilt that frame it. Daddi is Giottesque in a decorative vein, but no Giotto. That happens to be just right at Orsanmichele, where a masterpiece by Giotto would — especially if set in Orcagna's shrine — have looked almost disturbingly earthy and 'realistic'.

Yet the tabernacle tells of much more than its creator. Planned and put up in the decade immediately following the Black Death, it has something corporate to convey and can indeed be seen as the most splendid of votive offerings to the Madonna, conceived by those citizens of Florence specially devoted to praise of her and grateful to have survived the plague.

That in itself might be hailed as a miraculous event, and it is significantly the miraculous survival of the Virgin that forms the subject of Orcagna's large sculpted relief. In the lower portion she dies, or falls asleep, and Christ is shown present — in the tradition of the period — holding her soul. It acts as a solemn predella for the joyful, indeed glorious mystery of the bigger star-burst of the scene above, where the Virgin is borne to heaven by flying and music-playing angels in a sky of lacy filigree, light and lyrical in mood as in handling.

Revival is the theme, and it is hard not to think that along with the Virgin's Assumption is celebrated also the revival of Florence.

In standard art history Orcagna's relief 'leads on' to the early-fifteenth-century, more fluently accomplished sculpture of the Porta della Mandorla of the Duomo. The main subject there is again the Assumption of the Virgin, and again the scene includes the kneeling witness, St Thomas, receiving the Virgin's girdle as she is carried heavenwards. That was an aspect of local interest, topical too when Orcagna's work was executed, for the girdle itself was preserved at nearby Prato, a town purchased by Florence in 1351.

Taken altogether, with its setting, Orcagna's tabernacle leads nowhere. Its value lies in itself and in what it sums up. Not echoes but reaction would follow it. In the persons of Donatello, Brunelleschi and Masaccio, sculpture, architecture and painting would create a standard by which the tabernacle appeared isolated, even illogical and bizarre. Inside, Orsanmichele might retain its mystery and homogeneity. Outside, as the guilds responded to renewed calls to contribute statues of their patron saints, splendid but essentially human presences, of novel corporeality, and volume and weight, began to fill — and even make flimsy-looking — the thin, fretted niches carved for far less substantial

figures. In their painted niches within the building, the same saints painted on the pilasters become by comparison pale, if not insubstantial, unable to face the daylight and the competition of the vigorous new artistic world beyond.

A shrine within a shrine, Orcagna's tabernacle speaks to some extent in the accents of Chancellor Salutati, copious, varied, ingeniously and flagrantly artful. Wonder and awe are the conditions it is meant to produce. Detaching the spectator from normal experience, it creates an effect of visionary beauty. Nothing like it should have been seen before. By implication, only in Florence — with its piety, its resilience, its civic pride, its corporate patronage and its artistic practitioners — can such a monument be raised. Like Salutati's flourishes about the superb uniqueness of Florence, the tabernacle can be called a piece of rhetoric. Yet it is a fact. Under all its extravagant, fanciful show, it states a certain truth, and so also do the claims of Salutati.

CHAPTER THREE

The City and Its Citizens in Perspective

A FAMOUS PASSAGE IN the *Life* of Brunelleschi, written probably by a fifteenth-century fellow-Florentine, Antonio Manetti, describes how Brunelleschi first devised a practical illustration of his concern with the laws of perspective. He painted a small picture of the Baptistery and surrounding piazza, as visible from inside the Duomo. This was planned to be looked at not from the front but from the back, through a funnel that narrowed to a minute hole in the panel itself. Peering through that aperture, the spectator saw the composition reflected in a mirror, placed at arm's-length distance. The effect gave the scene a spatial coherence which made it appear, in Manetti's word, 'real'. To emphasise that this is no legend, he adds his witness-like testimony to having seen the panel itself.

Brunelleschi's concern was to demonstrate an optical effect. Utilised and refined, it would bring a revolutionary degree of visual logic, coherence and apparent realism to painting. The scheme is, admittedly, extremely artificial. Brunelleschi assumes a fixed, presumably central viewpoint. Only by looking at the composition from there — and then with only one eye — did the spectator find the scene falling into a convincing perspective.

Brunelleschi was not by profession a painter. Hardly more than his friends Donatello or Masaccio was he an all-round artist of the fourteenth-century or later fifteenth-century Florentine type. He was primarily an architect. Not by chance did his demonstration focus on an urban scene — and then no fanciful one but the familiar area around the Baptistery, though he probably showed it in an unfamiliar light as empty of people. Although that original composition is lost, something of its general effect — much diluted, peopled and turned partly fantastic — is probably echoed in some consciously decorative, semi-topographical Florentine panels that feature the Baptistery (one, the 'Cassone Adimari', is ascribed to Masaccio's half-brother).

Brunelleschi's pioneering experiments in perspective (he also painted a secular

counterpart, showing a corner of the Palazzo della Signoria, without the mirror device) may have been made around 1420. They were certainly undertaken in some form well within the lifetime of Masaccio. More than twenty years younger than Brunelleschi, Masaccio was to be profoundly influenced by him and perhaps no less by Donatello, close to Brunelleschi in age.

Here was a triumvirate of genius almost perfectly balanced, potentially a team or firm, capable of carrying out commissions in the three major arts for the improvement of Florence: Brunelleschi could design a building, Donatello supply the sculpture, and Masaccio paint the frescoes.

Unfortunately or not, such a building never came into existence. Things were to be a good deal more complex, and conditions by no means always sympathetic. There was no unanimous general agreement, for instance, that any project proposed by Brunelleschi would work, never mind whether it found aesthetic favour. The Florentines proved to be thoroughly Florentine in their scepticism, half-malicious chatter and volatility. They possessed in any case no particular monopoly of sound artistic judgment, despite living in the Renaissance. People encountering Brunelleschi in the street did not salute an out-standing architect; the evidence suggests that they were more likely to point him out to each other as a bit of a dreamer, at least until the cupola was built. He himself, rather than rejoicing in the contemporary 'enlightenment', may have wistfully thought at times how much easier an artist's life appeared to have been in Giotto's day.

Although the fact is often left unremarked in celebrations of the flowering Florentine genius in the visual arts in the early fifteenth century, there was a lack of any comparable flowering of genius in literature. That indicates that the Renaissance there was not a wholly pervasive phenomenon. That Florence produced no second Dante is understandable, but it might have fostered another Boccaccio. Instead, there was much learned literary activity, without much real inspiration. In the vernacular at least there were to be few poets of distinction before the amateur Lorenzo de' Medici, to be followed by a more profound poet, who — almost ironically in the circumstances — was also a supreme visual artist, Michelangelo.

During their long lifetimes neither Brunelleschi nor Donatello received any useful local literary recognition, apart from the friendly praise of another, gentlemanly artist, Alberti. Later in the century, when the Florentine bookseller Vespasiano da Bisticci was writing his detailed and well-disposed *Lives* of numerous contemporaries and near-contemporaries (from, inevitably, a pronounced Florentine angle), he devoted no 'life' to any visual artist, although airily remarking in the introduction to his book that painting,

sculpture and architecture were at their highest level, 'in the present age'. Who would guess it, one can only ask, if the evidence depended on him?

There are other reasons why the triumvirate of Brunelleschi, Donatello and Masaccio was not invited to take over Florence and steadily transform it. Masaccio died tragically young, aged only about twenty-eight. There was also a fourth prominent and gifted artist in the city, Ghiberti, older than Donatello and a close contemporary of Brunelleschi; he threatened to outlive them all and certainly managed to outboast them all. His art was partly governed by standards different from theirs. Active by 1401, he did not die until 1455. About his importance and his contributions to improving Florence there could be no doubt, for he sensibly filled any potential lacunae by writing his own account of his life and work, a quite unprecedented step by any visual artist anywhere in Europe. The wisdom of so doing is confirmed when we realise that Donatello, the greatest sculptor of the age, and one who left his permanent mark on Florentine art, as well as on Florence, received no biography in his native city in his own century.

That Ghiberti and Brunelleschi were bitter rivals – and had been from the time of the competition in 1401 for the second pair of Baptistery doors – also provided a novelty, as far as one can tell, on the Florentine artistic and social scene. If Taddeo Gaddi and Orcagna had disliked each other stylistically if not personally, as is conceivable, nobody bothered to record the fact. But artistic personalities were coming into a clearer perspective, despite Vespasiano da Bisticci's indifference to them. Ghiberti prepared his account of events with careful attention to his own successful role. On the dead Brunelleschi's behalf, Manetti replied (whether or not aware of Ghiberti's necessarily unpublished account), equally carefully and with positive venom. All this, of which a good deal surely circulated in the city as gossip, must have enlivened Florence and given a spice to more elevated interest in contemporary art.

As a painter, Masaccio was not perhaps opposed or criticised by any particular rival, and he did not live long enough to establish sufficient dominance to excite jealousy. He received no public commission. His art, gravely human but also heroic and rather poorly defined as realistic, was to be highly, though only gradually, influential. Indeed, Masaccio's actual style may have been too stark for most tastes. It was little copied, whereas the new Brunelleschian perspective had rapid, profound effect. Those patrons who were conservative in outlook may have preferred the typical, more patently colourful kind of picture of which the churches of Florence were full, or simply sought an established painter known to work efficiently – rather than assessing who was the most stylistically advanced.

Something similar though more mysterious occurs in the career of Donatello, the

most obviously successful of the trio, who was given plenty of important public commissions in Florence, and was in considerable demand elsewhere, from Padua and Mantua to Naples. The bold individuality of his art and its incessant evolution may have combined eventually to diminish demand for his work (Vespasiano does manage to mention him in his 'life' of Cosimo de' Medici, saying Cosimo employed him to keep his chisel from being idle). A contemporary comment on his reliefs on the bronze doors of the sacristy in San Lorenzo was sharply critical of their nervous, angular energy: do not make Apostles look like duellists, 'as does Donatello'. Conversely, silence surrounds the circumstances of the commissioning of his now-famous bronze *David* – the first post-antique, life-size, nude statue. During the sculptor's lifetime there are no references to it. It remains one of the most truly 'Renaissance' of all Renaissance achievements, but without a firmly documented origin. It may well have been commissioned as a symbol of Florentine success in negotiating peace with Milan (in 1428), quite possibly by Cosimo de' Medici.

R ECOGNITION OF AN unclear-cut state of artistic affairs in early fifteenth-century Florence helps to put into context the very real achievements in the city, even though they seldom came about with all the harmony they may now seem to convey. Donatello was on one occasion to contribute sculpture, in the form of coloured sculpted reliefs, to a building of Brunelleschi's, the elegantly classical small sacristy (the 'old sacristy') at San Lorenzo. The result may look delightfully homogeneous and typical of the period, but Brunelleschi had created his own abstract décor out of architectural elements, with pilasters and arches in a cool harmony of grey and white. According to Manetti, he was most distressed at Donatello's additions, which were commissioned by the most powerful man in Florence, Cosimo de' Medici.

Borrowing Brunelleschi's device of looking out towards the Baptistery from the Duomo, we may conveniently take in (as he would hardly care to) Ghiberti's earliest great, public achievement, the first pair of doors he executed, and we may also see, in the mind's eye at least, the pair that were to follow. Reversing the viewpoint brings the Duomo and Campanile into sight. For niches high up on the Campanile Donatello carved some of his most dramatic and pungent statues, gaunt prophets whose external weathering matches an inner turmoil but who yet possess a strong Roman senatorial air – all of which must have been virtually unappreciable before they were brought down to earth in the Museo dell' Opera del Duomo.

For the Duomo itself, Brunelleschi had succeeded in what had so often and long been dreamt of. He had given the Florentines their cupola, which represented a challenge of art, engineering and man-management – in terms both of organisation and of convincing the doubters. At what seemed a stroke but which had in reality taken years of labour, the final crowning of the city was achieved, the ubiquitous symbol of its might and splendour, which even in the crudest wood-cut henceforth stood for Florence (see Plate 1). In Italy it was *the* dome of modern times, offspring and successor, as it were, of that of the Pantheon in Rome, and the architectural expression of the place of Florence as Rome's successor. In the enthusiastic *Cronica Fiorentina* (Florentine Chronicle) of Benedetto Dei, composed in 1472, '*la gran chupola*' is the third of the great things to show foreigners in a city that is '*un' altra Roma novella*'.

Brunelleschi did not live to see the cupola entirely completed. No-nonsense but shrewd, and sharp of speech in Tuscan style, he might have smiled at the fine Latin epitaph that his '*grata patria*' gave him in 1446, when burying him honourably in the Duomo: the wonderful cupola of this most famous church bearing witness to his ability in 'the Daedalian art'. The phrase brings back the image Andrea Pisano had sculpted on one of the Campanile reliefs, of Daedalus tough and determined and for ever in the ascendant.

Brunelleschi's concern to put Florence into a literal perspective can be related to comparably new if wider concerns there early in the century, to scrutinise the state, the city, its citizens and its monuments, noting the facts and putting things into the perspective of history. Those decades up to 1434 were, as it happened, the last decades of the republic without Medici domination. Although the city might expel the family, it would never subsequently be free from it as threat or fact as long as the dynasty survived.

Already, in Vespasiano da Bisticci's view (and he was probably writing in the 1480s), the years from 1422 to 1433 were a time when 'Florence flourished greatly, rich in schools of learning and in illustrious citizens'. He perhaps hardly understood all the political implications of what he was saying, for he was devoted to Cosimo de' Medici, who returned from exile in 1434 and soon settled to become the effective ruler of Florence for the next thirty years. Vespasiano is on dangerous territory as he blandly talks of one particularly illustrious citizen, Palla Strozzi, uniquely rich, handsome, genuinely scholarly, a family man, a great builder and collector – the *beau idéal* of a successful, cultured Florentine citizen – who had actually been driven into permanent exile by the Medici, possibly through envy of his very qualities and status. Yet Vespasiano, while not making that explicit, speaks of the pre-1433 years as those when the 'good government [of Florence] made her feared and respected universally'.

It is rather too favourable a retrospect. Those decades were by no means entirely peaceful or relaxed, partly through the aggrandising policy of Florence – or of those men dominant in its oligarchy – inclined to go on the attack when not itself under attack. But at least the interior of the city was calmer. The passion for street-fighting seems to have subsided, and the dissensions of the Guelphs and Ghibellines were fading into a past darker and less civilised, though 'Guelph' was a word retaining evocative rallying power. When the Florentines embarked on a damaging war against harmless Lucca in 1429, one of the wiser citizens in Florence, Niccolò da Uzzano, warned against the whole enterprise and began by stressing that Lucca was a friendly, Guelphic city.

If Florence held up a mirror to itself – as in various ways it and its citizens did – the truthful reflection justified a good deal of pride. It had become not just a city but a state. It had bought or brought to submission some of the once-independent, flourishing cities of Tuscany, including Volterra, Arezzo, Cortona and Pisa. Siena eluded it until the sixteenth century, and Lucca was never to belong to it. Its rule was not notably wise or kind – more brutal and contemptuous – but it ruled. The passage of a century had given additional force to Pope Boniface VIII's remark about the Florentines as a fifth element in the world.

Although the government of Florence was riven by internal rivalries – with the factions of the Albizzi family and the Medici squaring up for a definitive struggle – it was publicly and emotionally a republic. Its citizens went on being duly elected as Priors, just as Dante had been. Its seat of government was still the Palazzo della Signoria (fourth in Dei's list of the sights to show foreigners), a building no longer new or 'modern' in style, but taking its admired place in the city's first architectural guide (written around 1423, by Gregorio Dati), and a continuing symbol of the Commune and the people. Florence represented the home of liberty and democracy. Its historians – then starting into existence in praise if not explanation of it – would assert as much, and a patriotic statesman like Niccolò da Uzzano would (in the words given him in Machiavelli's *History* a century later) solemnly and movingly declare, 'may God preserve the city from any of her citizens usurping the sovereignty'.

Culturally, too, the state was active and beneficent. Not his family, nor a patron, nor even the city, but the 'fatherland' had given Brunelleschi burial and commemoration in the Duomo (Machiavelli, who seldom mentions artists of any kind, was impressed by this honour as indicative of Brunelleschi's extraordinary merit). The guilds – not individuals as such – were the patrons of the great building achievements of the early decades of the fifteenth century: the Calimala were responsible for the Baptistery doors; the Lana

for the cupola of the Duomo; the Silk Guild for the Ospedale degli Innocenti in the Piazza Santissima Annunziata. Before Cosimo de' Medici took over and made San Lorenzo into a family church, no one person or family had 'usurped the sovereignty' by monopolising a complete church. It was the Commune which required the guilds to commission statues for Orsanmichele. And it was 'our people', the Commune informed Pope Eugenius IV, who had continued to expend money and care on building the Duomo even during wartime.

It was significantly as part of his history of recent times in Florence, which was meant to be more than a mere chronicle, that the silk merchant Dati wrote his guide to the city's buildings. Not content with vague praise of their general splendour, he described in appreciative detail the various monuments and their siting, not omitting the mills built along the banks of the Arno, which were of 'marvellous beauty'. He paused on the Ponte Vecchio, lined with 'most beautiful' stone-built shops of craftsmen. Almost in the middle of the city, he explained, the Palazzo of the Signori (the Priors) stands in a large piazza, and from its battlemented roof rises a high tower with a beautiful, battlemented balcony, on top of which is a crenellated structure holding the bells of the Commune. In the same piazza there is also a large, magnificent loggia (dei Lanzi).

Dati wrote accessibly in Italian, and though the vocabulary of his praise may be limited, he gives the impression of having looked at the city as truthfully – if not as expertly – as Brunelleschi. So, when he turned to events, did he aim to account for them. More obviously learned and literary people also contributed their praise of Florence and set it in a grander perspective. Leonardo Bruni, a Florentine by adoption and enthusiasm, spoke up for the city as early as around 1401, with a Latin panegyric of it as a bastion of republican ideals. In 1415 he began a larger and less rhetorical task, a Latin *History of the Florentine People*, in which he aimed to substitute facts for legend (republican sympathies encouraged his dismissal of Julius Caesar as founder of Florence). Confirmed as Chancellor of the republic (the post held earlier by Salutati) from 1427 until his death in 1444, Bruni was almost too eulogistic and official a mouthpiece. Yet his feelings for the city were genuine, and in a private letter written before he finally settled there (and writing not from exile but from the papal court, then at Viterbo), he sighed for the life he had known in Florence: 'There is no place in the world to compare with the splendour of Florence . . .' As a humanist scholar, Bruni praised the city as the home of the Muses but he disarmingly confessed to missing also its choice food and delightful wines.

Florence had good claims in those still truly republican years to be called at least *a* home of the Muses, in the sense that there – from before the beginning of the fifteenth

century, in fact – Greek as well as Latin scholarship had been actively and excitedly pursued by a small, varied group of humanists, of whom the young Bruni was already one. Humanism (meaning study of the ancient classical world, its literature and languages primarily, but also its visual arts and its whole ethos) provided a perspective learned and yet, to many of its devotees, profoundly relevant for living contemporary life.

That is an aspect which needs to be recalled, though it is harder to recover, before fastening on the 'rediscovery' of antiquity by visual artists. The largely literary and uncreative emphases of the first Florentine humanists mean that they are not obvious presences in the city that one visits today. The name of Bruni is preserved, for most people, by the fact that he happens to have a splendid Renaissance tomb in Santa Croce, sculpted by Bernardo Rossellino, elegantly and classically lettered with an epitaph (catching an echo of his own remark) referring to his death as mourned by 'both the Greek and the Latin Muses'.

Such preservation, however gratifying (Bruni had actually asked to be buried simply), tends to put the art before the scholar, which is not at all as the humanists saw it. Other leading contemporary humanists in Florence, or those keeping up Florentine contacts, have grown dim in general consciousness because they were not commemorated by any monument of art.

Bruni himself seems to have had no strong interest in the visual arts, although he was prepared to concoct a 'programme' for the Baptistery doors. Art historians have frequently mentioned that Bruni records seeing one contemporary work of art (the first of its kind to be referred to, it seems, in humanist literature), part of the Aragazzi monument, executed by Donatello's colleague, Michelozzo. They have seldom added that it prompted him not to any description but to reflections on the vanity of such sepulchral monuments, thus giving additional piquancy in retrospect to the fact of his own.

The early humanists were scholarly and erudite, sometimes rich but more often of limited means. They were more likely to consult an artist about adding an item to whatever collection of antiquities they could afford than to commission a work from him. Taste – not money – must lie at the root of it. A painting would be far cheaper than any sculpture other than a statuette or plaquette, and yet there are no signs of serious, 'neoclassical' pictures being painted for humanists in Florence in these years. Besides, the humanists' concern in linking past and present was usually more moral than aesthetic. How to govern the state, or oneself, and how to achieve the 'good' life, were their preoccupations. For them the greatest figure from the antique past was probably Cicero, philosopher, statesman, rhetorician – and republican. He was a figure who had himself

come into much clearer focus during the fourteenth century. That as a statesman he had not in fact been much of a success perhaps scarcely mattered. Undeniably he was a patriot and had been hailed as 'Father of his Country', a title to be revived and awarded to Cosimo de' Medici on his death. On most 'human' topics, Cicero had written something eloquent, but though he had owned a prized sculpture collection, he provided no thoughts about the visual arts.

Abstruse as these matters are, they need some recognition, however fleeting, to avoid, and possibly correct, any impression that Florentine humanism or 'enlightenment' brought together automatically in a single intellectual community scholars and artists. Artists might join in admiration of some antique object, but the exchange of letters in Latin (never mind Greek), annotation of a classical text, or even arguments about a citizen's relationship to the state were aspects of humanist activity from which most of them, however talented in their own right, were bound to be excluded. They lacked the necessary education, for one thing. Moreover, though the situation is far from clear, they probably tended to be thought of as inferior by their very profession. In the learned and yet gracefully intended, not unhumorous dialogues and discussions *all'antica*, set in a distinguished humanist's library or in a villa, visual artists are as notably absent among the speakers as are women.

The humanists represent something of a club — for men only. Boccaccio's perhaps partly imaginary yet desirable social vision of men and women meeting as lively, well-bred equals has disappeared, and in Florence the humanists appear to divide into married men of misogynistic tendency and bachelors of a markedly professional kind. Cicero seems to have passed at the period as a secular saint of misogyny (misinterpreted and accordingly canonised already by St Jerome), and from a feminist viewpoint his actual behaviour — divorcing his wife after thirty or so years to marry a younger woman — was hardly more exemplary. There was nothing particularly enlightened about Florentine society's attitude generally to women. Divorce might indeed have been welcome to them. A market woman probably enjoyed more freedom to move about than did the wives of the middle and upper classes, kept in semi-oriental seclusion and Christian submission, and probably gaining any real status and liberty as individuals only on becoming widowed.

The great visual artists were not so much secluded as left socially on the fringe. Although Vespasiano da Bisticci tells of the friendly patronage of Donatello by his great hero, Cosimo de' Medici, he also unwittingly reveals much of the underlying relationship when he describes how Cosimo gave the sculptor a set of respectable red clothes (stan-

dard citizen's wear), not liking the doubtless scruffy way Donatello dressed. Donatello was too independent to accept the gift and its implications; he put the garments aside, saying they were too fine for him.

If any visual artist was qualified to move as an equal, indeed, almost as a superior, in humanist circles, it was the brilliantly gifted Leon Battista Alberti. He was, however, distinguished not solely by remarkable all-round talents, erudition impressive by any standard and (for an artist at the period) unique literary ability. Although illegitimate and born to a father exiled from Florence (itself no novelty or disgrace), he belonged to a family who were established, prominent and wealthy. While it would be wrong to suppose him an artistic dilettante, it is yet hard to envisage someone who was employed at the papal court finding it congenial to labour in a workshop or a studio.

Brunelleschi and Donatello certainly shared a concern for classical antiquity as profound, in its way, as any humanist's. Whether they could articulate that concern, except through their art, is extremely doubtful. Why should they? To them it may have been the literary-biased humanists who were the amateurs and the ignorant, ignorant in their pedantry, messing about with old pieces of parchment and worrying about orthography when what really mattered was the beauty of the surviving objects. To be inspired by those relics required not learning but eyesight. An inability to read Latin was no barrier to appreciating the quality of a finely chiselled Roman inscription, any more than the perfect proportion of a statue was affected by whether it represented Apollo or Mercury. At all periods artists have fastened on what of past art will feed their own, impatient of and indifferent to any other criterion.

The homage paid to antiquity by Brunelleschi and Donatello was itself of a subtle, partly technical kind, and the same is true of Ghiberti, who was in any case less committed to study of it. As for Masaccio, little or nothing can be established about his attitude to antique art. Altogether, Florence did not, at least in the earlier fifteenth century, show itself quite the sympathetic forcing-house for the revival of classical subject matter and classical-style artefacts that might have been expected. Donatello's bronze, so-called 'Atys-Amor' statue remains quite untypical and eccentric, exuding a disturbing pagan-erotic amoral power which the strait-laced ethos of the city would not have cared to encourage. The work was most probably a private commission, in which the tastes of the patron and conceivably the sculptor met. No less pagan perhaps, and certainly no less delirious, are the dancing angel-children of one of Donatello's public commissions, the choir-gallery for the Duomo. But there the Christian context veils — to some extent — what might otherwise have caused scandal or disapproval.

Most of the important commissions given in Florence continued for some time to be for religious foundations: whether statues for an established one, such as Orsanmichele, or the creation of new chapels and churches, such as Brunelleschi's Pazzi Chapel at Santa Croce and his never-finished Santa Maria degli Angeli. Thus the ideally beautiful Renaissance-classical palace that Brunelleschi could undoubtedly have built does not exist, though attributed to him is the Palazzo Bardi Busini, with a classically pillared courtyard. The sole Renaissance-classical bronze equestrian monument that Donatello had the opportunity to create – the statue of the *condottiere* Gattamelata – was for a public space in Padua (a city rich in Roman associations) rather than for his native city. It is timely to recall that Florence had originally intended to honour its adopted *condottiere* leader, the Essex-born Sir John Hawkwood (who died there in 1394), with a handsome, three-dimensional marble monument in the Duomo, but shortage of money reduced that to a frescoed image. That in turn was replaced in the mid-1430s by Uccello's skilfully illusionistic 'blueprint' (though executed in *terra verde*) for an heroic equestrian statue – but it remained just that, a two-dimensional projection on a wall. Donatello, meanwhile, was asked to design a stained-glass window for the Duomo.

It was elsewhere in Italy, often in princely rather than republican cities, that there developed such portable forms of visual homage to antiquity as the medal. In architecture, the most personal and extreme manifestation of antique influence is the Tempio Malatestiano at Rimini. The painter most deeply and learnedly obsessed by antiquity was no Florentine but Mantegna, whose astonishing ability to re-create the world of stern, martial, antique history was given full expression in the Ducal Palace of the Gonzagas at Mantua with the *Triumphs of Julius Caesar*. Republican Florence might have preferred to see celebrated the triumph, brief though it was, of Caesar's assassination by Brutus. And when in the person of Botticelli Florence did produce a painter able, and possibly eager, to respond to the spell of the classical past, he proved no archaeologist but an artist whose concern was poetic re-creation of antique mythology.

Nevertheless, the coincidence and explosion of genius at Florence – in all the arts – which characterised the opening years of the fifteenth century made it unique. However splendid its previous achievements, the city had never before had so many great native artists on which to call simultaneously.

One aspect of the competition for the second pair of Baptistery doors in 1401 was to demonstrate (at least to the satisfaction of those involved in the judging – some

thirty-four people) that in Ghiberti and Brunelleschi Florence possessed two artists capable of carrying out the commission. It had been very different seventy years before when the city probably thought itself fortunate to find a 'foreign' sculptor as good as Andrea Pisano to execute the novel commission of the first pair of doors.

There is even something right about Vasari's error in including Donatello (then aged fourteen) among the competitors in 1401, for he was destined soon to join Ghiberti and Brunelleschi as an artistic protagonist in Florence and to challenge them successfully for pre-eminence in sculpture. By involving him in the competition, Vasari also tacitly indicates what was equally true: that sculpture was the medium which — symbolised by Donatello's sustained creativity during a career of some sixty years — became in Florence virtually a new art, with new potential to contribute to the prestige and physical embellishment of the city.

That this art proved able to create, in bronze as well as stone, life-size statues which were of unprecedented naturalism and 'humanity' was of the greatest significance — far more so in itself than in any debt that might be expressed to antiquity. Man was the subject: emerging into the light of everyday Florence from the material block of stone or mass of metal, and assuming human scale and human dignity, rather as in the Brancacci Chapel Masaccio's naked, elemental Adam, banished from the Garden of Eden, takes his first steps on the bare earth that is to be reality henceforth for him and all the rest of mankind.

It was the 'modern', accessible achievements of Florence, not its homage to the past, that gave it fresh and huge prestige. Little or no learning was required to appreciate the tremendous lifelikeness of Donatello's marble *St George*, armoured and alert, and individualised — a person before he is a saint — who would in future stand on guard outside Orsanmichele, where nearby perhaps already stood the calm majestic group of the *Four Crowned Saints* by another gifted sculptor, Nanni di Banco, and in a niche around the corner stood Ghiberti's bronze *St John the Baptist*, over life-size and the first large freestanding bronze statue to be cast in Florence.

Art history correctly distinguishes between the styles of these statues by three different sculptors, whose innate rivalry must have been increased by working for the same building and, in the case of Donatello and Nanni di Banco, on the same façade.

Florence would hardly have been Florence had each sculptor not had his partisans, but in showing the niches at Orsanmichele to some stranger in, say, 1420, a proud citizen is more likely to have stressed not the differences but the miracle of 'Florentine' art by which all these figures possessed an illusion of lifelikeness extraordinary and scarcely precedented. Any fair-minded stranger must have agreed.

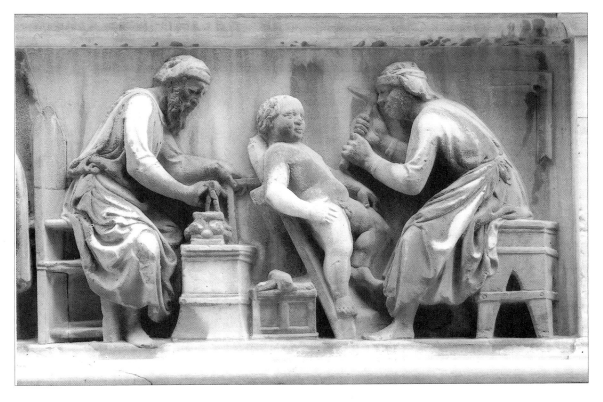

Nanni di Banco: Relief of a Sculptor at Work, *niche of the Four Crowned Saints, Orsanmichele.*

There might follow the history of why these saints had been selected and what they meant to the relevant commissioning guilds: St John, patron of the great Guild of the Calimala, as well as of the city; St George, patron of the Armourers, who conceivably provided the metal sword or lance originally held in the saint's marble hand; the *Four Crowned Saints*, traditional patrons of stonemasons in Europe and in Florence patrons of the very large guild of workers in stone and wood, whose activities are illustrated in the bas-relief below the group (and there one of the stone-workers is depicted at work on the statue of a profane-looking *putto*). And so to the citizens making up the guilds, who were revealed as responsible patrons and had such a pool of talents to call on that each of these wonderful sculptures was by a different master. Thus thoroughly human art and images led back to the human beings who created or ordered them all, reflecting and increasing the glory of Florence.

Connections and deductions of that kind, rather than debts to antiquity or nuances of stylistic difference, were probably uppermost in the minds of those who stopped to

look, pausing in a busy part of the city where, under the reassuring, protective gaze of those lifelike figures, a constant flow of living people passed by.

If at times or in certain moods such statues seemed too grand and public for all their power, Florentine sculptors, led by Donatello, could offer much smaller, more private work, as intimate in feeling as in scale, and simple in subject matter (often just of the Virgin half-length with the Child Jesus): carved reliefs and tabernacles whose figures were frequently painted or glazed to give them even more astonishing and personal lifelikeness.

At once pious and decorative, such objects easily fitted into a human, domestic context. From the ingenious invention of glazed terracotta by Luca della Robbia, Masaccio's contemporary but an artist of a very different character and far longer-lived (dying only in 1482), developed a complete category of undemanding, charming images of the Virgin and Child – gleaming white figures against enamel-blue sky, and framed by borders of glossy, realistic fruit and leaves – which eventually covered Florence, indeed Tuscany, to the detriment of the sculptor's reputation. The popularity of such work shows how well it answered a need. Luca della Robbia's own reliefs and tabernacles – above all his enchanting choir-gallery for the Duomo – reveal a skilful, serious artist, as well as a graceful one, who clearly believed in a heavenly earth or a human heaven. It is a vision cheerful rather than ecstatic, and it was shared by one great painter of the period, Fra Filippo Lippi (himself also tending now to be underrated).

At the opening of the century the overwhelming novelty in Florence lay in art and style and material, not subject matter. Images of the Virgin and the saints were not new (in the thirteenth century Folco Portinari had given a picture of the Virgin to the hospital he was founding), but the images created by, above all, Donatello were and would remain new in the sense of being unsurpassed in naturalistic-seeming vitality. The culmination of that *verismo* movement is Donatello's polychromed wooden statue of St Mary Magdalene (see Plate 11), which offends nearly all the canons, real or supposed, of classical antique sculpture but is nevertheless as typical of fifteenth-century Florentine ideals as his bronze *David* or his 'Atys-Amor'. The 'Atys-Amor' and the *Magdalen* may in one way seem poles apart, expressive respectively of exuberant paganism and perfervid Christianity, yet in each an excited, exalted, extreme emotional state is conveyed by a physical realisation of such intensity that it can disconcert the spectator at first sight. The two statues are too forceful to be overtly pleasing, and there seems some suitability in the fact that nothing is known in either case of why they were commissioned or by whom.

At the same time, there is so little strictly novel about an image of the Magdalen

repentant and emaciated that Donatello's concept has been traced back to a thirteenth-century Florentine painting (in the Accademia). And one of Brunelleschi's rare early sculptures was a painted wooden statue of the Magdalen for the church of Santo Spirito, destroyed in a fire in 1471, which may well have had some effect – not necessarily an influence – on Donatello.

Donatello subtly fuses art and nature to make his statue live and, indeed, move as well as breathe. Possibly the moment he captures is of the Magdalen advancing to receive her last communion. The terrifyingly skeletal and asexual body (which might pass for the Baptist's as much as the Magdalen's) is a frail yet animated case for a spirit which burns on and blazes out in the eloquent, fixedly gazing head and the upraised quivering hands.

All may look natural, but the statue is no waxwork. The Magdalen's hair artfully curls to emphasise the taut line of her cheeks, and the hair itself is flecked with gilt. Even in her emaciation, not least in the blue eyes huge in their hollow sockets, the saint seems to retain some hint of blonde, former beauty. And the whole statue is touched with premonitions of the stylish artifice of rococo sculpture, despite the overwhelming impression of its realism.

But that impression is the prime one, encouraging a relationship between it and the spectator which is the very opposite of sacred in any sense of holy apartness. The image is of a wretched, reduced woman who might have been found in actuality begging on a street corner in Florence, perhaps under a fourteenth-century painted tabernacle where a healthy, smiling Madonna nursed her contented Child. By stirring such associations and contrasts, Donatello's statue shocks and startles and compels anyone, learned or ignorant, sophisticated or naïve, to recognise how closely art – contemporary art -- can now mirror humanity and deepen awareness of the human condition.

In an inevitably different way, Brunelleschi's ecclesiastical interiors are also both novel and humane. Chance is responsible for the fact that the buildings' exteriors do not or cannot properly prepare the visitor for what will be encountered, but it seems more than chance that the most perfectly designed and executed of those buildings are small in scale: the Pazzi Chapel and the 'old' sacristy (more truly chapel than vestry) of San Lorenzo, where space and harmony are immediately apprehensible, virtually embracing and placing the human visitor at the centre of the scheme, under a circular dome contained within a rectangle. The clarity is at once intellectual and sensuous, a matter of perceived architectural relationships and of sheer luminosity. The pure white shapes of walls and arches are almost sculpturally defined by half-decorative mouldings in soft, carvable yet crisp-looking grey stone, Tuscan *pietra serena*, the potential of which Brunelleschi was

Filippo Brunelleschi: Interior of the Pazzi Chapel, *Santa Croce.*

probably the first to exploit. Subsequent Florentine architects made it almost a hallmark of the city.

From Santa Croce to the adjoining Pazzi Chapel is by any route physically short — a step away, in fact, through a door from the church not in use. But artistically and culturally the distance is enormous. Yet both buildings are wholly traditional religious ones, and the Pazzi Chapel is only a subsidiary family space, its founding principle no different from the chapels of the Bardi and Peruzzi — among others — within Santa Croce itself.

How poor the Pazzi must be, might have run the first thoughts of some resurrected fourteenth-century member of those great, still-flourishing families (one of the Peruzzi then actually being called Giotto) on entering Brunelleschi's chapel. There is no sense of

the illimitable, or of mystery. Walls bare of frescoes, even of simulated marble, and windows mainly without coloured glass, might suggest the building is unfinished – or conceivably not intended as a chapel at all. Even with its altar and its della Robbia roundels of the Apostles, it is indeed devoid of any sense of sectarian religious awe, though not – as one gazes up into its dome – of a sense of the eternal. Logical, light-filled, calm and yet exhilarating – almost, daringly, a space liveable-in – the Pazzi Chapel is unprepared-for, except by Brunelleschi's own earlier buildings. Certainly it is not pagan, whatever knowledge of antique architecture contributed to its creation. Yet it is something of a temple – a *tempietto*, rather – not only to God but to man.

It was in a truly Brunelleschian perspective that Masaccio united divine and mortal in a unique composition that seems resonant with all the preoccupations of the age in Florence, those of the ordinary bourgeois citizen (and even of his wife) as much as of the artist and the humanist: the Trinity fresco in Santa Maria Novella (see p. 94).

The perennial fascination of this painting lies in its several layers and levels of meaning and its fusion of traditional elements into one extraordinary, novel whole, symbolised by the great triumphal arch of classical-modern architecture which, with its perspective of a barrel-vaulted chapel beyond, sets even the triune Godhead in its framework. It is as if the painter, impelled as much as inspired by Brunelleschi, was asserting that architecture is the supreme art of all, the very model of the cosmos – anticipating Wren's remark that architecture 'aims at eternity'.

Had the fresco been designed for a place in a serene, silver-grey Brunelleschian church interior – in San Lorenzo or Santo Spirito – it would have fitted in as a perfect piece of illusionism: a logical extension of the real vista created by rounded arches, pilasters and Corinthian pillars (though those in the fresco are Ionic), leading the eye yet further on into space.

In Santa Maria Novella as it was in the mid-1420s, an interior of pointed, perhaps patterned arches, with frescoed angels and saints in niches overhead and multi-figured murals around, it must have stood out as austerely different, almost profane as architecture and speaking a new, unfamiliar language. The typical pinnacled tabernacles, painted or sculpted, that had been prevalent, aspired upwards, not inwards and in depth. Some of their beauty lay in the very insubstantiality and lack of weightiness, as if art consisted of reducing the architectural elements to a minimum. And that minimum was itself made more marvellous by being painted, inlaid and decorated.

Masaccio also creates what is in effect a tabernacle, on the grandest scale, but with a sense of weight as well as depth. Perhaps he gives it a little more colour (pinkish-red

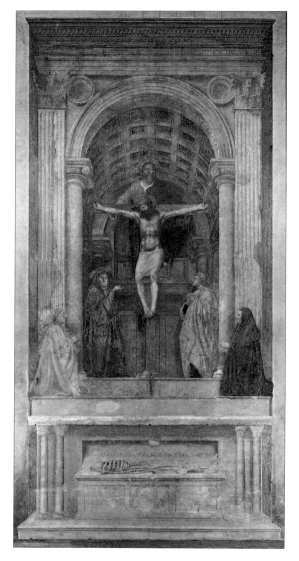

Masaccio: The Trinity, with Donors,
Santa Maria Novella.

capitals and ornaments) than Brunelleschi would have allowed in a real building of his. Yet basically the beauty lies not in surface decoration but in the harmonious interlocking of the plain, geometric shapes. They ask to be assembled in actuality, and they could be. Rather than being conceived of as attached to the wall on which it is painted, this structure appears to pierce the wall.

Its architecture announces the future course of Florentine architecture for a century or more. At the date it was being painted, San Lorenzo was being built, and discussions would soon be started with Brunelleschi about the new church of Santo Spirito. Even though Santo Spirito, in particular, was not completed according to his plans, the interiors of both churches incarnate much of what is adumbrated in the fresco.

If today the architectural idiom there no longer seems incongruous in Santa Maria Novella, that is partly because Vasari tidied up the church in the sixteenth century, and in one way or another much painted mural decoration has disappeared. The interior, too, possesses its own spacious, luminous character, despite being built in a style that Brunelleschi's century and the following one termed 'German' and deemed out-of-date.

In commissioning work from Brunelleschi, as from Masaccio, or indeed Donatello, patrons must have had to be prepared for true novelty. Thus at Santo Spirito Brunelleschi

was replacing a church built in an old, presumably 'German' manner by one in style like a Roman temple and more modern. Describing the chapel Brunelleschi added to the church of Santa Felicita, Manetti uses words which may be applied equally to the architecture depicted in Masaccio's Trinity fresco: 'of new fashion at that time, and very beautiful . . . new and rare, making marvel all those of understanding and of natural good taste'.

Perhaps a certain limitation is hinted at by those last words. Not everyone may have responded to such novelty in a church, of all places. Masaccio's fresco contains reassuring traditional elements, the familiar image of Christ crucified, a *memento mori* skeleton and large-scale donors (an earlier example of a donor being Guidalotti in the nearby Spanish Chapel), but in this combination, framework and intensely realised majestic form they all become new-minted. The painting is partly about the unavoidable fact of death, and if the skeleton – at the lowest, altar level – were not sufficient, classically styled letters spell out a medieval moral message about time's remorseless action ('I was what you are, and what I am you shall be'). But then, above and built over the tomb is the towering Christian perspective of the crucified Saviour, flanked by devotional rather than grieving figures of the Madonna and St John, and upheld by God the Father – a vision outside all temporal laws and granted for ever to a Florentine citizen and his wife who kneel before it piously yet confidently and solidly, their place assured in the scheme of salvation. Echoing the passage from St Paul's epistle to the Corinthians used in masses for the dead, Masaccio shows us a mystery, but does so in a palpably material way: 'For this corruptible must put on incorruption, and this mortal must put on immortality.'

And so, under the artist's hands, a member possibly of the Lenzi family and his wife have put on immortality. She is black-clad, nun-like, almost withdrawn from the world, but he appears in professional, scarlet, Florentine robes – very much an individual and, it might be guessed, of some note in the city. He has one of those keen, shrewd, lived-in profiles that seem to match ideally the self-portraits left in sometimes dry yet revealing diaries and letters by a class of merchants, bankers and lawyers who appear forever preoccupied in balancing their accounts between an earthly perspective and the heavenly one.

That the wife shares her husband's vision in Masaccio's composition is unusual, if not unprecedented, in Florentine art. Fifteenth-century northern pictures (such as Jan van Eyck's Ghent altarpiece) often show a bourgeois husband and wife taking complementary, equal places as themselves in a religious context. In Florence the practice was less common, and after Masaccio's couple there may well be no comparable instance

until, sixty years later, Ghirlandaio portrayed Francesco Sassetti and his wife facing each other at prayer in their family chapel at Santa Trinita.

Before Masaccio created his two donors, no painter in Florence had achieved such lifelike portrayal of people, and he lived long enough to depict not just a pair of citizens but a range of Florentine society in frescoes at Santa Maria del Carmine. Again, it seems that he was an innovator in bringing the citizens to life *en masse*, and again Ghirlandaio seems the artist most obviously indebted to him, though less well-known painters were to depict religious scenes sprinkled with contemporary portraits and, less commonly, completely contemporary populated scenes, such as the consecration of the church of Sant' Egidio by Pope Martin V, tepidly documented in paint, rather than creatively realised, by a much older painter than Masaccio, Bicci di Lorenzo.

In the Brancacci Chapel of the Carmine the context is still religious, although there the perspective has become less elevated. The scenes of St Peter's life and miracles are thronged with Florentine bystanders, many of whom remain anonymous, though tantalisingly individualised. The commissioner of the frescoes, Felice Brancacci, was among them but his portrait was later suppressed, as he was anti-Medicean. Down the vista of a thoroughly contemporary Florentine street (with a Brunelleschian-classical column in the background), St Peter walks, healing the sick by his shadow as he goes (see Plate 14). It is apt that Masaccio should illustrate that miracle, for one aspect of his revolutionary art is to depict cast shadows. Among the figures here Donatello is variously identified, sometimes as the bare-headed, barefoot man with hands clasped in prayer. If that is correct, a grain of sardonic humour may lie in the portrayal of the sculptor as shabbily or poorly dressed. Donatello and Brunelleschi seem to have enjoyed uttering mordant comments about each other and other artists, and Masaccio's portrait, assuming it is one, may unobtrusively be part of the same vein of banter.

It was in the cloister of the Carmine that Masaccio painted a fresco composition of pure genre subject, the ceremony of the consecration of the church, which had taken place as recently as 1422. The fresco was probably the first of its kind in Florence. It was wantonly destroyed in the very late sixteenth century and has to be reconstructed from drawings and the very full, very enthusiastic description of it by Vasari. Although Masaccio felt free to assemble his large cast of citizens regardless of whether they had actually been present on the day of the ceremony, he gave the whole composition a factual air and portrayed numerous recognisable, sometimes prominent people. Donatello and Brunelleschi were there, and so were the statesman Niccolò da Uzzano and the wealthy banker Giovanni de' Medici, father of Cosimo *'Pater Patriae'*. Vasari stresses how the rows

of figures were marvellously set in receding perspective; and the perspective extended socially, too, for Masaccio found a place in this great and distinguished concourse for the monastery porter, who stood there holding the keys.

The porter has not unfortunately left his account of the ceremony – or of being painted by Masaccio – but in various ways, and by various methods, Florentine people of nearly all ranks were to come into much clearer focus in the decade of Masaccio's activity.

Like so much in Florence, the recording tendencies were not strictly new. In terms of portrayal in painting, for instance, some sort of nod has to be made towards a fresco in the chapel of the Bargello, where Dante is painted, with and traditionally by Giotto. Chronicles of events were not new, as Villani and Compagni testify. The political deliberations of the city council had been written down in a series of *Consulte e Pratiche* (a cross between minutes and *Hansard*) from as early as 1382. They preserve a meeting-by-meeting, speaker-after-speaker flavour of what individuals said (if not necessarily always what they felt). For centuries, no other European community would provide such complete documentation of its political thought.

The underlying theme of Florence – its independent republican status and the welfare of its citizens – always sparked off the greatest eloquence, and that theme (perhaps under humanist influence) seems increasingly to have been put in the perspective of the classical past. References to God or, less commonly, to Christ (invoked once in a risky piece of rhetoric by a member of the prominent Bonciani family, claiming that Christ himself would have favoured holding a certain election in 1417) probably fell on fairly deaf ears. Cicero, Cato, Seneca – all heroic, republican figures – were more inspiriting and relevant. It is into such a context and perspective that Uccello's equestrian image of Sir John Hawkwood fits. No prayer for his soul disturbs his monument *all'antica*, where the associations are grandly Roman, though republican. He rides as a great Roman general, Fabius Maximus, had once been sculpted riding on the Capitol, but in a Christian cathedral. History, of course, could furnish examples to justify almost any cause or opinion. Those favouring the oligarchic status quo in Florence might – and did – gladly fish up the dictum of the ancient Spartan king Lycurgus that public affairs are best conducted by 'the few', with authority derived from the many.

An antique classical dictum, pseudo-Platonic in origin and in one form attributed to Seneca ('*Seneca morale*', as Dante had called him, placing him among the virtuous pagans in the pleasantest circle of Hell), defined 'wise counsel' as looking back from the present to the past, which offers precedents, and then considering consequences for the future.

In May 1413 a lawyer, Piero Beccanugi, enunciated this opinion (as his own) in a Florentine debate and has been given the credit of being the first person to provide a frame of reference which became almost as popular a verbal device as perspective among painters. High-flown classical historical allusions could privately be used for more amusing, deflating effect, as when the exasperated notary Lapo Mazzei wrote to his good if difficult friend Francesco Datini, the richest merchant in Prato, 'I am not bound to you as Orestes to Pylades, or Damon to Pythias . . .'

Privately, too, domestic chronicles and family memoranda, prepared for posterity, were factual ways of relating to the past which might, it was hoped, be constructive or useful for the future. It was not necessary to have played a prominent part in affairs of state, or to have great ancestors to tell of, before feeling the urge to leave an account of oneself and one's family. Indeed, it seems that most of the more prominent figures in early fifteenth-century Florentine political life tended to leave no memorials of themselves, out of either pride or prudence, feeling perhaps that their lineage was distinguished enough to require no record left by them, while their opinions and actions were a matter of civic record.

One fairly typical, prosperous Florentine merchant, Giovanni Morelli, bridging the fourteenth and fifteenth centuries in his *Ricordi*, declared that his purpose was to instruct his descendants 'by true example' and by recounting what had actually happened, recognising that not everything he put down would be of great significance. He was scornful of the tendency to claim a family background of impressive antiquity. The truth about his ancestors was that they had come — as many others must have — to the city from the countryside during the thirteenth century. They were not especially rich, yet they were honourable, and of course the family history turned out to go back quite a respectable way. The facts very much relate to money, used wisely, even at times generously. Morelli states that his father, Paolo (who died in 1374), was a great giver of alms and never refused requests from 'rich or poor'. Had he lived another ten years, Morelli somewhat ingenuously computes, he would have possessed a fortune as large as 50,000 florins (as it was, Paolo Morelli left property worth 20,000 florins).

Ghiberti's is probably the most remarkable of all the personal chronicles and accounts, not only because his is the first such record by an artist, and a leading one at that, but because he attempts to provide — in addition to rather confused artistic theory — a rudimentary history of Italian art. Unusually for a Florentine, he appreciated the painters of Siena, and he could look beyond Italy altogether in praising the work of a mysterious 'Master Gusmin', whom he describes as being a sculptor from Cologne.

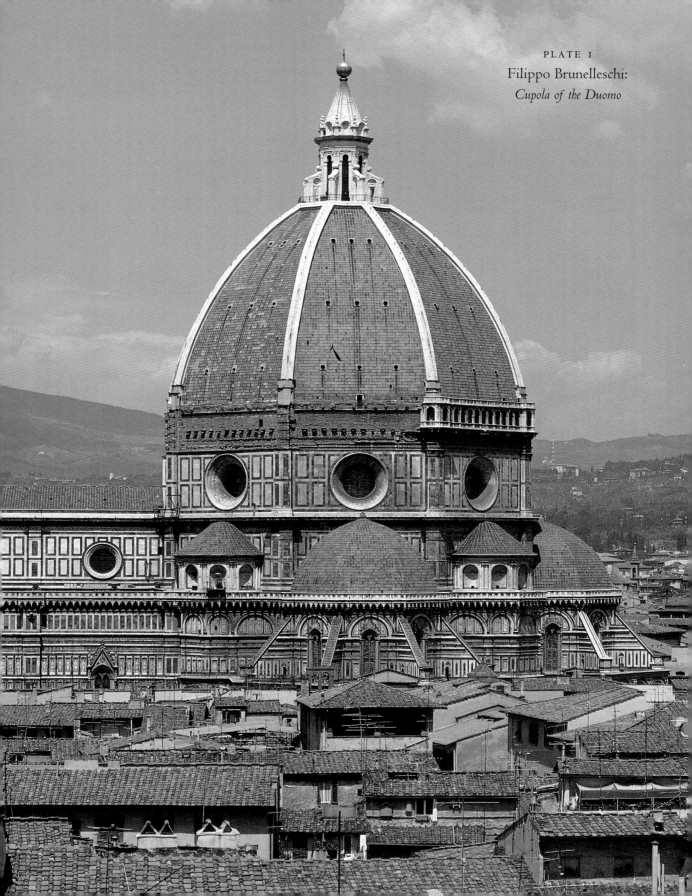

PLATE I
Filippo Brunelleschi:
Cupola of the Duomo

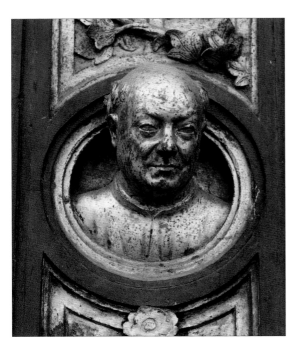

PLATE 2
Lorenzo Ghiberti: *Self-portrait, 'Paradise Doors'*
(detail), Baptistery

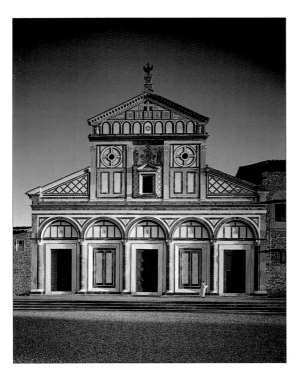

PLATE 3
San Miniato al Monte

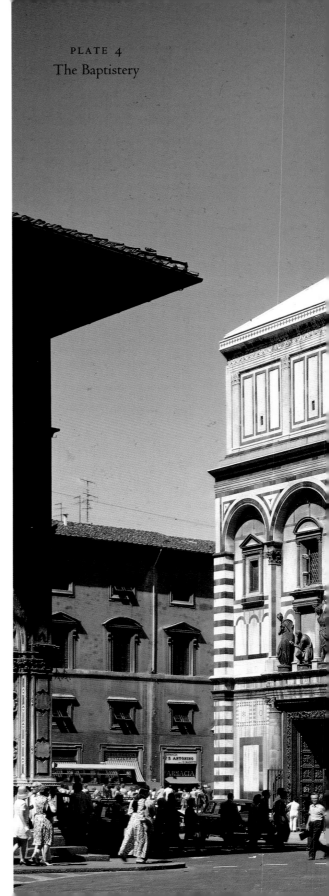

PLATE 4
The Baptistery

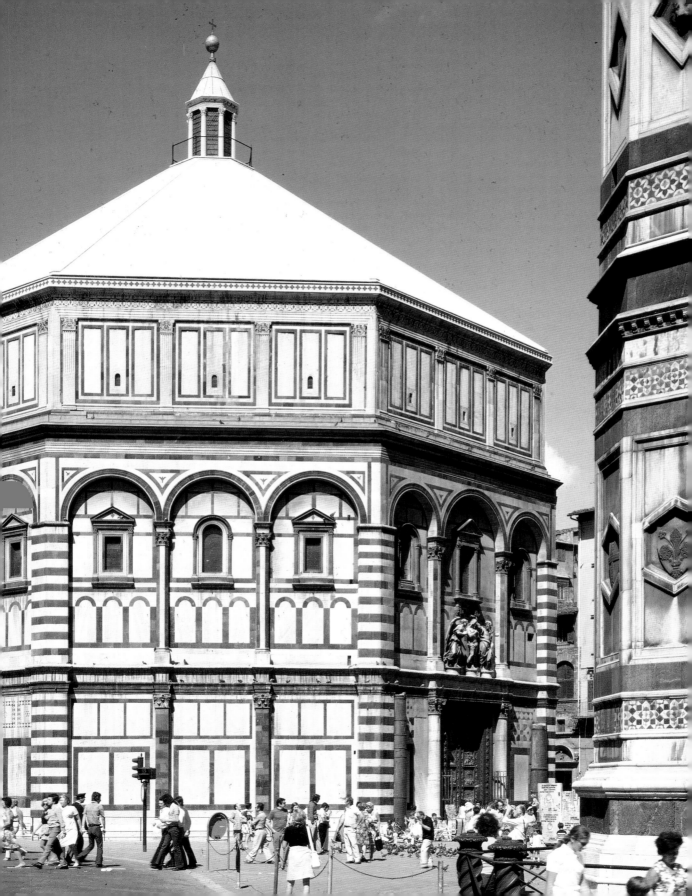

PLATE 5

View of the Ponte Santa Trinita

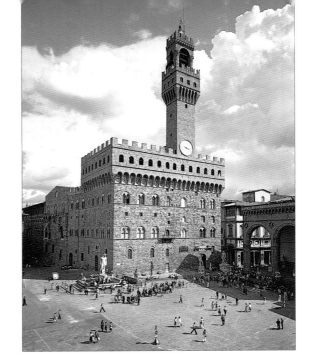

PLATE 6

The Palazzo Vecchio

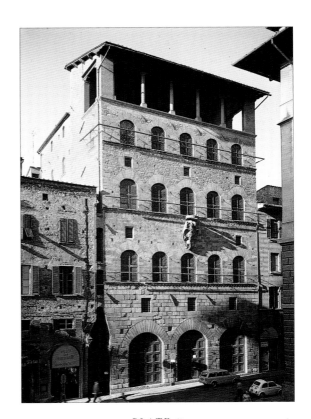

PLATE 7

The Palazzo Davanzati

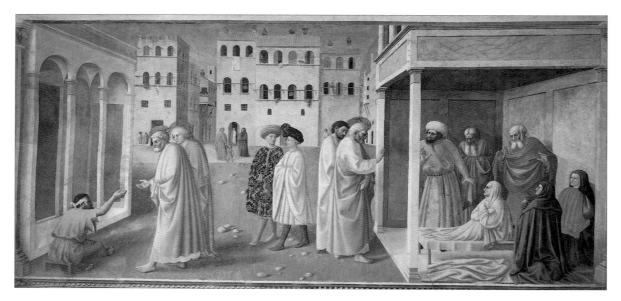

PLATE 8

Masolino: *Raising of Tabitha*, Brancacci Chapel, Santa Maria del Carmine

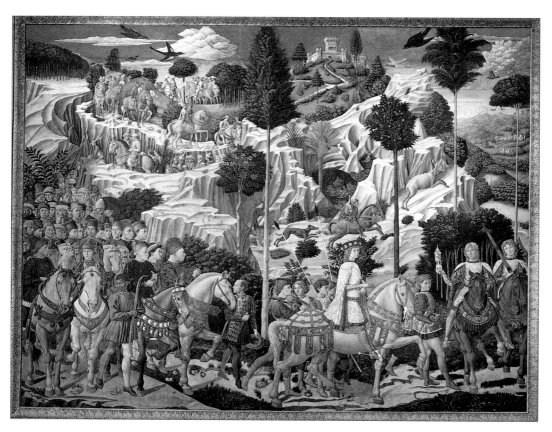

PLATE 9

Benozzo Gozzoli: *Journey of the Magi* (detail), Chapel, Palazzo Medici-Riccardi

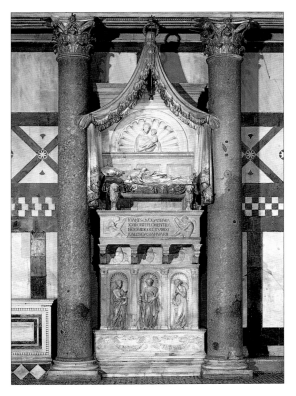

PLATE 10
Donatello and Michelozzo:
Tomb of ex-Pope John XXIII, Baptistery

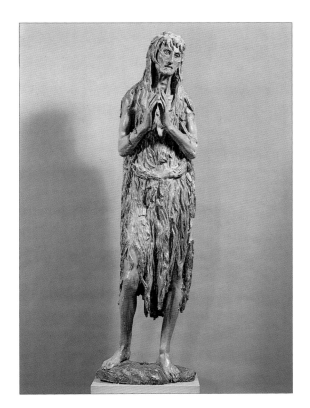

PLATE 11
Donatello: *St Mary Magdalene*,
Museo dell'Opera del Duomo

PLATE 12
Andrea dal Castagno: *Dante*, Galleria degli Uffizi

PLATE 13
Lorenzo Ghiberti: *Creation of Eve* (panel of the
'*Doors of Paradise*'), Museo dell'Opera del Duomo

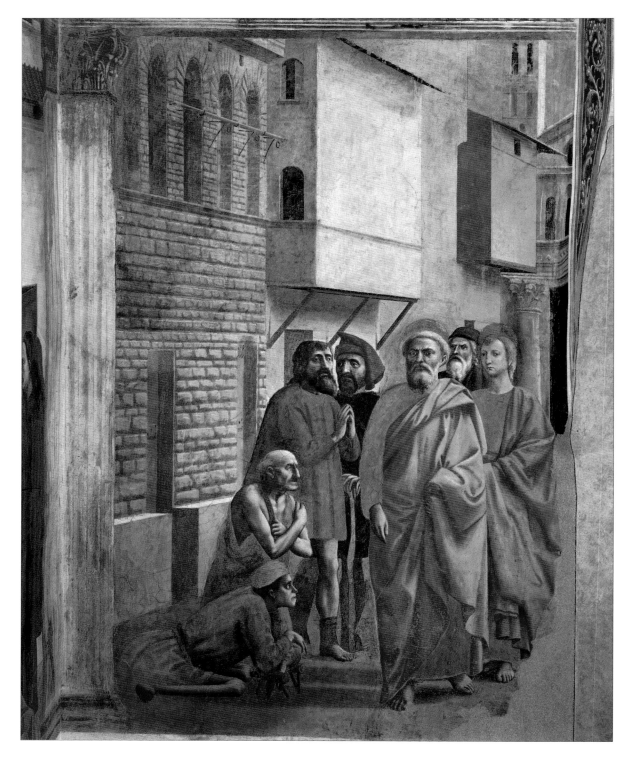

PLATE 14

Masaccio: *St Peter Healing with his Shadow*,
Brancacci Chapel, Santa Maria del Carmine

Ghiberti's account of some of his achievements deserves to be looked at along with them (in Chapter 4) but as a memorialist he must be added to the contemporary ranks of the Florentine bourgeois writers, most of whom had far less exciting life stories to tell, and told them far less boastfully. Ghiberti's account remained unrivalled until Benvenuto Cellini, another Florentine artist, more exuberant by temperament and confessionally far franker, wrote his autobiography (one quite unconcerned about theories or about art, apart from his own) — a fact which would doubtless have pleased Ghiberti.

B Y THE TIME Ghiberti was composing his *Commentaries* there had developed a sophisticated vision, perhaps best defined as stereoscopic, whereby a greater grasp of historical facts sharpened awareness of the present as much as of the past and brought them into direct relationship.

As well as the 'discovery' of antiquity there was concurrently, and not accidentally, 'discovery' of the individual. Ghiberti is the sole example of an artist attempting the stereoscopic approach, trying to put the antique past into perspective, in addition to his own life. But inverted commas may serve as a warning that those discoveries were not abrupt, overnight ones, not even in Florence, home of the Muses. They grew and developed from roots planted deep in the previous centuries of civilisation. That something happened, however, in the early decades of the fifteenth century, at least in the arts, and to a considerable degree in Florence, is clear. Brunelleschi's architecture, to take one important civic example, differs from all earlier Florentine architecture, not only the 'German' style buildings but the Romanesque ones (though those may have played their part in his ideas). Whether or not every contemporary Florentine cared for or understood his style, none can have doubted that the resulting architecture was unlike that which they had known since childhood.

The arts help to document or confirm increasing interest in the individual. Brunelleschi himself posthumously became part of the historical process: his features were preserved in a death mask, and a *Life* of him was to be written at considerable length, with vivid anecdotes, by a biographer who establishes at the outset, 'I knew and talked with him.' Nobody had bothered to leave a comparable account of Arnolfo di Cambio, or even of Giotto.

A few years after Brunelleschi's death, and well within Donatello's lifetime (he died in 1466), single bust-length portraits, painted and occasionally sculpted, began to emerge as a special category of art in Florence. (Ghiberti had led the way with portraits of him-

self on both his pairs of bronze doors, the earlier pair set up in 1424.) At first men alone were the subjects, reflecting the social values of the age, but eventually women too were 'discovered'. Some of the first male profile portraits look as if they had virtually been lifted from groups by Masaccio at the Carmine. The sitters cannot always be identified but they convey a pronounced, straightforward air of individuality.

It was not, however, art but a practical, long-debated measure which really put the individual into perspective in Florence, and in the countryside and in subject cities, with an astonishing thoroughness and unprecedented detail. The roof was raised on every household, and much revealed, in 1427, when the Council of the Commune voted – by the narrowest possible margin, one vote – to introduce a tax based on each householder submitting a precise statement of his circumstances, names and the number of 'mouths' that were his responsibility in the household, and of course of his financial position. The *catasto*, as it was called, was in mid-century to be decorated with some fine rhetorical phrases by which its ends were defined as saving and preserving 'the Florentine republic . . . its estate and . . . its liberty'. That it would fail to do, but it did provide a metaphorical wealth of information about those living in the republic – more wealth of that kind than officialdom then knew how to cope with. Indeed, not until comparatively recently was it all subjected to serious analysis.

Only one other city had established a comparably sweeping and thorough system – as Florence recognised – and that was the republic of Venice. The first proponent of the *catasto* being introduced in Florence was Rinaldo degli Albizzi, who was at the core of the oligarchic circle virtually ruling the city. Among eloquent supporters of such a tax was Machiavelli's ancestor, Francesco, whose speech acutely touched the nerve of rivalry: surely the Florentines could live and govern as well as the Venetians did. That was in a debate of 1422. Five years later the Florentines showed they could, and the fact is that theirs is the survey that has survived, whereas the surveys made in Venice have not.

To the business community of Florence, accustomed to keeping careful records of income and expenditure, loans and borrowings, and alms given, the practice of a tax return can have presented no difficulty, whatever feelings there were about the principle. For humbler people there must have been considerable problems and genuine puzzlement, and the *catasto* somewhat surprisingly required even household servants to make their own returns. Slaves did not count as 'mouths' (which is probably only too grimly true altogether), but were to be treated as part of property, along with shares, land and those animals judged 'worthy of value'.

On the face of it, it may seem strange that introduction of the *catasto* did not pre-

cipitate a revolt comparable to that by the wool-workers and others in the previous century, though this time by the privileged and wealthy. No doubt it says something for the cohesiveness of Florence that the *catasto* went ahead so calmly, and perhaps there was an advantage in its being launched – as at Venice – by a republic, rather than by a king or prince trying to raise taxes from his subjects for his own ends. A notional sense of equality hovered behind the *catasto*: each householder would pay according to his means, for the good of the state. Above all – and a factor which must have influenced the rich in their attitude of acceptance – it replaced a more haphazard system of neighbourhood assessment, which even in a community of saints would have provoked envy and back-biting. The rich might feel that at least facts would now replace wild guesswork about their worth; 'with open eyes on a certain basis', as Rinaldo degli Albizzi put it. That basis, incidentally, omitted the family domicile – a considerable and useful omission for those who lived in a large, well-furnished palace (and it is an agreeable irony that the first *catasto* offices were in the Palazzo Davanzati, hardly spartan quarters). Not that all the very rich favoured the *catasto* (Giovanni de' Medici was at best reserved about its introduction). As for the poorer-off, they might dream that between their family obligations and their lack of assets they would escape being taxed at all, which in theory was quite hard to achieve.

The 'truth' was the ambitious aim of the *catasto*. When every allowance is made for human error and, even more, for human evasion, there remains a mass of truthful documentation, extending far beyond matters of financial situation. The parent too old to work, the illegitimate or orphan child 'kept for the sake of God', the elderly married couple living alone – such are the bare statistics of different households which are revealed as living people. Their possessions, from a loom to a share in a vineyard, take shape, and around the very sums of money they owe or are owed accrues a personal, half-anecdotal air. Two shops are rented out by a prosperous citizen to a certain wine-seller; a farm he has is cultivated by someone who has borrowed 38 ½ florins from him but keeps a pair of oxen at his own risk. A merchant relates in detail a loss arising from a shipment of wool from far-away Tunis, and the debt owing to him from some leather he despatched to that city. Short and simple, by contrast, is the *catasto* declaration of a wool-carder living with his wife and two young daughters in a house not owned but rented.

When artists are involved, the location of their studios and something of the studio contents may be revealed. Masaccio, for example, lived with his mother and brother in the Via de' Servi, but his studio was elsewhere. For the tax return of 1427 Donatello's

partner, Michelozzo, supplied the information that among their other work the tomb of ex-Pope John XXIII, destined for the Baptistery, was three-quarters completed. Ghiberti listed a conveniently large number of his debts – to a tailor, a cutler, a stationer and so on – and shrewdly estimated two pieces of bronze sculpture in his shop as worth not more than about 400 florins. He ultimately received considerably more for them.

Although there is something untypical of tax-paying generally and suspiciously ingratiating about the citizen who submitted his *catasto* statement with a declaration of welcome for the new arrangements, 'since I see that you want to find out the truth . . .', his emphasis was correct. Not all the truth emerged, but much did.

Just to scrutinise one's hearth and household, count one's children and – often – guess their ages, in addition to one's own, must have been an unusual exercise, bound to sharpen the consciousness of being an individual, responsible for those particular 'mouths', living in such and such a quarter and yet inevitably distinct from one's neighbour, however physically juxtaposed. In a sense, the *catasto* compelled every Florentine householder to become a chronicler of sorts.

It would be neat if there were a comparable chronicling of the citizens in the visual arts, and as far as painting is concerned Masaccio had already provided in his destroyed *Consecration of the Carmine* fresco something of a pictorial *Who's Who* in Florence. The Brancacci chapel frescoes also include a number of contemporary individuals, and the theme of *Tribute Money* also seems remarkably prophetic in its allusion to the paying of taxes. Individual portraits, however, are sporadic and restricted at first to profiles. The full flame of verisimilitude came in three-dimensional form, perhaps first in a famous bust of a famous person, Niccolò da Uzzano.

The polychromed piece of sculpture is remarkable enough in itself, but it is not – as might be assumed – the forerunner of a series of such heads. No bust exists of Niccolò's leading contemporaries in the city, such as Rinaldo degli Albizzi and Giovanni de' Medici. Cosimo de' Medici, '*Pater Patriae*', never commissioned a bust of himself, not even from his favoured sculptor Donatello, who would have been best suited of all artists to create lifelike heads of a kind similar to that of Niccolò da Uzzano. The two men were in contact, for Niccolò was one of the executors of the deposed Pope John XXIII, who died in Florence and whose tomb in the Baptistery was commissioned from Donatello. Traditionally the bust of Niccolò is also by him, but the matter remains doubtful. The mask-like physiognomy – for all its frank, uncanny realism – is perhaps a little too close to life and insufficiently recast as art. Nevertheless, the important fact historically is that it exists. It unforgettably confronts the spectator across a gap of more than five centuries

not solely as the representative face of Florence in its final, unfettered republican years but also as the city's conscience.

The longer it is studied, the more apparent becomes the fact that this bust is more than a piece of skilful realism. From one aspect Niccolò da Uzzano's appearance is convincingly truthful and unidealised, with the very textures of his close-cropped hair and creased skin – with a wart near his mouth – reinforcing the immediacy and naturalness. Yet from another angle, as the heavy, porphyry-style drapery indicates, Niccolò da Uzzano is seen within a more timeless framework, or at least as removed from his own time, to recall ancient Rome and ancient Roman sculpture. Associations of heroism and patriotism accumulate around a likeness in no sense overtly heroic or handsome. Ultimately, he exists in a bifocal perspective: this is how he looked and that is what he stood for.

Both views are true. A wealthy banker, though not of a 'grand' or long-established family, cultivated, wise and widely respected for his integrity, Niccolò da Uzzano died before the Albizzi-Medici struggle for supremacy destroyed the republic. He never had to choose whether to accept the Medici or face banishment. A minor social disagreement between him and Cosimo de' Medici reveals two different temperaments. Cosimo de' Medici sourly disapproved of the pranks of young people at carnival time, closing roads and holding would-be entrants to ransom: in his view they were pernicious and corrupting. Niccolò da Uzzano felt they should be tolerated as a form of letting off steam. Although the writer recording this exchange calls Cosimo '*sapientissimus*', the wisdom seems to belong rather to Niccolò da Uzzano, a conservative in the best sense and attached to everything traditionally Florentine, one guesses, even the games in the street.

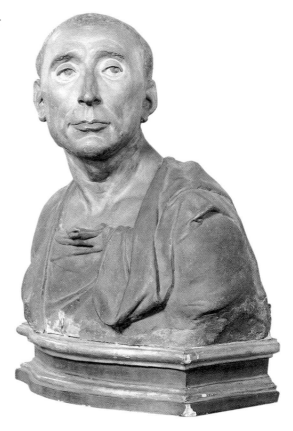

Donatello(?): Bust of Niccolò da Uzzano, *Museo nazionale del Bargello.*

That he looked like his bust can be established from other surviving images of him. And Vasari mentions a portrait of him not only in Masaccio's *Consecration* fresco but in the frescoes he commissioned of the saint's life in his local church of Santa Lucia on the Oltrarno, close to the handsome palace he had built in the Via de' Bardi (now Palazzo Capponi: one of his daughters married 'upwards' into that family).

We know other facts about Niccolò da Uzzano. His wealth was considerable. The *catasto* of 1427 records his gross assets as well in excess of 50,000 florins (the sum Giovanni Morelli mentions as within his father's grasp, had he lived another decade). His loans extended to princely despots such as the Malatesta ruler of Pesaro. He was unusually widely travelled for a Florentine, having been ambassador to numerous Italian capital cities. It is clear that he rose in Florence chiefly through his integrity and moral authority — and through his belief in the value of free debate in the city's councils.

He was — in a word — a republican. That is perhaps the keynote of the bust, in both the short and the long term. It is tempting therefore to see it as a posthumous celebration of a great man — arguably the first distinguished, truly virtuous statesman Florence had known — worthy to be ranked with the distinguished statesmen of the Roman republic. Is there possibly a suggestion that he was a modern Cicero (the highest of compliments at that date)? There is nothing to substantiate that, and only the classical drapery truly recalls antiquity. Yet this may be the first fifteenth-century portrait of a contemporary so clad. It would be not so much an irony as fitting if this bust expressed, however obliquely, the concept of Niccolò da Uzzano as *Pater Patriae*.

The perspective of the past cannot have been a matter of indifference to him. He was a collector of books, and one of the prominent cultured personages in Florence visited late in his life by the self-taught antiquarian and archaeologist Ciriaco d'Ancona. But the new passion for the past, as experienced at Florence, is personified by another Niccolò: Niccolò Niccoli, a close contemporary of Niccolò da Uzzano and the very opposite of a public, politically engaged or overtly patriotic figure. His fame was as a humanist. Ciriaco d'Ancona naturally visited him too and saw his remarkable library, as well as his collection of antique works of art. It would be of no concern to him that Niccoli ostentatiously scorned public life and immersed himself in the past, not for its relevance to the present but for its own sake. Ciriaco d'Ancona had travelled widely, even to Athens (then rarely visited). Niccoli scarcely budged from Florence. He was, or had the reputation of being, enormously erudite, a corrector of other scholars' mistakes and of such fastidiousness as a stylist that he wrote virtually nothing at all.

In Vespasiano da Bisticci's characteristically appreciative account, Niccoli appears

as a paragon of smiling, studious *vita contemplativa*, the finest flower of Florentine human-ism. His was a merchant family but Niccoli took little interest in business and was later to be generously supported financially by Cosimo de' Medici and Cosimo's younger brother Lorenzo (a figure obscured in history through his premature death). He was one of the first people in the city to learn Greek, benefiting from the presence there at the end of the fourteenth century of Manuel Chrysoloras, a native Greek scholar teaching at the university Florence had eventually founded in 1321. He was an avid collector of books (that is, manuscripts) and a great connoisseur (favouring among artists Brunelleschi, Donatello, Luca della Robbia and Ghiberti). Everyone of note who came to Florence had to visit him. He dressed elegantly and was most particular about his meals and how they were served. Throughout his life he was an exemplary Christian.

A lifelike, detailed, attractive portrait emerges from Vespasiano's pages – one with a good deal of factual truth. And it beautifully crystallises all the floating associations fostered, especially by the nineteenth century, about Florence as the shrine of Renaissance culture. Niccoli becomes virtually its high priest, as he moves gravely among his books and antiquities, unties a knotty problem of scholarship, welcomes consultation by Brunelleschi or Donatello, summons his housekeeper (he was unmarried) to arrange a gourmet meal with the best linen (all was of the whitest, Vespasiano records) and finally expires after reverently taking holy communion. Past and present smoothly fuse: the old devotee of everything pagan and antique is glimpsed in his last illness placed on a carpet, with half-tearful people kneeling around him, to receive the sacred body of Christ, before dying 'like a holy man'.

In this gentle, alluring light, the portrait is without a single wart. Indeed, the word seems as rude in the context as a belch during a memorial service. Yet the fact is that for several contemporaries of Niccoli, who had died when Vespasiano was in his teens, there were numerous flaws in his character. On their evidence, he was cantankerous, snobbish, ludicrously self-important, irregular in religious observation, shaky as a classical linguist and absurd when pronouncing on architecture.

Between these extremes the real Niccoli has to be reconstructed, in so far as that is possible. Perhaps no conclusive verdict can now be reached on a complex, elusive per-sonality to whom there certainly were disagreeable aspects which the impressionable Vespasiano passed over or never realised.

Partly maybe because of his failings, Niccoli is one of the first non-creative Florentines to emerge with a distinct, idiosyncratic and highly developed personality. In his fussy, crusty, bachelor ways, as in his compulsion to be visited and consulted, he

sometimes sounds like a Renaissance anticipation of a much later personality, the English banker-*littérateur*-connoisseur and collector, Samuel Rogers. The notes Byron made about visiting Rogers seem as though they could have aptly applied to visiting Niccoli: 'If you enter his house – his drawing-room – his library – you of yourself say, this is not the dwelling of a common mind. There is not a gem, a coin, a book thrown aside on his chimney-piece, his sofa, his table, that does not bespeak an almost fastidious elegance in the possessor. But this very delicacy must be the misery of his existence. Oh the jarrings his disposition must have encountered through life.'

Niccoli's attitude to politics was not merely the shrinking of a scholar from practical affairs. In quarrelling with him, his fellow-humanist and friend Leonardo Bruni called him 'a useless citizen', but Niccoli seems to have genuinely believed that the governing oligarchy had subverted the state, and that the wars it instigated were self-interested. It was a view shared by others, but only he dared to say as much. Bruni, by contrast, comes over as ever-eloquent but far more cautious: the high official adapting himself, his opinions and his flow of words to the occasion, in proto-civil service manner.

There was a third Niccolò of distinction living in Florence in the 1430s, Niccolò da Tolentino, a *condottiere* who became the republic's commander-in-chief and who is now probably best remembered for his appearance in Uccello's *Battle of San Romano* (in the National Gallery, London). As chancellor, Bruni made a speech when delivering the baton to him as head of the forces, declaring that no services were greater to a city than those of a military man. The philosopher yields to the captain: 'Plato is not to be compared with Alexander . . .' Niccolò Niccoli's opinions would probably have been the reverse, but then Bruni was orating as a public mouthpiece, with a soldier as his subject.

When every pretension has been stripped from Niccolò Niccoli, he still continues to symbolise the comparatively new perspective which could be provided by the antique past. To collect its works of art as fervently as he did was itself new, and no pastime but an obsession. His vision was monocular in its concentration on antiquity, and perhaps even slightly mad. One almost expects to read that he dressed in a toga to receive guests, or grew a beard, like the more fervent neo-classic followers of Jacques-Louis David centuries later in Paris.

Yet the act of recovering the past was no folly but a necessary step in civilised awareness. In Italy, antiquity had never fully receded, for some relics of Roman times remained to be wondered over before they became subjects of learned scrutiny. Rediscovery there had its constant physical actuality, and behind Rome there began to be discerned in the fifteenth century the further perspective of Greece. It is almost too neat that a Greek, the

scholar Chrysoloras from Constantinople, should have composed a widely circulated, highly charged description of the triumphal arches in Rome. Writing from there around 1411, he praised the variety and skill displayed in the reliefs, rivalling 'Nature herself'. And he exalts the visual art displayed in them over historical writers such as Herodotus: real people are to be seen laughing, weeping, excited or angry. To Donatello, at least, it cannot have come as news that sculpture can achieve effects more emotionally direct and 'realistic' than can literature.

Florence was not, of course, the only city or centre in Italy to experience vibrations from the classical past. In terms of distinction its earliest humanist scholars should probably be assessed as below the first rank and the first-rate. But, largely bolstered by its creative visual artists, and aided by its own powerful myth-making proclivities, Florence has assumed a shining place in everyone's consciousness, while humanism as practised at, say, Padua or Verona seems doomed to be relegated to minority interest.

THE GIANT IMAGINATIVE step which inspired so much humanist activity had been taken in the fourteenth century by Petrarch, a central figure for Europe, for Italy, but especially for Florence, as poet and scholar and the first international man-of-letters (providing the mould for Erasmus, Voltaire and Goethe, yet never for a British writer). In addressing letters to some great figures of Roman antiquity, Petrarch (whose own discovery had been the letters of Cicero) brought them into perspective as personages no longer of myth or magic but of history. They had once existed and thought and composed and despatched letters.

In Florence Petrarch became a cult. Added to Dante and Boccaccio, with probably much greater prestige in humanist eyes, he made up a trinity of deified local literary genius. The tradition has continued, blurring the inconvenient reality about Petrarch's tenuous links with the 'cloth-making city' which he seldom visited and for which he obviously had little feeling. The 'bagging' of him by Florence is a cool piece of cultural appropriation, only slightly more justified than would be the claim on Velázquez by Portugal, or on Mozart by Augsburg.

Petrarch's parents were Florentine, but his father had been banished by the 'Black' Guelphs, and the poet was born at Arezzo (before it became a Florentine possession). Living first in France, then in North Italy, visiting Rome, enjoying a stay of some years in Venice, which he greatly admired, Petrarch moved largely as a free spirit in an aura of fame and prestige, not so much seeking patronage as being sought out by anxious, princely

patrons. Dante had vainly aspired to be crowned poet laureate – in the Baptistery of his own city, 'mio bel San Giovanni'. Petrarch thought similarly of being crowned. In his case, Paris and Rome competed for the honour, and Petrarch decided in favour of Rome. It was an emperor who crowned him on the Capitoline Hill.

Only posthumously could Florence make its successful bid to a share in Petrarch's lustre (during his lifetime he had twice declined a professorship at the university, offered through Boccaccio). He was too valuable to forego, and his peripatetic existence, closing in solitude in the north Italian village of Arquà, left no city with a rival claim. Petrarch had addressed posterity, in addition to the past, and it is a pity he never prepared a letter for the city of Florence, refusing to be thrust into its diadem as one more jewel.

By 1400 Petrarch had become part of history. Only a few people living in Florence had or could have known him, and even he was not exempt – in some humanist eyes – from failings. Niccoli was possibly one of those who deprecated him as a poet, however respected he might be as a classical scholar – simply because he was modern and had written at times in the vernacular (and written love poems, too). It was conceivable to feel learnedly superior to him, since Petrarch had never mastered Greek. His interest in the visual arts might have been judged irrelevant, though it would be to his credit that he had owned and highly valued a painting by Giotto; less palatable in Florentine circles would have been his fond, friendly admiration for a great Sienese painter, Simone Martini, who had portrayed Laura for him and been celebrated by two of the poet's sonnets.

Contemporary art of any kind is unlikely to have attracted Niccoli. Antiquarian concerns were probably what united him to Brunelleschi, Donatello and Ghiberti, and those concerns take on wonderful immediacy in an anecdote related about Niccoli by Vespasiano, a small incident which has larger inferences and repercussions. All the sudden, exciting sense of 'discovery' which could then be made, simply by chance, in a street in Florence is conveyed by the story of how when Niccoli was leaving his house one day he noticed a boy wearing around his neck an unusual ornament, perhaps as a charm. Admirably sharp-sighted, Niccoli appears to have realised at once that it was an antique gem. He took the boy's father's name, and for five florins acquired a Roman chalcedony intaglio based on a Greek original, engraved with the figure of a seated, naked man.

To the element of discovery, and the thrill of possession, needs to be added the easy portability of objects of that kind. Gems and coins could pass without difficulty from hand to hand, and from owner to owner, in a way not feasible with sarcophagi and more monumental works of art. That aspect of collection and dissemination of antique objects was then perhaps the most pervasive of all, and certainly the most personal. There

were as yet no books of engravings to consult. To view and experience this fragment of antiquity required a visit to Niccoli, who probably took a collector's delight in telling of his find, before permitting sight of the gem.

Men like Ciriaco d'Ancona travelled to distant places to encounter antiquity. Niccoli had met it on his doorstep. One of the privileged people to whom he showed his find was Ghiberti, who in effect takes up the story in his *Commentaries*. Ghiberti himself collected some antiquities, but what he records is – most movingly – the pure, unenvious sensation of the Renaissance artist who has handled and held up to the light an intact, precious relic from that far-off past which takes on clarity and reality at the moment of contact. Ghiberti could only write wonderingly of the gem as 'the most perfect thing I ever saw'. Very likely he is the first artist to document such an aesthetic encounter, and there is no comparable incident until Dürer noted down something of his sensations when at Brussels in 1520 he gazed at the treasures brought from Mexico and marvelled at the 'subtle *ingenia*' of men in foreign lands.

Like a talisman, the gem which Niccoli owned and Ghiberti admired was to travel and to exercise its spell over great artists. It entered the collection of a future pope before returning to Florence in the collection of Lorenzo de' Medici, 'the Magnificent'. It was duplicated on a large scale in one of the Donatello-style roundels to be seen in the court-yard of the Medici Palace. Its influence has been traced in compositions by both Michelangelo and Leonardo da Vinci, and it was also used for an illustration in an illu-minated manuscript of Cicero's *Speeches*. Niccoli's chance find thus reverberates on, long after his death. He was not as useless a citizen as Bruni assumed.

Niccoli died in 1437, only a few years after Niccolò da Uzzano. Supported finan-cially by the Medici brothers Cosimo and Lorenzo, and to Cosimo (twenty-five years his junior) something of a humanist guru-figure, Niccoli is unlikely to have felt hostile to Cosimo's emergence as the dominant politician in Florence at the end of his life. If he bothered to consider the perspective of that life, he may rather have been inclined to feel a certain Socratic serenity, for he had grown up in fairly troubled and largely unenlight-ened times, when very few people in the city shared his antiquarian obsessions and nobody – it would seem – bothered to collect antiquities. His adulthood had coincided with an explosion of artistic genius, after a rather tepid period towards the end of the fourteenth century. Whether he cared to be or not, he was a witness to much positive modern achievement in the arts, in addition to being profoundly involved in pursuit and preservation of the past.

If we are to believe Vespasiano da Bisticci, Niccoli's proselytising sometimes

occurred on seeing a stranger in the street. Thus, in his role 'as Socrates combined with Cato' (as Vespasiano puts it), he publicly accosted the young and good-looking but pleasure-loving Piero de' Pazzi and urged him to reform and take up the study of Latin, which he did. Even if in reality this conversion was less sudden and dramatic than in Vespasiano's narration, it points to an ethos different from that of Niccoli's own youth. Then, an encounter in the street might have led to a brawl rather than a discussion about the advantages of learning ancient languages. Piero de' Pazzi became typical of a new generation of Florentines (his merchant father had disapproved of a classical education), prominent in public affairs and also cultivated and erudite, not afraid to spend money on books and manuscripts, and leaving at death one more fine library.

Since Niccoli's youth, a good deal had also changed in the artistic situation and the actual appearance of Florence. Painting was very probably the art that interested him least (no painter is mentioned among his artistic acquaintance, and painting's links with antiquity tended to be less obvious than those of sculpture and architecture), but by the mid-1430s leading practitioners of painting in the city included Uccello and Fra Angelico, as well as Fra Filippo Lippi. The Brancacci Chapel frescoes, too, remained simmering on the scene, a potent example of modern art which most painters are likely to have gone to look at, whether or not directly influenced by what they saw.

Both Uccello and Fra Angelico were – in their different ways – thoroughly up-to-date artists. Uccello's absorption in the new science of perspective is commemorated by one of Vasari's most vivid anecdotes, about how he would stay up all night studying it while his wife vainly called him to come to bed. Cloistered though he was, Fra Angelico was equally aware of the novel coherence and realism that perspective could bring to a painting, and was able to assimilate its lessons into his own art more smoothly than Uccello.

Niccoli the devout Christian could have seen and been satisfied by Fra Angelico's semi-public tabernacle (of 1433), painted for the Linen-weavers' guild. When the altar-piece is opened, the central image of the Virgin and Child is revealed as charming, pious, reassuring – almost old-fashioned – in its unforceful, linear modelling. But the three small predella scenes below are like echoes in miniature of the Brancacci Chapel frescoes – caught and re-phrased in Fra Angelico's own original accent of pure, unsurpassed candour. In a semi-Florentine city made up of satisfyingly solid, sharp-angled buildings, St Peter is shown preaching to an assembly of solid, varied shapes, male and female, who not only appear genetically Florentine but include individual portrait physiognomies.

Niccoli the devout antiquarian could just have seen, and certainly should have been

satisfied by, Uccello's equestrian image of Sir John Hawkwood in the Duomo: a fully public expression of modern perspectival achievement, yet redolent also of classical antique associations. Indeed, in an ideal world of Florentine humanism and culture, Niccoli ought to have been called in to advise Uccello on his fresco.

The Linen-weavers' tabernacle and *Sir John Hawkwood* are significant stages in the careers of the two painters, in addition to being great works of art. Although Fra Angelico never had the opportunity in Florence to paint a fresco-scheme of the perfection of his chapel in the Vatican for Pope Nicholas V, he faithfully served the Dominican order, and by extension the city, in frescoing the cells of the convent of San Marco. Together with the other paintings he provided for Florentine churches, they anticipate — though in no savage or austere spirit — the vision of a later Dominican friar, Fra Girolamo Savonarola, whereby Florence becomes the kingdom of Christ.

The historical, martial emphasis of *Sir John Hawkwood* suggests less spiritual values. Perhaps it needed a princely style of patronage — Medici patronage — to commemorate, in a wholly secular context, another commander of Florentine forces, Niccolò da Tolentino, who had won a battle of sorts against the Sienese at San Romano in 1432. Some twenty years later Uccello received the commission, probably from Cosimo de' Medici, '*Pater Patriae*', for the three large panels depicting the battle of San Romano which are now divided between Florence, Paris and London. That commission was virtually a state one, though the pictures were to decorate a private palace. The republic might have considered — but did not — ordering such work for the Palazzo della Signoria. Thus it was an individual who initiated in the city a new sort of picture, of a kind fairly new in Europe altogether: the portrayal of a recent historical event, heroic and dignified by patriotic associations. Perhaps there are also some antique associations in Uccello's trio of pictures, for Niccolò da Tolentino on his chalk-white charger may be meant to recall Alexander the Great at the Battle of Issus ('Plato', as Bruni had pronounced in reference to Niccolò da Tolentino, 'is not to be compared with Alexander').

Paintings of specific antique subjects had begun to appear in Florence within Niccoli's lifetime, though seldom if ever treated in an elevated, 'antique' manner. They were a developing aspect of prosperous domestic existence, one more visually agreeable than previously, and conceivably more comfortable too, for they were incorporated into the decoration of chests and beds. Portable 'birth plates', presented to mothers in child-bed, were a comparable form, decorated with perhaps a light-hearted Cupid or a scene of Paris awarding the golden apple to Venus. Delightfully 'incorrect' in costume, elegant and graceful and mildly erotic, these fairy-tale versions of the antique world would prob-

ably have seemed to Niccoli trivial and irrelevant. Yet in that secular genre Florence led the way in Italy — ahead of Venice in the fifteenth century — and the climate was prepared for the far greater and far more serious mythologies to be created by Botticelli.

Florentine social attitudes were growing less self-consciously restrictive and severely moralistic. The profane pleasures of putting on and witnessing a pageant-show for a pope or other very grand visitors seem to have become admissible, and public jousts and feasts could be quite ostentatious. Niccoli's young convert, Piero de' Pazzi, lived to astonish Florence when he left in 1461 as ambassador to the newly-acceded king of France, Louis XI, in a blaze of jewels and fine clothes, with a retinue of mounted attendants; and he returned in even greater state. According to Vespasiano da Bisticci, the *Signoria* actually asked Piero to ride through the city on his departure for France, so that 'the people' could see the sumptuous character of his train. Sadly, though doubtless as elderly, harder-headed, tighter-fisted men had anticipated, this lavish expenditure came close to ruining him.

It was for the adult Niccoli's Florence that Donatello had received a rare public commission of a profane kind — one with its own antique Roman associations, and again one on which Niccoli might gladly have advised. The republican city was very sparing in erecting outdoor monuments (and perhaps scarcely thought of sculpture in that way before the fifteenth century). It was a considerable innovation when the ancient column was brought to the Mercato Vecchio in 1430 and set up to serve as the pedestal for a statue carved by Donatello, representing *Abundance*.

In its unassertive fashion, this addition to the city was one of the most significant of the period. It fitted in so well at a corner of the market-place that it might have always stood there since classical times. Presiding like a beneficent deity over the essential activities around and below, *Abundance* was not so much a work of art as a guarantee in stone of the peace and prosperity of Florence. It might look merely fanciful and allegorical, but as the opposite of famine, itself real enough, the figure must have originally possessed almost sacred importance. Today, after various vicissitudes, a copy of the eighteenth-century *Abundance*, carved by Foggini to replace Donatello's figure, stands on the isolated, little-regarded column in the huge Piazza della Repubblica, presiding over nothing in particular except parked motor-cycles and an abundance of café tables.

A quite daring 'Roman thought', at a time of comparative prosperity, had struck the Commune and led to its self-confident commissioning of a resolutely non-Christian statue. Florence itself, 'flower of Tuscany', was perhaps symbolised in the female figure of *Abundance*, shown balancing a basket of produce on her head and holding a cornucopia.

No comparable column was set up elsewhere in Italy. At Venice the ubiquitous government image sculpted was of Justice, publicly stamped on the exterior of the Doges' Palace and made a Venetian speciality. At Florence, in the most democratic of public spaces, the market-place, where everybody sooner or later met, the chosen image was of a more basic, literally earthy kind, and one that also united city and surrounding countryside.

It was, too, an image to which anyone could relate, for it represented, after all, only an artistic refinement on the reality at its foot of the women and girls with their baskets of flowers and fruit, whom Antonio Pucci had celebrated in his verses in the previous century. Yet it had its learned aspect. By tradition, a statue of a genius had supposedly stood in the market-place in Roman Florence. And, more positively, Donatello's statue was derived from Roman images of plenty and felicity, to be found expressed in a government context on Roman imperial coins. Coins of that kind may well have been in Niccoli's collection, and Vespasiano definitely refers to the number of 'medals' that he owned.

Niccoli had known the two sculptors and the architect who had done most to enrich and effectively 'modernise' Florence in his lifetime. Nothing could be more dramatically changed than the state of the Duomo, whose nave was being built as he grew up — indeed, virtually grew with him, shedding old-fashioned concepts as it did so (in the clerestory, for example, round windows — *oculi* — took the place of the pointed ones of the original design). He lived to see the achievement of Brunelleschi's dome, 'ample to cover with its shadow all the Tuscan people', in Alberti's splendid phrase.

A Brunelleschian 'take-over' of Florence never came to fruition, and the ideal city he certainly could have devised has to be read about and guessed about and discerned amid often distracting actuality. Within the present-day city, Brunelleschi's dome is an effective, haunting silhouette chiefly from the north side, from territory broadly his: along the Via dei Servi that runs from the Piazza del Duomo to the Piazza Santissima Annunziata, where the Ospedale degli Innocenti first declared his idiom and ability. Just off that axis lies what remains of his unfinished octagonal chapel of Santa Maria degli Angeli. And although the Piazza Santissima Annunziata developed only after his death, the new church of the Annunziata (by Michelozzo) continued, even partly copied, Brunelleschi's ideas.

On the other side of the Arno, in the area around the church of Santo Spirito (where, by his will of 1437, Niccoli asked to be buried), Brunelleschi's plans promised to be yet more novel and bold — too bold, unfortunately, for his local patrons. When he was approached about a new church of Santo Spirito (the church that exists, with an interior

beautiful enough, although not entirely as he had intended it) he proposed not just a radically new building but a radical opening-up of a crowded, jumbled quarter of the city. As one threads one's way through the narrow streets which surround Santo Spirito, and help to isolate if not hide it (or would, were there no official direction-signs), and where there is more native bustling informality than grandeur or tourists, Brunelleschi's scheme still seems radical and arguably un-Florentine.

His proposal was that the church should be completely reorientated, with its façade turned towards the Arno. In front of it would extend a piazza reaching to the river bank, and from the river the new church would be proudly visible. His thinking was obviously less about a single building than about a section of the city – itself a novel approach to planning, as much 'baroque' as 'Renaissance' in its concern for scenographic effect. Above all, space – that valuable but rare commodity in Florence – would have been imposed, along with order, clarity and a sense of perspective, in place of the haphazard, cosy or mildly claustrophobic huddle of buildings which had grown up unsystematically and of which the church was part. It may be little exaggeration to say that Brunelleschi aimed to develop in reality, on the ground, and with Santo Spirito as the focal point, the vision which he had already expressed in miniature and in paint in the perspective panels of the Piazza del Duomo and the Piazza della Signoria.

That such an ambitious scheme was never to be implemented could almost be guessed. Brunelleschi's first biographer states that it did not please the '*potenti*'. And not merely powerful people in the neighbourhood must have realised that whole houses, and possibly streets as well, would have to be destroyed to make it an effective reality. The church authorities are bound to have thought primarily of their new church, not the promised new piazza. And even had Brunelleschi's scheme gone ahead, the failure to provide Santo Spirito with an impressive or indeed adequate façade would – unless corrected – have flawed the intended *coup d'œil*.

Niccolò Niccoli's opinion on the matter will probably always remain unknown. The old church of Santo Spirito survived for him to be buried in, and discussions about the new building went on long after his death. But architecture was an art that did interest him, as hostile testimony from a distinguished non-Florentine humanist, Guarino da Verona, usefully records. Niccoli *thinks* he understands the rules of ancient architecture, but as he gesticulates and expounds he makes himself everywhere a laughing-stock: such is Guarino's savage, prejudiced summing-up. At least Niccoli shows an interest, we may feel, and if he had opinions on contemporary architectural ideals, he is unlikely to have kept them from Brunelleschi, especially when they might affect the

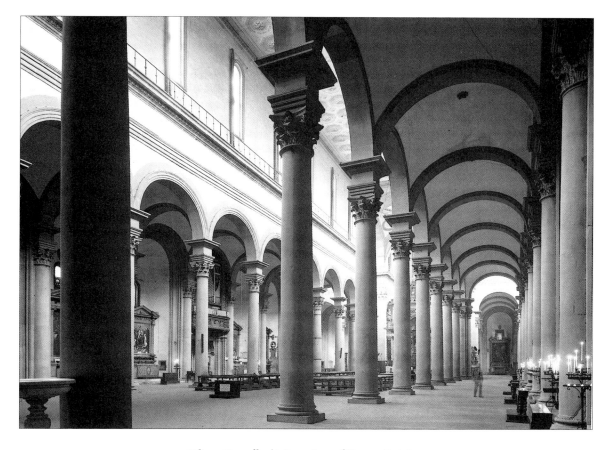

Filippo Brunelleschi: Interior of Santo Spirito.

future of Santo Spirito. For him a Roman temple of a church would have made the ideal burial spot.

Brunelleschi's Santo Spirito scheme is a might-have-been, one regretted yet barely missed perhaps amid the plethora of artistic monuments — the frescoes, statues and buildings — that were created in Florence in the first three or four decades of the fifteenth century and which make sufficient demand on everyone's imagination and on every visitor's stamina. It is as though the competition for the Baptistery doors, launched by the Guild of the Calimala at the beginning of the century, had set competing, in some way or other, every young artist in the city. The works that resulted came into existence only through the exercise of patronage, corporate or individual, but nothing should obscure the fact that the style of what was created, and the art of those works themselves, came from their creators.

Public Competition among the Artists

TWO SMALL, SIMILARLY shaped, highly finished bronze reliefs, exhibited close to each other, are likely to catch the eye of even the least interested or most jaded visitor to the museum that the Palace of the Bargello has become — if only because both reliefs depict the same subject, Abraham's sacrifice of his son Isaac.

It is rather extraordinary that these two objects survive at all and that they should have ended up virtually side by side, as though permanently competing for attention and comparison, and for adjudication.

They are the trial panels submitted by Ghiberti and Brunelleschi for the competition to choose the artists who should execute a second pair of bronze doors for the Baptistery (see p. 123). The idea of holding such a competition was novel, especially as — according to Ghiberti's account — this one was thrown open to all Italy and attracted 'very many skilled masters' from everywhere. '*Combattimento*', as well as competition, is his way of describing the event many years afterwards, and battle continues to be evoked when he goes on to speak of the award — to him, of course — of the 'palm of victory'.

The innovation of an artistic competition — one famously successful, since it produced the masterpiece of Ghiberti's first pair of doors and led directly on to his yet more esteemed second pair — probably prompted other, later competitions in Florence, such as that for the cathedral façade in 1480. It exploited latent or open rivalry between artists, in a quite hard-headed yet ostensibly democratic, 'Florentine' manner. If subsequent artistic competitions proved abortive (as did that of 1480), a sense of competing could still have its stimulating, creative effect, while the public nature of the exercise indicated that these matters held an important place in civic life. Since everyone would see the doors finally executed for the Baptistery, everyone — in theory and by delegation — should have a voice in selecting the best master for the task.

Among the things created particularly by artistic and architectural competitions, now as then, is resentment; and it is hardly possible to look at the trial reliefs by Ghiberti

and Brunelleschi without catching an echo of the buzz of controversy which must have hummed through Florence when each artist finally threw down the gauntlet fashioned out of the quantity of bronze allotted to him by the *Operai*, the committee of the Calimala in charge of the competition. As Ghiberti triumphed, his account of the judging is both sweeping and gleeful: so obviously was he the winner that the matter ceases to be controversial. But – an important but – there is also Antonio Manetti's account, incorporating opinion or feelings on behalf of the other competitor, itself a remarkable, fascinating fact. According to Manetti, the judges eventually decided that both trial pieces were '*bellissimi*', that there was nothing to choose between them and that the two artists should be partners ('*compagni*') in the commission. Brunelleschi stubbornly refused to collaborate, and thus the task went to Ghiberti. That it had not gone to Brunelleschi alone in the first place displeased his partisans. As a result, public opinion in the city was completely divided, and remained so. That at least is entirely credible.

Just as it is worth looking at the two reliefs in some detail, so it is worth looking equally at the two written depositions (as they might be called) submitted – with a view to posterity – in connection with them. The exact truth of the affair remains one of the mysteries of history, and it is a pity that no disinterested citizen-chronicler of the day left his account of what did or did not happen. Yet how Ghiberti won the commission which would result in some of the most celebrated works of art ever created, even in Florence, is a story that deserves to be scrutinised and, as far as possible, reconstructed.

Ghiberti is a witness knowledgeable, precise and speaking with the authority of personal involvement. Manetti was not born until 1423. He had to rely on hearsay, and as a witness he is highly emotional, not merely supportive of Brunelleschi's actions but strongly, positively slanderously critical of Ghiberti's. Nevertheless, he raises complications and makes some assertions concerning matters about which Ghiberti is silent, and these are not necessarily inaccurate.

Taking the two accounts together, amending or discarding here, hypothesising there, it is possible to discern the shape of what may have been the true sequence of events. The initial and undoubted facts are that both Ghiberti and Brunelleschi were unknown and very young in 1401 (twenty-three and twenty-four, respectively) and that neither had the experience requisite to undertake the challenging commission of the Baptistery doors. In short-listing them, the *Operai* representing the Calimala had shown admirable boldness, or perhaps patriotic bias. There is something almost parable-like in the assignment to each artist not of some talents of gold or silver but of so many pounds of bronze, with which they were sent away to realise a year later as the reliefs which now

survive in the Bargello. It could not have been anticipated that each — in its own personal style — would be a masterpiece, thus increasing rather than diminishing the difficulty of adjudication.

That it somehow came down to a contest between Ghiberti and Brunelleschi seems likely enough, although Ghiberti carefully records the names of five other competitors, as well as referring to the numerous gifted masters who arrived for the competition from all over Italy. He himself arrived back in Florence specifically because of it, as he makes clear in his *Commentaries*, adding a touch of drama to the tale of his triumph. Once again, the vividness of an artist of the period speaking in such detail of his early life has its impact in human terms, regardless of art or exact fact. Ghiberti relives it all, in words. It is an exciting and possibly unrivalled start of a career for any young artist, and no wonder it glowed in Ghiberti's memory.

'In the time of my youth', he begins, like many a traditional story-teller, in effect hushing an expectant circle of listeners:

> in the year of Christ 1400, I left Florence, because of the foulness of the air and because of the parlous condition of the state, in the company of a respected painter. He had been summoned by the Malatesta lord of Pesaro, who had had a room built, which was painted by us with the greatest diligence. My mind was largely turned to painting, the reason being the work promised us by the ruler and also my companion's constant indication to me of the honour and profit we would acquire.

A chapter otherwise unknown in Ghiberti's life starts to unfold, unfortunately only to collapse at once, leaving us ignorant of the identity of the painter with whom he had left Florence, and of the appearance of the room they decorated at Pesaro. What we do gain is a firm impression of how things in Florence appeared to a young and doubtless ambitious artist at the opening of the fifteenth century. The prevalence of plague and the threat of conquest by Giangaleazzo Visconti of Milan were a sufficiently unpleasant combination to make him eager to leave the city, and an opportunity came to accompany a 'respected' painter to Pesaro, some distance away on the Adriatic coast. Ghiberti does not claim that *he* was invited there. Presumably he was the junior person in the partnership, the assistant not the principal, which must have made easier his soon quitting Malatesta service.

Ghiberti's pictorial inclinations never deserted him, although he is not known to have later painted pictures as such. The panels of the 'Doors of Paradise' are, however,

like so many pictures in bronze. The painter with whom Ghiberti collaborated must have helped to fix ideals which the young artist never forgot. Perhaps he lived to boast of his early association with the creator of those doors. As for their patron, he was Malatesta, the son of Pandolfo II Malatesta, who had died in 1373, a '*signore di molto moneta*'. The son's links with Florence were or became chiefly financial, through his mounting debts. He very rapidly lost Ghiberti too, after the news reached the artist, from friends in Florence, that the Calimala had launched a competition in connection with the Baptistery. On learning of it Ghiberti acted decisively, perhaps all the same not quite foreseeing what was or would be involved.

'I requested', he goes on, 'permission to leave from the ruler and from my companion. Understanding the situation, the ruler granted it straightaway. Together with the other sculptors, I appeared before the *Operai* of that church [the Baptistery].'

If, having entered the competition, Ghiberti experienced any qualms or problems he left them unrevealed. By the next sentence the allotted year has elapsed, and he is telling how everyone was unanimous in recognising him (the youngest competitor, though he does not say so) as the victor: the thirty-four judges, the *Operai*, the officials of the Calimala and the entire guild. It seems a suspiciously smooth passage for anything accomplished in the Florence of the period. Not even Ghiberti's fellow-contestants emit any murmurs of disagreement. All of them, too, we are asked to believe, conceded victory to him.

Half a century later, it had perhaps begun to appear that that is what had occurred. Who was left living to contradict, with any personal knowledge, an old man's account of his first, tremendous success? The names of his competitors are not forgotten by him. They were: Filippo Brunelleschi, Simone da Colle, Niccolò d'Arezzo, Jacopo della Quercia, Francesco di Valdambrino and Niccolò Lamberti. Of these only Brunelleschi, like Ghiberti, was the son of a Florentine citizen. Lamberti and Niccolò d'Arezzo both came from the Florentine town of Arezzo. Simone da Colle came from the Florentine territory of Val d'Elsa. The two remaining sculptors were Sienese — a rare, disinterested concession, and even a dangerous one, since Jacopo della Quercia happened to be a genius, the sole competitor who can be ranked aesthetically alongside Ghiberti and Brunelleschi. Unlike them he is truly and completely a sculptor, best remembered for the serenely beautiful tomb of Ilaria, wife of Paolo Guinigi, lord of the independent city-state of Lucca, in the cathedral there. No widower in republican Florence sought to raise such a monument to conjugal love and grief.

The handful of largely local sculptors, mixed in age as in ability and experience, was

possibly sifted out of the group which had responded in Italy to the Calimala's competition. Or, more probably, there never was such a response, despite Ghiberti's phrases, and the seven men were those who actually presented themselves in the city as contestants. By Ghiberti's account, each of them received an allotment of metal to execute a relief of the Sacrifice of Isaac, and thus five solid bronze reliefs are missing. They may of course have been melted down, but otherwise the disappearance or destruction of them all seems odd, especially as there are no reliable references to what they looked like. It could just be, alternatively, that a first set of trial pieces was executed, but only in wax.

Manetti appears genuinely unaware of any final contestants other than Brunelleschi and Ghiberti. According to him, it was settled after many discussions and much advice that these two Florentines were the best artists to be found anywhere for the Baptistery doors. It was as a way of deciding between them that each was required to produce a trial piece in bronze, 'and they have been preserved to the present day'.

Somehow, this account has a more convincing ring to it. As many as seven lots of bronze parcelled out to seven contestants sounds almost reckless, and surely liable to make the next stage in the judging protracted, if not painful. Altogether, it may well be that what took place was an interim assessment of the seven sculptors (Ghiberti's naming of them must have some basis), after which the choice was narrowed down to the two who had most support, which in itself would have meant the two most native to Florence. To award such a public and sensitive commission as the Baptistery doors to a foreigner such as Jacopo della Quercia, when Florentine artists were striving to be selected (and Ghiberti had returned specifically for the purpose, sacrificing his prospects elsewhere as a painter), would have caused considerable acrimony. It needed no trial-pieces in bronze, executed over a twelve-month period, to establish that. And it is not probable that local feeling would have been assuaged by the judges pronouncing della Quercia's relief, say, to be the most beautiful. The judges would have found themselves being judged, and heavily condemned.

More than aesthetics was at stake. Those familiar words used in political debate, 'the honour and the good and the welfare of your city', would certainly have been repeated with ominous meaning for those blind to native talent and barely respectful towards the city's patron St John and his shrine. A decision to have it substantially adorned by a Sienese, paid for out of Florentine guild funds, would not so much have divided the community as united it — in violent disapproval.

Without undue cynicism, the competition can be seen as instigated not solely to reveal the best sculptor for a major scheme but to cover the Calimala when its final choice

was announced. And the more people involved in the judging process, the less likelihood there would be of damaging criticism: hence the fairly intricate procedures, which included, it seems, a report submitted in writing by the group of judges and – most notable of all – detailed stipulations about the composition of the trial panel of the Sacrifice of Isaac.

We do not know about those as a fact but they may reasonably be deduced from the two surviving reliefs, since both have exactly the same number of figures, down to the pair of servants who are mentioned in Genesis and who remain with the ass while Abraham takes Isaac up the mountain to sacrifice him, as God has commanded. It is unusual for them to appear in scenes of the actual sacrifice, and by stipulating their inclusion, as well as that of the ass itself, the organisers clearly indicated their wish for compositions that would be real displays of virtuoso skill within the literally narrow confines of the quatrefoil framework, borrowed from that around Andrea Pisano's scenes on the earliest door. His own narrative idiom had been terse, economical and compressed, and probably both Ghiberti and Brunelleschi learned a good deal for their trial reliefs by studying it, although they were expected to create an effect much more elaborate and more showy.

A subject had been cleverly devised that would tax any artist to the utmost, and which yet was not in itself abstruse. It called for a sense of drama, as the angel appeared from heaven to stay Abraham's hand even as he held the knife at his son's throat; for ability to handle the nude figure of Isaac, as well as the draped, and to accommodate the ass, the two servants and also the ram destined to be sacrificed in place of Isaac, and to convey the rocky landscape setting of the whole scene.

Although the competition was to find a 'sculptor', the task presented by the Baptistery doors was not entirely sculptural and certainly no monumental one. It was nearer goldsmith's work. The scale of the trial relief (some 17 x 13 inches) was the scale on which the winner would work, though he had to provide for the two doors no less than twenty-eight such reliefs (the same number as Andrea Pisano provided for his doors).

Of the protagonists, there was probably no one more suitably or immediately qualified at the date of the competition than Brunelleschi, young though he was. Although not yet matriculated as a master, he had applied for registration as a goldsmith by 1398 and could point to some work recently done by him on the elaborate silver altar of St James in the duomo at nearby Pistoia, a Florentine possession. The silver altar is a complex creation by generations of silversmiths, begun in the late thirteenth century and still being added to after Brunelleschi's death. 'Pippo da Firenze' (Filippo Brunelleschi) is recorded as a member of a collaborative partnership which received commissions for sev-

eral small figures in 1399 and in 1400. Traditionally and convincingly by him is a partly gilded silver panel, slightly less wide than the Baptistery trial relief, where in decorated quatrefoil frames are modelled two half-length Prophets gesticulating vigorously with nervous, claw-like hands, and projecting – almost impatiently bursting – from their old-fashioned surrounds. The panel is a minute portion of the rich, complete altar (Brunelleschi may have been responsible for one or two other figures on it), but the two sharply chiselled images of inspiration have a dignity and largeness that transcend size. All the same, it is quite a leap from their essentially miniature refinement to the colossal cupola of the Duomo.

Among the thirty-four judges Ghiberti refers to there were, in his words, 'men highly experienced as painters and as sculptors in gold and silver and marble'. Some of those may have been aware of Brunelleschi's work for Pistoia. If Ghiberti had 'friends' in Florence who could take the trouble to write to him in Pesaro, alerting him to the competition, Brunelleschi is likely to have had his friends too. Manetti is very free with his accusations about how, while slowly modelling his composition in wax, Ghiberti sought the advice of 'goldsmiths, painters and other sculptors, etc.', so as to have them on his side when the judging took place. Brunelleschi, by contrast, executed his relief speedily and then kept silent about it.

Effective though the distinction is, and admirable as is Brunelleschi's behaviour, it all sounds a little too neat and too good to be true. It would be closer to human nature to assume that both men had their partisans, and that by the time the two reliefs were actually shown to the judges, something of their character and quality had become known – and even that a certain amount of informal judging, if only through gossip, had been going on.

It is not impossible that the two artists – themselves as human as other Florentines – had each sought or gained an idea about how the other was treating the subject. Manetti states that Ghiberti indeed learned something of the '*bella cosa*' that Brunelleschi had created – so, on his own evidence, people had seen it and were talking of it. Manetti's Ghiberti is a nervous as well as a devious person, but the nervousness at least is extremely convincing at the date of the competition, though the aged, established artist recounting events could hardly be expected to dwell on that.

It was a considerable achievement in itself for Ghiberti to have got himself included among the contestants. He may have been trained as a goldsmith under his step-father, Bartoluccio, a goldsmith of some standing, but he could point to nothing (as far as we know) that he had actually executed in metalwork. A certain amount of campaigning or

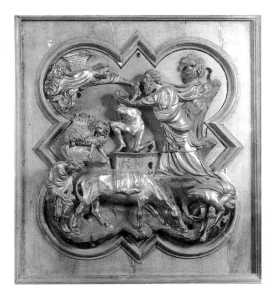 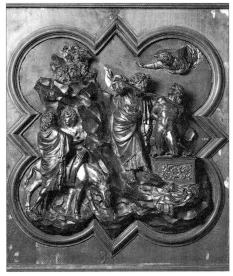

Relief of the Sacrifice of Isaac, by (left) Filippo Brunelleschi and (right) Lorenzo Ghiberti, Museo nazionale del Bargello.

special pleading on his behalf was probably necessary. Doubtless Bartoluccio had professional friends and acquaintances, some of them conceivably among the selectors. Vasari states that it was Bartoluccio who wrote to Ghiberti in Pesaro, recommending him to return to Florence 'and show what he could do'. Although Vasari probably lacked any basis for saying that, he may well have been right. In his version of events Bartoluccio plays a prominent part once Ghiberti has gained a place among the competitors: he helps him make several preliminary models and collaborates on polishing the final relief. Again, Vasari is probably guessing, but his guesses make good sense. Somebody, in brief, must have effectively urged the inclusion of the young Ghiberti among the contestants, and somebody must have helped so inexperienced a worker in bronze produce the final relief, so highly accomplished not least in terms of technique.

The differences between the two reliefs are a staple topic of art history. They are indeed obvious, although also perennially absorbing and by no means a simple question of old and new, still less of 'traditional' and 'advanced'.

Brunelleschi's relief is much more successful in capturing the enigmatic core of the incident (one peculiarly horrible in its psychological cruelty, even by the standards of the Old Testament). Obedient to God, Abraham is shown fully prepared to murder his own son. He has gripped Isaac's throat with one hand and in the other holds the knife already

at the base of his neck. Not a moment too soon does the angel manifest itself, confronting Abraham face to face and taking a necessarily firm grip on his right arm to stop him finishing off the terrified, desperately squirming, skinny boy. These three engaged, physically inter-related figures fill the upper and bigger portion of the relief, just leaving space for the ram, towards which the angel gestures and which adds to the action by naturalistically raising a rear leg to scratch its head. Below this group the donkey's body looms so large, while it placidly munches, that it seems to cause the servants, stooping to examine their feet on either side, to bulge out of the contours of the relief, more energetically than meaningfully.

Everything is perhaps a little awkward, and the style unfluent, but the grim drama of the main scene is made instantly legible. Any awkwardnesses help to increase the urgency, excitement and 'reality' of what is depicted — and all is summed up by the puny, naked Isaac, very much a victim, although he has escaped being a sacrifice.

The artist of this relief promises that, if awarded the commission, he will interpret the rest of the biblical scenes with equal forcefulness, frank clarity and conviction. There is a tang of robustness — of artistic brusqueness almost — about his approach and handling. The ram's casual animal naturalness, at a moment of great tension, comes close to being humorous, and something similar might be said of the preoccupation of the servants — skilfully kept by Brunelleschi in the lower level of the composition, below the mountain top and ignorant of what is happening — whose feet are clearly killing them.

Whatever the resulting ornamental effect overall of his doors, the scenes on them will not be tame or conventional. Although, of course, they were never to be executed by Brunelleschi, we can not improbably trace in Masaccio's Brancacci frescoes, as also perhaps in some of Donatello's late sculpture, the 'awkward' but expressive new idiom that Brunelleschi himself would have developed further from the trial relief.

There was novelty, too, with great accomplishment — and no hint of stylistic awkwardness — in Ghiberti's relief. Altogether, it is a more sophisticated performance than Brunelleschi's; the rocky terrain — itself rather better conveyed — suavely flows in a diagonal rhythm from the heraldic-like ram, 'lodged' at the upper left, down to the heap of Isaac's discarded clothes (a nice touch of observation) at the extreme right. Divided in that way, the composition can smoothly accommodate and subordinate the group of donkey and the pair of attendants earnestly engaged in conversation. The eye undistractedly glides towards the trio of main figures, fastening especially on the muscular, heroic and heroically posed Isaac, nude rather than naked, more defiant than afraid and yet somehow unthreatened. Less eager than Brunelleschi's Abraham, Ghiberti's stands

brandishing at some distance his upraised arm with the knife — a brilliant piece of modelling — as though hoping for heaven's intervention. The angel floats overhead, unseen by Abraham, a slightly ambiguous presence which could be read as sanctioning, not preventing, any sacrifice.

For while Ghiberti has ingeniously fitted in and met every presumed object and stipulation within the framework (which he clearly found no constriction), and incidentally created the first youthful male nude in Florentine art (elder brother of, among others, Donatello's bronze *David*), he has done little justice to the dramatic aspects of the subject. He illustrated it but failed to illuminate it. Even his clever disposition of the two attendants is achieved at the risk — if not loss — of tension. To anyone ignorant of Western artistic convention it might look as though the attendants were part of the main scene, and that the left-hand one of them is witnessing it. And then, although the ram has been equally cleverly disposed on the topmost rock, occupying an otherwise blank area, it has a visual prominence almost equivalent to the angel's. Its lofty position gives it an incongruous, mildly absurd air of presiding, sheep-like, over the events below.

Yet the relief is much more fluent, finished and refined than Brunelleschi's, and individual passages — such as the treatment of Abraham's garments, for example — show up the serious differences between the vision of the two artists. With Brunelleschi, there is a boldness and thickness in the very folds of the garments, making for an effect powerful and energetic. Abraham is entirely encased in solid drapery, concealing his feet and partly trailing along the ground. Such thickly modelled, heavily hung material looks most improbably air-borne in the regular folds of it that stream horizontally behind Abraham's shoulder, in a conventional, rhetorical suggestion of movement, one not really necessary, given the emphatic thrust of Abraham's pose.

Ghiberti too indulges in a piece of comparable visual rhetoric, sinuously and delicately twisting a portion of his Abraham's drapery up into a sort of tiny pennant, fluttering behind his upraised arm. But otherwise the patriarch's garments — embroidered and silky-looking and elegantly ankle-length — are beautifully composed, in a multiplicity of thin, graceful, falling folds. One might almost suppose Abraham was anxious not to disarrange them by any hasty action.

Whatever the judges detected, as they studied these two works of art, they can hardly have failed to see a dilemma. Each relief makes its contribution to the telling of the story. Each complements the other, and there are those similarities that prompt the thought that their creators had at some stage glimpsed each other's composition. The device of the flying drapery is perhaps a mere coincidence, but the box-like altar on which

both show Isaac kneeling is a definite oddity. Maybe it was stipulated as an item to be included, though when Genesis relates how Abraham 'built an altar' it does not mean that he constructed a fanciful, ornamental affair of the kind seen in the two reliefs – in both of which the essential wood of sacrifice which Isaac has carried (thus prefiguring Christ bearing the Cross) is strangely played down.

Whether or not Brunelleschi and Ghiberti had seen or heard of what the other was doing was of no concern to the judges. They had a commission to award – a large-scale one on which it was unlikely and indeed barely feasible that a single artist would labour unassisted. Twenty-seven more reliefs were required, and the completed series would need a sculpted, decorative framework.

The possibility of solving the dilemma – and even getting the doors executed more speedily – by persuading the two men to collaborate and form their own *compagnia* must have occurred to at least some of the judges. Young as they were, both artists had had experience of working in an artistic partnership, itself an accepted procedure. Looking ahead a few years in Florence, it becomes clear that collaboration of that kind was not inevitably stultifying. It produced the tomb of Baldassare Cossa, deposed Pope John XXIII, in the Baptistery, and the frescoes in the Brancacci Chapel, quite apart from numerous other less notable works of art.

That nobody among the judges, or among their friends, fellow-artists and fellow-citizens, thought of that solution is hard to believe. Manetti may have all the details wrong (although his account at this point can be interpreted as reflecting more on Brunelleschi than Ghiberti), but surely he is right in recording that the project of collaboration was mooted. Ghiberti, he adds, was silent on the matter. The officials made it plain to Brunelleschi that if he did not concur, the commission would become Ghiberti's. Since Manetti plainly states that Brunelleschi withdrew, declaring that if he could not have the commission in its entirety he was perfectly content ('*era contentissimo*') at its going to Ghiberti, the account is not unreconcilable with Ghiberti's own less explicit one, in which everyone agreed that his was the palm of victory. Ghiberti just happens to pass over the preliminary hitch, before Brunelleschi in effect left the field to him. The conclusion was the thing. And the conclusion was undeniably that he should execute the new bronze doors of the Baptistery – which, as everyone in Florence knew, he did, superbly. When it came to the question of the third pair of doors – and perhaps memories of the earlier competition played their part, if only negatively – Ghiberti received both the commission and, he says, permission to execute it as he judged best. By then the Guild of the Calimala might feel more indebted to him than he to it.

Surveying his career in the *Commentaries*, Ghiberti saw mid-fifteenth-century Florence as greatly improved aesthetically, very much thanks to him. It was not a matter solely of the two pairs of bronze doors, or even of his statues for Orsanmichele. Providing models and executing designs for other artists to follow, he had been (in his own eyes, at least) a fount of inspiration. He had designed the round west window of the Duomo, as well as subsidiary ones. As for the cupola of the Duomo, he had been Brunelleschi's partner in that project for eighteen years: they built it together, so it ranks among Ghiberti's achievements.

Documents confirm that Ghiberti was not making completely unsubstantiated claims, for he and Brunelleschi were paid as chief joint *capomaestri* of the cupola (with a third, lesser *capomaestro*, more manager than architect), but after a period Brunelleschi received a far higher salary, and was apparently looked on as the leading artist in the enterprise. Say or write what he would, Ghiberti probably never succeeded in convincing his fellow-citizens that the cupola should be numbered among his achievements. As Alberti asks in the prologue to the Italian translation of his *De pictura*, who on seeing the cupola could ever be 'hard or envious enough to fail to praise Pippo the architect . . . ?' The unworthy thought occurs that one person in Florence probably did fail, though he would have claimed that he did so not out of envy but out of respect for the truth. In Ghiberti's agreeable retrospect, his creative ability was manifested nearly everywhere he looked. 'Few things of importance', he was able to conclude, 'were made in our country that were not designed and planned by me.'

Yᴇᴛ ɪɴ ꜰᴀᴄᴛ Ghiberti's lasting fame and popularity do not derive from wide dissemination of his art. He is associated primarily, if not solely, with the doors he executed for the Baptistery, and even there the achievement of the first pair he created, with all the exciting competitive circumstances of their origin, has been partly eclipsed by the fame of the subsequent, second pair commissioned from him, the 'Doors of Paradise'.

By expending so much skill on that pair, Ghiberti helped to put his own first pair in the shade — a process that began at the period when the latter were moved to the sunless north doorway of the Baptistery, and the 'Doors of Paradise' were installed in the position of honour, facing the Duomo. The earlier pair tend additionally to make less visual impact, at least by day, since they are usually open and can easily be left unremarked by visitors hastening into or through the Baptistery.

It is true that they lack the complexity of composition and the sheer golden glitter

of the later, more famous pair, but their individual scenes possess a compensating suc-cinctness and, at times, a surprising sense of drama, which may not be native to Ghiberti but which suggests that he had noticed in Brunelleschi's relief some qualities worth bor-rowing. An ability to absorb varied and topical stylistic influences — rather than being an innovator as such — seems characteristic of Ghiberti. Regardless of competitions, he in effect makes a bid for everybody's vote. To everybody he offers something — something never too difficult to assimilate, and often residing in a disarming, naturalistic detail (such as the lizard wriggling on the rocks in his trial relief) which the spectator feels flat-tered to have discovered.

Ghiberti's art and his account of himself do not suggest an artist of dynamic, 'dri-ven' creativity, for all his spate of inventiveness and high technical competence. It would seem that no fiercely demanding vision had him under its spell. To deal with he was prob-ably quite easy-going — less temperamental than Brunelleschi or Donatello. Such a mix-ture of negative and positive, along with the variety of work in hand, is likely to have made his studio a useful, perhaps pleasant place in which to train, and one where a young artist could develop his own individuality without feeling challenged or crushed by the master. Whatever it was actually like, it was a studio through which passed, among others, Donatello and Uccello of the older generation, and of the younger Antonio Pollaiuolo, himself to rival Ghiberti in his all-round virtuosity as goldsmith, sculptor, print-maker and painter. Another artist who is likely to have worked for a while in Ghiberti's studio is the painter Masolino (something of a Ghiberti in paint), who was later to join Masaccio in painting the Brancacci Chapel frescoes.

All these artists benefited from training with Ghiberti, but he also benefited from them — especially where the huge task of the bronze doors was concerned. With the com-petition successfully won, he had the true major test to meet. He could hardly have intended to work single-handed, and his first task must have been to assemble some sort of team (possibly helped by his experienced step-father). He was beginning from scratch as far as designs were concerned, for a change of subject-matter had made the *Sacrifice of Isaac* relief redundant. The doors were now to illustrate the life of Christ, beginning with the Annunciation and closing with the Descent of the Holy Ghost. Twenty scenes needed to be designed, and the eight other panels were to be filled by individual seated figures of the Evangelists and the Fathers of the Church.

This lay-out partly echoes that of Andrea Pisano's doors, but Ghiberti's sequence of scenes from Christ's life can be logically followed only when his doors are closed, for he spread the scenes in foursomes, rather like linked sentences, across the complete

breadth of them, as if they formed one page. Probably no arrangement would have been entirely satisfactory for the reading of the narrative as such. Pisano began his story of St John the Baptist at the upper corner of the left-hand door and finished it in the lower portion of the right-hand one, which approximately accords with the Western convention of reading a book. Ghiberti, by contrast, starts at the lower left of the left-hand door and then zig-zags upwards, so that the final group of scenes occupies the highest level of the doors, and the last scene of all is in the upper right-hand corner of the right-hand door. That he was not entirely happy with this arrangement, despite the horizontal emphasis he had gained, is suggested by his reversion in the 'Doors of Paradise' to Pisano's sequence, beginning in the top left-hand corner and finishing at the bottom right.

Perhaps none of this much matters. Few people are going to be bothered to trace the life of Christ on the North Doors scene by scene, and it is not apparent in what order Ghiberti designed and executed them. What cannot be missed is the verve of invention which carried the artist through the exhausting task and made so many of the individual panels masterpieces of compressed story-telling. They are far more peopled and far more complex in their settings than Andrea Pisano's austere scenes – some of Ghiberti's most wonderfully modelled, most keenly living faces and figures are subsidiary ones – but the very restriction of the quatrefoil format prevented him from too much proliferation of detail. The medium of bronze seems to give its own hard clarity and sharpness to the images, and Ghiberti respects its enduring, stubborn properties here, whereas in the 'Doors of Paradise' the medium has become so highly wrought and refined and molten that it might be gilded wax.

If not every scene of the twenty on the North Doors is a masterpiece worth studying, none is less than skilful. The sequence starts in a tremendous rush of aesthetic energy, with the taut economical drama of the *Annunciation* (see p. 130). The subject was always popular in Florentine art. It had particular significance in the city, where the church of Santissima Annunziata preserved an old semi-miraculous fresco of the Annunciation, begun by a monk but finished by an angel, and where the calendar year commenced not on 1 January but on 25 March, the feast-day of the Annunciation.

It would be nice to think that Ghiberti began his series of reliefs with the first chronologically, for he seems there to be initiating new naturalistic aims and ideals that are to become typical of the new century. In the opening years of it, work on the North Doors of the Baptistery was itself the supreme artistic novelty in Florence, although work continued nearby on the stone Porta della Mandorla of the Duomo, and the young

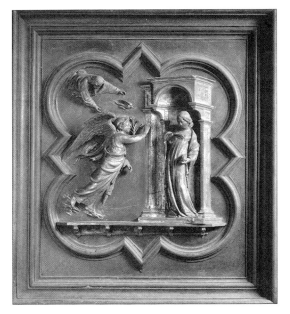

Lorenzo Ghiberti: Relief of the Annunciation,
North Door, Baptistery.

Donatello would move from Ghiberti's studio to execute his first independent commissions for small statues on the Porta. But that studio, and its chief activity, must have seemed where it was 'all at' for art in the city.

The *Annunciation* is a masterpiece of drama and psychological nuance, but neither it nor the other reliefs incorporate the perspectival devices and delicate planes of recession which distinguish the 'Doors of Paradise'. For those Ghiberti needed to learn from other artists, including perhaps his one-time assistant, Donatello. In the North Doors architecture is largely a matter of isolated archways and porticoes, though solidly modelled ones. Notably 'Renaissance' is the shell-shaped niche and centralised series of rounded arches that represent the temple in *Christ among the Doctors*. So little does it seem typical of Ghiberti that it is tempting to postulate some intervention by the youthful Donatello. A far simpler porch, yet conceived on a diagonal and thus in depth, shelters the Virgin in the *Annunciation*, a thoroughly human figure, a girl shrinking back startled at the abrupt apparition of the angel, mysteriously cloud-borne, tall and arresting in his salutation.

Few motifs in art can strictly be called new, and the concept of the scene as the disturbing encounter of two standing figures, the angel urgent and the woman alarmed, can be traced back to Sienese pictures of the thirteenth century. That interpretation is based on the Gospel of St Luke (sole source for the subject), which states that at the angel's greeting the Virgin 'was troubled'. Despite those words, however, the tendency of many fourteenth-century Florentine pictures of the subject had been to show a gently pious, contemplative scene, with both figures kneeling quietly, as if in joint prayer.

Ghiberti blows away that familiar concept, vigorously and perhaps contemptuously. He asks himself what it was really like when God sent the angel Gabriel to a virgin in Nazareth with the mighty tidings that she should give birth to His Son. The impact

of the news, not the Virgin's subsequent acceptance of her destiny, is Ghiberti's concern. Within the straight verticals of the shallow porch, his frail Virgin sways apprehensively, one arm raised to protect herself — almost under assault from the swirling angel and the hurtling, missile-like Dove overhead, launched by a God the Father who himself seems to be hurtling down from heaven on to the scene. Perhaps it is not too fanciful to see in the body movement that makes the Virgin's stomach slightly protrude a hint that this is also the moment of Christ's conception, as she is 'overshadowed' by the Dove (the Holy Ghost).

The central mystery of the Christian religion could hardly be realised more vividly and tensely — and thrillingly. Ghiberti has here suppressed that characteristic of his to embroider a composition — even, to put it harshly, to meander and show off. His trial relief of the *Sacrifice of Isaac* has not got a quarter of the economical power of the *Annunciation*, and virtually none of its daring. A graceful, vaguely soothing interpretation of the Annunciation would have served perfectly well for the Baptistery door; the Virgin might have knelt at an ornamental, ornamented prie-dieu and the angel genuflected before her suavely, as careful of his draperies as of his momentous news.

Not to be content with obvious solutions is the mark of the creative artist. In the *Annunciation* relief Ghiberti challenged himself. He may even have scrapped first impulses or thoughts of providing a slacker, less radical composition. Perhaps there was more fervour in him — especially at this period, when conscious of the need to demonstrate that he deserved what he had won — than one gives him credit for. To every great Florentine painter of the fifteenth century who had to tackle the Annunciation theme (and nearly all of them frequently had to), he issued a challenge, as though setting his own competition: to rival his achievement. And Donatello, sculpting the theme for his pensively beautiful tabernacle in Santa Croce, seems to show awareness — if only by avoiding a similar approach — of the masterly nature of Ghiberti's work.

Nearly a quarter of a century elapsed before Ghiberti's doors were cast, gilded and hung. By then, Donatello was an independent master, about to start on the tomb of the deposed Pope John XXIII inside the Baptistery. Masaccio was inscribed in the confraternity of St Luke in Florence and had already begun to work in collaboration with Masolino in the Brancacci Chapel. On the exterior walls of Orsanmichele, Ghiberti and Donatello and Nanni di Banco had fruitfully completed a succession of statues of patron saints of the relevant guilds. Brunelleschi may possibly have painted his famous perspective panels. He and Ghiberti were involved together on the project of the cupola for the Duomo, which was beginning to take shape.

Ghiberti's doors were a great undertaking, although physically not much greater than those of Andrea Pisano. Yet Pisano's doors had been designed, cast and installed within a nine-year period. Ghiberti took more than twice that time and was reproved for his delays by the Calimala. Some of the original judges may indeed have been dead by 1424, when the doors were finished – and publicly seen to be finished – and a once-daring choice of artist was publicly seen to be vindicated.

1424 was a bad year for the Florentine republic. Once again it was at war, and some-one of Ghiberti's age might well feel a certain circularity in events, since the new enemy was the Duke of Milan, Filippo Maria Visconti, younger son of the duke who had died so conveniently in Florence in 1402. Heavily jowelled and brutal-looking, Filippo Maria appears a formidable mastiff of a man as seen in profile on one of Pisanello's incisive medals, and he lived up to his image, bent on an expansionist policy throughout north-ern Italy. Numerous people in Florence declared him to be the city's enemy. Some coun-selled open war, while others, Niccolò da Uzzano among them, were for diplomatic negotiations, with no rash display of bravado or fear. 'That way', he advised, 'we can have peace.' The prudent, cautious, prosperous Giovanni de' Medici characteristically empha-sised the financial aspects of going to war.

Florence suffered several depressing defeats before managing to negotiate an alliance with its superior, sister republic of Venice – a far-sighted move, and one which averted the Milanese danger. Peace was signed in 1428, celebrated by processions and a formal public oration by Leonardo Bruni. In the Loggia dei Lanzi the Priors sat solemnly listening, having previously received from Bruni a copy of his literary works. All the out-ward appearances were of peace, success and calm, civic splendour. Inside the Palazzo Vecchio, discussions were divided and acrimonious (even peace had its controversial aspect, since Venice seemed to have gained territory, while Florence gained nothing). Soon Florence was again at war, launching its attack on Lucca. Among those who had strongly opposed that action was Felice Brancacci, patron of Masaccio and Masolino in his family chapel at the Carmine.

With hindsight, many of the tensions in the ruling circle during this period seem connected with the jostling for power of the factions of the Medici and the Albizzi. Two parties were emerging, only one of which would ultimately predominate, to become effectively the government. We know that the Medici were to be the victors, and that there would be no reversal – in the long term – of their victory.

Wars cost money, as Giovanni de' Medici had indicated. The war with Milan was expensive yet could be justified as necessary. The war with Lucca was a luxury and also a

blunder which could in no sense be afforded. Few of even the very rich in Florence avoided the effects of war and taxation, and the poor often faced a miserable future. One person whose wealth did increase (quite possibly as a result of the wars) was Cosimo de' Medici, who in 1429 became head of the bank and a prominent figure on the death of his father, Giovanni. More typical was the plight of the obscure painter Mariotto di Cristofano (married to Masaccio's sister, Caterina), who pathetically told the tax authorities three years later that there was no work in his profession, that he had six mouths to feed, 'and I want peace and not war'.

Meanwhile, Ghiberti had won several notable victories in his own sphere. The patent success of his first pair of doors led to a fresh commission from the Calimala (the contract signed early in 1425) for a second pair. Not only was Ghiberti freed from any hint of having to compete for this task but he was – in his own words – 'permitted to execute it in whatever way I believed would result in the greatest perfection . . .'. The exact number of panels was probably left to him, and the only stipulation was that the scenes should be taken from the Old Testament, as originally intended for his first pair. At last he would have the opportunity to use, should he wish, his design of the *Sacrifice of Isaac*, since Abraham naturally occurred among the subjects.

Another quarter-century elapsed before the 'Doors of Paradise' were completed and hung, but Ghiberti and his workshop managed to have the ten panels cast and ready for chasing and gilding by 1436. Two years earlier Cosimo de' Medici had been recalled from brief exile and had begun to establish what would be the virtual rule of Florence until his death in 1464. Yet the ostentatious, almost florid accomplishment of the 'Doors of Paradise' belongs in no 'golden' Medicean age. Just as was the cupola of the Duomo, those doors were largely created during years of warfare and of severe political and financial stress, and they suggest that the Guild of the Calimala had determined that contemporary difficulties should not hinder – should perhaps enhance – the splendour of its most public act of artistic homage to St John's Baptistery.

Enshrined in Ghiberti's glittering reliefs is the magnificence of a great guild. Such a concept really mattered at the period in Florence. In the same year that Ghiberti received his important new commission from the Calimala, the Guild of the Lana deliberated about the state of Orsanmichele and ruefully recognised that the tabernacles of guilds such as the Calimala and the Cambio (the bankers) surpassed its own. That did not redound to the Lana's honour, 'particularly when one considers the magnificence of that guild'. It was therefore decided that its tabernacle and statue of St Stephen must be re-made, in whatever ways would contribute 'to the splendour of the guild'. And keen

possibly to counter the Calimala by a thoroughly smart move, the Lana commissioned its new statue from – of all artists – Ghiberti. They obtained a statue from him but it turned out to be no masterpiece. In what was close to a competition for his services, the decisive winner remained the Calimala.

In these difficult, embattled years for the republic some degree of civic patriotic magnificence and outward display had (or was thought to have) its value for morale. Good news from the war front was thus received with almost excessive celebrations – bonfires and processions through the streets – while actual war was distanced (rather as it is in Uccello's *Battle of San Romano*) by bloodless jousts and tournaments put on to entertain both distinguished visitors and the ordinary Florentine citizens. Only rich upper-class men could participate in these jousts, for apart from the required expertise they had to possess sufficient money to equip themselves. Less aristocratic and more truly popular were the shows put on by the various confraternities, especially those taking place annually on the feast of Epiphany, when biblical scenes were enacted on a stage in the Piazza della Signoria. After a ten-year interval, during which the confraternities had been suppressed, they were revived in 1429, and the decree reviving them referred to the wish of the *Signoria* that none of those things should be neglected that were customarily done 'for the magnificence of the people of Florence'.

Art or artists could be employed not only to defy the consequences of war but to play a part in wartime defence or attack. Long before Leonardo da Vinci devised his various weapons and military machines, and Michelangelo became involved in the defence of Florence, Brunelleschi and Donatello found themselves being consulted in the campaign against Lucca. Brunelleschi, as a sought-after adviser for fortifications, is the first Florentine architect – perhaps the first Italian one – in a mould that became quite common. Florence, in particular, expected every artist to do his duty by the state. Art was a skill which had its practical aspects. Ghiberti was serving civic ends by designing beautiful bronze doors. Brunelleschi was equally serving the state by designing not only the cupola of the Duomo but some engineering-cum-hydraulic scheme or the fortifications for a Tuscan subject-town. Alberti, in the preface to his book on architecture (*De re aedificatoria*, not published until after his death), goes so far as to claim that history probably shows that architects, not generals, were really responsible for most military victories.

Manetti records a fascinating if inevitably fictionalised exchange between Brunelleschi and a distinguished soldier, Niccolò Gambacorti, whom the Florentines called in to inspect and comment on the architect's proposed plans for the fortifying of Vicopisano, close to Pisa. Deeply impressed, the warrior exclaimed, 'blessed be the

Florentine spirits'. Turning to Brunelleschi, he protested that he was no adulator yet he must warmly praise him for his work: 'your entire republic is greatly indebted to you.' Brunelleschi blushed at the splendid compliment. Eloquently and patriotically — and with a diplomatic tact that Leonardo Bruni might have envied — he deflected the praise to the official representatives of the republic who were present. It was due not to him but 'to the eminence of that magistrature and to those notable citizens'. Thus Florence gets, and deserves, the credit. The least one can say of Manetti's anecdote is that he knows how to tell the sort of story that the city loved to hear about itself.

Ghiberti, despite his supposed adroitness in flattering and conciliating people, seems never to have been tempted to credit anyone except Ghiberti with the success of what he created. It would probably have taken a giant compliment, even grander than Gambacorti's to Brunelleschi, to make him blush. It is notable, after all, that neither Brunelleschi (who was quite well-educated) nor Donatello bothered to emulate Ghiberti by writing down any account of their lives or their achievements. There is something assertive in Ghiberti's determination not to leave his art to speak for him but to accompany it by a running commentary.

Even if only tentatively, he seems to point to a difference between the circumstances in which his two sets of doors were designed. The first pair met the wishes of the commissioners and proved excellent and much admired. The second pair are more personal: they meet the ambitions of the artist and exceed anyone else's expectations. That, rather than any aesthetic superiority of one pair over the other, is what separates them — that, and the gap of time between them.

Had Brunelleschi, Donatello and Masaccio gathered together one morning to scrutinise Ghiberti's first pair of doors after they were installed, the trio would probably have agreed, reluctantly or not, that they represented a great achievement. But as artist-protagonists consciously practising new styles, and having several aims or interests in common, they could not have failed to agree also that there was an old-fashioned air about the doors.

It was not Ghiberti's fault that the quatrefoil framework of each scene in itself recalled past conventions and was, however ingeniously he disposed his figures within it, a constricting factor. It permitted only the most basic setting of each scene. Judged overall, the two doors relate back almost too adroitly to Andrea Pisano's. They certainly do not relate to the new perspectival experiments and devices initiated — at least traditionally — by Brunelleschi, some awareness of which seems shown already in Donatello's delicate, 'flattened-out' marble relief of St George and the dragon (and the Princess) under

the niche at Orsanmichele for his statue of the saint. Donatello had been paid for work on the niche in February 1417. The row of archways lightly carved in illusionistic recession to the right of the Princess — a sort of Florentine loggia — is, although nobody seems to have said as much, barely relevant to the subject. But it provides the pretext for a striking, novel and 'modern' effect, giving depth to the composition, and depth is increased by the ghostly group of trees no less lightly incised beyond.

What Donatello here conveys still hesitantly, he would later develop in complex, complete architectural settings of superb bronze reliefs destined not for Florence but for Siena and Padua. In Florence, however, it was Masaccio, along with Masolino, who took the seed of perspectival potential in the St George relief and made it sprout, indeed, swell, to fill great areas along the walls of the Brancacci Chapel. There also — as in his destroyed fresco of the *Consecration of the Carmine* — Masaccio displayed his ability to compose multi-figure groups powerfully realised to match their spacious environment. These frescoes were probably under way by 1425, the same year that Ghiberti began work on his second pair of Baptistery doors.

So there were new manifestations in the city which tacitly challenged him or possibly warned him that this second pair of doors had to be conceived very differently from the first, if they were to gain a place among truly up-to-date artefacts and win the praise of contemporary artists.

When Ghiberti comes to describe how he went about creating these doors — or, rather, the reliefs of which they consist — he reveals his consciousness of the new standards. 'Nature' and 'perspective', with compositions 'rich with many figures' and modelling ranging from high relief in the foreground to low relief in the distance, are the key words and the aims and principles he invokes. Perhaps he never understood intellectually about the laws of perspective, and though naïvely proud of including so many figures in some of his scenes ('in some . . . I placed about a hundred'), he could not always organise such large numbers successfully, nor quite integrate figures and architecture. 'Nature' he instinctively understood. His finest groups tend to be small ones, often as natural in feeling as in anatomy.

Yet he also created some very grand compositional effects in a wholly new manner. An extensive rocky landscape is devised for the Abraham panel, with a grove of thin-trunked trees, that may reasonably be called an advance on the scene of his trial panel. More striking still is the spacious and palatial architecture — dream-like in its soaring though unoppressive, lucid scale — that he created for the central two panels of each door (the two thus most easily visible *in situ*), which deal with the related stories of Isaac, Jacob

and Joseph. This is far more idealised architecture than that of the Brancacci Chapel frescoes. For his Old Testament stories Ghiberti evoked no Florentine street or piazza but visionary, half-antique yet timeless structures. An airy succession of high, open archways lightly incised and seemingly receding into infinity forms the setting of the Isaac relief. In the Joseph relief an equally open, majestic building, circular in shape ('Nature delights principally in round figures,' Alberti was to write in his treatise on architecture), dominates the scene. Its function in the story is as the storehouse where Joseph had prudently accumulated the Egyptian grain, but visually the building is more temple than silo, not without some hint perhaps of the Colosseum in Rome.

In art or actuality no such buildings had ever before existed in Florence. Nor could they have been expected from Ghiberti. They show how bold he could be and how instinctively receptive he was to the artistic climate (and how eager to do anything Brunelleschi could do). Architecture of this lofty kind entered painting through his demonstration of its potential to dignify – to magnify – a figure subject. Botticelli and Leonardo da Vinci learned in this way directly from him, and even Ghiberti might have felt the compliment had he been able to know that his example lay behind the fresco of the *School of Athens* by Raphael.

To some extent, the 'Doors of Paradise' are less sculpture than a cycle of frescoes – only their executant kept relapsing into the mode of a manuscript illuminator. Given nearly complete freedom to execute the doors as he saw fit, Ghiberti almost – but not quite – forgot their function as doors. He found it easier – left to himself – to be florid than to be bold. The fact that the original bronze panels are now detached and exhibited in the Museo dell' Opera del Duomo, where they can be examined one by one in detail without mental or physical strain, is in one sense an aesthetic gain, as well as an aid to conservation. In their original context they tend to be too profuse, too demanding on the eye, too sheerly pictorial to be read as doors at all.

Presumably it was Ghiberti who decided to cut down to five the number of the panels on each door (compared with fourteen on the earlier set); this allowed much larger, more picture-like rectangles for each theme. It was an aspect of freedom that brought its own problems, not least the difficulty of making clear, coherent compositions out of each panel when it often had to contain several incidents within it. No doubt he enjoyed inventing and relating these incidents to each other, but the relationships are less successful than the invention, which is extraordinary in its copiousness and continual flow of imagery – lending itself to being photographed, enlarged, in minutest detail.

At the centre of his Adam and Eve panel he places Eve's creation (not Adam's).

From the sleeping Adam's side, a graceful, naked female body — the first perhaps in Florentine art — wafts into existence through the air, tenderly clasped and carried by baby angels summoned by the sternly upright Jehovah, like a breath of spring and with echoes of the birth of Venus (see Plate 13). In the Abraham panel, three humanly individualised angel figures are shown visiting him outside his tent, while he humbly offers them water for their feet (Ghiberti carefully depicts a bowl for the purpose). It is as a subsidiary scene — a vignette or thumbnail sketch in bronze — that he treats the sacrifice of Isaac, but Ghiberti has drastically revised his original concept, giving it almost wild drama. Not heroic but resigned, bowed and virtually trembling, the boy Isaac crouches, anticipating death. Abraham has swung his knife in a fearful arc high over his head, but before it can fall the angel appears and seizes the knife.

Saved, grown old and wealthy, patriarchal and also blind, Isaac becomes the theme of one of the most effective and calculated of the ten panels, although several incidents are illustrated in it. Outside no tent but the high, echoing, triple archways of his halls he sits, realised most poignantly clutching and blessing his kneeling younger son, Jacob, whom he has been deceived into taking for the elder, Esau. Despite the partly timeless costumes, it might be the action of some Florentine merchant of the period, sending his son out into the world.

Ghiberti keeps devising 'human' motifs and details and groups. On the other side of the complex Isaac composition he models a quartet of conversing servant girls, slim and fluid in semi-classical, slightly swaying draperies, almost dancing as their bodies interrelate and their heads nearly touch. It is one of the most beautiful of all his groups — of all his inventions. The girls are justified there, in narrative terms, solely because of Rebekah lying in child-bed, incised in a space behind and entirely eclipsed by their vivid grace and elegant animation.

Most artists would have been content to have created the elaborate compositions of the reliefs. But Ghiberti went further, risking distracting attention by embedding them in door-frames of equal animation and far greater fantasy and decoration. On his earlier pair of doors, a plain, repeated, leaf-like motif, alternating with heads at the corners, had run in taut criss-cross ribbons around all four sides of each relief. Now, having set the new, larger reliefs in a plain moulding, he framed the two doors themselves in borders which are like three-dimensional interpretations of those of some magnificent illuminated manuscript: frozen bronze cascades of ornament intermingled with powerfully projecting busts (his own among them) and modelled miniature niches holding miniature figures at full-length (see Plate 2). And then he actually had that gilded framing

framed with a carved bronze surround of fruit and flowers, birds and beasts, on a bolder scale and with *trompe l'œil* naturalism. Only after that was he content to stop.

Other fine sets of bronze doors were to be commissioned and executed in fifteenth-century Florence – those, for example, by Donatello in the old sacristy of San Lorenzo. And to testify to the brilliant outpouring of metal-work at the period there are reliquaries, crucifixes, croziers, brooches for copes and the completion of the great silver altar-frontal for the Baptistery.

That had been begun as early as 1366 (the date inscribed on it, with the names not of its first creators but of the first guild officials commissioning it). It was to be completed in all its elaboration late in the fifteenth century. It may have exercised some indirect influence on Ghiberti. In its final state when installed, with its big scenes in relief of the Baptist's life, its rows of innumerable tiny statuettes and, at the centre, a part-gilded figure of the Baptist by Michelozzo, it must have had a filigree, visionary quality as it was disclosed, especially by the opening of the 'Doors of Paradise'.

One of the artists working on the altar-frontal was Antonio Pollaiuolo. He contributed a highly pictorial relief of the *Birth of St John the Baptist*, well after the death of his old master, Ghiberti. And there is attractive neatness, if not entire truth, in Vasari's statement (borrowed from an earlier source) that the quail modelled on the left-hand surround of Ghiberti's doors was the work of Pollaiuolo as a youth in the master's workshop. It serves at least as a reminder that Ghiberti had not laboured unaided on the doors. In fact, we happen to know, through a surviving document, that in 1451 Ghiberti and his son Vittorio undertook to have the 'Doors of Paradise' entirely finished within twenty months, employing 'four good masters and three not so skilled and a boy'.

Such was the team which saw the doors through to completion. In that achievement, their now anonymous part deserves some fleeting recognition. Yet, of course, the triumph was and remains Ghiberti's. Further fifteenth-century Florentine sets of bronze doors and other marvellous metalwork, such as the silver altar-frontal, have simply lost out in terms of fame and popularity. There is probably no work in Florence by Donatello (not even his bronze *David* or marble *St George*) holding anything like a comparable place in popular esteem. Ghiberti's doors are, or have become, virtually a symbol of Renaissance Florence, hardly challenged for pre-eminence in sculpture and comparable media until Verrocchio's *Boy with a Dolphin* and Michelangelo's *David*. Possibly the doors give far greater instinctive pleasure to most spectators than the Masaccio-Masolino fres-

coes in the Brancacci Chapel, even after cleaning, for all the notorious 'importance' of the latter.

In every sense, the 'Doors of Paradise' have always been visible. That is sufficiently true today, although what one gazes at reveals on close examination its replica status. Obvious as is the fact of the doors' physical accessibility, it is very much part of their fame. Not only are they a free exhibit but they can be visited at all times, with none of the tediousness and frustration caused by lengthy or semi-permanent church and museum closures, queues, poor light, small rooms and over-officious warder-staff.

'Strangers passing through Florence view them eagerly; they are captured by a desire to see . . . and the day slips quietly by.' That was written in 1475 by an enthusiastic and not disinterested person, Piero Cennini, whose father Bernardo was a goldsmith who had been one of Ghiberti's team of assistants. Few things slip by quietly in modern Florence (though the Piazza del Duomo has been largely cleared of traffic) but the rest of Cennini's words continue to be remarkably true.

Physical accessibility can be only one aspect of the enduring appeal of the doors. After all, near at hand is the carved Porta della Mandorla of the Duomo, very much a key monument in art-historical accounts of the Renaissance, frequently analysed and discussed, and always fertile ground for the exercise of fresh attributions. Yet it is more respectfully acknowledged than widely admired — perhaps simply not 'taken in' in the pressure of average sightseeing. It is a work of collaboration suffering to some extent from that very collaboration. No single artist can claim it as his, and the history of its evolution (up to the late, unsuitable insertion of a mosaic *Annunciation* from Ghirlandaio's workshop towards the end of the fifteenth century) is somewhat complicated. At first sight, too, its discoloured stone appears drab. In contrast, Ghiberti's doors glitter alluringly, as he intended, and his imagery is immediately accessible, regardless of any prior knowledge of the Bible or Christianity. Here are men and women, children and animals, rocks and trees and buildings, skilfully assembled into scenes that are lifelike, effortlessly legible and wrought with a strongly tactile sense in a material precious-looking and enduring, which to the naïve eye might really pass for gold.

Ghiberti has taken the concept of carved doors to a pitch of elaboration and richness which cannot be surpassed. The 'Doors of Paradise' seen closed — as they are normally seen today — are not only rich in themselves but enhance the idea of the richness, or specialness, of the building they appear to guard as much as to lead into (beyond such a gateway appears to lie a visual or spiritual experience of no ordinary kind). Rightly did the old artist, composing his account of all his numerous works, conclude: 'this is the

most outstanding one'. Ultimately, what the doors enhance is the public, permanent image of Florence itself.

Yet neither their steady, glittering allure, nor their creator's complacently biased view of his all-round services to art in the city, should obscure the fact that the years of his main activity are also those in which Donatello came forward to do the state some service too. Less outspoken than Benvenuto Cellini, Ghiberti never referred in writing to a sculptor he must have realised was not merely a rival but far his superior, most patently in marble and wood, materials Ghiberti never handled. As for Donatello's attitude to Ghiberti, a brusque, stinging, Degas-style *bon mot* of his, recorded by Vasari and others, suggests real contempt. When asked to say what was Ghiberti's finest achievement, Donatello replied: 'Selling Lepriano' (a farm Ghiberti had bought and subsequently sold as unprofitable). Apart from the aesthetic put-down, there is perhaps a hit at Ghiberti the worldly wise bourgeois, delivered by an artist notoriously impatient about possessions and who found his own small country estate (a gift to him from the Medici family) such a time-consuming irritation that he gladly got rid of it and took a pension instead.

At Orsanmichele a kind of 'anything-you-can-do-I-can-do-better' pattern grew up, as if the two sculptors were engaged in an artistic game of chasing each other round the building. Nanni di Banco was involved as well but was eliminated by his premature death in 1421 (and he, in any case, did not work in bronze).

About 1407, when Ghiberti was engaged on his first pair of doors, he had employed no fewer than twenty-one assistants – though not all at the same time – and among them was Donato di Niccolo di Betto Bardi (Donatello), paid a top annual salary of 75 florins. Four years later Donatello, a practising sculptor on his own though not yet matriculated in the guild of St Luke, was assigned the marble statue of St Mark at Orsanmichele. It was a significant commission which came to him after being taken away from Niccolò Lamberti, one of the sculptors defeated in the competition for the Baptistery doors. Understandably enough in the circumstances, Lamberti soon left Florence altogether, to continue his career at Venice.

The assigning to Donatello of the St Mark, by the Linaioli (the linen-weavers' guild), was probably in recognition of his rising fame. He was indeed the sculptor of the future, who had already indicated his instinctive-seeming gifts of brain and skill in a large-scale, seated statue of St John the Evangelist, destined for the façade of the Duomo; even in its unfinished state, or perhaps particularly in that state (which continued until 1415), it must have appeared a novel, majestic concept, presenting a very Jove of evangelists, grandly posed, heavily draped and with huge hands that increase the air

of majesty. Michelangelo is said to have been profoundly struck by Donatello's *St Mark* at Orsanmichele, but he paid a more profound compliment to Donatello's *St John*, for it is the clear inspiration for his own *Moses*.

Donatello had – at twenty – gained an important, testing commission, but if we are to believe Vasari, the resulting statue displeased the guild officials when they first saw it, on the ground and presumably in the sculptor's studio. Whether it tended to appear insufficiently noble or even clumsy – at that level – in its proportions, it could well have disconcerted, if not disappointed, those who had backed the young artist.

Vasari's imagination was bolder in the literary sphere than in the visual, and he tells numerous entertaining stories that are demonstrably untrue. In this case he enjoyed recounting how Donatello asked the officials of the guild to allow the statue to be placed in its niche, because after he had worked on it further it would look quite different. They agreed. After fifteen days of its being in place but hidden, it was unveiled, whereupon everyone admired it. In curiosity-ridden Florence, the fifteen days could only have whetted appetites for the moment of revelation, and Vasari has a point to make about obtuse patrons and vindicated artists: the statue had not, according to him, been reworked at all by Donatello.

Such a tale might seem hardly worth credence, were it not that it contains at least one grain of truth. In *St Mark*, as again and again in later statues, Donatello has obviously calculated cleverly on how his work would look *in situ*. *St Mark* is to be gazed up at, and the proportions of the body assume that. It is quite conceivable that the statue was altogether too powerful and original in its first impact on a group of officials timid and unsure how their fellow-members and the public would react. Once it was seen in its niche, and clearly looked right, they could join in the chorus of approval and indeed be congratulated on their choice of sculptor. That Donatello's genius and suitability for working at Orsanmichele were quickly recognised is shown by the fact that two further commissions for statues there followed in succession.

Before that happened Ghiberti received a commission for a statue at Orsanmichele of St John the Baptist, given to him by the Guild of the Calimala, which was responsible for the Baptistery and of course its doors. Ghiberti now had the opportunity to challenge not only Donatello but artistic and public expectation throughout the city. His statue was to be of bronze – an expensive medium compared with stone, and all the more expensive on this occasion since Ghiberti's design was more than eight feet high. No statue that size had ever been cast in Florence before; nor had Ghiberti himself ever worked on anything like that scale.

We may feel sure he had no intention of being left out, of being publicly eclipsed by his one-time studio assistant, Donatello. The first pair of Baptistery doors was by no means finished, although most of the reliefs had probably been cast. Florence had as yet nothing major of Ghiberti's on show, and the *St John the Baptist* commission must have seemed a convenient way of reminding everyone of his abilities – of astonishing everyone, as it proved, by the feat of casting such a huge statue in a single piece.

Speculation can only have been intense over whether he could, technically and aesthetically, succeed. There is no doubt of his technical success. He revealed the dazzling potential of bronze as a medium for major statuary, and nobody would grasp that lesson more superbly than Donatello. Ghiberti 'finished' the textures of his *St John* most beautifully, from the rough-haired garment at his breast to neatly sandalled toes, and the delicately incised features of the gaunt face. Yet there is little sense of a body under the loose folds of drapery, and the gaunt face is a mask noble but bland, verging on the blank. The entire figure only just balances, oddly draining away at the feet. Seldom has St John the Baptist looked less likely to become 'a voice crying in the wilderness'. As for his calmly impressive pose, even to the disposition of his hands, there perhaps can be detected echoes of Donatello's *St Mark*. If Ghiberti had a chance to see that statue at some stage before he fixed the design of his own, he could hardly have failed to benefit.

The Calimala were doubtless as happy with Ghiberti's *St John* as the Linaioli with Donatello's *St Mark* – arguably, happier. Any stylistic differences would weigh less than the degree of realism of the two works, and nobody could fault the careful realistic detail of the surface of *St John*, which may well have been the more popular statue. In any event Donatello was quick to supply another marble statue at Orsanmichele, a *St George* (see p. 144) for the Armourers' Guild, which was soon to be famous and praised beyond Florence.

Alert, resolute and seemingly stirring into life in the niche where he stands with feet planted firmly apart, as though for ever fixed and holding his ground, the *St George* makes Ghiberti's *St John* look both ineloquent and inert. Yet Ghiberti received a second commission for Orsanmichele, a year or two after *St George* was installed. The Bankers' guild, the Cambio, decided to have sculpted a *St Matthew* in bronze (see p. 144) and elected a committee of four (among them Cosimo de' Medici) to implement the decision. It was their intention to obtain something very splendid indeed from Ghiberti, who was required to produce a statue as large as, or even larger than, his *St John the Baptist*.

Being Ghiberti, he met their wishes, and exceeded them. He introduced into the huge new statue a classical dignity and sense of solidity combined with subtle yet distinct drama. The saint sternly holds out his inscribed, open book with his left hand, and with

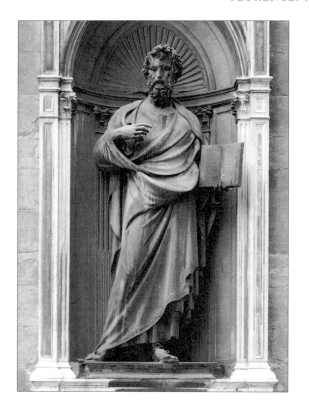
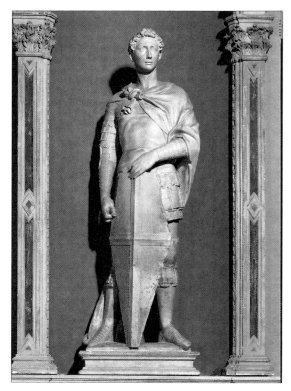

Left: *Lorenzo Ghiberti:* St Matthew, *Orsanmichele.*
Right: *Donatello:* St George, *Museo nazionale del Bargello.*

the other gestures in its direction across his body, perhaps towards his ardent heart. The upraised, almost quiveringly nervous hand is a clever display of technique (much less well-realised is the draped arm behind), but also an arresting, half-rhetorical device; and St Matthew is given all the commanding eloquence of pose that would have better suited the Baptist.

By now there were scarcely any niches left empty at Orsanmichele. On the east façade, however, the central niche remained unoccupied. It was flanked by a marble *St Luke* by the somewhat unlucky Lamberti and by Ghiberti's famous, unprecedented bronze of *St John the Baptist*. To Donatello was assigned a statue for that niche, of St Louis of Toulouse, the patron saint of the Parte Guelfa, whose headquarters were nearby. The documents of the commissioning have not survived, but very likely they specified from the first that gilt bronze should be the medium of this important statue.

It was Donatello's turn to be tested, for he had never before sculpted a statue in

bronze – and this one was to adjoin Ghiberti's smoothly accomplished masterpiece. Ghiberti might not have been alone in wondering, amiably or otherwise, what the result would be. Perhaps he could afford to smile with relief when he eventually saw it.

Nothing like so effortlessly suave and graceful as Ghiberti's *St John the Baptist*, Donatello's bronze saint is at once bulky, awkward (as if the medium was recalcitrant) and oddly fluid where the figure's draperies meet its base. Despite Donatello's ability, the heavily gloved hands seem poorly related to the arms, and altogether the fact that the gilt bronze statue had had to be cast in several pieces is only too apparent. Something of beginner's work hovers around the *St Louis*, but Donatello would come to master the medium as forcefully as he had mastered that of marble, and outshine Ghiberti in grace and suavity also. The bronze *David*, executed perhaps shortly after Ghiberti's death, is his answer to all that the older sculptor had demonstrated at Orsanmichele about the potential of bronze statuary.

What was a triumph, noted or not, for Donatello's *St Louis* was the niche in which it stood: a pedimented, Brunelleschian tabernacle of Ionic columns and Corinthian pilasters, without the illusionistic depth of Masaccio's near-contemporary Trinity fresco in Santa Maria Novella but even more grandly 'classical' and antique in motifs. This is a niche which could hold a statue of Apollo or Hercules. Its rational clarity and logic certainly offer an alternative, if not a positive rebuke, to Orcagna's extravagant, fantasy tabernacle so close at hand inside the building.

Ghiberti's first bronze doors for the Baptistery were installed facing the façade of the Duomo, a façade which – together with the sides of the Campanile – gave Donatello something of a showcase for his marble sculpture. But Donatello was never to have in Florence a single, concentrated site comparable to the Baptistery for public display of his art, itself too ranging and restless to be contained or assembled in any obvious way. Before him there had been no sculptor in the city capable of responding to – perhaps stimulating – commissions in every medium and virtually of any format. However, from early on, within his lifetime, his statues were subject to moves and substitutions which may not always have diminished their accessibility but certainly robbed them of their intended context.

At Orsanmichele his *St Louis* left its niche around 1460–3 and was placed – strangely – on the façade of Santa Croce. A marble *David* he executed for a position on the Duomo was never put up but was bought in 1416 by the *Signoria* and placed in the Palazzo Vecchio (it is now in the Bargello). There is in the Palazzo Vecchio today his late, sombre and visionary bronze group of *Judith and Holofernes* – Cellini's *Perseus and the Medusa* anticipated

and reversed in theme — which can appear a highly appropriate symbol of republican sentiment and of religious faith over pagan brute strength.

Not deigning to glance at the body she straddles, her scimitar raised avengingly in one hand while the other grasps the snaky locks of Holofernes' hair and one foot tramples on the pulse at his wrist, Judith is a hooded incarnation of deadly, inspired purpose. The group's mood is typical of Donatello in its ambiguity and its elusive overtones of sexuality and poignancy. As the utterly naked bronze David seems invested with a pensive, semi-melancholy after the moment of victory over Goliath, whose severed head he half-casually spurns like a football at his feet, so there hovers about the *Judith and Holofernes* a trace of sadness, though once more it illustrates the triumph of the virtuous weak vessel, guided by God, over the strong and sensual. Holofernes had planned to seduce Judith, but Donatello's virile, stripped-to-his-drawers general seems to pass from stupor into death as a victim not quite unpitied or anyway not quite ignoble.

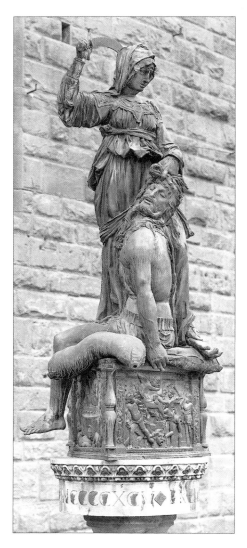

Donatello: Judith and Holofernes, *Palazzo Vecchio.*

Nevertheless (much as would occur later with the work of Michelangelo), the overt message of the group, not its inner tension, was what most contemporaries would have looked for. Almost certainly, the Judith originated in a private commission, from the Medici, and it is mentioned as in the garden of their palace before the end of the 1460s. The group seems to lend itself to interpretations of a moral and possibly civic kind: humble, arguably republican virtue overcomes tyrannical pride. Ideally, it is the sort of work which one might have expected the Florentine republic to commission; as such, it would enhance the concept of

ever-enlightened, art-loving Florence, although the state would probably have preferred an example of masculine virtue, rather than the disturbing one of a woman cutting off a man's head. Whatever the original meaning of the group, and whatever Donatello's own personal creative urge, the *Judith* gained full public significance only through events at the end of the fifteenth century. Having expelled the Medici and confiscated their property, the state moved the group to a prominent position outside the Palazzo Vecchio. An inscription was added to its base: a warning against tyranny, with pointed application to the very family which had owned and most likely commissioned the sculpture.

In recent times conservation concerns have added pressure to a move to withdraw Donatello's work from permanent open exhibition in Florence. To his contemporaries his sculpture was far more generally visible and more widely dispersed. Perhaps there never was one grand focal point comparable to the Gattamelata statue at Padua (the *Abundance* column, however fine, can have been no substitute for that), but even from inside the Baptistery and the Duomo great works of his have gone. The Florentine 'Donatello-trail' is thus much shorter than it originally was. It ends rather rapidly in the inevitably impersonal museum spaces of the Bargello and the Museo dell'Opera del Duomo, conveniently, of course, but not always meaningfully for the non-instructed visitor.

In the mind's eye the Duomo, in particular, should still contain Donatello's marble choir loft, installed above the entrance to the 'old' sacristy, at the right of the crossing under Brunelleschi's dome — and installed while the dome was taking final shape. It too was conceived in a sort of unofficial competition with a complementary choir loft positioned above the doorway of the 'new' sacristy, at the left of the crossing, by a younger sculptor already proficient but little-known at that date, Luca della Robbia. No doubt these two famous works are easily viewed, contrasted and compared as they face each other reconstructed in the Museo dell'Opera del Duomo (see pp. 148-9), but they were largely dismantled and removed from their original settings for an ephemeral and — as it turned out — thoroughly ill-omened occasion in the late seventeenth century, the wedding of Grand Prince Ferdinand de' Medici, Cosimo III's heir, when the Duomo was decorated in 'modern' style. In the vast, greyish, gloomy expanses of the Duomo the pale, ivory elaboration of their ornament, their panels and friezes of exuberantly animated groups of figures and the joyful visual noise they very consciously create would be intensely welcome.

In terms of beauty the two choir lofts equal each other, but each is a wonderfully crafted reflection — or, better, distillation — of its creator's artistic character. Demure for all their vivacity, innocent in their pagan, sometimes naked, frolicking and music-mak-

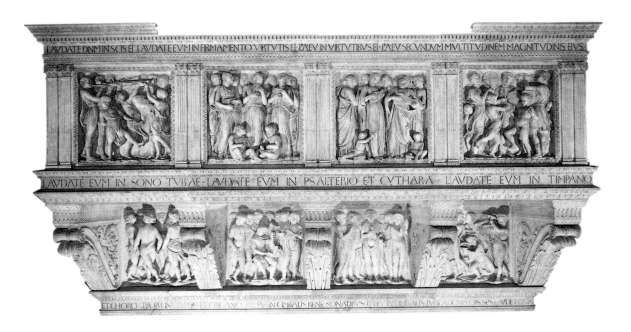

Luca della Robbia: Choir Loft, *Museo dell'Opera del Duomo.*

ing, della Robbia's youths and girls and children possess a charming, confident candour, inherent — it seems — in the gentle manner of their actual carving. They are calmly grouped in their separate panels, composed between Brunelleschian-classical double pilasters and no less classical acanthus-leafed corbels. Despite the verses from the last of the Psalms ('Praise God in His sanctuary . . . praise Him with the sound of the trumpet . . .') elegantly incised along the parapet, and the barely apparent, sausage-cushion of clouds on which they perform, these figures are no winged heavenly creatures, though they are still more ideal than earthy. Delicately oscillating between the Christian world they celebrate and the antique one which has dressed and undressed their graceful limbs, they exist in a truly pure, emotionally crystalline sphere, half-corporeal, half-spiritual. It is of Luca della Robbia's own creation but it is at the same time profoundly of its period and an essence of all that is meant by the word 'Renaissance', at least in Florence.

Donatello's choir loft was also both personal and impregnated with similar Florentine 'Renaissance' sentiments. He did not need Luca della Robbia to lead him into an awareness of the antique past. But he may have responded the more keenly to his task in the Duomo from seeing or gaining some idea of how della Robbia was treating his choir loft. Being the more experienced sculptor, Donatello must definitely have realised

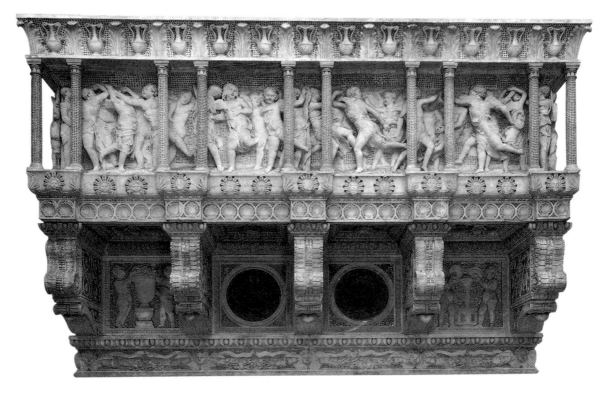

Donatello: Choir Loft, *Museo dell'Opera del Duomo.*

that the dim location and high positioning called for bold effects and vigorous rather than delicate handling of marble. He had previously received a somewhat comparable commission, for the curved open-air pulpit of the cathedral at Prato (which he and his associate Michelozzo, along with assistants, took a leisurely decade to finish). At Prato the design was of several panels of lightly tripping, winged *putti*, set between double pilasters, much as envisaged by della Robbia. The interior of the Duomo called for a different solution.

As della Robbia was later famously to discover and exploit, a coloured background throws into literal relief the figures carved or modelled in front of it and adds its own decorative effect. Donatello gave a background both coloured and sparkling to the main area of his choir loft by making it of mosaic. Against that uneven, enlivening, speckled surface he carved not compartmentalised panels but one single complete frieze of wildly dancing, intricately interlaced children, young Maenads more than conventional angels, who might be treading out grapes under their pounding feet and some of whom in their

riotous glee look a little tipsy. Wreaths are being tossed and passed among them like so many quoits, and on the ground over which their feet fly is formed an undulating, natural carpet of leaves, acorns, flowers and perhaps fruit – a marvel of crisp detail where the eventual high location in the Duomo is happily forgotten in sheer creativity.

Donatello has unleashed his full sculptural energy before which della Robbia's charming, sprightly, mildly mischievous people become almost staid. In their joy they remain playful, but Donatello's manic figures verge on the threatening in their earnest abandon. It seems significant that they dance not along clouds but on a solid fertile earth, for they seem eternal earth-creatures, expressions of a primal, erotic, engendering force far older than mankind. Barely are they contained behind the miniature mosaic pillars which Donatello has carved to give greater three-dimensional, architectural effect to the choir loft, and they kick up their legs to the rhythm of pairs of *putti* banging out primitive music on cymbals.

Did the authorities of the Duomo blink on inspecting what was one of the most complete and concentrated recapturings of pagan antiquity since the fall of the Roman empire? Probably not. Although by no means as 'finished' – deliberately so – as della Robbia's choir loft, Donatello's is more elaborate, as well as more profuse in polychromed ornament. It is among those superb Florentine achievements of the period which meet the continual, if vague, requirement of being 'as beautiful as possible'. That, we may suppose, was sufficient to palliate – or possibly make irrelevant – its secular imagery and spirit. Perhaps, in the fervently pious climate of seventeenth-century Florence, Medici wedding festivities were only a pretext for banishing from the Duomo such wantonly non-Christian work.

In the Baptistery Donatello's presence, though weakened, has remained prominent, indeed unmissable. His wooden statue of the Magdalen may have departed to the shelter of the Museo dell'Opera del Duomo, but permanently built into a wall of the Baptistery is the remarkable tomb of Baldassare Cossa, one-time Pope John XXIII, a monument also to a remarkable episode of history. No other pope, quondam or otherwise, is buried in Florence, and nobody subsequently has been buried in the Baptistery.

If there is no other tomb in Florence quite like this one, that seems appropriate for its subject, someone of extraordinary ambition, lust and venality – even by Renaissance papal standards. One of his Florentine supporters, Filippo Corsini, was to admit at a city council discussion in 1415, the year the would-be pope was taken into custody, that he did have 'strange habits'. That is a kindly verdict. No one else seems to have come to the papal throne after an early career as a pirate. Few popes have had quite John XXIII's re-

putation as a seducer of women, rivalling that of his namesake, Don Giovanni. Although the operation of the Holy Spirit upon conclaves is perhaps at its most mysterious during the Renaissance — John XXIII was only one of three claimants to the papacy — Baldassare Cossa's character anticipates much of Pope Alexander VI (and Alexander VI's involvement in Florentine affairs — see Chapter 9 — was to have horrible and tragic consequences, though not, unfortunately, for himself).

To Florence, John XXIII was notably friendly. He was much indebted to the city's bankers, most outstandingly to Giovanni de' Medici, for the money which financed his activities and endeavours. The Medici, in turn, gained influence from the association. Apart from his political and financial support in the city, John XXIII had humanist links with it (his complex character was the opposite of philistine), and at his court two future scholarly chancellors of Florence, Leonardo Bruni and Poggio Bracciolini, were employed.

When he was driven out of Rome the pope had sought refuge in Florence, and it was to Florence that he returned in 1419, humbled if not broken, having been tried, deposed and imprisoned by a General Council of the Church, before being ransomed and released (possibly through Medici money and intercession). In Florence he made his submission to the universally acknowledged pope, Martin V, who was temporarily living there, accepted more grudgingly than enthusiastically by government and citizens. Florence had been pointedly slow to congratulate Martin V on his election, and perhaps continued privately to prefer the ex-pope, a Neapolitan by birth who had become almost a Florentine by adoption and friendship.

When he died in Florence in 1419, rehabilitated as a cardinal bishop, his executors included Giovanni de' Medici and Niccolò da Uzzano, and in their hands was placed the slightly awkward task of negotiating and arranging for his tomb. Both men were, however, sufficiently influential: Niccolò da Uzzano was a prominent member of the Calimala and thus responsible for the Baptistery, and there it was eventually agreed should be the site of a tomb, 'brava et honestissima'. Cossa had taken the name John on his election as pope, in honour of St John the Baptist, a reliquary of one of whose fingers he owned. In several senses of the word, there was to be something brava about his tomb. Nothing is stated on it of his bishopric, but with a certain defiance he is for ever identified as 'Joannes, quondam Papa XXIII'. No later pope cared to choose the name until another energetic but more saintly John XXIII in 1958.

A marble slab and a sarcophagus had served to commemorate and bury the twelfth-century bishop Ranieri in the Baptistery. In the mid-1420s Ghiberti sculpted a simple

though lifelike and dignified bronze relief for the tombstone in Santa Maria Novella of the Dominican Order's general, Leonardo Dati. Very much grander — of unprecedented grandeur in Florence — was to be the monument to Cossa, the tone of which was in effect set by locating it between two of the giant pillars of the Baptistery. Perhaps Ghiberti's name was considered at some stage for the task, but in fact it went to the partnership of Donatello and Michelozzo (see Plate 10). Giovanni de' Medici seems to have taken little interest in art, and it was probably his son Cosimo (the future *Pater Patriae*) who acted as his representative over the Cossa tomb, selecting two artists whom he himself was later to employ on important commissions of his own.

Michelozzo is remembered today chiefly as an architect, most notably of the imposing new Medici palace that Cosimo was to have built in the city (see p. 183), and of a cluster of Medici villas outside. Ten years younger than Donatello, Michelozzo had similarly begun in Ghiberti's workshop. Unlike him, he graduated to become a *compagno* or partner of Ghiberti, before leaving to assist Donatello, first on the bronze statue of St Louis at Orsanmichele. He was certainly in demand by both artists, for in 1436 he is named as going to assist Ghiberti on the chasing of the 'Doors of Paradise'.

Michelozzo's was probably the larger share in designing and also executing the Cossa monument which — although often described as the first Renaissance tomb — is developed from an earlier, well-established tradition of the wall-tomb, to be seen in Florence and also in Naples, with a completely sculpted image of the defunct lying on a tomb-chest-cum-bier, under a form of arch or curtained tent. Using a 'classical' rather than 'German' idiom, Michelozzo has retained and increased the various levels and motifs such as lion-heads supporting Cossa's bier (if these particular lions derive, as is said, from a porphyry stairpost in the palace then belonging to Niccolò da Uzzano, there is an obvious bow towards one of the patron-executors). The monument tends to suffer from its plethora of motifs, supplied perhaps by sculptors other than Donatello or Michelozzo. Swags of curtain suspended from a massive ring break the lines of the upper architectural area, and the sculpted relief of the three theological Virtues is an inadequate support visually for the hefty sarcophagus placed above it, on top of which stands the bier with the ex-pope's effigy. The height of the central figure is in fact too remote, and the later, truly harmonious and 'Renaissance' tombs in Santa Croce of Leonardo Bruni and his successor as chancellor, Carlo Marsuppini, correct that fault, allowing the spectator closer access to the deceased, as though to encourage not only gazing but mourning.

What is strikingly new in the Cossa tomb, and not repeated in later Florentine Renaissance monuments, is the combination of marble with bronze, bronze for the

image of the deceased, which is gilded so that it gleams out in contrast to the dark, leaden-like pillow and drapery of the bier and the remainder of the huge marble complex. For repetitions of that multimedia effect, itself proto-baroque, one must look beyond the Renaissance.

Cossa's image in death is the portion of the monument that really matters, aesthetically speaking, but appreciation of it has to be supplemented by photographs which reveal the unremitting frankness with which his features have been portrayed. He is carefully and correctly shown in episcopal, not pontifical vestments, and the actual pose of the recumbent image is no different from that of, for example, Bishop Tedice Aliotti lying on his lion-supported sarcophagus, in Santa Maria Novella, executed more than a century earlier.

Cossa's face probably derives from his death-mask, yet he looks robust and ready to rise again, without waiting for the last trumpet. With a great wart on his fattish cheek and a tuft of hair just protruding from his mitre, he has a physiognomy that matches his individual character — giving real force to the cliché of one not dead but sleeping. Interpreted in bronze, his bulging mitre takes on something of the appearance of a helmet and in his gloved right hand the fist is as metallic as the glove. With more than Ghibertian accomplishment Donatello now handles the tricky bronze medium, making the quondam pope's chasuble and alb ripple into a gleaming river of half-restless creases and folds, all the way down to his sharply pointed feet.

When the Cossa monument was installed in the Baptistery, that building was already decorated with Ghiberti's first pair of bronze doors, gilded and set up in the east portal, and he was at work on the second pair, destined to displace them. Whether or not he liked it, he had provided an ideal context for approaching not only the ancient baptismal font and the silver altar-frontal but also a unique contemporary, major addition to the Baptistery, created by two sculptors who had once been no more than his studio assistants.

CHAPTER FIVE

Artists in Collaboration

COLLABORATION, RATHER THAN competition of any kind, had meanwhile produced – during the same artistically crucial decade of the 1420s – a monument as assertive, in paint, of modern Florentine achievement as anything by Donatello or Ghiberti or Brunelleschi: the frescoes by Masaccio and Masolino in the Brancacci Chapel of the Carmine.

Not the least revelation from the cleaning and restoration of the frescoes has been the fact that the two painters clearly collaborated closely and harmoniously, despite a considerable difference in age. Nor is there any longer justification, if there ever was, for allowing all the credit and glamour of the frescoes to be given to the young, advanced, short-lived Masaccio, while treating the much older Masolino (who lived on some fifteen more years) as an old-fashioned, uninspired plodder who happened to be uneasily yoked in the commission with a genius. Quite why Masolino has generally been reduced to the ranks of mediocrity by official art history – and found guilty, as it were, before being tried – is not altogether a mystery. It arises from acceptance of received fact (what is called teaching) in preference to scrutiny of the evidence, that is, Masolino's own sometimes unaided work. His St Catherine frescoes in San Clemente in Rome would be sufficient in themselves to justify reconsideration of the normal verdict, but they too have been 'explained' as painted with the help of Masaccio, so the case for Masolino's artistry is probably unwinnable.

Nevertheless, the frescoes in the Brancacci Chapel that are uncontestably by him – such as the large combined scene of two miracles by St Peter, the healing of a lame man and the raising of the dead Tabitha – suggest an intelligent, receptive and gifted painter, 'softer' in style than Masaccio but far from annihilated by working alongside him. As the fresco of the two miracles shows, Masolino too was interested in perspective effects (especially architectural ones). He also could give a dignified sense of three-dimensional volume and solidity to his figures, as in the austere statuesque St Peter, who summons Tabitha back to life and whose body casts a shadow across her threshold (see Plate 8). In the Brancacci Chapel he possibly suppresses the natural decorative tendencies of his art,

to match the more sober standards of his collaborator, but cleaning has revealed how much bright colour – pinks and blues and greens – exists also in Masaccio's contribution.

The commissioner of the scheme, Felice Brancacci, was a prominent and successful citizen, but no art historian. He is likely to have made no qualitative judgment between the two Thomases ('big Tom' and 'little Tom' were the affectionate or familiar diminutives of, respectively, Masaccio and Masolino) and to have been more concerned about their getting on with the job. As well he might, for Masolino went off to Hungary in the autumn of 1425. Masaccio continued at work for a period, but around 1427 he left Florence for Rome, never to return.

The fresco scheme was still incomplete when Brancacci himself was banished from the city, shortly after the coming to power of Cosimo de' Medici. In the early 1480s a third painter was brought in to complete the frescoes, Filippo Lippi's son and Botticelli's pupil, Filippino Lippi. It might have resulted in a disturbing intervention, but Filippino obviously attempted to match the chapel's idiom – and he must also have felt a certain awe as he measured himself against the accumulated prestige and achievement of Masaccio, even while his artistic sympathies were closer to Masolino's. Yet, broadly, Filippino succeeded. He continued the strong architectural emphasis of the frescoes, and also continued – if not indeed increased – the sense of the scenes from St Peter's life occurring against the background of fifteenth-century Florence, with many of the bystanders being portraits of prominent citizens. He keeps his narrative simple, even somewhat archaic, and adopts a colour scheme according with that of the two earlier painters.

Homogeneity and clarity are the first impressions conveyed by the chapel. Neglect, damp, fire and 'improvements' have oddly helped to concentrate the eye on the verticals and long horizontals of the two layers of compositions, each in its thin yet distinct frame of painted architecture, which not only cover the walls but help define them. Originally there was much more floriated ornament around the windows, and the vault of the chapel was frescoed by Masolino as part of the scheme. Few people today are likely to look up, or look up for long, at the pretty, powder-puff rococo ceiling decoration provided in the mid-eighteenth century by Vincenzo Meucci, which shows a heavenly vision of the Virgin handing over the Carmelite habit to St Simon Stock (subject of a superb painting by Tiepolo in the School of the Carmine at Venice, of almost the same date). Meucci is competent and agreeable in fresco; his milky, mildly illusionistic decoration would look fine elsewhere – preferably a few yards away from the Brancacci Chapel in the chapel opposite, of the Corsini family.

Tuning up for their harmonious collaboration in the Brancacci Chapel, Masaccio and Masolino created an altarpiece which represents Masaccio's sole surviving altarpiece as such for a Florentine church: the *St Anne Enthroned with the Virgin and Child* (now in the Uffizi), painted for Sant' Ambrogio.

The church was one of the oldest foundations in Florence. Its name commemorates the visit of St Ambrose to the city in the fourth century, and it had the prestige of owning a miraculous relic of Christ's blood. The interior of the ancient building, dating back to the thirteenth century, was to be considerably embellished throughout the Renaissance, and thus a suitable location for a painting where traditional, established elements mingle with the forward-looking.

The St Anne altarpiece, now celebrated, much discussed and analysed, occupies a place in fifteenth-century Florentine painting somewhat comparable to that of Giotto's Ognissanti altarpiece in the previous century – or so it seems in retrospect. Yet it may well have passed without much notice at the time, and nobody appears to have referred to its existence before Vasari did so, only in the second edition of his *Lives*, in 1568. Why the two painters chose to collaborate on it is not clear. Nor do we know what first brought them into association. Strictly speaking, their collaboration on the altarpiece is unconfirmed, and Vasari mentions it simply as the work of Masaccio.

Although study would suggest that two hands did indeed go to its execution, the picture has a marvellous internal cohesion. Its generative theme is expressed in a series of ovoid forms; even its shape is approximately ovoid. Like a graded set of Russian peasant dolls or eggs, the figures of Child, Virgin and St Anne fit one into the other, and the group is contained within the embroidered cloth held up behind them by a trio of angels.

Truly grand is the concept of the aged, hieratic grandmother St Anne, with one hand lightly touching her child Mary, who is seated between her knees, the other hovering in benediction over the head of that child's Child. On her nun-like, scarlet-clad image Masaccio perhaps assisted Masolino, but stylistically, and for all her grandeur, St Anne is a rather more linear and less solidly modelled shape than either the Virgin or the Child. Light and shade sculpt especially forcefully the compact body of the Child – felt as a real, rough, rock-like weight on his mother's lap, and almost rudely naked, his genitals displayed without even a wisp of conventional veiling. In that concept, as in the execution, there is a new, distinct, earthy energy – as if of a Donatello working in paint – which is surely the young Masaccio's.

Masolino descends from a well-established artistic line, from Orcagna down to the Sienese-born Lorenzo Monaco, a monk conveniently and contentedly living in Florence

in the early fifteenth century, but outside a monastery. In sculpture Masolino's equivalent would be Ghiberti, whether or not he had actually worked in Ghiberti's studio. Masaccio, however, seems instinctively to look back singlemindedly — before leaping forward — to a sole artistic ancestor: Giotto.

In a way, the Brancacci Chapel frescoes are Giotto's frescoes in the Arena Chapel at Padua revised and brought up to date for contemporary fifteenth-century Florence. But Masolino's part in them is a useful reminder that no one overall pictorial idiom was current in the city in the first quarter of the century.

Amid the brilliant new talents revealed in the fifteenth-century Florentine firmament, with some shooting stars and the inevitably lesser lights, what is noticeable is how new categories of picture were still slow to evolve. Religious painting was as much the chief requirement then as it had been in Giotto's day. The fresco scheme on the walls of a chapel; the large altarpiece for a church; the small devotional work for a private house — these were the types of picture expected from anyone setting up to be a successful painter. His artistic interests (women painters did not exist) had to be harnessed as best they could to run along the tramlines of old, long-familiar Christian subject matter — an aspect of classically learned, intellectually lively Florence usually overlooked. There was an Inquisitor for heresy active in Tuscany, credulous as well as zealous; and the penalties for anything that could be called witchcraft culminated in beheading or burning at the stake.

It doubtless suited Fra Angelico to remain entirely a painter of religious pictures (which are, however, great as works of art not as mere pious exercises). Fra Filippo Lippi, not quite so unworldly a character, may have sighed occasionally at being compelled to paint yet another decorous Virgin annunciate when his thoughts were straying more towards Venus Anadyomene.

Of course, the painters rapidly learned (or, perhaps, instinctively understood) how to introduce their fresh interests and their observation into the stalest of subject matter. Although the large central composition of the average altarpiece tended to be a static, sometimes slightly dutiful affair, the small scenes in the predella below offered considerable opportunities for lively narrative and varied settings of landscape and townscape. Often enough, the painter's sense of freedom produces predella panels of the greatest originality and beauty, in which his personality may be more apparent than in the main picture.

If Fra Angelico represents the perfect marriage of profoundly religious temperament with painterly genius, he was very far from being blind to the facts of the physical

world, just as he was thoroughly aware of current Florentine innovations in the art of pic-
ture-making. He showed himself to have the potential to be a superb landscape painter,
a promise he fulfilled in the atmospheric, panoramic setting of his big *Deposition* in the
church of Santa Trinita (it is now in the Museo di San Marco). There he also demon-
strated his potential as a portrait painter. Several of the faces of the non-saintly male per-
sonages have a strong tang of individuality, and one is traditionally identified as
Donatello's ex-partner, Michelozzo, architect of the new, enlarged monastery of San
Marco, which Fra Angelico lived in and frescoed.

Had the demand existed, and had he been willing, Fra Angelico could certainly
have supplied portraits and landscapes — as well as no doubt enchanting, half-fairy-tale
interpretations of antique history and mythology — to the Florentine society of his day.
He was perhaps the most poised and stylistically integrated of its painters: able to absorb
the new natural, coherent, scientific ideals represented by Masaccio, Brunelleschi and
Donatello, without jettisoning old ones of crisp line and bright colour. In Fra Angelico's
art the colour has been refined to a pitch of exquisite, expressive intensity, and gold
is used concomitantly with joyful, near-mystic belief in its supernatural properties.
No Florentine painter, except perhaps Botticelli, ever burnished the rays of a halo or
spangled an angel's robe with more love and more conviction.

The artistic climate in which the Brancacci Chapel frescoes were conceived and exe-
cuted was no all-embracing one of clear, committed, programmatic revolution (nor was
Masaccio some early Renaissance avatar of Courbet). Rather was it diffuse, mixed and
somewhat misty, unsettled in an agreeable way that allowed for plenty of variety.

Among the older painters flourishing and fully employed, the most distinguished
was Lorenzo Monaco, painting in his own attractive yet hardly 'advanced' idiom, inno-
cent of any fresh scrutiny of nature and ignorant probably of the latest discoveries about
pictorial perspective. If the metaphor were not too chilly for his art, he might be called
the tip of an iceberg, because Florentine churches continued to be filled by lesser artists
with frescoes and altarpieces in a comparable, delightful, undemanding style — more ice-
cream than iceberg, and in the pale tones of ice-cream.

To complicate and enrich the climate excitingly, there arrived in Florence at this
moment a rare bird — less of passage than of paradise, Gentile da Fabriano. He was a
painter of Lorenzo Monaco's generation but more travelled, more experienced and
tested, and also more sophisticated. Coming from the small Umbrian town of Fabriano,
he had worked in the Doge's Palace at Venice and was to work for Pope Martin V at
Rome. Nearly everywhere he went — including Perugia, Brescia and Siena — he left work,

now sadly destroyed or reduced to fragments. Florence holds a supreme masterpiece almost intact, a civic treasure, commissioned in the city and to become retrospectively part of the city's artistic heritage: the altarpiece of the Adoration of the Magi, painted for Palla Strozzi's family chapel in the church of Santa Trinita (now in the Uffizi).

Masaccio had matriculated in the painters' guild of Doctors and Apothecaries in January 1422 (the same year that Masolino is first definitely heard of as a *pittore* in Florence), and in November the visiting Gentile da Fabriano matriculated – doubtless to qualify for the task in hand (for the church of the district where, incidentally, he was living).

Gentile's patron was then one of the richest – if not positively the richest – of all Florentines. His tax return in the *Catasto* records of 1427 takes up thirty-three folio pages – absorbing reading for the tax clerks. He owned more than fifty farms and more than thirty houses. As well as being rich and powerful, Palla Strozzi was scholarly and intellectual, and had been one of the first prominent citizens to learn Greek and promote Greek studies. Vespasiano da Bisticci describes him as modest and as shrinking from public attention – wise precautions, as Vespasiano recognises, in envy-ridden Florence.

It would be as easy as it is misleading to see in Gentile's *Adoration of the Magi* a rich man's idea of art, realised only too opulently and in a way undemocratically, in a style aristocratic, remote and etiolated, lacking all Masaccio's solid, 'honest', searching humanity. That the *Adoration of the Magi* blazes with colour and is literally encrusted with gold cannot be denied. Most people in Florence probably loved it for those effects alone.

Gentile went on to paint another altarpiece, now dispersed, for another influential Florentine family, the Quaratesi, whose church was San Niccolò across the Arno and who ranked quite modestly in the *Catasto* declaration of 1427, two years after Gentile had moved on to Rome (and the year he died).

The *Adoration of the Magi* altarpiece is a response to being in Florence and is also rich in resonance for Florentine painting. Fra Angelico must have quickly looked attentively at it, and from Gozzoli to Leonardo da Vinci painters dealing with what became a popular subject could find inspiration in the splendid, pageant-like treatment of the theme. Something of its courtly, chivalric air was surely recalled by Uccello when painting his panels of the Battle of San Romano. And a picture by Gentile at Rome moved Michelangelo sufficiently for him to pay the long-dead painter a neat and graceful compliment (recorded by Vasari) that his style as an artist matched his name.

It is most unlikely that Palla Strozzi and Felice Brancacci – very much men of the same class – were consciously patronising opposite trends in painting, even granting that

real opposition exists between Gentile's art and that of Masaccio. Masolino would have appreciated the *Adoration of the Magi* as warmly as anyone, and Masaccio seems to have been happy enough to work in close partnership with him. To admire Gentile da Fabriano's art it was not necessary to paint precisely in his style. Contemporaries like the Italian biographer of illustrious men, Bartolomeo Fazio, could at the same time admire a painting by Gentile and the very different art, more emotional in mood, more naturalistic in style, of the Netherlandish painter, Rogier van der Weyden.

Nor is it necessary to overstate the opposition of Masaccio's ideals to those of Masolino. Across the upper walls of the Brancacci Chapel the two main frescoes, Masaccio's *Tribute Money* and Masolino's *Miracles of St Peter*, do not so much confront as complement each other. They symbolise the mingled, undoctrinaire ethos of the city where — whatever the individual rivalries among certain artists — the general conclusion was doubtless akin to that of the guilds commissioning work at Orsanmichele: you chose Ghiberti or you chose Donatello, and either way you obtained a work of art.

In the case of the two Brancacci Chapel frescoes, complementing may have reached the point of collaboration. It has more than once been suggested that the head of Christ in Masaccio's composition is by Masolino. In Masolino's fresco it could be argued that the coherent perspective scheme of the buildings is governed by Masaccesque thinking. It does not matter. The fact is that once again two masterpieces have been created.

Masaccio's has always, inevitably, been the more famous composition, but it does not follow that Masolino's is reduced to hopeless inferiority. Admittedly, Masolino could not conceive anything as naturally majestic and majestically natural as the group of grave figures gathered around Christ like so many primeval stone presences, moulded by the elements and rooted there eternally. Nor could he match the lakeside landscape they inhabit, with its coldly rippling water and stony, muscular humps of mountains over which the cloud-filled sky hangs so heavily. Very old and half-alien seems that epic world. Although it contains one familiar-looking, Florentine-style house, located strangely on that site, yet beautifully compact and of almost surreal clarity in its three-dimensional voids and solids, there is an overwhelming sense of the scene as set outside the temporal, as well as the mundane.

Nothing like this had been seen before in Florence, but neither had anything like the equally large-scale vision conjured up on the opposite wall by Masolino (see Plate 8): in place of Masaccio's spacious, timeless landscape he offers a spacious, topical townscape — given much of the air of the Piazza della Signoria, idealised but also peopled, and with fascinating vistas in the perspective of streets beyond. All this is in itself an

achievement. And in that city he has united time present with time past. Mediating between the two incidents of St Peter performing miracles are a couple of smart young Florentines, chatting while they stroll in step, wholly contained within their own environment, blithely unheeding of momentous events that happened once and are perhaps being enacted down the ages.

The effect is startlingly different from the well-established convention in painting whereby modern men were among the witnesses to a sacred incident. Masolino allows ordinary daily life to go on regardless, but he also gives some natural, diurnal sense to the supernatural moments. St Peter has not, in fact, yet healed the cripple begging for alms at the left. At the right, the widow Tabitha sits up in an open semi-loggia of a building quite calmly, only her waxen pallor indicating that she is actually being raised from the dead.

Few painters followed Masolino's example so daringly, but that serves merely to underline its boldness. Nor does his treatment trivialise the basic theme. Even if we cannot fully explain what he meant by giving his composition such intensely Florentine connotations, we can at least realise how effective the result is. The remote city of Joppa, where St Peter performed this miracle, has taken on the appearance of early fifteenth-century Florence, with the implication that miracles might still occur, at least in the lives of those who are, as was Tabitha, 'full of good works and almsdeeds . . .'

There is an interesting art-historical aspect to Masolino's composition. His juxtaposition of indifferent modern figures and a biblical scene, set partly inside what is virtually an architectural box, has a germ of the composition of Piero della Francesca's later, more rigorous and more mysterious small painting of the Flagellation of Christ (in the National Gallery of the Marches, Urbino).

We know that this great Umbrian artist was working as a young painter in Florence in 1439. He was one of a new generation of painter-visitors and native painters attracted to and active in a city which was now confidently established as a capital of art and culture. That is the Florence celebrated by Alberti in the dedicatory paragraphs of the Italian version of his treatise, *On Painting*, which praises Brunelleschi, Donatello, Ghiberti, Luca della Robbia and Masaccio. Their achievements were in evidence throughout the city.

Less obtrusively, political achievements had occurred by the mid-1430s, establishing the basis, within a republican framework, for Florence to be effectively ruled by a single family, the Medici.

CHAPTER SIX

'To Florence and God the wrong was done'

As usual, Browning is extremely positive:

> To Florence and God the wrong was done,
> Through the first republic's murder there
> By Cosimo and his cursèd son.

In his impatient way, he brushes aside any lingering respect for Cosimo 'il Vecchio' de' Medici, to whom Florence had awarded at his death in 1464 the unique title of *Pater Patriae* (Father of the Fatherland). Browning is of course writing not history but a poem, 'The Statue and the Bust'. He might have found it difficult to explain exactly why Cosimo's son, Piero, who succeeded him as effective ruler of Florence, was to be singled out as 'cursèd', unless for reasons of alliteration or metre, and later in the poem he asserts, equally positively and cheerfully, that a crime will do to show commitment to life ('Let a man contend to the uttermost/For his life's set prize, be what it will!').

Browning's attitude, however, expresses a typical mid-nineteenth-century liberal view of what Cosimo de' Medici and his immediate descendants had done to the Florentine republic. It is a view very much coloured and perhaps partially confused by generous sympathies with the ideal of liberty and by a consciousness that a non-united Italy continued to suffer from autocracy and foreign domination. A few yards from where the Brownings lived in Florence, an Austrian Grand Duke of Tuscany was reigning from the Palazzo Pitti.

Leaving God out of the matter, later historians and other scholars have realised that questions of Cosimo's actions and intentions, and the degree of 'wrong' he may have done to Florence, are a good deal more complicated, even if they will never become entirely clear. He himself would no doubt have been pleased to know that the secret springs of his conduct, as of his character, remain largely hidden. Whatever he spent or gave away in terms of money, he gave away virtually nothing about his inner self. Yet

Cosimo de' Medici was for thirty years an immovable, fundamental fact of Florentine life, wealthy and famous and powerful to a combined degree unique for any individual in the city. Praised or vilified, supported or plotted against, he simply went on consolidating not merely his own position but that of his family. For all his farsightedness, however, he could scarcely foresee one of history's neatest tricks: that a second Cosimo, his great-great-grand-nephew, should become the ruler of Florence within three-quarters of a century of his death and found a dynasty that went on ruling there until 1737, keeping as an annual public holiday the birthday of himself, Cosimo 'il Vecchio'.

The first man in Florence in his day, Cosimo de' Medici is also the first man in Florentine history to survive as a complex, many-faceted yet distinct personality who can be discussed as a businessman, a politician, a humanist, a patron of the arts and a vividly 'human' human being. His discreet exercise of power, his attitude to religion, his collection of books, his shrewdness and caution, his lack of ostentation, his terse speech and dry 'Tuscan' wit — all are topics which contribute to the portrait, and most of them are already present in Vespasiano da Bisticci's sympathetic and intimate study of him. It is from Vespasiano that we know that the only game he enjoyed playing was — characteristically — chess. Vespasiano can describe at first-hand going out to the Medici villa at Careggi one February, to discover Cosimo pruning his vines each morning before settling down to read St Gregory the Great's *Moralia* ('an excellent work', as Vespasiano purringly puts it, 'in thirty-five books'). There are also things which Vespasiano was scrupulous not to say. He could not praise Cosimo for personal beauty, unlike Palla Strozzi. Nor, while stressing Cosimo's knowledge of Latin, could he speak of him as a scholar of Greek, again in contrast to Strozzi.

With so much information available about so resolutely un-grand, intelligent, active and central a figure on the Florentine scene, it seems at first odd that Cosimo de' Medici should remain somewhat opaque and ambiguous, and perhaps somewhat repellent too. But there are good reasons for being unable to reach any clear-cut view — not least of Cosimo as just hero or villain. His career, like his political and artistic patronage, was predicated upon enormous wealth (and Vespasiano testifies interestingly to his prickings of conscience about how some of that had been gained). Without wealth he would not have had his network of local supporters (nor his papal connection) nor anything like the prestige. His personal lack of ostentation was effective simply because it was widely known that he could afford to be ostentatious beyond most men's dreams. It is a device the very rich have continued to use, and it rarely fails. It helps counteract envy — to Cosimo a matter of near-obsessive concern — and enhances a reputation for thrift,

supposedly an exemplary trait. Still, Cosimo built a family palace that was as a statement dangerously princely.

There is also the allied matter of ambition. It is hard to believe that a scholarly merchant banker turned into a wily and immensely powerful politician by chance or by the sudden pressure of events. Cosimo may not have murdered the Florentine republic, which in constitutional fact was not suppressed. He was always careful to indicate that he was not and could never be the city's dictator. He was no bloody, dissipated tyrant. Nor did he keep a court or army. His aims for Florence were broadly neutral and broadly peaceful (though he hankered after the conquest of Lucca). Yet perhaps he was not the city's saviour either, and some sort of oligarchic government might have successfully muddled on – while ordinary people went on living and artists went on working – had he never returned from exile in 1434.

One final obstacle to seeing him with real clarity, apart of course from the sheer distance in time, is the legend of Cosimo 'il Vecchio' – old indeed, it seems, from the moment he makes any appearance, older than his actual years, grave and gaining maybe from the associations of age with wisdom and experience and rueful acceptance of life's blows. The legend provides plenty of anecdotes to show Cosimo as a human personality, but it is noticeable that this personality accords almost too patly with a quintessential Florentine type, to which Giotto (ugly, gifted, commonsensical and salty of tongue) had conformed.

It is as though Cosimo, who certainly had a profound perception of his fellow-citizens' nature, knew not only how to guide them politically but how to tailor his own image to fit their concept of the ideal citizen. It may be unfair but a sense lingers of being manipulated, especially as a good many of the best stories about Cosimo come from pro-Medici sources. In an unobtrusive way, they help to heroicise him, even while apparently humanising him. He becomes a sort of folk-hero, earthy, pithy, ready-witted – never at a loss, never over-awed, never less than the victor in a verbal exchange, whether with a peasant or a pope. He is seen as inscrutable – a useful quality in any leader – but not lofty. He underplays his role in Florentine affairs, and although Vespasiano must presumably have really found him pruning his vines at Careggi, the incident almost suspiciously recalls Livy's story of the Roman dictator Cincinnatus found at the plough. What seem typically Florentine are his family values. Anecdotes suggest an indulgent grandfather but not quite so amiable a husband, something of a fifteenth-century anticipation of Jane Austen's Mr Bennet in exercising his wit upon his wife, whose place in his life was in any case less as a companion than as a housekeeper.

No anecdotes and hardly any facts exist to illuminate the early, youthful years of

Cosimo 'il Vecchio'. Those years were probably formative in several ways, for the key figure in the shaping of his life and character is likely to have been his father, Giovanni di Bicci de' Medici, who did not die until 1429, by which time Cosimo was forty. It was Cosimo's father who set the pattern, established the basis and accumulated the means for the family to move decisively on the Florentine chess board. A pet Medici scholar and philosopher of the mid-fifteenth century, Marsilio Ficino, expressed the matter in a more fulsome manner, inebriated with his own rhetoric. Like a second Abraham, Giovanni de' Medici seemed to have received a promise from Almighty God, 'Thy offspring, O Giovanni, shall enlighten the age . . .'. The rather hyperbolic analogy may have been prompted in part by the fact that Brunelleschi's bronze relief of Abraham sacrificing Isaac was then in Giovanni's sacristy at San Lorenzo. Giovanni's character, in so far as it can be distinguished, is in the same image as his son's: shrewd, cautious, reticent and not publicly self-seeking – acting as no aristocrat but as a bourgeois businessman, doing his duty by his bank, his family and his city, probably in that order, not omitting to place them in an overall Christian context, rather as he placed his children under the patronage of certain saints.

Giovanni di Bicci de' Medici was not eloquent or impressive as a speaker and professed a wish to concentrate on his successful business affairs, which he recognised (according to one contemporary chronicler) to have raised him above other citizens. This appreciation of the advantages of wealth was deepened by the experience – not felt by his immediate descendants – of having once been poor. He can have had only a rather elementary, practical education, and yet to see him as a narrow-minded, culturally unenlightened merchant-banker of the old Florentine type seems likely to be a mistake. For one thing, he had travelled and worked outside the city – in Rome and Naples and Venice – and may have looked at the odd local monument, for instance, when he was not looking into local accounts. His two sons, Cosimo and his younger brother Lorenzo, were given a humanistic education of a profound kind (one that took permanent hold of them both). Cosimo's study in his father's house in 1417/18 contained sixty-three books, including, suitably enough, a Latin life of Saints Cosmas and Damian, and some of these belonged to Lorenzo. Giovanni di Bicci could perhaps read no more than two words of Latin, but his household was in effect sheltering scholarship; and his was the money that had given his sons the possibility of indulging in the collecting and commissioning of books. At least one other contemporary Florentine, the notary father of the youthful humanist Pietro di Ser Mino, opposed his son's pursuit of such knowledge because it was not lucrative – hardly a problem to trouble Cosimo and Lorenzo de' Medici.

As a very rich, and therefore highly respected citizen, Giovanni di Bicci was liable to be drawn, regardless of his private interests or expertise, into serving as a judge, or a juror, or as one of the *Operai* on some of those schemes for the betterment of Florence which we tend to see primarily in aesthetic terms, but which had often an initial practical aspect, from which any 'art' followed. We admire the exterior effect of Brunelleschi's Ospedale degli Innocenti (although 'improved' to its detriment and the architect's annoyance by a certain Francesco della Luna), yet it was built not just to be a graceful loggia — or an architectural 'statement' — but as a charitable asylum to care for foundlings, as it long continued to do.

Charity and piety and worldly prestige, whether civic or personal, along with the never-to-be-forgotten prospect of the next world, were the driving forces that sometimes — as in an ecclesiastical project — mingled to the point where no one can now disentangle them. The churches and palaces of the fifteenth century would have gone up even if the results were later to be judged artistically deplorable; and as it is, the palaces are perhaps more monotonous and restricted in their character and beauty than is often recognised. As statements they are certainly as much about their owners as their architects. The truths of patronage were well expressed by a rich man who was also a great artistic patron, Giovanni Rucellai, reflecting happily in mid-fifteenth-century Florence (a period and place in which he rejoiced to be living) on the pleasure he obtained from his various commissions: 'they serve the glory of God, the honour of the city, and the commemoration of myself'. To see what he means one has only to look at the handsome façade of the church of Santa Maria Novella, completed for him by Alberti. Across that marble façade, in large capital letters, runs no dedicatory inscription to God or the Virgin but the name of Giovanni di Paolo Rucellai, commemorated permanently, publicly and — for his century — uniquely. None even of the early Medici, scattering their devices and arms on buildings and artefacts, cared or dared to leave quite so assertive a signature on anything they commissioned.

Giovanni di Bicci was in no sense a patron of Rucellai's calibre. Compared with his two sons, especially the longer-lived Cosimo, he appears on the whole dubiously interested in 'art'. Yet compared with his shadowy father he appears far more concerned and involved — having the advantage, of course, of living in an age when Ghiberti, Donatello, Michelozzo and Brunelleschi were available to carry out commissions for a patron. Conceivably, he was the first Medici owner of the large antique carnelian, the so-called 'Seal of Nero', for which Ghiberti describes creating an elaborate, fantastic setting (now lost, though the gem itself survives in the Museo Nazionale, Naples). As the friend and

a chief executor of the deposed Pope John XXIII, Giovanni di Bicci employed Donatello and Michelozzo on the tomb in the Baptistery, which he may yet have looked on as fulfilment of a pious duty rather than as a work of art.

Unlike Felice Brancacci, he commissioned no fresco series — and never, as far as we know, employed Masaccio or Masolino. Unlike Palla Strozzi, he ordered no sumptuous altarpiece from Gentile da Fabriano. Painting, as such, may have held little interest for him, but then he had inherited no family chapel to adorn. Broadly, an interest in painting is more sporadic than developed among his immediate descendants, although they did commission some great pictures (by Fra Angelico and Uccello, for instance), even while their personal tastes inclined more perhaps to books, tapestries, *objets d'art*, antique or modern, and gems. Pictures of a kind, chiefly devotional, were in Giovanni's palace in 1417/18. Among them is mentioned a large altarpiece which interestingly depicted Saints Cosmas and Damian, unfortunately without the painter's name being given. Cosimo's own suite of rooms contained a *desco da parte* (one of those 'birth plates' which it became a fashion in fifteenth-century Florence to present to a mother following the birth of a child and which were often painted by good artists) with a complete picture. As Cosimo's elder son, Piero, had been born just a year or two previously (in 1416), that 'plate' may have been a present for the occasion.

One artist-craftsman-sculptor who specialised in comparable decoration was Dello Delli, noted for painting furniture. Vasari speaks admiringly of some specimens of his work still remaining in the sixteenth century in Florentine houses, though outmoded as furniture, and he states that Dello had painted the entire furniture of one room 'for Giovanni de' Medici'. If, as is sometimes assumed, he was referring to Giovanni di Bicci, the work had been given to a very young artist, since Dello left Florence in 1424, aged no more than twenty-one, and returned only years later, long after Giovanni di Bicci's death. It is perhaps to his grandson, Giovanni, Cosimo's younger son, that Vasari referred.

All that is at best tentative and marginal. The exact opposite is true of Giovanni di Bicci's concern (in which surely mingled all the motives Giovanni Rucellai was to list) with his local parish church, the ancient, venerated foundation of San Lorenzo. There can be no doubt that it was he who took the first steps in the process by which, fostered by generation after generation of the family, the church and adjoining buildings became overwhelmingly Medicean. The church ceased to be 'local'. It was now central to the city and the state. Felice Brancacci's chapel and even Strozzi's patronage at Ognissanti were in effect knocked out of the competition. The two men themselves were also knocked out by the political rise of the Medici, although Strozzi's son returned to the city to build one

of the greatest of all palaces and reassert the family tradition at another church, Santa Maria Novella, with which the Strozzi had been connected since 1319 (at a time when the Medici family was relatively minor and comparatively modest in status and wealth). The Brancacci faded away. In the sixteenth century the Strozzi and the Medici clashed again, and again the Strozzi were defeated and dispersed, some of them this time leaving Italy altogether. There could be no continuing patronage from that source. The Medici were established as masters of the city artistically as well as politically, and San Lorenzo went on being the focus and physical expression of the family's dynastic achievement — all under God's eye. Perhaps Marsilio Ficino's rhetoric about Giovanni di Bicci as a second Abraham was not as impudent and excessive as it might seem.

When Giovanni di Bicci chose the name Lorenzo for his younger son, born in 1395, he forged the first link in the chain of connection between his family and their local church. His own patron saint was St John the Evangelist (not the Baptist). For his two sons he selected names previously unused in the family but which would thenceforward be repeated over and over down the centuries, sometimes to a confusing degree. Cosimo itself was perhaps an unusual name in Florence in the fourteenth century. Cosimo 'il Vecchio' was not, apparently, born on the saint's feast-day, but that day became his official birthday. The obscure doctor saints, Cosmas and Damian, martyred at some early, unknown date, seem always to have been traditionally looked on as protectors of the Medici (perhaps originally because 'Medici' means 'doctors'), and they are the last two saints in the small, select company invoked by name in the Canon of the Mass.

St Lawrence's name occurs there too, and in the young Lorenzo de' Medici's room in the family palace in 1417/18 was a picture of the Madonna covered by a curtain on which were painted two large images of his patron saint. By that date his father's direct involvement at San Lorenzo had been established for more than a decade.

Giovanni di Bicci emerged — probably with due caution — into public life only as the fifteenth century got under way. In 1402 he was elected for the first time to the *Signoria*. He went on his first embassy, to Bologna, in the following year. By 1405 he was one of the three local syndics elected to nominate four *Operai* to serve as a board or committee raising money and overseeing the fabric of what would become a new church of San Lorenzo. These people were all laymen. That was the shrewd, Florentine way of getting a religious building scheme financed. Those who served as *Operai* and so on were likely to be prepared — often to want — to become patrons, sponsors and effectively owners of an altar or an entire chapel for their family.

Giovanni di Bicci was probably the richest man in the neighbourhood. His status

virtually required the acquisition of a family chapel, something the Medici previously had conspicuously lacked (as far as one can tell). So it was not pure or at least disinterested piety that impelled him to become involved in supporting the re-design and enlargement of San Lorenzo. For most of the remainder of his life he continued to serve on the church committee, and increasingly became the dominant patron of the new church (partly because only a few other families came forward or were able to sponsor chapels in it).

The area of the high altar was not of course available for lay patronage, but Giovanni di Bicci obtained a key area, a new sacristy-chapel – a complete room – which must early have been destined to be the burial place of himself and his wife, and which was dedicated to St John the Evangelist. To build that space, encroaching on ground to the south of the old church, houses had to be demolished, as indeed they had elsewhere when the new design began to be implemented. For that, government approval was needed and forthcoming, which suggests another reason for having prominent, influential citizens on a building committee. Yet a sort of democracy, or a skilful exercise in public relations, was also at work, for the committee of parishioners in 1416 ranged from Giovanni di Bicci to a certain Lorenzo di Andrea, who was a local butcher. However flourishing his business, Lorenzo di Andrea cannot have aspired to fund or found a chapel of his own in the grand new church of his patron saint, but he could speak up for the lesser people in the area and was perhaps on the committee to make suggestions about dispensing charity (which was one of the concerns of the *Operai* in the year he was elected).

Meanwhile, Giovanni di Bicci took on responsibility for a further chapel, a large double one close to the sacristy, one which either already was or became dedicated to his elder son's patrons, Saints Cosmas and Damian. Thus, in territorial terms alone, he advanced the family's hold on the new San Lorenzo. What can be called 'his' sacristy was in existence a year before his death. He was to receive a public funeral – itself some indication of his standing in Florence and paid for, with a modest outlay, by the state. No fewer than thirty male members of the Medici family followed the coffin. For his sons remained the duty first of having his tomb suitably executed and then of continuing to support, indeed foster, developments at San Lorenzo.

The architect of the new church, chosen or accepted by Giovanni di Bicci, was a new and untried genius, Brunelleschi, whom the parishioners of Santo Spirito, on the other side of the Arno, would later call in to design their new church. At San Lorenzo Brunelleschi began with Giovanni di Bicci's sacristy – a first masterpiece of his style,

which Cosimo de' Medici was to have enriched by Donatello and which a poem written in honour of Cosimo would praise as not only so beautiful and so wonderful but so joyful ('*sì giulìa*').

It was doubly if not triply appropriate that into the altar added to the sacristy should be inserted Brunelleschi's bronze trial relief of the *Sacrifice of Isaac*. It seals association of the church's architect with the church's chief patron, and by a work of art created for a public competition but now acquired by a private owner (perhaps slyly indicating a preference for what had notoriously been rejected). The subject of the relief takes on fresh significance as applied to the patriarchal figure of Giovanni di Bicci, a second Abraham, assured of the same promise God had made to the first through the mouth of the angel at the scene of sacrifice: 'I will multiply thy seed as the stars of the heaven . . . and thy seed shall possess the gate of his enemies.'

Wealth, civic status, a strong stake in the conduct of public affairs, a prosperous business, a family mausoleum and virtually a church, and a sense of being placed under divine patronage favoured by tutelary saints, while being an enlightened patron on earth – these were all legacies in the substantial bequest made by Giovanni di Bicci to his heirs. Above all, he left them a supreme example of how such things could be not so much conserved but used, built on and expanded, in a thoroughly approved, biblical way: 'because the Lord thy God shall bless thee in all thine increase' (Deuteronomy).

T HE DEATH OF Giovanni di Bicci created no immediate, obvious ripple in Florence, once his public funeral was over. In Machiavelli's *History* he makes an improbably eloquent dying speech to his two sons, declaring that he dies content, knowing how rich, healthy and respected he leaves them, and also exhorting them to live as he has done, avoiding envy and danger by taking a share in state affairs only as allotted by the law and their countrymen. He is naturally silent about whether and how those countrymen can be influenced or guided – or bribed.

The Medici family firm was consolidated, made effectively a company, in the names of Cosimo and Lorenzo, who took on a twin-like unity, linked commercially and personally, in terms of patronage and charity and possibly also as collectors. They were matched if not in character then certainly in scholarly, humanist interest, where Lorenzo was conceivably the more erudite. At a period when brother was often opposed to brother (as in the rival Albizzi family), the concord of the two Medici brothers must have been notable. Although Lorenzo has now disappeared from general public consciousness

(disappearing from life prematurely in 1440), he was firmly associated with Cosimo, not least as donor and patron and dutiful son. Jointly, in a private gesture, they donated books to a convent. Openly and proudly, their names are inscribed (unusually, at the beginning of the inscription) on the tomb they built for their parents: 'Cosmus et Laurentius de Medicis . . .'

Thanks to Giovanni di Bicci's adroit negotiations, both of them were advantageously married to women from established, highly respected families, poorer than the Medici but socially superior. It was the start of a series of marriage alliances that would culminate in two Medici princesses crossing the Alps to become queens of France, while their daughters in turn married Philip II of Spain and the future Charles I of England.

Both Cosimo and Lorenzo were fathers of sons old enough to walk in the family procession that followed Giovanni di Bicci to the grave. And both were more than prepared to play their part in the conduct of government, with Cosimo doubtless always the more active and politically 'engaged' figure. The pro-Medici faction or party crystallised around a clever, ambitious personality, Puccio Pucci, almost a creature of Cosimo's, who was rising socially – as once had the Medici – from complete obscurity and, in his case, a very humble background in trade. He belonged to a minor guild, was first married to a mercer's daughter and had possibly practised as a smith of sorts. In the one generation, his own, and by his skills as orator, politician and financial speculator, his family rose far and fast. There were to be few subsequent cases of such rapid social mobility in Florence.

The later Pucci owned an oratory at Santissima Annunziata (for which Pollaiuolo painted the big altarpiece of the *Martyrdom of Saint Sebastian*, now in the National Gallery, London) and built a large-scale palace or palaces, symbolically close to that of the Medici built by Cosimo, though in a different street. Medici patronage, along with the vital fact that the Medici ultimately triumphed, did much for Puccio Pucci. At the same time, he had done much for them, not least perhaps in deflecting attention from whatever might be their ambitions and by gathering 'democratic' adherents around himself. He remained Cosimo de' Medici's faithful henchman for three decades. When the long-brewing power-struggle between the Medici faction and that of the oligarchic nobility, led by Rinaldo degli Albizzi, broke into open antagonism in 1433, and the Medici and their partisans appeared decisively defeated, Pucci received the same sentence as Cosimo – a ten-year banishment from the city. Lorenzo de' Medici, however, was banished for only half that duration.

Although there was high drama in Florence in the autumn of 1433 – Cosimo was briefly imprisoned and in some danger of being formally sentenced to death – there was

no fighting in the streets. Compared with the old methods of the Guelphs and the Ghibellines for settling accounts with each other, the conduct of the Albizzi faction was almost decorous, its outcome unstained by blood, and arrived at ostensibly in the name of the *Signoria* and the republic.

It is quite likely that a majority of the inhabitants were slow to grasp what exactly had happened – or did not grasp it fully. Much like the ordinary citizen of most cities today, though with far greater excuse, the average Florentine, male and female, may never have understood the city's constitution – a subject which is indeed sufficiently complex to require complete books from modern historians. In retrospect, we may equip each citizen with 'Renaissance' intellect and semi-legal powers of explication, fully conversant with the exact distinctions between the *Collegi* and the *Consigli* and the *Balìe*, and able to define what the role was of the *Gonfaloniere di Giustizia*. In reality, most people probably lumped those bodies and the *Gonfaloniere* together as 'government', and mentally and physically stayed within their own quarter – not stirring unless summoned to the public assembly, the *Parlamento*, in front of the Palazzo della Signoria. Even on those important occasions, perhaps because they were important and thus might overawe a simple or timid man, there was a tendency for only a small group of citizens to appear. Nor did every person elected to an office necessarily possess the mind of a proto-Leonardo da Vinci. Many were probably nearer the level of the constables and comparable civic personages in Shakespeare's comedies – such as Dogberry and Dull, who stagger muzzily through his Messina and Navarre.

During the period from Giovanni di Bicci's death until the year of Cosimo's imprisonment and exile, the inescapable major fact that loomed for everyone in Florence was the war with Lucca, a war unpopular and unproductive. Rinaldo degli Albizzi weakened his own position by violent advocacy of it and subsequent failure to secure a Florentine victory. Nothing seemed to go right for the republic. An ingenious plan of Brunelleschi's to flood the countryside around Lucca and isolate the city proved less than successful. A minor encounter with Sienese troops at San Romano had to be treated as a tremendous battle (later commemorated for the Medici in Uccello's three pictures), celebrated in Florence as a morale-boosting triumph of 'our' forces. When peace came, it was a relief. No one, however, a contemporary noted, was happy, except the very poor.

Yet all the while life in the city went on at its various levels. Not everyone was as notoriously aloof from public affairs as Niccolò Niccoli but equally not everyone of standing was a politician or concerned with government. Nor was every humanist exclusively concerned with ancient literature as such. A friend of Niccoli's, and at least a

friendly acquaintance of Cosimo de' Medici's, was Paolo dal Pozzo Toscanelli, distinguished as a scientist and mathematician, astronomer, astrologer and geographer. His culture was impressively wide, to judge from the fact that Alberti dedicated to him a book of satires modelled on those of the ancient Greek philosopher Lucian. Toscanelli, who did not die until 1482, at the age of eighty-five, was a figure famous and influential beyond Florence, and his own view of the physical world extended excitingly towards the East. He was even alleged to have exchanged letters with Columbus, who may really have seen a map devised by Toscanelli opening up new geographical prospects. At home, Toscanelli is recorded (by Manetti) as admiring Brunelleschi's intellect.

As well as secular humanist scholars there were men like Ambrogio Traversari, a Camaldolese monk and a friend of Niccoli and of Cosimo de' Medici, an earnestly Christian humanist much respected in Florence by men who included Rinaldo degli Albizzi (himself not to be automatically written off as uncultivated, or indeed unpatriotic, because he lost out eventually to the Medici and has suffered a loser's fate in history generally). In 1433 Traversari was to be plunged into events as an envoy between the imprisoned Cosimo and Rinaldo degli Albizzi, and he left a record of his conversations with them both.

An interesting exact contemporary of Cosimo de' Medici, and also his friend, was the saintly Antonio Pierozzi, a Dominican friar who became prior of the convent of San Marco (Fra Angelico's convent and a foundation benefiting greatly from Cosimo's patronage) before becoming Archbishop of Florence. He is on the way to canonisation already in Vespasiano's *Lives* and was to be canonised, as Sant' Antonino, some sixty years or so after his death. His was an ascetic yet far from withdrawn attitude to the problems of the world and daily existence in Florence. A theologian, an ecclesiastical reformer and partly a social one, as well as an exponent of practical charity, Sant' Antonino seems to have been a rare example of the truly good man. And in certain ways, he seems to anticipate another fifteenth-century Dominican at San Marco, Savonarola.

The future saint had a stern message for the rich: that Divine Providence had not given them abundance to dissipate it, 'in dogs, falcons and horses, extravagant dress, games and banquets . . .' Rather, they were to give, after their own needs were covered, to God's poor. Yet although he bestirred himself about the exploitation of textile workers, for example, his message for the poor was conservative even in its sympathy: Divine Providence permits some people to lack temporal goods, and patience in poverty leads to eternal life. At the same time, his activities and his positive reaction to helping the poor, especially those shamed by their poverty (a natural feeling in a city where wealth was so

widely respected and equated with success), point to that stratum of society which very much existed all around in Florence but which conventional history long ignored.

On being met, he would probably not have burst into enthusiastic discussion of his 'enlightened' age or the contemporary artistic miracles of Ghiberti and Donatello (or even of Fra Angelico) but deplored the plight of many ordinary people in what was meant to be a civilised and Christian city, and indicated how it could be, indeed ought to be, eased. He seems to have disapproved of ostentatious charity, and his own severely frugal lifestyle demonstrated commitment to what he preached. He was something of a conscience for the rich and something of a rebuke to the run of Renaissance archbishops and other prelates, not to mention popes.

In the politically memorable year of 1433, when there was first an end to the war with Lucca and then the sudden banishment of Cosimo de' Medici and his adherents, other less momentous events occurred and were probably gossiped about in Florence. The *Signori*, 'the lord priors', may themselves have found it easier to frame a statute or condemn a vice than to puzzle their heads over the Duke of Milan's foreign policy and the intentions of the Venetian republic.

As more than a moral duty – a pleasure – must have come 'mature deliberation', as it was solemnly termed, about the curbing of excessive female dress and ornament. Every Florentine male was an authority on that. The Priors agreed that 'women were created to replenish this free city . . . and not to spend gold and silver on clothing and jewellery'. This 'problem' had often occupied Florentine officialdom, and the records show a degree of pettiness that now seems quite funny, as well as ironic in a city famous for its cloth and silk merchandise and its jewellers. In 1378 a certain Nicolosa Soderini had been prosecuted and fined for wearing a dress made out of two pieces of silk, with tassels and bound with black leather. She was aged ten. In 1433 new dress regulations were approved and confirmed with almost a snarl in the wording about 'the bestiality of women'.

More constructively, there was action against gambling, often openly conducted in a piazza or street. Vespasiano da Bisticci described how Sant' Antonino actually overthrew some gambling tables when he noticed them one afternoon, and the gamesters were suitably chastened. The tribunal of the 'Defenders of the Laws' learnt in June 1433 of various gambling sites in the city, where the players included a barber, a horse-dealer and a painter (Piero di Donnino). Sometimes a tavern was the inevitable location, and there were complaints of loaded dice and blasphemous language. More than a decade later, the particular complaint about a gambling den in the Via de' Servi, leading to the church of Santissima Annunziata, was of the scandal caused, since so many foreigners

came to Florence and all wanted to visit the church – and saw *en route* the throng of gamblers. A certain poignancy attaches to the organiser of the den, Francesco di Gaddo, reported to be 'when he wants to work a first-rate shoemaker'.

In 1432 a new magistracy had been created, entitled the 'Officials of the Curfew and the Convents', whose business was specifically to deal (not for the first time in Florentine legislation) with extirpating sodomy and with preserving purity among nuns. How successful its efforts were in both areas is doubtful. By a wise provision, it had no power to declare any individual guilty without a confession or evidence from witnesses, though 'public knowledge' was evidence, and secret denunciations and accusations were encouraged.

Some incidents that Boccaccio might have liked to put into *The Decameron* are documented among the cases that arose. A certain Michele di Piero Mangioni, employed as a mason, gained access to a convent in San Miniato through his work and started an affair with a nun. When he decided to confess his sins to an Augustinian friar he ingeniously disguised himself as a fellow-friar, and in that habit managed to enter the convent again. The story suggests that the case of Fra Filippo Lippi, who really was a friar and did successfully run off with his chosen nun, was not unique. Michele di Piero Mangioni's story had its happy or at least peaceful ending, for although fined and imprisoned, he was released and made a pact with the abbess and nuns of the relevant convent. A touch of tolerance, possibly even of admiration, can be detected in the treatment of him. Rogue male though he might be, he had shown his share of Tuscan shrewdness and initiative. The abbess herself – one can't help suspecting – was not unamused.

Less agreeable fates were reserved for sodomites, especially molesters of boys, whose final punishment could be of Dantean ferocity: burning at the stake. There were lesser punishments – in the form of fines – for first, second and even third offenders; and the additional punishment of being ineligible 'for a period for all offices of the Commune' may not have been quite such a deterrent as the government supposed. But anyone just suspected of the vice was not to be voted for in elections, according to the legislation, and that seems to open the way for a good deal of gossip and insinuation and slander. Between those who actually were homosexual in Florence – a distinct proportion of the male population at several periods, it would appear – and those who were suspected or accused of being homosexual, not all that many men can have emerged unscathed. Among those who seem to have done so are the members of the Medici family during the early Renaissance. Cosimo 'il Vecchio' was even able to make a joke in public about buggery to a member of the Salviati family, someone notorious for his homosexuality but described as otherwise 'prudent'.

The action of the rare saint and the more common spectacle of the sinner, the presumed sinner, and generally the dress and conduct of one's neighbour – and one's neighbour's wife – were by no means the sole topics of gossip or preoccupation in Florence in the period leading up to the drama of Cosimo's expulsion in 1433. Although it may not be apparent in detail how the poorer classes suffered, nobody – the rich least of all – can have been ignorant of the strained and partly perilous economy of the city. The war against Lucca was enormously expensive. Taxes had to be raised, and some rich men borrowed money at high interest to meet them. Some bankruptcies occurred, Palla Strozzi's among them. Other prosperous citizens had lent money to the state which was not always repaid. The chief mercenaries employed by Florence to fight on its behalf demanded – and received – huge sums of money. Niccolò da Tolentino alone had cost more than 50,000 florins by the time peace was signed at Ferrara in May 1433. The full sum expended on mercenaries' wages in single earlier years of the war (records do not survive for the later ones) ranged between approximately 400,000 and 550,000 florins. Some relative light is thrown on these amounts by noting that in 1429 the Guild of the Calimala declared that it was paying Ghiberti (working on his second pair of Baptistery doors) 200 florins annually. That was clearly a generous salary and, incidentally, not Ghiberti's only source of income. Around 1480 it was calculated that a married couple with three or four children could live 'civilemente' in Florence for about 70 florins a year, and that a large quantity of people were doing so.

Uniquely placed, and cushioned against penury or even financial inconvenience, was Cosimo de' Medici, the richest man in the city and likely to remain in that position. His vast wealth was the prime, dominant fact about him, and everything that happened in his life derived from it. However remarkable his character, it is most improbable that he would have been heard of in history had he not been very rich. As other colossally wealthy people have found, up to our own day, huge amounts of money present problems, not least of what to do with the excess of it.

Cautiously generous as he learned to be, Cosimo de' Medici could hardly have avoided the status, prestige and potential exercise of power with which sustained wealth equipped him, unless he had literally followed Christ's injunction to the man of great possessions and sold all he had and given it to the poor. The Church itself set the best example of ignoring that precept. It was from his surplus, after handsomely providing a lifestyle of homes and estates for his immediate family, that Cosimo as 'first citizen' made charitable donations to the indigent and impoverished, sometimes half-unconsciously revealing his means by donating more than was conventionally expected. Ten barrels of

his favourite wine and twenty-five lambs constituted a gift of his in May 1444, as if in celebration of a near-decade of effective ruling in Florence. Giving on that scale was itself a confirmation of his own wealth and unique position. Whether he intended it or not, the recipients – grateful and hopeful – became bound to him as his subjects.

In 1433 the situation was fluid and very different. Once the war with Lucca was over, the fragile, uneasy consensus within the ruling circle ceased to exist. Florence could now go to war with itself. An inglorious peace had left nobody content, and the summer climate in the city was, at least metaphorically, heated and unsettled. Cosimo de' Medici withdrew to one of his country estates, in order to avoid (he himself records) the quarrels and factions. Like many another Florentine, he compiled some *ricordi* of events in his life for the benefit of his family.

Unfortunately, no comparable memoirs seem to have been left by his chief opponent, Rinaldo degli Albizzi, who used the summer months to manoeuvre people and events on the local chessboard in preparation for a sweeping, final victory over the Medici and their adherents. The Albizzi have not had much luck in terms of reputation or survival – except for a handsome street, the Borgo degli Albizi (sic) in the area of Florence where the family had been established since the twelfth century. One Albizzi palace still exists there but Rinaldo's own palace in the street was taken over by another family and remodelled – and he would not be pleased by the bust of Duke Cosimo I de' Medici on its façade. Except for its seventeenth-century portico, the Albizzi church of San Pier Maggiore no longer exists. Books on the Medici naturally abound, but the Albizzi appear to be waiting vainly for their story to be told by any modern, sympathetic historian.

Rinaldo degli Albizzi provides a compelling example of someone winning a battle and losing a war. Aristocratic, haughty, choleric and violently anti-Medicean, he may appear the stereotype of a narrow-minded conservative pitted against liberal, vaguely democratic and somehow 'good' Cosimo de' Medici. Perhaps he was what we would call a snob, and a reactionary too, but he was also a patriot. He was older than Cosimo de' Medici, and his family was old in service to the republic. His father, Maso degli Albizzi (who died in 1417), had been an able, upper-class political leader, whose ideals no doubt shaped Rinaldo as his heir, much as Giovanni de' Medici's shaped Cosimo's. Rinaldo degli Albizzi may very well have believed that the Medici, in the person particularly of Cosimo, represented a threat to what he saw as the essence of the Florentine state. And no one can be absolutely sure that he was wrong.

Rinaldo degli Albizzi certainly 'fixed' things for the autumn of 1433. Among his more adroit minor moves was paying off the debts of a potential *Gonfaloniere di Giustizia*,

Bernardo Guadagni. The *Gonfaloniere* (Standard-bearer 'of justice') was one of the nine priors and an evocative symbol as protector of the people, with powers to summon them to a *parlamento*. Guadagni was disqualified for election because of his debts. Albizzi money solved that problem, and somehow Guadagni's name emerged as the newly elected *Gonfaloniere*. He thereupon advised Cosimo de' Medici to return to the city 'for some important decisions' (as Cosimo described them in laconic understatement).

The really important decision was revealed when Cosimo visited the Palazzo della Signoria on 7 September, for about the third time after his return, and found himself arrested. In his own terse and stoic account of the sequence of events, which culminated in his banishment from Florence to Padua for ten years, he does not mention the speech, half-boastful, half-pleading, which he made before the *Signoria*, asking them to ask their soldiers how often their wages had been paid 'by me . . . out of my resources' ('*da me . . . di mio proprio*'), the Commune paying him back only when it was able to. These were risky reminders. Soldiers were being assembled by Niccolò da Tolentino, his friend, to create an armed uprising, which was technically treason. The role of being in effect the republic's banker could be misinterpreted as a subtle form of purchasing men. Indeed, some of Cosimo's enemies accused him of having favoured the war with Lucca because it gave him an opportunity to be doubly great in Florence: profiting financially from his loans to the state and increasing his grasp on power.

Rinaldo degli Albizzi seems to have been intent on having Cosimo legally condemned to death and executed. Official opinion in the city was obviously nervous about such a drastic step. Had any citizen so prominent (and so wealthy) ever been condemned to death there for political crimes? The absence of a precedent was helpful to Cosimo, and influential outside voices pressed for leniency and release: the marquis of Ferrara and the Venetian republic, both good clients of the Medici bank; and there was intervention by Ambrogio Traversari which was perhaps prompted by the pope, Eugenius IV, whose coronation had been facilitated by a loan from the branch of the Medici bank in Rome. Money proved to have 'talked' to useful effect in these friendly areas.

Cosimo left for a comfortable exile, which would last barely a year. Rinaldo degli Albizzi had a far more miserable twelve months in Florence, coping with persistent pro-Medici feeling and trying to form stable alliances. The arrival of Eugenius IV in the city was an accident, in so far as the pope fled there from hostile Rome, but his presence was to prove remarkably significant when Rinaldo degli Albizzi rashly exchanged ballot-box manœuvres for naked, military force.

By September 1434 a fresh round of elections had brought into place a new *Signoria*

favourably inclined towards the Medici, and a new *Gonfaloniere di Giustizia* equally sympathetic to that cause. Rinaldo degli Albizzi wildly miscalculated by attempting an armed coup, which some of his presumed supporters failed to join. There were skirmishes of a rather ineffectual kind, and he was summoned to an interview with the pope – a lengthy one, as it turned out – at which he apparently agreed to disband his men and was perhaps led to believe in his own political survival. In fact, he was fortunate not to be either imprisoned or banished – or even executed. Not much 'magnificence' in terms of bravery or leadership had been shown by the magnificent lord priors of the *Signoria*, who were indebted to the pope's intervention for the fact that civic stability was regained. The pope seems to have felt himself placed in a false position when the *Signoria* reasserted its authority and started handing out sentences to the Albizzi and their followers; he had perhaps envisaged a truce and pardon all round. But with only moral authority, and as the city's guest, he needed to behave circumspectly.

The Florentine democratic machinery now creaked ponderously into action. A *parlamento* was convened, and it called into being a *Balìa*, a huge *ad hoc* council. To nobody's astonishment (unless Rinaldo's) sentence of exile on the Medici was revoked, and various Albizzi supporters were banished. Rinaldo himself was disqualified from office and placed under a form of ban. With his son Ormanno, he broke bounds a few years afterwards and openly took part on the losing Milanese side against Florence in 1440 at the battle of Anghiari (the subject later of Leonardo da Vinci's composition in the Palazzo della Signoria). He was then condemned to death in his absence, and as a public sign of infamy, his effigy was depicted on the walls of the Palazzo del Podestà (the Bargello), with appropriate verses provided by the Commune's herald.

The painter is traditionally said to have been Andrea dal Castagno – a suitable choice, young though he would be in 1440. Castagno's sinewy, harsh and uncompromising art – the art of a Florentine Mantegna, stony and strongly sculptural (under Donatello's influence) – was admirably adapted to painting dead and disfigured bodies in pitiless, convincing detail.

Castagno was one of the most exciting and original of a new generation of Florentine painters, able as a portraitist (even of people from the past, such as Dante – see Plate 12 – Boccaccio and Petrarch) and daring as a painter of religious subjects (bony, beardless and vital, his resurrected Christ rises, rejuvenated, from the tomb). Castagno's image of Rinaldo degli Albizzi must soon have faded away on the walls of the Bargello but his painted commemoration of Niccolò da Tolentino (who died in 1435) survives in the Duomo, a companion to Uccello's *Hawkwood* – and a contrast. Hawkwood rides a

horse with head in profile, a bloodless if noble beast, a touch ludicrously equipped with a human eye. Niccolò da Tolentino's is a mettlesome animal whose heavy head is turned outwards and is modelled with keen, half-champing, almost exaggerated musculature, as if its anatomy had been dissected and studied by the painter. Beyond Florence not much work by Castagno exists. He was probably in his late thirties when one more outbreak of plague killed him in 1459.

As cruel, but stranger, was the fate of Rinaldo degli Albizzi, a proud, energetic man doomed to end as an image of disgrace in his native city, exhibited not far from his own family's quarter. His actual death came in 1442. Devoted to his father's memory (he recorded being swayed once by his father's appearance in a dream) and to Florence, he could hardly feel he had enjoyed the career that his father had envisaged. Of great antique figures he resembled rather too well the Roman patrician Coriolanus, though even as a soldier he proved unsuccessful. Ever the diplomat, Leonardo Bruni had dedicated to him a treatise on military service, *De Militia*, in the days when Rinaldo degli Albizzi was a respected, leading citizen of the republic, but in practice it had not helped the 'knight', as opponents called him (hitting at his aristocratic status and perhaps his airs). No legend of his wit and wisdom was to be compiled by obliging *littérateurs*. Part of his ill-luck lay in his not being a humanist. His collection of books and bric-à-brac, his patronage of this or that scholar or artist – none of those agreeable aspects was provided by him for posterity to admire as truly 'Renaissance' and Florentine.

How very different, runs the common assumption, was the composite character of the family by whom Rinaldo degli Albizzi was ousted: the Medici. The family's active, impressive, extensive patronage, continuing long after the Renaissance had ceased, cannot be denied. At the same time, a degree of adulation, especially of the fifteenth-century Medici, from the first inflated and thus distorted the facts. Even today, a serious, otherwise sober study of the conditions of Renaissance artistic patronage can assure us: 'This family's patronage made possible the innovations of architects Brunelleschi, Michelozzo and Alberti, the sculptor Donatello and the leading painters of Florence' (Bram Kempers, *Painting, Power and Patronage, The Rise of the Professional Artist in the Italian Renaissance*, 1992).

It is unnecessary to waste time rebutting the simplistic proposition that – at any period – patronage makes artistic innovations 'possible'. Such a god-like faculty does not belong to patronage. For Florence it is sufficient to point out briefly that the Medici never patronised Masaccio, the supreme example of an innovatory 'leading' painter, or Alberti, and that Brunelleschi achieved the colossal innovation of the cupola of the Duomo without any form of Medici patronage.

From the political events of 1434 stems the triumph of the Medici family, in fact and in legend. Had they never returned to Florence from exile the history of the city would doubtless have been very different indeed – and so would the history of its art or, at least, of its artistic monuments. But that does not mean that great artists, from Brunelleschi and Donatello and Masaccio to Botticelli and Leonardo da Vinci and Michelangelo, would have created nothing in and for the city, not to speak of the major achievements of them all, except perhaps Brunelleschi, in places away from Florence.

In 1434 Cosimo de' Medici and his immediate entourage crept back to the city very quietly, at sunset one evening in early October. The stealth of his entry symbolises the 'softly-softly' approach he would adopt to controlling and effectively governing Florence for the next thirty years. He established a basis of power by apparently disclaiming power, though not interest and influence, which would last almost to the end of the century – to the end of the life of his grandson, Lorenzo 'the Magnificent', who died prematurely in 1492.

It is an extraordinary story, whatever interpretations are placed upon it. Only individuals of unusual calibre and determination, and of self-discipline, could have managed the peculiar compromise which made each of them in turn – Cosimo, his son Piero and Piero's son, Lorenzo – not prince but *princeps*, the first citizen or senator, in what remained outwardly and jealously a republic. The wonder is not that this precariously balanced, partly undefined style of government, in which appearance and reality, fiction and truth, were confusingly blurred, came to an abrupt end but that it managed to endure so long.

Policy would probably have dictated to Cosimo a quiet return in October 1434, but that was also the express wish of the *Signoria*, anxious to avoid any popular demonstration, with the threat possibly of a counter-demonstration. The city was calm, as Cosimo would record, but crowded. The news of his return had brought people to gather in front of the Medici house in the Via Larga, and even the road he was expected to take was lined with people.

Almost as secretly as he had slipped out of Florence the previous October, also by night, he was returning to the same place, the Palazzo della Signoria, where he had been imprisoned. It must have been an odd experience dodging the obvious, expected route and going round the walls, as he describes doing, and then entering the palazzo unseen, while the crowds went on waiting in the Via Larga. Surely it crossed his mind that the *Signoria* might once again have an unpleasant reception in store for him, especially as he was accompanied only by his brother Lorenzo and one servant, apart from the mace-bearer of the Commune.

No trumpets or acts of homage greeted him. It was a low-key encounter, but Cosimo slept that night in the palazzo as guest, rather than prisoner, of the *Signoria*. One would like to think that Bruni was somewhere on hand, proffering a hastily honed compliment about the distinguished exile's return, perhaps with an analogy drawn from perusal of Plutarch's *Lives* of eminent Greeks and Romans (some of which he had himself translated into Latin). About the best prototype would have been Pericles, as events showed, for although never banished from Athens, he had become its first citizen and effective ruler while the city continued to be a democratic republic.

No particular office was vacated or created in Florence for Cosimo de' Medici. Not until the beginning of 1435 did he have any official position, and then he acted for the customary two months as *Gonfaloniere di Giustizia*. On the surface nothing had changed. The Florentine constitution was not amended. For the majority of people life resumed its normal course.

Yet from the moment Cosimo stepped into the palazzo and met the *Signoria*, and all passed off amicably, he had crossed the Rubicon as significantly as had Julius Caesar in antiquity, though Cosimo returned peacefully and legitimately. However much he dissimulated, he was the master of Florence. For the first time in its history the city had an acknowledged single, native-born figure who would guide its affairs at home and abroad. Kings, princes and popes must have welcomed the innovation, making diplomatic dealings with Florence both more personal and more assured.

This embodiment of Florence was not a mere merchant or some local lawyer or civil servant thrust awkwardly into the limelight. He was a clever, industrious, wealthy and established banker presiding over a network of banking houses spread throughout Europe – in France and England, in Geneva and in Bruges, as far north as Lübeck, and as far east as Cracow, in addition to the Italian branches in major cities such as Milan and Rome. Commerce was entwined with financial activity, and wool and silk and alum (valuable for the process of dyeing), and jewels and tapestries and *objets d'art*, were all passing internationally along Medici channels, while Medici clients and connections abroad sooner or later embraced the King of France, the Duke of Burgundy and Edward IV of England.

However, Cosimo's grip on Florence was not based on international business or prestige. Foreign policy for the city meant chiefly alliances within the Italian peninsula.

Opposite: *Michelozzo:* Exterior of the Palazzo Medici-Riccardi.

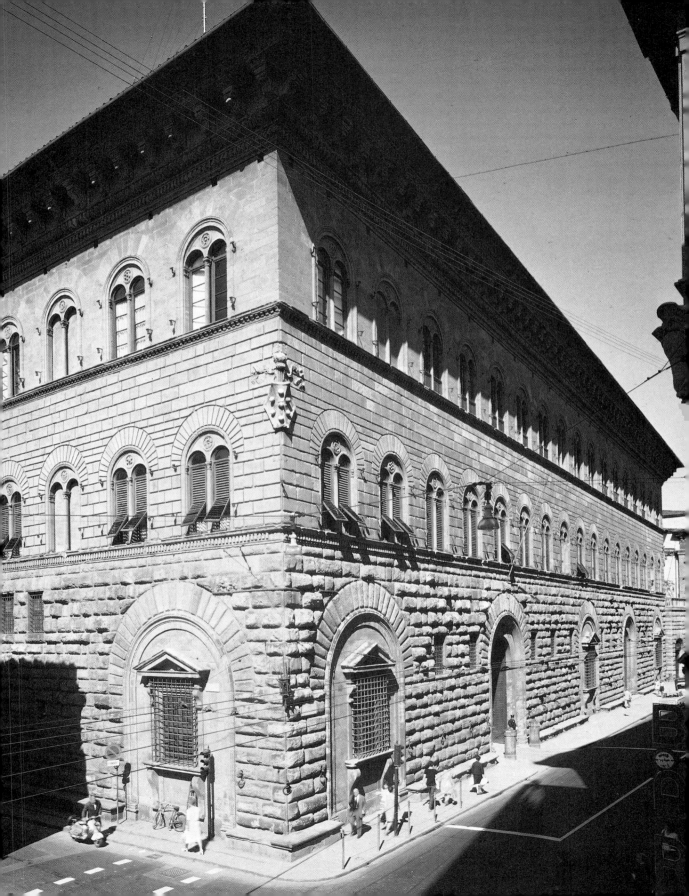

It was never to be a power in Europe comparable to Venice. Perhaps part of Cosimo's control of it was possible just because – despite possessing subject cities such as Pisa, and wide ramifications of its trade, and becoming the site in 1439 of the Church Council that brought east and west face to face, with the Emperor of Byzantium seen in its streets – it remained in many ways 'small-town' in ethos. Certainly, it is hard to think that one man could ever have gained a position like Cosimo's in the Venetian republic, and impossible to suppose that if he had he would be succeeded in it by his son and grandson. The sheer structure of the state was too large and complex – and firm – to accommodate personal power wielded so ambiguously. And openly to take a role of patent authority, to become as it were the Doge of Florence, would not have suited Cosimo's personality, whether or not it suited his fellow-citizens.

Even now it is not altogether clear in every detail how he maintained his power. Like that of a conjuror, the essence of an *éminence grise* is mystery, and there is also considerable appeal – not least to English minds – in the underplaying of his influence by someone clearly influential and preferably wealthy. To be discreetly prominent in modern Britain Cosimo de' Medici might have found it useful to move from banking into law – temperament making him less barrister than solicitor.

In Florence his path was smoothed first by a spate of banishments, among them that of Palla Strozzi. During the rest of his life there were to be a few fitful signs of grumbling and opposition – a positive conspiracy erupting and being quelled in 1457 – but broadly the Medici-dominated regime could claim stability and popular support.

People were very much the secret of it all. Cosimo's had been and remained a psychological victory. No doubt he and his supporters cajoled, manipulated and possibly even bribed people, but they used no force. Social levels were conveniently adjusted, as could be done in Florence, so that the old nobility, the *grandi*, were declared *popolani*, which lowered them but granted the right to be elected to public office. However, by some chance, none of them was. People from the lower though not labouring class, *uomini bassi*, were conveniently raised in status, entered guilds and became eligible for office – and were elected. Loyalty was likely to follow, and a new middle class of sorts came into being, probably quickly acquiring a middle-class distaste for change or extremes.

When Cosimo de' Medici died in 1464 there existed a generation of adult Florentines who had never known government except with Medici predominance. It is not surprising that plenty of people were prepared to see things continue similarly under another Medici, his son. And as that generation had been growing up in the city, so had there become increasingly visible expression of the family's presence, its importance, its

wealth and its benevolence — concomitantly with its legend. The state gave Cosimo and his heirs something of much more lasting value than a public funeral when it gave him posthumously the title of '*Pater Patriae*'. By itself that put the family of Medici in a unique position — legitimising, in a way, any 'wrong' done to the republic.

Some of the forms taken by Medici artistic patronage are unexpected, even disconcerting, not least in degrees of display or magnificence. The great Renaissance wall tomb, with an image of the deceased, as Donatello and Michelozzo had provided for Cosimo's good friend Baldassare Cossa, was not duplicated for Cosimo himself. He was buried very plainly in the crypt of San Lorenzo, with almost ostentatious absence of ostentation.

Yet the bulk of the new Medici palace in the Via Larga (see p. 182) could never have seemed modest or been overlooked, and elsewhere in Florence, as on buildings in the surrounding countryside, Medici emblems and the Medici arms — the *palle* or balls — had begun to appear. Piero, Cosimo's elder son, sickly and not long outliving his father, is sometimes thought of as a faint, rather ineffectual figure. Yet his chosen emblem and motto are the utter opposite in their confident assertion of immortality — emerging in a flash of aristocratic pride from under the modest cloak of ordinary citizenship: a falcon holding a diamond ring and the single word, '*semper*' (always).

CHAPTER SEVEN

The Republic under First Medici Sway

A<small>T THE BEGINNING</small> of the fifteenth century, no competition had been held to establish the cultural capital of Europe, which was perhaps wise. Sufficient causes of dissension among states and cities already existed. In any such competition, and giving emphasis to the visual arts in the concept of culture, one of the strongest contenders would have been Florence.

The claim did not diminish as the century advanced, but challenges to it became much more serious. The intellectual-artistic 'movement' that we call the Renaissance may have exploded with particular *éclat* in Florence, where in the persons of Dante and Giotto alone its foundations had long before been laid, but it refused to be confined to Florence, or indeed to Italy — a fact possibly still insufficiently appreciated.

By the time Cosimo de' Medici settled into his role of presiding over, without quite ruling, Florence (keeping concealed, as Vespasiano da Bisticci wrote, the source of his influence as well as he could), many a European city prided itself — or should have done — on its culture. Even those places, such as Lübeck and Cracow, which might seem remote indeed when surveyed from the top of Giotto's Campanile, were no huddles of mud-huts inhabited by peasants. They happened to be handsomely built, highly civilised cities with an appearance expressive of their flourishing status, commercial or intellectual. At Cracow the university had been founded as early as 1364. It sometimes surprised Italians to find how cultivated non-Italians managed to be. Leonardo Bruni paid tribute to an English monk who visited Florence and was enthusiastic about humanist studies, 'as far', Bruni kindly put it, 'as one of that nation can comprehend [them]'.

Admittedly, much of the fifteenth century in England was occupied by war, first a losing war with France and then civil war, the Wars of the Roses. 'Affairs here are in great confusion [*in grandi garbugli*],' Simone Ginori reported from London to Cosimo's younger son, Giovanni, in 1460, referring primarily to trading conditions, but '*grandi garbugli*' about sums up the hectic succession of events which calmed down only in 1485, with one final

battle, that of Bosworth Field, when Richard III was defeated by Henry VII. Yet amid it all Henry VI had founded Eton and King's College, Cambridge (in whose chapel Cosimo de' Medici would surely have understood and shared Wordsworth's sentiment: 'Tax not the royal Saint with vain expense'). And almost the exact contemporary of Vespasiano da Bisticci, the Florentine bookseller dealing with manuscripts, was William Caxton, disseminating books in the new medium of print.

For France to become a great cohesive power politically, and perhaps culturally too, it needed to expel the English from its soil, which it proceeded to do during the early years of Henry VI's reign. Two years after Cosimo de' Medici was 'restored' and entered Florence from exile, Charles VII of France, for whom Joan of Arc had fought and undergone a most horrible death, entered Paris and proceeded to re-establish it as the capital of his large kingdom. Soon there was a revived French court for artists to serve, and a truly Renaissance artist, working chiefly but not solely as a painter, appeared in the person of Jean Fouquet.

No provincial figure, Fouquet was in Rome in the 1440s and is likely to be the French artist recorded as painting a portrait of Pope Eugenius IV (since lost). He was appointed royal painter to Charles VII's successor, Louis XI, who had succeeded his father in 1461. Florence hastened to send an embassy to a king with whom Cosimo de' Medici had already been in friendly contact when he was Dauphin. That was the embassy headed so sumptuously by Piero de' Pazzi (compare Chapter 3). France and Italy were being drawn into an extraordinary relationship of attraction and repulsion, with France usually the physical aggressor but culturally admiring of its victim.

Florence was soon to be caught up in this fiercely swirling *contre-danse*, although politically reduced to sitting it out when popes and monarchs began assailing or wooing each other. French invasion of Italy was countered by the Italian invasion, culturally and by invitation, of France. Florentine artists were among the most sought-after, and France acquired — and has nearly if not quite naturalised — a supreme genius, Leonardo da Vinci. It may be no more than legend, though it is one retaining resonance from Vasari onwards, that Francis I was present to soothe Leonardo on his deathbed. Even as legend it has its symbolic value, indicating the respect in which artists might hope to be held by great patrons, and there is a distinct sense of social achievement when stories start to be told of how the illegitimate son of a Florentine notary has died in the arms of the King of France.

In the elder Cosimo de' Medici's day France had not yet proved so receptive to Italian culture but it had a gift in store specifically for the house of Medici — one that

seems prophetic of the increasingly aristocratic status of the family. Louis XI granted Cosimo's son Piero the privilege of including the fleur-de-lys on the balls of the Medici coat of arms. This was not precisely a unique honour for a Florentine family (King René of Anjou had already given comparable permission to the now obscure Bono di Boni), but it proclaimed agreeable, useful, royal approval.

While France was politically the country to watch, as far as Italy altogether was concerned, the real challenge culturally to the prestige of Florence in the fifteenth century came from the kingdom of Burgundy, ruled for a considerable portion of the period by Philip 'the Good', who died in 1467. It was in that shaggy, approximate half-moon of territories, a buffer curving between the borders of France and Germany, that a real civilisation of the Renaissance had been fostered for decades. Efficient government was the basis. Philip 'the Good', pious rather than renowned for moral goodness, was wily and on occasion harsh, yet also cultivated and thoroughly a *grand seigneur* in the pageantry and showy chivalry which characterised his court. It was he who instituted the most glamorous of international orders of knighthood, the Order of the Golden Fleece, which Duke Cosimo I de' Medici would be shown proudly wearing in Cellini's superb bust of him and which was still valid centuries later to be conferred on King George IV of Great Britain.

Duke Philip, the second of that name in Burgundy, inherited a kingdom where a masterly proto-Renaissance sculptor, Claus Sluter, had been at work in ducal service. The artists in his service included Jan van Eyck, whose equal, the duke once angrily told his slow-paying accountants, he would not find for '*art et science*'. His was a court where music accompanied almost every ceremony, religious or lay. Burgundian music represented the dominant 'modern' style all over Europe, and the great composers, such as Binchois and Dufay, were renowned figures (coupled with one English composer, John Dunstable, who died in 1453). Among the items exported for the Medici from fifteenth-century Bruges to Florence was a local tenor singer. Philip 'the Good' was himself one more client of the Medici, and when the duke responded to Pope Pius II's call to princes to rally to a new crusade in 1459 (after the taking of Constantinople by the Ottoman sultan, Mehmed II), the Medici company obliged him by arranging for the building of his crusade ships at a Tuscan port, Porto Pisano.

The wealth and splendour of Burgundian court culture often found expression in ephemeral ways. Some of its monuments have perished, and many of its art treasures are dispersed. The kingdom, too, soon disappeared, eventually becoming Belgium, Holland and Luxembourg, as well as part of France. For all these reasons it has failed to make any

coherent impact on general cultural awareness, and applying terms like 'Flemish' and 'Netherlandish' to the arts and artists involved only increases its elusiveness. In Bruges, for example, it is often an effort to recall that the other end of the same kingdom once was Dijon, and vice versa. In Luxembourg it is often an effort to recall that it ever had a serious history or culture.

For much of the fifteenth century, however, Burgundy possessed political and cultural significance, and Florence was well aware of both. Vasari has helped to underestimate the interwoven international character of the early Renaissance by his belief in automatic Italian superiority in the arts, and by his obsessive concern with an idea of 'progress' in them, alongside an awareness that antiquity had played little part in revival of the arts north of the Alps. He can scarcely be blamed for being a man of his time, living in a period when — not least to Tuscan eyes — all art culminated in Michelangelo. What is less pardonable is the continued tendency into our own times to see the Renaissance as primarily an Italian phenomenon.

The implications of the topic are vast, and extend beyond the fine arts, as they extend beyond Florence. *En passant* it is worth recalling the peripatetic career of the northern composer Josquin des Prés (almost an exact contemporary of Leonardo da Vinci), a genius recognised as such throughout Europe, himself crossing and recrossing the Alps as did his rich output of music. The courts of both Milan and Ferrara welcomed him, and he entered the pope's service in Rome, before serving Louis XII of France and receiving at least one commission from the Holy Roman Emperor, Charles V.

Although a painting by Jan van Eyck looks very different from one by Masaccio, it would be a mistake to place them in some sort of opposition when it comes to aims. It is wiser to take a hint from the contemporaneousness of the creators and note that in May 1425, at about the date the Brancacci Chapel frescoes were in hand, Philip 'the Good' appointed van Eyck to be his painter and *valet de chambre*. The two artists were united in breaking away from past conventions and in studying freshly — using the evidence of their own eyes — what can only be defined as 'nature'. And without troubling themselves overmuch about theory, their contemporaries seem to have understood that. Jan van Eyck's sitters included Italians visiting or living in northern Europe. It was the Italian humanist scholar, Bartolomeo Fazio (who died in 1457), employed at a highly cultured court, that of Alfonso, King of Naples, who wrote the first 'life' of Jan van Eyck, the opening words of which are: '[he] has been judged the foremost painter of our time'. No chauvinism there.

It was a Florentine high ecclesiastic, Cardinal Ottaviani, who owned one of van

Eyck's rare profane – indeed erotic – subject pictures, enthusiastically described by Fazio as of lovely women emerging all ruddy from the bath. The cardinal was obviously no prude, and van Eyck's painting (lost but known from copies or derivations) has good claims to be the first expression of a theme to become enormously popular – though never in Florence, as opposed to Venice – down the centuries in European painting, particularly in French art, from Clouet to Bonnard and Matisse, via Boucher, Fragonard and Degas.

In van Eyck's picture nothing seemed more wonderful to Fazio than a mirror painted there, of which he could say only that the effect was like looking 'in a real mirror' ('*quam speculum . . . in vero speculo*'). We can fortunately share his wonder at the demonstration of van Eyck's art, since an even more marvellous use of a painted mirror occurs in an even more remarkable picture, the portrait of a man, probably Giovanni Arnolfini, and his wife (which now hangs in the National Gallery, London). There the mirror is as central to the concept as it is to the composition. Without it, the picture would still be an extraordinary, revolutionary seizure in paint of two ordinary people standing in a spacious light-filled and yet ordinary environment.

The dignity of man – even when naked and ashamed – and the interest in his environment which Masaccio and Masolino had expressed on the walls of the Brancacci Chapel are no less forcefully expressed by van Eyck in the Arnolfini picture, though there is no nakedness, any more than heroism, about Giovanni Arnolfini (whose body looks anyway one best kept from exposure). But in this microcosm is contained a massive amount of information and observation, of nature and life and individuals, as well as of their possessions. The frail, unidealised appearance of these two people proclaims them as human beings, and humanity descends to the scrupulously detailed and differentiated footwear, a pair of clogs and a pair of slippers – his and hers – lying discarded on the intensely realised floorboards receding down the room.

The picture bears the date 1434, a year of real resonance in Florence, being that of Cosimo de' Medici's return from exile. It is the work of a northern painter unconscious that he was working contemporaneously with such leading Florentine painters as Fra Angelico and Uccello, and at a period when Donatello was at work on his choir loft for the Duomo where Brunelleschi's cupola was reaching completion. Yet very easily could van Eyck's picture have portrayed some Florentine merchant and his wife living in Bruges (whereas the sitters were of that class but in origin from rival, nearby Lucca). As easily could the picture have been sent to Florence; and there, for all its obvious differences in style, artists and patrons would at once have recognised it as a valid 'Renaissance' work,

novel and up-to-date, demonstrating a grasp (empirical rather than theoretical) on perspective, along with an astonishing command of realism, conveyed through a no less astonishing command of oil paint, unparalleled in dexterity by any Italian painter, Florentine or otherwise. Vasari himself, to be fair, paid explicit tribute to the perfection of Jan van Eyck's paintings, and paid him further tribute in presuming he had invented the technique of oil painting. He also mentioned that one painting of van Eyck's was owned by Lorenzo de' Medici, 'the Magnificent'.

In a very different medium, one literally precious link between Burgundy and Florence exists, the exquisite enamelled and jewelled rock-crystal reliquary of marvellous Burgundian workmanship which belonged to Lorenzo's father, Piero (now in the Treasury of San Lorenzo). That highly wrought object, studded with great globular gems but also adorned with delicately carved and coloured human figures and foliage at the base of the slim glass vessel itself, preserves for us some concept of the rich, refined fantasy aspects of Burgundian court art, and its presence in Piero de' Medici's collection (by 1463) confirms that such work was prized in Florence. The piece refuses to be categorised by any broad stylistic label such as 'Gothic' or 'Renaissance', and, extraordinarily, it survives — is even enhanced by — the eighteenth-century Florentine rococo addition of the elegant angels in silver who serve to support it (see Plate 18).

Such was the European cultural context for fifteenth-century Medicean Florence. The city today possesses no paintings by Jan van Eyck, and the Northern Renaissance may seem a distant, distracting occurrence amid such a panoply of native art. For many visitors it may well be that not until they arrive in the Uffizi at the unforgettable, unmissable vision enshrined in the Portinari altarpiece by Hugo van der Goes does fifteenth-century Netherlandish art seem to 'arrive' in Florence — that is, in the late 1470s. But for several decades before that specially commissioned northern masterpiece of painting was despatched to Florence by Tommaso Portinari, the Medici firm's agent in the Netherlands, tapestries and more obviously portable artefacts (not forgetting the occasional singer) had been reaching the city.

One great Netherlandish painter, Rogier van der Weyden, had actually visited Italy in or around 1450, and probably paused for a while in Florence. A poignant Pietà-cum-Entombment by him (now in the Uffizi) may have been painted there for some member of the Medici family. By an irritating irony, what must have been a specific Medici commission, or at least a gift to them — a small devotional picture by him of the Virgin and Child, with saints who include Cosmas and Damian, and with a central shield blazoned with the Florentine lily — has ended up in Frankfurt.

We have to think of various members of the Medici family in the fifteenth century taking an interest in matters artistic and generally cultural, concerned with furnishing their own apartments handsomely, contributing to embellishing a religious building or indulging a taste for music – or all three. It suggests a calm current of prosperous but fairly normal life, much of it scarcely visible to the outside world. Then that abruptly altered. As father of the family, and as the embodiment of its wealth and its now incontrovertibly established nature, Cosimo de' Medici threw off any pretence of civic ordinariness, and by 1445 had set work in hand clearing a corner site in the Via Larga for a huge new house, referred to from the first as 'the palace', '*il palagio*'.

The implications and the effect of this action were to be considerable, and not solely in architectural or artistic terms. What Cosimo built became virtually an alternative focus of government to the *palagio* away on the other side of the Duomo, the public Palazzo della Signoria. More important policy decisions were probably reached by informal talks in the new Palazzo Medici than by the elected councils and committees meeting in the old symbolic seat of republican government. And, following a constitutional reform in 1458 (when yet one more council was created, a Council of One Hundred, the *Cento*), formal political meetings also were apparently held in the palace, according to the admiring description of Pope Pius II, who wrote of Cosimo as 'king in all but name and state'. Cosimo's house was certainly the location of one key activity: the filling of the electoral bags with the names of those eligible for office, both in the city and in the surrounding territory. Doubtless all was conducted with impeccable integrity, but it would be surprising if people did not talk. In any case, there was a distinction – fully savoured at the time – between those elected to office and those who actually governed.

Among the prestigious features of the Medici palace was its family chapel (today famous for Gozzoli's frescoes on its walls), a privileged possession in itself and perhaps unique as a feature among Florentine palaces of the period. Small though it is, the chapel served on occasion as a secular reception room for important visitors, and in 1459 it was there that the aging Cosimo received a youthful ducal sprig, the Count of Pavia, the fifteen-year-old son and heir of Francesco Sforza, Duke of Milan, whom he had decided to lodge as his personal guest 'in his palace' ('*nel suo palatzo*' [sic], as a contemporary reported back to the duke). Nothing could by then conceal the fact that one reigning sovereign was entertaining the heir of another, and the numerous festivities taking place there emphasised the agreeable grandeur of the setting. Writing home to his father, the Count of Pavia enthusiastically declared that the garden, where supper had been served one April

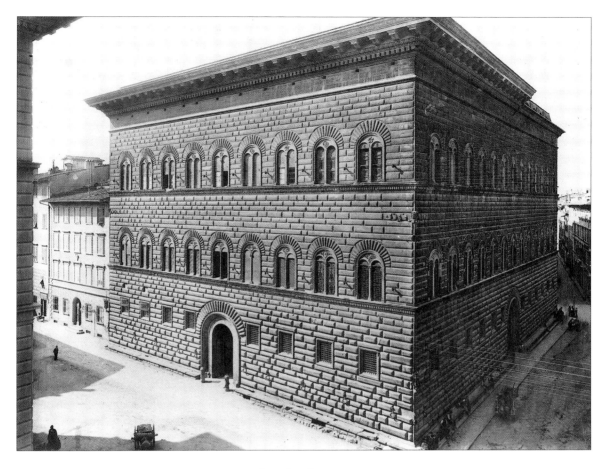

Façade of the Palazzo Strozzi.

evening, was in his opinion 'the most beautiful and ornamental ever seen' (he was very young).

Other rich Florentine families were at least the equal of the Medici as patrons of the arts, though they would not have thought of it quite in that way. Other fine private palaces were to be built in the wake of the Medici palace, among them the gracefully logical, more elegant than assertive Palazzo Rucellai, designed by Alberti for Giovanni Rucellai (he whose name is on the façade of Santa Maria Novella), and that grandiose pile begun for Luca Pitti on an extensively cleared and commanding site on the Oltrarno – to mention only two of the most celebrated. Broadly, it was a period less of new churches than of new palaces (which, unlike the churches, usually got completed).

Very rich and very ambitious (at least in Luca Pitti's case) as the builders of them

might be, they never came near to rivalling the prestige and political power of the Medici. In a sense, the great fifteenth-century private palaces, however architecturally significant, are misleading indications of the situation, suggestive of a group of ruling families when in fact increasingly there was only one. Wisely perhaps, the Rucellai cultivated a low profile in public affairs ('there is nothing which I esteem less,' Giovanni Rucellai wrote, in giving advice to his sons). If their palace symbolises anything, it is the pursuit of a leisured, cultured but quiet existence. Luca Pitti's palace has retained his name, despite being acquired later by the Medici, but it commemorates a man whose nerve failed him when he joined a frustrated anti-Medici conspiracy in 1466, and a family which ceased thereafter to be of political importance.

A rather similar history lies behind the outward grandeur and strong physical presence of one of the centrally located and most familiar palaces in the city, the Palazzo Strozzi, standing huge and four-square, proudly creating an aura of proud isolation, for all its urban setting. It was built late in the fifteenth century by the enormously wealthy Filippo Strozzi (see p. 193), a friend and supporter of Lorenzo de' Medici 'the Magnificent', and it rivals – perhaps eclipses – the Medici palace. Filippo's son married into the Medici family and yet, as already mentioned (in Chapter 6), opposed what he saw as a threat to the republic from the ambitions of Duke Cosimo I de' Medici. Defeated and captured in battle, he died in prison – in a new and sinisterly imposing building added to the city in the sixteenth century, a fortress, the Fortezza da Basso. It is true that the Strozzi family was far from ruined or extinguished. Several members went off to seek careers in France. Others rose to local prominence, and in the seventeenth century were ennobled or became antiquarian scholars (Carlo Strozzi's amassing of documents is valuable for tracing details of Ghiberti), but the Strozzi took no major role in the governing of Florence, and for most people they are remembered primarily for having built a monumental palace.

There are other fifteenth-century palaces of great architectural merit, if less grandeur of scale, which tell no story of the family's distinction – or tell of a family's disgrace. In its own small piazza, facing and yet seeming coolly to distance itself from the elaborate, animated baroque façade of the church of San Gaetano opposite, is the severe, compact palace of the Boni family (now Palazzo Antinori), its plain, restrained façade of stone untampered with and unenlarged. While a church like San Gaetano, fine though it is, might be seen in any major Italian city, the palace is quintessentially Florentine. But the Boni family played no part in the history of Florence. Indeed, they soon lost possession of a home so characteristic, so effective in its very restraint, and lapsed into bankruptcy.

The Pazzi family, proud and of long-established nobility, built one of the most impressive of all fifteenth-century palaces in the city. Although the site was merely a street one, the building that rose rusticated along it might seem an 'answer' to the Palazzo Medici, and like that it possesses a notably handsome courtyard. As befitted an old family, it was built in the old, Dantean quarter of the city, between the Duomo and the Palazzo della Signoria. And in the Via del Proconsolo it still stands (the headquarters of the Istituto Nazionale della Previdenza Sociale, restored and kept up as it deserves). The Pazzi famously played their part in the fifteenth-century history of Florence — with a conspiracy in 1478 to assassinate Lorenzo de' Medici which came dangerously close to success (see Chapter 8). The conspirators were hanged, and the palace was confiscated. The Pazzi family continued to exist, but never again was it a power in the state.

From Rinaldo degli Albizzi to the Pazzi conspirators and the Strozzi, the challengers to a Medici regime had — to put it mildly — bad luck. God appeared definitely favourable to one family taking a grip on the city and settling into dynastic control of it.

For much of the period from Cosimo's return in 1434 to the death of his grandson Lorenzo 'the Magnificent' in 1492, Florence was at peace, partaking of the comparatively calm era experienced generally in Italy. Cosimo de' Medici's personal foreign policy led Florence to an alliance with its earlier enemy, Milan, now ruled by the Sforza. Milan and Venice agreed to a peace settlement, signed at Lodi in 1454. In the same year a defensive alliance was formed between Florence, Venice and Milan, which was soon joined by Alfonso of Aragon, King of Naples, and the pope, an able, attractive, genuinely enlightened figure, Nicholas V. Nicholas V's chief defect is that he did not reign long enough, dying in 1455, aged fifty-eight, after a papacy of eight years. Alfonso of Aragon died three years later.

These personalities and places happen to have more than political connections with Florence, at least as we look back. They too were profoundly associated with — often active participants in — the cultural Renaissance, although apart from Venice they have tended to be obscured by the blinding light cast and assiduously cultivated by Florence. The Neapolitan early Renaissance, for instance, was manifested by the patronage of Alfonso, 'the Magnanimous', building lavishly and encouraging humanist scholarship, being himself 'a lover of letters', in the words of Vespasiano da Bisticci, for whom he was a model of piety, literacy and good government, as well as magnificence — a sort of Cosimo de' Medici for Naples. But, somehow, outside specialist circles, little glamour or interest attaches to the concept of the early Renaissance in Naples, despite the fact that at least some of Alfonso's monuments survive on the spot. And in passing it is worth not-

ing that among his paintings were several by Rogier van der Weyden and a triptych by Jan van Eyck (since lost).

Not only some sort of context but some sort of standard is provided for assessing fifteenth-century Medicean Florence by glancing, however cursorily, at a few of the other centres of Italian Renaissance culture, especially those where princely contemporaries showed themselves far more daringly 'Renaissance' in individualistic, perhaps aggrandising ways. The result is frequently art more exciting and idiosyncratic, and more outspoken, than that fostered by the early Medici (in stark contrast to their own descendants), either because of their taste or their consciousness that republican susceptibilities had to be respected in Florence. In no area is that preference or inhibition more marked than in the tremendously 'Renaissance' one of portraiture, painted and sculpted, and in the avoidance on Medici funerary monuments of the period of any likeness of the deceased.

In other Italian city states the ruler was often preoccupied by ways of preserving his image or his way of life, or his fame, through art — and though that is not a human impulse newly discovered in the Renaissance, and not in itself a proof of culture, it was to be the inspiration for a number of great works of Renaissance art at highly cultured courts.

Some of those once flourishing centres have dwindled into backwaters as far as tourism is concerned, and even when visited their culture has partly to be reconstructed by a process of reading as well as looking. Yet the loud, repetitive hymning of '*Florentia bella*' by Benedetto Dei in his *Cronica Fiorentina* must not wholly drown out words of praise for beautiful Ferrara and Mantua, for instance, and for eccentrically impressive Milan, not forgetting Naples, and Rome as it was to develop under Pope Nicholas V. And, supremely, there is Urbino, so much smaller than Florence but a jewel of Renaissance cities, seat of the court of Federico da Montefeltro, one of the first rulers to be both an effective military leader and a passionate student of literature. Portrayed by Piero della Francesca, among other painters, he was celebrated by Vespasiano da Bisticci in a lengthy pen-portrait which presents a personality of far greater ability, far wider experience and more extensive culture than Cosimo de' Medici (with a subtle love of music, for example, and a knowledge of geometry, and an unrivalled library of books, ancient and modern, ranging beyond the obvious classics to the visual arts, theology and medicine). Even Vespasiano could not fail to remark on Federico's major ornament: his palace (which, fortunately, still stands). 'It has no superior among the buildings of the time,' he wrote, and no one will disagree who has walked up its lucid staircase and through its beautifully proportioned rooms, whitewashed and empty, yet not unadorned, where the chimney-

pieces and the framing of windows and doors are at once sculpture and architecture, perfectly calculated, permanent furniture and exquisite, enchanting works of art.

Perhaps it is harder to reconstruct the tone of the court at Ferrara, which was also perhaps among the most sophisticated of the smaller cities. There the Este family ruled for several centuries, with political expertise and a brilliant record of enlightened patronage, in literature and music as well as in the visual arts. Some of fifteenth-century Ferrara has been destroyed by its rulers through their own building activities – including frescoes by Piero della Francesca in one palace. Other palaces, decorated by gifted local artists, were sadly burnt, but at least there still exists the Palazzo Schifanoia, with its grand 'Hall of the Months' (frescoed in 1471). The walls are like a calendar illustrating the life of Duke Borso d'Este and the cycle of the seasons and the signs of the zodiac – its very mixture fascinatingly of the Renaissance, and interpreted with poetic, near-fevered intensity in typically Ferrarese artistic style. The heavens, rather than a Christian heaven, watch over Duke Borso as he goes about his daily affairs.

Images are more palpable than cultural tone, and so one inevitably reverts to them, or gives them priority, in glancing at these cities. In Ferrara one can hardly ignore Mantua (after all, Isabella d'Este was a famous export from one city to the other), and the 'Hall of the Months' leads on to the Gonzaga palace at Mantua and Mantegna's *Camera picta* of just two or three years later, a mirror reflecting with uncanny illusionism the ruling family and life at the Gonzaga court.

If nothing else of the fifteenth century immediately catches the eye in heavily baroque Naples, the triumphal arch Alfonso of Aragon erected as the entrance to 'the new castle', the Castelnuovo, can scarcely be missed. It was a classical Roman form revived and reinterpreted and reinflated, too, for it was intended to be a more gigantic complex than what now stands. God and saints combine with reliefs of the king himself, as soldier with his army, and in peaceful procession as a beneficent ruler (anticipating the dual aspects of Federico da Montefeltro) – in an elaborate sculptural programme which would doubtless have appealed to other Italian despots while reducing the average Florentine citizen to disapproving silence. We need waste no time searching for such an archway in 'Florentia bella'. Not until 1737 (see Chapter 14) was anything comparable erected there.

Very chary indeed was Cosimo de' Medici of having his likeness taken (thus creating a headache for subsequent artists' portrayal of him). It is almost as if he had some superstition on the subject, though his reluctance could be ascribed to a form of modesty. Ideally, he should have sat for a bust to Donatello, a bust which – apart from its

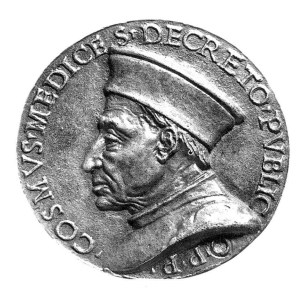

Anonymous Florentine, 15th century: Medal of Cosimo 'il Vecchio' de' Medici,
Museo nazionale del Bargo.

expressive aesthetic qualities – would have summed up the sympathetic relationship
between patron and artist. No such bust exists, and probably none was ever created. Only
a medal of the period gives us a good likeness of him.

The shadowy nature of Cosimo's brother Lorenzo is increased for us by the fact
that no satisfactory record exists of what he looked like. For his tomb no image was
carved, and none was carved for that of Cosimo's younger son, the hedonistic, music-lov-
ing Giovanni, whom tradition makes his father's favourite. Both men died before Cosimo.
They were mourned by him but apparently left uncommemorated by specific posthu-
mous effigies, though their faces may occur in some Medici-commissioned religious
compositions, such as Gozzoli's *Procession of the Magi* frescoes.

Busts were executed – either for Cosimo or for the sitters – of Giovanni and his
elder brother Piero, later Cosimo's uneasy successor as 'first citizen' in Florence, by a
sculptor of a new generation, Mino da Fiesole (both works are now in the Bargello).
Giovanni's bust shows him for some reason in armour, possibly to heroicise him in
homage to antiquity: he was no soldier in reality.

Piero is shown in contemporary costume, one made more personal by being deco-
rated with his device of a diamond ring, and the bust is identified on the back as done of
him at the age of thirty-seven (that is, in or around 1453, when the sculptor was aged only

about twenty-four). It is a gawky portrayal of a tense, gawky-looking person, whom we know to have been congenitally ill and in pain, but who was of some culture and of some ability (and who has probably been underestimated on both counts).

The bust gets a due mention in art history as the first datable sculpted portrait bust of the Florentine Renaissance – and so of the Italian Renaissance altogether, for the category was one in which Florence pre-eminently led the way. It deserves a little more attention in its own right, not least because it is the only certain, straightforward depiction of Piero in his lifetime. It may lack the characterfulness of the bust of some masterful older man, all high cheekbones and venerable wrinkles, but it has an intriguing, nervous, half-vulnerable air that is the opposite of bland or idealised. No more than Giovanni Arnolfini does Piero de' Medici have an overtly impressive physiognomy, but like him he has a distinctive one. The taut shape of the thin lips, and the premature frown lines sharply marking the juncture of eyebrows and nose, suggest that Mino da Fiesole had looked searchingly at his sitter and meant to show him exactly as he was.

Additional interest attaches to the bust because it seems originally to have had a companion piece of Piero's wife, Lucrezia Tornabuoni (now presumably lost). Vasari speaks of the two busts as set up over doorways in Piero's apartments in the Palazzo Medici – at the period surely a novel indication of a wife's co-existence alongside her husband. The bust of Lucrezia was in any case something of a social-artistic 'first' in the city. Had a woman sat before for a portrait bust? The choice of sitter has its significance, for Lucrezia Tornabuoni was very much more than a Florentine *Hausfrau* in the mould of her mother-in-law, Cosimo's wife, Contessina. Gifted in character and intellect, she held opinions about public affairs and wrote religious poetry, without neglecting her traditional role as wife and mother. She exercised her own patronage, and in a list of six founders of chapels in San Lorenzo she is the sole female among them.

No woman like her had previously appeared in the Medici family – nor, probably, in Florence. She was unfortunately to have few successors in such a male-oriented society. Yet well before the end of the fifteenth century the sculpted portrait bust was taking account there of women, capturing character and costume in a vivid, appreciative manner. All that is lacking in these often charming busts is any indication of the sitters' identity. That they were not significant from a dynastic or political viewpoint was inevitable in a republican ethos; and naturally there were no secular careers open to women. Perhaps the triumph in art of the ordinary, unimportant Florentine woman, living and not the subject of any poetic cult, was slow in coming. When it came it could be seen as almost constituting revenge for any earlier neglect or indifference. Leonardo's *Mona Lisa*, painted

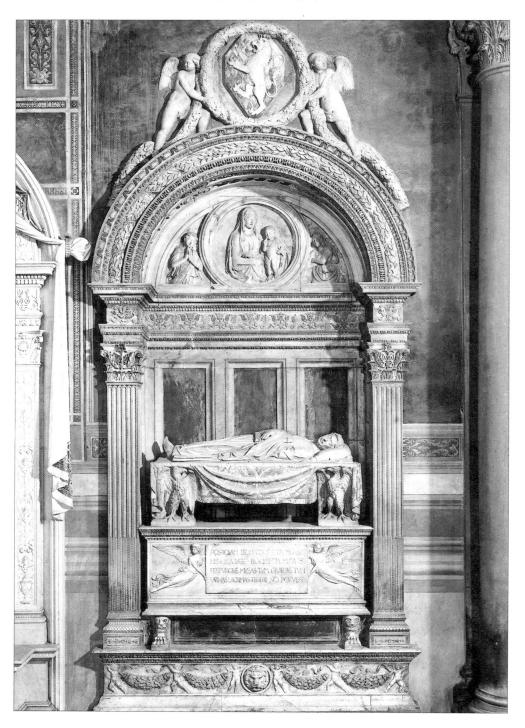

Bernardo Rossellino: Tomb of Leonardo Bruni, *Santa Croce.*

just at the start of the sixteenth century, is one of the most famous images in the world, arguably the most famous and familiar of all. It celebrates and portrays the wife of a certain Francesco del Giocondo, a woman until then truly of no importance.

In fifteenth-century Florence there could never be one single dominant fount of patronage, and as with the palaces so — perhaps to a lesser extent — with the greatest funerary monuments, which do not always accord with history's sense of an individual's greatness. The republic gave at least tacit sanction to the tomb in Santa Croce of its chancellor Leonardo Bruni (who died in 1444) by Bernardo Rossellino, a sculptor-architect of a new generation, born in 1409. Rossellino showed his architectural bent by creating virtually a chapel on the wall, taking hints from the tomb of Baldassare Cossa in the Baptistery but greatly improving and fusing the elements of architecture — tall pilasters and soaring, wreathed archway — with sculpture, chiefly the image of the dead man lying dignified on his bier.

No Florentine personality had previously received such a splendid monument of a tomb. To appreciate it as it will have appeared *in situ* around the mid-century, we have to think away the clutter of monuments along the south wall of the church — especially the appallingly tasteless pastiche of Bruni's tomb which was juxtaposed in the nineteenth century, incongruously commemorating the composer Rossini — not Florentine by birth or work — who is there because Santa Croce became a sort of Westminster Abbey, enshrining all the nation's important figures, while Florence was the capital of Italy.

Bruni was succeeded as chancellor by Carlo Marsuppini, also a respected humanist scholar but a less prolific writer, and shorter-lived. He died in 1453, and opposite Bruni's tomb there was erected for him a tomb of similar pattern and grandeur, including an image of the deceased on his bier (see p. 202). For this monument a much younger and more brilliant sculptor was employed, Desiderio da Settignano, who was himself to die prematurely in 1464, two years before Donatello, aged no more than thirty-five.

Desiderio wielded a chisel of incomparable delicacy, seeming at times less a tool for carving than a silver-point for drawing. He cannot have worked unaided on the Marsuppini monument, but his is certainly the exuberant yet controlled fantasy of the actual sarcophagus, its marble not merely decorated with leaves and flowers and ribbons but positively transmuted into a profusion of springing fronds and twisting curlicues, at once fragile yet firm, as if formed there by the action of frost. Above lies the grave, grimly defunct chancellor, dead to everything, and below his sarcophagus breaks into lyrical floral life, with feathery wings and a fan-like shell and a pair of hairy, griffon-like paws as its legs — making up a series of symphonic variations in stone. Such is the artistry that

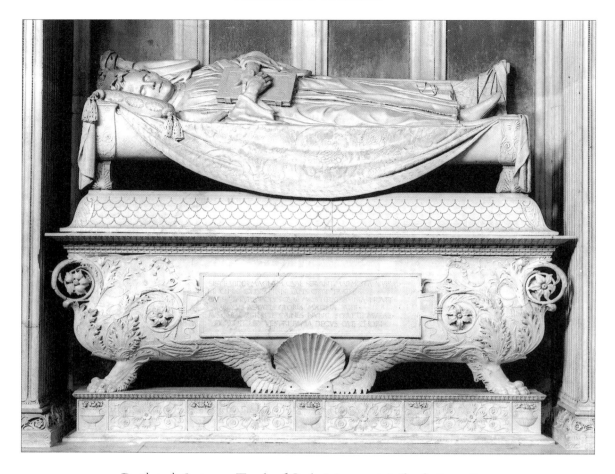

Desiderio da Settignano: Tomb of Carlo Marsuppini *(detail), Santa Croce.*

died with Desiderio, and today we are bound to grieve far more for the sculptor than for his subject.

The year of Desiderio's death was also that of Cosimo de' Medici. For him might have been expected a fourth great Renaissance tomb – the greatest of them all if prestige and unique power, and the gratitude of the republic, were to be taken into account. It is true that Cosimo had, characteristically, considered carefully how and where he wished to be buried: without pomp and in the family church of San Lorenzo. But the *Signoria* certainly envisaged providing some monument to him, as well as posthumously conferring on him the title of '*Pater Patriae*', and of course it could still have done so even after his wishes about his actual burial had been devoutly followed by his son Piero.

Elsewhere in Italian Renaissance cities a ruling family, or the ruler himself, would

not have hesitated to erect an arch or a statue celebrating such a lengthy, prosperous reign. In Milan Cosimo's friend and ally, Francesco Sforza, was intended to be commemorated by a huge, bronze equestrian statue, a project which Leonardo da Vinci left Florence to undertake. Even in republican Venice the monuments of the Doges can take on a tone personally assertive and openly triumphant, though patriotic. Not recumbent, not in fact dead, Doge Pietro Mocenigo is sculpted by Tullio Lombardo on his splendid tomb in Santi Giovanni e Paolo, standing there alert, armoured and clearly more prepared for battle than for the next life.

In Florence it was all to be more ambiguous, and not solely because of Cosimo's own professed policy of underplaying his status (though that in turn was partly conditioned by the city's ethos). Prudence rather than modesty probably dictated his desire for an unostentatious funeral. It would avoid envy and smooth the succession of Piero. And perhaps the *Signoria* – its membership changing so constantly – grew less eager to do anything publicly, once the title of '*Pater Patriae*' had been bestowed on the dead man.

The visitor to Florence finds no great monument to Cosimo de' Medici and could easily miss his actual tomb. Virtually hidden in the crypt of San Lorenzo is the plain, by no means aesthetically remarkable, chest-like structure which contains his body and which is incorporated into a squat pier supporting the low roof. While in one way this is diametrically the opposite in display or 'magnificence' of the tomb Cosimo had been involved in getting built in the Baptistery for his friend the ex-Pope John XXIII, it has – once located – a certain symbolic grandeur. Cosimo appears to shoulder the burden of supporting the church overhead, and he does it alone (for the tombs of his immediate family were not placed in the crypt). And then the existence of this most unusual if discreet tomb is marked in the church at a key point, on the pavement in front of the high altar, by a big, inlaid abstract marble design – laid there like a permanent carpet – with inscriptions identifying Cosimo as '*Pater Patriae*' (see Plate 17). The effect is of someone not so much shunning the limelight as backing into it. As the Medici palace near at hand reminds us, while he lived Cosimo had had moments of openly manifesting his wealth and his central place in Florentine government and society.

The grandly beautiful funerary monument not raised to him, a culmination of the type as it had evolved in Florence, was, however, to be built. For the city, for art, for the pleasure of thousands of people subsequently, it was fortunate that a highborn yet quite unimportant young man happened to die in Florence, a few years before Cosimo, in 1459. An exotic in the republic, being foreign and royal, and unusual as a cardinal notorious for

purity and piety, Prince James of Portugal had known he was dying and asked to be buried out of the immediate city, up in the church of San Miniato al Monte.

To that serenely beautiful, aloofly contemplative Romanesque interior, with its air of antiquity and intactness (despite such earlier fifteenth-century additions as a prominent tabernacle built at the expense of Piero de' Medici), was added on – without incongruity – a complete funerary chapel, with its own serenity and contemplative air, in an idiom thoroughly Renaissance (see Plate 15).

No native Florentine aspired to or inspired such a concatenation of the artistic media – painting, sculpture and architecture – as is present in this modest yet harmonious space, in plan echoing Brunelleschi's 'old' sacristy in San Lorenzo and designed by his follower Manetti. Ceiling, floor and walls were carved and patterned and frescoed with an unprecedented yet not excessive richness. On the altar stands a painting (the original is now in the Uffizi) by the brothers Pollaiuolo, showing the cardinal's patron saint, St James, flanked by Saints Vincent and Eustace, but the cardinal's tomb on the side wall was and is the real focus of the chapel. There Antonio Rossellino (the much younger brother of Bernardo) sculpted the figure of the cardinal in death – the peaceful face modelled on his death mask – and made that effigy a point of absolute stillness amid the surrounding busy imagery of *putti* and angels and the visionary circle of the Madonna and Child smiling down on the dead man from heaven.

Perhaps there is nothing in the chapel more sheerly miraculous than its ceiling by Luca della Robbia. It must be one of his masterpieces, possibly *the* masterpiece among Florentine ceilings of the period – and certainly only in Florence could it have been created. A heaven of eternity is conveyed by the abstract design of five circles, the circumference of four of them just touching that of the fifth, the central one, and all as though ruled out with the compasses of the divine architect. Such portion of the area they do not fill, the background against which they virtually revolve, is covered by a dazzling chequer-pattern which can be read as consisting of repeated cubes, projecting from or recessed into the ceiling and as innumerable as the sands of the seashore or the stars of the Milky Way.

Each circle is outlined in white and contains within it a band, a border, of gleaming, half-translucent tiles of a celestial, gradated blue, themselves framing an inner circle of white ornament, like the wide rim around a dish, and here each dish is blue. All that, set against the blue and yellow tiles that cover the rest of the vault in a cubist constellation, would be marvellous enough. But to the cerebral design and the sensuous, heavenly colour-scheme, della Robbia adds figures. The four outer circles each contain a three-

quarter-length angel, symbolising one of the cardinal virtues. The central circle is radiant with gold. Like spokes of a wheel, the Seven Candlesticks of the vision in the Apocalypse alternate with the golden rays emanating from the motif in the middle, the Holy Ghost in the form of a pure white dove, hovering there with outstretched wings. The charm of della Robbia's invention of glazed faience is familiar enough. Here he shows that it could be used with profound, even cosmic seriousness.

Everything in the chapel speaks of thought and measure and balance. Pride and also piety are present, and as well as intimations of immortality there is a recognition of death. All the optimistic Christian symbolism is above and overhead. Below, at the very base of the tomb, runs a relief of entirely pagan imagery, carved with a pair of delicately posed unicorns (alluding to the cardinal's chastity) which support a swag of rich wreath, from the centre of which emerges a grinning skull. In the end, despite every exertion of art, every association of royalty and youth, and the promise of life eternal, the chapel is a place of mourning.

Yet it would hardly have been brought into being had the person mourned not been a secular prince as well as a prince of the Church. Vespasiano da Bisticci states that the cardinal's aunt paid for most of the chapel. She was the third wife of Duke Philip 'the Good' of Burgundy, and artistic threads oddly interweave around her, for as Isabella of Portugal she had sat for her portrait to Jan van Eyck, commissioned to travel there and paint it for her future husband.

There were to be no other princes in fifteenth-century Florence for whom chapels comparable to the cardinal's might be built. Yet it has its successor in the following century, when Michelangelo immortalised two fairly minor but ducal members of the Medici family in his new Sacristy at San Lorenzo, working for the second Medici pope.

T HE CARDINAL OF PORTUGAL'S chapel was finished and consecrated in 1466, a testing year politically for Piero de' Medici, who yet managed to outmanoeuvre and outface his opponents in Florence. For what remained of his life – he died on 1 December 1469 – the Medici party was preponderant in affairs, but the future was unsettled. That a third generation of the family should assume a leading role in the republic was no automatic step. Cosimo and Piero had been mature men when they took their undefined places as chief citizens. Piero's successor as head of the family was his elder son, Lorenzo, aged only twenty and as such ineligible to vote in formal discussions. Nevertheless, as he was to note, the principal citizens arrived at the Medici palace ('our house', as he referred

to it, with the casual assurance of one raised in a palace) and encouraged him to take charge of the city, 'as my grandfather and father had done'.

Seldom can encouragement have been less needed. Lorenzo must virtually have been drumming his fingers impatiently as he waited for the deputation to appear. Still, the civic proprieties had been observed. There had been no vulgar grabbing at the crown. It is usual to reflect, as did Lorenzo himself, on the transmission through Piero back to Cosimo, but perhaps it is the yet earlier generation that we should recall and Giovanni di Bicci's advice to his sons (as given by Machiavelli) to take only that share in state affairs that their fellow-citizens offer.

Forty years had elapsed from Giovanni di Bicci's death to what can be called the accession of Lorenzo, 'the Magnificent'. The old patriarch had not quite reached Abraham's impressive age ('an hundred three score and fifteen years') but his seed had multiplied and flourished almost as fruitfully, and it was into a great inheritance and, in effect, a kingdom, that his twenty-year-old great-grandson now entered. If he entered confidently – and he did – it was because he had never known his family not in the ascendant in Florence, had never known his own position as other than that of heir-apparent.

A famous, half-mythical 'golden age' was initiated under him. Although historians constantly and correctly emphasise that 'the Magnificent' was not a specific title of his (being an honorific applied to all distinguished citizens, among them that 'magnificent citizen', his grandfather), Lorenzo alone continues obstinately to be 'the Magnificent' to posterity. Even when it is realised that he did not commission Botticelli's superb secular masterpieces of the *Primavera* and the *Birth of Venus*, or discover Michelangelo, or contribute any buildings to Florence – so that physically the city changed little in his years of 'rule' – his existence, his personality and his strong 'hands-on' cultural and political involvement with what was going on have not so much coloured as irrevocably drenched the Florence of his day retrospectively with Laurentian magnificence.

Lorenzo himself coolly looked back, just a year or two after coming to power, assessing what the Medici had done for the city in terms of expenditure: from 1434 to 1471, he discovered from an account book, 663,755 florins had gone 'on buildings, charities and taxes, not counting other expenses'. Even he found the sum incredible. He concluded that it had all been money well spent, for 'it gave great lustre to the state'.

Part of that lustre is no longer easy to detect. Medici charity took various forms, some immediate and practical, and semi-private, as well as ones more public and permanent. At the lowest level, we know for example that Lorenzo's mother, Lucrezia Tornabuoni, gave a poor shoemaker who came begging at the Palazzo Medici one

morning 16 lire in cash and two jackets, and intended to get two of her women friends to do likewise.

On the grand scale of building there remains in addition to San Lorenzo the monastery of San Marco, lying at the northerly end of the Via Larga and near to the houses that had originally served as the Medici home. San Marco was an ancient monastic foundation taken over, with the sanction of Pope Eugenius IV, by the Dominicans shortly after Cosimo returned from exile. If San Lorenzo was already destined to be the family church, San Marco became for Cosimo a personal, specially favoured and less obvious object of patronage, a convent where he too could briefly pass as a friar. It was remodelled and extended at his expense by Michelozzo, endowed by him with a fine library (its basis the books he had acquired from Niccolò Niccoli's collection), and for a while presided over by a prior who was his friend, the future St Antonino.

Inside and out, the church of San Marco no longer suggests anything redolent of the fifteenth century and suffers from a late eighteenth-century façade of off-putting insipidity. But Michelozzo's unspoilt convent buildings, with their calm, airy cloisters and pillared library, still exude a sense of profound, tranquil retreat, as though the city were not yards but miles away. These spaces do not ask for furnishing or decoration. It was fortunate that the first, contemporaneous frescoes to be executed in the corridors and cells were by Fra Angelico and his assistants, and were conceived of as so many equally tranquil meditations, clear-coloured and cogent, chiefly on events in Christ's life. Within the double cell traditionally Cosimo's is frescoed the *Adoration of the Magi*. The outer cell has its special application to him, showing – most unusually – St Cosmas kneeling at the Crucifixion. Cosimo seems to have been a benefactor of the lay religious confraternity dedicated to the Magi, and Gozzoli's pageant frescoes in the chapel of the Medici palace at once come to mind. The San Marco composition (probably also the work of Gozzoli) is not merely simpler, however, but more didactic, almost admonitory. Earthly grandeur and rank must bow down before the Child who is the King of Kings. The occupant of this cell is to meditate upon that truth, and perhaps Cosimo did not entirely forget it in asking that there should be no pomp (*'non voleva alcuna pompa'*) when God summoned him hence.

At Santissima Annunziata, where a small cloister by Michelozzo precedes entry to the church, and the loggia along the façade (actually finished as late as 1604) retains an early Renaissance air, it is Piero rather than Cosimo de' Medici who is – or should be – recalled first. If he is not, that partly arises from the overlaying of so much of the interior

of a church popular with later Medici patrons by stucco and silver and *pietre dure* decoration until its fifteenth-century bones have to be searched out. Ironically, amid the glittering lamps and ex-voto offerings, Piero's contribution of a handsome, Corinthian-pillared tabernacle over the precious, miraculous fresco of the Annunciation suits its present surroundings so well that it has lost some original impact (and anyway its design by Michelozzo is 'improved' by a baroque top-knot). It is often remarked that the tabernacle is boastfully inscribed 'The marble alone cost 4,000 florins' (a substantial item even in the Medici account book), though perhaps that inscription dates from after Piero's death. In any event, it is less often remarked that at Santissima Annunziata Piero had his private cell, analogous to Cosimo's at San Marco, which he could enter unperceived, to pray close to the shrine he had had erected.

Yet the greatest lustre of the family on which the young Lorenzo de' Medici could reflect in 1471 lay in the Palazzo Medici itself. Although then not so large a building (being extended in the late seventeenth century), its interior was far more habitable, and richer, than suggested by the bare, stripped rooms to be seen today. The chapel would not have been the isolated item it has become, which gives it – for all its charm – an excessive emphasis. Tapestries, busts, reliefs, paintings and books would have helped furnish the family's living quarters, and there would have been some actual furniture – a carved cupboard or two, chests, beds and chairs and stools, though perhaps never in profusion and not of obvious comfort. Within the palace's perimeter would have been the garden so admired by the Count of Pavia.

Piero de' Medici's own study not only contained at least some of his jewels and coins and his beautifully written and illuminated books (his elegant copy of Aristotle's *On Logic* declares on its title-page that the treatise was translated into Latin at his instigation), but must have been something of a work of art as an environment. It might not have been quite so choice a study as that marvellous surviving one created for Federico da Montefeltro in his palace at Urbino, but its novel refinements included a ceiling and floor of glazed tiles from Luca della Robbia's workshop (now in the Victoria and Albert Museum), later referred to admiringly by Vasari and praised at the period by the mildly dotty architect-theorist Antonio Averlino, called Filarete.

A Florentine settled in Milan, Filarete may never have seen the inside of the Medici palace, as some vagueness amid his praise would indicate, and a promise of his to provide a drawing of the exterior in his treatise on architecture was not fulfilled. Yet he manages to suggest both the richness of the general décor (ceilings painted in gold and blue 'and other colours') and the practical layout of the building, which took account of kitchens,

latrines and dwellings for servants. It is intriguing that he should also mention a room 'to the memory' of Giovanni de' Medici, Cosimo's younger son, who had died in 1463. It was presumably part of Giovanni's suite of apartments, and a tantalising hint of how it was furnished is gained from Filarete's reference to panelling and to a bedstead finely decorated with *intarsia* (inlaid wood).

Valid works of art could be created in that medium at the period, on designs often supplied by leading artists; and how pictorially ingenious compositions of variously tinted, patterned woods could become is shown by the *trompe l'œil* choir stalls in the Duomo. Less showy but more satisfying in their gracefully abstract patterning are the pair of doors in San Lorenzo that lead into the 'old' Sacristy – as paradisal in their mellow, superbly crafted wooden way as anything wrought in bronze by Ghiberti (see Plate 21). A bedstead of comparable quality, especially perhaps if it had been Giovanni de' Medici's deathbed, was likely to be preserved and treasured. Not only in contemporary Medici eyes would such objects seem at least as valuable as pictures – indeed, frequently more valuable. Behind the rugged or smooth but always stony façades of mid-fifteenth-century Florentine palaces we have to envisage some womb-like rooms of dark or gilded wood, cabinets almost literally, where at his desk the master of the household totted up his wealth and penned his letters or, if his taste was akin to Piero de' Medici's, took out and lovingly fondled his collection of curios and *objets d'art*.

Sitting in the Palazzo Medici in 1471 Lorenzo 'the Magnificent' could rightly calculate that he was the owner of a vast array of possessions, and also share something of the public lustre purchased in Florence for the family by that 'incredible' outlay of more than 660,000 florins.

Privately and publicly, he had every reason to feel freshly assured of his own position. He had been married in great style during his father's lifetime, to a Roman wife, Clarice Orsini – an event celebrated in Florence with astonishingly aristocratic display: a tournament in which he appeared elaborately costumed, on horses presented to him by the Duke of Ferrara and the King of Naples, in armour presented by the Duke of Milan, followed by a plethora of lavish entertainments in the Medici palace. In 1471 Clarice de' Medici gave birth to her first son, named Piero after his dead grandfather. In the autumn of the same year Lorenzo was picked as one of the Florentine ambassadors (in almost a charade of equality) sent to Rome to congratulate the new pope, Sixtus IV, on his election. He himself noted that he was shown 'much honour'. The pope made him a gift of two antique Roman busts (one of Augustus), and he also brought back a number of cameos and medals to add to the Medici collections, among them the multi-figured mag-

nificent 'Farnese Cup' (now in the Museo Nazionale, Naples), which was to be valued subsequently at 10,000 florins.

In the acquisition and prizing – not to say pricing – of this piece there is something accidentally revealing about Lorenzo de' Medici's relationship to the visual arts of Florence. They were never to be, as we would say, a priority of his. His 'patronage' partly consisted in recommending Florentine artists for employment outside Florence. Literature and music obviously meant much more to him, and so did classical gems and oriental or otherwise rare vases, in jasper and amethyst, on which it was presumably he who had engraved a bold, uncompromising *LAV. R. MED.* Punctuated thus, his name might be interpreted – if only fancifully – as *Laurentius Rex*.

Yet there seems a fanciful aspect altogether to Lorenzo de' Medici's sway over Florence. Perhaps this is partly due to knowledge of the deluge that followed his death, inundating much more of Italy than just Florence, but it is possible to see his personality – vivid, creatively literate, many-faceted and mercurial – as blurring the reality of his position politically, and culturally too. To posterity he may be the most attractive and accessible of the Medici, but he moulded the state far less than Duke Cosimo I. Was he ever really a predominant force? Did he have any clear vision of what Florence should be? As far as the city is concerned, did he – does he – ultimately matter?

These may be difficult questions, to which the answers will come only gradually and then not necessarily definitively. Within the history of Florence his years of prominence certainly seem in the nature less of a new epoch than of an epilogue.

Lorenzo de' Medici and 'the most beautiful city'

T HE RICH INHERITANCE which came to Lorenzo de' Medici at the age of twenty in 1469 included headship of the family. For him that was to be an important matter, one by no means of merely passive care for the family's position. Its active advancement, and on a stage far larger than any provided by Florence, was very much his concern.

For generations the Medici had financially aided a succession of different popes, and the family's accumulated credit was in effect called on when Lorenzo de' Medici pressed Pope Innocent VIII to create his second son, Giovanni, a cardinal at the age of less than fourteen. The pope agreed, although requiring that the elevation be kept unofficial and private for three years. Perhaps deliberately, the news was leaked to Florence, and the diarist Luca Landucci (an apothecary whose diary is an absorbing, extraordinarily all-round account of life and events in the city during the last decades of the fifteenth century) noted in March 1489 that 'we heard' that six new cardinals had been made, one Florentine, the son of Lorenzo de' Medici: 'It is a great honour to our city in general, and in particular to his father and his house.'

Even by Renaissance standards it was a remarkable appointment. In a long letter of advice, shrewdly mingling the worldly with the unworldly, the proud father would remind his son, when three years later the boy went off to live in Rome, that he was 'the youngest cardinal, not only in the Sacred College of today but at any time in the past'. Lorenzo referred to the event as the greatest achievement 'of our House'. Nor was it necessarily the last one, for he must have realised very well that — long though the odds might seem in 1492 — he had entered his son in the papal stakes. Twenty-one years later, Cardinal Giovanni de' Medici became Pope Leo X. For the first time in its history, Florence could share directly in the jubilation accompanying the announcement of a new papacy. Thanks ultimately to Lorenzo de' Medici's foresight, the city received the one distinction it had previously lacked: a Florentine pope.

But the House of Medici which Lorenzo 'the Magnificent' headed was becoming

partly a house divided. Some of the results of that physical and emotional division are mainly of relevance in a history of the family but others are bound up with the history of Florence, and the Medici family tree (see p. 475) begins to break into two main branches, both significant for the future, with the descendants of the two sons of the patriarchal Giovanni di Bicci de' Medici, Cosimo and Lorenzo.

For several generations there was an odd, minor pattern, of the death of the younger brother before the elder, which makes for apparent gaps and mildly confusing lines of relationship scarcely clarified by the repeated use of the same first names. As Lorenzo died before Cosimo, so Cosimo's son Giovanni died before Piero, the father of Lorenzo 'the Magnificent' whose sole younger brother, Giuliano, was murdered in the Pazzi conspiracy.

So much for the elder branch. From the marriage of Cosimo's brother Lorenzo were born two sons, Francesco and Pierfrancesco, of whom Pierfrancesco at least seems to have felt resentful that he had not received his due share of the family's fortune at Cosimo's death. Pierfrancesco himself died in 1476, leaving two young sons, Lorenzo and Giovanni, of whom the younger, Giovanni, died in 1498. Both boys were in the guardianship of their cousin, Lorenzo 'the Magnificent', but after his death his son, a second Piero, had them exiled from Florence in his short, disastrous attempt to preserve the Medici hegemony. On his own exile, they were free to return.

Lorenzo di Pierfrancesco was an important patron of Botticelli (the *Primavera* was probably painted for him rather than his famous namesake). Giovanni has no importance for art history or, strictly, for history, though both he and his brother seem to have sympathised — as had their ancestor Salvestro in the fourteenth century — with 'popular' republican government. Giovanni's interest is posthumous. By his wife, the formidable Caterina Sforza (militant, amorous and aggressively untypical of the Florentine ideal of a wife), he had a son, known as Giovanni delle Bande Nere, an able though short-lived *condottiere*. The wedding of Giovanni delle Bande Nere united the two branches of the family, for he married Maria Salviati, granddaughter of Lorenzo 'the Magnificent'.

Thus the heredity of their one child, a son, was heavy with grand Medicean associations, and those associations probably helped privately to feed the child's ambitions. When power unexpectedly came to him, while still in his teens, he would show Florence and Italy how calmly he was prepared for it. He had been born in June 1519, only a month after the premature death of Lorenzo, Duke of Urbino, grandson of Lorenzo 'the Magnificent', the sole legitimate, non-clerical Medici heir, and for the new heir was

revived another evocative family name, Cosimo – given to him at the express wish of his godfather, Pope Leo X.

The second Cosimo would more than live up to the expectations of his name, becoming not only acknowledged ruler of Florence but the first Grand Duke of Tuscany. Yet in several ways he proved to have affinities less with his namesake than with Lorenzo 'the Magnificent'. The myth of Lorenzo – effectively prince of Florence before the word could be used of a ruler there – was to be both potent and useful to his descendant. Lorenzo had been hailed by admirers in his own lifetime as a divinity: 'that Phoebus of ours', Marsilio Ficino called him in a letter of 1481. Unlike his grandfather, Lorenzo did not dissemble his power and involvement in Florentine politics, or in Italian affairs altogether. Unlike his grandfather, he also possessed, and openly displayed, glamour – something of a novelty among canny prominent Florentine citizens, unaccustomed to a sun-god or a sun-god's behaviour. Grand Duke Cosimo did not bother to appear glamorous. He would be concerned with carefully keeping a grip on his god-like position as ruler not just of the city but of a duchy. But he too would intend his reign to be one glorious culturally, as well as politically, echoing and perhaps outdoing Lorenzo's in the previous century. For his personal device he chose the zodiac sign of Capricorn, the goat, which was the astrological symbol under which Lorenzo 'the Magnificent' had been born.

I T W A S N O T merely in retrospect that Lorenzo's Florence appeared to be virtually as 'magnificent' as was he. What characterised the city in the years of his rule was a sense – half-irrational and half-justified – that, thanks to him, it was enjoying a period of peaceful, creative felicity. Such a condition was thoroughly deserved, of course, given the unique beauty and status of the city, and the wisdom and prudence of its inhabitants. But heaven and fortune had not always adequately recognised or rewarded all its remarkable qualities. Very difficult times indeed followed the death of Lorenzo in 1492. Even the weather in Florence seemed to worsen. His death, at the age of only forty-three, was generally felt to be a disaster ('bitter for him', would write the Florentine historian Francesco Guicciardini, a boy of nine at the date, '. . . and bitter for his country which had flourished marvellously'), and with it a golden summer age for Florence, one not heroic but hedonistic, sophisticated and assured, seemed abruptly to end, as if it had all been his personal vision.

Some things he fostered; others coincided with the twenty or so years of his regime.

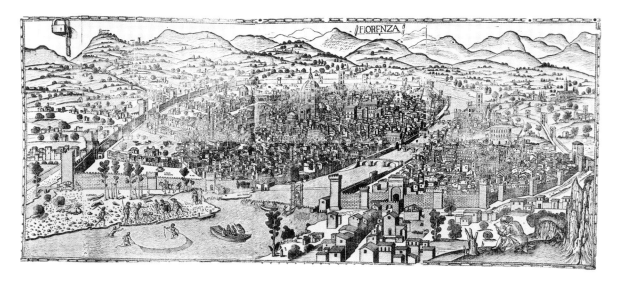

'Della catena' engraved view of Florence, Print Room, Staatliche Museen, Berlin.

It was in that period that the image of Florence as a physical entity emerged from being a subsidiary occasional feature in paintings (though it continued to exercise appeal for painters) and became a subject in itself, in a comparatively new medium, that of engraving.

Closely contemporary with Lorenzo de' Medici, being born a little earlier in 1445, was Francesco Rosselli, in business as a cartographer, producing globes and maps of the world, and – nearer home – probably the instigator of a large, six-piece wood-engraving which provided the first panoramic view of the city. It has good claims to be the first convincing-looking projection to be executed of any Western city, along with its environs. It gave a view at once sweeping and detailed of Florence, seen from the south-west, and seems to have been based, with adjustments, on the appearance of the city as it could be surveyed from Monte Oliveto, taking as a yet higher vantage point no doubt the church of San Bartolomeo, being rebuilt in Renaissance style at about the same approximate date as the panorama, 1472.

The city is shown densely built at its centre but unpeopled. On both banks of the Arno the walls generously encircle considerable peripheral areas of open land, and one of the many impressive features of the view is its extensive depiction of the surrounding hilly countryside, dotted with churches and villas and farm buildings. The view serves partly as a guide. Each gate of Florence is identified, as are the bridges and prominent palaces (especially prominent is the single but towering block of the Palazzo Pitti) and some of

the chief churches and other monuments – for example, the Ospedale degli Innocenti. Life, in the sense of human activity, is glimpsed outside the walls, in the foreground, in almost a conspectus of society: a peasant urging his mule over a small bridge, naked fishermen hauling a net in the river, while nearby a trio of men is being ferried across it. Tricky labour is involved for a pair of workers on a scaffolding erected over a dam; and they are balanced by a pair of middle-class-looking citizens standing on the riverbank, engaged in nothing more strenuous than a dialogue. The latter pair give off intimations of the spectator role of Ruskin and Carlyle in Ford Madox Brown's *Work*.

The final human activity is the most interesting and relevant. High up on a convenient mound at the right foreground sits an absorbed young artist, drawing the scene in his sketchbook. He has only got as far as the semi-circle of the northern walls, so he has a good way to go. But (like the other figures) he is more symbol than factual indication, reminding those who look at this exhilarating new 'realistic' achievement that it was composed through scrutiny on the spot – and, by implication, that the city of Florence is a work of art worth study and recording.

Almost as important as the visual achievement of the coherent panorama is the medium in which it is executed – a new, 'mechanical' one, which permits of duplication. The engraving may not possess the obvious and unique dignity of a painting (although a talented artist, with an interest in anatomy, must have provided the fully realised foreground figures) but it has the advantage – like a printed book – of being cheaper and more widely available. Prints of this view of Florence could be despatched throughout Europe and thus, in a way impossible before, reveal to people in distant lands, as also to those in other parts of Italy, the beauties of this famous city, its geography and its architecture – the way the Arno flows through it, and how Brunelleschi's cupola of the Duomo dominates the city centre. All this, and more, it conveys without the need for any reading. The enormously popular genre of the topographical print, accurate yet picturesque, has here been invented. It would be a factor in stimulating the curious traveller, the 'tourist', to set out, and it would continue for centuries to give some vicarious sense of travelling to those resolutely staying at home. Even Jane Austen's timid Mr Woodhouse perused a few Italian views, though not of Florence but Venice.

About the time this print was prepared, Benedetto Dei, an agent of the Medici company in several cities, was composing his euphoric factual tribute in words – his mantra – to '*Florentia bella*'. Taken together, print and chronicle put Florence on any person's mental map. Dei is unashamedly propagandist. In addition to its monuments, its mills, its 50 piazze, 270 wool shops and 83 silk shops, '*Florentia bella*' has seven necessary

'things' without which no city can be called superior. They begin with 'total liberty' and end with 'banks and accounting firms the equal throughout the world of any Venetian or Milanese or Genoese or Neapolitan or Sienese'. It is a neat, proud, Florentine encapsulation of the ideal and the practical.

Never before perhaps had Florence felt so sure of itself than under Lorenzo de' Medici's 'protection'. By August 1489 Landucci was recording that 'Men were crazy about building at this time, so that there was a scarcity of master-builders and of materials'. Building of the Palazzo Strozzi had by then begun, and Landucci — living nearby — also records the concomitant environmental nuisance (usually overlooked by posterity), what with the dust and the workmen and the crowds who gathered just to watch. And while Filippo Strozzi was putting up this grandest of all palaces, work on which proceeded very speedily, his neighbour of far humbler rank made his own modest gesture of prosperity: opening a new shop opposite, and choosing for it the sign of 'The Stars'. Nor did Landucci have any cause, as it happened, to envy Filippo Strozzi, even had he been so inclined. Suddenly, Strozzi was dead. He never lived to see his palace finished, Landucci moralised, which illustrates the vanity of human hopes. Yet 'this palace will last almost eternally'.

The mood of the later years of Lorenzo de' Medici's regime and life, according with the period of comparative peace experienced throughout the Italian peninsula, was summed up not by any open piece of Medicean propaganda or flattery, still less by anything directly instigated by Lorenzo himself. It was expressed in an inscription, which can now be read as also something of an epitaph, appearing in one of the frescoes painted by Ghirlandaio for the main chapel, that of the high altar, of Santa Maria Novella and commissioned from him by Giovanni Tornabuoni, brother of Lucrezia Tornabuoni and therefore Lorenzo's uncle. And the frescoes themselves are painted in the same euphoric mood.

Because of their location they have to illustrate religious subject matter, chiefly scenes from the life of Tornabuoni's (and Florence's) patron saint, St John the Baptist, and from the life of the Virgin. But the life that they really speak of is life in late fifteenth-century Florence. To deplore the presumed prosaicness of Ghirlandaio's approach, or his sometimes perfunctory attention to the sacred aspect of a scene, is to miss what he celebrates so positively and with such real gusto. Taking hints from Masolino's work in the Brancacci Chapel, not unmixed with awareness of Gozzoli's frescoes in the Medici Palace chapel, the popular painter of a new generation, an exact contemporary of Lorenzo de' Medici, exerts himself to seize and fix — almost as if conscious of being one of the last

witnesses of it — the profound *douceur de vivre* investing his native city. All is bathed in a glow literally golden, or at least gilded; and, far from being prosaic, much is touched with exuberant fantasy. Comparisons with photography badly miss the mark, even in terms of denigration.

The truth is that Ghirlandaio was a poetic painter, though not a lyric one like Botticelli, with whom he is often compared to his detriment. He was more of a Crabbe than a Keats. For him poetry resided not in some imaginary mythological past but in the solid, factual here and now: in the line of the streets and in the shape of the rooms of Florence, in the cut and colour of the citizens' clothes and, above all, in their physical appearance. What he portrays is a society, of individual, recognisable people from a sophisticated, prosperous milieu where — at last, one feels — women may be shown moving in some sort of pictorial equality with men. That is a novelty. It contrasts with the major scenes in the Brancacci Chapel, where Filippino Lippi had a few years earlier (around 1480) completed the compositions with plenty of contemporary Florentine bystanders, but male ones only.

And whatever the current deliberations of the *Signoria* about the requisite sobriety of women's dress, Ghirlandaio's ladies (as they clearly are) flout them in low-cut bodices, ostentatious jewellery and brocades of pink and gold. The presence of these well-born and well-bred young women cannot help accidentally reminding us of the young women of the *Decameron*, who had met in the same church almost a century and a half before.

That it *is* a church, and its chief chapel too, in which Ghirlandaio's frescoes are painted, could easily be forgotten. The fact is not so much a criticism of him as of Florence, in so far as nobody there had the wit or initiative to capitalise on his sturdy *bon bourgeois* gifts, and commission from him, for a private palace, frescoes of a purely genre kind. He could, for instance, have painted the Medici family on the walls of their own home, with all the conviction and illusionistic naturalism of Mantegna's frescoes of the Gonzaga family in the '*Camera picta*' of their palace at Mantua.

In one of the most imposing of the compositions at Santa Maria Novella, that of *The Angel Appearing to Zacharias*, Ghirlandaio flanks the central biblical incident with a series of groups of notable Florentines, members of the Tornabuoni family and leading intellectuals, leavened by only a rather conventional, subordinate sprinkling of women. Although the architecture is ideal, Roman antique in style and decorated with triumphal battle reliefs, the pervading air is of Florence, '*Florentia bella*', flourishing and tranquil, personified in those soberly dressed, serious-looking citizens, each vividly characterised but *en masse* expressive of the republic. This is the fresco that bears the significant

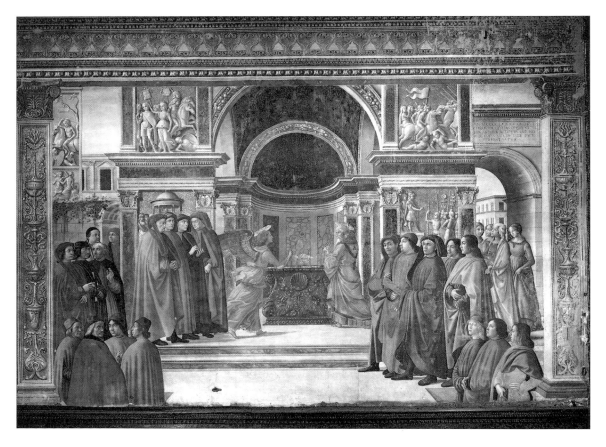

Domenico Ghirlandaio: The Angel Appearing to Zacharias, *Santa Maria Novella.*

Latin inscription (on an arch at the right): 'The year 1490 when the most beautiful city [*pulcherrima civitas*] renowned for abundance, victories, arts [*artibus*] and noble buildings profoundly enjoyed salubrity and peace.'

Even without that explicit statement, the message of Ghirlandaio's instinctively optimistic frescoes (where the overall tenor is barely disturbed by a grisly scene of the *Massacre of the Innocents*) is one of deep, peaceful reassurance. Nearly as significant as the inscription on the arch is that picked out in letters of gold along the panelling of the room in which St Anne has given birth to the Virgin – a handsome Florentine room, with Florentine lady-visitors and a delightfully smiling youthful nurse, cradling the infant: 'Your birth, O Virgin Mother, announced joy to the whole world.'

For Ghirlandaio 'the whole world' comes down to a strongly visualised and essentially joyful yet normal world of everyday experience, filled with material objects (often

of great individual beauty), and he cannot paint them without celebrating them, whether it be a carpet, a cornice, a maiolica pot, or a key (one in its lock in the woodwork under St Anne's bed indicates a conveniently sited, space-saving cupboard). Giovanni Tornabuoni had stipulated in the contract for plenty of detail in the frescoes ('figures, buildings . . . cities . . . hills . . . water'), and Ghirlandaio supplied it generously. The result is an extensive 'picture', virtually a compressed chronicle, of late fifteenth-century Medicean Florence. No painter was better suited than Ghirlandaio to convey its sense of its own stability.

The subject of the birth of the Virgin might have stirred ambivalent vibrations in Giovanni Tornabuoni, whose wife had earlier died in childbed, and for whom he grieved, but he had a single daughter, who is perhaps the upper-class young lady portrayed making a stately visit to St Anne. Tornabuoni himself and his wife (brought back to life) appear kneeling full-length in prayer on either side of the high altar, and the most obvious absentee from the faces of family and friends is Lorenzo de' Medici.

Ghirlandaio had included him in frescoes of a few years before in Santa Trinita, painted for Francesco Sassetti, a manager of the Medici bank and socially less grand than Giovanni Tornabuoni. Even more patently does Florence there pervade scenes from the life of St Francis which actually occurred in Assisi and Rome (see Plate 16). One ecclesiastic at Pope Honorius III's court was, understandably, surprised to see the tutor of Lorenzo's sons, Angelo Poliziano, leading the boys up a stairway and gazing reverently towards the figure in profile of their father – an image wonderfully unflattering but perhaps the most vivid ever painted of this famous man. Plainly dressed and discreetly posed between two older men (one of whom is Sassetti), he yet quite fails to pass unnoticed (in fact, Ghirlandaio shows him as the tallest of the three, and with a much bigger head). The long, squashed-in nose, jutting chin and shock of untidy black hair somehow suggest not only individuality but vitality – and certainly a forceful character, making an almost grimly seamed mask of face for a person in his mid-thirties.

He is missed in the Tornabuoni frescoes, being absent partly perhaps because of his very status by then in Florence. Besides, Giovanni Tornabuoni was concerned with emphasising – just as had Giovanni Rucellai previously – that after God his priority was 'exaltation of his house and family'. He was a Tornabuoni. A Medici had had the good fortune to marry his sister. Distinction might lie less in the fact that he was Lorenzo de' Medici's uncle than in Lorenzo being his nephew.

In the inscription on the fresco of *The Angel Appearing to Zacharias*, the happy prosperous condition of Florence in 1490 is carefully ascribed to no one in particular – not even

to the collective sagacity of its citizens. Perhaps it may piously all be assumed to be God's doing, though He is not mentioned either. Nor, in lapidary inscriptions of this kind, is anyone on oath. Nevertheless, allowing for rhetoric and euphoria, and an upper-middle-class viewpoint (that of somebody described in the contract as 'magnificent and noble . . . citizen and merchant of Florence'), the statements in it are reasonably accurate.

The abundance or plenty of Florence had been perpetually invoked by setting up Donatello's statue in the market-place. In 1490 the economy of the city seems, as far as can be judged, to have become broadly stable. The financial situation probably tended to favour those who were already well-off: the few were doing better, as they usually do in capitalist societies, than the many. And the few were, as usual, at the centre of government organisation.

Like its ever-fluctuating internal political structure, the civic finances of Florence represent an intricate area to explore, and one obviously subject to even greater fluctuations. More than two hundred years had passed since the funded debt of the Commune, the *Monte Comune*, had been established. At its simplest, the system was to pay interest to those who lent the state money. By 1470 the *Monte* was described – in a law phrased in extremely non-legal language – as 'the heart of this body which we call city . . . guardian fortress, immovable rock and enduring certainty of the salvation . . . of your State'. Money seems there to be attracting a near-religious form of enthusiastic worship, not unique perhaps to Florence but surely typical of it.

Most citizens invested something in the *Monte* (the National Savings scheme of its day). The organisation was constantly reformed – inevitably in Florence – constantly grew in scale, as did the state debt, and had constantly to be staffed. One of Botticelli's brothers was an official of it. The wars of the fifteenth century put an enormous strain on the *Monte* to supply the state with funds to pay for them. Taxes had to be raised by new means (the Church did not escape), while interest on loans to the *Monte* was lowered. In June 1477 Landucci noted that the duty on wine – of all things – had gone up. He seems touchingly credulous, as well as patient, in adding that a promise was given that the new duty 'would not last for more than five years'.

It is true that by 1490, in which year a second Commission of Seventeen Reformers was instituted to review the financial workings of the government machine, direct taxation had fallen. In contrast to the strain and real hardship of the preceding years when, quite apart from high taxes, creditors had often not received the promised return on their investment, there was relief, if not exactly 'plenty'. That was due to peace, achieved by victories not military but diplomatic. Those owed much to Lorenzo de' Medici's sometimes

daring personal involvement, which in turn made him appear (more even than his grand-father had done) the personal ruler of Florence to rulers elsewhere. As the Pazzi conspiracy was to demonstrate, this focus on him was not always agreeable.

Whatever the cheerful martial reliefs of Ghirlandaio's fresco might suggest, the one aggressive campaign undertaken by Florence – very much at Lorenzo de' Medici's instigation – was a dubious moral victory, if not positively shameful. The proud, restless, hill-top city of Volterra was judged to have revolted against Florentine interests. Federico da Montefeltro was the great *condottiere* hired to punish it. When the city surrendered in 1472 his troops ran amok, brutally raping and pillaging to an extent that left a notably non-squeamish age with lingering distaste. Machiavelli's account did not omit the horror, and he added coolly, 'The news of this victory was received with great joy at Florence.'

For posterity it is the reference to '*artibus*' – as well as to 'noble buildings' – that has the greatest resonance in Ghirlandaio's inscription, although the term is probably meant to apply far more widely than just to the visual arts (taking in the 'arts' represented by all the guilds). It is understandable, however, that a general glow should be given off by the artistic scene in the later fifteenth-century Florence. The glow is indeed so general that it helps conceal the lack of a mature sculptor of Donatello's genius or an architect of Brunelleschi's. In 1490 Michelangelo, briefly a pupil of Ghirlandaio, was just a talented boy of fifteen.

The great all-round artistic figure who had been dominant was Verrocchio, active as a painter as well as a sculptor and goldsmith, in whose busy studio Leonardo da Vinci was trained. Verrocchio's studio was probably what Ghiberti's had been to an earlier generation. Verrocchio was much patronised by the Medici family, succeeding as it were to the position of Donatello. For them he created not only famous surviving statues, such as the ever-popular *Boy with a Dolphin*, executed for the villa at Careggi, and the graceful, yet discreet, Desiderio-inspired sarcophagus of Piero and Giovanni de' Medici in San Lorenzo (a tomb, not a monument), but also now-lost painted portraits and standards for tournaments.

Verrocchio himself was lost to Florence from 1483, having won the competition for a huge equestrian statue in bronze to be put up in Venice at the expense and to the memory of the deceased *condottiere* Bartolomeo Colleoni. The superb statue we see today – sole equestrian statue in Venice and a bold assertion of individuality in that republic – had not even been cast when the sculptor died there five years later.

Before Verrocchio's departure for Venice there had been another artistic emigration from Florence, by Leonardo da Vinci, allured to Milan by a comparable prospect:

the executing of a colossal bronze equestrian statue of the reigning duke's father. The statue was never finished, but not until early in the following century would Leonardo return.

Plenty of gifted artists remained in Florence, to be employed there or to be attracted for shorter periods elsewhere to display their gifts. It is not necessary to see Lorenzo de' Medici's hand subtly behind every move, although sometimes it was he whom a foreign ruler addressed for artistic advice – even, on occasion, for the actual artists. Building his new palace of the Topkapı in Istanbul, the sultan Mehmed II, justly called 'The Conqueror', wrote to Lorenzo for the despatch of Florentine craftsmen skilled in *intarsia* work, a fair exchange for the return to Florence by the sultan of one of the Pazzi conspirators who had escaped.

If he had not exactly approved the Pazzi conspiracy, Pope Sixtus IV had approved its aim: the annihilation of Lorenzo de' Medici. A few years later the pope was pleased to employ leading Florentine painters on the frescoes in his chapel (the Sistine Chapel) in the Vatican. Ghirlandaio and Botticelli worked there, alongside Perugino and Signorelli. To another great Florentine all-round artist, of an older generation, Antonio Pollaiuolo, Ghiberti's one-time assistant, was entrusted the pope's elaborate tomb, perhaps under discussion before his death in 1484: an effigy in bronze, lying amid a gratifying array of the Virtues, theological and cardinal, and the Liberal Arts. In 1489 Lorenzo de' Medici called Antonio Pollaiuolo 'the leading master of the city [of Florence]'. Pollaiuolo's last years were spent in Rome, working first on the tomb of Sixtus IV and then on that of his successor, Innocent VIII, where he introduced a contrast, with the un-Florentine concept of the pope depicted seated and alive, one hand raised in blessing. 'Leading master' or not, Pollaiuolo had received no such major sculptural commissions in his native city.

It was less in Florence than in his various country villas that Lorenzo de' Medici's personal patronage appears to have been visibly exercised. He never followed up ideas mooted earlier in the century for a grand 'Medici' civic complex around San Lorenzo which would bring the church and the family palace into relationship. He seems to have shown no interest in completion of the façade of San Lorenzo, although he himself submitted a design for the façade of the Duomo when instigating an abortive competition for it to be finished in an up-to-date style. Medici panegyrists would write glowingly of how greatly he excelled in architecture, at least in architectural theory. Guicciardini more dispassionately concluded that compared with the numerous buildings of his grandfather, 'one can say he built nothing'.

His villa at Spedaletto, near Volterra, was the most distant of all his homes (it was

later burnt). For it he had commissioned frescoes from the trio of Florentine painters who would have been recognised by most people as the leading ones of the period: Ghirlandaio, Botticelli and Filippino Lippi, son of Fra Filippo whom the Medici had earlier patronised.

The subjects seem to have been mythological, and some echo of their decorative style is perhaps detectable in Filippino's faded fresco in the villa of Poggio a Caiano, the one significant building associated with Lorenzo de' Medici. Out of a simple farmhouse the architect Giuliano da Sangallo, urged on by an eager patron (who probably had ideas of his own to contribute), evolved a non-rustic, positively palatial villa, the first of its kind in Tuscany with a pedimented portico, and tinged with anticipations of Palladio. Lorenzo died before it was completed, but the villa became a prized Medici possession, enhanced and virtually consecrated to his father's memory by Leo X. Its survival more than compensates for the loss of the Spedaletto.

Giuliano da Sangallo was probably Lorenzo de' Medici's preferred architect. At least, he both employed him and recommended him enthusiastically and widely to other patrons, including the King of Naples. Sangallo was a Brunelleschi follower (born around 1443, just within Brunelleschi's lifetime) influenced by Alberti. Medici influence got him involved in the neo-Brunelleschian sacristy of Santo Spirito, and it also gained him the commission for Santa Maria delle Carceri, a fairly small, nigh-perfect, free-standing church, the design of its marble exterior according with its harmonious interior – built, however, not in Florence but in Prato.

Thus, for one reason and another, there is less palpable evidence of Lorenzo de' Medici in Florence today than might have been expected. And it is useful to counter the myth of pervasive Laurentian artistic patronage by emphasising the continued existence of civic sources of patronage. But the matter is not always clear-cut. Behind the scenes, Medici influence, if not indeed Lorenzo, may on occasion have played a part, either in the choice of a given artist or a given subject, and possibly at times both.

It was in 1483, when Lorenzo was very much the dominant personality in the governing of Florence, that an important piece of public sculpture was unveiled: the bronze group of Christ and St Thomas, which had been commissioned many years before from Verrocchio by the Magistracy of the Mercanzia for a prominent niche on Orsanmichele. The group, which filled the niche previously occupied by Donatello's *St Louis*, is a masterpiece of movement and gesture, so ingeniously and successfully fitting two figures into a niche originally planned for one that its success, like its familiarity, can be taken for granted. Verrocchio is not a sculptor with the emotional profundity of

Donatello, but he was a master of the effective, proto-baroque pose. In this group he subordinates the doubting saint, placing him outside the niche proper, while Christ seems to swell majestically within it, even as he invites the probing physical contact of St Thomas's extended hand. Verrocchio seems to be articulating a new, dramatic language for sculpture, with anticipations of the three-figure groups that would go up on the exterior of the Baptistery in the sixteenth century.

The commission for Orsanmichele was, on the face of it, a typical, communal one. The Magistracy of the Mercanzia consisted of six officials from the major guilds who adjudicated on merchants' disputes. Their representatives involved in commissioning a work for the church included, however, Medici adherents (and at one point the young Lorenzo himself, replacing his father). Verrocchio was certainly a sculptor patronised by the Medici, as seen notably at San Lorenzo. So, obliquely or perhaps directly, Medici patronage may have lain behind the commissioning of what has become one of the most famous pieces of Renaissance sculpture in Florence.

The main focus for commissions in the later part of the fifteenth century was the interior of the Palazzo Vecchio. The original character of the beautiful décor then devised may not be entirely apparent to visitors, since the sixteenth century showed scant respect for it, but enough remains, particularly in the Sala dell' Udienza (of Audience) and the Sala dei Gigli (of Lilies), to convey its accomplishment and its emphatically republican tone (see Plate 20).

There, it was the magnificence of the 'Magnificent *Signori*', symbolising the government and Commune of Florence, that found expression in the scheme of Benedetto da Maiano, sculptor as well as architect (the architect in part of the Strozzi Palace) and co-ordinator of a team of several craftsmen. From tiled floors to superbly coffered ceilings blazing with blue and gold, he and his fellow-workers turned these two rooms (created out of one larger one) into the most magniloquent surviving statement of the Republic's pride – under the Medici but with no open acknowledgment of them. Had the Palazzo Vecchio continued to be decorated so sumptuously it might have begun to rival the Doges' Palace in Venice, but history as well as art was involved. Not merely did sixteenth-century Florence have to make do with Vasari, while Venice had Veronese and Tintoretto for comparable decoration, but the Palazzo Vecchio inevitably ceased to be a showcase of republican sentiment. Celebration of Florence gave way to celebration of Duke Cosimo I de' Medici in his own home.

Benedetto da Maiano's two rooms called on virtually every Florentine art to glorify the city (and the actual day of the formal decision to set the basic work in hand was the

feast-day of St John the Baptist, 24 June 1472). The lilies and lions of Florence are worked into ceiling and cornice. One handsomely carved marble doorway is topped by Benedetto's statue of a svelte St John. Above another is a statue of Justice. The exquisitely inlaid doors between the two rooms show Dante and Petrarch. In the Sala dei Gigli, the walls are a snowstorm of *fleur-de-lys* repeatedly patterned, though a figurative fresco scheme was intended for it. Only Ghirlandaio and his assistants seem to have executed anything, and the resulting fresco is fascinating for its mingled subject matter, regardless of the quality of painting. A grandiose simulated architectural framework contains an altarpiece of St Zenobius enthroned, guarded by a pair of lions, respectively holding huge banners of the city and of the people of Florence, and in archways high up at either side stand two trios of antique Roman republican heroes: Brutus and Mucius Scaevola with Camillus; Decius Mus and Scipio with Cicero. Under the double inspiration of Christian piety and pagan history, integrated here into a single scheme, the future of Florence seems guaranteed. The images of the great men of antiquity evoke those debates and discussions held in the palace in which such names had been so passionately cited, while another perspective is suggested by the view from the wide window embrasures over the city towards the omnipresent, giant silhouette of the cupola of the Duomo.

Almost every talented artist in the city was commissioned to provide something for the seat of government in these years. Some of the very glass of the windows was specially commissioned from a master glazier, Alessandro Agolanti. The *Signoria* bought Verrocchio's bronze statue of David from Lorenzo and Giuliano de' Medici and turned it into a republican symbol, placed in a commanding staircase site. Botticelli, Antonio Pollaiuolo and Filippino Lippi were all assigned paintings to execute, as was Leonardo da Vinci, who received the commission in 1478 to paint an altarpiece for the palace chapel of St Bernard. That was important official recognition, but Leonardo seems not to have bothered to do anything. Florence is fortunate to possess any paintings by one of the greatest of Florentine painters — chiefly the *Adoration of the Magi* (now in the Uffizi), which the artist never finished and never delivered to the monks of San Donato a Scopeto, who had commissioned it in 1481.

That commission is a reminder that another source of patronage, the Church, still offered important opportunities to artists — perhaps the most important. And although Leonardo's altarpiece remained hardly more than sketched out on the panel, its originality and its tremendous range of motifs — its gamut of faces aged and youthful encircling the Virgin and Child, its ruined yet mighty architecture, its noble horses and riders, its hints of distant mountainous landscape — were evident, and the effect is all the more

haunting because not fully realised. A masterpiece in a quite new style of magical naturalism had already taken shape there, and Leonardo has woven around one of the most traditional and familiar of Christian subjects a web of personal obsession that gives the composition an air of strangeness. Yet in some ways it can be said to be only a 'High Renaissance' re-interpretation and elaboration of the elements to be found in Gentile da Fabriano's *Adoration of the Magi*.

When he went to Milan Leonardo left his *Adoration* in Florence to exercise its spell on contemporary artists, and it undoubtedly did. That he was not a greater loss to the Medicean city is explicable in one word: Botticelli. For despite the real gifts, and often the greater versatility of a cluster of other Florentine artists, and despite the never-to-be-despised talent of Ghirlandaio, it is the genius of Botticelli which best exemplifies the highly cultivated, learned, literary, hedonistic and yet not impious climate that attached perhaps less to the city as such than to the circle around Lorenzo de' Medici.

If Ghirlandaio caught much of the ordinary physical look and feel of the period up to Lorenzo's death (he himself died two years later in 1494), Botticelli caught something more impalpable, a glimpse of mentality and tone not ordinary but exclusive. Thus the two artists complement rather than contrast with each other. Not only were they close contemporaries, sometimes working for the same patrons and virtually side by side, but they each partook of the other's qualities. As Ghirlandaio could display flourishes of fantasy, so Botticelli could confront 'reality' and match, for example, Ghirlandaio as a painter of portraits, whether in their own right or included in a religious composition.

Yet it is Botticelli who extends and deepens our awareness of the complex Florentine atmosphere, whereas Ghirlandaio – for all his ability – tends to confirm what we already know. Botticelli lived on into more troubled times and continued to respond to atmosphere. He is indeed a supreme witness to the days when Medici rule seemed vanished for ever from the city, and in a climate earnest, if not desperate, and certainly non-hedonistic, there reigned instead a king: Jesus Christ, the king of Florence. In his kingdom Botticelli fervently believed.

As Botticelli finished, so he had begun: as a religious painter. The altarpieces and comparable pictures he painted for Florentine churches need to be put back – if only in the mind's eye – into their original settings, because from the 1470s that was the aspect of his art which most contemporaries could see and praise. Unlike Leonardo, he usually carried out the commissions he received.

In Santo Spirito was his great altarpiece of the two saints John (executed for Giovanni de' Bardi), with the Virgin and Child enthroned in a bower of richly wrought

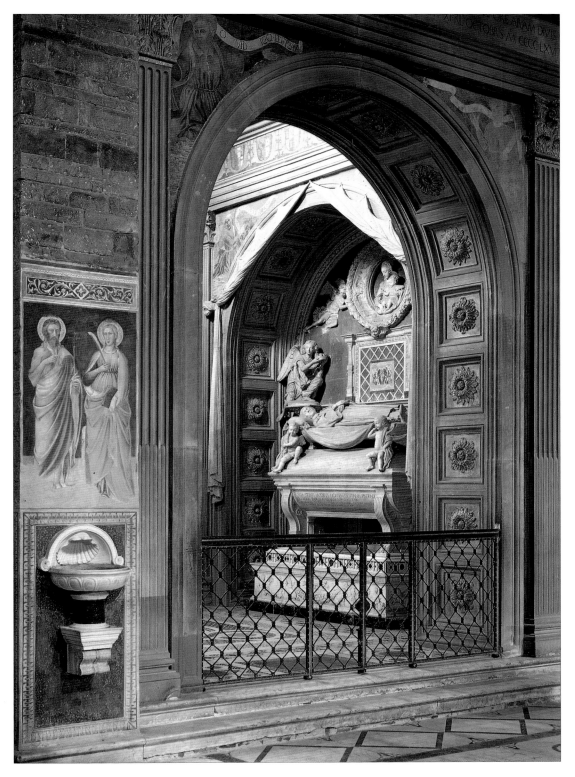

PLATE 15

Chapel of the Cardinal of Portugal, San Miniato al Monte

PLATE 16

Domenico Ghirlandaio: *Confirmation of the Franciscan Rule*, Sassetti Chapel, Santa Trinita

PLATE 17

Andrea del Verrocchio (?): *Tomb-marker of Cosimo 'il Vecchio' de' Medici*, San Lorenzo

PLATE 18

Burgundian, 15th century: *Rock-crystal Cup*, Treasury of San Lorenzo

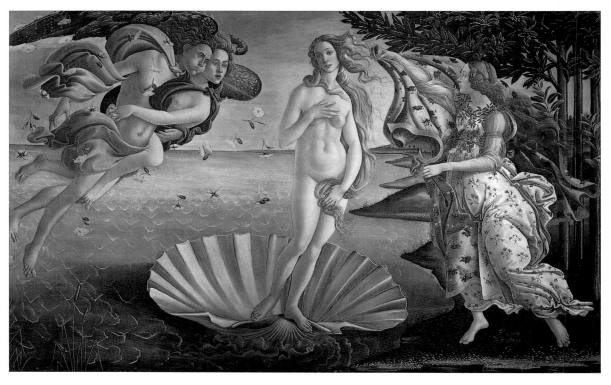

PLATE 19

Sandro Botticelli: *The Birth of Venus*, Galleria degli Uffizi

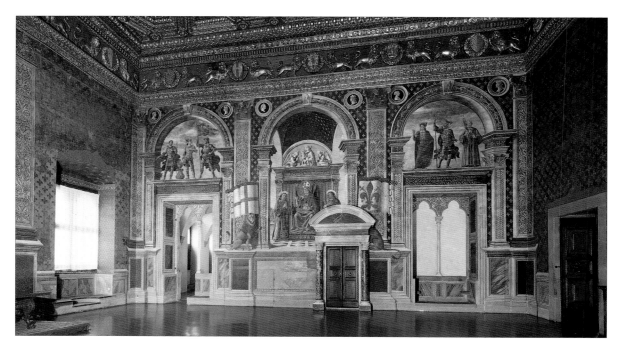

PLATE 20

The Sala dei Gigli, Palazzo Vecchio

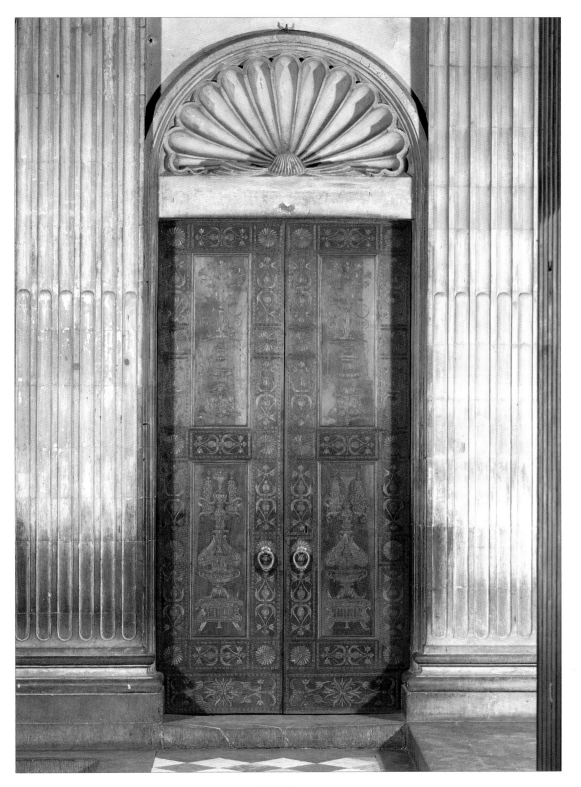

PLATE 21

Florentine, 15th century: *Intarsia Doors of the Old Sacristy*, San Lorenzo

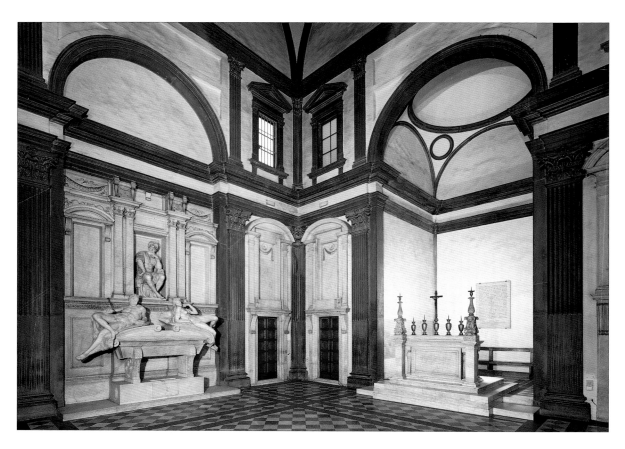

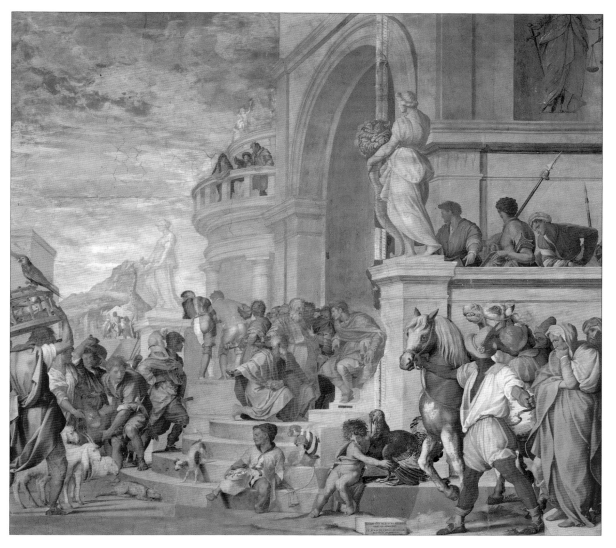

PLATE 25
Andrea del Sarto: *The Tribute Paid to Julius Caesar*, Medici Villa, Poggio a Caiano

FACING PAGE (CLOCKWISE FROM TOP)
PLATE 22
Michelangelo: *The New Sacristy*, San Lorenzo
PLATE 23
Giovanni Antonio de' Rossi: *Cameo of Duke Cosimo I de' Medici and his Family*,
Museo degli Argenti, Palazzo Pitti
PLATE 24
Agnolo Bronzino: *Eleonora di Toledo and her Son Giovanni* (?), Galleria degli Uffizi

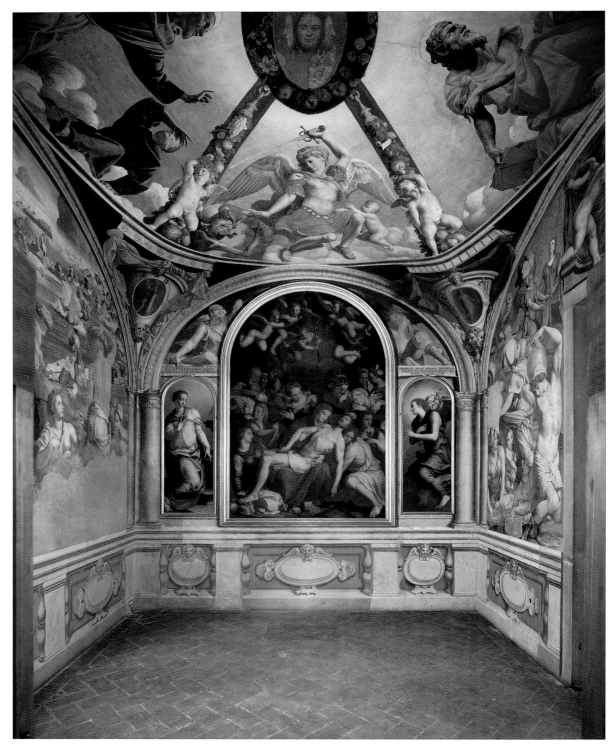

PLATE 26

Agnolo Bronzino: *The Chapel of Eleonora di Toledo*,
Palazzo Vecchio

marble and bristling shrubbery – now in the Gemäldegalerie in Berlin. For a chapel in his own local church of San Paolino he painted a *Lamentation over the Dead Christ*, where Christ is a beardless, barely wounded, naked figure, with a body like that of an Apollo or Meleager – now in the Alte Pinakothek in Munich. One of his interpretations of the Annunciation is of formal, polished clarity, with the angel kneeling close to a swaying, almost swooning Virgin, and painted for a convent that became Santa Maria Maddalena de' Pazzi – now in the Uffizi. Another – also now in the Uffizi – he frescoed for the hospital of San Martino alla Scala, and there, outside the bedroom where the Virgin kneels, the angel hovers above the pavement of the courtyard, flown there or blown there like some eternal, airy spirit, brother to the pagan Zephyr of the *Birth of Venus*.

The content and emotional charge of Botticelli's religious paintings are almost disturbingly many-layered and deep, reflecting not just a sophisticated society but the sophistication and the profound thought of their creator, always refining and reworking – chiefly, one is bound to feel, to meet the needs of his own vision and the pressures of a temperament as individualistic as Leonardo's. His increasingly anti-naturalistic style is the ultimate assertion – a remarkably brave one by the early sixteenth century – of individuality.

Botticelli's art seems, from the first, to have found a sympathetic reception in Florentine society. As well as being capable of delivering the large-scale painting for a church, he showed he could meet the need for domestic, devotional images of graceful, tender subjects, usually of the Virgin and Child, a theme he happily repeated with effortless-seeming variations. Technically extremely accomplished and adaptable, working on panel or canvas or plaster, he showed himself able also to provide painted decorations for furniture, where the subject matter was frequently secular, and could be courtly and gently or playfully amorous.

The artist, like his work, must have gained some sort of sympathetic reception or recognition in society. Soon he was receiving direct Medici commissions (a tournament standard for Giuliano de' Medici) and was chosen by a Medici adherent, Guaspare del Lama, to paint an *Adoration of the Magi* for his chapel in Santa Maria Novella where, amid other portraits, the different generations of the Medici family are portrayed, beginning with Cosimo as the oldest, most prominent of the three Magi. Several years before Ghirlandaio's bourgeois frescoes were painted for Giovanni Tornabuoni in the main chapel of the same church, this small altarpiece (now in the Uffizi) had gone further in blending sacred and secular, and proclaimed a unique, almost blessed, place for the Medici at the feet of the new-born Child. Gozzoli's *Procession of the Magi* frescoes in the

Medici palace had been private ones. Botticelli's picture is a public manifestation of status. While the Medici family in kingly guise pay homage to Christ, the picture's commissioner, Guaspare del Lama, pays homage to them.

In this climate of the personal, the *recherché* and the beautiful — with overtones of aristocracy, if only an aristocracy of mind — commissions to Botticelli to paint non-Christian deities might be expected to result in unusual, if not unique pictures. What breathes from the *Primavera* and the *Birth of Venus* is complete accord between artist and patron or social circle or environment. Those two masterpieces reflect one aspect of Florence in the late fifteenth century but an aspect untypical generally of the city, abstrusely learned and literate, didactic, private almost to the point of being secret and hence still recondite and elusive. We do not even know who commissioned the *Birth of Venus*, and though we know that the *Primavera* belonged to Lorenzo di Pierfrancesco de' Medici (and was incorporated into a piece of furniture in the house in Florence belonging to himself and his brother), we have no knowledge of the circumstances surrounding its origin.

Yet through the dense layers of literary allusion detectable in both pictures (from classical antique authors like Hesiod to the contemporary poems of the Medici tutor, Poliziano) and the vague, conflicting hints of personal application (high-flown moral admonition to a young man or straightforward epithalamium on his marriage), there shines out the profound commitment of the painter. In both pictures a divine force is shown being celebrated as it manifests itself on earth — by nativity or rebirth, whether of Venus or of Spring, and the mood is hardly different from that in which Botticelli celebrates the birth and adoration of Christ.

A limited section of Florentine society permitted — fostered — for a period, at a confident moment of peace and prosperity and culture, the synthesis expressed with such intense power in Botticelli's mythological pictures, which are actually very few in number. None dates — as far as we can tell — from after Lorenzo the Magnificent's death in 1492. Neither the mood of Florence, as the political sky darkened, nor the mood of the painter (sensitive and always fiercely attached to his native city, the least peripatetic of artists) encouraged any all-embracing vision of love — only Christian love. When Botticelli was subsequently commissioned to paint two profane decorative panels, probably for furniture and possibly for a marriage, the choice of subjects seems repressive: two heroines of Roman history, Virginia and Lucretia, each martyrs to chastity.

The cosmic energy celebrated in the *Primavera* and the *Birth of Venus* is, by contrast, openly erotic. Beauty and love are embodied in Venus (not Cupid, a quite minor, con-

ventional presence in the *Primavera*), clothed in the *Primavera* but naked in the *Birth of Venus*, a nude woman made — for the first time in Florentine painting — the central focus of attention, of admiration and desire (see Plate 19). Although in his mythologies Botticelli may occasionally add a few lighthearted touches to the main theme, he is always in essence serious. The world of those pictures is worlds away from some average piece of pretty painted decoration on a chest or settle — not so much in scale as in concept.

Of all Botticelli's literary sources, none seems closer to his own vision than that of the great Latin poet Lucretius, whose *De rerum natura* was familiar to scholarly Florentines (including Lorenzo 'the Magnificent'). The poem opens with an exordium to Venus as life-giving goddess and principle of generation throughout the universe. The *Primavera* is certainly more than an illustration of that or any other single passage of poetry, but its tapestry-like profusion of wild, joyful, germinating natural motifs — at their most inspired in the flowers that flow from the mouth of the nymph clasped and breathed on by Zephyr — seems an uninhibited invocation in paint to love as the primal force of life. Well may it have been commissioned to celebrate a marriage.

Despite its originality and its overwhelming beauty, however, the picture can be seen stylistically as a culmination of much in fifteenth-century Florentine art. Although its flower-studded grass and exquisitely glowing orange grove are more than natural, the picture exists in a naturalistic, partly traditional convention. It could almost pass as a giant calendar-page from a Book of Hours.

After its tapestry effect, the *Birth of Venus* appears a bas-relief. It is calmer, colder and far more concentrated. Indeed, part of its now colossal fame resides in the cunning simplicity of its composition. Profuse naturalism has been replaced by intense economy. Botticelli speaks to those who can accept a few wavy lines as being water and a few gilded poles as tree trunks. What he illustrates is not, in fact, the birth of Venus but her impending first contact with earth after being born at sea. Elemental, isolated and nude, she drifts under the volition of the entwined Winds towards the jagged teeth of the coastline, where she will lose her nakedness, and this moment of her gazing enigmatically out, floating free and pure against the wide, pale expanse of sea and sky, will also be lost.

Nothing like this picture had been seen before in Florence, or elsewhere. The head of the Mona Lisa looks almost commonplace beside the perfection of the barely shadowed assembly of lines that makes up the face and waving hair of Botticelli's Venus, whose unsmiling, hardly animated features invite a myriad interpretations, none final.

This painting alone casts sufficient lustre on the city at the period in which it was created. Lorenzo de' Medici's Florence can now scarcely be thought of without it, or at

least its creator, and in some irrational yet rooted way symbiosis has occurred between the two men in our concept of late fifteenth-century Florentine culture. One might almost expect to learn of some compliment to Botticelli from Lorenzo, anticipating that ascribed to Pope Urban VIII in addressing Bernini: 'It is your great good luck, Cavaliere, to see Maffeo Barberini Pope, but we are even luckier that the Cavaliere Bernini lives in the time of Our Pontificate.'

Lorenzo de' Medici was comparably lucky, whether or not he knew it, and all the more so as his direct patronage of Botticelli must always have been meagre and is now non-existent. But Lorenzo himself refuses to expire, as it were, regardless of the visual arts of the period. Somehow, more than just politically, the Florence of his day remains his.

Lorenzo 'THE MAGNIFICENT'S' posthumous presence in Florence is a triumph of personality — and that personality is not mere myth.

In its many-faceted way it was far more obviously glittering and attractive than that of his father or grandfather. It brought into being around him a new phenomenon for Florence, a cross between a circle of lively, literate friends and a court. Cosimo de' Medici had already befriended and made a devoted Medici adherent of Marsilio Ficino (very much his junior in age), a leading proponent of neo-Platonism and translator of Plato's dialogues, both philosopher and priest, anxious to reconcile paganism and Christianity, and also deeply credulous of astrology. Him Lorenzo inherited, but he drew around himself other more creative and sometimes younger literary figures, poets in the vernacular like Luigi Pulci and Angelo Poliziano, and the brilliantly learned young Count Giovanni Pico della Mirandola.

Both Pulci and Poliziano wrote poems of frankly flattering, courtly and personal allusion which kept alive the tournaments of Lorenzo and his brother Giuliano — pageant-tournaments held in the Piazza Santa Croce, with homage to local queens of beauty and opportunities for dressing-up in fantastic armour. It is difficult to think of Cosimo 'il Vecchio' at any age indulging in such ostentatious and gracefully amorous goings-on, which were perhaps profounder in sentiment than they appeared to the average spectator.

Pico della Mirandola dedicated to Lorenzo much more solidly erudite fare, including an *Apology* in defence of his speculative philosophic-religious *Conclusions* (900 of them), which had aroused suspicions of heresy in Rome. He was an attractive personality in his own right, nobly-born, handsome and an individual thinker, who was in-

creasingly to be influenced by the preaching of Savonarola, a novel and quite unexpected voice on the late fifteenth-century Florentine scene.

Ficino was the longest-lived of these associates of Lorenzo's, not dying until 1499, but Pulci died in 1484, and both Poliziano and Pico died in 1494, just two years after Lorenzo de' Medici, whose circle seemed to dissolve with him.

Almost frenetically active – riding, hunting, writing letters, making jokes, amusing his children, entertaining his friends at one or other of his villas – Lorenzo held his place at the centre of the circle not just through money or status, nor even as patron, but through positive creativity. It was another novel facet for a male Medici, not merely to absorb literature passively but to add to it – and unashamedly in his native Tuscan tongue.

If Lorenzo is to be called an amateur poet – and perhaps it might be fairer to describe him as, inevitably, an occasional one – he was at least impelled by intense personal feeling. His experience of love, of religious emotion, of the sights and sounds of the countryside, needed to find expression in verse. Whatever his poems lack, they do not lack genuine impulse. They convey a personality of baffling variousness, now bawdy and now spiritual, now in thrall to a rather abstract concept of beauty and now sharply responsive to every seasonal detail of the natural world. And even though there may be a degree of literary convention in his poetic preference for the pleasures of the countryside in contrast to city buildings, '*Le piazze, i templi, e gli edifizi magni*', and something too of a complex personality's yearning for the simple life, he seems to have genuinely found solace in thoughts of a little green meadow full of lovely flowers ('*Un verde practicel pien di bei fiori*'), rather similar perhaps to that in Botticelli's *Primavera*.

In terms of a modern obituary, his friends would surely have recorded that around Lorenzo de' Medici 'things' were always happening, and that he made things happen. With him as instigator, poems were written and wine was consumed. An evening reading of St Augustine somehow led on to music. A bust in the Duomo went up to commemorate Giotto, and it was Lorenzo's friend Poliziano who provided the inscription ('I am he through whom extinct painting was brought back to life . . .'). A new clockmaker arrived in Florence. And Lorenzo – the owner ultimately of seven clocks – was informed of his wonderfully constructed clock with its numerous automata, all working together.

'When will Loencio come?' the baby Giovanni, the future Pope Leo X, kept lisping, according to his mother Clarice de' Medici, Lorenzo's wife, writing to him during one of the frequent periods when they were apart. The adults in the circle of family and friends who found themselves in the city while Lorenzo was in the country, or vice versa, must often have asked the same question.

Around even Lorenzo de' Medici there occurred few things more dramatic than the Pazzi conspiracy in 1478. Yet, like the Gunpowder Plot in England, it is an event of disproportionate fame, notable chiefly for its failure. Indeed, it and its aftermath could be said to have actually helped consolidate Lorenzo's position in Florence, for it was largely a conspiracy directed from Rome by the pope's nephew, Cardinal Girolamo Riario, and a violent interference in the affairs of the city. Grumbling about Lorenzo de' Medici's position was one thing, assassinating him was another.

On Sunday, 26 April 1478, at the moment of the elevation of the Host during high mass in the Duomo, Lorenzo and Giuliano de' Medici were attacked by a group of conspirators. Giuliano died immediately, under a savage rain of sword and dagger blows, but Lorenzo, although wounded, escaped into the 'new' sacristy along with some friends (Poliziano among them). Its bronze doors were shut on him, and the essential purpose of the conspiracy foiled. A short time afterwards he was escorted safely back to the Medici palace.

The conspirators had included the Archbishop of Pisa, as well as several members of the Pazzi family, a few hired assassins and two disaffected priests. The archbishop fumbled his part in the scheme, which was to go to the Palazzo della Signoria and seize it in the name of liberty. He was himself seized. The whole city was alerted by the tolling of the palazzo's bell, and some attempt to rouse the people against the Medici resulted in counter-cries and the death of those conspirators who had not fled. The archbishop was hanged the same evening. Other hangings followed the next day, as Landucci records in his diary. Gradually, calm returned to the streets, despite the fact that Sixtus IV excommunicated Florence. As that sacred weapon failed, the Holy Father (as Landucci called him without apparent irony) declared war, with the King of Naples as his ally.

Daring tactician, if no great strategist or statesman, Lorenzo de' Medici took himself off to Naples when the war looked like dragging on, with Florence suffering defeats and also outbreaks of plague. God is punishing us, Landucci concluded, after listing a catalogue of woes. Then in March 1480 Lorenzo was back. It was known he had negotiated peace with the King of Naples. The bells rang in rejoicing this time. The new Florentine year, beginning on 25 March, the Feast of the Annunciation, was ushered in by proclamation of the peace. There were still a few problems, not least the fury of Sixtus IV, and it took some time for the peace conditions to be fulfilled. But whether recognised grudgingly or gladly, Lorenzo de' Medici emerged from it all as the saviour of Florence. And he had become a leading figure in the larger and constantly eddying world of Italian politics. Although there were other, minor plots against him, and probably a continued

undercurrent of antagonism to his personal 'rule' (brought into the open by Savonarola's Lenten sermons of 1491), he sustained his unparalleled position until his death.

He did not allow the Pazzi conspiracy to go uncommemorated. The unusual, perhaps unique event of the attempted, partly successful assassination of two brothers was marked unusually, if not uniquely, by the casting of a double-sided medal, designed by Bertoldo. Bertoldo was a favoured Medici artist and curator of the Medici antique sculpture collection, which Lorenzo moved from the palace in the Via Larga to some gardens near San Marco, thus creating a sort of museum or school for Florentine artists.

Bertoldo di Giovanni: Commemorative Medal of the Pazzi Conspiracy, *Museo nazionale del Bargello.*

At first glance, the two sides of the medal look very similar, and they are intended to be – tragically – complementary. Both depict the moment of attack near the high altar. On the reverse the scene is of the murder of Giuliano, with his head in profile above it and the words *Luctus publicus* (public mourning). On the obverse the scene is of Lorenzo defending himself and then escaping, with his head in profile above and the words *Salus publica* (not so simply translated but approximately 'public safety', or 'welfare', with overtones of having been saved from death).

Within a few months of the Pazzi conspiracy, Lorenzo had received the first examples of the medal, more striking for its iconography than as art, but a highly emotive object, a permanent reminder of a sacrilegious crime and a lucky survival – both of more than private import and conveyed with entirely classic stoicism (no R.I.P. or gratitude to God). The medal was Giuliano's chief memorial. He had been buried in his father's grave, and no monument in the style of the Cardinal of Portugal's was created in grief at his fate: to be cut off at the age of twenty-five.

Lorenzo de' Medici took on a further family duty, becoming guardian to the illegitimate son Giuliano had fathered, Giulio. Medicean magic certainly worked for this

boy's career: his cousin, Leo X, would make him Archbishop of Florence and a cardinal, and in 1523 he became the second Medici pope, Clement VII.

One of the most unexpected facets of Lorenzo de' Medici's character, and not the least attractive, was his inability to be businesslike or much concerned over money matters. Under him, as historians usually note disapprovingly, the affairs of the Medici bank declined in efficiency and prosperity. He himself certainly required enormous sums of money, and borrowed heavily from the inheritance of his cousins Lorenzo and Giovanni di Pierfrancesco (ceding to them the villa of Cafaggiolo in part-settlement of his debt). He may too have dipped his hand into state funds, possibly intending to reimburse them one day. If it sounds somewhat reprehensible, there is at the same time something refreshing about a near-spendthrift Medici and prominent Florentine citizen not preoccupied with watching his money grow and making cautious investments and charging high interest. In Lorenzo's case it perhaps indicates a would-be aristocratic disdain of the family's commercial roots.

It cannot be said that he left nothing behind, for the inventory of his possessions at death is a chronicle of blazing, literal magnificence, from property and furniture and jewels, *objets d'art* and paintings, to armour, sumptuous stuffs, fine linens and Florentine brocaded velvets, inclusive of porcelain and china (some Eastern and Hispano-Mauresque), and maiolica of local manufacture, sometimes bearing the Medici arms.

What he could not bequeath was the ability to preserve Medici predominance in the governing of Florence. Under his inexperienced, arrogant and vacillating son Piero, in times of acute difficulty for all Italy which might have taxed even Lorenzo, that predominance was soon lost — and, it must have seemed, for ever. Charles VIII of France invaded Italy in 1494, dividing the various states in their attitude. Piero de' Medici attempted to negotiate with the king face to face, agreeing to surrender Florentine territory — to the rage of the republic. The city reasserted its republican status. Cries of 'The People and Liberty' filled the streets. Piero de' Medici fled, without waiting for the sentence of exile passed on him. He never set foot again in Florence. As a republic, the city prepared to welcome Charles VIII: a republic in which the views and voice of the Prior of San Marco, Savonarola, became daily more influential.

Lorenzo de' Medici had sent for him as he was dying at his villa of Careggi in April 1492, and had been much comforted by the visit. Although its purpose was religious, the meeting seems a poignant recognition of a new era coming, one purer, sterner and less pleasure-loving.

A casual quatrain of Lorenzo's poetry — written as a carnival song and unoriginal,

almost trite in its 'gather ye rosebuds' sentiment — is always quoted in connection with him. It is not perhaps the verse he would have chosen as representative of his poetry and of his attitude generally to life, but it has a haunting quality in Italian, scarcely conveyed by banal prose translation: 'How beautiful is youth, that is fleeting all the same! May he who would be joyful, be so; of to-morrow there is no certainty.'

Lorenzo's own lines vibrate with unexpected resonance. They take on something of the character of a threnody, as if lamenting the inevitable passage of his century as well as of human existence:

> *Quant' è bella giovinezza,*
> *Che si fugge tuttavia!*
> *Chi vuol' esser lieto, sia;*
> *Di doman non c'è certezza.*

CHAPTER NINE

'The Troubles of Italy'

Tʜᴇ ʟᴀꜱᴛ ʏᴇᴀʀꜱ of the fifteenth century were a time of confusion and terrible trouble for most of the Italian states, not excepting Florence.

No year was more significant, as contemporaries already saw, than the year 1494, when there descended on Italy the French king, Charles VIII, with his army — approaching like a fifth horseman of the Apocalypse, spreading fear, conflict and disease (syphilis or the *mal francese*). Guicciardini, no mere chronicler but a writer of vision and a shrewd, experienced student of affairs, was to sum it up as 'a most unhappy year' for Italy.

In 1494 Florence expelled the Medici. With unusual adroitness and unusual cohesion, the republic welcomed Charles VIII to the city, outfaced his threats and became his ally. It was, perhaps, the republic's finest hour. A new 'democratic' constitution was framed, very much at the behest of Savonarola, the Dominican friar and prior of San Marco, whose sermons of mingled moral admonition, prophecy and political guidance thrilled the city, for a period.

Meanwhile, Piero de' Medici, now head of the family, remained a threat to Florence. He made three separate attempts to take the city by force. A further threat developed in the person of Pope Alexander VI (Borgia), increasingly perturbed by Savonarola's denunciations and determined to be rid of this particular meddlesome friar. In 1498 a combination of secular and supposedly sacred interests fatally entrapped Savonarola. The Florentine republic was seen at its most supine and shabby when it abetted the pope's efforts, and Savonarola was shuttled back and forth between the authorities of Church and state, tortured and finally burnt publicly at the stake. There were uneasy consciences in Florence after that had happened. Pictures were painted to record the event, and for some people Savonarola seemed a martyr. The smell of human sacrifice lingered on in the city and has perhaps never been entirely dispersed.

With the coming of a new century it might have seemed, and certainly must have been hoped, that a calmer, more tranquil era for Italy was in prospect. Alexander VI declared 1500 a year of Jubilee, attracting a quantity of foreign pilgrims to Rome. A peace treaty — the Treaty of Granada — was signed that year by the new French king, Louis XII,

and the King of Aragon, partitioning a prized bone of contention, Naples. Earlier in 1500 Louis XII had defeated and taken prisoner Lodovico Sforza, Duke of Milan, and occupied the city. Yet the pope's son, Cesare Borgia, was also on the march, efficiently regaining or conquering large tracts of Italy to enhance the papal state. His troops arrived at the outskirts of Florence (as close even as Peretola, now the site of the airport), but did not actually attack the city. Cesare Borgia received a large cash payment, and in a touching cultural gesture the *Signoria* also sent their musicians to play at his camp in his honour.

When the news of Louis XII's capture of Milan reached Florence, which had remained pro-French in policy, there was great celebration. Shops closed and bonfires were lit. The Palazzo della Signoria was decorated with draperies, and at the main entrance 'a beautiful figure' of Christ was erected. The apothecary Luca Landucci, an invaluable witness to the bewildering succession of events in these stirring years, noted the figure and confided to his diary that he thought it implied that the citizens of Florence wished to say, 'we have no other King but Christ'. And that seemed divinely inspired, for it recalled the very same words often uttered by Savonarola about the city having only Christ as its king. Landucci had been greatly swayed by Savonarola's sermons, and dismayed and frightened by his fate. Probably, privately, he remained sympathetic to the ideals of Savonarola, who was certainly not forgotten in Florence — could, indeed, never be forgotten. Landucci lived on, to see not the millennium but the triumphant return, in 1512, of the Medici, to which he appears to have been less welcoming than resigned ('everyone ought to be content with what Divine Providence permits').

Landucci charts the necessary, prosaic, day-to-day existence of the ordinary Florentine, not as politician or historian or important personage, but as one whose chief concern is to survive during troubled times. The plague and the weather and the high price of corn could be as momentous in their way as the great events of the day — frequently more momentous, because more directly bearing on daily life.

It was, however, another Florentine, just a few years younger than Landucci, no more than he a politician or a historian, and someone ostensibly of no greater importance, who documented — with extraordinary intensity — the sensation of being alive on the threshold of the sixteenth century, fully conscious of the plight of Italy and yet poignantly confident of imminent, divine accord in the world. In 1500 Botticelli was moved to paint his vision of harmony in the so-called *Mystic Nativity* (in the National Gallery, London), painting with almost wild lyricism a proto-Miltonic ode, in which Christ's birth is shown initiating (as in Milton's poem on the subject) 'a universal peace through sea and land'.

The most remarkable thing about this altogether remarkable interpretation of the familiar, frequently treated subject of the Nativity is that Botticelli was not content with realising his vision in paint. Uniquely, he added words to the picture, actually inscribing on it, in diary-like style, who painted it, and when, and what its significance is. For solemnity — and possibly also to protect his message from profane or critical eyes — he wrote in Greek (knowledge of which was, even in classically inclined Florence, comparatively restricted; Machiavelli, for example, may have had little or no Greek).

Botticelli seems to become a witness, urgently testifying to what is depicted and also affirming his faith in the brightness of the future, while acknowledging the present darkness: 'This picture I Alessandro painted at the end of the year 1500 in the troubles of Italy . . .' Since the Florentine calendar dated a new year from 25 March, the picture is placed approximately in the period when Cesare Borgia was ominously drawing closer to Florence, coming down from the north-east, taking first Faenza (where the citizens paid a huge ransom to preserve it from sacking) and then by May reaching Firenzuola, virtually the halfway point between the two cities. And before the old year ended there had been a new outbreak of plague in Florence.

Well might Botticelli's inscription go on to refer, somewhat cryptically, to the Apocalyptic gospel of St John and mention the loosing of the Devil 'for three and a half years' after which — so it states — he will be chained. The final words are annoyingly damaged but indicate that then 'we shall see' what is visible in the composition. It is a vision cosmic in its scope: of interlinked angels rejoicing in a heaven of gold, of men embraced by angels on earth, and the Christ Child worshipped by shepherds and Magi, all of whom wear crowns of olive. Olive branches and wreaths of olive form a ubiquitous motif in the picture, reinforcing its pacific theme for all to see. The new-born Child has come to begin his reign as the Prince of Peace. Olive branches had a symbolic reality for the citizens of Florence in the days of Botticelli and Landucci, and Landucci mentions how — when Pisa surrendered in 1509 — a horseman arrived bearing 'the olive branch'. And on Palm Sunday in 1495 Savonarola had organised a vast procession of boys and girls through Florence, carrying olive branches and wearing olive wreaths. It was thought a particularly happy omen when, in 1499, an olive twig stuck in the revered image of the Madonna of Impruneta as it was carried into the city, and it was left in place.

Whether or not inspired directly by Savonarola's actions and sermons, Botticelli seems to be thinking very similarly — and no less fervently — about the current state of Italy and about the sole hope it has in Christianity. More specifically still did he relate Christ's life on earth to Florence itself, in an irreparably damaged, smaller picture

(painted possibly a year or two before the *Mystic Nativity*) which shows Christ hanging bleeding on the Cross, with the city of Florence in the background (now in the Harvard Art Museums, Cambridge, Massachusetts). St Mary Magdalene lies prostrate, clasping the foot of the Cross, and an angel stands over her, holding up and apparently wounding a tawny-coloured animal. God the Father is seen amid angels in heaven overhead, and other angels descend from the sky, overcoming devils and bearing white shields with red crosses – the shield of the people of Florence (and the device adopted by the 'democratic' Lorenzo di Pierfrancesco de' Medici, of the younger branch of the family, when he was recalled to the republican city).

What the picture may mean precisely remains unclear, but there can be no doubt of its close relationship with events of the period, conveying a mood not so much ecstatic as penitential. The pacific green olive of the *Mystic Nativity* is here exchanged for the red of blood, and the atmosphere is stormy rather than serene. Despite abstruse symbolism and obscure details (made more obscure by physical damage), the picture still speaks eloquently enough of the troubles afflicting Florence. To that extent, it is an unusually political painting, though it sets politics in a profoundly theocratic perspective, remaining closer to Savonarola than to Machiavelli.

At the same time, these two mystical, visionary pictures have a Dantean quality. They might be termed Botticelli's personal, visual variations on the *Paradiso* and the *Purgatorio*. Not only do poet and painter share a gift for finding concentrated, vivid and highly concrete imagery through which to express complex abstract thought (and belief), but they share a patriotic zeal for their country and their city, which drives them to intermingle in their art allusions to the temporal along with the spiritual. It is not unreasonable to suppose that Botticelli found the courage and deepest inspiration for his two paintings in reading the *Divina Commedia* (for which he positively set himself the task of drawing illustrations in the later years of his life).

Dante would have had no difficulty with the concept of Christ crucified outside the gates of Florence, nor with suggestions of a punished but purged Florence. It is, after all, in paradise itself, and virtually at the foot of a cross on which Christ shone forth ('*quella croce lampeggiava Cristo*') that Dante meets his ancestor Cacciaguida and shares his vision of Florence as it once was and should ideally become again: a tranquil city of glorious, justice-loving people whose banner of the (white) lily was unstained by civil bloodshed.

'The troubles of Italy' actually increased as the sixteenth century progressed, culminating in the sack of Rome in 1527 in the reign of the second Medici pope, Clement

VII. The fortunes of Florence were — as will appear — hardly less harsh, for it was Clement VII, his own fortunes and forces bolstered by the very enemies who had sacked Rome, who took up arms against the city of his birth, besieged it and imposed his family, by force, as its rulers. It was the supreme act of Medici treason, carried out by Christ's vicar on earth, and it was largely successful. Dante himself might have despaired of summoning sufficient poetic fury to characterise Clement VII's conduct of St Peter's barque. 'O navicella mia' he had had St Peter wail at the spectacle of the medieval papacy (*Purgatorio*, canto xxxii), but Pope Clement VII would more appropriately have incited a gnashing of teeth.

Much of that depressing future was spared Botticelli. He died six years before Landucci, in 1510, in a Florence strangely at peace and — outwardly, at least — staunchly republican. Florence's chief act of war, the lengthy fight to retake Pisa, which had rebelled against Florentine domination, had ended happily (from a Florentine point of view) with Pisa's surrender. If scarcely a sign of peace on earth, it was an occasion for great rejoicing in Florence and could be interpreted as God's handiwork.

Botticelli's predictions for a future with the Devil securely chained might be claimed as having been partly borne out by events. Pope Alexander VI died unexpectedly in 1503, and his death was followed a month or two later by the equally unexpected demise of Piero de' Medici, drowned while escaping after a battle. And in 1507 Cesare Borgia died: killed, not unsuitably, while fighting. He had ceased to be a threat or a power in Italy on the election of Pope Julius II, himself no timid fighter where aggrandisement of papal territory was concerned. Venice rather than Florence was the republic Julius concentrated on despoiling and humiliating. Landucci, reflecting on events, wrote more than once of his horror of war and of the continuing wickedness prevalent in Italy, yet could only conclude in 1509 that 'God has permitted the Venetians to be deprived of their strength'.

In the last years of Botticelli's life a novel and rather ingenious improvement to the constitution had been devised in Florence, one which might seem to promise stability and to satisfy (in so far as anything could) the various classes of citizens, and which usefully embodied the republic in a single, semi-presidential figure, analogous to the Doge in the Venetian constitution. In 1502 the office of *Gonfaloniere di Giustizia* was made into a post tenable for life, and to this new position was elected (in his absence) Piero Soderini. He was a member of an established patrician family, someone who had been an ambassador to France and whose sympathies were markedly pro-French.

Although today a very dim, broadly unfamous figure, and never a glamorous

'Renaissance' personality, being neither criminal nor ruthlessly self-seeking, Soderini was at his election judged by Landucci to be a 'good and valiant man'. He was certainly patriotic and moderate, not always an easy role to take, especially in intrigue-ridden Florence. His fate was to please no party. Yet his concern for the republic extended to employment of some of the great Florentine artists of the period, Leonardo and Michelangelo among them, on tasks to dignify and glorify it. On being compelled in effect to surrender Michelangelo to Pope Julius II, he wrote to his brother, Cardinal Francesco Soderini, enthusiastically commending the artist's ability and his character: 'with encouragement and kindness he will accomplish anything'. In the Rome where Michelangelo had proved the truth of that — with, supremely, the Sistine Chapel ceiling — Soderini was to die, exiled from Florence, in 1522.

When he became *Gonfaloniere* for life, and Florence seemed to have withstood the threatened return of the Medici and to have evolved — at last — a sensible, satisfactory form of government, neither too oligarchic nor too 'popular', he and his fellow-Florentines could look forward reasonably hopefully. And they could certainly look back on a deeply troubled decade separating them from the death of Lorenzo de' Medici.

An enormous amount of history had been packed into those ten years. Even if neither Soderini nor anyone else bothered to recall the fact, there is some irony in realising that he, elevated to be a symbol of anti-Medicean republicanism, was the son of Tommaso Soderini, who had played a leading part in ensuring Lorenzo de' Medici's succession to the family's primacy in fifteenth-century Florence.

T HE LAST TROUBLED and partly tragic years of the fifteenth century in Florence seem to belong very much to Savonarola, and culturally they can appear largely negative, even repressive, given the common association of him with 'bonfires of vanities'. While it is impossible to say what exactly was destroyed, it is unlikely that many priceless works of art were thrown on those pyres, which were no daily occurrence but intended as annual counter-carnival demonstrations of piety. Admittedly Vasari, none too friendly towards Savonarola (dead years before he was born) and fond of dramatic anecdotes, declares that the painter and future Dominican friar Fra Bartolommeo was swayed to destroy 'all his studies of the nude' in one of the bonfires. So also — according to him — was Lorenzo di Credi (an early full-length *Venus* by him survives in the Uffizi, and does not make one greatly regret whatever he burnt).

In those years one significant piece of building was begun and quickly made usable,

with the positive encouragement of Savonarola: the vast Hall of the Great Council in the Palazzo della Signoria. Perhaps it was more significant politically than aesthetically. It was built in haste, to house the latest legislative body, a large elected council brought into being in the flush of republican and democratic enthusiasm. The hall was the site of the two patriotic battle paintings commissioned, under Soderini, from Leonardo and Michelangelo – both destined to be abandoned barely begun. Its original instigation and purpose were erased – visually and, as it were, from memory – by the deliberate alterations carried out by Duke Cosimo I de' Medici, whereby the room became a showcase chiefly for his family and himself. At the centre of the ceiling of the largest overt monument raised by Renaissance republican Florence was installed Vasari's painting, a unique glorification of absolutism, an apotheosis of the duke, seated alone and saint-like on clouds in a secular heaven. No wonder if a conscious effort has to be made – in that transfigured environment – to recall the room's resolutely 'popular' origin.

Emancipated from the Medici, the reborn republic was quick to sell off (rather than burn) the rich household effects of the banished Piero de' Medici, including some of the pictures he had owned. Two masterpieces of sculpture it turned into state property. At the same time as Donatello's *Judith* was removed, his bronze *David* was taken from the Medici palace courtyard and set up in that of the Palazzo della Signoria. The possibility had first been mooted that the two statues should be placed in the Great Council hall.

They were not merely taken over but reinterpreted in a republican context. Around the marble base of *Judith* were inscribed the pointed words: 'Placed by the citizens as an example of public deliverance, 1495'. As obviously as Judith could David be seen as a divinely guided victor over an ostensibly stronger tyrant, and the white and red shields of the people and of the Commune, and liberty, were subsequently added to the column on which *David* stood. Thus the city as symbolised by the Palazzo was guarded by two statues of David – Verrocchio's being already installed on a staircase inside. During the *Gonfaloniere*-ship of Soderini a third would be added, by a third great sculptor, when it was agreed to set up outside the entrance the *David* of Michelangelo.

Although Michelangelo was out of Florence from 1496 to 1501, and Leonardo had left in the 1480s (returning only in 1500), the republic was not lacking in good native artists. Apart from Botticelli, there lived on Filippino Lippi (who died in 1504) and Piero di Cosimo, master of a great painter of the next generation, Andrea del Sarto, and himself most renowned in his lifetime for brilliantly inventive, inevitably ephemeral costumes and decorations for masques and carnival processions.

Echoes of his ingenuity are caught in Vasari's by no means sympathetic – or necessarily accurate – 'life' of him, for even Vasari had to admire what he knew of Piero's flow of whimsical, decorative fantasy. Some of that is fortunately apparent in Piero di Cosimo's untamed, often amusing, and always touchingly idiosyncratic mythological pictures, for which there was definitely a demand in Florence by private patrons. Vasari himself owned one of these decorative masterpieces, the panel of Venus and Mars lying in a landscape (now in the Gemäldegalerie, Berlin). It did not require the return of the Medici to activate a fondness in Florence for fantastic pageantry and for manifestations of pure fantasy in painting. Filippino Lippi shared Piero di Cosimo's predilections, although he was a less profoundly imaginative artist. He received a state commission to paint an altarpiece for the new Hall of the Great Council (it was never executed) and was also engaged in finishing his frescoes in the Strozzi chapel of Santa Maria Novella, where serious religious subject matter notably failed to dampen down his exuberant, perhaps over-excited relish for inventing impossibly elaborate architecture, weird statues and fanciful costumes.

Florence was always in need of artists to run up schemes for temporary decorations – triumphal cars and arches and painted coats of arms. Filippino Lippi and the non-native Perugino were responsible for the various festive decorations and devices that greeted Charles VIII of France when he entered the city in 1494 (the Medici palace was transformed by ornamental columns and displays of the French arms and so on – all 'too intricate to describe,' Landucci frustratingly says). Even the edifying processions organised by Savonarola have their festive aspect and more than a touch of theatre. And one should not overlook the Florentine habit of enlivening street corners in winter by modelling lions and other figures out of snow. For Piero de' Medici, Michelangelo was said by Condivi to have modelled a very beautiful snow-statue in the courtyard of the Medici palace one winter (probably after the exceptionally heavy snowstorm of January 1494).

Chance and the generally unsettled climate of Florence, rather than any anti-artistic policy fostered by Savonarola, seem to account for the comparative absence of major commissions in the regenerated republic in the late 1490s. When it got its second wind, with the creation of the life tenure of Soderini as *Gonfaloniere*, a number of civic and otherwise official assignments were put in hand, resulting in such deservedly famous works as the sculptural group of St John the Baptist preaching, by Giovanni Francesco Rustici, over the North Door of the Baptistery. There was an unfortunate tendency, however, as indicated by Michelangelo's career, for the greatly gifted Florentine artist to be sought and pressed into service by important, importunate non-Florentine, and frequently non-

Italian, patrons. The republic was to suffer a steady drain of its native talents abroad, repeatedly to France but also to Spain and Portugal, and, in a novel development, to England (where Pietro Torrigiano created the tombs of Henry VII and Elizabeth of York in Westminster Abbey).

Even during the uneasy 1490s, however, work continued on, for example, the imposing Strozzi palace, the design of which possibly involved at least three architects or master-workers in stone. The sculptor Benedetto da Maiano (who died in 1497) may have devised an early plan, but it was Giuliano da Sangallo, Lorenzo de' Medici's favourite architect, who supplied the model for the palace. Construction work was supervised by Simone del Pollaiuolo, nicknamed il Cronaca, the builder of the Hall of the Great Council. He was someone known to Landucci, and is said by Vasari to have been an adherent of Savonarola.

Cronaca seems to have become responsible for designing the cornice and the courtyard of the Strozzi palace, and Landucci (whose apothecary's shop was nearby) notes the steady progress of the building amid more hectic and sombre events. Thus the second row of windows was finished in May 1498, a day or so before the arrival in Florence of Pope Alexander VI's envoy, who had come to 'examine' (that is, to have tortured) Savonarola, in preparation for his execution. The brackets of Cronaca's massive cornice on the main façade did not go up until July 1500, but it was finished by September, shortly before Florence heard that Cesare Borgia was leaving Rome with his army and marching north. By mid-November the beautiful, spiky, wrought-iron lanterns had been placed where they remain, at the four corners of the building.

Cronaca (whose nickname was gained as a 'chronicler' in studying antique Roman architecture) became a leading – perhaps the leading – architectural personality in Florence up to his death in 1508. He often worked in collaboration with other architects (such as Giuliano da Sangallo), and was possibly in demand not only as a designer of building projects but also as a manager of them. He certainly had plenty to do, for he held a part-time post in connection with the Duomo, in addition to his involvement at the Palazzo Strozzi and the Palazzo della Signoria, and can be credited with one grandly austere, arguably 'Savonarolian' church, San Salvatore al Monte, on the hilly slope adjoining San Miniato, a setting more rural and isolated before the nineteenth-century creation of Piazzale Michelangelo. The façade looks schematically simple, almost like the diagram of a church in a Renaissance book of theory, though its three windows are unusually (for its date) varied in framework, with two pedimented and the central one curved. The high, wide interior, of a single nave, is classical in its pilasters and classic in its restraint. The

eye is led to the huge arch rising over the central altar on which stands no altarpiece, only a crucifix. But any associations of Savonarola in this severe and spiritual-seeming interior are, to say the least, paradoxical. The church is a Franciscan foundation, enlarged from an earlier one, and the traditional hostility of the Franciscans to the Dominicans flared openly in their attitude to Savonarola. Moreover, one of the few monuments in the church is a bust of Marcello Adriani, chancellor of the Florentine republic, chiefly remembered as the man who signed Savonarola's death-warrant.

That Cronaca was prepared to consider even an amateur's architectural proposals is shown by the rather charming episode reported by Landucci in 1505, when he gave Cronaca a memorandum, 'and a drawing', to convey his idea for a splendid new church in Florence, to be dedicated to St John the Evangelist, on the site of the existing oratory to the saint on a corner near the Medici palace and San Lorenzo. Cronaca, he records, was eagerly enthusiastic, about both the proposal and the design, which envisaged a large building with a cupola. It would have occupied space in Piazza San Lorenzo (from which houses and shops would have had to be cleared away), facing towards San Lorenzo itself. Nothing more seems to be heard of this ambitious proposal, which was possibly under wider consideration than Landucci admits. Much later in the century a new church of San Giovanni Evangelista (now San Giovannino degli Scolopi) was to be planned and built by Ammanati on the site, though not reoriented to face San Lorenzo.

Landucci's motive, as he records with some earnestness, was to invoke for Florence another advocate in heaven, along with St John the Baptist, selecting the saint who had been the beloved brother of Christ on earth. In approaching Cronaca with his scheme he may have looked for more than artistic sympathy, especially if Vasari is right in stating that the architect was an adherent of Savonarola. Landucci's adherence is not in doubt, though he was no fanatic and had become timid, out of instinctive piety, when the friar clashed with the pope. Landucci's one-time hopes for Florence as a new Jerusalem, of which he wrote in his diary, are a reminder of Botticelli's *Mystic Nativity*, with its reference to the apocalyptic gospel of St John. The evangelist of prophecies and visions may have appealed, in varying ways, to all three contemporaries who recollected Savonarola and his fate, and pondered on the future of Florence. Botticelli's brother Simone had been an acknowledged follower of Savonarola, and Botticelli himself is recorded as actually questioning one of Savonarola's most violent enemies about why he had deserved such a shameful death. It was a matter not of morality but of expediency, he was told: the loss of his life or ours. That was why they had determined on the death of 'the prophet'. The answer has the merit at least of honesty, though it is not the complete one.

The story of Savonarola retains a grim and pathetic fascination, as does the protagonist. His appearance is fixed by the familiar profile portrait, attributed to Fra Bartolommeo, hanging in his cell at San Marco. In the sallow, waxen face the eye burns darkly, like a candle in its socket, and the features seem convincingly those of someone consumed, as Savonarola spoke of being, by inner fire.

Girolamo Savonarola was not a Florentine, and that fact seems of the utmost significance in his history. He might look on himself as an adopted citizen, caring passionately for the city to which he came in 1481, after childhood in Ferrara and several years in a Dominican monastery at Bologna. But he had no family roots, patrician or plebeian, in Florence, no ancestor renowned for doing the state some service and no local patron-protector. None of that mattered until he became involved in Florentine politics. Then, especially as a foreigner, he was more vulnerable than he perhaps ever realised. One of his opponents was to ask scornfully what cause had he, a *'forestiere'*, to bring his new laws to the Florentine people. Yet his ultimate fate would probably have been not death but banishment, had he been a layman.

At the same time, a layman could scarcely have achieved the ascendancy and popularity Savonarola gained through his sermons. As a religious he was answerable to a power beyond Florence, one with weapons both political and spiritual. It was expecting a lot of Florence, if Savonarola ever did, to stand by him after he had roused the wrath of the pope.

In the early seventeenth century the Venetian republic bravely defended and protected the native-born Servite friar Fra Paolo Sarpi against the papacy, when the days of popes going to literal war were over, and Venice was sufficiently independent of papal edicts. The real difference, however, is that Venice and Sarpi were in accord. It defended him because he was a valuable polemical defender of its position. When Alexander VI moved against Savonarola, the move suited partisans of conservative, upper-class interests in Florence. They had doubtless resented all along his 'interference', as a foreigner and a friar, with their oligarchic government.

In some ways, the surprising thing is not that Savonarola ended up being burnt at the stake but that he ever became a force in the political affairs of Florence. To earlier generations there — as possibly to some later ones — his sudden domination might appear a further sign of the confused times, the lack of outstanding civic leadership and the dangers of idealism. Even as penetrating and thoughtful a contemporary observer as Machiavelli seems never quite to have made up his mind about his attitude to Savonarola's activities.

Savonarola had been preaching in Florence — sometimes, pertinently, on the Apocalypse — to increasing popular enthusiasm well before the death of Lorenzo 'the Magnificent'. Guicciardini may never have heard Savonarola preach (he was only fifteen when Savonarola was put to death) but he read his sermons and coolly judged them 'very eloquent'. That eloquence was not restricted to urging repentance and prophesying tremendous events but denounced the behaviour of the rich in Florence, hit out at Medici tyranny and lectured the *Signoria* (giving a sermon before them, he none too tactfully began by a comparison of himself with Christ in the house of the Pharisee).

The death of Lorenzo 'the Magnificent' left a power vacuum which his arrogant son Piero failed adequately to fill. There was, in fact, nobody in Florence to fill it except — in the spiritual sphere — Savonarola. But for all his eloquence he would never perhaps have achieved any effective hold on affairs had there not been an important exterior factor disturbing the whole city: the advance of Charles VIII, whose crossing of the Alps was welcomed and seemed foretold by Savonarola. 'We believe him to be a prophet,' Landucci recorded in November 1494, a few days before Piero de' Medici fled from Florence. It is Landucci's first reference to the friar who had become prior of San Marco, and he mentions him as one of the five ambassadors chosen to go to negotiate with Charles VIII at Pisa. The remaining four were non-clerical Florentine citizens (Piero Soderini was one). In selecting Savonarola the *Signoria* paid him a compliment and acted diplomatically in sending the king such a well-disposed holy man. Savonarola humbly followed the other ambassadors on foot, but he was now treading, however unselfishly, an openly political path. He must have believed it was all for the good of Florence, all part of God's purpose to save the city. Florence would indeed be saved; Savonarola would have to die.

Nevertheless, it was not Savonarola but a member of one of the very oldest and richest of all Florentine families, Piero Capponi, who symbolised the plucky spirit of the republic after Charles VIII had entered the city in great pomp and put forward his terms for a peace treaty. Guicciardini can be sensed patriotically identifying with Capponi ('talented and brave . . . belonging to an honourable family') as he describes how Capponi tore up the treaty in the king's presence, declaring — in a phrase that became famous — 'if you sound your trumpets we will ring our bells'. Terrified, or anyway cowed, the French gave way. What seems in retrospect so splendid about Capponi's defiance, though seldom remarked, is its element of bluff. Had the trumpets and bells sounded the signal for a contest, Florence would have become the scene of bloody street fighting and would probably have been the loser.

The banishment of the Medici and the quiet withdrawal of Charles VIII's army left

Florence with its usual domestic problem: how was the state to be governed? Were it not basically sad, it would be ludicrous that this by then ancient, handsome, prosperous seat of a republic, widely celebrated for its culture and its business acumen, should at the end of the fifteenth century still be seeking a satisfactory, workable constitution. The *Signoria* solemnly summoned a special meeting of the citizens in November 1494 for advice on what 'the people' would like in the way of government in the future. As Landucci describes the subsequent goings-on – 'many schemes of government were taken to the palace' – it sounds as though democracy was being reduced to the level of an essay competition. It is understandable if Savonarola, who had the advantage of fiercely held opinions, for which he claimed divine sanction, and had a pulpit from which to enunciate them, appeared to win first prize.

What he recommended was a more 'popular' form of government by the establishment of a Great Council (to which a large number of ordinary citizens would be elected), on the model of the *Maggior Consiglio* of the Venetian constitution, but without a Doge (a point he emphasised). A Florentine Great Council came into existence, much as Savonarola had proposed, and he referred to the new regime as introduced by him ('*da me introdocto*'). As Landucci saw it – being on the spot but seeing only the public aspect – everything had been done 'at the instigation of the Friar'.

In fact, the matter was much less simple behind the scenes. The very idea of a Great Council may have originated not with Savonarola but in the upper-class Florentine circle of men used to holding government posts and governing. Few appear to have opposed it. If for some of the liberals among them the measure was a desirable and democratic one, offering more citizens more say in their affairs (and also providing a safety valve should a head build up of popular, revolutionary steam), for others, deeply conservative and aristocratic, it was probably seen as a convenient sop – not any real surrender of grasp on the levers of power. There was in any case not much democracy in terms of representation about the Venetian *Maggior Consiglio*, a body of nobles; and as well as a Doge, Venice possessed a Senate. The concept of a small group of upper-class citizens governing Florence, in effect a Senate, ruling lawfully and with the tacit support of the people (as represented chiefly by the Great Council) was probably nearer the ideal of most upper-class patriots than Savonarola's vision of a democratic republic whose sole ruler was Jesus Christ.

In a statement far less famous – and less public – than his defiant utterance to Charles VIII, Piero Capponi declared (in a letter to a fellow-citizen) his belief that only such a government of twenty-five to thirty men of substance, devoid of personal feeling, ambition and avarice, could take care of 'that poor city' ('*quella povera città*'). Unfortunately,

Capponi's standards seem impossibly high, at the period or perhaps at any time. The ancient Greek philosopher Diogenes had notoriously experienced difficulty in trying to find one honest man. Capponi's recipe required some twenty-five from a city he justly described as poor (or unhappy), where every shade of party feeling and dissension flourished, accompanied by intense if not always naked ambition.

To speak of shades is no figure of speech, for among the parties that emerged – some given purpose by Savonarola's own prominence – were the 'Whites', the *Bianchi* (citizens who supported the new constitution of the republic), and the 'Greys', the *Bigi* (who were opposed to it and remained strong Medici supporters). Those who hated Savonarola most virulently were called by his followers the 'Rabid', the *Arrabiati*. His own group, the most coherent, were the 'Monkish ones', the *Frateschi*, dubbed with a string of contemptuous nicknames by their opponents, of which *Piagnoni* (big blubbers) was the most common.

Vainly did Savonarola urge that in the cause of unity all such names as *Bigi* and *Bianchi*, 'which are the ruin of the city', should cease to exist. Even if the words did not designate altogether clearly defined parties (and certainly not classes), they stood for elements determinedly opposed in a situation that yet remained – as would be said nowadays – 'fluid'. So fluid was it that a reliable contemporary historian (Piero Parenti) records that the *Bianchi* lost out at one point in elections to the *Bigi*, who gained Savonarola's support since it suited them temporarily to fall in with his preaching of peace.

Modern historians, with all the sources at their disposal, have had to work with extreme discrimination to assemble an intelligible picture out of the eddying, uncertain, complex political scene in Florence as the fifteenth century came to an end. Savonarola cannot be blamed if he failed to understand quite what forces were leagued against him there or were partly manipulating him. Or perhaps he did discern, gradually and sadly, if not indeed painfully, that in practical politics idealism withers away once power has been achieved. It was not enough to rely on God's wishes, as interpreted through Savonarola, to ensure that affairs in Florence proceeded smoothly on a perfect footing. At a less elevated level, men had to be persuaded to vote, interests had to be placated, the effect of promulgating laws had to be discussed. In brief, the preacher had to turn politician. It may be that Florence tended to produce more wily or more ruthless politicians than this Ferrarese monk, whose exalted sense of his destiny included some prescience about his own eventual fate.

When Pope Alexander VI first summoned Savonarola to Rome, he declined to go,

excusing himself by explaining that he was needed in Florence, where through his work ('*mea opera*'), God had 'restored' peace and holy laws. He also referred to the existence of enemies of his, in and outside the city. That was in 1495, and he must already have foreseen, possibly even welcomed, a martyr's fate. In the increasing tussle between him and the pope (with the pope getting in some shrewd, warning digs about the effect of preaching to the Florentines as a people unruly and factious), Savonarola continued to preach and continued to refuse to go to Rome. If his martyrdom was to occur, it should take place in Florence. To that extent he won the battle.

From the pulpit Savonarola was able to urge on such a practical matter as the construction of the new hall for the meetings of the new Great Council. If necessary, workers could be diverted from the Duomo, he exhorted, since their labour would be pleasing to the Lord. Anyone who has ever suffered from builders' delays will envy Savonarola's possession of an ultimate, divine inducement to ensure completion of a project. It must have been somewhat galling, however, for those workers who hastened to get the hall built that the speed of its construction was popularly attributed to the assistance of angels.

Savonarola expressed understandably austere views about the character of religious art, complaining of the prevalence of coats of arms displayed on sacred buildings (the Medici must have been in everyone's mind) and even on vestments. Images of the Virgin as painted by Botticelli, and especially by Filippino Lippi, of an elegant figure almost sinking under gauze veils and spangled robes, seem pointedly rebuked by his comment that in reality the Virgin had gone dressed like a beggar. It might be argued that, for one reason or another, Botticelli did move towards a certain stylistic austerity in his late religious pictures, though there is nothing of the beggar about the Virgin in them. Filippino's Strozzi Chapel frescoes certainly do not suggest any particular shunning of ornament or a concern to be severely spiritual. Yet Savonarola himself could use strongly pictorial imagery – as in describing the procession of the mystic chariot which carries Christ triumphantly through the world, drawn by apostles and prophets, and in its train infidels with their books burnt, their idols shattered and their altars overthrown (in some ways analogous to Filippino's fresco of *St Philip Banishing the Dragon from the Temple of Mars*). His visions of a hand holding a sword in a sky that suddenly darkened, or of a black cross rising from Rome and a golden one from Jerusalem, have a clarity which could easily be translated into visual art (and the hand holding a sword was reproduced on contemporary medals of Savonarola). Botticelli's intense, mysterious picture of Christ crucified outside Florence seems to share something of the same vivid if no longer comprehensible apocalyptic imagery.

Two broad facts characterise the years in Florence from the peaceful departure of Charles VIII from the city in November 1494 until the day in May 1498 on which Savonarola and his two companion friars, Fra Domenico and Fra Silvestro, were led out of the Palazzo della Signoria to be burnt in the piazza. Florence showed it had no need of the Medici family to survive as an entity (rather, unfortunately, the Medici family needed or lusted for Florence), and during those years, whatever the underlying fragility of his position, Savonarola held an undefined but unique place in the public governance of Florence. Whether viewed as a prophet sent by God, or as a meddlesome friar, he could not be overlooked. If in his increasing criticism and defiance of the pope in Rome there are some echoes of Wycliffe and Huss, and perhaps faint anticipations of Luther, he is distinguished from all of them as much by his political prominence as by his unquestioning fidelity to the teachings of the Catholic Church.

For Florence it was an extraordinary, unprecedented experience to be under the sway — as it undoubtedly was — of one man whose power-base lay solely in fiery eloquence and personal magnetism, and whom nobody could accuse of self-seeking. The non-native friar proved one of the greatest disinterested patriots in Florentine history and had a care too for the state of Italy. When Pasquale Villari's important book on Savonarola was translated into English in 1888 (*Life and Times of Girolamo Savonarola*), author and translator dedicated it, with resounding suitability on several counts, to Gladstone.

That Florence should be a republic pure (in every sense of the word), and as far as possible simple, was no bad ideal. Savonarola gave fresh, burning expressions to a dream which, in varying forms, had haunted earlier statesmen, theorists and patriots. One might recall the efforts of Dino Compagni at the beginning of the fourteenth century, when he tried to unite the citizens assembled in the Baptistery, and had begun by appealing to them as all alike having received baptism there, at its font. And that the great-grandson of Dante should be given special treatment over his tax difficulties and permitted, with the sanction of the Great Council, to return to the city in 1495, takes on a certain symbolic appropriateness. After a reformed system of voting-in the new *Signoria* was introduced in June of the same year (in place of lots), Landucci noted that everyone seemed contented with this and felt it corresponded more nearly than ever before to the true Florentine concept. In 1496, when the new Hall of the Great Council was being prepared for meetings, a marble tablet was installed, with an inscription beginning 'This Council is from God . . .'

Beyond Florence there were the concerns of other Italian states, including the Papacy. The policy of Alexander VI was militantly anti-French, not unreasonably so, and

the 'holy league' he formed of Italian states, including Venice, harried Charles VIII on his march back to France in 1495. The pope was eager for Florence to join the league, while Savonarola stood out as championing the French alliance, itself very much a matter of Florentine tradition. When the pope solemnly excommunicated Savonarola, in a brief read in various churches in June 1497, a few days before the great feast-day of St John the Baptist, his tone was naturally lofty and religious. The Florentine envoys in Rome were, however, not deceived. They reported that the pope's chief motive was to induce the Florentines to break off their alliance with France and join his league.

The *Signoria* that came to power in the summer of 1497 was favourable to Savonarola and wrote to the pope pleading for him as a good, innocent and pious man. The *Arrabiati* partly neutralised that by submitting a document accusing Savonarola of numerous crimes. For a few months, nothing dramatic happened on either side. Florence was afflicted by yet one more outbreak of plague, and the discovery of a pro-Medici plot led to the execution of five well-born chief conspirators, including a young Tornabuoni.

After a very cold winter, when the Arno froze, and with the coming of Lent, Savonarola prepared to preach publicly again, regardless of the fact that he was excommunicated. For the second year running, a 'bonfire of vanities' was arranged on Shrove Tuesday in the Piazza della Signoria – an ominous foretaste of the next bonfire to be held there. That the time was approaching in the Church calendar for commemorating Christ's Passion and death is unlikely to have escaped Savonarola. And the new *Signoria* which came into office in the spring of 1498 was largely opposed to him. The convenient traditional Florentine device of the *pratica*, an *ad hoc* discussion among representative citizens, was invoked to consider what should be done about the friar who, as the pope had sternly reminded the *Signoria*, must be silenced and put in custody, if not handed over to him. The familiar style of Florentine rhetoric was displayed in the somewhat inconclusive though predominantly hostile debate, with references to the fate of Troy, destroyed by its refusal to give up Helen to the Greeks. With comparable ancient examples in mind, it was seriously argued, should the pope be denied Savonarola? At any other juncture the incongruous classical comparison might have appeared funny.

Savonarola's support in the city was in any case melting away. Various disturbing incidents occurred, the strongest of which was an abortive trial by fire between a Franciscan friar and a Dominican representative of Savonarola. The people assembled excitedly for a spectacle which failed, amid squabbles and delays and pouring rain, to be enacted. The general angry disappointment was adroitly directed towards Savonarola, and on the following day, which happened to be Palm Sunday, he was arrested or surren-

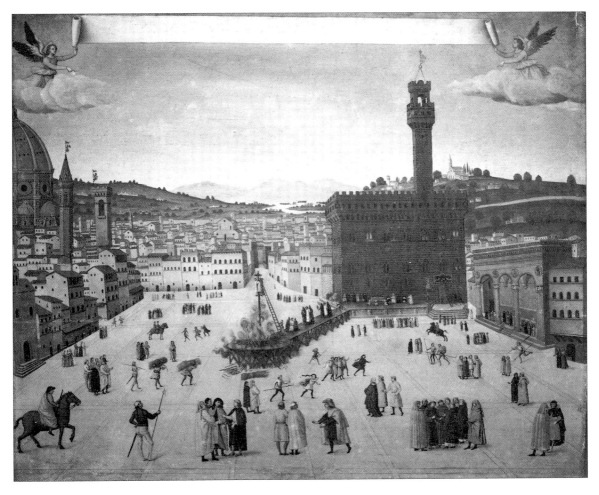

Anonymous Florentine: The Execution of Savonarola, *Museo di San Marco.*

dered after an attack on his convent of San Marco. And although the news had not yet reached Florence, Charles VIII of France had suddenly died, dying while the city was preoccupied by the prospect of the ordeal by fire.

Tortured and tried, and probably confessing under torture part of what his enemies required, Savonarola might just as well have been allowed to die by Easter. His two companions, Fra Domenico and Fra Silvestro, had been arrested with him, and eventually on 23 May the three men were led out to be burnt alive in the Piazza della Signoria at an elaborate pyre, in the presence of the pope's representatives and the government of Florence. Thanks to that combination, the assembled populace had their spectacle, after all.

Today, a discreet grey plaque marks the presumed spot on the pavement, walked

over unheedingly by thousands of visitors, where Savonarola and the other two Dominicans suffered and died. Within a week of the execution some pious women had been found kneeling there, and modern guide-books state that on 23 May every year flowers are laid on the plaque. Luca Landucci would have been pleased to know of that, but it seems strangely irrelevant to the ardent zeal of Savonarola.

As long as Florence continued to be a true republic something of Savonarola's ideals lived on. His monument was then not a modest one outside the Palazzo della Signoria but inside, in the huge Hall of the Great Council. The pro-French policy which he had advocated went on being the republic's policy. And in the ultimate, desperate days of the republic, which ended with its capitulation to the combined imperial-papal forces in 1530, a stern mood of neo-Savonarolaism gripped the city. Once again, Florence proclaimed that its sole ruler was Jesus Christ.

Momentous events had occurred in the world in the period since the death of Lorenzo 'the Magnificent' and the rise of Savonarola to a position of great moral authority. The extent of the known physical world had itself widened dramatically, with continents 'discovered' both east and west of Europe. Christopher Columbus had set off for the first of his famous expeditions to find the Indies in 1492, the year of Lorenzo's death. A member of the Florentine Vespucci family (some of whom were Botticelli's patrons), Amerigo, had joined the Medici firm in Spain and also became involved in exploration of some of the previously unknown territories across the ocean in the west. Spurious or garbled publication of his voyages fostered the notion that he – not Columbus – was the true discoverer of the new land. In 1507 a German cartographer issued a map that showed the recently discovered continent as a separate mass, and he suggested it should be named after Amerigo as America. This modest proposal was to be adopted with permanent success. If only obliquely, it enhanced the prestige of Florence. The city which had added Petrarch to its literary crown could now claim a further jewel, on an even more dubious basis. But that the world was expanding was recognised as a fact. Luca Landucci, then entering his seventies and keeping his diary more intermittently, noted in 1508 that there was talk of the King of Portugal's acquisition of an island discovered by his ships, 'at 34 degrees beyond the equinox, opposite Alexandria'.

Less dramatically but more relevantly for Florence, the character of Europe was changing. Christendom would cease to be a united entity, though perhaps the Reformation was of less immediate significance than might have been supposed, given

that the Catholic states continued to be furiously at war with each other, and the pope was usually at the centre of any conflict. Landucci was merely a humble, pious, Florentine apothecary, looking on at events he was powerless to affect, but there is a good deal of timely sense and justice in his observations in 1512 about Christian disunity and those ambitious, supposedly Christian rulers who showed no pity for the poor afflicted people of Italy.

The major nation-states of Europe seemed indeed united chiefly in assuming that the Italian peninsula was a cake to be cut up and hacked about as their appetites prompted. If the King of France was not invading the country, it was the German Habsburg emperor, while the King of Spain was nearly always ready to be involved, since Naples notionally belonged to him. Almost as frequent as the wars themselves, and even more bewildering, were the constant shifts of alliance. Broadly, however, it could be presumed that the 'Most Catholic' King of Spain and the 'Most Christian' King of France would be opposed to each other, and that the pope would tack between them, keeping a weather-eye open for the leading rulers in Germany, without neglecting any part to be played by the Swiss army (no joke but a highly efficient force), and not indifferent to support from the King of England.

Given such an international scenario, the Florentine republic managed remarkably well for a few years after the start of the sixteenth century. The lack of a Medici regime was far from a disadvantage, and for a time Venice seemed the main Italian focus of papal aggression as instigated by Julius II. Florence just maintained its pro-French sympathies and its own private war against Pisa, which surrendered in 1509. And the republic had in its employment two of its most distinguished historical figures, Niccolò Machiavelli and Francesco Guicciardini.

As the much older man, Machiavelli had entered the Florentine civil service in 1498, employed in affairs at the Palazzo della Signoria. He was to become Secretary to Soderini during his *Gonfaloniere*-ship and to suffer political disfavour on the re-establishment of the Medici. His exclusion from any exercise of power or involvement in government was a loss which brought the gain, however unwished for, of leisure.

With the experience behind him not only of the daily conduct of Florentine affairs but of having met several leading personalities on the larger stage, such as Cesare Borgia, he was well placed to savour, analyse and express what he believed to be the secrets of statecraft. Most notoriously, Machiavelli produced *The Prince*. But he produced much more literature in his enforced retirement, composing poems and plays (such as *Mandragola*, a comic masterpiece), letters and treatises and a *History of Florence*, commis-

sioned from him by Cardinal Giulio de' Medici, the future Pope Clement VII. Posterity may be glad that his career as diplomat-bureaucrat had ceased.

The career of Guicciardini was, at least ostensibly, much more successful. He was to hold numerous representative posts under the two Medici popes in various cities and was able to sum up their characters from direct observation. The Guicciardini were a distinguished patrician family, and Francesco's father had been a Medici supporter. His was a thoroughly aristocratic character, colder perhaps than Machiavelli's and somewhat pompous, but also one extremely shrewd and capable of profounder analyses. In sum, he was a much better historian. With supreme ambition, he undertook a history of 'contemporary' Italy, beginning at the end of the fifteenth century, in effect with the death of Lorenzo de' Medici, and closing with the death of the second Medici pope, Clement VII, in 1534. He enters the story of events in 1511, making his début when the Florentines sent an ambassador to the King of Aragon: 'Francesco Guicciardini . . . he who wrote this history'. He himself died in 1540, having been edged out of his original advisory councillor role by Duke Cosimo I de' Medici. The *History of Italy*, at once massive and incisive, was published in 1561, during Cosimo's reign, with his 'privilege', along with that of the pope, Pius IV, and the Holy Roman Emperor, Charles V's brother, Ferdinand I. Guicciardini had earlier started a *History of Florence* and left numerous reflections and maxims (*Ricordi*), among other political-theoretical writings.

Both Machiavelli and Guicciardini were very much 'modern' men, professional and sophisticated as writers, scrutinising motives and assessing human actions in a manner that Landucci, say, would have thought daring and shocking, if not impious. God as a force in affairs has been largely banished from their vision. And although Guicciardini served Leo X well enough after his election to the papacy in 1513, itself following hard on the heels of the Medici 'restoration' in Florence the previous year, he delivered a stinging epitaph on a pope whom he judged as having greatly failed to fulfil the expectations aroused on his election. Nor did he doubt that with the imposition, by force of arms, of Medici rule, liberty had been lost to the city – even if that had happened because of disagreement among its citizens. In his *Discorsi* Machiavelli had considered the nature of a republic, concentrating on the ancient Roman republic but pertinently reflecting that a princedom cannot be established in a city where there is equality. With very different characters, and from different viewpoints, Guicciardini and Machiavelli would probably have agreed that ideally – and each might have stressed the adverb resignedly or ironically – Florence should be constituted as a republic.

In sixteenth-century Europe the continuing attempt to be or become a republic was

almost perverse when manifested by a city which, unlike Venice, had no firmly settled form of stable government, no empire and, possibly, no clear conviction about its proper place as an Italian power. To be '*Florentia bella*' was no more sufficient than to be under the sole rule of Jesus Christ.

Ambitious, headstrong, highly individualistic and often showy rulers now dominated Europe, personifying their countries or states and exercising a sort of personal allure regardless of policy or morality. With Francis I of France and Henry VIII of England, and Julius II as a warrior-pope who was also a great artistic patron, there was a promising, colourful mixture or clash, if not a competition, to be king of any available castle. The reigning Doge of Venice, Leonardo Loredan, was perhaps only a somewhat weak figurehead but, at least as portrayed by Giovanni Bellini, he looked a superb incarnation of Venetian wisdom and assurance. And although resolutely unshowy and physically insignificant, the key ruler of the period was the young prince, then king and finally Holy Roman Emperor, Charles V, true child of the century, being born in 1500, whose empire was of vast, unprecedented extent (inclusive of the new world) and who reigned over it all from the age of nineteen.

In any international forum represented by these personalities, supported as they often were by statesmen and soldiers of equal ability or bravura, the Florentine republic was like a tiny child, or a lamb led to slaughter. Where was the stirring personification of Florence who could take on such opponents, as Piero Capponi had briefly taken on Charles VIII of France in 1494? Capponi had died two years later. Machiavelli and Guicciardini were to be invaluable intellectual assets for the long-term renown of Florence but possessed neither sufficient status nor the temperament to lead their countrymen. Piero Soderini was an honourable man, but he presided over a divided city (pro-Medici and anti-Medici, with other factions favouring a form of oligarchy in place of broadly based 'popular' government).

A plot to assassinate Soderini was discovered in December 1510 and seemed Medici-inspired. Filippo Strozzi, owner of the magnificent palace and the husband of Lorenzo 'the Magnificent's' granddaughter, Clarice, is reported to have tackled his mother-in-law about this. Other people detected the long arm of Cardinal de' Medici, the future Leo X. For one party, Soderini might be behaving too much like a prince. For another, a prince was the answer, providing he came from the family of Medici.

Soderini's image even as patron of the arts has suffered to some extent since Vasari made him the butt of a well-known anecdote in which his would-be expertise was sardonically ridiculed and exposed by Michelangelo. An element of traditional legend exists

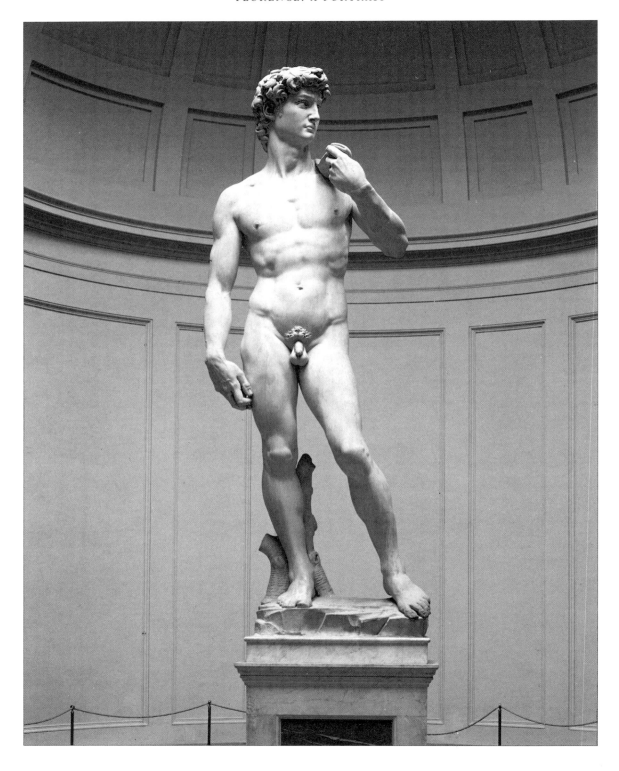

in the story — of the obtuse or pretentious patron who presumes to advise an artist on how to improve his work — but conceivably Soderini did go to look at Michelangelo's giant *David* while the sculptor was still working on it. Perhaps he ventured the criticism Vasari records: that the nose was too large. According to Vasari, Michelangelo climbed the statue's scaffolding and merely let fall a quantity of marble dust, whereupon Soderini declared that the statue now looked much better. No Medici patron, of course, would behave so ridiculously in Vasari's pages. Soderini was a safe target, though it is interesting that Vasari did not include this anecdote in his account of Michelangelo published in Michelangelo's lifetime. A curt letter from Rome might have told him not to malign a dead Florentine patriot who had been friendly towards the youthful genius in the early sixteenth-century years of the republic. And as a benevolent man, childless himself but kind to the little son of one of the *Signoria*'s fifers, a certain Giovanni Cellini, Soderini was to be gracefully recalled in the opening portion of Benvenuto Cellini's famous autobiography.

The *David* is the most potent symbol of all the aspirations of the period of its origin, and its sculptor conceived it as such: as David had justly defended his people, with God's aid, so should Florence be defended by its government. Donatello's *Judith* had been transferred and adapted to serve as a similar example, but Michelangelo's statue was carved within and for the period and is shaped by its ethos, one shared by the sculptor.

Michelangelo was making a statement on a huge scale: his first of such magnitude in his native city. It was a public work in every sense, a public expression of confident *respublica* within a Christian context (in the Bible David meets the armed Goliath if not naked at least without armour, and with only a stave and a sling, but he comes 'in the name of the Lord of hosts'), and also a public expression of Michelangelo's own confident creativity. His '*confidenza*' is mentioned in Condivi's biography (sanctioned by Michelangelo and published in his lifetime) as the attractive aspect to the commissioners of the statue (the Guild of the Lana and the *Operai* of the Duomo), who had on their hands a huge block of marble partly and badly carved. When Michelangelo began work on Monday, 13 September 1501, the very words of the memorandum convey his assurance: he had begun 'strongly and steadfastly' ('*firmiter et fortiter*'). Those terms might equally be applied to the mood of the statue itself.

Yet although the *David* quickly became, and has remained, a supreme incarnation of defiant Florentine pride and freedom, it was only one manifestation of the republic's

Opposite: *Michelangelo:* David, *Galleria dell'Accademia.*

proposed harnessing of the arts to state service. With the return of Leonardo da Vinci from Milan another local genius was available, and earlier in 1501 he had started a cartoon of the Virgin and Child with St Anne. He had commissions from France for paintings but appeared reluctant to occupy himself with anything except mathematics and geometry. If Soderini ever had Leonardo in mind to be the sculptor of the impaired marble block from which *David* was created – as Vasari states – he was well advised to drop a proposal which would almost certainly have come to nothing.

The artistic 'story' of these years, chiefly those during Soderini's *Gonfaloniere*-ship, is a chequered one, with more perhaps to record of high civic ambition than of work accomplished. Yet it was a period of concentrated lustre in the city. To all the available local talents must be added Perugino, who was treated as virtually an honorary citizen, though he retained links with his native Perugia. The assembly of more than twenty artists, which was convened in 1504 to consider where the *David* should be sited, included him. From around the same year the young Raphael was living, on and off, in Florence, keenly responsive to the latest manifestations of Florentine genius, most patently those of Leonardo and Michelangelo. He sketched the *David*, and in so doing invested it with his own brand of suavity. If he received no official recognition, he was none the less commissioned to paint a number of Madonna pictures for private individuals, as well as at least one altarpiece for a Florentine church (for the Dei family chapel in Santo Spirito, now in the Palazzo Pitti). He also painted some portraits, such as those of the merchant Agnolo Doni and his wife (showing awareness of the *Mona Lisa*), for whom Michelangelo almost contemporaneously painted his unique tondo, the 'Doni tondo', of the Holy Family (now in the Uffizi).

Some tantalising echo of artistic contacts and conversation in those years is caught in Vasari's life of the architect Baccio d'Agnolo, aged forty in 1502. He was responsible for a good deal of highly esteemed functional woodwork, now tending to be taken for granted, and also carved the frame for a large altarpiece for the Hall of the Great Council, commissioned first from Filippino Lippi. In Baccio's studio, according to Vasari, discussions would take place – especially in the winter – between artists who included Filippino, Cronaca and Raphael, and occasionally also Michelangelo.

The Palazzo della Signoria was inevitably the focus for exercise of government patronage. Cronaca designed a new staircase, to lead up to the Hall of the Great Council, where the important, fixed portion of the walnut furniture was the work of Baccio d'Agnolo. Elsewhere, the character of the palace changed or was adapted with the creation of apartments for both Soderini and his wife. For a woman to be living there was, as

Landucci commented, 'quite novel'. It not only signalled Soderini's presidential-style appointment for life but gave a peaceful, almost domestic aspect to an otherwise official building. And allocation was made to Madonna Argentina Soderini of an upper terrace where she could grow flowers, another development that would have seemed novel to the original builders and users of the palace. Characteristically Florentine was the proviso after Soderini's downfall that wives of the annually appointed *Gonfalonieri* must not live there.

It was the Hall of the Great Council which offered the most obvious scope for embellishment. As it had come into existence to house a body modelled on the Venetian Great Council, it seems apt that its decoration should have echoes of the mingled sacred and secular themes painted in the Sala del Maggior Consiglio of the Doge's Palace at Venice. Before either Michelangelo or Leonardo had returned to Florence, the sculptor Andrea Sansovino – older than Michelangelo but younger than Leonardo – received the commission for a statue of Christ the Saviour (and perhaps as King of Florence) for the hall. A model was later approved, and a block of marble delivered to Sansovino's studio. And that seems to have been the end of that. No statue was set up. If Condivi's account is correct, Andrea Sansovino had also had his eye on the marble block that became the *David*, and it sounds as if his interest in doing something with it acted as an additional spur to Michelangelo's determined bid to take it on.

Sansovino was one of those gifted artists soon lost to Florence (in his case much occupied, under Leo X, with work on the 'Holy House' at Loreto), but before leaving he was involved in another important and highly public commission, part of a programme of renewal in the first years of the century of the groups of statues that stood over the three Baptistery doors. They had been executed in the early fourteenth century by Tino da Camaino, but had suffered considerably from weathering and – of equal relevance – had come to look 'clumsy and ill-made' and out-of-date. Sansovino began, though he did not complete, marble figures of the Baptism of Christ, perhaps destined originally to be put over the south doorway (above Andrea Pisano's doors). The group was eventually finished, decades later, by Vincenzo Danti, the sculptor of the dramatic bronze group of the *Execution of St John the Baptist* now *in situ* above the south doors. Sansovino's group was given the most honourable of all positions, above the east doorway and thus over Ghiberti's 'Doors of Paradise'. Rustici's contribution, the *Preaching of St John the Baptist*, was commissioned for the north doorway in 1506. Bronze was specified as the medium for the group, since a previous discussion had mentioned that that would accord better with the bronze doors.

The memorandum of the discussion documents a consciousness of the conspicu-

ous place occupied by da Camaino's statues, which as they stand 'bring shame rather than honour and repute to the city . . .' Rustici's trio of figures, powerfully realised, with muscular bodies that hint at movement and heads of pronounced physiognomy, at once reversed that situation. Together, they form a coherent, psychologically taut tableau of a kind novel in sculpture, the two auditors 'held' by the eloquence inherent in the central statue of the Baptist. In a new century, for a new generation, they bring further honour and repute to Florence.

In the Hall of the Great Council honour and repute were of even greater importance. One major project was for the large altarpiece to be installed there, for which the commission went to Filippino Lippi (who already in 1486 had painted an official, 'Florentine' altarpiece of the Virgin and Child with saints for the Palazzo). At Filippino's death in 1504 nothing had been finished — had perhaps not even been begun. The commission was re-assigned to Fra Bartolommeo, who sketched out a magnificent, truly High Renaissance composition, its centre a group of the Virgin and Child adored by St John the Baptist, and including St Anne, mother of the Virgin, exalted behind them. That altarpiece would have made its dignified impact in the hall, but — like so much connected with the room under the republic — it was fated never to be completed. It remains in Fra Bartolommeo's convent (now museum) of San Marco.

At least Fra Bartolommeo's painting exists. Far more tantalisingly elusive and dispersed are the traces of the most exciting initiative undertaken for the room: the decoration of one wall with two battle frescoes, to be painted respectively by Leonardo and Michelangelo. Everything favoured this scheme, which should have resulted in making the Hall of the Great Council one of the finest Renaissance rooms in the world (something of a secular counterpart to the Sistine Chapel) and also have given artistic refulgence to Soderini's republican regime.

Michelangelo's *David* was finished but had not yet been publicly unveiled when, in May 1504, the 'Magnificent and Sublime *Signori*', along with the priors of Liberty and the *Gonfaloniere*, set out in a document their terms for Leonardo's completion of a task assigned to him some months previously. He was to proceed with the picture for the wall of the Hall of which he had begun the cartoon, and the document was drawn up in the presence of several witnesses, of whom the first, the representative of the *Signori*, was Machiavelli.

Opposite: *Fra Bartolommeo:* The Virgin and Child with St Anne and Other Saints, *Museo di San Marco.*

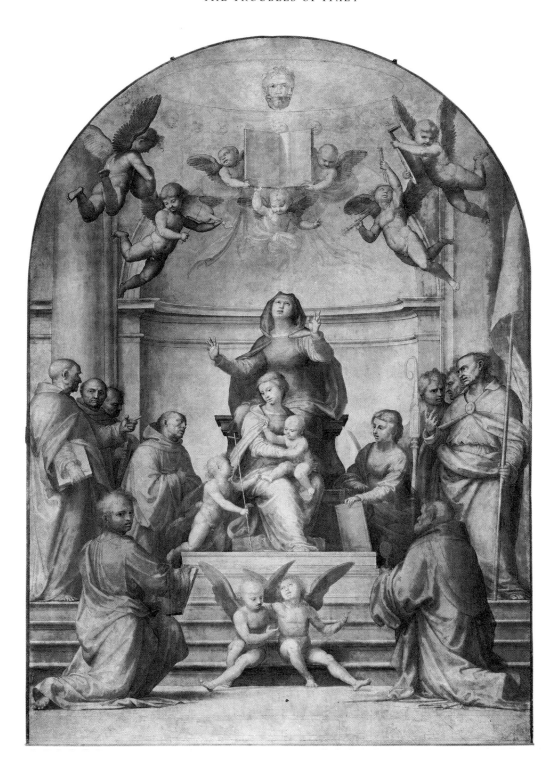

The subject of Leonardo's composition was the Battle of Anghiari, a Florentine victory (of course) which had occurred outside that town in 1440, when the combined forces of Florence and the pope defeated the Milanese. In commissioning a battle picture, to be followed up by the commission to Michelangelo to execute an adjoining picture, of the Battle of Cascina, a victory over the Pisans in 1364, the government must have been aware of Uccello's battle pieces commissioned probably by Cosimo 'il Vecchio' de' Medici, which had remained in the Medici palace. By chance or not, the subjects chosen for the Hall of the Great Council were, however, battles without obvious commanders. They were not, in fact, tremendously famous victories, and Machiavelli's *History of Florence* was to pass over Cascina altogether and be dismissive (not entirely accurately) of Anghiari as a mere skirmish. Yet in a general way the subjects were stirring and patriotic, recalling the old days of the republic and two traditional – and topical – enmities, with Milan and Pisa. In the early 1500s Milan was under occupation by the French, and Pisa was under attack by Florence.

From the point of view of the two painters, the interest of the subjects lay elsewhere. Leonardo's notebooks contain an energetic description of how to represent a battle, with a good deal of emphasis on the frenzy of the horses and the grimacing of the combatants. It is very much the atmosphere of any battle, and Leonardo is unlikely to have felt a particularly patriotic thrill in depicting the Battle of Anghiari as such or to have bothered to peruse any of several fifteenth-century accounts of the battle (which included one by the chancellor at the date, Bruni). He had a memorandum on it and – far more important – he had his imagination.

The Hall of the Great Council as he knew it was a less well-lit room than it became under Vasari's adaptation, and with a ceiling lower by some twenty feet. Painting on its long east wall was not exactly working in the dark, though that perhaps added to the practical and psychological difficulties which Leonardo experienced in translating his preparatory cartoon into a finished picture. But central to his thinking, and to the composition, was a marvellous group of armed men on horseback, fighting furiously for the standard, and Vasari is at his most eloquent in describing the effect. He himself obliterated whatever Leonardo had actually painted, while the cartoon, yet more marvellous no doubt, and admired and pored over by generations of Florentine artists, at last disintegrated. Copies preserve something of what was presumably visible on the wall before Vasari started his improvements, and sufficient preliminary drawings survive to prove that on this occasion at least his eloquence was not misplaced.

Marvellous as were the contorted physiognomies of the skilfully integrated knot

After Leonardo da Vinci: The Battle for the Standard, *Palazzo Vecchio.*

of shouting, falling, dying men, nothing probably equalled the rearing, plunging, half-wild horses. Some of those people fortunate enough to see the original area of wall painted by Leonardo conveyed their impression of it by describing it simply, almost breathlessly, as 'the horses' or 'the group of horses'. The noble creatures Leonardo had introduced into the background of the unfinished early *Adoration of the Magi*, and had restudied for the equestrian monument to the Duke of Milan, now became almost the *leitmotif* of a composition. He must have been proud of his artistic horsemanship, and his own written recipe for a battle picture extends to a final, barely paintable image of a river within which horses are galloping and foam is swirling, and water is flying up amid their legs and bodies. Human beings are forgotten in a battle of two natural forces which always fascinated Leonardo and which are likely to have had more evocative power over him than could Anghiari.

To give him Michelangelo as his aesthetic sparring-partner, for a comparable subject and task on an adjoining area of the same wall, was a way of instituting direct competition – indeed rivalry – ingenious and almost 'Machiavellian', though it probably originated with Soderini. As a method of speeding up Leonardo, it might seem es-

pecially subtle and effective; and for Michelangelo, with the *David* statue completed by early 1504, there came the opportunity to demonstrate equal mastery in another medium, Leonardo's preferred one and the one to which his writings allot a superior place over sculpture.

No less marvellous and even more personal than Leonardo's *Battle of Anghiari* was what Michelangelo composed of the *Battle of Cascina*, a cartoon which illustrated not the battle but the preliminary incident of Florentine soldiers surprised by the Pisan army while bathing. That was intended to be a subsidiary portion of the fresco, but it was the portion and aspect of the subject which meant most to the artist. It gave him — or, perhaps more truly, he seized — the opportunity to depict the male body: naked, or virtually so, in violent movement and from every angle. His frieze-like composition of tightly interlinked bodies was no idyll of the bathers disturbed beside some grassy river-bank (and no languid scene of a men's bath, as shown in one of Dürer's woodcuts).

Although his cartoon perished long before Leonardo's, the *Bathers* portion was copied with some degree of accuracy. As with Leonardo, there survive preliminary drawings and sketches perhaps almost as wonderful in their way as the cumulative effect of the cartoon, for some of them are direct, intensely concentrated studies of a single body, from life. Aesthetically superb as the *Bathers* must have been, however, its subject could scarcely have been identified from that composition alone. These twisting, contorted, interlocked bodies might seem at first sight engaged in a struggle among themselves, and the scene is nearer to the Last Judgment, or a circle of Dante's *Inferno*. The perpendicular, razor-sharp rocks would make nude bathing agony, and nothing is more desolate amid the preoccupied faces and the writhing limbs than a pair of hands extended in despair from the water — all that is visible of a drowning man. It is a vivid but terrible and human image, more terrible in its hopelessness than any death in battle.

Michelangelo, it seems, never got his wall-painting to the stage even of Leonardo's (possibly never, as stated by some scholars, put brush to the wall). In 1505 he was summoned to Rome by Pope Julius II, and though back the following year for some months, and again in 1508, he did nothing in the Hall of the Great Council. And then in 1506 Leonardo sought leave of absence from the *Signoria*, to go to Milan to serve important French patrons. Soderini was most reluctant to release him, writing that the artist had not met his obligations to the republic, having made only a small start on a large work (*'una opera grande'*) he ought to execute. But when it became clear that the King of France, Louis XII, wished for Leonardo's presence in Milan, the republic had to give way. Although

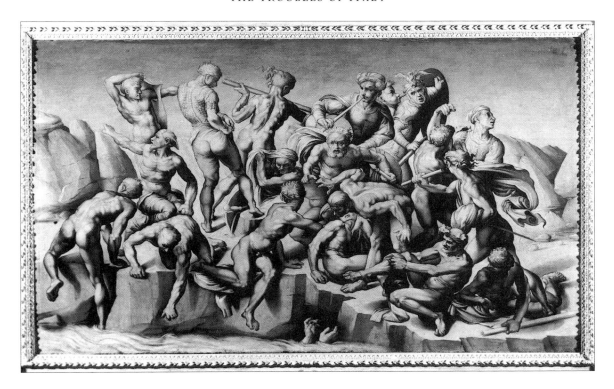

After Michelangelo: The Battle of Cascina ('The Bathers'), *Earl of Leicester collection, Holkham Hall, Norfolk*

Leonardo returned to Florence once again, for the winter of 1507–8, he too appears to have contrived to avoid working further in the Hall.

Behind all these admitted absences, and other patrons and other tasks, and allowing for Leonardo's gift for procrastination, there seems to lie one fundamental reason why neither genius ever executed his state commission for the Hall of the Great Council: it was not truly congenial. Each artist had interpreted it, modified it or emphasised it as his imagination prompted, and in so doing created a series of drawings, even exclusive of the cartoons, to rank among the finest in Western art. That fact is unlikely to have consoled Soderini for the empty spaces in the hall. It might be magnificent but it was not war; not, at least, the intended battles.

Happier was the ending to the question posed by the *David* on its successful completion: where should it be placed? In 1504 Florence had very few free-standing public statues and nothing on the scale of this one, which everyone referred to as 'the giant'. Emotionally, it should have been put in the Hall of the Great Council, and that possibil-

ity was aired by one of the speakers at the meeting convened to discuss potential sites in January 1504.

The minutes of the meeting are interesting psychologically as well as artistically. Such a convocation of Florentine Renaissance minds may promise a dazzling display of intellectual brilliance but in reality there was practicality and common sense, with just a faint suggestion here and there of characters and views anticipating those of the Athenians who in *A Midsummer Night's Dream* convene at Peter Quince's instigation to put on a play. Messer Francesco, the herald of the Palazzo della Signoria, led off the exchange of views with the proposal, finally adopted, of putting the statue in front of the palace, in place of Donatello's *Judith* (which was later moved to the Loggia dei Lanzi). That location was probably the one preferred by Michelangelo, whose own views on the question several artists – notably Filippino Lippi and Piero di Cosimo – recommended should be sought. Messer Francesco seems to have been prompted by a distinct distaste for Donatello's statue. Not only did he think it an evil omen but its subject disturbed him: it was not proper, he said, that a woman should kill a man. Florentine male chauvinism was clearly as flourishing as ever.

The *David* had originally or notionally been thought of as a statue for the exterior of the Duomo. It is interesting to note that in the January 1504 discussion only a small minority, of whom Botticelli was one, favoured that alternative. The majority was for bringing the statue into the secular context of the Palazzo della Signoria: to stand either outside the entrance or, since the marble was fragile, within the shelter of the loggia. A rather cool endorsement of the latter proposal was made by Leonardo da Vinci. Cellini's father demurred, thinking the statue would not be fully visible in the loggia; his suggestion was to place it in the courtyard of the palace (where it would have displaced Donatello's bronze *David*), and he added that the sculptor would find that agreeable as the site was worthy of the statue. Among those present who did not put forward a specific opinion of their own was Perugino.

Even though the minutes do not say so, all the participants probably recognised they were discussing the destination of a marvellous, significant work of contemporary art, then 'almost finished'. It belonged to the republic of Florence, and its eventual siting outside the Palazzo della Signoria seems, in retrospect, inevitable. And whatever alterations and additions were made to the surrounding area, there it remained until 1873; nor could it be removed without a copy replacing it. Something had been added in 1504 not just to the palace or the piazza but to the whole concept of 'Florence' as city, state and artistic centre.

What was destined to become the most famous single piece of Western sculpture began its slow journey through the city, from the workshops of the Duomo to its chosen destination, on the evening of 14 May 1504. The journey is itself the equivalent of a triumphal progress: the perfect symbol of the arrival of High Renaissance achievement. It must have been an extraordinary, awesome sight as the upright 'giant' moved forward on greased beams, tugged by more than forty men. Nobody in Florence had seen anything comparable. Early in the morning of 18 May it reached the piazza, though not until September was it completely unveiled. From the windows of the Palazzo della Signoria Soderini may not have had an ideal view of it, but at least he could see that it was *in situ*.

If DONATELLO's *Judith* might be interpreted, however naïvely, as a bad omen, Michelangelo's *David* surely represented the promise of good times ahead. 'The troubles of Italy' looked to have receded as far as Florence was concerned. In 1505 topical associations were given to the battle commission in the Hall of the Great Council when a minor victory at Barga over the Pisans took place. Pope Julius II appeared friendly, conceded a 'pardon' to the city and a jubilee to the church of Santissima Annunziata; and from Perugia in 1506, he requested Florentine military aid in his campaign of recovering papal territory. When Ferdinand, King of Aragon (husband of Isabella of Castile), passed through Tuscany in the same year, Florentine ambassadors hastened to honour him, and government presents to him included plenty of red and white wine and various delicacies, not omitting biscuits for his troops.

The never-ceasing campaign for the general physical improvement of Florence continued: Santissima Annunziata was repaved, and the cornice of the cupola of the Duomo was constructed. The larger portion of the Palazzo Strozzi had been completed in 1504, when a male Strozzi married Lucrezia, daughter of Bernardo Rucellai, with great pomp. The silver plate and the musicians of the *Signoria* were lent for the occasion, and so Cellini's father was doubtless one of those piping away.

'The troubles of Italy' were soon to drown out any such cheerful, festive sound. The death of Piero de' Medici in 1503 had made his brother Giovanni, the cardinal, head of the family. In the same year Julius II had been elected pope. It was to prove an unlucky combination for republican Florence since the interests of the two churchman coincided (and the new pope was markedly friendly towards the cardinal). Although his approach was subtle, the cardinal's aim was simple: the restoration of Medici rule in the city. Proceeding by always being affable and welcoming to Florentines visiting Rome — even

giving a banquet in 1504, well attended by them, though attendance at it was technically illegal — he kept alive the family's renown. With his high position at Julius's court, his ability, his culture and his friendly manner, he projected a far more potent image of Medici prestige than had his weakly arrogant elder brother.

Nevertheless, aside from fomenting an uprising in Florence, he could probably have done little positive in regaining power there had Julius II been well-disposed to the city and the Soderini regime. By remaining pro-French, Florence angered a pope whose wrath was never slow in manifesting itself. As Guicciardini saw it, Soderini was the prime object of the pope's hatred, for it was he who supported the alliance with Louis XII of France. From the removal of Soderini to the restoration of the Medici was a short, logical step. Julius took it.

There had been several ominous and extraordinary indications of the drift towards the Medici — or, at least, against Soderini. In 1508 a new Archbishop of Florence was elected. He was not the candidate originally favoured by Cardinal de' Medici, nor Soderini's brother, Cardinal Francesco, who might have coveted the post. Cosimo de' Pazzi was the man chosen with Cardinal de' Medici's support and the pope's approval. He was of good standing, both within the Church and socially, but he was also a member of the family who had famously conspired to kill Cardinal de' Medici's father, and had killed his uncle, thirty years previously. The days of Florentine family vendettas down the generations might be shown as ended, but the motive of the Cardinal de' Medici was hardly of pure, disinterested forgiveness. And soon he was pressing the pope about obtaining from Florence a pardon for himself and his brother, Giuliano, as Medici exiles.

When Soderini was about to take up his position in 1502 as *Gonfaloniere* for life, he had given a banquet, and his wife had commissioned a poem to celebrate the occasion. A 'golden age' was beginning anew, this time under Soderini — the poet declared — and all Florentines were united under him. It was no more absurdly adulatory a poem than many that had been, and would be again, addressed to members of the Medici family. Soderini's dream, if one may suppose such a thing, of a new, peaceful golden age could — almost — have become a reality. In Florentine art, at least, it was to be partly realised.

In 1512 the pope, with the support of Spain, demanded that Florence join the latest 'Holy League' against France. Florence offered the league money, but declined to abandon its ally. Perhaps the confused city, where contradictory opinions naturally ran, did not entirely understand the consequences. Although, ironically, the King of Spain had become suspicious of the pope and apparently did not wish for the overthrow of the Florentine government, a Spanish army advanced towards the city and took and horribly

sacked nearby Prato. Cardinal de' Medici was with the army, deploring the bloodshed but recording that the capture of Prato served as a good example.

It was certainly a good example of Medici determination. Soderini was banished. Florence capitulated and passed into Medici hands, though not as smoothly as Cardinal de' Medici might have hoped. Like 'the troubles of Italy', the troubles of Florence were by no means over.

T HE RETURN OF the Medici represented essentially the death of the Florentine republic, although it would display a last galvanic twitch of life in 1527 following the sack of Rome before being starved into surrender three years later, with fresh and final imposition of Medici rule.

Outwardly, in 1512, the republic continued to exist. The Medici and their adherents had to move prudently in a susceptible city, as volatile and as disunited as ever, always jealous of its 'liberty' but wholly unclear about how best to preserve it. Strenuous debates took place, as usual, about reforming the constitution, a topic on which anyone of any status in Florence was an authority. As a result, a new constitution was rapidly evolved. It included a *Gonfaloniere di Giustizia* but he would in future serve only a one-year term. The Great Council was not abolished (as the Medici party must undoubtedly have desired), but a new body, a Senate, was created, with certain powers transferred to it from the Great Council, which continued to carry recollections of Savonarola and the *Piagnoni*.

Everything was ostensibly democratic, just as in the days of Cosimo 'il Vecchio'. Speeches were made and votes were cast. Yet, of course, as the Medici were very much physically present, and the Spanish troops a nearby threat, there was a certain unreality about the proceedings. And the leading members and associates of the Medici family were not themselves entirely at one. In Florence the family was represented at first by Giuliano de' Medici, the cardinal's younger brother, no less cultivated but more genuinely kind, a private, thoughtful and unassertive figure, perhaps already undermined by illness. When the newly elected *Gonfaloniere* turned out to be Giovanbattista Ridolfi, a man of some standing, presumed liable to take republican reform seriously, regardless of Medicean pressure (possibly raising the spectre of Pietro Soderini), the more committed Medici partisans persuaded Cardinal de' Medici that strong action was needed. Although he may have temporised, for political rather than any profoundly humane motives, he ultimately sanctioned a *coup d'état* which can be seen as impending all along if the Medici wished — and they did — to govern and possess Florence. It hardly mattered

what fresh constitutional refinements were discussed or put in place, and whether a council was called the One Hundred, the Eighty, or the Eight. It might be prudent to leave a council of some sort to pass laws or to 'advise' — even a pope had to have councillors in the form of the cardinals — but in plain, brute fact Florence was under the yoke of the Medici. The appearance of republican government was misleading and indeed bogus.

The *coup d'état* was a bloodless affair, a display of armed force which sufficed just as a display. Giuliano de' Medici had entered Florence quietly on 1 September 1512. On 14 September his brother, the cardinal, entered — not in a formal processional way, as was usual for a papal legate, and in the company of citizens, but, a contemporary chronicler noted, amid soldiers. Two days later, Giuliano and a group of adherents, all armed, entered the Palazzo della Signoria and occupied it. The piazza was filled with troops, and with shouts of the Medici rallying word, '*Pallé*' (unavoidably to be translated 'balls'). The bell in the tower was rung, and even the bell-loft was packed with troops. A very meagre proportion of the people of Florence, the *popolo*, assembled and dutifully voted for the establishment of a *Balìa*, the familiar Florentine device of council or commission, invested with unique authority to implement that familiar Florentine solution to the problems of government: a new constitution.

It is hardly surprising that the quite small membership of this particular *Balìa* (only 55 in number, whereas some in the late fifteenth century had had more than 200 members) came up with a 'conservative', even backward-looking constitution, recalling that of the time of Lorenzo 'the Magnificent', with two councils of 70 and 100, and with the abolition of the Great Council. Plenty of intrigue and negotiation, and distinctly modified rapture about the Medici and their return to dominance in the politics of Florence, lay below the fairly calm surface. But while some people never ceased to hate the Medici, and others remained disgruntled, quite a few distinguished men chose if not to shout then at least to whisper '*Pallé*' and hastened to trim their sails to the Medici wind. Among them was Ridolfi, as well as one-time friends of Piero Soderini and even followers of Savonarola.

The seat of government in Florence was still the Palazzo della Signoria. Tradition demanded no less. Its proud, massive, fortified bulk symbolised centuries of republican rule, but it might as well have been made of cardboard in terms of realpolitik. Sensible and far-sighted citizens looked across the city to the house Cosimo 'il Vecchio' had built, the imposing Palazzo Medici, for the true centre of government, and the more prominent of them frequently visited the palace, to give a word of advice or receive a favour and generally to pay their court. That the latest constitution, like the earlier fifteenth-century

ones, allowed no place to any member of the Medici family as such, was a fiction which deceived nobody.

Four very different male personalities stood for the family at the core of power, though the ramifications of the Medici tree through marriage surrounded that core with a good deal of useful foliage. As it happened, for various reasons, none of the four was yet married. But Lorenzo 'the Magnificent' had had daughters as well as sons, and some of their husbands, Jacopo Salviati, for example, were closely connected with the regime. It was Jacopo's daughter by Lucrezia de' Medici, Maria Salviati, who was to be the mother of Cosimo I, the first Grand Duke of Tuscany.

In 1512 the quartet who mattered most was headed by Cardinal de' Medici, who withdrew from Florence in November, though only to Bologna, where he continued to be the controlling force in the take-over operation. Fat and affable-seeming, luxury-loving and ostentatiously generous, he gave the family image useful glamour and grandeur, with a dash of piety. He was, after all, a prince of the Church. He raised associations of a larger world beyond Florence, that of Rome and the papacy, enhanced by his own favoured place at the court of Julius II. Close to him, closer perhaps than his brother Giuliano, was their cousin Giulio (sole and illegitimate child of Giuliano de' Medici who had been killed in the Pazzi conspiracy). Giulio had also become a churchman. Physically a contrast to the cardinal, lean and saturnine, he was the opposite of showy or generous or affable, but cautious, wily and adroit in political manoeuvring, very much the cardinal's right-hand man. They made a good team, and the native shrewdness of Cardinal Giovanni, underlying all the *bonhomie*, is shown by the trust he put in his cousin.

Giulio had stayed in Florence, keeping one eye on Giuliano and one on affairs in the city, and maintaining close liaison with the cardinal on both aspects. Giuliano de' Medici seems to have lacked the driving ambition of his brother and his cousin, and had perhaps never envisaged a return to Florence, or not at least as its *de facto* ruler. In exile he had enjoyed pleasant times at the graceful, civilised court of Urbino (and his friend Castiglione makes him a participant in the dialogues located there in his book *The Courtier*). Already in November 1512 he was incapacitated by illness, and he may have found governing a burden, especially as he lacked a free hand. But he took his role seriously enough and seems to have had far more sympathy for Florentine ways, and Florentine preferences, than the rest of his family. He had taken care to enter the city wearing an ordinary citizen's plain gown and without his usual beard (thus meeting old-fashioned standards).

That he was the son of Lorenzo 'the Magnificent' had real meaning for him. He

revived a cultural feature associated with his father and steeped in Medici tradition: a secular company, his called the *Diamante* (an old Medici device), of young men who would plan festivities for the carnival of 1513. The young men were chosen mainly from the sons of men who had been in Lorenzo's own company of the *Magi*. The dinner to inaugurate the *Diamante* (Diamond) was held in the Medici palace. It heralded a mini-manifestation of a Florentine renaissance, of those good old pre-Savonarola days when carnival meant carnival, not hymn-singing by platoons of prim boys. There would be elaborate floats, designed by leading artists, and plenty of cheerful, profane music to accompany the verses of adulation composed by obsequious poets. Everyone would turn out to see the sight, which was planned as no casual expression of spontaneous exuberance but as a complete, public celebration of the return – to power as well as to the city – of the Medici. It would be pageantry with a propaganda purpose.

There was even, conveniently, a new Lorenzo de' Medici to be hailed, the fourth male member of the family, who took a share in the celebrations and would soon take a predominant share in the government. He was the youngest of them but also the heir apparent, as it were, being the son of Piero, the eldest son of Lorenzo 'the Magnificent'. From his father, Piero, Lorenzo had inherited arrogance and ambition of a narrowly egotistic kind, quickly revealing his impatient and competitive nature within the family circle of his elders. His uncle's creation of the *Diamante* company instigated him to create a rival company, the *Broncone* (Laurel Branch), the mere name of which suggested his status as a flourishing twig or sprig of the Laurentian trunk. The *Broncone* had their programme for the carnival of 1513, the more ostentatious and triumphant of the two – intentionally so and regardless of any lingering republican susceptibilities in Florence.

Whether or not some of them may privately have shared such feelings, the local artists seem to have been happy enough with the opportunities for employment provided by the return of the Medici. Aesthetically at least, they gave their allegiance, perhaps believing that a new golden age of patronage had arrived and that anyway it was not for them to trouble their heads over political questions.

There was a Florence esteemed, intact and outside politics: '*Florentia bella*'. Time had only consolidated that city. In 1510 had been published a small and not notably accurate yet highly significant book, the first guide-book to the modern works of art in Florence (the first proper guide-book to the modern works of art in any Italian city): Francesco Albertini's *Memoriale* ('of many statues and pictures which exist in the illustrious city of Florence'). Albertini was a priest who, according to his Latin guide-book of the new and ancient wonders of Rome, also published in 1510, had known Ghirlandaio in his youth.

His preface to the *Memoriale* is addressed to a living sculptor, Baccio da Montelupo, whom he mentions as having proposed the project to him, and Albertini is able to bring his readers up to date with such recent additions to the city as Michelangelo's *David* (the 'marble Giant') and Leonardo's '*Horses*' in the Hall of the Great Council. Of earlier major works of art, he mentions Ghiberti's two sets of Baptistery doors, the Brancacci Chapel frescoes, several of Donatello's statues and several of Botticelli's publicly accessible pictures and — not surprisingly — yet more of Ghirlandaio's. He also draws attention to works by Giotto and Cimabue to be seen in the city.

His may be something of a whistle-stop tour, and his book certainly has novelty and priority as the first of the 'Florence in three hours' style of brochure. Having listed the various works, he has performed his task — like a guide pointing out from a bus window what is worth photographing. But the *Memoriale* is also a further indication of Florentine consciousness of Florentine artistic achievement, one printed and published and usable by any visitor.

The city as tourist attraction exercised its appeal even in the troubled and uncertain days that followed the sack of Prato and the Medici return. The Spaniards continued their depredations in the neighbourhood and were themselves ambushed and killed, one of them in the piazza of Santa Maria Novella. But still the Spanish viceroy dared to come to Florence, not as conqueror but as sightseer. He wanted to visit the churches and, particularly, to go up into Brunelleschi's cupola of the Duomo. It seems as though his visit passed off peacefully.

When the two Medici companies began their preparations for the carnival of 1513 they had a new wave of artistic talent on which to call. But any 'golden age' expectations of enlightened patronage were tarnished by one political effect on a major work of art: not only was the Great Council abolished but so, to a considerable extent, was the hall where it had met. The woodwork and the hangings, and the sheer space of the room, were all deliberately spoilt. It had been an honour to the city, Luca Landucci lamented in his diary, to have such a handsome hall, impressing foreign embassies received there. Now it was divided up and troops were quartered in it. Yet at the same time, regardless of the intentional downgrading of the hall, and perhaps unknown to Landucci, the Works authority of the Palace took care to order a carpenter to construct a poplar-wood screen, 'so as not to harm' Leonardo da Vinci's wall-painting. Whoever had commissioned it, art so great must be preserved. Perhaps hope still glimmered that it would one day be completed.

The artist himself was then living in or near Milan, a city far from immune to fluc-

tuating political events. From there he moved to Rome, attracted by the opportunities offered after the election of Leo X as pope, though it was Giuliano de' Medici (who had by then surrendered his position in Florence) who became his direct patron. At Giuliano's death in 1516, he agreed to go to France. In all these travels, however, he did not go back to Florence.

Michelangelo was in Rome, in the service of Julius II, and continued to serve him by work on his tomb for several years after Leo X's election in 1513. He made brief visits to Florence, chiefly to see his family, but had no Florentine commissions until that in 1516 for the façade of San Lorenzo. Unlike most artists, Michelangelo was not apolitical. He probably never ceased to believe in Florence being a republic as strongly as did any Florentine, however much work he did or was urged to do for the Medici family. The sack of Prato disturbed him, though he pointedly denied stories that he had spoken against the Medici. He was on terms with Giuliano which allowed him in 1512 to address him personally from Rome by letter concerning the indemnity every Florentine citizen had to pay as part of the price for the bloodless but enforced return of the Medici. Rather like Dante's, his patriotism did not exclude a savage assessment of his fellow-Florentines: he had never met, he wrote to his father, people more arrogant or more ungrateful. The 'troubles' of Florence were thoroughly deserved. In more measured tones, befitting an historian, Guicciardini would conclude much the same. What allowed the return of the Medici in 1512 was primarily disagreements among the citizens.

All the same, Michelangelo might not have felt that the Florentines deserved the sugared pill that the carnival celebrations of 1513 represented, for under the opulent, gilded show was an iron determination to keep the city subservient to a Medici regime. 'The people lapped up trivia and follies', was the sour conclusion of one contemporary chronicler, Giovanni Cambi, noting that the cost had been 1,700 florins. What he did not consider in his indignation was the more sinister aspect: that as an exercise in propaganda the money was well spent.

While prominent citizens were adjusting their principles to accommodate changed political circumstances, it is not surprising if the artists in Florence gratefully sat down to design fanciful carnival floats rich with pseudo-antique-Medicean allusions and to pocket some of the 1,700 florins disbursed. Only a year or two before, Piero di Cosimo had devised his wonderful if frightening carnival float on the theme of Death, with ghastly figures dressed in black, and skeletons and crosses, accompanied by gloomy singing of a penitential psalm. In 1513, as Cambi remarked, 'there was no talk of penitence'.

But Piero di Cosimo's macabre invention was not forgotten, and Vasari says that old people who had witnessed the actual carnival procession still talked of it while some artists purported to think that its theme of death alluded to the 'dead', exiled Medici. When the Medici returned, and banished their opponents (as he puts it), it all seemed to take on a certain retrospective appropriateness.

Piero's fertile imagination may not have been under requisition for the carnival in 1513 but it hovered creatively over the project, and several of the painters involved had been, however briefly, pupils of his. Nevertheless, the new generation of artists was more profoundly indebted to the absent masters Leonardo and Michelangelo, who remained pervasive presences, especially through the cartoons they had left for the Hall of the Great Council commission — perhaps more stimulating and suggestive for young artists than would have been the finished works. Michelangelo had also left in Florence one extraordinarily resonant and revolutionary painting — and his sole certain panel picture — the tondo of the Holy Family, executed for Agnolo Doni, which survives in its original, elaborate, circular frame.

The subject could scarcely be simpler or more traditional, and the circular format had been popularised by Botticelli for devotional paintings in the late fifteenth century. Botticelli was still alive when the Doni tondo was finished, around 1508, but nothing could appear more alien to his artistic ideals than the essentially sculpted group of Virgin, Child and St Joseph, carved as if out of one solid block of polished, coloured marble, lit with dazzling clarity and set in a rocky landscape where naked youths, half-athletes, half-bathers, strangely lounge. Something of the athlete, or the athletic, is sensed too in the Virgin's complex pose, as she turns, with arms bared and raised, to take from St Joseph the very weight of the Child — plump as a baby Bacchus, and almost a minia-ture athlete. Awe, rather than piety, seems the chief emotion caused by contemplating the picture. Doni may not have been expecting quite the picture he received. Nothing like it had been painted before in Florence, and the heroic language it speaks preludes that of Michelangelo's frescoes on the ceiling of the Sistine Chapel in Rome.

Its aesthetic implications were to be considered by the young Florentine painters growing up at the date of its completion. It was something of an artistic time-bomb, in fact, and its impact would best be absorbed by the youngest genius, Bronzino, himself not so very much older than the Child in the painting when Michelangelo started on it.

The amount of great 'modern' art available in Florence by 1513 verged on the over-stimulating, for to the supreme native accomplishment expressed by Leonardo and Michelangelo must be added the far less overtly dominant but no less powerful, possibly

indeed more seductive, style of paintings executed there by Raphael. That none of those three major figures was any longer working in the city could even have been a cause for relief. Their absence offered a breathing space, as well as an opportunity, for other artists to establish themselves. Possibly not every Florentine artist aspired to leave the city and face competition — at least that of Rome. A revised, 1513 edition of Albertini's *Memoriale* would have had to take account of a new constellation, especially of painters. They formed a true constellation because they were closely associated with each other, though the most gifted of them shone with individual brilliance.

THE CARNIVAL PROCESSION of 1513 brought into prominence Pontormo, then aged less than nineteen, who received the largest share in painting the floats of the *Broncone* company and also painted those of the *Diamante*. It was the beginning of his career and of important Medici-related patronage for him, and much can be forgiven patrons so enlightened. What he painted and how the floats actually looked has, despite contemporary descriptions of them and oddments of pictorial evidence, to be largely guessed at. Whoever chose Pontormo had, accidentally or not, picked an instinctively inventive and idiosyncratically accomplished young painter — temperamentally Piero di Cosimo's heir — and one confident enough to fashion his utterly personal style amid all the disparate and daunting surrounding influences. Well might Michelangelo (according to Vasari) salute an early product of Pontormo's own genius with generous words of praise.

Among other artists involved in the carnival floats of 1513 was probably the young sculptor Baccio Bandinelli, destined to be highly favoured by a succession of Medici patrons, beginning early with Giuliano. Bandinelli was stridently ambitious, worked hard and added considerably to the public statues of Florence, though not always to the enhancement of the city, as contemporary criticism tartly noticed. His *Hercules and Cacus* (dated 1534) stands in the Piazza della Signoria looking rather tame and under-realised for all its vigorous subject matter, and his seated statue of Giovanni delle Bande Nere, Duke Cosimo I's father, in the Piazza di San Lorenzo, is barely competent. Much more effective, and altogether more original, is the group of the *Dead Christ with Nicodemus* on his own tomb in Santissima Annunziata, where the features of Nicodemus are an idealised version of his own. To rival Michelangelo as a sculptor was one of Bandinelli's main motives in life. He failed, but not from lack of opportunities, and few Florentine artists had more cause than he to be grateful for the return of the Medici (he left the city, incidentally, during its last, short republican phase from 1527 to 1530).

It was not likely that the most respected and established painter in Florence, Fra Bartolommeo, would be interested in devising or painting carnival decorations — and perhaps still less, as a Dominican 'converted' by Savonarola, in joining Medici celebrations of any kind. The dismantling of the Hall of the Great Council made it fruitless for him to continue work on his altarpiece commissioned to be placed there, but he remained active and in demand as a painter of religious pictures, in Florence and in other cities, up to his death in 1517. He is a reminder also that church patronage, or at any rate the painting of religious pictures, continued to be of fundamental importance for the livelihood of Florentine artists. However daring his interpretation might be in aesthetic terms (and Pontormo would show daring unsurpassed), every painter had to be prepared for the majority of his pictures to be sacred in subject matter and in purpose. While it would be wrong to infer that painters felt that as a restriction, any opportunity for profane, decorative work, such as for portraits, must have had its compensatory appeal.

More representative therefore than Fra Bartolommeo, and involved in varied work and widely influential, was a younger painter, Andrea del Sarto, who had emerged on the Florentine scene in 1508, at the age of twenty-two. His artistic godfathers were the trinity of Leonardo, Michelangelo and Raphael, and he seems to have had no difficulty in absorbing from each of them what he needed for his own smoothly accomplished but undramatic, rarely challenging and never disturbing art. In aesthetic temperament he was probably closer to Raphael than to his Florentine godfathers. He was in effect the Raphael of Florence — and partly its Correggio as well. Like Raphael also, and unlike Leonardo, he was an efficient executant, carrying out a flow of commissions halted only by his death in 1530. He has failed to gain adequate modern recognition or general popularity, perhaps to some extent because his art looks all easy solution, without apparent striving or strain, and may therefore seem to lack inner 'interest'. In artistic terms, Sarto is a painter with perfect manners, and that too may militate against him nowadays.

He composed with effortless, well-bred assurance. In fresco and oil paint he showed himself to be a subtle colourist, arguably the most subtle Florence had yet produced. Acting perhaps on hints from Fra Bartolommeo, he revealed a deep interest in landscape. Even in an age of great Florentine draughtsmen, he created drawings that are outstandingly beautiful, often in the medium of red chalk, to which he can give a bewitchingly sensuous feel, in addition to masterly, literal grasp. Indeed, in those superb studies his art takes on an element of novel intensity.

His contemporaries in Florence could see, almost yearly, a succession of public

works by Sarto, chiefly for churches and other religious foundations. Already by 1513 he had painted several frescoes in the cloister that forms the atrium to Santissima Annunziata, including scenes from the life of St Philip Benizzi (one of the founders of the Servite order whose church it was). There lies a good starting-point for appreciation of Sarto's synthesising genius: his power to compose with instinctive spaciousness; his fondness for gracefully grand figures and gestures; his response to landscape, and his choice, refined colour-sense. There too does any Sarto quest end, for in the church he was to be buried. Early in the following century (1606) his bust was placed in the atrium by an admiring Prior of the Servites.

By 1513 Sarto had already received the commission for what would be one of his most majestic works, not least in scale, the fresco of the Last Supper in the refectory of the convent of San Salvi, then outside the city proper. Some of his numerous altarpieces were already to be seen in local churches. And the individualised if idealised heads of many a saint in his religious compositions made it unsurprising that he showed himself also to be a sensitive portrait painter, investing both male and female sitters with a moody, introspective-seeming aura, picturing not only their faces but, it would seem, their minds.

Apart from a brief, none too happy sojourn in France, Sarto lived all his life in Florence. He was formed there and was at the centre of artistic creativity. Around him, and sometimes collaborating on projects with him, were gifted painters such as Franciabigio (a near-contemporary), Granacci (of an older generation) and Bacchiacca (of the younger) — names that now tend to be unfairly obscured, fallen under Sarto's shadow as the artists themselves fell under his beguiling influence. Brilliantly individual painters such as Rosso and Pontormo passed through his studio like comets, and so too did the more mundane, not to say mediocre young Vasari who probably found his master too easy-going and insufficiently pedagogic. Sarto's own closest personal links seem to have been with sculptors: Jacopo Sansovino, his exact contemporary, and Rustici.

Physical links consolidated personal ones, for in an area between Fra Bartolommeo's convent of San Marco and the church of the Annunziata, in old, disused rooms of the university, the Sapienza ('House of Knowledge'), a group of like-minded artists had taken studios. There they gathered for lively social occasions, with music (both vocal and instrumental) and feasting and displays of the utmost ingenuity in table decoration and even in the food. Sarto once contributed an edible octagonal church, resembling the Baptistery, made of meat and sugar and cheese, with choristers that were roast thrushes.

So any demand made in 1513 by the companies of the *Broncone* and the *Diamante* for carnival decorations can have presented only a welcome challenge to him. Those two Medici-instigated companies were in any case something of an 'official' development from similar companies meeting privately in Florence and enjoying – without ulterior motive – a full range of cultural delights: from specially and fancifully adorned rooms to the performance of plays (Machiavelli's *Mandragola*, for instance), never forgetting the banquets of elaborate sweetmeats that were served. To one such company, that of the *Cazzuola* (the Trowel), both Sarto and Giuliano de' Medici belonged.

Sarto was definitely involved in the design of some of the carnival cars in 1513, probably those for Giuliano's company, and it was possibly he who saw to it that Pontormo received a large share in the actual painting of others. The theme of the *Diamante* floats was the acceptable truism of the three Ages of Man (Boyhood; Adulthood; Old Age), but that of the *Broncone* had a narrower application, not so much to all human life as to life in Florence and to a recent, major, public event. Its emphasis was on the return of the Age of Gold (rather poignantly one may recall that Soderini's wife had commissioned a poem a decade or so earlier, promising much the same). After seven floats heavy with allusions to ancient Roman kings, senators and emperors, there came a chariot bearing the prostrate body of a man in rusty armour from which appeared to emerge a boy standing naked and gilded. He symbolised the newly revived Golden (Medicean) Age, replacing one of Iron, and the chariot moved along to the accompaniment of a poem sung and addressed to Florence, 'city happy and beautiful', whither had returned Truth, Peace and Justice.

The troubles of Florence, if not those of Italy, were proclaimed as finished ('After the rain the sky turns serene', as the poem put it). It might subsequently seem something of an unfortunate omen that the boy who had personified the new Golden Age, a baker's son, died from the effects of the gilding. And the Medici hegemony in the city was under direct and long-distance threats. The carnival floats must still have been subjects for talk when later in February 1513 a conspiracy was discovered against the Medici, and two of the chief conspirators, Pietropaolo Boscoli and Agostino Capponi (another member of the honourable 'republican' family), admitted their intention of killing Giuliano de' Medici. They were summarily executed. Others presumed involved were imprisoned and tortured, among them Machiavelli.

Meanwhile, Julius II's attitude to the Medici had altered. He intended to weaken their position in Florence – conceivably to reverse it – by having the protection of Spanish troops withdrawn. Had he lived for a few more months he might have changed the course of Florentine history, but he was gravely ill, and soon was known to be dying.

The bells of Florence tolled for his death on the day Cardinal de' Medici left the city for Rome and the conclave to elect a new pope.

All the boastful, reckless assumptions behind Lorenzo di Piero de' Medici's Golden Age triumph received swift and astonishing vindication. First as a rumour and then as incontrovertible fact, the news reached Florence that the new pope was Lorenzo's uncle, Cardinal de' Medici, who had taken the name Leo X. The city exploded with noise and illuminations and joy. Happy, beautiful and now blessed, Florence prepared for the new age of gold, while the baker's family were perhaps still mourning the death of the boy who had personified it.

CHAPTER TEN

Triumphal Entries and Fatal Exits

ON FRIDAY, 30 November 1515, the citizens of Florence woke up and went out into the streets to find their beautiful city transformed and made yet more beautiful, though only temporarily.

It was not quite a surprise. Every artist and craftsman in Florence had been labouring for more than a month to achieve the transformation which in places remained incomplete. Walls had been pulled down, houses altered and some church interiors utilised for carpentry work. The result was novel and astonishing. At strategic points throughout the city could be seen huge and elaborate triumphal arches with gilded pillars and statues. In one street a large shrine had been put up to the Virgin. In the Piazza della Signoria there was a statue, in feigned bronze, of Hercules. Elsewhere, there rose a fortress, an obelisk and even an equestrian monument. For the occasion, the Duomo had been improved by a splendidly contrived façade which, if it did not entirely conceal the existing unfinished one, soared high overhead. It was in a rich and highly contemporary idiom, a complex arrangement of tall columns and cornices, and reliefs both sculpted and painted.

Nothing comparably extensive as a scheme of decoration for the city had ever been carried out before. But then never before had Florence been able to welcome the entry of a Florentine pope. Nor, of course, was that all. The pope in question was Leo X, a Medici and the elder surviving son of Lorenzo 'the Magnificent', who would enter Florence on 30 November 1515 as, effectively, its temporal ruler as well as the spiritual head of Christendom.

His visit was, as it happened, precipitated by political urgency: the need to meet and reach amicable agreement with the new young king of France, Francis I, who had earlier in the year crossed into Italy and gained a decisive victory at the battle of Marignano. Florence itself had been under consideration as the site of their meeting. No sooner was that rumoured there than the price of provisions went up. In fact, the Medici ruling cir-

cle in the city had advised against the pope meeting Francis I in Florence, recognising the amount of discontent seething just below the surface. The old Florentine tradition of alliance with France could conceivably have been invoked and turned to republican advantage. Instead, Bologna became the city selected. Leo X was to move on there from Florence. Although he entered his native city in triumph, he had yet to see if he could negotiate successfully face to face with the French king.

His grand *entrata* of 1515 was the culmination of a series of publicly staged celebrations instigated and arranged by the Medici family, of which the carnival procession of 1513 had been the first. Each subsequent celebration seemed to mark the family's advance socially and politically in Europe, and also its increasingly firm hold on Florence as a family possession. Already behaving like a princely ruling house, the Medici found occasion to make a pageant out of every important event affecting them, reinforcing with display the message that the city belonged to them and benefited from them.

It was good news for the artists (in every medium) and bad news for those citizens still devoted to republican ideals. The majority of the people probably enjoyed the pageantry while it lasted and liked the stir of great occasions involving great personages, though they also felt the cost. All the necessary plaster and wood and canvas, as well as the workers' wages, had to be paid for ultimately out of taxpayers' pockets. On Leo X's visit, many of the papal retinue had to be accommodated, free of charge, in private houses. It was a year of bad harvests, and with many more mouths to be fed, the price of grain rose. Just how much money had to be expended – and was pocketed by suppliers of goods – is shown by the fact that Filippo Strozzi's wool company earned nearly 2,000 florins for providing cloth to reclothe the whole household establishment of the *Signoria* on the occasion of Leo's visit. When the pope left for Bologna there was probably a communal sigh of relief. That he should return and stay again in the city, admittedly after the highly satisfactory outcome of his negotiations with Francis I (who retained possession of Milan but left undisturbed Medici hegemony in Florence), seems distinctly inept. Provisions of all kinds became costly. The Florentines were amazed by how much food the visitors consumed. The poor suffered, and the pope was only reluctantly persuaded to withdraw from the city, having done nothing to alleviate the situation.

At his *entrata* his attendants had taken care to scatter silver coins to the crowd. That was minimum *largesse* in the light of the homage Florence publicly did him on the day. Slowly traversing the city, having entered from the south, at the Porta Romana, the pope

paused, while complimentary verses were sung, at each of the triumphal archways. All the ingenuity of Andrea del Sarto, Pontormo and Rosso, among others, had contributed to those. The statue of Hercules was the work of Bandinelli; and the hero bearing the lion's skin alluded to the heroic virtue of Leo. The decorative façade of the Duomo was chiefly the work of Sarto and Jacopo Sansovino. It might remind the pope that his father had devised a competition for completion of the real façade, but if so it was only one of several recollections and associations from the Medici past which his visit must have prompted in him.

Although the final destination of the *entrata* was Santa Maria Novella, where the papal apartments had been enlarged, and the ceiling of the pope's private chapel specially painted with Medicean devices (by Pontormo, among others), the stop at the Duomo was to be the most solemn pause on the journey and the one perhaps richest in associations. Well might Lorenzo de' Medici's son be noticed to pray unusually long there, before rising to give his apostolic benediction. Accompanied by his cousin Giulio, whom he had made a cardinal and Archbishop of Florence, he knelt under Brunelleschi's cupola, within sight of the choir lofts by Donatello and Luca della Robbia, and virtually on the spot where the Pazzi conspirators had killed Giulio's father and very nearly killed his own. The illegitimate Giulio had not even been born then, and the future pope was a boy of three years old, the child Giovanni who asked eagerly when would Lorenzo come to see the family. Bertoldo's medal recorded the scene in the Duomo in 1478. Thirty-seven years later, the boy early destined by his father for an ecclesiastical career had become the Supreme Pontiff, acclaimed with the heady words, '*Tu es Petrus . . .*', and stood there distributing his blessing to the assembled people of Florence.

Before that climactic moment there had been an extraordinary, emotionally charged encounter of past and present when at the second stage of the *entrata*, in Piazza San Felice, the pope had seen that the decorations included a portrait of Lorenzo 'the Magnificent'. With flattery that verged on blasphemy, the portrait was inscribed in Latin, 'This is my beloved son': the words uttered from heaven by God the Father (in St Matthew's gospel) at the baptism of Christ. More than one chronicler records that on seeing the portrait thus inscribed the pope was touched to tears.

Wider Medicean associations were bound to be stirred by the choice of church for the pope to treat as his Sistine Chapel: San Lorenzo. As Florence had partly undergone a transformation to make it, briefly, Rome, so San Lorenzo was transformed – probably without decorative aid – into a chapel where papal mass could be celebrated publicly and magnificently, with the assistance of the pope's own choir. And enthroned within the

chancel of San Lorenzo, the first Medici pope might plunge into longer, deeper meditations of mingled sacred and secular character.

The chroniclers are valuable enough in their way, but one wishes that Leo X had possessed something of Queen Victoria's application and observation and left us his account of returning to Florence as pope. At San Lorenzo he can hardly have missed the inlaid marble slab in the pavement before the high altar, marking the site below of his great-grandfather's grave, with its proud inscription naming Cosimo as '*Pater Patriae*'. It had been erased by a decree of the *Signoria* in 1495, when the Medici were expelled from Florence, but must have been recut after their 'restoration' in 1512.

Almost exactly a century had passed since an earlier Giovanni de' Medici, Giovanni di Bicci, Cosimo's father, had begun the family connection with San Lorenzo by joining the building committee of local men formed with the intention of replanning and enlarging the church. From that modest-seeming adhesion had developed increasing responsibility for the new church, as well as the choice of a great architect, Brunelleschi, to design it. And the domed sacristy built by Brunelleschi had become a semi-private chapel, reserved for Medici burial, with at its centre the double tomb of Giovanni di Bicci and his wife, Piccarda.

For all the internal beauty and dignity of San Lorenzo as the church of the greatest family of Florence, its lack of an adequate façade was incongruously, humiliatingly obvious — and certainly must have seemed the more so during the pope's ceremonial use of it. As the church was not on the route of his official *entrata*, it had presumably been left with its bare, brick exterior unadorned. More weighty matters were no doubt on the pope's mind when he eventually travelled back to Rome, but Florence under several aspects is likely to have been in his thoughts. For one thing, his brother Giuliano was dying, not inconveniently as far as Leo's territorial ambitions were concerned. Giuliano's rule in Florence had already given way to that of their nephew, Lorenzo, never a popular or conciliatory figure in the city. For him the pope's eye was on the duchy of Urbino, legitimately ruled by Francesco Maria della Rovere, where Giuliano had been made welcome in the years of Medici exile. In March 1516 the duke was summoned to Rome and deposed. A day or two later Giuliano de' Medici died, the Duke of Urbino's faithful friend to the last. By June Lorenzo was celebrating his seizure of Urbino, and in August he was proclaimed duke.

The repercussion of these diverse events in and for Florence could hardly have been foreseen. In immediate terms there was a new wave of anti-Medicean feeling, although officially the city had to go through the motions of rejoicing at the capture of Urbino.

Duke Lorenzo's demand for especially lavish celebration of the city's great annual feast-day of St John the Baptist that year caused a number of Florentines to retire pointedly to their villas in the surrounding countryside.

Since 1513 Florence had enjoyed or grown inured to celebration of Medici triumphs. A solemn *entrata*, though nothing like as elaborate as that subsequently of the pope, had been made by Giulio de' Medici after being created Archbishop of Florence in 1513. In his desire for the St John's Day festivities to be of outstanding splendour, Lorenzo, future Duke of Urbino, had asked his uncle, the pope, as early as 1514 to lend him his elephant, a gift from the King of Portugal. Although Leo X declined to allow the animal to travel, plenty of wild animals were conscripted to amuse the Florentine populace by savaging each other or being tormented to death. It was found disappointing that they tended to be too terrified to fight among themselves.

The death of a prominent male Medici called for celebration in a different mood, though with no diminution of show. A very grand funeral was held in San Lorenzo for Giuliano de' Medici, and beyond his immediate kin at least there was probably some genuine mourning. He had married a French royal bride, Philiberte of Savoy, in the year before his death, and been given a French dukedom, that of Nemours, by Francis I.

To be an unambitious member of the Medici family was in itself an attractive trait, though not unique, for it reminds one of those shadowy younger brothers of two earlier generations, Lorenzo, brother of Cosimo 'il Vecchio', and Cosimo's younger son, Giovanni. Rather like them, Giuliano de' Medici seems to have been highly cultured, and with a personality – clearer than theirs – humane and sympathetic. To him Machiavelli had probably intended to dedicate *The Prince*. Giuliano's death caused him to make Duke Lorenzo the dedicatee – someone in far greater need of lessons in prudent statecraft than his uncle. But Giuliano was probably not fitted to be Machiavelli's 'Prince', and nor perhaps was either Florence or Rome the ideal city for his particular Renaissance interpretation of a ruler's role. He might better have stayed in France and created an Urbino-style court at Nemours.

However grand his funeral, it was an ephemeral event. Whether he should be commemorated more permanently had apparently not become a question in 1516, but before the end of the year Leo X showed a concern for the family reputation and for the church of San Lorenzo in deciding that it should be given a handsome façade. In Rome, as in Florence, great artists were at his disposal. The pope's first thought seems to have been to give the task to Raphael, but he settled instead on Michelangelo, diverting him from work on the tomb of Julius II. Michelangelo prepared a wooden model of the façade

which the pope approved, and a considerable quantity of marble was quarried and even blocked out by him into columns before the whole scheme was cancelled in 1520.

Another death, less anticipated than Giuliano's, had by then occurred in the Medici family. Lorenzo, the new Duke of Urbino, died in May 1519, and like his uncle he left no legitimate male heir. For the future of Medici rule in Florence the sky looked far from serene, but this second major death seems to have been the catalyst for re-thinking both the employment of Michelangelo in connection with San Lorenzo and Medici use of the church.

The very names of the dukes Lorenzo and Giuliano recalled the fifteenth-century Lorenzo 'the Magnificent', and his brother Giuliano, fathers respectively of Pope Leo X and Cardinal Giulio de' Medici. The brothers had been buried in San Lorenzo but lacked sepulchral monuments, and the concept of building some mausoleum uniting the four bodies in a suitable chapel there would certainly represent a more obvious dynastic statement, and be a more personal form of *pietas*, than providing the church with a façade. The initiator of that proposal was most probably Cardinal Giulio. It was he who wrote to Michelangelo in November 1520 expressing his liking for Michelangelo's idea of placing the four tombs in a free-standing structure 'in the middle of the chapel'. Already – at the express order of the cardinal – a building called the 'new sacristy', and balancing in the right transept Brunelleschi's sacristy in the left one, was in the course of construction. Michelangelo may well have been involved from the first in the interior design of that, for the chapel and its monuments originated in the same funerary purpose. At that date the cardinal destined the chapel to contain a fifth tomb, which should be his own.

It was logical aesthetically – and also in Medici family terms – that the new sacristy should be on the same scale as Brunelleschi's old one, with a similar ground-plan and similar disposition of space under a main dome and a smaller one in the area of the altar. To anyone who walked down the aisles or nave of San Lorenzo there would be disclosed doorways leading at the left to the burial place of the earlier generation of the family (in a chapel beautiful yet unostentatious in ethos) and at the right to the grandiose mausoleum where would be buried two Medici dukes and Lorenzo 'the Magnificent'. The ideal vantage point for savouring the balance of the scheme, with its branches left and right, was the central spot before the high altar of the church where the inlaid slab inscribed '*Pater Patriae*' marks the grave below of Cosimo 'il Vecchio'. By implication, Cosimo's is the central viewpoint in the overall plan, looking back to a monument of his wise (and wealthy) bourgeois father and forward to those of his ennobled descendants.

And gazing down on the tomb slab's pattern of circles contained within rectangles is not unlike the sensation of gazing up at the ceiling of the new sacristy.

Many an affinity is inevitably missed when one visits San Lorenzo today, since the intended entry from it to the new sacristy is kept closed. How that chapel relates to the rest of the church must be a mystery for the average tourist unless he or she bothers to study a plan. Quite arbitrarily, the new sacristy has been treated as a separate physical entity, detached from the main body of San Lorenzo and accessible to visitors only by going outside the church and approaching it (having duly paid a 'Medici chapels' entrance fee) via the crypt and a narrow, normally crowded corridor connecting it to the later chapel of the grand dukes. That vast, still often-despised marble hall has its own ethos of opulence and mournful grandeur, but it is as unsuitable as it is irrelevant as a preparatory experience to Michelangelo's sacristy.

So famous a chapel, so familiar from descriptions and photographs (though not, in fact, very easy to photograph as a space), may seem to offer few surprises on first impact, except for the surprise of its smallness. An effort is required to appreciate its conscious visual enhancement of the elements of Brunelleschi's sacristy, physically close at hand but – regardless of accessibility – distanced and somewhat eclipsed by Michelangelo's achievement.

There had been nothing in Florence comparable to this Medici chapel, nothing anywhere in Europe. Even in the tremendous effect it makes, however, it is not as the artist envisaged it. As a scheme it is far from complete and most of the individual sculptures are unfinished. The upper part of the marvellously austere, all-embracing white and grey setting, in which the statues take on the tone and in places the sheen of ivory, would have been softened by the design and colour of decorative frescoes. Some of the empty niches, which possess a shuttered and desolate severity, would have been occupied by carved figures, of river gods and so on. The flat, blank wall in front of which are placed Michelangelo's unfinished statue of the Madonna and Child and the two statues of saints Cosmas and Damian (by assistants of his) was meant to be filled by the double tomb of the 'Magnifici', Lorenzo de' Medici 'the Magnificent' and his brother Giuliano. Various events and other tasks interrupted Michelangelo's work for the chapel. He never even saw installed the mighty allegorical statues that recline uneasily on the lids of the sarcophagi of the '*Capitani*', the younger Lorenzo and Giuliano. He left Florence finally in 1534, to return only at his death thirty years later, as an honoured corpse.

Yet the Medici chapel speaks not of incompleteness but of accomplishment which never ceases to astonish and awe, though also to disturb (see Plate 22). After the com-

forting, if not comfortable, and literally colourful old sacristy, the new one possesses the stark chill of a frigidarium. In that cold climate there is little sense of ordinary humanity or of Christian belief in heaven. We are in a tomb-chamber as alien, in its way, as any ancient Egyptian one, but in an idiom that is like a dream of imperial, classical Rome. Michelangelo has turned two facing walls – where the statues of the *'Capitani'* are seated, armoured and heroic – into a framework of pilasters and cornices and pediments that can be read as at once palatial façade and triumphal arch. At that level all is – or was intended to be – expressive of the pride of life. Less than the apotheosis of the persons commemorated (not, it is notable, identified by any inscription) is the collective apotheosis of the house of Medici, symbolised by two emperor-like yet hardly individualised figures. Never before in a Christian religious environment had any man been raised at death to the status of a demi-god. These are twin personifications of the ideal ruler, physically magnificent, victorious by implication, commanding, armed, alert and also thoughtful. It is very much the concept of himself that, with the help of Canova, David and Ingres, Napoleon wished to leave for posterity.

That the statues did not resemble the actual Lorenzo and Giuliano was rightly recognised by Michelangelo (and probably by his patron, Cardinal Giulio de' Medici) as beside the point. They had neither looked so heroic nor behaved so heroically, but the sculptor – like a writer of epitaphs – was not upon oath. His aim was less truth than praise. Indeed, as far as true character is concerned, the bare-headed, younger-seeming, assertively posed statue of Giuliano (as one must ultimately accept) conveys a better image of his nephew Lorenzo, while the helmeted, older-looking statue of Lorenzo (see p. 292), posed in profound reflection, approximates the better to Giuliano's humane character. Together, they make up a composite image, of a kind previously unknown in Florence politically as well as artistically, but prophetic of its future: the image of the prince. Machiavelli had, only shortly before, sculpted in words the comparable double aspect of 'The Prince', who should appear – even, if possible be – compassionate, honest, kind and pious, but should also show himself capable of being the opposite when necessary. And we recall that Machiavelli had had both the subjects of Michelangelo's statues in mind as suitable dedicatees of his treatise.

To Michelangelo's contemporaries the marvel of the Medici chapel probably resided most not in the figures of the *'Capitani'* but in the two pairs of male and female

Opposite: *Michelangelo:* Tomb of Giuliano, Duke of Nemours, *'New' sacristy, San Lorenzo.*

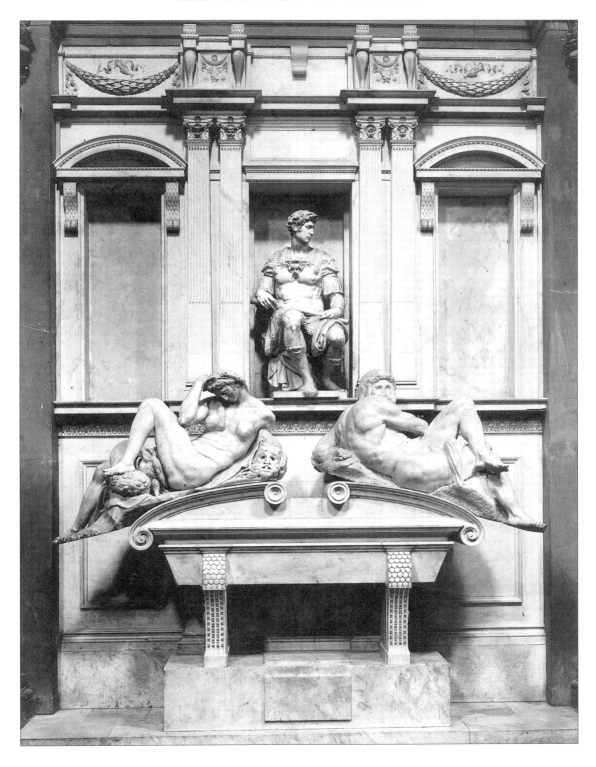

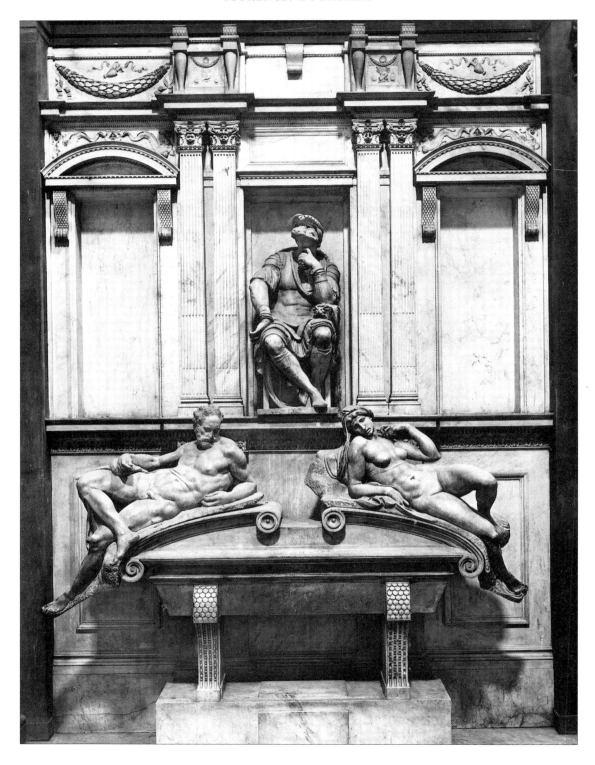

figures, who not merely lie along the curved sarcophagi but seem to seal those down by the weight of their muscular, exposed and daringly naked bodies. Familiarity has blunted for us the novel boldness of carving a completely bare female body, posed frontally and stretched, or rather stretching, out sensuously, as if on a bed, and placing that sculpture in a sacred context – within sight of the priest officiating at the altar in the chapel (for the celebrant stood behind the altar, which faces outwards). The effect is rather as though the high altarpiece of some Venetian church was found to be a painting of Venus or Danaë by Titian.

Nor are Michelangelo's powerfully physical statues – the men as overt in their virility as the women are feminine – to be explained as symbolising some convenient pairing of theological Virtues. They are more elemental than that. They symbolise the inexorable cycle of Time, of Day and Night and (most likely) Dawn and Dusk, which brings with it death. These giant figures, conceived as larger than the seated dukes above, loom as a barrier between them and any spectator, reminders that this is a mortuary chapel and that these images – for all their superb lifelikeness – are of men prematurely dead and buried here.

Almost certainly, the main theme of the chapel and the tombs was developed by Michelangelo himself, creating his own 'programme' as his ideas evolved. Characteristically, literary expression sometimes accompanied his visual thinking. On the back of one drawing he wrote a fragment of dialogue between Day and Night, who speak of how their 'swift course' led Duke Giuliano to his death. Below another drawing – a sketch for the double tomb of the '*Magnifici*' – he wrote of Fame holding the epitaphs, going neither forward nor back, 'because they are dead and their task is done'. It is a thoroughly Renaissance, proto-Shakespearean theme:

> Let fame, that all hunt after in their lives,
> Live register'd upon our brazen tombs,
> And then grace us in the disgrace of death.

Love's Labour's Lost

The mortal chill of Michelangelo's Medici chapel is the more intense because he has experienced it himself. In some ways the death of the dukes is only a pretext or the occasion for profound meditations upon Time's 'swift course' in every life, not excepting

Opposite: *Michelangelo:* Tomb of Lorenzo, Duke of Urbino, *'New' sacristy, San Lorenzo*

Michelangelo's own. His favoured biographer, Condivi, vividly tells how the sculptor intended to carve a mouse to signify Time, leaving a small piece of marble on one of the statues for that purpose, because the mouse continually graws and consumes things, just like all-devouring Time. It is an irony, in itself characteristic of so much in Michelangelo's career, that he never had time to carry out that intention. As with several of his greater projects, the tiny creature remained unrealised.

When Michelangelo began thinking about the Medici tombs and conceived a free-standing monument in the centre of the chapel, he was harking back to the earliest project for the tomb of Pope Julius II, planned to stand similarly four-sided in the new St Peter's in Rome. By 1516 the design of that tomb had shrunk to being a wall-monument, and it is easy to see why Michelangelo's impulse was to revive his grand earlier project, in the sacristy of San Lorenzo. But the sacristy's given dimensions were a difficulty, one quickly pointed out by Cardinal Giulio de' Medici on seeing the preliminary idea. Tactfully, he said more than once that he left it up to Michelangelo as to how the tombs were disposed, but he feared that there would be insufficient space around any adequate free-standing central monument. He was right, and obviously Michelangelo soon saw that he was.

Condivi described the story of the Julius II monument, which shrank still further over the years under external pressures on Michelangelo and his inner difficulties, as 'the tragedy of the tomb'. What was finally put *in situ* in San Pietro in Vincoli might almost be termed a travesty, despite the majestic statue of Moses. But the loss to Rome was a gain to Florence, for not even Michelangelo could have concurrently created a suitably splendid tomb for Julius II and also the Medici tombs. At the heart of his thinking about the tomb and its connotations seems to have been the idea of life, or fame, which the artist alone can give to someone who is dead and which for the great personage requires artistic expression in forms not only grand but combining allegory and human image in one cosmic scheme.

It is interesting that there were to be no images of the deceased '*Magnifici*' on their monument in San Lorenzo, not even idealised ones. And somehow, for whatever reason, Michelangelo seems never to have been roused to full creative energy in designing that tomb (indifferent, perhaps strangely so, to the myth of Lorenzo 'the Magnificent', patron of the arts and indeed traditionally his own early patron). But possibly the death of Giuliano, Duke of Nemours, someone younger than himself, had been a cause for grief or regret or consciousness of vulnerability, although it is not likely that he mourned the yet younger Lorenzo, Duke of Urbino.

Much anyway of what Michelangelo had hoped to express in the tomb of Julius II – not least in raising a monument to himself as artist – was fruitfully diverted into the triumph of the Medici chapel. By chance or not, he gave his native city his sole sustained sculptural scheme, even recapturing something of the majestic pose of the *Moses* in the statue of Duke Giuliano. He also gave colossal renown to the Medici family, two of whose more obscure and largely unimportant members were effectively catapulted thenceforward into as near eternal fame as art can provide.

Although the exterior of San Lorenzo had received no enhancement, apart from a modest cupola to the new sacristy, the church's notional place in Florence had dramatically altered. Its lack of a façade was more than compensated for by the addition of the new sacristy, to become increasingly a place of aesthetic pilgrimage. And whatever the hold of the Medici on Florence as a city, they had established a primacy in visual terms which was unchallengeable. All that could be done, eventually, was to build on and extend the concept of Michelangelo's masterpiece by adding a third Medici chapel, much larger and more ornate, yet clearly paying homage to his in its idiom. If there was any thought, however, of eclipsing his achievement, it would be judged by later centuries to have failed.

Writing to a fellow-Florentine, the architect Giuliano da Sangallo, Michelangelo had once mentioned his promise to design a beautiful tomb that, if built, would 'not have its equal in the world'. That was written in 1506, and the reference is to the tomb then planned for Pope Julius II. In the event it was years later, in a different context, that the words became true, doubly so, in the new sacristy of San Lorenzo.

Cardinal giulio de' medici had proved a shrewd and understanding patron of Michelangelo, and something similar could be claimed of his attitude at the same period to Florence. As the city's archbishop he had pastoral care of it, but with the death of Lorenzo, Duke of Urbino, its future was very much his secular concern. In fact, he, as the most skilful and efficient administrator among the Medici men, and perhaps the most far-sighted, had been attending to the affairs of Florence from Rome since the election of Leo X in 1513. He seems to have possessed a genuine interest in the city, one far more sustained than the pope's, just as he appears far more genuinely interested in employing the genius of Michelangelo.

The governance of Florence by the Medici as represented by Lorenzo, Duke of Urbino, had been a largely unsatisfactory business, virtually a misgovernment. His

absences were prolonged, and his presence was not particularly agreeable, either. That his mother Alfonsina (born of the Roman family Orsini) interfered over nominations to official posts, and generally exercised political influence, was doubtless greatly resented in a city where women traditionally had no public role and were barely presumed to have minds or views at all. Sociologically, Alfonsina de' Medici is a remarkable, untypical phenomenon in Florence, and she may reasonably have suspected that her abilities were no whit inferior to her son's. For the later years of his brief overlordship his representative and chancellor was Goro Gheri, a native of Pistoia, somewhat unenviably placed between instructions from Rome and local pressures, but a devoted servant of the Medici family, or at least of Lorenzo. It was Gheri (according to Vasari) who commissioned from Pontormo a fascinating, semi-propaganda portrait of Cosimo 'il Vecchio' brought back to life (now in the Uffizi). It was possibly painted in the crucial year 1519, in which first Lorenzo died, and the legitimate Medici male stock seemed withering perilously, but then soon after came the birth of a son to Maria Salviati and Giovanni delle Bande Nere, whom Leo X requested should receive the name Cosimo. In Pontormo's intense portrayal, Cosimo 'il Vecchio' sits with hands clenched, gazing in the direction of a laurel tree, one of the two stems of which is severed. The other has entwined within its flourishing twigs a scroll inscribed (in words borrowed from Virgil) 'One departed, another is not lacking.'

Duke Lorenzo was probably chiefly known to the citizens of Florence as the central figure in pageant-style ceremonies which stressed his and the family's unique status. In August 1513, on the day before Cardinal Giulio made his *entrata* as archbishop, Lorenzo received the unprecedented honour (normally given to a non-Florentine) of appointment as Captain-General of the Florentine forces, to the sound of trumpets and bells and artillery. 'He has become the ruler of Florence,' the Venetian envoy reported home, and that was clearly the impression meant to be given. In 1518 he married a French wife, Madeleine de la Tour d'Auvergne, and returned to Florence for an elaborate civic-cum-family reception which began with a procession and ended, some days later, with feasting and dancing in the Medici palace. The pope and Cardinal Giulio were present in effigy, for Raphael's portrait of Leo X with the cardinals de' Medici and de' Rossi had been despatched from Rome and was set up at the table at one of the banquets (Cardinal de' Rossi was present also in person).

Less than a year later the bride and bridegroom were both dead, leaving a baby daughter Caterina, the future Catherine des Médicis, Queen of France. Once again San Lorenzo was the scene of solemn obsequies, though extremely little grief. Despite

actually being in Florence, Cardinal Giulio did not attend the funeral, possibly more preoccupied with ensuring that Medici hegemony, as embodied by him, was preserved without unrest.

A contented prospect for Florence now opened and might have continued had the cardinal chosen or been able to settle there. Michelangelo's new sacristy at San Lorenzo is only the most famous, enduring piece of evidence of the cardinal's plans for embellishment and improvement of the city — in moral and political spheres, as well as in practical and artistic ones.

After the Medici family's own ostentation, a sumptuary law of Giulio's relating to wedding feasts seems belated, at best. His introduction of a new law against sodomy doubtless won general approval, though it may not have changed behaviour much in practice. He seems to have considered several constitutional reforms which would not weaken Medici grasp on Florence but would make it more palatable and less like arbitrary dictatorship as exercised by Duke Lorenzo. A Medici cardinal-governor of Florence, responsible, responsive to the city's needs and personally austere, was far more welcome than Medici creatures exercising power on behalf of an arrogant, absentee individual.

The cardinal initiated a programme of public works in the city, including a flood channel for the fish-weir on the Arno and improvements to the fortifications (a nice irony, as a decade later his troops would be attacking them). Various Medicean projects for improving Florence, often in more family-motivated terms — such as an enlarged palace — had been in the air, and before the cardinal's 'hands-on' direction of affairs a considerable addition was made to the harmony of Piazza Santissima Annunziata by the building of the loggia (by Baccio d'Agnolo and Antonio da Sangallo the elder, brother of the preferred architect of Lorenzo 'the Magnificent') facing Brunelleschi's and modelled deliberately on it. The most graceful of Florentine squares was taking shape. The long nearby street running northwards, Via San Sebastiano (now Gino Capponi), was also newly made. In 1519 compulsory sale of land had been ordered by the authorities to allow the building of more houses along it, and on a corner of that street Andrea del Sarto acquired a plot in 1520, after coming back from working for Francis I in France, to build a dwelling-house in an area open and uncrowded, filled with orchards and gardens. Around the corner, not far away, he had a separate building for his studio.

Sarto was to be one of the painters involved in the fresco decoration of the main saloon of the Medici villa at Poggio a Caiano, and the cardinal was probably the instigator of that work, even if he acted in the name of Leo X, as head of the family, and left the

choice of painters to a collateral member of it, Ottaviano de' Medici, himself a good friend and patron of several artists, notably Sarto and subsequently Vasari.

The theme of the painted decoration at Poggio was glorification of the Medici family in a manner perhaps only advisable or admissible — at that date — in a private villa well away from the centre of Florence. Whatever the boastfulness implicit in Michelangelo's Medici tombs in the new sacristy of San Lorenzo, it is veiled and justified by the mood of mourning. In the main saloon of the villa the mood is of frank, joyful and lordly celebration but then the room itself, with its curved, ornate, stucco ceiling, is on a lordly scale, grander than many a room in a Florentine palace and certainly untypical of previous villa interiors in the surrounding countryside.

It was to be a completely painted room, the side walls frescoed with large scenes illustrating incidents from antique Roman history alluding to notable events in the lives of Cosimo 'il Vecchio' and, particularly, Lorenzo 'the Magnificent'. The *Return of Cicero from Exile* thus refers to Cosimo's return to Florence in 1434, and the *Tribute Paid to Caesar* to such exotic tribute to Lorenzo as the Sultan of Egypt's gift to him of a giraffe (see Plate 25). This programme was conceived at Leo X's court in Rome by an obliging scholar-historian, Paolo Giovio, and probably he meant it to be taken a little less lightheartedly than it was in the fresco treatment of those subjects by respectively Franciabigio and Andrea del Sarto. Franciabigio was none too successful at integrating figures and landscape, or at composing figure groups altogether. There is something unintentionally ludicrous about the way he depicted Cicero being carried by his supporters, like the hero of a football match, and he seems to have been happier inventing fantastic buildings in a steep, strange landscape in the background — a reminder that he had devised admired architectural sets for a play staged as part of the marriage festivities in Florence of Lorenzo, Duke of Urbino, and his duchess.

With far more imaginative power, and at least equal *insouciance*, did Sarto approach his subject, giving Franciabigio a lesson in passing about how to compose grandly without apparently striving. Raphael's concept, embodied in the *School of Athens*, of a composition marrying noble architecture to noble figures, is reinterpreted and enlivened by the subject's opportunity for amusing, incidental, colourful touches — for parrots and pet monkeys, not forgetting the giraffe, and goats and a noisy dog. Quite what is happening might be anyone's guess, but the effect is spacious and vaguely splendid, and truly decorative in a style more Venetian than Florentine (Veronese and even Tiepolo seem to hover over the scene). Sarto did not finish the fresco, and it was completed quite adroitly in the late 1570s by Bronzino's pupil, Alessandro Allori, who completed the whole decorative

Jacopo Pontormo: Vertumnus and Pomona, *Medici villa, Poggio a Caiano.*

scheme of the room with a clever, fluent but slightly superficial competence. He enlarged Franciabigio's fresco as well as Sarto's, but performed his task with markedly greater empathy for the latter.

Whatever the emphasis of the scheme on the glory and renown of the Medici – something that emerged re-stressed from Allori's treatment – it was to decorate a country villa, a place of relaxation and retirement from the burdens of position. As such, the villa had appealed to Lorenzo 'the Magnificent' and went on appealing to rulers, up to the first king of Italy, Vittorio Emanuele II, who made use of the villa in the nineteenth century. And partly as such it was to be decorated with the most delightful fresco of all, Pontormo's *Vertumnus and Pomona,* in the awkward space of the large lunette, pierced by a circular window, at one end of the saloon. Pontormo was meant to go on to paint other frescoes in the room, but even had they been executed they might not have reached the pitch of felicity of this elegantly rustic, semi-contemporary interpretation of the old, Etruscan deities of fields, gardens and fruit. The composition is so ingeniously contrived that the awkwardness of the area is forgotten, and so lightly allusive to Medici laurels and

renewal of the family that its propaganda message might be overlooked amid the leafy, playful sense of an enchanted, walled, country domain where nature is ever bountiful. Its exuberant mood is at the furthest remove from that of Michelangelo's chapel in San Lorenzo. Yet both are owed to Medici pride and Medici patronage.

The unique position of the Medici in Florence, and their need and wish to use the arts to proclaim — and to maintain — that position, may have made them the most powerful of artistic patrons. But artists were not dependent solely upon Medici commissions, leaving aside ecclesiastical ones. One of the most attractive-sounding of secular schemes was privately instigated for a private palace, though no longer surviving as an entity. When Pierfrancesco Borgherini married Margherita Acciaiuoli in 1515, the bridegroom's banker-father commissioned the magnificent furnishing of a bridal bedroom, with woodwork by Baccio d'Agnolo inset with paintings on the biblical theme of Joseph by a group of leading Florentine painters, among them Pontormo and Andrea del Sarto. The commission is like the culmination, or a sophisticated updating, of earlier Florentine fondness for painted marriage chests and other furniture (beds too, sometimes). Both Sarto and Pontormo produced vibrantly coloured, delicately finished works of art — Pontormo's *Joseph in Egypt* in the National Gallery, London, is the most famous portion of the scheme — which, along with the other pictures, hang now scattered in various galleries.

The effect of the whole room, with this almost too exquisite furnishing, has to be guessed at. It may have set something of a fashion, for Vasari speaks of another citizen, Giovanmaria Benintendi, having a room decorated similarly. Vasari also tells of how Margherita Borgherini, as she had become, indignantly denounced and frustrated an attempt in the last republican days, during the siege of Florence in 1529–30, to strip her bedroom of its wonderful decoration and present it to Francis I of France. She herself was the daughter of a strong Medici partisan, and her husband was equally pro-Medici (being exiled to Lucca during the siege period), though he had a brother, Giovanni, as strongly republican in sentiment until the decisive establishment of the Medici which followed the capitulation of Florence in 1530. The tug of war over the Borgherini bedroom was probably stimulated by political differences, for the would-be giver of it to Francis I was Giovan Battista della Palla, protected by the king and prominently anti-Medici.

If the artists tended to accept commissions gratefully but take no sides politically, it is understandable. Nobody could possibly predict the future fate of Florence, the body politic of which had the Medici rather like a bout of the plague. In a fairly feverish situation it was not yet clear whether the plague was there to stay. Some brave or sympathetic artist may have contributed to an extraordinary manifestation of counter-Medici feeling

organised early in 1519 (before the death of Lorenzo, Duke of Urbino) by Jacopo Cavalcanti, a member of a very ancient Guelph family. He gave a dinner to a large group of friends in a room hung with pictures and other decorations in praise of the Medici. After the meal, however, the lights were extinguished. When they were relit, they revealed the room hung in black and decorated with reversed images of the arms of Florence and women with plaques bearing the motto 'Liberty ground underfoot'. That gesture cost Cavalcanti his own liberty; he was arrested and condemned to the galleys.

The fragility of life and the gnawing, mouse-like action of time came home to the Medici, and to Florence, with a further and sudden death in December 1521, that of Leo X. Cardinal Giulio was now the family's head, and before a conclave could be held to elect the new pope he arrived in Florence, to act prudently and with magnanimity where anti-Medicean suspects were concerned (freeing those imprisoned in the panic caused by Leo's death).

He was very badly placed to find a suitably close and convenient member of the family to rule in the city. There were two legitimate Medici children, still infants, the boy Cosimo and the girl Caterina; and there were two illegitimate boys of about ten or eleven, Ippolito, son of Giuliano, Duke of Nemours, and Alessandro, usually described as Duke Lorenzo's son but often supposed to be the son of Cardinal Giulio. Medici authority did not seem to be helped by the election of Pope Hadrian VI, a devout, ascetic Netherlander, a proto-saint in his conduct and aims, at least as compared with Julius II or Leo X. He was too good for the world of Renaissance European politics and expired, exhausted, in 1523. A very protracted and divided conclave ensued before the traditional great joy could be announced: the new pope was Cardinal Giulio de' Medici, who took the merciful name of Clement, becoming Clement VII.

In Florence none of the jubilation occurred that had greeted Leo X's election ten years before. Ill omens and general unrest marked the occasion, and the omens were appropriate. For better or worse, it was obvious that as pope Cardinal Giulio would not be able to attend to Florentine affairs on the spot, and his election exacerbated the dilemma of finding a competent, trustworthy representative of Medici power. He chose Cardinal Passerini, Cardinal of Cortona, who was not merely non-Florentine but from a subject city, and that fact continued to be a disadvantage even after he had been formally granted citizenship. His was in any case an unrewarding role, for Ippolito de' Medici lived in the Medici palace and was at that date being groomed as the future family 'ruler', while Alessandro de' Medici was lodged out at Poggio a Caiano. And some public prestige attached to the loyal and cultured Ottaviano de' Medici.

The outward form of the government still looked republican. There was still a *Signoria* meeting in the old medieval civic palace, and documents conjured up those magnificent men acting in the name of the republic and commune of Florence. In reality, the foreign policy of the republic was virtually dictated by Clement VII, and the day-to-day governing of the city hiccuped along with constant if minor disagreement among the interested, somewhat heterogenous combination that represented the Medici party, itself answerable to the pope.

Probably none of those involved was entirely satisfied with the results, and opposition to Medici conduct of affairs became quite open. At the core of the problem was Clement VII, proving far less adept and decisive as pope than as a cardinal Secretary of State. He had inherited a complex international situation, personified by the Holy Roman Emperor, Charles V, and Francis I, King of France, and perhaps he believed he could outwit them both and free Italy from foreign domination. His military efforts cost Florence large sums of money, and his diplomatic manoeuvres, allying the papacy with France against the emperor, caused the imperial army to march on and sack Rome in 1527. A few weeks after that traumatic event Florence rose against the Medici and restored a 'popular' government. It was like a rerun of the year 1494 – even to the fact that the Medici were removed from rule only to return, by force of arms, and consolidate their hold on the city. And when they returned in 1530, they did so to remain its rulers for two centuries.

W ITH THE PAPACY Clement VII also inherited – or could take total possession of – the greatest living artist, who happened to be a fellow-Florentine, Michelangelo. Leonardo and Raphael were dead. Titian was a painter working in Venice and not yet recognised outside northern Italy. Whatever the extent of Clement's bungling of political matters in Florence, he continued to prove an enlightened patron of it artistically. Michelangelo had received the news of his election with marked enthusiasm. Writing from Florence shortly after it had taken place, he mentioned his expectation of 'many things' going to be put in hand there.

By early 1524 models for the Medici tombs had been completed, and so had the elegant, slim-pillared lantern designed by Michelangelo for the exterior of the cupola. Everyone admired it, Michelangelo reported, writing directly to the pope; he hoped His Holiness would too, when he saw it. Clement had by then assigned him a fresh task, an expression of secular *pietas*: the creation of a building at San Lorenzo to house the Medici

library of manuscripts and books, which, after vicissitudes, had been taken by Leo X to Rome and which might have gone to swell the Vatican Library.

The return to Florence of the library (opened to the public in 1571) was Clement's most munificent and revealing gesture, worthy of an *entrata* in itself. He was to be buried not in the city but in Rome, and in a tomb designed not by Michelangelo but by Bandinelli. More than the new sacristy is the Laurentian Library his monument in Florence, although it was not completed until decades after his death in 1534, by Florentine artists who at that date were only just emerging on the local scene. His great-grandfather too was recalled, for several of the manuscripts in the library bear the *ex libris* of Cosimo and some had been specifically copied for him. The bibliophile activities of the two subsequent generations, of Piero and his son Lorenzo 'the Magnificent', were also recalled in what amounted to a collective donation to their native city, and one which added another facet of lustre to the church of San Lorenzo. In the carved wooden ceiling of the vestibule to the library the middle motif is of the Medici diamond ring — of four rings interlinked. The pattern is also repeated in the intricate yellow and red tiled floor of the reading-room itself.

Together, vestibule and reading-room can stand for the mid-sixteenth-century Florentine profane interior, however untypical in function and in being designed by a genius, for virtually every detail — inclusive of the furniture of the inlaid desks and the elaborate, painted glass of the windows — has survived intact.

Although the vestibule and its staircase usually get the lion's share of most visitors' attention, the long, luminous reading-room, where the design of the delicately carved panels of the ceiling is echoed by that of the floor tiles, has its own quiet, calculated harmony. Its atmosphere may appear entirely studious and hushed, but the painted glass is almost skittish and distracting in its fanciful 'Pompeian'-style grotesques and curlicues and *putti* and ribbons and birds, all designed in pale grey with a transparent lightness of effect that has its practical aspect in a room for reading. Looked at closely, the motifs become meaningful too: one of the *putti*-supported swags turns out to be the Golden Fleece (awarded to Grand Duke Cosimo I) and the egg-shaped, yolk-coloured centrepiece of each window is a shield with the six Medici *palle*. Not Michelangelo but artists at the court of Cosimo I were responsible for these refinements. Yet Michelangelo's is the mind behind the reading-room no less than its vestibule.

He began his thinking about the scheme of the library in Florence contemporaneously with work on the Medici tombs during the early 1520s, in the opening years of Clement VII's reign. At no period is the tone of Michelangelo's letters cheerful and opti-

mistic, but he seems at that date particularly harried and depressed – almost maddened – by the pope's multiple demands on him, the petty intrigues of local Florentine officials and the consciousness of his obligation to execute, in some form, the tomb of Julius II.

Indeed, his letters are a salutary corrective to any romantic assumptions that in the Renaissance a great artist enjoyed ideal conditions for exercising his creativity and just painlessly proceeded to do so while contemporaries stood around applauding the result. The Medici tombs were not built in a day, and as one now gazes at them it is worth recalling the hard slog, the corporate activity and the routine involved in such an enterprise. When the human constituents – the foreman, the stonemasons, the accountants – were not proving obdurate, Michelangelo had to struggle with the problems of the actual material, faulty blocks of marble needing to be replaced, and the replacement blocks, lying about in Piazza San Lorenzo, requiring inspection on a July morning yet sufficiently early to avoid the heat of the sun, before they were dragged inside the chapel.

The library was a fresh task, presenting fresh problems. At first Michelangelo had no idea even where the pope wanted it to be built. Nor was it clear who, if anyone, had authority to pay for the costs of the work. The pope was eager and only too liable to have yet further tasks for him in Florence. Michelangelo was more sculptor than architect, especially in his own eyes. Clement suddenly conceived a proposal for a colossus that could be put up at a corner of the Medici palace garden, a proposal that shrivelled away under the fierce blaze of Michelangelo's mockery.

It is no wonder that he declared he felt old, at the age of fifty, and might die before the pope. On his side, the pope reminded Michelangelo that 'we pontiffs do not live long'. From Florence a certain canon of San Lorenzo, overseer of the fabric, sent the pope his opinion that Michelangelo was inactive and was anyway designing a library that would look like a dovecot (though the point of that remark is not obvious). Clement's interest, patience and enthusiasm, and his good humour, are the more extraordinary given the political difficulties that faced him at the time. By 1526 he was absorbed by them. Funds for the work at San Lorenzo were being curtailed, and in November that year Michelangelo was writing to Rome, reverting to the outstanding question of the Julius II tomb, and saying – perhaps without sarcasm – that he would gladly obey the pope's will, providing he knew what it was.

The latter part of his sentence might well have been echoed by many contemporary students of European affairs. Earlier in 1526, the pope had shifted from support of the Emperor Charles V to support of Francis I, in an alliance against the emperor which was ratified by the League or Treaty of Cognac. Florence was not named in the document, but

it was compelled to agree to the league, and found itself caught up in wasteful, losing campaigns. A further blow came with another prominent and premature Medici death, that of Giovanni de' Medici, called Giovanni delle Bande Nere ('of the Black Bands'), father of the future Duke Cosimo I. He was a rare military figure in the family, a great soldier, who died of wounds received in battle, aged only twenty-eight, in 1526.

A Medici library in Florence looked less appropriate than a Medici mortuary chamber, and besides the city was preparing to rid itself of the family as overlords. That the pope was engaged in a war that might lead, or had already led, to the ruin of Italy was a view expressed by one distinguished republican figure, Niccolò Capponi. When the Medici were overthrown in 1527, the Medici arms displayed in the city were removed or defaced. Once more the inscription on the tomb marker of Cosimo 'il Vecchio' in San Lorenzo became provocative, and once more the words 'Pater Patriae' on it were abraded, although Capponi (by then Gonfaloniere di Giustizia in the republican city) specifically pleaded for leaving the slab undamaged. One of the sketches by Michelangelo that exists, showing the library doorway topped by the papal arms, might have become almost an incriminatory document in the emotionally charged, suspicious atmosphere of Florence in the days of the last republic, when denunciations were frequent and harsh sentences could be imposed for quite trivial offences deemed crimes against the state.

It was no time for working on Medici commissions, and Michelangelo had in any case volunteered to serve the republic. In 1529 he was appointed Superintendent and Procurator-general of the fortifications of Florence. The post was no sinecure from the first, and sent him travelling to inspect fortifications at Pisa and Leghorn, and at Ferrara. In the autumn of 1529 the siege of Florence began, to end with the city's capitulation in August of the following year.

Clement VII hastened to take back into favour the weary and emaciated artist, though one might question whether the artist could ever again look favourably on a pope who had besieged and brought down his native city. In any event, the Medici were restored. Michelangelo concentrated on the tombs in the new sacristy at San Lorenzo and also oversaw resumption of work on the library. It had of course no sculptural component, but lacked a key element: the staircase in the ground floor vestibule that would lead to the reading-room and library, which is built over one side of the cloister adjoining the church. No staircase was in existence when Michelangelo left Florence for Rome in 1534, to reach Rome two days before Clement VII died. The pontiff had won the gloomy competition between them, and behind him remained – inevitably – a mass of unfinished business, not least in the area of the arts.

The Medici family, by contrast, he could regard as thoroughly accounted for and settled. Caterina he had married to a son of the King of France. Able and intelligent, she was destined to be its queen and queen mother and might have made a good job — in a less prejudiced environment — of ruling Florence. Ippolito de' Medici had been diverted or frustrated, created a cardinal when his inclination was to be a soldier. And, whether or not he was Clement's son, Alessandro de' Medici had become first the *capo* or head of the government of Florence, with the Emperor Charles V's sanction, and then 'Duke of the Florentine Republic'.

At San Lorenzo in Florence the Medici Library, like the Medici tombs, awaited completion. For all his eagerness over these Florentine projects, the pope had had a further final large-scale task on which to employ Michelangelo: frescoing of the altar wall of the Sistine Chapel with a scene of the Last Judgment. Michelangelo undertook it and finished it in the reign of Clement's successor, Paul III. The sculpture for the chapel at San Lorenzo was never to be finished. As for the library, it too would probably have suffered a similar fate had Michelangelo not been skilfully cajoled by Cosimo I de' Medici and his court artists to produce a design for the missing staircase. Twenty-one years — almost to the day — after leaving Florence for ever, the now truly aged artist wrote from Rome to his friend and admirer, Vasari, describing his concept for the staircase (subsequently sending a clay model of it) and speaking of recollecting it 'as if in a dream'. With the co-operation of the leading Florentine architect-cum-sculptor, Bartolomeo Ammanati, the dream was at last realised.

The impressively stony effect of the vestibule, with its brackets and paired pillars of grey stone complementing the almost fountain-like flow of the tripartite, grey stone staircase, seems perfectly devised. Its idiom is comparable to that of Michelangelo's Medici chapel, and indeed it might be the ante-chamber to such a mausoleum. But it is not how Michelangelo conceived of the staircase itself when he wrote about it to Ammanati in 1559. His preferred material for it was not stone but wood — walnut, which he felt would be more in keeping with the library, with its wooden desks and wooden ceiling. As he envisaged it (and it is remarkable that despite an overwhelming sense of failing faculties he could still envisage it) the high grey and white walls would have enclosed and set off a mellow-toned, doubtless carved or inlaid staircase which would have been both architecture and furniture, and more warmly welcoming than Ammanati's stone one.

Perhaps it hardly matters, for in either medium the ingenious design of the staircase had turned what might have been merely functional into a work of art. The smallness of the floor area (rather smaller than that of the Medici chapel) could have acted as an

Michelangelo: Staircase of the Laurentian Library, *Complex of San Lorenzo.*

inhibiting factor, but it seems to have stimulated Michelangelo to defy space and suggest grandeur and complexity, with ease of ascent or descent, by a series of ingenious variations, varying even the format of the steps from rectangular to lozenge-shaped, the cumulative effect of which is to make one forget the small scale. Here, with its divided flights, its broken balustrades, and absence of them, its curlicues of stone and — above all — its feeling of movement, is the essence of the baroque staircase. Some credit is probably due to Ammanati as more than just executant, and something is due too to Duke Cosimo I, as equally relentless in pursuit of an artistic end as of a political one.

Although Michelangelo no longer lived in Florence, he was yet notionally a member, the most highly honoured of all, of the duke's circle, and the two men were to meet

when Cosimo and his wife visited Rome in 1560. What Michelangelo might possibly execute for Florence, or at least advise about, continued to be very much Cosimo's concern, and his letters to Michelangelo must be easily the most respectful and flattering he addressed to any artist, while Michelangelo responded with graceful praise of the duke's taste and his exercise of artistic patronage.

Michelangelo had witnessed and experienced so much history, especially as it affected Florence, that he had acquired status as a fascinating, nearly unique figure, in himself a piece of history, regardless of his artistic genius. In Michelangelo Duke Cosimo I was meeting someone who had known his mother's grandfather, Lorenzo 'the Magnificent'. Medici patronage of Michelangelo could be traced back for seventy or more years. And when the duke sought Michelangelo's views on altering, 'improving', the Hall of the Great Council in the Palazzo della Signoria, he must have stirred extraordinary memories of the distant past in the aged artist's mind: of Savonarola and of Christ as sole king of Florence, and of Pietro Soderini's commission for him to compete with Leonardo da Vinci and paint the *Battle of Cascina* for the republic in the hall. Responding to a sight of the new model of it in 1560, he made a practical comment about its height, which had probably occurred to him at the time Cronaca first built it. It seemed rather low, and he recommended substantial raising of the ceiling (which Vasari carried out).

What neither Michelangelo, nor anyone else, could have foreseen was that there would be a Duke Cosimo I de' Medici in Florence. He was not part of the plans of Clement VII for the family. Such future as he might have was presumed to be private and obscure. It had taken another unexpected death, a violent one, to precipitate his emergence onto the scene.

T HE NEWS OF the Sack of Rome seems to have reached Florence on 11 May 1527. Within a week, Medici rule in the city had been overthrown, painlessly, and an alternative, aristocratic government had been installed. Jacopo Cavalcanti might have held another, less lugubrious dinner-party, this time to celebrate the recovery of liberty. A member of the long-established, traditionally anti-Medicean family, Antonfrancesco degli Albizzi, summed up what was probably a very general feeling when he wrote (in a letter of 1 June 1527) that so noble a city as Florence, full of the worthiest citizens, was not fittingly dominated by priests and a cardinal from a subject city, and by two *putti* of dubious birth. Nevertheless, no punitive measures were taken against Ippolito and

Alessandro de' Medici, or the girl Caterina. Indeed, a law was passed expressly protecting them. The upper-class families who opposed Medici rule – led by Niccolò Capponi – did not wish to do anything to encourage attacks on individuals and property, or disturb their own hegemony.

Getting rid of the Medici was an easy step, once Clement VII had been humiliated by the Sack of Rome. Far more problematic was the putting into place of a new government and constitution. Once again, the Venetian republic was looked to as a model, and Capponi actually wrote to a Florentine lawyer then in Venice, Donato Giannotti, a confirmed republican, for a summary of its constitution. Giannotti provided a résumé (he wrote a book in praise 'of the republic of the Venetians') and came back to serve in the chancery of the republic of the Florentines, while it lasted.

We know that the republic's duration was to be brief. Perhaps it would have staggered on, or even gained ultimate, successful cohesion, had not outside forces – marshalled by Clement VII – put intolerable pressures, physical and mental, upon the city and its citizens. Whatever its faults and its fears, the republican government that came to replace the Medici, and to replace the oligarchic rule envisaged by Capponi, was a form of democracy with ideals that may have been naïve but were not ignoble. It was inevitable that the Medici representatives and associates in the city could not be indefinitely protected and that there should be some outbreaks of harassment, if not persecution, though never a reign of terror as such, in sheer reaction to the infuriatingly arrogant assumption of generations of the Medici family that Florence belonged to them.

The increasingly theocratic republican government, partly a throw-back to the days of 1494, with the Great Council re-established and Jesus Christ solemnly re-elected as king of Florence, could not be expected to show itself particularly tolerant. The divisive nature of the Florentine people continued to be a reality, and so were the activities of Clement VII. Had he died in 1527 things would have been much simpler for the republic. Perhaps there would then never have come any threat of siege or restoration of the Medici. But although the pope had suffered the humiliation of seeing Rome sacked and himself a prisoner of the imperial army, he was alive. Soon he regained his freedom (though he kept away from Rome, living first at Orvieto and then at Viterbo), and soon papal envoys were making contact with Capponi in Florence, finding him extraordinarily receptive to a *rapprochement* with the pope over the future of the city.

Appeasement seems to have been Capponi's idea of policy, and even while he complained that his opponents in Florence thought him a Medici adherent, he privately behaved towards Clement and the Medici family in a way that helped justify their suspi-

cions. Assuming he was basically honest, he seems to have taken an attitude towards the pope somewhat similar to that of Neville Chamberlain towards Hitler. For whatever reason, he positively refused to approve of Michelangelo fortifying the hill of San Miniato as a defensive measure and made him abandon it after he had begun work there. Like Chamberlain, he did not live to see the full, horrific consequences of his misjudgments. He died in 1529, having already been replaced as *Gonfaloniere* by Francesco Carducci, anti-Medicean and representative of a more 'popular' faction.

What Florence significantly lacked in the crisis of confrontation with Clement VII was a great, Churchill-style leader who could symbolise republican spirit, unite the citizens and possibly cow or outwit the pope. A brave, tough, humbly-born soldier, Francesco Ferrucci, was thrown up by events and seemed the human, military answer to Florentine prayers when the siege got under way, but he was to be attacked by Spanish imperial troops at the village of Gavinana, north-west of Florence, and killed in the last desperate days before the city surrendered.

The perfervid religious atmosphere which settled on republican Florence well before the siege began, and which grew yet more feverish during it, is sometimes rather unsympathetically judged by modern historians, partly perhaps in reaction against earlier liberal or romantic views of it, as signifying patriotic struggles against external tyranny. Religion was invoked with the clear intention of giving cohesion to the community – not in itself an unworthy aim – and in a mood half-penitential and half-optimistic that the city rededicated to Christ and the Virgin Mary would be saved from increasing peril. Against the machinations of the pope, allied to the Holy Roman Emperor, only God could successfully intervene.

Numerous laws and edicts reiterated that Florence was under the protection of the heavenly powers. It was – or should be regulated into becoming – a holy and peaceful city, where any blasphemy was punished and where (as specifically promulgated) everyone was required, regardless of what they were doing, to pause and genuflect when the Angelus bell sounded at noon, and again in the evening, reciting as they did so a Paternoster and an Ave Maria.

Sufficient documentation exists to convey this mood of civic-religious fervour, which was not all spiritual uplift but had a down-side of frequent denunciations, harsh penalties and near-vendetta against actual or presumed Medici adherents. The pietistic atmosphere is recovered most thrillingly and attractively in art, outstandingly in that of Pontormo. He, rather than Andrea del Sarto, seems impelled by, and expressive of, the emotional intensity of the time. Much as Botticelli had done, he replaces a keen,

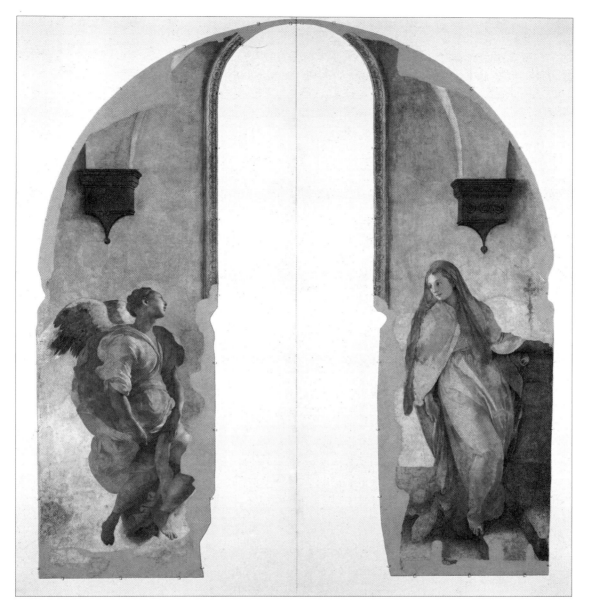

Jacopo Pontormo: The Annunciation, *Capponi Chapel, Santa Felicita.*

inventive response to pagan hedonism (as expressed by his fresco for the Medici villa at Poggio a Caiano) by equally original, personal interpretations of sacred themes.

The Angelus edict is recalled, or anticipated, in his beautiful and tensely urgent — almost breathless — *Annunciation*, frescoed in two portions ingeniously devised to form a

coherent whole on an awkward wall space, interrupted by a window, in the Capponi chapel of Santa Felicita. It was for a banker-member of the family, Lodovico di Gino Capponi, someone who had lent the Medici money but who was regarded as a doubtful ally of theirs, that Pontormo decorated the chapel. On the altar is his most famous work, the panel of Christ being carried to the tomb, a marvellously arresting painting which yet should not be allowed to steal all the attention in a scheme which includes the *Annunciation* fresco.

The chapel, which Lodovico Capponi had recently purchased from another Florentine family, was dedicated to the Annunciation, a subject which virtually every local painter had for years been expected to treat in one context or another. But Pontormo's *Annunciation* is freshly minted, and startling in its simplicity. The wall provides a minimum, minimalist setting for the two tall, slim, twin-like figures whose red-haired heads eloquently incline towards each other, as the Angel's greeting of 'Ave Maria' alerts the Virgin to this celestial, sexless manifestation, mysteriously hovering there with swirling, vaporous draperies like sun-tinged clouds, and bare feet that might be dancing on air. It is essentially a spiritual interpretation of the theme, in which all fifteenth-century fondness for charming, semi-genre detail is suppressed. Herself uplifted, exalted, a vessel of honour, at this moment filled or filling, even swelling, with grace ('*gratia plena*'), the solemn-eyed Virgin does not shrink from her destiny. She seems to belong in an exalted Florence where the daily sound of the Angelus bell stops every citizen in his tracks and brings him to his knees, echoing the Angel's words on appearing to her at the dawn of Christianity, and reverently beseeching her and her Divine Son to watch over the contemporary city.

Christ's Crown of Thorns was — the *Signoria* further decreed in 1529 — to be added above the main door of their palazzo, to signify the will of the Florentine people to reject all servitude except the service of 'the true immortal king'. The Crown of Thorns was a reminder too that Christ had suffered and died for mankind. Pontormo's altarpiece for the Capponi chapel is a lamentation over the dead Christ set in an empty, unlocated, timeless sphere, where women try to assuage the Virgin's grief but the male bearers of the corpse look outwards, staring urgently and fixedly at the spectator, as though to activate in each living individual a whirlpool of emotion.

Lamentation, deposition, bearing of Christ's body to the tomb — the picture is all three, and none of those incidents is so much illustrated as meditated upon, shown in a heightened, visionary way, with a deliberately unusual, not immediately decipherable blend of flowing limbs and agitated folds of drapery, both dyed in unexpected, beauti-

fully strange tones of pale turquoise and strong cyclamen pink, with touches of scarlet and green. Nothing is quite natural – or, at least, ordinary. And that is only fitting, given a terrible, sacred and poignant subject, mourning over the ordeal of the Redeemer of the world. At the altar on which the picture stands, the Creed recited during every mass told what it epitomises: how the Son of God was incarnate by the Holy Ghost of the Virgin Mary, was made man, was crucified under Pontius Pilate, suffered and was buried. It was for us men and for our salvation ('*propter nos homines et propter nostram salutem*') that he came down to earth. And on the third day he rose from the grave. He sits at the right hand of God the Father and he shall come again, to judge the living and the dead, and of his king-dom there shall be no end ('*cuius regni non erit finis*').

As well as sorrow and repentance, hope is adumbrated by Pontormo's picture. The dead body of Christ – its marble smoothness barely marred by any marks of his Passion – will miraculously return to life again, as miraculously on the altar it will become pre-sent in the wafers consecrated by the priest at mass. That Catholic message was not new when Pontormo painted his altarpiece, but it had new and desperately fervent meaning in the regenerated Florentine republic whose government declared itself 'just, political and popular', based on the immovable rock of Jesus Christ.

Quite explicitly did Pontormo contemporaneously paint for another church a reli-gious-political (or anyway civic) picture, destined for the church of St Anne, on the out-skirts of the city, and commissioned by the *Signoria*. Surrounded by saints, the Virgin and Child are seated in St Anne's lap, and the group floats on a cloud at the foot of which is painted a miniature, medallion-like composition showing the black-and-red-clad mem-bers of the *Signoria* processing, accompanied by the mace-bearer of the republic and trum-peters from whose instruments hang banners displaying the arms of the People and the City of Florence, just as they can still be seen today on an official, public occasion in the city. On 26 July, St Anne's feast-day, the *Signoria* went in procession to the church, in com-memoration of the expulsion of the Duke of Athens from Florence on that day in 1343. Pontormo's picture celebrates the annual ceremony, but with additional, topical refer-ence to the recent expulsion of the Medici. It was perhaps finished and in place for St Anne's day in 1529, the last occasion that the *Signoria* could pay their visit to the church, for it was one of the numerous outlying buildings destroyed as the city grimly prepared to withstand siege. The altarpiece was transferred to another church of St Anne but it has ended up far away from Florence. In Napoleonic times it was looted by French officials and despatched to the Louvre, from which it has never returned.

Despite all the hopes and vows and prayers, and the literal dedication of the city

to Christ and his Mother, the threat of siege became a reality. The terms of the Peace of Barcelona, signed on 29 June 1529 between the Emperor Charles V and the pope, included a clause in which the emperor undertook to do all in his power to restore the Medici to their previous position in Florence. At the same time, the betrothal was announced of the emperor's illegitimate daughter to Alessandro de' Medici.

Twice before in recent history had the Florentine republic faced a grave external threat. At the beginning of the fifteenth century the Duke of Milan had been poised to attack, and then suddenly died. At the beginning of the sixteenth century Cesare Borgia's army had loomed menacingly close but ultimately withdrew. And in 1512, following the Sack of Prato, no resistance had been offered to the return of the Medici, so that Florence had again escaped physically unscathed.

In 1529 there was to be no dramatic divine intervention. Death, which Machiavelli had declared to be so often beneficial to the Florentines, failed this time to favour them. Machiavelli himself was dead (dying in 1527), spared the spectacle of a Florentine pope instigating an attack on Florence.

The city was not inactive. It prepared to defend itself in ways Machiavelli would have approved, with bands of militia raised and joined by its citizens, and inflicting on itself the necessary self-sacrifice of pulling down buildings on the perimeter which might become vantage points for the enemy. It had Michelangelo to superintend its fortifications, in the spirit of his own *David* outside the Palazzo della Signoria. And it seemed to have chosen well in appointing Malatesta Baglioni, a prominent *condottiere* of the powerful, bloodthirsty Perugian family, as commander of its army.

Not every Florentine artist was as willing as Michelangelo to commit himself to the cause of the republic. Cellini was one with little loyalty to it. Although conscripted into the militia of his local quarter, and dressing up handsomely, he preferred to take himself off to Rome, in obedience to the pope's wishes, serving him and Alessandro de' Medici and facilitating his own future career. Equally and more pardonably prudent was the young Giorgio Vasari (born in the subject city of Arezzo in 1511) who had already entered Medicean circles and enjoyed the protection of Cardinal Passerini in Florence. He decamped to Pisa until the siege was over. That proved no handicap to his later painting the scene.

In the preparatory destruction of peripheral but fine buildings, some works of art – chiefly frescoes, which could not be detached from walls – were unavoidably lost. Outside one of the northern gates, the Porta Pinti (itself destroyed in the nineteenth century), the particular casualties were cycles of frescoes by Andrea dal Castagno and by

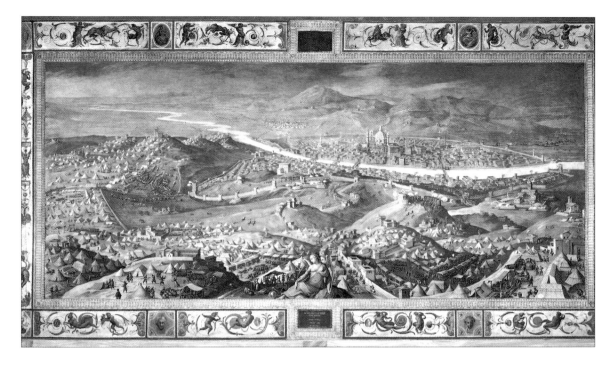

Giorgio Vasari: The Siege of Florence, *Palazzo Vecchio.*

Perugino, and probably they need never have suffered, because the imperial forces came from the south and concentrated on besieging Florence from that direction. More vulnerable was the ancient treasure-house of San Miniato on its hill overlooking the city. Its campanile had been solidly rebuilt at the beginning of the sixteenth century, designed by Baccio d'Agnolo. Michelangelo protected that against bombardment and also used it for firing on the nearby enemy troops. Coming under fire in turn, the campanile largely withstood the cannon-balls, though marks of them can still be detected. Vasari says blithely that the campanile gained additional fame, beyond the beauty of its workmanship, for its resistance to enemy action.

Vasari is not alone in telling one vivid and touching story about how the civilising spell of art was felt in Florence even during the dark days of the siege. Perhaps it became improved in the telling, but it seems true that when a rumour reached the city that the monastery of San Salvi, then outside the city limits, was to be occupied by the commander of the imperial-papal forces, the Prince of Orange, a demolition squad hastened to raze the building-complex. That native hands should be compelled to ruin ancient native architecture (*'L'arche di Padri nostri'*) was lamented in a poem by the Chancellor of the

Republic, Salvestro Aldobrandini, who also emphasised that this fate had been thrust on Florence by 'a pope, a citizen'.

The church and campanile of San Salvi were destroyed, but when it came to destruction of the refectory of the adjoining monastery, the squad is said to have paused and left it standing, because of the fresco of the Last Supper there by Andrea del Sarto. What is sure is that its loss would have been a tragedy, for Sarto never executed anything more majestic than this composition, occupying with supreme assurance a whole sweep of wall. He had received payment for it as late as June 1527, a few weeks after the establishment of the regenerate republic, and with Pontormo's decoration of the Capponi chapel at Santa Felicita it conveys the intense but unforced originality achieved by Florentine religious painting at the period.

Refectories of monasteries throughout Florence offered a variety of differing, often delightful depictions of the Last Supper. Sarto and his generation were bound to be conscious of one famous example by a Florentine artist, Leonardo, frescoed not in Florence but Milan. Sarto may recall that in his grouping of the austerely clad, 'classical' group of Christ and the Apostles at the table, itself a long, austerely bare horizontal, uninterrupted by glasses or food. The sacramental severity of such an interpretation accords with the mood of religious fervour fostered under the republic. Yet the truly original and memorable aspect of the scene is its architectural setting, conceived as a huge and lofty hall, in a style grand but uncompromisingly severe, blocked out in rigid rectangles that open unexpectedly to the twilit sky, against which are silhouetted figures of the landlord and a servant. A breath of the ordinary world, and several breaths of space, thus provide a context for and contrast to the profoundly solemn, emotionally taut and tightly realised mystic meal below, where Christ institutes the Eucharist at effectively the first mass.

Photographs poorly convey the illusionistic impact of this tremendous work. There is an optimum point for experiencing that, in the ante-room to the refectory and in fact from under the high chimney-piece embrasure. Looked at from there, and framed in the refectory doorway, the full breadth of the fresco cannot be viewed but what does appear is the dissolution of the wall on which it is painted, extended to form a further room, of the same dimensions, the rigid architecture of which gives place to the softly glowing, forever receding, atmospheric evening sky. A few purplish clouds there not merely float but, as they diminish and recede, help to suggest infinity.

In this profoundly impressive composition Andrea del Sarto had given Florence its definitive 'High Renaissance' version of a popular, long-established subject, which can be traced back to the fresco, no less grandly conceived, in its own idiom, by Taddeo Gaddi

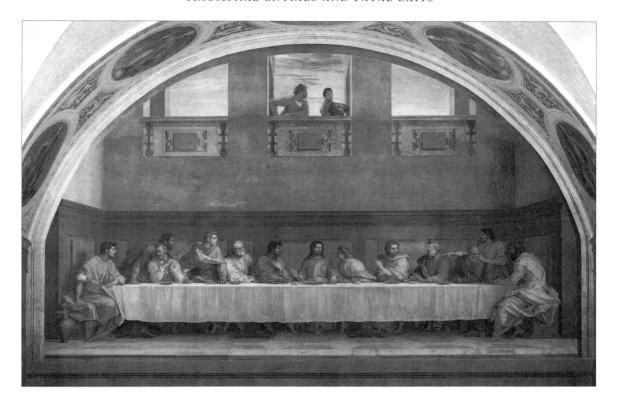

Andrea del Sarto: The Last Supper, *Museo di San Salvi.*

in the refectory at Santa Croce. More even than that for the Medici villa at Poggio a Caiano, the San Salvi commission revealed Sarto's Raphael-like gifts for monumental decoration (any connotations of superficiality in that term are misleading). The bigger the scale, it appears, the more inspired he was, but there were to be no comparable further opportunities to release his energy in that direction. The instinct to preserve his very recent achievement at San Salvi was itself inspired. Its preservation is the more poignant since, although the painter survived the siege, he succumbed to plague a month afterwards. One of his last works was a fresco or frescoes, of a sort, a commission from the defiant republic: to paint public effigies of three disgraced captains who had abandoned the defence of Florence and gone over, with their soldiers, to the besiegers' camp.

As treachery that was a minor incident, but it occurred in 1530, after five months of siege which could only weaken Florence fatally the longer it lasted. No Italian or foreign power came to the republic's aid. Its subject cities had never been well or wisely treated, and it was very much alone and exposed, without any territorial barriers for surrounding

support. Although it was to be bombarded, and there were some troop engagements, it was primarily starved into submission, defeated by hunger and plague and fatigue, with consequent loss of morale.

The ruthless and courageous Ferrucci was killed after being captured, though not before the Prince of Orange too had been killed in the same battle. The republic decreed public obsequies and also a statue to Ferrucci's memory. It was one final, splendid but empty gesture. By that date, early in August 1530, Florence had food for only eight more days. Unlike Ferrucci, the hired *condottiere* commander, Baglioni, had no cause to feel patriotic and was not even loyal. Self-interested and disillusioned, he started secret negotiations with the pope, contributing so successfully to the city's defeat that he was afterwards thanked and rewarded handsomely by Clement VII for his treacherous behaviour. At sunrise on the feast-day of St Laurence (saint of the Medici church of San Lorenzo), 10 August 1530, Florentine emissaries went to the imperial camp outside the city to bargain over the city's surrender.

The Florentines had lost any will to struggle on. Most, in the words of Benedetto Varchi, an eyewitness who was to write a factual account of Florence at this period, simply resigned themselves to God — just as Luca Landucci had done at political upheavals — and awaited not merely death but death in the most horrible circumstances. The Sack of Prato which had accompanied the return of the Medici in 1512 must have been uppermost in every mind.

Power rather than vengeance was the pope's aim in 1530. He had no wish for the fabric of Florence to be damaged, and in any case the city's surrender had been not to him but to the representatives of the Emperor Charles V. The fears of the citizens were widely shared, even by the emperor himself away at Augsburg, but there was to be no Sack of Florence. All that the city lost was its liberty. That was the personal achievement of Clement VII, once its cardinal-archbishop protector, the bastard son of one of the least important or distinguished males of the Medici family, and someone with no more claim to rule Florence than to legitimacy. Perhaps, after all, there had always lain in his character an unconscious urge for revenge. More than a Medici chapel and a library, though they were the work of Michelangelo, would have been needed to compensate for his crime against the city of his birth.

Florence set about the task of physical recovery. In the city with its shrunken population and in the surrounding countryside there remained extensive signs of poverty and misery, and meanwhile the pope's ostensible clemency and benevolence cloaked his intention of installing Alessandro de' Medici, possibly his own bastard son, as its ruler.

In 1531 Alessandro entered Florence, having been confirmed as head of the state by Charles V – a new and necessary procedure. In the following year Clement firmly guided (that is, manipulated) the city to agree to a fresh constitution, with a fresh, senatorial council (the Council of the Forty-eight) and – most relevant of all – with Alessandro recognised by the ominously anomalous title of 'Duke of the Florentine republic'. His male child or next immediate heir would succeed him, and so the republican principle died, as did effectively the republic. And in 1533 there arrived in Florence for a few days his fiancée, Margaret, Charles V's illegitimate daughter, who was received with what had become typical courtly festivities, though their marriage took place only in November 1535. By that time Clement VII was dead, and earlier in the year there had also died the young Ippolito de' Medici, who had become a dangerous source of Florentine disaffection with Alessandro's rule. To Alessandro his death, from natural causes, was the happiest of accidents.

As the duke's wife, Margaret returned to Florence in the summer of 1536, making an elaborate and grand Medicean *entrata* into a city which had passed from the aftermath of siege conditions to relative recovery. The duke was a compulsively dissipated individual but a by no means indifferent or ineffectual ruler – nor a mere tyrant. Nineteenth-century historians stigmatised his 'low forehead, and mean expression' as indicating his low 'type' and absence of intellectual power (thus T. A. Trollope), but physiognomy (as we strikingly see in that of Trollope's brother, the novelist Anthony) is never a reliable guide to mentality. The Medici were not renowned for good looks, and Duke Alessandro's portraits at least suggest he did not compel flattery from artists, any more than had Lorenzo 'the Magnificent'.

Alessandro de' Medici added one prominent landmark to Florence, the massive Fortress of St John the Baptist, the Fortezza da Basso (see p. 320), standing today peacefully islanded in greenery, well beyond the tourist trail. Its image in history may be that of a Bastille, for it was intended not so much to defend the city as to coerce the inhabitants. It was a novelty for Florence: a citadel and a bastion of imperial-cum-Medici rule, openly proclaimed as such. When the first garrison took possession of it, at yet one more grand, ceremonial occasion, the standards raised above its frowning ramparts were not of the city or 'the People', as displayed at the ancient Palazzo of the Signoria, but of the Medici and the emperor.

Yet the shadow of the fortezza, sinister as it seemed and was, should not obscure other aspects of Alessandro's reign. He showed himself perhaps most truly a Medici in his interest in the visual arts. The fortezza is no formless heap of stone. Its steep walls are

Exterior of the Fortezza da Basso.

patterned and studded with the Medici *palle* like sliced-off cannon-balls, and its pentag-onal design is by the younger Antonio da Sangallo, whose uncle Giuliano had built the villa at Poggio for Lorenzo 'the Magnificent'. Alessandro employed Pontormo to dec-orate a loggia for the Medici villa at Careggi with allegorical frescoes (now lost), and

Pontormo assigned a share of the work to his most brilliant ex-pupil, Bronzino, then emerging as the last great painter of the Florentine Renaissance. To Vasari the duke sat for a portrait (commissioned by Ottaviano de' Medici and now in the Uffizi) which shows him full length in profile, in armour, literal *dux* of Florence, a *capitano* echoing in pose Michelangelo's statue of Duke Giuliano in the Medici chapel. What he is seated on, however, is a footstool, one that not fancifully incorporates the armless, legless and subordinate Florentine people, bound and steadied, as Vasari put it, by the fortress that has been built. Almost as an afterthought, he added that the people were also bound by love, 'towards his Excellency'. Primarily the point is that they are bound, and who can overlook the Old Testament associations of the enemy made a footstool?

In Alessandro's service were two members of the Cellini family, sons of the *Signoria's* fifer: Francesco, a soldier, and Benvenuto, the artist, in whose autobiography the duke comes briefly to life, debauched, short-tempered but admiring of Cellini's fine models of coins for him and able to laugh at Cellini's cheek. Some indications are gained, too, of the small circle around the duke, including the neurotic Lorenzino de' Medici (descended from Lorenzo, the brother of Cosimo 'il Vecchio') and the youthful Cosimino, son of Giovanni delle Bande Nere and Maria Salviati. Cellini was later to meet the Duchess Margaret, who recalled her husband's esteem for him. She was a woman of character, who matured to become a capable Regent of the Netherlands. Together with the duke, she might gradually have given Florence the unprecedented experience of a husband-and-wife team of rulers, even if her role had always to be restricted to one behind the scenes.

For the *entrata* that followed her marriage, Lorenzino organised a play with music – an ancestor of opera – with scenery designed by Bastiano, nicknamed Aristotle, a member of the Sangallo family of architects, who had made himself a name by devising perspective sets for staging plays. Vasari has a lurid, improbable-sounding tale, worthy of the playwright John Webster, about how Lorenzino planned that the heavy scenery would collapse during the performance and kill Alessandro, but was frustrated.

Yet there may be truth in the story. The comedy went ahead in 1536 and the duke and duchess commenced their version of married life. Alessandro continued his Don Giovanni escapades in pursuit of other women, one of whom, Lorenzino led him to believe, was prepared to make an assignation with him. On a Saturday night in January 1537, Epiphany night as it happened, a blacker comedy took place, as Alessandro lay in bed waiting for what turned into his assassination. With no compliant woman, but a ruffian hired to help in doing the actual deed, Lorenzino entered the room, and the Duke of Florence was savagely stabbed to death.

CHAPTER ELEVEN

'A young man on a marvellous horse'

I T W A S A good phrase, as quoted above, and an even better assessment, that Benvenuto Cellini came out with – according to his own later testimony – when he heard in Rome that, following the assassination of Duke Alessandro, the teenage, untried and largely unknown Cosimo de' Medici, Cosimino as he was then sometimes called, had been elected Duke of Florence.

Speedily and smoothly, the Medici faction in the city moved into action after the discovery of Alessandro's murder. The sudden, shocking event was at first kept secret and no doubt helped to concentrate the minds of those who knew of it. Republicanism in Florence might revive, as too might outside challenges. No longer was the pope conveniently a Medici. He was Paul III (Farnese) who had flagrantly open ambitions for his own family, some of whom were his sons and grandsons. He might be eager to fill any vacuum in Florence with a Farnese representative. So, a day or two after Duke Alessandro's death, the Medici succession was ensured by the election of Cosimo as head of state (not at that date, in strict fact, with the title of Duke). Among the prime movers in his election was the historian Guicciardini. And, as Cellini's informant took care to report, Cosimo had been elected within distinct constitutional limits. The Florentine Senate was the body which chose him, and Florence still called itself a republic.

Nevertheless, Cellini reacted to the news with his acute analogy. The men of Florence, as he saw it, had mounted Cosimo on '*un meraviglioso cavallo*' and turned him out into a delightful, flowery field, while telling him he could go only so far. Yet who could hold him back once he had determined to advance? Whether or not Cellini entirely foresaw in 1537 Cosimo's steady ride in the direction of near-absolutism, he seems to have had a shrewder insight into his real nature than senators like Guicciardini. It would not be long before Florence, and then Europe, became aware that the man in the saddle was a ruler instinctively authoritarian and almost endlessly ambitious – and also quite astonishingly able.

All, and more, conveyed by Cellini's verbal image eventually assumed permanent, sculptural shape not in his own work but in that of a more consistently great sculptor, Giambologna (Jean Boulogne, of Franco-Flemish origin). In 1594, twenty years after Cosimo's death, Giambologna's equestrian bronze statue of him, showing a ruler mature, armoured and commanding, holding the reins of a calmly-pacing, noble horse, was unveiled in the Piazza della Signoria (see Plate 28).

It was the first equestrian statue to be put up in Florence, and one of the first such statues of rulers to be put up generally in Europe. Cosimo deserved that artistic primacy. The statue commemorates a man who became not only the first Duke of Florence and Siena but the first Grand Duke of Tuscany. On the sides of the high stone pedestal of the statue are inset three bronze reliefs which chart in essence the steps in Cosimo's personal achievement: as young, beardless ruler, he receives the homage of the senators of Florence; markedly older, he enters Siena in military triumph, having conquered and added the hated, rival republic to his principality; finally, he kneels before Pope Pius V in Rome, being crowned as Grand Duke. On the front of the pedestal a bronze plaque, with a Latin inscription in classically bold capitals, salutes him in the name of his son, Ferdinando I, the third Medici grand duke, as 'pious, fortunate, invincible, just, clement . . .', best of fathers and of princes.

Even now, after cleaning and restoration, this splendid, dignified, gleaming monument seems to detain few of the concourse of Florentines and visitors who stream daily through the piazza, and fewer still pause to decipher the reliefs and the inscription. Equestrian statues to rulers, accompanied by maniloquent inscriptions celebrating their virtues and renown, have become familiar throughout Europe, to the point of fatigue and cliché. Anyone who does bother to halt at the foot of Cosimo's statue, on which an indifferent pigeon is quite likely to be perching, may be tempted to smile cynically at the claims stated there. Yet just as Giambologna's bronze sculpture deserves recognition for its real accomplishment, being also of great originality in its day (though raising aesthetic associations that lead back to Donatello's *Gattamelata* at Padua and ultimately to the *Marcus Aurelius* at Rome), so its subject deserves recognition as really embodying much of what is stated and implied there. Indeed, more can be claimed for Cosimo, in addition to his successful, stable reign, and his successful, stable private life. Under him, the city of Florence — especially in the immediate vicinity of his monument — was dramatically and definitively changed, added to and enhanced. Time has tamed the drama and made Cosimo's additions quintessentially part of the fabric — and the very concept — of Florence.

He was fond of, or anyway did not forbid, comparisons with the Roman Emperor Augustus, and in building terms they are apt. To Cosimo Florence owes, above all, the Uffizi (built to serve not as picture gallery, however, but as literal 'offices' for government business), Ammanati's graceful bridge of Santa Trinita, Cellini's famous statue of *Perseus* and the *Neptune* fountain – the first major public fountain in Florence – created by a team under Ammanati and located in the Piazza della Signoria, close to where Grand Duke Ferdinando I would have Giambologna's monument put up to the best of fathers and of princes.

It was Cosimo who turned the palazzo which had housed for centuries the *Signoria* of the republic into a semi-private residence for himself as duke and his family. To that end, which also included turning the palace into a painted and sculpted showcase of Medici family history, it underwent radical physical alterations, conducted by the ever-industrious, ever-obliging Vasari, an artist of all-round talent, only fitfully touched by any spark of genius. The environment Cosimo required extended to images of himself at key moments in his reign. He was already absorbed into the glorious story of the Medici – or rather, even as he lived, he represented its apotheosis. And, whatever one may think about the style in which he was commemorated, the laudatory form yet expresses an underlying truth.

What had been first the Palazzo della Signoria, and then the Palazzo Ducale, became the Palazzo Vecchio when Cosimo made his second, definitive move – out of it. The Palazzo Vecchio it has remained, remaining also very much the building as lived in and decorated for Cosimo, not forgetting the fact that some of it was decorated for his wife, Eleonora di Toledo. Their life together there, along with their children, can – without much difficulty – be recaptured. The often cramped and usually dark rooms exist, not greatly lightened – in any sense – by their painted decoration. And duke and duchess, and family, re-inhabit them with marvellous vivacity and intimacy in the pages of Cellini's *Autobiography*, a literary masterpiece of such robust and colourful incident that it often reads like a historical novel by Dumas *père*. It has more of 'Renaissance' verve than some of Cellini's works of visual art.

In that effervescent broth of a book, packed with a cast of lively, jostling, conversing characters, the duke and duchess of Florence are leading protagonists. The reader follows Cellini through the rabbit-warren of their private apartments that were so inadequately private that once he stumbled on the duchess at a highly 'inconvenient' moment. Her flash of anger – one of several that occur – is understandable. But the rooms of the Palazzo Vecchio rang to a range of moods uninhibitedly expressed by both

husband and wife, expostulating or quarrelling, now laughing at Cellini's *badinage* with their sons and now displaying great princely graciousness. Vasari and his team may have provided the décor, but Cellini has provided verbal portraits – speaking likenesses – of the occupants that are probably unparalleled among accounts of sixteenth-century rulers in their close-up, ever-animated observation and candour.

In Eleonora di Toledo Cosimo had taken a wife with a personality and will of her own. To her perhaps, more than to him, is owed a fresh impetus that was to have over-whelming effects, psychological as well as physical, upon Florence: the move, possibly long-envisaged, of the ducal family from the fortress of the Palazzo Vecchio, to which no amount of ingenious contrivance could give domesticity, still less space and air, into the agreeable and potentially rewarding environment provided by the Palazzo Pitti, on its isolated, imposing, hilly site across the Arno. It was a building purchased by the duchess herself (or so it is usually said) and destined to be no homely palace but rather a palatial home. Among its more obvious potentialities was that for the creation of a garden or gardens. Eleonora di Toledo lived to see only the start of grandiose schemes, beginning in Ammanati's courtyard at the back of the palace which opened onto the hillside and called for landscaping to complete the scenographic effect.

The leap from the irremediable medieval constriction of the Palazzo Vecchio to all the expansionist opportunities of the Palazzo Pitti was a bold, almost baroque one, and before the end of the sixteenth century, during the reign of Grand Duke Ferdinando I, the partly enlarged palace (not yet enlarged to its existing extent) had become the centre-piece in a scheme of formal gardens and grottoes and fountains that clothed the slope behind and around in a series of proto-baroque vistas. One of the fountains, the marble *Fountain of Ocean*, had been commissioned by Cosimo from Giambologna (although the components of it were not assembled until two years after the Grand Duke's death), and 'baroque' may justifiably be applied to the unusual, triangular pedestal Giambologna designed, on which are seated three crouching river gods, artfully composed to encourage the spectator to walk all round the fountain's rim.

So, between them, Duke Cosimo and the Duchess Eleonora had instigated a development that far outstripped any private, domestic aim. The palace that Luca Pitti had built for himself in the fifteenth century became the seat of grand ducal rule in Florence as long as grand dukes reigned, well after the direct male dynasty of the Medici had expired, and would in the nineteenth century become a royal palace. As late as 1913 Baedeker could note that 'it now is occupied by the King of Italy when in Florence'. In its eventual present-day form, with its long façade and projecting wings preserving homo-

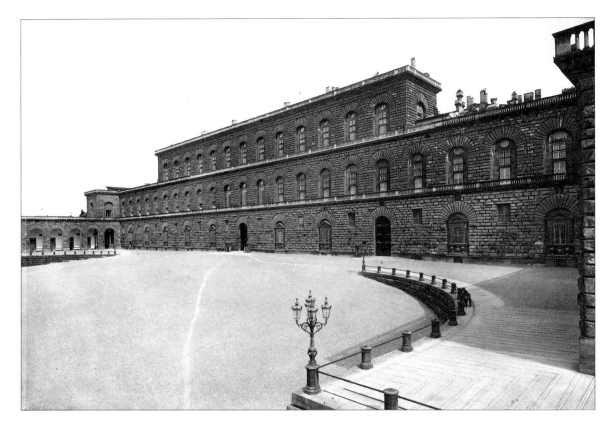

Exterior of the Pitti Palace.

geneity, thanks to the rusticated idiom and the use of honey-toned stone throughout, it presents itself as the most overwhelmingly palatial of all Florentine palaces, requiring a sort of physical obeisance from the visitor who toils up – and it is up – the vast, dusty incline to its main entrance. Few buildings and none of the other palaces in Florence possess the advantage of such an awesome and spaciously sweeping approach, in which the lie of the land has been exploited so skilfully. Already in 1594 the traveller Fynes Morison described it as 'the most stately Pallace in the Citie'. That claim could now be challenged only by the huge Palazzo Corsini, stretched out in the late seventeenth century beside the Arno, but it enjoys no isolated position; and for all its Roman-style massiveness and its river aspect, it is still very much a palace in a street.

The space of hillside behind the Palazzo Pitti gave it a further unique advantage, for a garden created there would naturally (the adverb is apposite) take exciting and partly irregular forms. In its very terrain the site was effectively baroque, and as over the cen-

turies the gardens spread – all the way south to the city boundary of the Porta Romana – they became no longer an appendage to the palace but a large-scale work of art in their own right, deserving their own name, the Boboli Gardens, among the most famous gardens in Italy. What the sculptor Tribolo began to put in hand as a terraced garden visible from the central rooms of the palace has grown enormously, like the palace itself, but the Boboli Gardens are one more superb addition to Florence owed in origin to the first Grand Duke Cosimo and his wife. Had the Palazzo Vecchio been a more amenable residence for a family, the Boboli Gardens might never have come into existence.

The Pitti and Uffizi palaces, the Ponte di Santa Trinita, the *Perseus* statue and the *Neptune* fountain are merely the most obvious, the most unmissable results of Cosimo's concern with improving the physical aspects of Florence, enhancing it for purposes typically firm and clear, and only secondarily aesthetic: as the outward symbol of his successful rule and as the capital of his kingdom.

All that had been haphazard, however ambitious, about Medici domination of the city ceases with him. Regardless of being 'the best', he was the first fully professional, ceaselessly industrious head of state that Florence had known, and none of his grand ducal descendants (not by any means all to be dismissed as buffoons or bigots) could approach him in unremitting application to the task of governing, with absolute involvement in every detail of it. Whether it was a matter of diplomatic negotiation with popes and emperors, or of the colour of his pages' caps, Cosimo took the decision. In re-dedicating to him the second (1568) edition of his *Lives of the Artists*, Vasari asked rhetorically to whom else could the book be dedicated, since the duke was 'sole father, lord and unique protector' of the visual arts in Florence. To quibble that there were other Florentine patrons would be to misunderstand Cosimo's supreme and indeed sole place at the centre not just of artistic affairs but of affairs under every aspect.

He was an extraordinarily efficient and consistently successful ruler – one of the great rulers of Europe, despite the comparative insignificance of his kingdom even as expanded by his conquests and his diplomacy. About his piety, beyond conventional observance, there might be doubt, though he was morally austere, personally frugal and famously faithful to his wife. His armies were victorious, while Florence enjoyed decades of much-needed undisturbed peace. Seldom perhaps was he merciful, but he prided himself on being just and embodying justice. To him a subject could appeal against decisions in the lawcourts: a further indication of that 'sole' position which he profoundly believed he filled in the state system. Of all later rulers, Louis XIV and Napoleon are the ones who are foreshadowed in Cosimo's assured and all-round self-belief, his eye for detail and

his sheer appetite for governing – with a touch or two of Queen Victoria's equal assurance and appetite (and her instant aplomb on acceding, young and inexperienced, to a throne).

Any supposition that Cosimo was not really autocratic, or that he felt some obligation to councillors, or to the Florentine Senate, or to the Holy Roman Emperor, is dismissed by his own categoric statement to his ambassador treating with Francis I of France in 1545. The ambassador was instructed to inform the French king that 'we are a ruler who accepts the authority of no one apart from God'. What a message, one cannot help exclaiming, from someone who had, a few years before, been an obscure, uncourted and apparently aimless scion of the Medici family.

Just how badly even contemporary well-wishers misinterpreted Cosimo's character is amusingly illustrated by a letter written to him in the early months of his reign by Pietro Aretino, the proto-Voltaire of *littérateurs*. Aretino had been a devoted friend of Cosimo's father, Giovanni delle Bande Nere, and now presumed on that, and his own fame, plus his inimitable brand of sycophantic impudence, to advise Giovanni's son on his conduct as ruler. Aretino's flowery phrases are not without their shrewdness and sharpness (the House of Medici owes more, in his opinion, to Giovanni delle Bande Nere's arms than to the mitres of the popes), but he advises the youthful prince to be counselled by the emperor's representative in Florence, Cardinal Cybo, and keep beside him the Vitelli family, one of whom, Alessandro, commanded the Spanish garrison of the Fortezza da Basso.

Although it was Alessandro Vitelli who won a key battle for Cosimo, the battle of Montemurlo in 1537, which decisively defeated the exiled, anti-Medicean forces, it was Cosimo somehow who gained credit for the victory. A column from the Baths of Caracalla, subsequently presented to him by Pope Pius IV, was later to be set up in the Piazza Santa Trinita to ensure remembrance of Cosimo's achievement. And, far from being retained at the side of the Duke (as Cosimo had become), Vitelli was dismissed. Some time afterwards the Spanish garrison was entirely withdrawn from Florence. As for Cardinal Cybo, who had thought of Cosimo as his puppet, he quickly found himself outwitted and wrong-footed, and denounced to the emperor, by the boy whose iron resolve became yearly more apparent. Cybo decamped, and Cosimo ruled – as no doubt he intended to from the day of his election – alone.

He saw to it that he ruled not just a city but a state. Tuscany was to be improved and strengthened, no less than Florence, with great tracts of marshes drained and the duke's protection given to other cities, notably Pisa, where a palace was adapted and a church

(Santo Stefano) built in the main piazza, for use by the order he had founded, of the Knights of St Stephen. The handsome space of the Piazza dei Cavalieri is a Renaissance 'reply' to the medieval complex around the Campo Santo. He built a new harbour at Livorno, turning a small modest town into a significant commercial port whose economic importance has lasted into modern times. His possessive vision extended down the coast and across to the nearby island of Elba. He had two fortresses built there and named the town they overlooked after himself, Cosmopoli (today, less gloriously, Portoferraio).

Cosimo's arms and Cosimo's image were to be impressed and displayed wherever he built. More novel, in Florentine terms, was the fact of the display of his own person, as he moved – like a miniature monarch – from city to city in his territory, honouring Pisa in particular with prolonged stays. The people could see their prince, and he could see that whatever project he had initiated was proceeding as planned. Even in the more limited orbit of his movements around Florence there was implicit grandeur and perhaps also precaution. *En prince* he proceeded through the city or left it for one of the Medici villas, accompanied by his wife, his children, his household, 'German' guards, a squadron of cavalry and a hundred foot-soldiers toting muskets. However simple his private tastes, he had assembled a court, inclusive of the traditional court appendage of a dwarf, Morgante (often to be painted and sculpted). It was his 'German' (actually Swiss) lancers who gave their name to Orcagna's civic loggia in the Piazza della Signoria; it became, as it has remained, the Loggia dei Lanzi.

In leaving Florence for one or other of the Medici villas in the surrounding countryside, often preferring that of Castello, further away than Careggi, he was not retreating, like Lorenzo 'the Magnificent', to a convivial rural life amid friends. Friends he had dispensed with, probably by nature and also as unsuited to his high position. He might relax and joke on occasion, doffing his ducal dignity, but in a way characteristic of royal personages at all periods he froze off any reciprocal familiarity. In the country he hunted, with the same obsessive pertinacity that he governed. It seems improbable that he ever emulated Cosimo 'il Vecchio' in pruning his own vines, and in any case the earlier, homely farmhouse ethos of the villa as such had and would continue to be changed, significantly, by him.

If at Castello the villa structure never became as imposing as the duke had intended, its gardens – anticipating the Boboli Gardens – were conceived, and partly executed, as an ingenious, elaborate and magnificent marriage of nature and art, with art the predominant partner. Cosimo entrusted the scheme to the sculptor Tribolo, and somewhat

overwhelmed him by the technical, hydraulic problems of the task (in addition to giving several other burdensome commissions to this timid, slow, easily worried artist). For the artificial lakes and the plethora of proposed fountains Tribolo had not only to conceive the statuary but to devise methods for bringing water to them from a distance — and Vasari's lengthy account of what went on at Castello makes it plain that the duke took a leading, typically practical and detailed interest in how everything would work.

The programme for the garden sculpture had its strong Medicean and indeed propaganda element, making it something of an open-air complement to the interior decoration of the Palazzo Vecchio and strikingly anticipatory of sculpture schemes for the gardens at Versailles under Louis XIV. Statues of rivers such as the Arno, or of the Four Seasons, were to be supported by figures illustrating the greatness and the virtues of the House of Medici, and they in turn would be actual portraits of outstanding members of the family. Cosimo 'il Vecchio' stood for Wisdom, and Lorenzo 'the Magnificent' for Nobility. The duke's father, Giovanni delle Bande Nere, represented Valour. Inevitably, the duke himself represented Justice. Perhaps the scheme was too huge and elaborate ever to be completed, and in any event Tribolo kept being distracted by further orders from Cosimo. But sufficient was achieved at Castello to win the enthusiastic praise of the earliest visitors. Their existence is a further indication of changed times. Those who visited the gardens at Castello were not just privileged guests of the Medici but effectively ordinary travellers — tourists — such as the Welshman William Thomas, who published his admiration of Cosimo and of the garden at Castello, 'one of the excellentest thynges in all Europe', in his *Historie of Italie*, which appeared in the London of Edward VI in 1549. Thomas's must be among the first printed tributes to Cosimo's capability as a ruler. He described him as 'one of the rarest princes of our tyme' and judged him to be 'absolute lorde and kynge within himselfe'.

If that was the impression Cosimo made on a foreigner at a comparatively early stage in his reign (before he had added Siena to his dukedom), how much stronger must have been his impact on his subjects, especially those in Florence. For generations it had been accepted, with a good deal of local pride, that the Florentines were contentious and disunited, difficult to govern and loud in complaint about whomever was in government. That too now changed. It was as if Florence, trying on new constitutions almost more frequently than men then changed their clothes, had all along half-hankered for the smack of truly firm, stable government which rule by a single individual could give, providing he displayed supreme confidence and supreme capability. Cosimo displayed both. It was by no means enough that he should be a Medici but — adroitly handled — it helped.

A selective view of the previous hundred years of Florentine history, looking back from the vantage point of 1550, might suggest that the greatest periods of the city's peace and prosperity had occurred when a male Medici dominated its government: the first Cosimo, the first Lorenzo (pedantically, the second) 'the Magnificent', and the second Cosimo, the living, reigning duke.

Compared with his two famous, ruling but never precisely reigning ancestors, Cosimo was a thorough professional. He was no more likely to wander into the market-place and crack a sly joke, à la Cosimo 'il Vecchio', than to sit down and dash off some poetry, as Lorenzo had done. He may have been an autocrat, but even to that role he brought professional qualities of efficiency and order – evidenced by his creation of the centralising mini-Whitehall of the Uffizi – to be associated with the best kind of bureaucrat. It was a formidable combination. A Venetian ambassador penned a detailed portrait of Cosimo in 1561 (in, as it happened, the last unflawed year of his double fortune as prince and as husband-cum-father) that verges on the fulsome but emphasised his keen intelligence and his retentive memory for income and expenditure, for troops and munitions, although, the ambassador noted, on all these matters he had memoranda.

Indeed, he had or demanded memoranda and information on everything that could conceivably relate to the state. Its security was an essential concern, and a darker though entirely comprehensible aspect of his rule was a system of secret policing, of spies and informers and imprisonment, which must have contributed a good deal to keeping the voluble, volatile citizens of Florence untypically mute and quiescent. However, it seems wrong to see a cowed population perpetually mourning its loss of liberty. Cosimo had not robbed the city of that. In contradistinction to the pair of Medici popes, he had not sent armies to defeat Florence. In one sense he was about as constitutional a ruling prince as a state could have. As pictures and bas-reliefs would take care to record, he had been elected as head of government by fellow-Florentines and under no persuasion or pressure from Rome. It could be claimed that less hypocrisy, less ambiguity at least, surrounded his open position as the appointed ruling figure than had accompanied that of the earlier Cosimo and of Lorenzo 'the Magnificent'. No doubt the sixteenth century in Europe was a more absolute age, but Duke Cosimo could hardly have ruled so long and so successfully had he not met the feelings, consciously or not, of the majority of his subjects. One might even say that his behaviour was moulded by their expectation of how a prince should behave.

The final proof of how acceptable to Florence was his form of autocracy lies in the permanence of its establishment. Unchallenged, his dynasty ruled there for two complete

centuries, from his election in 1537 until 1737, ending only with the cessation of direct male heirs. Even then, grand dukes continued to reign from the Palazzo Pitti – some reigning most effectively – until 1859, after which Tuscany became part of the Kingdom of Italy.

Although the tangible evidence of Cosimo's rule is everywhere stamped in Florence, some of the less tangible manifestations also deserve to be recalled. As he physically improved the city, so he animated, and gave direction to, its cultural life. The image of a prince, and the tradition of his ancestors, were probably incentives stronger in him than any profound love of literature, or any of the other arts. He did not need to declare he was a plain, blunt man, more practical than imaginative: it was apparent in everything he did and said and wrote. Again anticipating Louis XIV and Napoleon, he realised how conveniently culture could serve state ends; and for all three rulers the state ended, as it began, with themselves. History was an obvious literary form to patronise (as in the visual arts were pictures of historical events). Cosimo attracted back to Florence the exiled republican writer Benedetto Varchi ('my very dear friend', Cellini called him), who compiled a *Storia fiorentina* of serious, lasting value. Other histories of Florence were contemporaneously written, and Cosimo looked to them to be factually accurate. His were achievements that required no flattering gloss. The truth about them was sufficiently impressive.

It may mean little or nothing in today's Florence that Cosimo founded a learned academy, the Accademia Fiorentina, for discussion of literary and philological topics (pointedly excluding political ones) and gave encouragement to the establishment of another, for visual artists, the Accademia del Disegno. It was an age of academies as well as of absolutism. Perhaps the two had something in common. But valuable status and recognition accrued to the members of an official academy, basking in the ruler's approval and under his 'protection', while his image was burnished culturally by this patronage.

Cosimo went far in commanding culture to revive in Florence (as throughout Tuscany), and to add a sympathetic, softening lustre to his sterner qualities. The already established tradition of grand Medici state occasions provided one way of publicly demonstrating the variety of talent in every medium. There was also a less contrived intermingling of the arts which gives its tone to Florence at the period. Music was played at some of the sessions of the Accademia Fiorentina (Cosimo himself did not neglect to patronise an eminent local composer, Francesco Corteccia). The great painter at Cosimo's court was Bronzino, who was also an admired poet, writing sophisticated son-

nets deploring the death of the duchess, whom he had portrayed, and that of Pontormo, whom he mourned as 'friend and brother, or rather father and master'. And, like Cellini's, some of his artistic work prompted praise from poets. Varchi showed an intelligent if 'academic' interest in the visual arts, lecturing on the subject to the Accademia and questioning distinguished living artists about the relative merits of painting and sculpture.

All that was taking place under Cosimo, and even the works of art themselves, can be represented by unsympathetic interpreters as sterile or inferior to those of the glorious, implicitly carefree years of the Florentine *quattrocento*. It is not in mortals to command culture, though that is something of a modern view, nervous of patronage that restricts and exerts pressure on the artist. To Cosimo it was one of his princely functions both to employ and to direct painters, architects, writers and musicians, and the resulting creations are not automatically diminished by that origin, or by the tendency to pay homage, overt or otherwise, to their instigator. As patron of Florence, Duke Cosimo I easily eclipsed the activities of any previous member of his family.

Suitably enough did the death of Michelangelo occur in his reign. The opportunity to honour the artist who had traditionally been 'launched' by the Medici in the fifteenth century, and who had undoubtedly been greatly and fruitfully patronised by later Medici such as Clement VII, and whom Cosimo himself had always hoped to lure back to Florence, also gave a fresh, unique opportunity to display the splendour and unity of the Florentine arts, under the contemporary Medici aegis. In Florence Michelangelo received a public funeral, organised by the Accademia del Disegno, of a kind previously reserved for prominent members of the Medici family, and perhaps even more sumptuous. Although Michelangelo was buried in Santa Croce, it was in the Medici church of San Lorenzo that his obsequies were celebrated. The Accademia petitioned the duke for permission to celebrate them there, and requested that he allow Varchi to deliver the funeral oration. (Varchi had last spoken similarly on the death of Cosimo's younger daughter, Lucrezia.)

In agreeing to these unprecedented honours for an artist, Cosimo paid his own homage to culture and virtually adopted Michelangelo as an honorary member of the Medici family. Ingenious and elaborate pictures were executed to decorate the interior of San Lorenzo, several illustrative of Michelangelo's life. They began chronologically with his being received as a boy by Lorenzo 'the Magnificent'. They ended with the encounter between him and another Medici, more than seventy years later. The aged, illustrious artist was depicted entering a room in Rome to meet the young Prince Francesco, Cosimo's heir, the future Grand Duke – a meeting of the generations remarkable enough

in itself, for the prince was the great-great-grandson of Lorenzo. Much more remarkable was Francesco's action in the picture, a record of his behaviour in real life. As Michelangelo entered, he had risen from his chair and offered it to him. Then he remained reverently standing. It was the ultimate recognition of artistic genius by the ruling Medici dynasty.

As Cosimo deserved to be favourably commemorated as prince, so he deserved comparable remembrance as father and as husband. With him the roles could barely be separated. It was an aspect of his establishment of quasi-royal dominance that he should possess — and be seen to possess — a wife and family. With characteristic, obstinate care he finally chose as his wife Eleonora, the coldly beautiful younger daughter of the Spanish Viceroy of Naples, Don Pedro de Toledo, who had first offered Cosimo his elder daughter. Eleonora perfectly looked the part of consort for such a duke. She had a manner that passed for haughty, and was pious (though she was also addicted to gambling, to jewellery and to getting her own way).

ONE MORE NOVELTY for Florence to swallow was the presence of a reigning ducal pair (the brides of Giuliano, Duke of Nemours, Lorenzo, Duke of Urbino and Duke Alessandro de' Medici had had no time, for various reasons, including mortality, to make any impact). In death, as in life, the duchess was a presence — portrayed, for instance, in the grandest of all sixteenth-century Medici *entrata* celebrations, those for the wedding of her son, Prince Francesco, to Joanna of Austria in 1565, three years after the duchess's death. Her apartments in the Palazzo Vecchio had to be decorated with flattering allusions to famous, virtuous women of the past: Esther, Penelope and the excessively prim Gualdrada, a medieval Florentine wife renowned for refusing to allow the emperor Otto IV to kiss her. Eleonora had her own chapel in the palazzo, painted fortunately not by Vasari but by a genius, Bronzino. In Cellini's *Autobiography* the duchess appears as often giving him a hard time (favouring Bandinelli over him) but also as a person of pronounced artistic tastes and, as he stresses, of intelligence.

Eleonora's chapel is at once an exquisite and complex work of art, and the art begins with the transformation of an exiguous and uninteresting space into an elaborate and almost compulsively decorated cabinet. It has a religious function but not, at first glance, very marked religious feeling. The smallness of scale seems to have suited rather than perturbed Bronzino. He was required to be both frescoist and painter in oils there, but free to give the maximum polish to every inch of surface he touched. That was important, for

all the decoration of the chapel was entrusted to him. Everything was to be achieved not by *quattrocento*-style fusion of the various arts but by paint alone.

The sense of 'infinite riches in a little room' is almost overwhelming for the visitor, stooping to enter the confined space of the chapel (see Plate 26). Perhaps the inspiration for such a painted room comes from Gozzoli's chapel in the old Medici palace, from which the duke and duchess had moved. And perhaps, as there, the religious subject matter is to be read as having topical, even political overtones for the family. The frescoes that deal with scenes involving Moses may hint at Duke Cosimo as leader of his people, and the four saints posed on the ceiling against an atmospheric, semi-illusionistic blue sky may have each his specific application to the Medici (certainly St Francis recalls the name of the duke's heir, Francesco). Although the spectator may not know it, Bronzino planned to occupy the centre of the ceiling with the Medici-Toledo family arms united. Its place in an ostensibly religious scheme might have seemed too overt: it was replaced by an image of the triune Godhead, but a half-profane air still hovers in the chapel, for all the Old Testament subject matter and the *Lamentation over Christ* as the altarpiece.

Bronzino is so sophisticated an artist, so oblique in his attitude to subject, that the beauty of the room takes precedence over piety. The very colours of the draperies, wrapped at times about bodies of pale, silky flesh, possess a greater intensity, a deeper 'reality', than any of the incidents illustrated. As a '*camera picta*', the chapel has total perfection: it is literally finished, to the highest degree. That it does not at once yield its full significance on entry is part of its art. It demands a sophisticated spectator, and doubtless had that in not only the duke but his duchess, its commissioner. Eleonora di Toledo was creating a precedent for a woman in Florence by ordering her own shrine, but her example was to be followed in various ways by her grand duchess successors.

Eleonora di Toledo's wedding in 1539 had been celebrated in Florence by another grand *entrata*. As she processed through the city for the first time, one of the triumphal arches welcomed her with words of hope about her role of motherhood: that she would be 'fruitful in the finest of offspring' and thus guarantee everlasting assurance for the Medici name. Perhaps it is not cynical to suspect that some basis for her contented marriage lay in the efficient rate with which, annually for five years from 1540, she gave birth to healthy children. The family consisted eventually of five sons and three daughters.

'Divers faier children' by his wife was one of Cosimo's advantages as described in Thomas's *Historie of Italie*. That the duke dined simply and *en famille* was noted by the Venetian ambassador, and sporadic evidence suggests that Cosimo took a fond interest in at least some of the children, as well as valuing them as pledges, even pawns, in advanc-

ing his political concerns. Bronzino was enlisted to paint portraits of several of them, when young, not omitting Cosimo's illegitimate daughter Bia, whose paternity is proclaimed by her wearing a medallion with his image. The second son, Giovanni, a bright, plump, attractive child, was a favourite with his father. Bronzino portrayed him — characterised him — at the age of eighteen months, with a likeness testified to at the time by the duke's major-domo as truly lifelike. The smiling vivacity so precisely and sensitively caught in the child's features compels an answering reaction from every spectator stopping in front of the portrait in the Uffizi today.

That Cosimo wanted such pictures of his children is notable (and he was to be duly informed when Giovanni acquired his first teeth). Bia de' Medici was not hidden away, in life any more than in art. Eleonora di Toledo mothered her, and the small girl was said to be the delight of the court circle. The duchess herself, young and serene in her pale, pearl-like beauty, her head and neck adorned with real pearls and her dress an intricate triumph of white silk, black velvet and gold brocade, sat to Bronzino for a portrait with one of her very young sons (possibly Giovanni), in an image of proud if impassive Madonna-style maternity (see Plate 24). It is a masterpiece and a quintessence of court portraiture. One might be looking not at the beginnings of a ducal dynasty, sprung up in a deeply republican city, but at the culmination of a lengthy line of some country's reigning sovereigns. In Bronzino the duke and duchess had a painter whose polished artistic assurance matched their joint personal and political one.

Not since Lorenzo 'the Magnificent' had the head of the Medici family and Florentine state been so prolifically a father. Like his ancestor, Cosimo manoeuvred the children's destinies, marrying off or planning to marry off his daughters advantageously and arranging for Giovanni early to be made a cardinal, while Francesco was treated from birth as heir to the dukedom still being carved out. Much had yet to be striven for, despite the propaganda air of total control. In the early portraits for which Cosimo too sat to Bronzino, he is depicted in full armour, very much the alert warrior, a contemporary St George who will fight and defend Florence — and will go further, going on the attack.

Where even Cosimo was defenceless was in the face of death. As father and prince he was to see death ravage his family, starting with the death of Bia when still a young child. Two of his daughters died before they were twenty. In 1562, within a month, there died Cardinal Giovanni and his younger brother Garzia, both succumbing to malaria. The duchess was already an ailing, perhaps consumptive woman — portrayed in another, sad portrait by Bronzino, sumptuously dressed as ever but in physical decline. Following rapidly on Garzia's death came hers.

In his grief, the duke was stoical, but perhaps never the same man again. He fought back, however, contriving that another son, Ferdinando, should be made a cardinal and continuing to work for the grand ducal crown, though some of his formal powers were transferred to Francesco in 1564. He lived on for another ten years, dying in the same year as his faithful artistic servant Vasari. He had kept Vasari employed. 'Like Solomon', in Vasari's words, he wished to have churches restored, in addition to all the other architectural and sculptural schemes he had initiated in and around Florence. Santa Maria Novella and Santa Croce – the city's two great Dominican and Franciscan churches – were thus 'improved' by Vasari, and the duke gave Bronzino, himself growing old (dying in 1572), some late religious commissions.

A marked religiosity was once again creeping into the atmosphere of Florence, due perhaps to the arrival of the Jesuits, and bringing with it a puritan aesthetic. Perhaps it should be seen not as new but as a revival, with different emphases, of the emotions stirred up by Savonarola. The sculptor and architect Ammanati protested to the Accademia del Disegno in 1582 about representations of the nude and reinforced his intolerant attitude in a plea to Duke Ferdinando I in 1590 for banning and removing all those naked images that made Florence 'a nest of idols or of lustful, provocative things'. Sensibly, the duke did not undertake what could have been a huge task, beginning with Ghiberti's *Eve* on the Baptistery doors and Donatello's bronze *David*.

Despite Vasari's praise, Duke Cosimo had not been primarily an instigator of religious buildings. His concerns for Florence as a physical entity were far wider and more obviously practical. He might well have thought that the city needed no more churches, but there was one type of semi-religious monument that his own private experiences sadly prompted, reinforced by his Medici inheritance and his own dynastic achievement. He planned that there should be a third sacristy at San Lorenzo, to serve as a mausoleum for his immediate family: his parents, the Duchess Eleonora, his children and himself. It would be of variegated marble, and Vasari was designing it at the date (1568) of the reprint of his *Lives of the Artists*.

This final grand enhancement of Florence Cosimo did not live to see. Its concept developed and was enriched when realised, and perhaps the duke would have been gratified to know that the winner of the competition for the design was the illegitimate child of his premature old age, Don Giovanni de' Medici.

The debt of Florence to Duke Cosimo I is enormous, but it has never been very generously recognised. Lacking the supposed charm and glamour of Lorenzo 'the Magnificent', he has failed to become a figure of myth, enlightened, perceptive, talented

and applauded. The very art he encouraged and ordered is often, if only tacitly, depreciated, sometimes by comparison with that of the fifteenth century. And a final irony is that no previous ruler of Florence – few among rulers anywhere in Europe – took such pains to ensure that his image in every guise, as prince, as father, as warrior and as statesman, should be preserved, along with images of his family, for posterity.

T HERE ARE SOME good – or at least understandable – reasons why the image of the Grand Duke Cosimo I and the nature of his achievements for Florence, and the many tangible monuments of his reign to be found in the city, have – with a few exceptions – failed to excite any wide, popular interest.

His reserved, somewhat secretive and distinctly forbidding personality exercises, on the available evidence, little human appeal. Combined with an unsensational, indeed uxorious private life, his ruthless efficiency and ability as a ruler deprive his career of the sort of colourfulness enjoyed posthumously and unfailingly by, say, Henry VIII of England, a contemporary sovereign until 1547. Not much can be made of the fact that after Eleonora di Toledo's death Cosimo took a mistress or two and eventually married one, Camilla Martelli, shortly before being crowned Grand Duke of Tuscany in 1570. Yet there is human poignancy, if no obvious drama, in the dwindling into premature near-senility of a man previously so strong both physically and mentally; and in his having elevated his family to such semi-royal status that he had virtually to apologise to his eldest son, the future Grand Duke Francesco, for marrying a commoner. Francesco's fears extended to the prospect of the woman receiving and keeping valuable Medici jewels.

Posterity generally would probably have taken a greater interest in Cosimo had he been more flagrantly tyrannical and less calmly competent as ruler, father and husband. The draining of marshes and the organising of a census of a city's inhabitants (Florence, in this case) are not the first attributes associated with Italian Renaissance princes, and certainly do not provide thrilling 'copy'. And then some of the more visible and famous civic memorials to Cosimo's rule, such as the Ponte Santa Trinita, came into existence for entirely prosaic reasons. A new bridge would not have been built had there not been a flood in 1557 which washed away the old structure. And although Cosimo instigated an enormous quantity of artefacts and architectural projects, all of which should in principle contribute to an alluring image of him as enlightened Renaissance patron, his actual aesthetic response to works of art seems rather unsure and was possibly never very intense. It is depressing – and probably significant – that though Cellini sculpted a bust

of him in bronze (now in the Bargello), Cosimo effectively sent this imperial and imperious likeness – truthful, at the same time, down to the prominent, hairy wart on Cosimo's left cheek – to exile at Elba, while an unanimated, thoroughly tepid marble bust of him, executed by Bandinelli (also now in the Bargello), was kept in the ducal apartments in the Palazzo Vecchio. Well may one go on to wonder if Cosimo ever realised quite how superb as works of art were the portraits Bronzino produced of and for him and his family, far transcending mere likenesses. (So too may one wonder, incidentally, with perhaps yet more reason, about Henry VIII's appreciation of his court painter, Holbein.)

Benvenuto Cellini: Bust of Duke Cosimo I de' Medici, *Museo nazionale del Bargello.*

Leaving aside the personality of Cosimo, other hindrances exist to widespread understanding and wholehearted response to the art and architecture taking shape in his reign, and subsequently in the reigns of his two sons, which carry Florence into the seventeenth century.

It may sometimes be a matter of location or use, as with Ammanati's *Neptune* fountain, which appears rather casually sited in the huge and irregular Piazza della Signoria, and as with Vasari's Uffizi nearby, an ingeniously designed pair of buildings. They were built as government offices. They connect the Piazza with the bank of the Arno but their original functions have become lost in the association of the Uffizi with its celebrated picture gallery. There is little or no inducement to study the exterior architecture of a building daily under tourist siege and encumbered with postcard and souvenir stalls.

It is true that Renaissance fountains better planned and executed than the *Neptune* can be found in other Italian cities, notably no further off than Bologna. The big, blanched statue of the sea-god suffers from a sense of constriction, caused by the nar-

Giorgio Vasari: The Uffizi

rowness of the block of marble from which it was carved. Yet Florence had been poorly provided with any grand-scale fountains before this one was constructed. The giant figure enlivens the Piazza, and the fountain is made attractive by the inventive assembly of sea-creatures in bronze, clustering on its rim, though several of them are by sculptors other than Ammanati.

Even more worthy of appreciation is the Uffizi as a piece of architecture. A visit is perhaps best undertaken in the evening, when the crowds and the stalls have departed, and only their grubby detritus is left behind. It deserves to be approached from the river side, through the scenographic grandeur, unprecedented in Florence, of its high-arched loggia, which frames the view down the twin, colonnaded façades towards the bulk of the Palazzo Vecchio and the stern, castellated silhouette of its tall tower.

The plan imposed order as well as grandeur on what had previously been something of a jumble of houses of different heights. Instead, there was created virtually an

enclosed street of officialdom, at once solemn and regular yet far from dull. The actual space was not great, but the long colonnades (with probably an echo of those of the official Procuratie Vecchie at Venice) give a certain spaciousness and allow for lingering as well as protection from the weather. Quite novel was the concept of an open-air pantheon of statues of Tuscan worthies, to fill the niches between the pillars and increase the official, state-like atmosphere of the area. With this building, rather than by his too numerous paintings, Vasari made a significant and lasting contribution to the Florentine urban scene.

Other obstacles to appreciation of a period that is in fact fascinating come from mere accident. Both the *Neptune* fountain and the Uffizi are partly collaborative achievements, requiring scholarly analysis in matters of attribution which are unlikely to engage the average person. There is also a perceived lack of vivid artistic personalities – Cellini apart – in the later Renaissance in Florence. Vasari himself is no tortured or profoundly intellectual genius. Bronzino is, in human terms, enigmatic if not dim. The great sculptor Giambologna is a figure only recently become at all familiar to the general public. It is still difficult to gain information in English about the multifariously gifted, aptly named Buontalenti, the outstanding, much-employed creative artist at the Medici court and in the city. Excellent concise yet comprehensive dictionaries of artists omit his name. Sadly, when visual artists are not written about they tend to drop into obscurity. Many people hesitate to trust the evidence of their eyes unless they have first been informed that something is worth looking at.

Finally, there has been a difficulty inherent in scholarly writing that tries to form an unprejudiced view of Florence and Florentine art at this period – attempting, that is, to judge it not in old-fashioned though still current terms of a 'decline'. Art history is fond of nomenclature, and the artistic style of this period, notionally placed between the massive pillars of 'Renaissance' and 'Baroque', may appear fragile and is not immediately definable. 'Mannerism' has been devised and indeed elevated into one stylistic label, and perhaps it has its uses as indicating the period's emphasis not so much on mannered, eccentric and capricious art (of which examples can be found in the West from medieval times up to Gustave Moreau and Beardsley, not to speak of the twentieth century) as on *maniera* in the sense of sheer artistic accomplishment, extreme elegance and conscious grace.

But it is probably more sensible, and certainly more enjoyable, to disregard attempts to tie a specific stylistic label to, for instance, Buontalenti, especially as it is unlikely to serve adequately to characterise Giambologna, though the two men were

active contemporaneously in Florence, were sometimes involved together in Medici commissions and both died in 1608, a year before their last grand ducal patron, Ferdinando I. The Florence to which their art contributed gains a point of reference by recalling that Rubens had been among the city's visitors by that date. He had come to attend the proxy marriage in 1600 of Maria de' Medici, Grand Duke Ferdinando's niece, to Henri IV of France, when the Duomo was elaborately decorated with a scheme by Buontalenti. And to Buontalenti had been entrusted the décor for the obsequies of Grand Duke Cosimo I, which took place in 1574 in the one-time Hall of the Great Council, the enlarged and redecorated Salone dei Cinquecento in the Palazzo Vecchio, a room which Cosimo continues figuratively to inhabit.

Yet if one item alone had to be selected to stand for Cosimo in all his aspects, and sum up his artistic ideals, it is not that vast, official reception space, and not even Cellini's *Perseus*, but a small, portable object: an onyx cameo (in the Museo degli Argenti in Florence), now more than slightly incomplete but still profoundly expressive of – profoundly impressed with – Cosimo's triple pride as ruler, husband and father (see Plate 23).

Small though the gem is, it is big for a cameo; and even bigger is its scope. A family group was the subject to be carved in the few inches (some seven by six) of the material, a group portrait of a kind not commissioned from Bronzino and indeed never otherwise ordered by Cosimo. The Milanese artist and engraver Giovanni Antonio de' Rossi, an almost exact contemporary of Cosimo in age, worked on the gem first in Florence and then in Rome, reporting his progress on it, as did also Cosimo's ambassador.

In profile, the duke and duchess are delicately yet precisely outlined, facing each other and surrounded by the heads of their five sons, of whom the youngest, Pietro (born in 1554), appears hardly more than a baby, clasping his mother's supporting arm, though dressed in a miniature toga. Hieratic and heavy with classical antique associations, starting of course with the material itself, the cameo shows the duke in minutely realised Roman armour, at once general and emperor, while no less minutely realised is the duchess's rich contemporary costume, with its profusion of pearls, its brocade and fur. Where all has been so skilfully worked in terms of individual portrayal, it would not be difficult at first to mistake for a natural, half-translucent stratum of the mineral the fluid, almost streamlined figure of Fame, outstretched trumpeting above the row of profiles.

Her presence is one reminder of the more public, official side of the cameo, which not only brings together a princely family group but assembles it around a circular central space, now empty, which the duke and duchess embrace and support. The space

was once filled by a medallion (now missing) which showed an image of either Florence or Tuscany. The ducal pair, gazing into each other's eyes, are fixed in the marble-like substance as complementary *genii* or tutelary spirits — merging, virtually, into a double-headed single figure — the guardian protectors of the city or the principality.

Exquisite as is the cameo's execution, its only begetter can have been nobody but Cosimo.

Gasparo Miseroni: Cup in the Form of a Shell, *Museo di Mineralogia.*

He alone, and most remarkably, would have allotted such a prominent role, the equal of his own, to his consort. The hyperbole of poets and visual artists, including the painter-poet Bronzino, vaunting her as Juno to Cosimo's Jupiter, takes on reality. By implication, she has become the mother of the state, as well as of five sons. Its design must be unusual, if not unique (certainly in Florence) in its homage to a ruler's marriage, and no other work of art of the period tells more about the place of Eleonora di Toledo in Cosimo's scheme of things.

It tells much, too, even in its material, of his expectations from art and of his taste — and also possibly of his Medici inheritance. The hard, gleaming, milky substance, capable of being polished and cut into with precision, has associations of the rare and of the imperishable. It is valuable and it will endure. Something similar in polished precision no doubt appealed to Cosimo about the technique of Bronzino's paintings, with their unyielding, quartz-like forms, and their transmutation of faces, eyes and hands into metal, enamel and ivory. A jewel carved out of onyx seems well fitted to join the treasury of antique cameos and goblets collected by Lorenzo 'the Magnificent', and at the same time it foreshadows the tremendous Florentine vogue, given particular stimulus under Cosimo's son Grand Duke Francesco, for opulent yet stylish works of art of all kinds in precious and semi-precious stones, from a vase or a figurine to cabinets and even a chapel, the Chapel of the Princes. Once established as a Florentine speciality, the manufacture of objects in *pietre dure* became and has remained a typical industry of the city, though it hardly chimes with concepts of intellectual, 'spiritual'

Florence and might seem more likely to have been fostered in sensuous, luxury-loving Venice.

Cosimo's interest in such objects is documented fact. Characteristically, his interest manifested itself in careful scrutiny of designs before an actual work was executed. For a small cup (see p. 343), fancifully shaped like a sea-shell and ingeniously balanced on the back of a tortoise (one of Cosimo's symbols, as a creature slow but sure), the wax model had to be despatched from Florence to Pisa, where the duke happened to be, and receive his approval before it could be executed in lapis lazuli. 'His Illustrious Excellency', a secretary responded, 'has seen and considered [it] and has commanded me to inform you that he is satisfied with it . . .'

Vasari fully shared his master's fondness for the highly wrought work of art in rich and recondite materials, 'hard' in every sense of the word, and demanding great skill from the executant, in addition to inventiveness from the designer. Almost salivating as he writes, Vasari lists the choice materials which were at the time (1568) being incorporated into a cabinet for Cosimo's heir, Prince Francesco: jasper, lapis lazuli, agate, sardonyx, cornelian . . . To be taken for granted were gold and silver.

That particular cabinet was designed by Buontalenti (trained as a painter under Vasari), the artist who keeps popping up with more than Vasarian versatility, and ability, in Florence of the later sixteenth and early seventeenth centuries. Vasari praised his 'beautiful genius', and of that Buontalenti was to give some substantial architectural demonstrations in the years following Vasari's death. Always in Medici service, and always in demand, whether creating designs for an ephemeral occasion or for a major building scheme, Buontalenti was nicknamed 'delle Girandole' (of the fireworks) in tribute to his brilliantly contrived firework displays. The effect of those is inevitably lost, but Buontalenti was no less brilliant at contriving fireworks in masonry, with effects fizzing, capricious and astonishing, which break many a solemn, supposed rule of architecture as stone is twisted and bent, and pulled and pricked, as if it were so much pastry.

It might seem something of a paradox that such invention and such lighthearted effects — not just reserved for villas and gardens but appearing on and inside urban buildings — should develop in Florence during the reigns of grand dukes as resolutely unlighthearted as Cosimo and his eldest son. But, especially with Cosimo, the far more conscientious public and publicly minded ruler of the two, art and artistry of every kind was in constant requisition. The artist, whatever his medium, came under intense pressure — not necessarily unenjoyably — to show off and perform, frequently achieving technical feats of the greatest ingenuity in the handling of his material.

The Grand Duke Francesco was himself a more than competent, semi-scientific craftsman, no dabbler but expert in gem-cutting and inventive in devising methods of creating *objets d'art* out of rock crystal. In him his mother's passion for jewellery took a practical turn. Indeed, he needed his own laboratory and eventually his own completely separate foundry establishment. He had the Casino Mediceo, near to San Marco and in the same street as the old Medici Palace, specially built for this purpose. His architect was Buontalenti, who created a residence that was a cross between a villa and a palace.

At first glance, the Casino's long façade on the Via Cavour looks modest enough and demurely 'Florentine', but when its detail is examined more carefully the flat frontage is seen to be bristling with a variety of fantastic, decorative motifs. Under the ground-floor windows are inwardly curving sills supported by bulging consoles framing giant shells and dependent, tasselled wreaths. On the first floor the lintels of the windows are set high and seemingly detached from them to project along the façade in thin slabs, which in sunlight read like Morse Code dashes realised in stone. The principal entrance to this elegant and unusual building, which flaunts its personal and eccentric character as if to emphasise it is an unofficial, private dwelling, though of an important personage, sums up that dual message with a fluent, theatrical verve unprecedented in Florentine architecture (see p. 346). Although the portal is lightly rusticated and carries a rect-angular balcony above it, there is a marked sense of movement around the arch of the doorway framed by an extraordinary, wavy, pie-crust-like frill that curves upwards to become the huge cartouche for the Medici arms, topped by the grand-ducal crown. Over that juncture of portal and balcony are thrown the thick folds of a fringed drapery sculpted out of stone. It is the sort of effect that might be expected on a baroque tomb but rarely on a building, and definitely not on one in sixteenth-century Florence. The balcony above is positively playful in its vivacious decoration. Between the interstices of the balustrade runs the zig-zag of an elaborately carved wreath, and each baluster post is topped by the moulded mask of a leonine animal head.

Most bizarre of all is the treatment of the inner arch of the doorway, filled by a graceful shell – a respectable fifteenth-century motif here interpreted with rippling effect, not so much solid as silken, like that of a fan unfurled. Emerging tortoise-like from under the shell are the paws and head of a monkey. Perhaps there is meaning in the juxtaposition of inanimate and animate, and possibly a hint additionally of mysterious or magical goings-on in the building where this whimsical imagery greets any would-be visitor. Buontalenti was no stranger to Francesco de' Medici (whom he had accompanied on travels in Spain when the prince was twenty-one) and must have been meeting his

Bernardo Buontalenti: Entrance Doorway of the Casino Mediceo.

patron's wishes in designing the casino, just as he had met and would meet them on numerous other occasions. Ingenious, unexpected and partly playful as his doorway may be, it is also majestic. Of all its motifs the most dominant is the gracefully devised but

distinct reminder of worldly status: that cartouche of the long-familiar Medici *palle*, displayed surmounted by the latest, greatest symbol of their attainments, the grand-ducal crown of Tuscany. It was still a novelty, politically and aesthetically, when this doorway was built, around 1574, but it would soon become a common sight in Florence, as it became a common fact – never without recalling that its achievement was due to Duke Cosimo.

Buontalenti's profuse though scrupulously calculated vocabulary, with its masks and mouldings and bold treatment of decoration, as revealed at the Casino Mediceo, was to have a strong and liberating effect on Florentine architecture. Doorways both more imposing and even more fanciful would subsequently appear on palace façades but they have today to be sought out in busy streets. Sometimes there is no convenient vantage point from which to study them, and often the overall sobriety of the Florentine palace idiom, never fully emancipated from its fifteenth-century origin, obscures or tends to nullify the decorative novelties and freaks of fantasy which the buildings bear, rather like patient, dressed-up elephants. The architecture of the un-elephantine Casino Mediceo itself receives no mention in several modern, useful and otherwise admirable guidebooks.

Plain and blunt, indeed brusque, as Duke Cosimo was, he was not unsophisticated. He took a serious interest in the challenges involved in any technical aspect of the art he commissioned, as Cellini's convincing record of their sharp exchanges over the *Perseus* shows. When the duke saw the wax model, he admired its beauty, but soon afterwards he questioned how it could possibly be cast in bronze. Of course, Cellini's narrative famously describes how, despite the duke's doubts, he succeeded; but Cosimo's sceptical probing, along with his willingness to hear the artist's answers, suggests his pragmatic, practical approach.

He was more practical than aesthetic when, on another occasion, he refused at first to buy a handsome-looking pearl necklace coveted by the duchess, because the pearls had flaws, although eventually he gave way to her importunity. The pearls (which involved Cellini as expert in an amusing if awkward predicament, caught in the cross-fire between wife and husband) were probably baroque ones, big and showy despite not being regular or of great value. Pearls of that kind were increasingly to be used for jewelled pendants and trinkets all over Europe. Their shape served to stimulate extravagant creation of realistic or fanciful animals and birds, as well as mythological beings, executed often in enamelled gold, with the irregular pearl employed as the body. Within a generation or two, the descendants of Eleonora and Cosimo would be adding such jewels to the existing accumulation of fabulous Medici treasures.

Basic difficulties arise in defining anything that could be called Cosimo's 'taste', not only because of lingering doubts over whether he possessed a coherent aesthetic viewpoint but because of the sheer variety and sweep of the projects he set in hand, and which ranged throughout his kingdom, far beyond Florence. His was almost a bifocal vision, whereby the arts might be employed now on a major scheme of town planning, with all its public state associations, and now on the minor, private yet still to him important task of fashioning an elaborate girdle in gold as a gift for his wife.

Of style as such he was perhaps hardly conscious. A work of art or architecture had to meet the criteria of being functional and accomplished, as well as 'truthful' by his standards in conveying the message he intended. What was said was more important than how it was said. As de' Rossi's cameo originally showed, he did not disdain allegory, if allegory reflected what he saw as reality: himself and his duchess guarding Florence. When Vasari submitted his design for a picture of Cosimo and his councillors planning the conquest of Siena (as part of the painted decoration of the ceiling of the Salone dei Cinquecento in the Palazzo Vecchio), Cosimo delivered a crushing yet revealing verdict: there was no need to depict any councillors, as 'we were alone'. In place of councillors Vasari could supply some figures of Virtues, and Cosimo named a highly significant one, the Virtue of Silence. Thus the final composition is a memorably direct portrayal of the duke in his study, fiercely preoccupied with his plans (rather as Napoleon would be portrayed by David) and oblivious to the abundant allegorical personifications, naturally including Silence and also a *putto* bearing a laurel crown, with which Vasari has surrounded him. Aesthetically, the two idioms coexist awkwardly, but for Cosimo's purposes the result is fine. And, indeed, it has its own sophistication. He himself is accurately painted, 'alone', while his good qualities and his victory can be deduced from the subordinate figures.

Too much mere allegorising might blur his intended message. Vasari had conceived the central roundel in the ceiling of the Salone dei Cinquecento as a manifestation of Florence in all her glory. The duke had himself substituted as the protagonist, basking in his own glory, and Florence was reduced to being a female figure who crowned him.

The most practical aspect of Cosimo's patronage is represented by the immensely long corridor he had Vasari build, to connect the Palazzo Vecchio to the Palazzo Pitti. It had to be built speedily, virtually bulldozing private dwellings that lay in its path – rather as the area around the Uffizi had been fairly brutally cleared to make the space necessary for its construction. The corridor crossed the Ponte Vecchio, running above the shops that were then of varied trades, not solely for goldsmiths, and passed through the church

of Santa Felicita, which received a remodelled porch as a result, and inside an opera-box gallery was created from which the duke could attend mass.

One obstacle to the corridor's linear progress was the old, medieval tower belonging to the Manelli family and situated close to the Ponte Vecchio on the Oltrarno side. The family protested against proposals for their property to be intruded on, or purchased. Their success is apparent today. The Manelli tower remains standing, and at that juncture Vasari's corridor can be seen to project outwards, having to make its detour around the structure. It is a rare monument to a rare occasion, of the duke not getting his own way.

If the corridor represents Cosimo at his most severely functional as commissioner, Cellini's *Perseus* represents him at his most fanciful, or indulgent, sanctioning a work of art which might not have been expected to find immediate favour with him. But the *Perseus* – so famous that it is one of those works of art more easily nodded to on the spot than paused over – has much to convey about Cosimo, as well as about its creator, as also about the period in Florence during which it was created.

According to Cellini, Cosimo mentioned that for some time he had wanted to have executed a statue of Perseus, when he and the sculptor met at Poggio a Caiano in 1545, shortly after Cellini returned from France. For his part, Cellini spoke about being eager to sculpt 'a great statue on his handsome piazza' (*'sua bella piazza'*). So, from the first, it seems, the statue was destined for the most public of spaces in Florence, the Piazza della Signoria, outside what was then Cosimo's palace. It was also the area – the arena – of artistic focus and competition. Michelangelo's giant *David* stood at the palace entrance, flanked by Bandinelli's *Hercules and Cacus*. Within the palace courtyard was Donatello's bronze *David*, on a column, and in the shelter of the Loggia dei Lanzi, yet very much on exhibition, was his bronze group of *Judith and Holofernes*.

Into that testing environment Cosimo and Cellini agreed to introduce a new piece of sculpture – both risking their reputations, but both having an urge to demonstrate their different kinds of power and accomplishment. Cosimo avoided a biblical subject, with its overtones in Florence of the republic as well as of religion. Nevertheless, Perseus was a hero of mythology celebrated for a single act of outstanding bravery against the odds, for killing the baleful monster of the Gorgon, Medusa – much as David and Judith had, against the odds, taken on and slain Old Testament enemies.

Perseus was a hero far less frequently represented in Renaissance art than Hercules, for example, and perhaps partly appealed to Cosimo as a subject for that very reason. Political use of him as a symbol was made elsewhere during the sixteenth century. In a

tableau vivant at the entry of William of Orange into Brussels in 1577, William was portrayed as Perseus, liberating the Netherlands. The story of Perseus was an unusually exemplary one, effectively ending happily when he killed a monster and released Andromeda, chained to a rock as a sacrifice, and married her. As Donatello's *Judith*, in particular, had earlier been turned into a symbol of republican release from Medici tyranny, so Cosimo doubtless meant the Perseus to reverse the symbolism. Medici triumph was embodied in the youthful naked figure who, aided by the gods (as Judith and David, by Jehovah), has killed the Gorgon and holds aloft her severed, bleeding head. As even in death her gaze can petrify, some admonition to the citizens of Florence may well have been in Cosimo's mind when thinking of the subject. He might also think of the perils of Perseus' mother, Danaë, exposed at sea with her son when the hero was a baby, and of the hero growing up fatherless, though his father was a god, Jupiter. The widowed Maria Salviati and her son had not faced precisely that ordeal, though they had once fled from Florentine territory to Venice. But Cosimo was considerably indebted to her for his upbringing and tactful introduction on to the larger political scene. She had died two years before Cellini and Cosimo met.

The duke approved Cellini's model for the statue, although any grim or gory elements implied by the choice of story seem early to have disappeared from the concept, and the final statue is delicate, graceful and elegant. If not as pensive as Donatello's *David*, Cellini's boyish hero is unexultant and modest in victory. Killing the Medusa was a feat less of strength than of ingenuity. Mercury had lent Perseus his wings and the short sword which Cellini has him hold; Minerva had lent her shield, an element in the incident that Cellini omits. The contest was thus totally different from the trial of strength exemplified by Hercules overcoming Cacus.

A subject and interpretation permitting grace rather than force suited Cellini's art. He took care to study both Donatello's bronzes nearby, especially *Judith*, to which his statue — once its location in the Loggia dei Lanzi was settled — would form a pendant of sorts. The earlier Cosimo de' Medici had commissioned that sculpture, and now another Cosimo continued the pattern of patronage. As Donatello's Judith treads on the body of Holofernes, so Cellini's Perseus is poised on the headless corpse of Medusa. In Donatello's sculpture a cushion lies under Holofernes, suggesting his sleep in his tent. Cellini put a cushion under Medusa, but it has no relevance to the subject and adds a slightly disconcerting boudoir touch.

More revealingly, Cellini could not match — supposing he wished to — the tense and sombre mood of Donatello's piece, despite the similarity of theme. Effortlessly, Perseus

has performed a deed which is somehow lacking in impressive horror, although, or even because, it is conceived with bravura virtuosity. In death the body of Medusa is cleverly collapsed, folded over not unlike a deck-chair – and from it spurt, as from her upheld severed head, serpentine streams of blood, modelled in bronze that seems gravity-defying and yet half-molten. The effect is astonishing, and it is justified, for according to some versions of the story Medusa's spilt blood became snakes. Nobody could fail to admire Cellini's statue, which enjoyed success in Florence from the day it was installed. But nobody could detect in it much significance, psychological or symbolic. Incongruously, as far as the characters of patron and artist are concerned, it only just escapes the danger of being over-refined. It stands quite outside the ethos of Donatello and looks forward, rather, to that of a much later, Anglo-Saxon sculptor, Sir Alfred Gilbert.

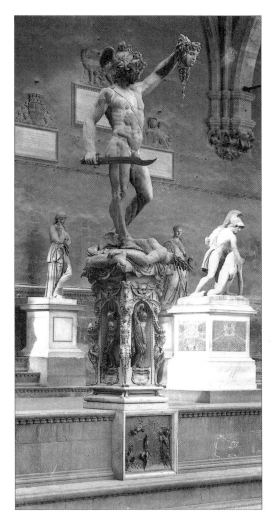

Benvenuto Cellini: Perseus, *Loggia dei Lanzi, Piazza della Signoria.*

Where Cellini was most himself, one feels, was in creating for his statue a pedestal. That word poorly describes the tall, highly wrought, encrusted and also hollowed-out marble base, with four scalloped niches for statuettes in bronze. It can be appreciated as a separate work of art: no mere pedestal but an altar to sixteenth-century Florentine fondness for fantasy, as well as to the gods who had aided Perseus. Buontalenti might have gazed respectfully at this copious though by no means confused medley of interlaced and intricate motifs, curving and covering every inch of the material, with wildly staring masks and goats' heads and scrolls and garlands, and a many-breasted caryatid positioned sphinx-style at each corner.

All or most of the imagery could be explained by sophisticated exegesis, beginning at the simplest level with the goats' heads that allude to Cosimo's zodiac sign of Capricorn. That he and his duchess were delighted by the slim statuettes for the niches we know from Cellini. The duchess coveted them for her own collection, understandably. At once elegant and nervously vivacious in pose, and slim to the point of being anorexic, the five naked bronze bodies belong to one single stylish family, artistically and humanly, from the boy Perseus by his young mother's side to the mature, paternal Jupiter who brandishes a thunderbolt (and that Cosimo's father's symbol was the lightning flash seems pertinent).

Cosimo's approval of the *Perseus*, pedestal and all, is evidence that he was able to enjoy novelty and fantasy and sustained, refined richness in a work of art that — whatever its instigation — approximated finally to art for art's sake. He gave Cellini a superb opportunity, and Cellini excelled himself in responding.

Cosimo deserves credit also for a wider view. Like the later *Neptune* fountain, the *Perseus* was part of his plans for improving and making visually harmonious the whole Piazza della Signoria, plans that never reached fruition, any more than had his first impulse to have the exterior of the Palazzo Vecchio modernised. In Florence a residual medievalism and traditionalism resisted — much as the Manelli would when their old tower was under threat — attempts to create out of it a fully Renaissance city, as a second, much grander, mainland Cosmopolis.

Nevertheless, what Cosimo achieved for Florence as his capital was as substantial as his achievement for his dynasty — and, unlike that, it has endured. The Florence of worldwide fame and appeal would drastically drop in popularity, and be drastically diminished both culturally and artistically, were it deprived of every monument that Cosimo added to it. Some of its familiarity would be lost without such landmarks as the Uffizi and the Ponte Santa Trinita, and the *Perseus*, and the Boboli Gardens as well. That is very far from completing the tally of even the more public and visible contributions he made to the city, but it gives some indication of their magnitude.

CHAPTER TWELVE

The Princely City

I T HAD TAKEN an international army and a traumatic siege to force on republican Florence its first duke, Alessandro de' Medici, and only his sudden, bloody, unforeseen murder had thrust Cosimo de' Medici from obscurity to succession.

By contrast, it was in an atmosphere of decorous tranquillity, and inevitability, that on Cosimo's own death in 1574 he was succeeded as grand duke by his eldest son, Prince Francesco. Not the least of Cosimo's achievements had been to ensure a smooth transition of power by virtually abdicating ten years earlier, handing over a city and a state at peace, administered efficiently and justly. To consolidate the succession, he arranged the grandest of marriages for his heir, to Joanna of Austria, sister of the Holy Roman Emperor, Maximilian II. It proved useful in terms of Medici status, for in 1576 Maximilian accorded formal recognition to his brother-in-law's *de facto* claim to be Grand Duke of Tuscany. As a marriage dynastically splendid but personally unhappy for both parties it was, however, to set an unfortunate precedent for later Medici grand dukes, and in offspring it produced only daughters and a single sickly male child, who predeceased his father.

Nevertheless, no interruption or challenge arose to the continued succession of Cosimo's descendants. It was as though his legacy — already rich enough metaphorically and in actuality — included a guarantee of inheriting the grand-ducal crown. When Grand Duke Francesco himself died in 1587, to be succeeded by his brother Ferdinando, half a century had elapsed since Alessandro de' Medici's dramatic murder. Florentine citizens who could recall that event were growing fewer, and fewer still must have remained committed republicans. Cosimo's system of government made skilful use of numerous important-sounding and sometimes actually important functionaries. The patrician class in Florence was able to believe it was playing its part in the Senate and on various councils, some of which continued to bear the traditional titles they had had in the old days of the republic. A middle class of professional men (though often not Florentines) found employment in the extensive bureaucracy. The populace, the labouring lower class and the very poor had sunk into respectful quiescence.

No doubt grumblers about the grandeur and style, and regime, of the Medici grand dukes were to be found in the city, but the famed unruliness of the Florentine people seemed — and indeed was — a thing of the past. The style and grandeur with which the Medici now reigned had itself become something traditional and a matter for pride. Florence was conditioned to expect on the slightest provocation festivities that were lavish, open-air and partly accessible to everyone, while such important events as the marriage of the grand duke's heir were celebrated with increasingly elaborate and ingenious — almost scientific — pageantry, each manifestation vying in splendour with the previous one and all helping to reinforce the sense of Florence as uniquely glorious.

When Leo X had made his celebrated *entrata* in 1515, he was in effect being welcomed home, although he was not expected to stay. The pageant-receptions of the customarily foreign brides for Medici sons were more a matter of introducing these fortunate women to the manifold glories, cultural and artistic, of the city where they would, it was hoped, settle down to become fruitful mothers and eventually beneficent partakers in their husbands' rule.

A complete conspectus of Florentine history, from its largely mythical origins, going back to Mars and his 'temple' of the Baptistery, and coming up to the verge of the present with the only recently deceased Michelangelo, was arranged to greet Joanna of Austria when she entered Florence in 1565. This was the most magnificent of all such pageants up to that date. It was so huge in scope and so complex in design, as well as highly sophisticated in its learned, often local, allusions, that the bride can scarcely have comprehended a quarter of what confronted her in the yards of painted canvas, the Latin inscriptions, the emblems, the statues and arches and other edifices, as she progressed from the Porta al Prato through the city, via the Duomo, to the doorway of the Palazzo Vecchio. Whether or not she managed to notice it, the image of her father-in-law, Duke Cosimo, had been a ubiquitous feature of the decorations, and a further instalment of freshly painted scenes from his life awaited her within the courtyard of the palace.

Although the decorations naturally included several complimentary to her and to the House of Austria, and ostensibly the whole scheme had been devised to pay her honour, the underlying theme was a celebration by Florence of Florence past and present. Interwoven with that was a concise account of the Medici family, beginning chronologically with a portrait of Giovanni di Bicci but steadily and subtly insisting at each turn on the qualities and deeds of the living Duke Cosimo.

To the Florentines, rather than to Joanna of Austria, was all this propaganda

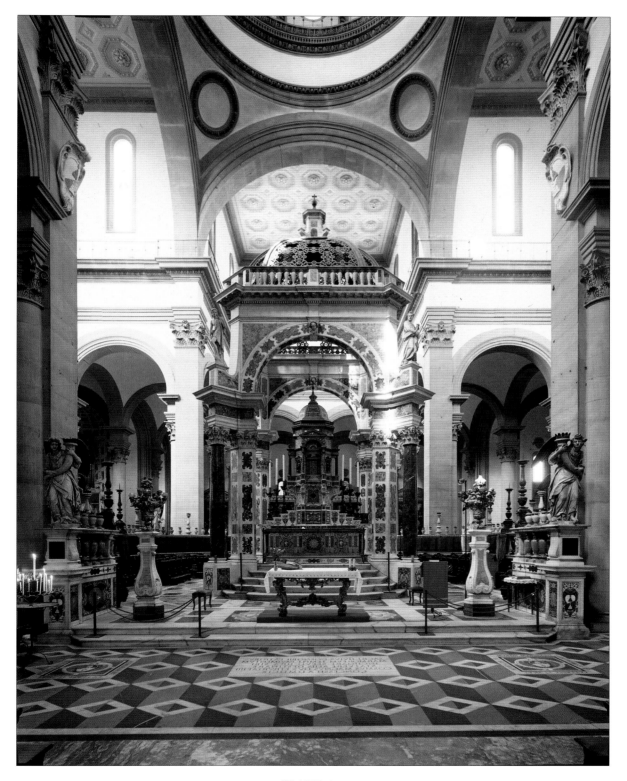

PLATE 27

Giovanni Caccini: *Baldacchino of the High Altar*, Santo Spirito

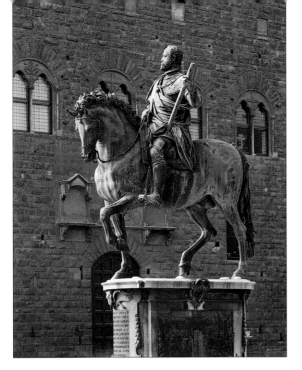

PLATE 28

Giambologna's statue of Grand Duke
Cosimo I de' Medici, Piazza della Signoria

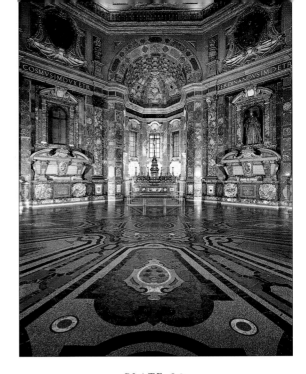

PLATE 29

Interior of the Chapel of the Princes,
San Lorenzo

PLATE 30

Pietro Tacca (and others): *Statue and Sarcophagus
of Grand Duke Ferdinando I de' Medici*,
Chapel of the Princes,
San Lorenzo

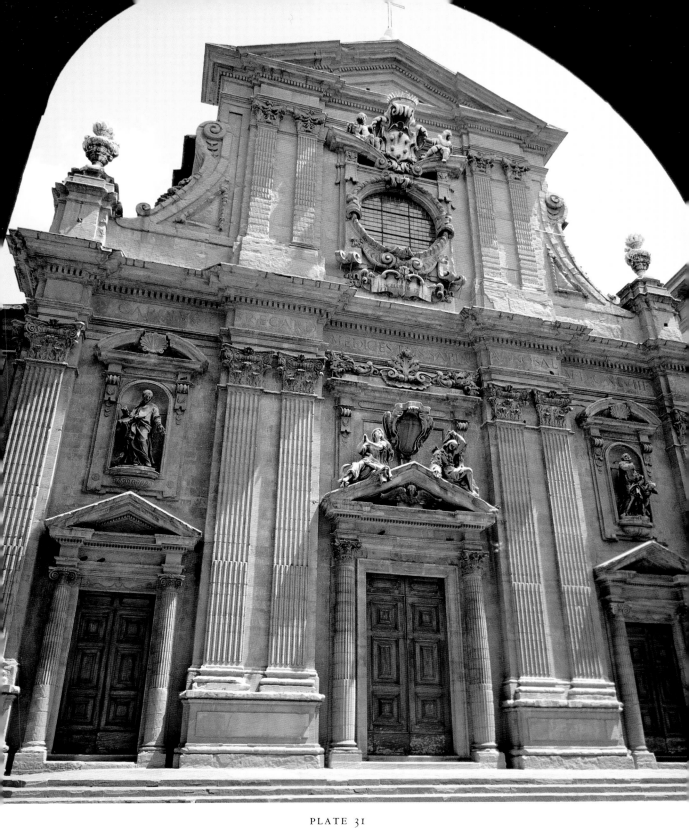

PLATE 31

Gherardo and Pier Francesco Silvani (and others): *The Façade of Santi Michele e Gaetano, Piazza Antinori*

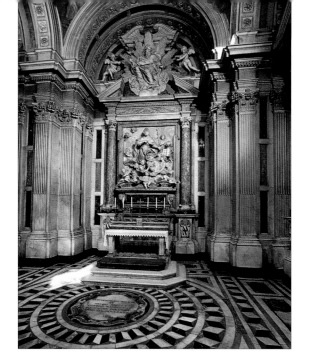

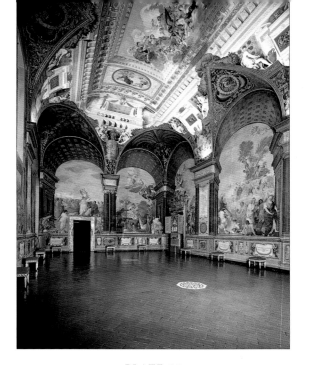

PLATE 32

Giovanni Battista Foggini: *The Chapel of St Andrew Corsini*, Santa Maria del Carmine

PLATE 33

Giovanni da San Giovanni (and others): *The 'Giovanni da San Giovanni Room'*, Museo degli Argenti, Palazzo Pitti

PLATE 34

Michele Castrucci (and others): *Ex-voto of Grand Duke Cosimo II de' Medici*, Museo degli Argenti, Palazzo Pitti

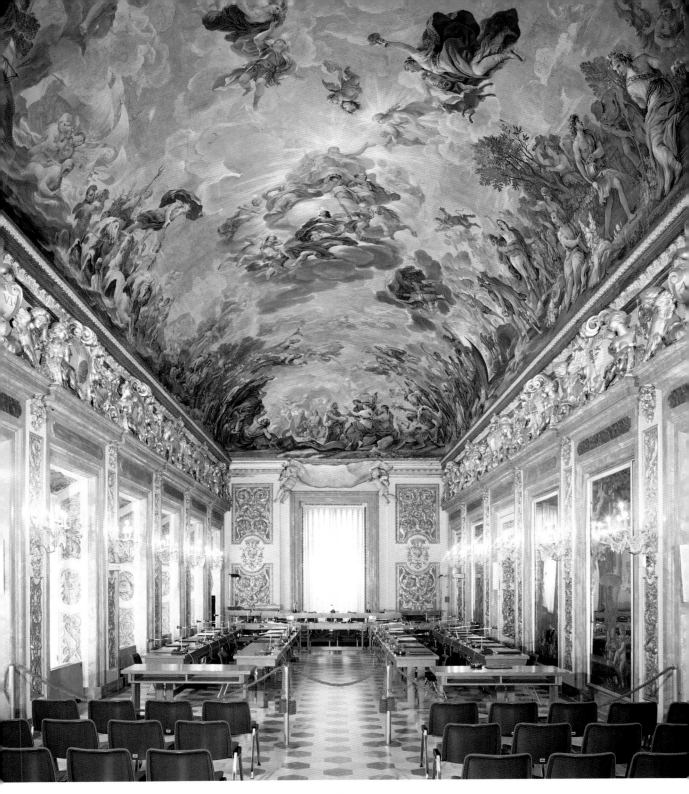

PLATE 35

Luca Giordano (and others): *The Galleria,*
Palazzo Medici-Riccardi

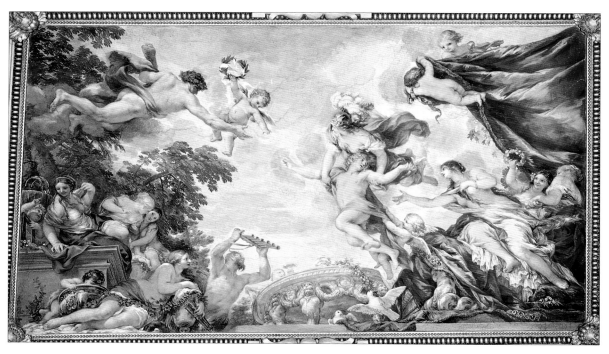

PLATE 36

Pietro da Cortona: *The 'Venus Room'* (detail), Palazzo Pitti

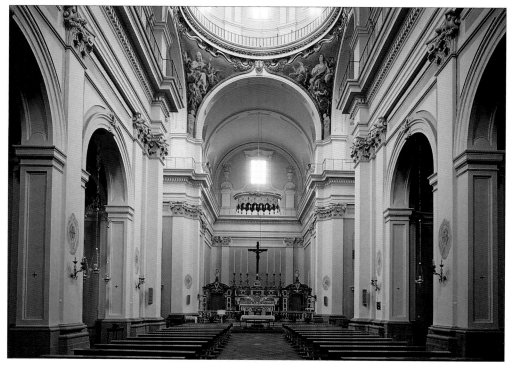

PLATE 37

Giulio Cerruti (and others): *Interior of San Frediano in Cestello*

PLATE 38

Bernardino Radi: *The 'Palazzo delle Missioni'*, Piazza de' Frescobaldi

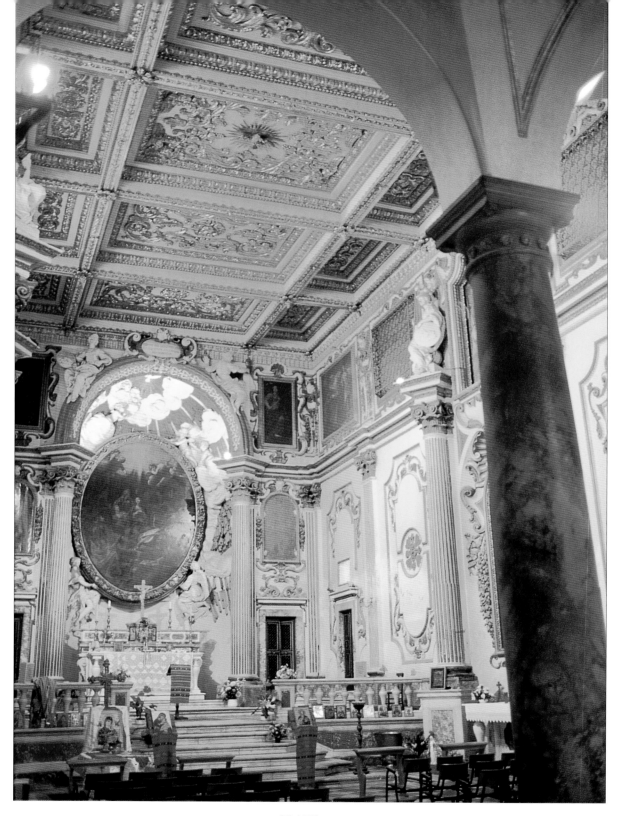

PLATE 39
Giovanni Battista Foggini: *Interior of San Giorgio alla Costa*

pageantry addressed. At the same time, it was far too cleverly calculated to express merely mindless or offensive adulation of one man at the expense of the city and civic susceptibilities. Some of the other great and ancient families of Florence – the Strozzi, Acciaiuoli, Donati and Albizzi – were represented by outstanding personages in the anthology of history, albeit as 'bit' players. Florentine self-esteem must have been gratified to see Navigation represented by Amerigo Vespucci. Piero Capponi, famous for his defiance of Charles VIII of France, was depicted, and so too, less expectedly, was the republican warrior Francesco Ferrucci.

The occasion was one for unity, for stimulating corporate pride and patriotism, in a way that perhaps none of the earlier *entrate* had managed or meant so purposefully to do. How much thought and care went to the devising of the minutest details is apparent from the correspondence exchanged between the two chief collaborators, Vasari and his friend Don Vincenzo Borghini, responsible respectively for the visual and the literary aspects of the celebrations. Vasari had his own literary concerns, and Borghini, a priest appointed by Cosimo as Prior of the Ospedale degli Innocenti, was something of a connoisseur of art as well as a *littérateur*. In addition to friendship and interests in common, they shared Cosimo's favour and a sensitivity to the atmosphere both at court and in the city. Who should be 'in' and who 'out' among the candidates for depiction was one intriguing topic of discussion, and a certain irony attaches to the subsequent explanation that a portrait of Varchi would have been included among the famous Tuscan literary figures represented had he not been alive (though in fact he died before the end of the year).

Three or four things seem especially significant about the pageantry which Francesco de' Medici's marriage occasioned, and each tends to lead back to his father, Cosimo. Taken together, they make of the wedding (itself ultimately of no consequence) an entirely justified celebration of how far Florence had advanced under him. It was a moment to look round and reflect on the city's prestige and possessions.

Unmistakable was the confident air surrounding the event. It might be a dynastic coup to obtain the Holy Roman Emperor's sister as bride for a Medici heir but the general impression diffused was of her good fortune in coming from Vienna to Florence. The royal status of the Medici family in Europe was proclaimed – as if to counter any latent Austrian snobbery – by visual emphasis on Caterina de' Medici as Queen Mother of France, shown with two symbolic children, a boy for her son, the French king, a girl for her daughter, the Queen of Spain. And that beyond Florence, nationally and territorially, lay the rest of the newly extended kingdom of Tuscany was one aspect stressed by the decorations. '*Tuscia clara*' was invoked as being united as an implied equal to Austria,

and her numerous cities were shown to include Siena, while illustrated elsewhere was Cosimo's triumphal entry there after its capture (anticipating Giambologna's relief on the pedestal of his equestrian statue).

Another significant aspect of the Florentine pageantry of 1565 is that although most of the décor itself was as ephemeral as usual, the scheme was preserved, in all its learned elaboration, by more than one written account, subsequently printed and published. Borghini and Vasari may have presumed as much from the first (Vasari supplied a very full description, not written by him, in the second – 1568 – edition of his *Lives*), and so may the duke.

The issue beforehand of a printed programme explicating the allusions and significance of the visual apparatus would have been useful, especially for the foreign bride who was seeing the city, as well as its festive décor, for the first time. As published afterwards, it served as a form of report on contemporary Florence: paying tribute to Cosimo; illustrating the gracefully learned literary climate fostered there by him, and – perhaps most significantly – providing some sort of indication of the city as a beautiful, harmonious and 'modernised' urban entity.

No guide-book to Florence had been published since Albertini's long out-of-date *Memoriale* of 1510. There was to be no other until 1591, when a much more professional and dependable work appeared, frankly entitled *Le bellezze della Città di Firenze*, by Francesco Bocchi. That was a true guide-book, surveying the city topographically and pausing appreciatively over its numerous and various '*bellezze*', although such major new buildings as the Uffizi were credited not to any named architect but to their instigator, Grand Duke Cosimo.

For the portion of Florence traversed by Joanna of Austria on her *entrata*, the subsequent printed descriptions provided a brief, interim guide. They made plain to what an extent the city itself had been ingeniously utilised and incorporated into the whole decorative scheme. Borghini opposed any decoration that might spoil a broad and handsome vista. So a fine street might be left relatively unencumbered, while a narrow or ugly one, or some awkward angle, was effectively camouflaged by temporary, illusionistic structures, in an ornate contemporary style – like a promise of what architecture had yet to contribute permanently to the appearance and layout of the city.

A brief pictorial conspectus, as it were, of its chief 'views' had only shortly before been produced, under Vasari's supervision, in one of the rooms for Eleonora di Toledo in the Palazzo Vecchio, that dedicated to the excessively prim wife, Gualdrada. As the sole Florentine representative of feminine virtue, she was the centre-piece of a scheme

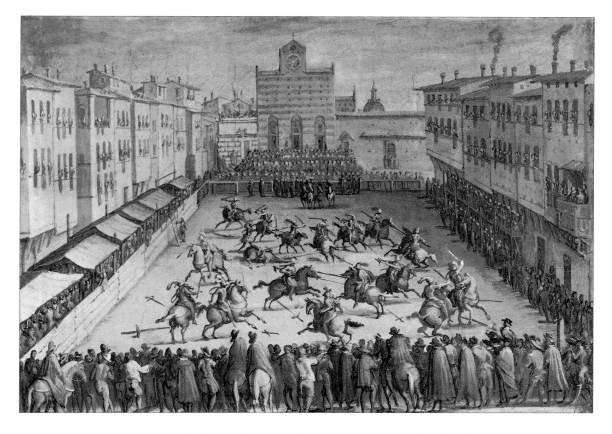

Giovanni Stradano: A Joust in Piazza Santa Croce, *Palazzo Vecchio.*

where the frieze literally reflected Florence in a series of topical, topographical scenes, showing the city as very much populated, mostly for festivities. They are the work of a non-Florentine artist, the Fleming Jan van der Straet, who became Italianised as della Strada or Stradano. As a northerner acclimatised and honoured in Florence (a member of the artists' academy and working frequently for Duke Cosimo), Stradano was well placed to survey the city with an attentive eye for human as well as architectural detail. Perhaps he was really happier with life in the streets and piazzas than with the buildings, for he presented a stolid, drab, even faintly oppressive Florence, devoid of visual glamour. The Baptistery looks to be largely of brick and oddly proportioned, and Giotto's Campanile might be an early example of factory architecture. No wonder several smoking chimneys are featured, because Stradano's city has a cold, grey feel to it. Nevertheless, as strictly urban views, and partly through their prosaic, semi-documentary character, these pictures represent something of a novelty. Great art they are not, but they underline

and recall Cosimo's steady concern for the fabric of Florence, and it would be no hindrance to his appreciation that their aim is factual.

The *Descrizione* that Vasari tacked on to the second, expanded edition of his *Lives* had its direct relevance there, since despite its minute, admiring account of the *entrata* decorations, the *Descrizione* omits any mention of who their individual creators were (apart from Vasari's own involvement in the scheme, other leading artists, such as for instance Bronzino, had executed or supervised the execution of some specific decorations). Somehow, even though it may not be stated explicitly, the credit goes back to Cosimo. And indeed, when the *Descrizione* reaches the ducal palace (the Palazzo Vecchio), it bursts into a paean in which Cosimo is compared to the Roman Emperor Augustus, for a variety of reasons, of which the last is that as Augustus found Rome brick and left it stone, so Cosimo received a Florence already of stone but will leave it to his successors vastly more beautiful, ornate and enhanced.

Some of the solid evidence underlying that rhetorical claim would be disclosed on the course of Joanna of Austria's journey through the city. And what could not be seen on the route was often alluded to pictorially. What Cosimo had done amounted to an opening-up of the city, in so far as that could be achieved without destroying too much of its dense, medieval character, or interfering with monuments that were sacred in Florentine eyes, regardless of their exact function. His instinct, if that is what it was, for greater scenic spaciousness had been anticipated in small part by Brunelleschi's scheme for the area around Santo Spirito, and was to be actively shared by most later rulers — and also by the civic planners of the nineteenth century, creating new large-scale squares, developing the boulevards along either side of the Arno and eventually razing the ancient 'heart' of Florence, the Mercato Vecchio.

Cosimo had visited Rome in 1560 (meeting Michelangelo there and hoping to tempt him to enter his service in Florence), and no doubt the experience stimulated thinking about his own capital. He had already supplied it with a new market building, the loggia of the Mercato Nuovo, in the traditional quarter of banking and mercantile activity, at the meeting point of the Via Porta Rossa and the Via Por Santa Maria. That was built for him by Giovanni Battista del Tasso, someone Vasari was conspicuously sniffy about as an architect, while praising him as a good wood-carver.

Tasso's large, open-air, pillared hall may not have been visible on Joanna of Austria's route but it gained a fleeting allusion among the painted decorations, where Industry presided over a portico resembling it. The loggia today has gone 'down-market', being so crammed with stalls of tourist tat (admittedly, not all of it unbeguiling) that any archi-

tectural quality it possesses is barely apparent, but at least the building still exists and is in use, even though both its architect and its instigator are unlikely to be familiar names to the average vendor or purchaser there.

Without much difficulty, and prompted by the *Descrizione*, one can walk along the processional route taken by Joanna of Austria, noting the efforts Cosimo had made to give the city space, cohesion and grandeur. At the same time, it is only fair to add, his efforts tend to blur with those of his immediate successors, his sons Francesco and Ferdinando. Francesco, indeed, was an active if idiosyncratic patron during his father's lifetime, and both sons added to the sense of Cosimo as a pervasive presence in the city, not least by sculpted likenesses of him on buildings. It is right to think less in terms of precise dates and more of a general impetus shared by the father and the two sons, sharing frequently the same artists and the same aims. After all, the quintessential monument of the Chapel of the Princes, which began to take shape only under Ferdinando I in 1604, had been conceived by Cosimo and would arguably never have been built but for him. Besides, not every handsome new building going up in the late sixteenth-century city was a direct Medici commission. Some of the finest palaces were private ones, following the example of the rulers and paying courtier-like tribute at times by displaying on the façade a stone escutcheon with the arms not of the owner but of the Medici.

After Joanna of Austria's procession had passed down the deliberately not over-decorated Borgo Ognissanti (a street, 'as everyone knows', the *Descrizione* enthused, 'most beautiful, spacious and straight'), it came into the wide space (today Piazza Goldoni) at the juncture of the Ponte alla Carraia, then the first of the city's bridges on the approach from the west. Although less elegant and less famous than the Ponte Santa Trinita, the Ponte alla Carraia had recently been reconstructed by Ammanati, at Cosimo's instigation, and at that point Joanna of Austria had her earliest glimpse of the Arno. The riverside avenue did not start until there, and there the personified river, a giant figure garlanded with the lilies of Florence, appeared on a decorated arch, rejoicing at the bride's arrival and seemingly just risen from the water.

The further bank of the river, across on the Oltrarno, was only patchily built on, for it was virtually the fringe of the city. The bride and her procession had to wait until reaching the next bridge, the Ponte Santa Trinita (see Plate 5), to gain some idea of Cosimo's civic planning, though on the day little can have registered of where fact began and the feigned ended, so elaborate and eye-deceiving were the decorative structures. But the bridge already served to connect the piazza in front of the church of Santa Trinita with

View of the Piazza Santa Trinita.

the wide, straight thoroughfare of the Via Maggio (properly Maggiore) on the Oltrarno. As a piece of coherent planning that relationship had been established as far back as the mid-thirteenth century; and by the fifteenth century the Via Maggio was recognised as a street of handsome houses inhabited by prosperous merchant families. Cosimo's plans, however, threw a novel, Roman-style air of grandeur over the whole area, and his presence in his own nearby palace of the Pitti added further *cachet*.

In the piazza of Santa Trinita the procession in 1565 was able to take in Cosimo's latest addition of the ancient granite column sent from Rome to him by Pope Pius IV and set up there, 'as a gift [by the duke] to the city', as the *Descrizione* obsequiously phrased it. A statue of Justice was destined to top the column (as – if anyone looks up – it now does): a characteristic choice of subject by Cosimo, who commemorated by it his victory over the exiled anti-Medici Florentines at Montemurlo in 1537 and his rule over Tuscany. The column was important enough in his eyes for its inscription to be re-cut after he became grand duke in 1569. For the festive occasion of 1565 the statue of Justice was not ready but

a large clay model of it, coloured to look like porphyry, had been placed on the column – yet one more indication of the extent to which Florence and its ruler were putting themselves on exhibition. We may be sure that even if Vasari had failed to notice that the column lacked its statue, or thought it did not matter, the duke would have sharply reminded him to the contrary.

From the Piazza Santa Trinita the procession moved towards the Via Tornabuoni, on its way to visiting the Duomo. While the Palazzo Strozzi was a building large enough and splendid enough to be praised in its own right, there were signs nearby of old, unimproved Florence – a medieval tower, an ill-proportioned piazza – which contemporary taste preferred to have masked. Thus, painted perspectives of streets were placed in some of the decorative arches, to give a more pleasing effect, and the stony look of the Piazza della Signoria was softened and made colourful by a series of tapestries. That the piazza itself had one permanent, 'modern' improvement in the *Neptune* fountain was obviously felt to be a good thing (execution of the central statue of Neptune had been specifically hurried on, according to the *Descrizione*). The courtyard of the palace seemed dark and unattractive and resistant to decoration, but it too had been transformed. To the author of the *Descrizione* it was now perfectly lovely, with its rather squat columns given a filigree cladding of gilded, stucco ornamentation, its vaults frescoed with grotesques and its walls with views of various cities of the Habsburg empire.

As the stern, one-time seat of republican government was to be the home of Joanna of Austria, while her father-in-law lived, this transformation – at great speed – of the courtyard behind the massive façade was a graceful, welcoming gesture. Cosimo had earlier had Verrocchio's famous *Boy with a Dolphin* removed from the Medici villa at Careggi and installed in a fountain designed by Vasari in the centre of the courtyard.

Today, the frescoed views have inevitably faded, and the rather fussy gilt pillars look incongruous and slightly frivolous, like giant wedding-cake decorations left waiting to be put away. Somehow, the courtyard of the old palace of the Priors, of Dante and Cosimo 'il Vecchio' and Machiavelli, refuses to be festive or particularly cheerful. Even Verrocchio's delightful statue (a replica of the original) pirouettes rather vainly, a little too daintily, in that environment, which on the December day in 1565 must have been chill if not gloomy.

Yet the décor is a permanent reminder of the idiom of the whole processional scheme, elaborate and intricate but also partly playful and – in its own style – elegantly accomplished. It was the fashionable idiom of the period. Regardless of Joanna of Austria's arrival, there was a feeling that the face of Florence could be enlivened as well as

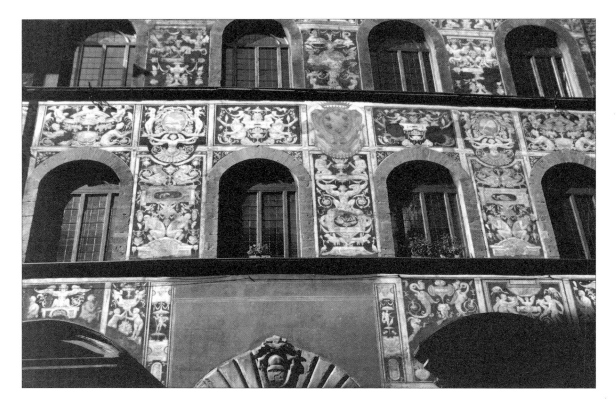

Façade of the house of Bianca Cappello, Via Maggio.

made grander. The medieval church of Santa Trinita would soon be dressed – inside as well as out – with ingenious, semi-theatrical devices designed by Buontalenti. Across the Arno, in the Via Maggio, the façade of the palace he adapted for Bianca Cappello, mistress and eventually wife of Grand Duke Francesco, was covered with exuberant fantasy-grotesque patterns in black and white (still to be seen), of a kind that an earlier generation might have reserved for book-decoration or a piece of maiolica.

The swags and creatures that animate the pedestal of Cellini's *Perseus* have been transferred to a flatter medium, though with no loss of vitality. And although the Jesuits had settled in the city, and though counter-Reformation religious earnestness was possibly seeping into the arts, such a painted façade as that on Bianca Cappello's house hardly suggests a mood of sobriety or discretion. Indeed, by *quattrocento* secular Florentine standards, the façade shamelessly flaunts itself. The average Florentine merchant of that century would probably have pursed his lips at the extravagant sight, concluding sourly that the house was suitable only for a woman.

362

Cosimo's 'Roman' thoughts about Florence conceived the Via Maggio as serving as the main artery leading to a piazza that would balance that on the other side of the river and also be adorned with a comparable column celebrating another of his victories. Not far from the Palazzo Pitti (though then rather further removed than nowadays, since the palace block had not yet been enlarged), the Via Maggio intersects with the Via Romana, helping to form the piazza of Santa Felice (not to be confused with Santa Felicita). There Cosimo had Ammanati design a column that was to be topped by a statue of Peace, though what was celebrated was the pacification of Siena following the battle of Marciano. The column duly went up in or around 1572, but the statue was never executed. After Cosimo's death in 1574 the project lapsed, but the column remained for several centuries. By 1835 it had become a serious obstacle to traffic, and the Grand Duke Leopold II, the last Grand Duke of Tuscany, ordered its removal.

A third column was added to a Florentine piazza in the final years of Cosimo's reign. In the Medicean environment of the Piazza San Marco, where there was plenty of space, a column went up in honour of Joanna of Austria, a colossal statue of whom crowned it. It was a novelty which did not long survive *in situ*. The column came down, and the sculpture (showing the princess as Abundance) was incorporated into the statuary of the Boboli Gardens.

With its squares given new dignity and focus by columns, fountains and statues, with old churches given new façades, and quite often rearranged interiors, and with the development of ostentatious private palaces, the Florence Cosimo handed on to his successor was vastly enhanced from the city into which he had been born in 1519. He had done much to change its appearance but even more perhaps in pointing — in leading — the way towards yet further changes. And as smoothly as he bequeathed the grand-ducal crown politically, so did he pass on the brilliant artistic jewels of it in Buontalenti and Giambologna, artists already in fact (rather as was the crown) in Prince Francesco's possession.

On the prince's marriage in 1565 both Giambologna and Buontalenti had contributed to the festivities. Buontalenti's share was ephemeral, chiefly work in collaboration with Vasari on designs for theatrical entertainments staged in the Palazzo Vecchio and in the open air. Giambologna's sculptures for the occasion were also partly to be ephemeral, but fortunately an allegorical group, of *Florence Triumphant over Pisa*, executed by him in clay, was preserved. And so successful had it been judged that the bridegroom commissioned a marble version of it from the sculptor. It was probably this work about which the prince wrote sharply to Giambologna two years later, requiring him to return

to Florence from Bologna (where he had completed his impressive *Neptune* fountain) and execute 'what we have already ordered'.

That the prince was a very different character from his father, and would in turn be succeeded by a brother temperamentally antipathetic to him, are matters of unsurprising human nature and history. As far as Francesco is concerned, he doubtless suffered from an early age the double burden of being the heir of a domineering, demanding personality who was at once the ruler and his parent. That he would escape into a private, secret world, out of his father's shadow, might have been anticipated. If his brother, the cardinal, was more jovial and relaxed, that was perhaps because expectations of him had been fewer; as the fourth son, he had scarcely been destined to rule in his father's stead. Far-sighted as Cosimo was, he could not foresee that eventuality.

For the city of Florence, however, and for its future worldwide fame, Francesco and Ferdinando de' Medici were his ideal scions, imbued with very similar cultural and artistic aims, though almost certainly with more instinctive – and definitely admirable – personal taste, and free from any aggressive need to establish themselves as rulers.

Cosimo had begun to make a princely city out of the capital of his Tuscan kingdom. The ambition of his two succeeding sons coincided with the duty they owed 'to the best of fathers': to make Florence yet more magnificent and princely.

T HE GRAND DUKE Francesco (often designated Francesco I, though unnecessarily, as he was, strictly, the sole grand duke of that name) has one supreme claim to be remembered by posterity. He made the building his father had planned to accommodate government offices, the Uffizi, into a gallery to house instead the Medici art collections. By 1591 the rooms were visitable by members of the public, with written permission, and the first museum in the modern sense had been created.

Among Francesco's large-scale additions to the building were the Tribuna, the richly decorated, domed octagonal room designed by Buontalenti to display some of the most valuable pieces, and a roof-garden at the extreme end of the further corridor, constructed over the Loggia dei Lanzi. Buontalenti also built a complete, very high theatre within the Uffizi – one more significant novelty in Florence, where previously palace rooms or courtyards, or even piazzas, had been utilised *ad hoc* for staging plays and comparable entertainments.

All that is left of Buontalenti's theatre is its façade (on the first floor of the gallery), with three handsome, dignified marble doorways and a bust of Grand Duke Francesco,

by Giambologna, above the central one. But the Tribuna is still intact and still the choicest room in the Uffizi, housing among other treasures Bronzino's portraits of the first Grand Duke Cosimo and his family. Buontalenti lit it beautifully and gave it an elegant exterior appearance, rising tall and distinctive over the neighbouring rooftops, in a silhouette best seen from across the Arno, though often unremarked. Within the room so many varied objects, not solely paintings, compete for the visitor's attention, that the deep, gilded cornice and the ribbed, shimmering ceiling of inlaid mother-of-pearl — like the inside of some huge, rare casket — may also be insufficiently noticed.

The roof-garden, with its view over the Piazza della Signoria, where the reigning family took the evening air or listened to music, has not survived as such, but in recent years something of its one-time atmosphere of relaxation has been recoverable, along with enjoyment of its vantage-point, by the imaginative use of it as a cafeteria (a rewarding amenity, at the end of an exhausting tour).

Grand Duke Francesco is a personality associated more often with private than with public works in Florence, and that chimes well enough with his undynamic, uninterested, even negligent attitude to the business of governing a state. Politically, he had little to strive for once he was acknowledged by the Holy Roman Emperor and by Philip II of Spain as Grand Duke of Tuscany. Himself half-Spanish, and someone who knew Spain directly, he favoured a pro-Spanish policy. He had been christened Francesco after St Francis of Assisi (following a pilgrimage made by his parents to the saint's shrine at La Verna), but his own son was christened not, as might have been expected, Cosimo, but Filippo, after Philip II.

Events in Francesco's reign were never such as to drag him from his private preoccupations, his semi-technical interests and experiments and his devotion to Bianca Cappello. The state ticked over quite satisfactorily — it seems — without his bothering to involve himself much in actively ruling it, though he forewent nothing of the dignity attached to being its ruler. The most patent, possibly the most characteristic aspects of his artistic patronage are creations sophisticated and *recherché* but which can all be seen in terms of retreat and seclusion: the Casino Mediceo in Florence, and outside the city the villas and their grounds which he delighted in building and adorning, offering opportunities for creative liberty seized on by Buontalenti.

Francesco is associated, above all, with the Studiolo (see p. 372) in the Palazzo Vecchio, the quintessence of contemporary concepts of the cabinet of rare objects — a sort of private museum — becoming a rare and precious piece of artistry, an *objet d'art*, in its own right. It can appear symbolic that this small, windowless, womb-like room,

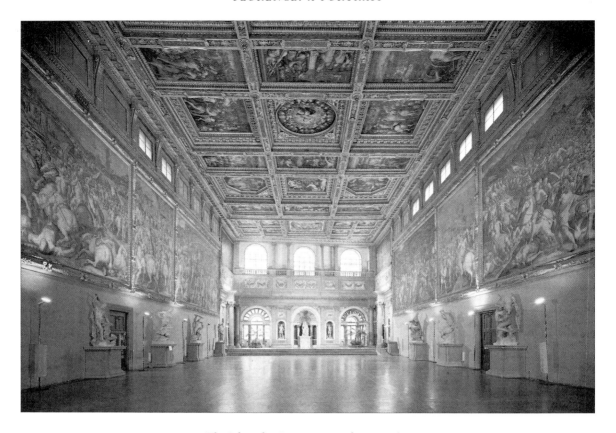

The Salone dei Cinquecento, Palazzo Vecchio.

gilded, intricate and highly wrought, with its semi-cryptic decorative scheme alluding to the unity of nature and art, should adjoin the huge public space of the Salone dei Cinquecento, with its scheme of patriotic-historical decoration, that is very much imbued with Cosimo's character. From that overt expression of dynastic authority, Francesco may be seen withdrawing to a more personal and intimate space, reflecting his particular, personal interests.

Yet that is rather too simplistic an interpretation of Francesco's view of himself as ruler. The Studiolo was a product of his years as Cosimo's adult heir — that ever-awkward period at all times for princes to occupy while waiting to succeed — and in any case among the Medici the richly adorned private study or cabinet might be found already in the apartment of Piero, father of Lorenzo 'the Magnificent', in the family's fifteenth-century palace.

As Grand Duke, Francesco ordered — from Giambologna and his workshop — eight

Giambologna (studio): Relief showing Grand Duke Francesco de' Medici Inspecting
the Model of a Fountain by Giambologna, *Museo degli Argenti, Palazzo Pitti.*

small reliefs of incidents in his life. They were to be executed in opulent, antique style, in
gold on panels of amethyst, and set into a piece of furniture, a miniature 'temple', which
would be placed in the centre of the room he had had Buontalenti design, the '*Studiolo
Nuovo*' (the Tribuna) in the Uffizi. Since the piece of furniture was never completed, and
after Francesco's death his brother divided the series, these truly precious, revealing
documents of his reign have lost their intended context and location and something
probably of their impact (though the seven surviving reliefs are to be found among the
massed treasures of the Museo degli Argenti in the Palazzo Pitti).

Four of the scenes were rectangular, and four lunette-shaped. In each composition

the largely profile figures are delineated with great precision. Most of them are dressed in contemporary costume, and the grand duke is vividly characterised — even to his stance and his way of wearing his cloak. At the same time, the Vasarian idiom, approved by Grand Duke Cosimo, of mingling allegorical personages with living ones, continues: a naked man holding a pitcher personifies a river, and so on, and Giambologna introduces a few genre touches, including a bushy-tailed dog which in one relief seems to be trying to compete with the grand duke for his master's attention (his master being Buontalenti). In the groupings, and in some of the poses too, there is an echo — given further resonance by the gilded surface — of Ghiberti's Paradise Doors, very different though the purpose is of Giambologna's reliefs.

The reliefs tell of a ruler who wishes to be commemorated in exquisite, jewelled, proto-Fabergé art — more as builder and artistic patron than as sovereign, but in a public role no less than a private one. Admittedly, Francesco's reign had lacked dramatic incidents, one of the most momentous being his sudden death from fever in October 1587. Of the eight scenes only two are of political import: he is invested as regent by his father; and he listens from the throne as the imperial decree confirming him as grand duke is read to the Florentine Senate. The six remaining scenes carry him briefly through his kingdom, always accompanied by Buontalenti, except for the relief in which Giambologna depicts himself presenting to the grand duke the model for a fountain in the gardens of the villa of Pratolino. Elsewhere, Buontalenti shows the grand duke plans for fortifications on Elba, and the grand duke explains to Buontalenti his proposals for fortifying Leghorn. In another relief Buontalenti submits to the grand duke his plan either for reclaiming the marshland near Pisa or for controlling the rivers of Tuscany. Two scenes deal specifically with aspects of Florence: ruler and architect stand watching progress on the building of a new fortress up on the crest of the hill behind the Palazzo Pitti, the Fortezza del Belvedere; and the seated Francesco, surrounded by courtiers, looks and listens as Buontalenti displays and elucidates his model of a new façade for the Duomo.

Several of these projects were to be taken over by Grand Duke Ferdinando I on his brother's death — much as he took over and utilised some of Giambologna's gold reliefs, as well as employing both him and Buontalenti on entirely fresh projects of his own. Leghorn was to become virtually Ferdinandopolis, with its fortifications augmented, a cathedral built and also a commanding statue of Ferdinando in armour, on a pedestal to which are chained four Turkish captives. The Fortezza del Belvedere went ahead at Florence, although there was in fact no need for any further defences of a city that was

never again to be in danger of attack, and the whole ingenious, star-shaped arrangement of ramps and platforms and gateways was almost an academic demonstration of how to construct a fortress. It now provides an exciting, almost aerial viewpoint from which to survey the panorama of Florence and the surrounding hilly countryside.

Buontalenti's part in devising the fortezza was shared with another professional architect, Alessandro Pieroni, and with a non-professional one, Don Giovanni de' Medici, the illegitimate child of Grand Duke Cosimo's late years. But above a doorway where a tablet records Ferdinando, 'Third Grand Duke of Tuscany', the Medici arms are sculpted with unmistakable Buontalentian flair and wit. The stucco shield is suspended against a hanging in ribbons, and the Medici *palle* have lost their normal circular form and become ovoid, elliptical shapes, as though pulled out of true by the force of gravity. Delight in the potential of the ellipse as a shape is very much a mark of Buontalenti's style. It is nice to think that he stood so confidently close to his grand ducal patrons (just how close to Francesco, Giambologna's reliefs confirm) that even their arms could be modified by him, in the cause of graceful novelty. And when one examines the Fortezza del Belvedere relief, it is seen to include a workman carving a Medici coat of arms.

Nevertheless, one project on which Buontalenti and Grand Duke Francesco had perhaps set their united hearts did not proceed. The grand duke, so often viewed by posterity as initiating only private projects in Florence, took radical, decisive action about one of the continuing architectural embarrassments of the city: the failure to complete the façade of the Duomo. In the first months of 1587 he ordered the dismantlement of what existed of Arnolfo di Cambio's original façade, inclusive of the statues (see page 11), which were dispersed (some to become ornaments in Florentine gardens like the Boboli). It was a daring act, an uncompromising statement that the 'Gothic' style of the façade was hopelessly out-of-date, but (according to one anonymous writer of the time) the destruction was mourned by many citizens. Francesco seems to have intended that a façade designed by Buontalenti should replace it, and Buontalenti's large wooden model (in the Museo dell'Opera del Duomo) reveals how handsomely he would have solved the age-old challenge with the newest of solutions: a pedimented, classical temple-style façade, animated by scrolls and swags, niches and mock-windows, conceived as rising in three tiers of pillars or pilasters to an elaborate, consciously tricksy triangle of pediment enclosing an oval cartouche surely intended to be inscribed, in the patron's name, 'Franciscus M. Dux Etrur . . .'

Such a façade would have borne no stylistic relationship to the interior of the Duomo, and that was an important part of its appeal. Already, under Duke Cosimo,

Vasari had started to cover the bareness of the cupola's surface over the high altar with a vast, colourful fresco of the Last Judgment (finished by Federico Zuccari, helped by Florentine collaborators), but the church could not be totally transformed without being rebuilt. Buontalenti might have relished the task of at least clothing the interior with a fresh skin, and he clearly felt no inhibitions about creating on the stripped cliff-face of the old cathedral what would have been a resolutely modern mask. Were that to be criticised, he could plead that he was only following the precedent established by Michelangelo, whose proposed façade for San Lorenzo had equally been 'classical' in style, decorative in surface and conceived yet more independently of the church's interior design. Indeed, it is obvious that Buontalenti had looked at Michelangelo's solution in evolving his own. He may also have been aware of Palladio's designs for certain churches in Venice, such as San Giorgio Maggiore and the Redentore, which were still in the process of being built, although Palladio himself had died in 1580.

Some envy might be experienced, along with admiration, by Buontalenti in contemplating Palladio. The Redentore was an entirely new church, on a prominent new site, and San Giorgio represented the complete rebuilding, inside and out, of an old one.

In Florence Buontalenti's opportunity to create a façade for the Duomo was buried with Grand Duke Francesco, whose funerary decorations in San Lorenzo were designed by him. How the problem of the now-naked front of the Duomo was to be resolved continued to be a preoccupation for later Medici grand dukes, and the modern-classical idiom of Buontalenti's design was kept very much alive. Models that proposed a giant order of columns, with a single order superimposed above, were ultimately rejected. The final choice in 1636 was of a design less exuberant and fancifully inventive than Buontalenti's but no less resolutely modern, and conceived, like his, of three orders. That design, too, was never realised, because of squabbles between the architect and the sculptor. Bold anti-historicism and bravura were replaced in the late nineteenth century by timid historicism and pedantry, and the Duomo received its detailed, deadly pastiche of a Gothic façade.

Francesco de' Medici's concern for something better and finer for Florence is preserved in Giambologna's relief (where the spirit rather than the exact design of Buontalenti's model is conveyed, impressively none the less). If the grand duke was foiled in his aim of enriching his city in that grand and public manner, and if his initial step in creating the Uffizi Gallery tends to blur with those taken by his successors, even some of his most private commissions have now become public property. His Studiolo in the Palazzo Vecchio is an extraordinary survival, which a subsequent age might well have

obliterated. Its flavour of the personal, the choice and the recondite has something to say about the period generally in cultured Florentine circles. There were probably other, comparable rooms and retreats which have disappeared. Francesco's beloved grand duchess, Bianca Cappello, is mentioned as having planned '*uno scrittoio*' (a study) for pictures and sculpture, and some indication of its scale and aesthetic emphasis is provided by the fact that for it she received the gift of two small, exquisite paintings by Botticelli (*Discovery of Holofernes' Body* and *Judith Returning to Bethulia*; both now in the Uffizi).

Outside Florence was the villa of Bernardo Vecchietti which Raffaele Borghini described enthusiastically in print in *Il Riposo* (the villa's name), published in 1584. The villa is the setting for discussions about artists and artistic matters, but its rooms and their contents are also described. Like Grand Duke Francesco, Vecchietti (who died in 1590) was a great patron of Giambologna, and is credited with having first introduced him to the young prince. In addition to bronzes by Giambologna, Vecchietti owned numerous works in clay and wax — models therefore — which imply a private taste and a preference perhaps for the artist's first ideas. Gems, porcelain, rock-crystal, shells and medals were also displayed in the villa; and Vecchietti shared the grand duke's predilection for working as a craftsman (he had had installed an anvil and a lathe), producing his own curiosities and *objets d'art*.

In Francesco's Studiolo the painted panels are doors to cupboards that held the material appropriate to the scene depicted. Thus, for that containing coral, Vasari himself painted *Perseus Freeing Andromeda* and included the head of Medusa whose blood is transformed as it drips into the sea to become coral branches. The bronze statues in their niches are of deities or natural elements personified. Giambologna's negligently yet elegantly posed *Apollo*, the embodiment of grace not force, represents Fire in the sense of light and warmth, while Fire as the agent for working steel and iron is represented by *Vulcan*, executed by the sculptor Vincenzo de' Rossi. Francesco appreciated the *Apollo* sufficiently to have it placed on a revolving mechanism, whereby every angle of its subtle, serpentine composition could be enjoyed without removing it from its niche. The learned yet not too strenuously erudite 'programme' for the Studiolo scheme was drawn up by Borghini, Vasari's friend and author of the elaborate scheme for Joanna of Austria's *entrata*. Nevertheless, it had to be submitted to Francesco, and Borghini expressed satisfaction on hearing that 'his Highness the Prince' approved what he had proposed.

Not then envisaged is the final fascinating aspect of the decoration. At each end of the room are lunettes which were originally to be filled by further personifications, of the Seasons. The whole decoration was then preponderantly of timeless allegory. Although

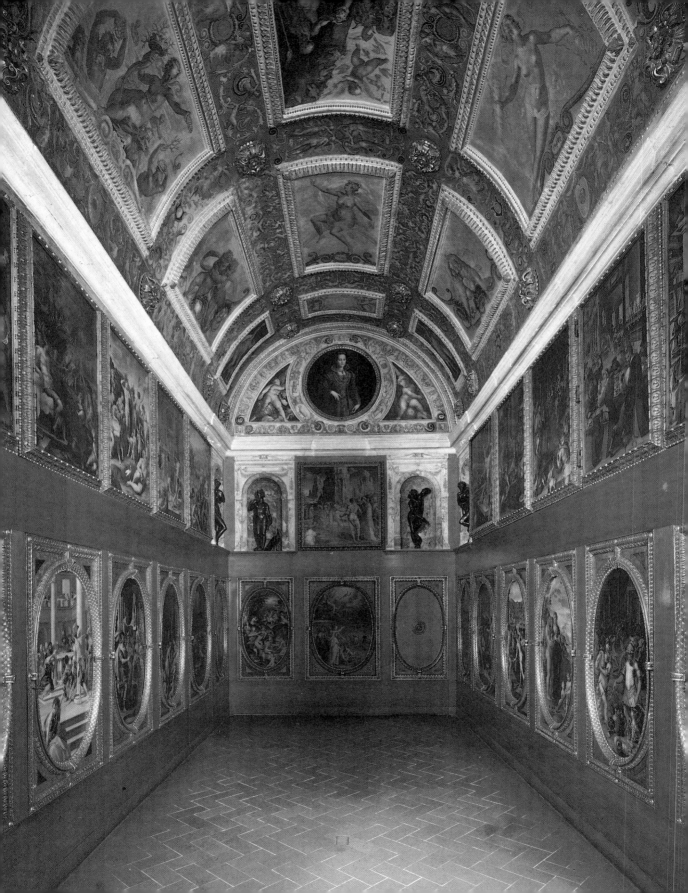

the seasons remained in the lunettes, the figures themselves (of *putti*) were subordinated to central circular portraits which it had been decided by 1573 should be of 'the Grand Duke and the Duchess Eleonora'. Francesco's parents thus entered his Studiolo as protective icons, as it were, of their son.

For these portraits, images of the duke and duchess looking as they did when young and first married were made use of, and the deliberate intention seems to have been to recall the period, thirty or more years earlier, of Francesco's birth. The duchess's gold-embroidered crimson and scarlet costume, with its upstanding ruff, may not be of a style fashionable until a later decade, but that she once ordered a gold-embroidered red over-gown, with a scarlet skirt beneath, is known (it followed the birth of her third son), and what mattered — and matters — about the Studiolo portrait of her is that she should appear in all her youth and beauty. Not too fancifully might one claim that she has become something of a personification, and something of a triumph over time, as she stands there in her own perpetual spring.

Francesco de' Medici's fondness for the work of Giambologna can properly be called a passion. The *Apollo* in the Studiolo represents the private aspect of his appreciation, but he had large-scale public tasks for the sculptor as well, most famously the three-figure marble group of the *Rape of a Sabine Woman* (see p. 374), still to be seen in the Loggia dei Lanzi, for which it was destined if not from the first at least from early on. As to what the figures represent, the sculptor seems to have cared little. Indeed, he began the group with no specific subject in mind. What was important to him was to achieve, and weave into a single sculptural harmony, variations of physique and pose and mood expressed by the naked human body. Over the crouching, defeated yet vigorously gesticulating mature man strides the younger, muscular one who seizes and also holds up, almost for display, the more softly modelled nude woman, whose flesh yields under his pressure and whose breasts, buttocks and pudenda are artfully revealed as she twists in his grasp, throwing up her left arm to create a graceful crescendo, the final spiral in an intricate play of spirals that begin at the sculpture's base with the crouching man's bent legs. A ballerina rather than a victim, the woman seems not unexhilarated by being launched aloft, and her would-be rapist is more her partner.

If one were told that Giambologna drew his inspiration from seeing the performance of a trio of acrobats it would make excellent sense, and the group seems — for all its nudity — to exist within the same conventions governing plays and other theatrical

Opposite: *The Studiolo of Francesco de' Medici, Palazzo Vecchio.*

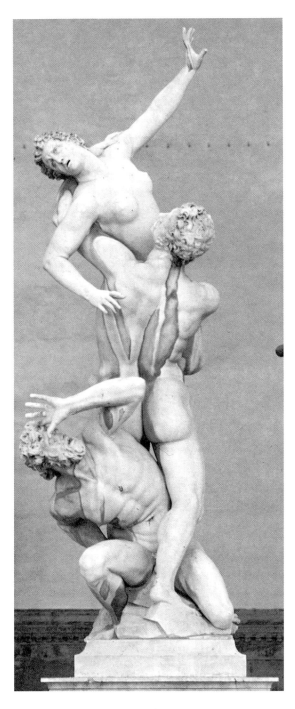

Giambologna: Rape of a Sabine Woman,
Loggia dei Lanzi.

occasions of the period. What it does not suggest is a peculiarly puritan or repressive climate for the arts in Florence. Conscious spectacle in stone as it is (its effect diminished by its being caged immobile in the Loggia dei Lanzi, whereas it demands a Studiolo-style turntable), it conveys a distinct erotic *frisson*, especially notable in a piece of public sculpture. To that extent, it may be surprising that no criticism or disapproval was voiced when, in January 1583, it was unveiled in the loggia. At the time, the lack of unfavourable comment, 'extremely rare in Florence', was noted by a contemporary. Everyone enjoyed the work and appreciated the way Giambologna had beautifully interwoven the three bodies into a single group.

The public reception of it was important and significant — unusual, too, in being accorded to a non-Florentine artist, a non-Italian in fact, who had a further quarter of a century's life and activity before him. In demand all over Europe, with a studio and assistants organised to produce work and replicas of his work in a way no previous sculptor had managed (the very reverse, in all that, of Michelangelo), Giambologna remained in Florence, his gifts always primarily at the disposal

of the grand dukes. In 1581, before the *Rape of a Sabine* was unveiled, Grand Duke Francesco is reported to be among the many connoisseurs who already rated Giambologna on a par with Michelangelo and as likely to outstrip him. Giambologna wanted glory more than financial gain. To rival Michelangelo was his admitted goal. The grand dukes (and their consorts) seem to have understood that in him they possessed not only a versatile genius but a valuable resident one, whose presence in the city he had adopted as his home brought it fresh renown.

In adding another and instantly celebrated piece of sculpture to the Loggia dei Lanzi, Grand Duke Francesco confirmed the loggia's function — even before any open- ing of the Uffizi — as a public museum, one accessible to all, without formalities. Could any other European city boast of such an amenity? And following in the tradition of his father and his brother, Grand Duke Ferdinando I commissioned an important mytho- logical piece, Giambologna's forceful *Hercules Slaying a Centaur*, which was first set up publicly at a street intersection near the Duomo, the Canto dei Carnesecchi; only some centuries later did it join the select group of sculptural masterpieces in the Loggia dei Lanzi.

To make room for the *Rape of a Sabine Woman* in the loggia, Donatello's bronze *Judith* had been moved in 1582 — demoted in favour of the modern work already hugely admired, though it had not yet been unveiled. With his group exhibited permanently beside Cellini's *Perseus* and in sight of Michelangelo's *David*, Giambologna joined the pantheon of great native sculptors, regardless of being a foreigner; and it was fitting that among his Florentine commissions should be a statue for one of the guild niches on Orsanmichele, a bronze *St Luke* for the Guild of Justices and Notaries. The renowned, centuries-old scheme, which had involved Ghiberti and Donatello, and later Verrocchio, thus received a work which took its place there remarkably successfully, despite being dated 1602 and by a sculptor who signed it as a 'Belgian'.

Perhaps no previous sculptor equalled Giambologna in sheer versatility, and that is exactly the quality his patrons expected and demanded. Francesco de' Medici's own patronage of him ranged from the massive marble *Rape* to the sometimes amusing but never trivial menagerie of animals and birds in bronze, most of which were probably for the grotto of the Medici villa at Castello, though now to be admired in the museum of the Bargello.

Strictly, these sympathetic and positively empathetic studies in natural history thus form no part of the embellishment of Florence. Yet, in addition to their aesthetic sub- tlety, with an almost expressionist brilliance in the handling of feathers and fur in bronze,

they provide evidence of the semi-scientific climate of the city, typified by – perhaps led by – Francesco as prince. Florence itself was not unusual in the Europe of the period in its zoological interest, though the serious study of animals, birds and reptiles, along with serious writing about them, was generally new. One specific novelty for Europe had been the turkey, a recent import from America when Giambologna executed the most stunning of all his creatures, a bristling, swelling assemblage of wattle and plumage, instinct with life and scarcely seeming to be as solid as bronze, which constitutes his 'portrait' of the exotic bird.

Today, one can walk from contemplation of that smallish object across the city to the church of San Marco (a church overshadowed by the popular fame of its adjoining museum-monastery of Fra Angelico), to see in the Salviati chapel work by Giambologna that is large in both scale and scope. The chapel was built out of motives of patriotism and pride, as well as piety. It was dedicated to St Antonino, the revered Archbishop of Florence, who had been canonised in 1523, and paid for by members of the Salviati family, which could claim the saint as a distant relation. It was an opportunity for Giambologna to design not only the sculpture but the complete chapel (a sketch by him for the altar-wall exists in the Uffizi). The result is a nigh-perfect conspectus of late sixteenth-century Florentine artistic ideals, and from Borghini's *Il Riposo* we know that Giambologna aimed to create a chapel both logical in design and rich in effect.

His success is evident. Pale, giant pilasters give cool grandeur to the space and frame panels of variegated marble ('like jewels in rings' was Borghini's happy analogy). Marble statues of saints stand in surrounding niches, and above them is inset a series of bronze reliefs of scenes from the life of St Antonino. The big bronze candlesticks on either side of the altar are also to Giambologna's design. Frescoes decorate the vault of the chapel, the chief ones by the fluent and competent Bernardino Pocetti, a successor to Vasari as an unfailingly industrious painter-decorator, active all over Florence, though Pocetti's manner is more graceful and his palette more colourful. The marble-cold, clearly drawn and 'enamelled' altarpiece is by Bronzino's pupil and adopted son, Alessandro Allori, and might almost pass as by Bronzino himself. A pale and elegant Christ is shown descended into Limbo, received by female souls with a well-tempered, and well-bred fervour that accords with the chapel's atmosphere.

But it is for Giambologna's contributions that the chapel demands visiting. The Florence of his day had no painters to match the genius either of him or Buontalenti, and

Opposite: *Giambologna:* Chapel of Sant' Antonino, *San Marco.*

it is very high up, on the apex of the architectural framing of the altar, that he added his crowning, final touch (none too easily discerned, unfortunately), with the slim bronze form of an angel, its wings outstretched, as if just alighted there. Two charming reclining bronze *putti* flank it but cannot compete with the dynamism of the lightly draped, lightly poised, half-fluttering figure, glancing down and gesturing with one arm towards Christ below, while raising the other arm towards heaven.

Giambologna's *Turkey* is pungently earthy, swollen with self-importance and wholly natural. His *Angel* is a spirit, pure and purified and seemingly supernatural. Such, in essence, was his range. And that those two contrasting masterpieces should yet share the medium of bronze cannot be fortuitous. Giambologna was a master in any medium, from clay to marble, but bronze is the one where he appears most at ease and artistically most himself. It had not been a medium utilised by Michelangelo, and would not be one to interest Bernini, but Giambologna obviously found it sensuous and responsive. Under his hands it proved as pliant as wax, though with surfaces chased and chiselled and polished to a degree impossible for wax. A great seventeenth-century French sculptor, Puget, was to boast, '*le marbre tremble devant moi*'. Little given to boasting, Giambologna might nevertheless have spoken similarly of bronze.

The Salviati chapel was a type of commission which his two major patrons, Grand Duke Francesco and his brother, did not give him. But following the example of Bandinelli, who had acquired a chapel for himself in Santissima Annunziata, and the more recent one of Ammanati (who had died in 1592), who similarly designed a funerary chapel in his own newly built church of San Giovannino degli Scolopi (originally San Giovanni Evangelista), Giambologna also acquired a chapel – in Santissima Annunziata – for his eventual burial. It is altogether more modest than the Salviati chapel, but it is the central, apsidal chapel of the group around the high altar, and the sculptor donated to it his own bronze reliefs of the Passion and a starkly simple bronze *Crucifix*, as well as a *trecento* painting of the Virgin and Child. Under Medici protection, the sculptor had achieved distinguished social standing in Florence in addition to artistic status.

Giambologna's two chapels serve to emphasise that not every improvement to the city stemmed directly from Medici initiative; but the two successive grand-ducal sons of Cosimo represented the central focus of what was undertaken, and as far as Giambologna was concerned their permission was required before he could undertake tasks for other patrons. It was only with the agreement of Grand Duke Francesco and the Grand Duchess Bianca that he was allowed to work for the Salviati at San Marco. When at the same date the Duke of Urbino wanted some statuettes from him, the duke's agent in

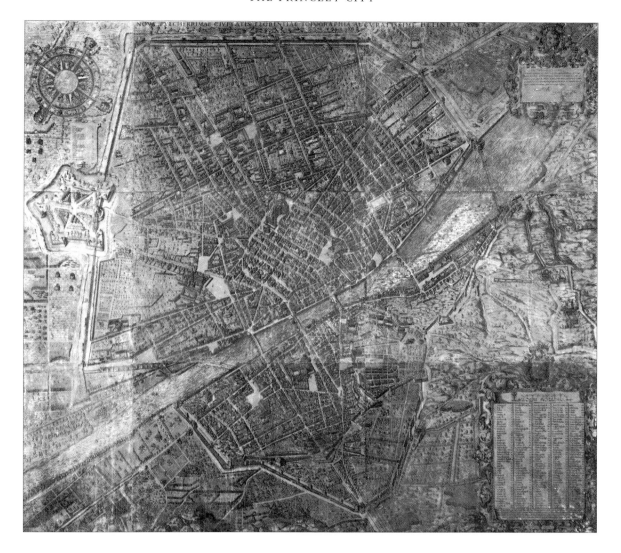

Stefano Bonsignori: Map of Florence in 1584, *Museo di Firenze com'era.*

Florence explained, in the course of a long, absorbing, appraising letter, revealing Giambologna's role as the outstanding sculptor in the city, that while he was able to satisfy every kind of demand, each must be mediated through the grand duke.

Although no guide-book to Florence was published in Grand Duke Francesco's lifetime, there was issued a new map, by Stefano Bonsignori, in 1584. This was justifiably entitled 'A new, most accurately drawn map of the most beautiful city of Florence' and showed, in axonometric form and great detail, the buildings, the layout of the streets, new

developments such as the (Boboli) gardens of the Pitti Palace, new monuments such as the Montemurlo victory column in the Piazza Santa Trinita and something also of the countryside beyond the city walls. It was dedicated to the grand duke. Bonsignori in effect submits to him, as the inscription on it states, this precise panorama of a city 'worthy on account of its beauty and its magnificence, to be seen by all mankind'. Sight of it should cause the grand duke to feel gratified at being 'Prince and King of a city so noble and so illustrious that celebration of it is superfluous'. And he may rejoice to see again, in the map, *'gli ornamenti'* which he and his father, and his ancestors, have added to the city.

The impetus acclaimed by Bonsignori would continue under Grand Duke Ferdinando I, whose *'ornamenti'*, both temporary and permanent, were greater and much more sumptuous than anything his elder brother had lived to achieve. Buontalenti and Giambologna had no need to fear any diminution of the ruler's patronage when Cardinal Ferdinando so suddenly succeeded in October 1587.

The Grand Duchess Bianca died at the same time as her husband, and it was inevitable that there should be rumours (though without foundation) that they had been poisoned. They left no children, which was convenient. The new grand duke quickly slipped out of his cardinal's robes and settled down to enjoy all the appurtenances of a secular ruler, including a wife and family. In 1590 his eldest son was born, assuring the dynasty's future. He was christened Cosimo.

Less withdrawn than his elder brother, and considerably more genial and hedonistic than his father, Grand Duke Ferdinando was almost a throw-back to Pope Leo X in character, though more truly enlightened. That he intended to take pleasure in his position, and also make his subjects' lives tolerable, if not indeed enjoyable, was soon obvious. He was fortunate in being the most happily placed of all the Medici rulers of Florence, on a prosperous cusp between the years of aggressive establishment of power and those that would bring slow yet steady decline to the Tuscan state. And in the opulence and effulgence of his reign, his predecessor tended to disappear, as if the crown had passed directly from Cosimo to Ferdinando.

Yet Francesco de' Medici deserves to be remembered as more than just the princely creator of the Studiolo. Not every project of his was abortive. For one thing, in 1583 he founded an academy for the purification of the Tuscan language, the Accademia della Crusca ('of the Chaff'), which asserted the prestige of Florence in the linguistic area and which — unlike the Accademia del Disegno — has survived. Down the centuries, the Accademia della Crusca was to be vigorously active and by no means narrow in its care and interpretation of 'good' literature. It would thus recognise Cellini's autobiography

(first published at Naples in 1728) as part of the Florentine heritage, in addition to many solemn, prosy and 'academic' texts. By the eighteenth century, its standards were at once traditional and unexpected: the model for 'our language' was the forceful, terse, lucid, beautiful and graceful style that had flourished in the time of Boccaccio. Some later, rhetorical Italian literature might have benefited from paying attention to the pure doctrine of the Accademia della Crusca.

Francesco de' Medici has acquired an after-life, of sorts, in two rather different pieces of literature. He is probably the first member of his family to appear in an English play, Webster's *The White Devil* (printed in 1612). There he revenges himself on Paolo Orsini who married his sister, Isabella, but had her killed in order to marry Vittoria Accoramboni, the 'White Devil'. The macabre historical truth of that murder is blackly and thrillingly embroidered by Webster — literally blackly, as the grand duke disguises himself as a Moor to take his revenge more effectively on the spot. He fades from the play before the great final death scene between Vittoria and her brother, Flamineo, and he can hardly be said to have any coherent character. He is 'Florentine' and Machiavellian ('O, the rare tricks of a Machiavelian,' Flamineo exclaims, after Orsini has been first poisoned and then strangled) in the way English Renaissance writers liked to interpret those words — an interpretation which would have astounded any contemporary Florentines who happened to attend a performance of Webster's play. Francesco de' Medici may have been a moody man, and never a popular ruler, but he was not a fiend.

In a less lurid role, as almost a stooge, does he appear in a series of dialogues Vasari wrote to provide a guide to the subjects of the frescoes painted by him in the Palazzo Vecchio. The *Ragionamenti* (Discussions) are held between the painter and the young prince, as he was, virtually between a pedagogue and his pupil, though the outward forms of respect are observed and fulsome praise of Duke Cosimo runs consistently through Vasari's fond expositions of his own work.

The *Ragionamenti* seem never to have been published in a popular English edition, but they are fascinating and also revealing, not least of the conceit of the author — a conceit blander and smugger than any *trait* in Cellini, and faintly asinine as a result. They reduce Prince Francesco at times to a startling level of ignorance and triviality. On friendly terms with his guide (whom he addresses as 'Giorgio'), he is made at one point to ask who are the three women seen around Venus in a painting ('Sir, they are the three Graces'). Looking at the *Rape of Europa* he comments, as might some old-fashioned visitor to the Royal Academy summer exhibition, 'I especially like that barking dog.'

Perhaps it was prudent of Vasari not to publish these *Discussions* in his own lifetime.

Nor were they printed until after Grand Duke Francesco's death. By then the frescoes in the Palazzo Vecchio were themselves becoming a matter of ancient history, and the exact significance of each subject might well require elucidation. Out of *pietas* and yet also as part of general homage to the Medici, Vasari's nephew saw to the publication of the *Ragionamenti* in 1588, dedicating the book in the best laudatory style of his uncle to the reigning grand duke, Ferdinando: 'the countless distinguished deeds of numerous members of your house, Most Serene Duke, have provided the opportunity for many a page by writers and equally for many a picture and fresco by painters, among whom was Giorgio Vasari . . .'

Thanks more to the *Lives* than to the *Ragionamenti*, Vasari would survive rather better than Grand Duke Francesco, while in Florence some of the major *'ornamenti'* proceeded without direct Medici involvement. Although Buontalenti failed to gain approval to build the Duomo façade, he subsequently received a sort of accidental consolation prize in being commissioned to design a façade that was executed: that for the old, much-adorned church of Santa Trinita, whose largely Gothic interior includes the Sassetti chapel, frescoed by Ghirlandaio. Buontalenti had already made his own interior addition of an elegantly balustered and partly curved, partly shell-shaped double staircase leading up to the choir (perversely removed in the nineteenth century and installed in a church near the Ponte Vecchio, Santo Stefano al Ponte). The standard 'explanation' of this original, ingenious and proto-rococo staircase has it developing from Michelangelo's Laurentian Library staircase, but it is far more teasing, even playful, as well as altogether slighter in its eye-deceiving effect. Once again, Buontalenti shows his gift for making stone swerve and sway and seem to move. Such sprightly ideas he had previously evolved for the décor he proposed for the baptismal ceremony of Prince Filippo de' Medici, which became considerably modified in the event. And although his staircase has been banished from the church for which it was designed, there remain near the main entrance two notably graceful, obviously late sixteenth-century holy-water stoups, their bowls unusually slim and ovoid in shape, which suggest his style.

For the façade, novel in Florence, or elsewhere, and still remarkable enough, Buontalenti recalled in simplified form his design for that of the Duomo. Quite flagrantly ignoring the style and to some extent the very plan of Santa Trinita, he produced a front of giant pilasters, leading the eye up to the high, strongly vertical sweep of the upper storey, pierced by a prominent oculus and crowned with a pediment. Typically, the capitals of the pilasters are capriciously created out of swags and masks. A winged angel's head completes the sculptural framing of the oculus, and at either end of the cornice

Façade of the Palazzo Nonfinito, Via del Proconsolo.

above stare out huge bat-like faces. Yet the façade is unexpected — and impressive — without strain or tiresome, obtrusive eccentricity. It is the sole church façade Buontalenti executed in Florence and it made a fitting preparation for the masterpiece of his staircase then within.

Buontalenti had ideas no less novel and lively for palace architecture. On a corner site in the Via del Proconsolo, a street of grand palaces, he began a superb one for Alessandro Strozzi, the Palazzo Nonfinito (so called because its second storey was never built). It was '*non-finito*' in a different sense for Buontalenti. Having had disagreements with his patron, he left the project, which other artists took over. All the same, the eventual building has a good deal of Buontalentian detail, not least in the bulging, vigorously scrolled framework of the high, massive ground-floor windows and the huge, boldly projecting porch of the entrance from the Via del Proconsolo (see p. 383). The porch was in fact the work of another contemporary architect, Caccini, but one of Buontalenti's own sketches shows that he envisaged a very imposing main entrance, incorporating a balcony and the owner's coat of arms (the sketch is actually for the other façade, that on the Borgo degli Albizi). No longer was the entrance to a Florentine palace a simple, framed opening set flat in the wall (as even the Pitti Palace retained) but had become an arresting feature which interrupted the line of the street and made a statement about the building and its owner. Other, yet grander entrance portals, sometimes with sculpted, semi-fantastic decoration, were to be devised for Florentine palaces in the seventeenth century.

Meanwhile, in the grand-ducal city of Cosimo de' Medici's two ruler sons, further private palaces and public monuments were under way. Buontalenti had been involved in an extension to the constantly developing complex of the hospital of Santa Maria Nuova, Folco Portinari's foundation, which nearly every Medici grand duke would patronise. The Piazza Santissima Annunziata had received the addition of one façade of the dominating, peach-red block of the palace designed by Ammanati for Ugolino Griffoni, a palace unusual in Florence for being built not of stone but brick. And for the centre of the piazza, the most formal and coherent of public spaces in the city, and increasingly the most beautiful, Ferdinando I had Giambologna execute an equestrian statue of himself, no novelty in appearance as it echoes in pose the statue of his father in the Piazza della Signoria but unprecedented in Florence as raised by a ruler in his lifetime.

In Giambologna's studio the horse ridden by Ferdinando was varied from that ridden by his father, and perhaps because of being much better sited the second monument altogether gives the impression of being a finer work. The grand duke seems to have just a touch more swagger, even in his similar pose. In a subtle variation, the folds of his scarf are bunched and looped up to fall over the long diagonal of his sword, and that minute detail adds animation to the figure.

By the time the statue was unveiled in 1608, Giambologna was dead. A certain amount of the actual modelling of the monument had been undertaken by his gifted, experienced pupil Pietro Tacca, the author of the pair of highly animated bronze fountains also now in the piazza, though originally planned for Livorno. Visually subordinate to the equestrian statue, not dynastic but entirely decorative, and actually slightly too small for their site, they complete the overall harmonious interest of the square.

Grand Duke Ferdinando I had already had standing statues of himself – in marble – set up in squares at Arezzo and Pisa, in addition to that at Livorno. Only in his capital, however, was he depicted in imperial Roman fashion, and in the mould of his father, calmly and eternally triumphant on horseback, in bronze. The medium had its topical significance, for (as an inscription on the horse's girth states) metal seized from the 'Thracian foe' was used in the making of the statue. It was Turkish cannon captured by the 'crusading' order of Santo Stefano which provided that metal, and Ferdinando wears around his neck the cross of the order.

The statue was unveiled at a particularly felicitous, significant moment for him, on 4 October 1608, just a fortnight before the tremendously elaborate *entrata* into Florence of a second Austrian bride for a Medici heir: the entry of the Archduchess Maria Maddalena, daughter of the Archduke Charles and sister of the wife of Philip III of Spain. She came to marry Ferdinando's eldest son, Cosimo. With that marriage the apogee of the reign was reached. Early in 1609 Ferdinando died, and Cosimo acceded as fourth Grand Duke of Tuscany.

The state of the kingdom Ferdinando bequeathed to his son was epitomised in the peace, prosperity and splendour enjoyed by Florence. For someone not brought up to rule, Ferdinando had governed extraordinarily well – as triumphantly and calmly as Giambologna's equestrian statue of him implies. Everything that happened to him, beginning with his elevation as a cardinal, turned to his advantage. Residence in Rome provided him with a perspective on his own city, experience of administration and opportunities to develop his artistic tastes. Among the works of art he collected in his Roman villa was the once-celebrated 'Venus de' Medici', a piece of sculpture he left behind when

he returned to Florence as grand duke but which was placed in Buontalenti's Tribuna in the Uffizi during the reign of his great-grandson, Cosimo III. On public show there, in the centre of the room, it became for generations one of the most admired and famous statues in the world, a chief reason for visiting Florence. Even the naturally unsusceptible historian Edward Gibbon paid it measured tribute: 'I first acknowledged, at the feet of the Venus of Medicis [sic], that the chisel may dispute the pre-eminence with the pencil.'

The Rome that Cardinal Ferdinando had left in 1587 was that of Pope Sixtus V (and also of St Philip Neri, Florentine by birth), a pope actively engaged in changing the face of the city — more radically and splendidly than any grand duke might manage in Florence. Still, the example is unlikely to have been lost on the ex-cardinal who reverted so unexpectedly to lay status and became a ruler himself. More sympathetic politically towards France than Spain, he was able to marry off his niece Maria, daughter of Grand Duke Francesco, to Henry IV of France, whom the successor of Sixtus V, Clement VIII, had absolved from excommunication. The king's death in 1610 would be mourned in the grandest style, with numerous depictions of incidents from his life in San Lorenzo. And for a few heady days in 1605, while Ferdinando reigned in Tuscany, there was the substantial joy of a Medici pope once more: a collateral relation of his became Pope Leo XI. That was too much good fortune even for the Medici, and Leo XI died within a month of his election.

In Florence the grand duke had quickly shown after his succession how a ruler should behave in times of disaster as well as prosperity. When havoc was caused in the city by the flooding of the Arno in the winter of 1589 he personally appeared on the scene, to distribute grain to the distressed, manifesting a concern that was genuine. That action would be commemorated by one of the cycle of frescoes dealing with the lives of the Medici grand dukes that Ferdinando's younger son, Carlo, himself a cardinal, would have painters execute in the Casino Mediceo. (It was a further aspect of Ferdinando's sustained luck in life that his marriage brought him eight children.)

The most lavish if transient of Ferdinando's concerns as ruler was celebration of the grand — grand rather than necessarily great — occasions of his reign, dynastic ones which began with his own marriage in 1589, continued with that of his niece in 1600 and culminated with the most sumptuous of all, in 1608, for the marriage of his heir. That final fling, elaborate and ingenious, might almost be seen as his *Nunc Dimittis*, though he is unlikely to have conceived it in those terms, or expected to die, aged sixty, only a few months later, before any child of the marriage had been born.

Although such festive celebrations, and most of their actual décor, were bound to

pass away, they could now be preserved not only by written descriptions but in images — engravings that ensured something of their splendour was transmitted to those not present on the occasion itself, helping to disseminate more widely the glory of Florence under its third Medici grand duke. It was very much in the established tradition of his forebears that Ferdinando I offered his Florentine subjects spectacular pageantry that fostered a corporate sense of pride in the city's *bellezze*. One of the great novelties of the festivities in 1608 was an aquatic display on the Arno, using the river for a nautical 'battle' of Jason and the Argonauts (whose quest had been for the Golden Fleece), perhaps intended to demonstrate — among other things — that the maritime prowess of Florence rivalled that of Venice.

Engravings were issued to record the scene on the river, and other related events. While they may not always be relied on for complete topographical accuracy, these engravings show us not only the ephemeral pageantry and the performers, and also the onlookers, but some of the permanent '*ornamenti*' that had been added to the city. The Ponte Santa Trinita, for instance, appears with its latest embellishment, the four statues of the Seasons, paired at either end of the bridge, which had been placed in position as recently as September 1608.

Another art contributing to the splendour of these occasions has, however briefly, to be recalled — the art of music. The Ponte Santa Trinita *Seasons* happen to provide a reminder *en passant*, for two of them (*Summer* and *Autumn*) are by Giovanni Caccini, whose brother Giulio was both singer and composer. He was the writer of the music for a *Rape of Cephalus* (lost) which was one of the dramas of the period in Florence that formed stepping-stones towards the emergence of opera as a form. Not all the Florentine musical activity of that kind originated at court. Indeed, the focus of musical activity — and theoretic discussion of music — was primarily among a group of private citizens, meeting informally. It was in the palace of one of them, Jacopo Corsi, that there was first performed a pastoral play, *Dafne*, with music by Corsi and by Jacopo Peri, which is usually treated as the first opera as such. The writer of the play, the poet Ottavio Rinuccini, collaborated again with Peri in 1600, producing the opera *Euridice* for the celebrations around Maria de' Medici's marriage to Henry IV of France.

Much as opera was foreshadowed, so was later operatic history in so far as feuds and dissensions are concerned. Caccini and Peri were bitter rivals (Peri himself was also a singer), and Caccini managed by sheer obduracy to have some of his own music sung in Peri's *Euridice*, as well as being honoured by the fact that the chief musical event was a performance of his *Rape of Cephalus*. It took place in Buontalenti's theatre in the Uffizi with

scenery designed by him. Far from appeased, Caccini was led further by competitiveness to compose – and at once publish – his own *Euridice*.

Nevertheless, Caccini seems to have lost the operatic war, if not at the time certainly with posterity. And neither composer went on, perhaps from lack of opportunity, to consolidate their ventures into music drama. Caccini died in 1618. Peri lived until 1633, providing music for many ballets and entertainments at the Medici court. The initial impulse in Florence to develop the opera form oddly fizzles out. In 1608 Peri declined to travel to Mantua because he was busy with carnival preparations. Without realising it, he was missing a chance to meet the first supreme genius of opera, the Duke of Mantua's *maestro di cappella*, Claudio Monteverdi, who had already in the previous year composed for the court there his version of the Orpheus and Eurydice story, *Orfeo*.

It was, nevertheless, at Ferdinando I's court in Florence in 1600 that the spark of enthusiasm for 'opera' had been lit in the Duke of Mantua, who attended the festivities (bringing Rubens in his train). So, obliquely, Ferdinando gains yet another cultural point as patron. Based on an antique classical story, with poetry, singing and plenty of spectacle, and often the pleasurable sensation of a happy ending (even for Orpheus and Eurydice), the typical opera of the period seems very much in accord with Ferdinando I's tastes and character. He would probably have concurred with the judgment of the diarist John Evelyn, encountering the novelty of this art form for the first time: 'taken together it is doubtlesse one of the most magnificent & expensfull diversions the Wit of Men can invent.' If Ferdinando did not directly instigate 'the first opera', he had the luck to be reigning when it was first created, an inclination to patronise it, a theatre in which to do so, and the financial resources to see it done with suitably spectacular effects.

Once again, Florence could be greeted as the cradle of a new art. Only, in this instance, the city failed to rear the infant, who would grow to maturity in other centres, above all in Venice.

That was not yet an accomplished fact in Ferdinando's reign, during the last years of which 'magnificent & expensfull diversions' in other media took on solid and lasting shape. The final twelve months of his life were studded with a succession of occasions and improvements, some quite slight, which might have been part of a conscious programme for making Florence grander and more opulent.

Not only was Giambologna's statue of Ferdinando unveiled, and the statues of the Seasons set up on the Ponte Santa Trinita. In the Piazza of Santa Maria Novella the two wooden obelisks were replaced by marble ones. The choir and high altar of the church of Santo Spirito were solemnly consecrated – an act which followed from the sumptuous

realisation of designs (largely by Caccini) which produced a new, vastly more elaborate altar area of inlaid steps, a new tabernacle and a huge, highly wrought *baldacchino*, marble-pillared, adorned with sculpture and with an ingenious open-work cupola of fretted metal (see Plate 27). It is an 'apparatus' perhaps more splendid than any devised for a theatrical-cum-musical occasion at the Medici court, and it remains pristine and *in situ*, although arguably incongruous to a painful degree and *de trop* in a Brunelleschian setting.

Grand Duke Ferdinando took a marked interest in Caccini's achievement, visiting work in progress several times, in the company of distinguished visitors, one of whom, the art-loving, sybaritic Cardinal del Monte, a Medici adherent, also visited the workshop nearby. There he saw (as a diarist records) 'assorted marbles of various stones of jasper and agate...' The new or newish fashion and passion for *pietre dure* was now moving into church decoration. Yet the colour and splendour of Caccini's *baldacchino* can be seen as merely a reinterpretation — in, of course, a radically new style — of the tall, glittering tabernacle raised in Orsanmichele by Orcagna.

It was not Ferdinando but a private citizen, Giambattista Michelozzi, who had undertaken to pay for all the work at Santo Spirito, though he needed the grand duke's permission. Ferdinando himself had contemporaneously embarked on a much larger and ambitious scheme, setting in hand building of the dynastic sacristy at San Lorenzo first mooted by his father and for which his brother Francesco had accumulated the choicest *pietre dure*.

That third sacristy — the Chapel of the Princes — had preoccupied several architects, Buontalenti for a while among them. The eventual scheme, unparalleled in its scale and its richness, created not so much a sacristy as a mausoleum — and also an artistic manifesto for seventeenth-century Florence. It was the most lavish and princely of all Medici additions to the city — adding a new dome to its familiar profile, as well as creating a positive museum of *pietre dure*. Ferdinando lived to see the exquisitely coloured drawings for the chapel executed by the preferred overseer and architect, Matteo Nigetti. And work on the foundations of the chapel proceeded fairly fast. Distinguished visitors to Ferdinando could inspect what had been done on the spot or admire the array of *pietre dure* being prepared, in the Uffizi, to clothe the walls.

Of all the *bellezze* and 'ornamenti' of Florence, this one promised to be the most astonishing and magnificent. Ferdinando had set in hand a work which would not be finished for several centuries: it has, in fact, never been finished in its entirety. But one of the very last events of his reign was completion of the crypt of the chapel; and there was to

be no serious halting of the impetus he had given to this culminating monument of Medici pride.

Only in one important particular was his vision to remain for ever unfulfilled. Inspired by the pair of famous statues Michelangelo had sculpted of his princely forebears, he envisaged statues of the grand dukes to take their places above their tombs in the new chapel. Two alone were sculpted – his son's and his own.

CHAPTER THIRTEEN

Putting on the Style

THE CHAPEL OF the Princes is where anyone who has come under the spell of Florence, fascinated by the city and its history and its art, needs to pause not only to look around but to reflect. Standing there, in that spacious-seeming, coldly gleaming marble cavern, the visitor is effectively poised at a cultural crossroads and faces a significant choice.

The question is hardly escapable. In fact, it is pressed on one by surroundings of the greatest grandeur and lavishness, in a style not previously encountered in a chronological tour of Florence. At its simplest, the question is whether one can 'take' the Chapel of the Princes. Is it worth trying to understand both what we see and the ambitions, dynastic and artistic, fated never to be fully realised, which lie behind it?

To give any sort of affirmative answer is to commit oneself to going forward, metaphorically if not literally, to seek out what may be called a 'second' Florence, a city more shadowy and elusive to some extent than the famous, familiar medieval-Renaissance one, certainly far less present to the eyes or the consciousness of the average visitor. That second city and its story are adumbrated in the very structure and arrangement of the Chapel of the Princes. Its story begins in the tremendous opulence of the chapel itself (see Plate 29), instinct with semi-regal Medici family assertion, and stylistically proto-baroque. It virtually closes in the bare crypt below, where in the mid-nineteenth century the last grand duke of all, Leopold II, of the succeeding Austrian-Habsburg dynasty, saw to the proper, dignified burial of the coffins of his predecessors and their relations, and set up an austerely classical altar for masses to be said in their memory.

It was one of Leopold II's last acts in and for Florence. In April 1859 popular revolution precipitated his departure from the Pitti Palace, and he was never to return. Just twelve months later, King Vittorio Emanuele II arrived at the palace, in the company of Count Cavour, to celebrate the annexation of Tuscany to the new kingdom of Italy. Another, 'modern', and soon to be physically modernised, Florence had come into existence.

What begins to unfold in the Chapel of the Princes is a tissue of history with its

own fascinating texture, studded at steady intervals at least well into the eighteenth century by great, often grand-scale artistic achievements. As it unfolds, it offers its own sometimes *recherché* aesthetic rewards, and with them a certain tang of excitement, for much of it still retains novelty. Many of even the finest monuments of that later Florence are pristine in the sense of being little visited and little gazed at. The explorer who goes in search of them may legitimately feel daring — and perhaps on occasion intrusive — as he or she breaks in on their lonely, slumbering beauty. And in the Florence of today there is welcome novelty in coming upon great works of art, of architecture and sculpture especially, that are unencumbered by hordes of people, and unillustrated and unpraised, when indeed even mentioned, in the more popular type of guide-book: works of art that are, in a word, underestimated.

If only as a change, not to say a relief, there should be a strong appeal in the unfamiliar face of Florence: a face sophisticated, deliberately adorned and, as it were, heavily made-up. But it is wise to be prepared for a grand manner, for rich artistic fare, for challenges to conventional concepts of good taste, for travel along a track which may not be the beaten one but is paved with precious stones.

On that track lie also serious problems and difficulties, some practical as much as aesthetic. And always there is bound to be — as the very location of the Chapel of the Princes serves to bring home — a powerful associative tug, tacitly urging one to turn back to the safely known and universally esteemed: to the calm, intimate, *quattrocento* beauty of Brunelleschi's nearby sacristy or to the blanched sacristy even closer at hand in which all Michelangelo's genius as a sculptor is imperiously and disturbingly enshrined.

The church of San Lorenzo itself sums up and speaks overwhelmingly of old Florence, of the birth of the Renaissance there and the rise of the Medici, mingling with Brunelleschi's name those of Donatello and Verrocchio. It carries one much further back too, for a church dedicated to St Lawrence (an early Christian martyr in Rome) had first been founded there in AD 393, at a date when the site lay outside the walls of the then small city. St Ambrose of Milan had traditionally come to consecrate it, for his friend, the first bishop of Florence, St Zenobius, a saint never celebrated in the wider world but revered down the centuries as a local patron saint. Two hundred years before Dante's birth, the ancient church had been replaced by a new one, in up-to-date Romanesque style. That remained, with its arcaded portico and tall campanile, until Giovanni di Bicci, the first prominent and seriously rich member of the Medici family, assumed the major responsibility for a new, Renaissance church, the existing one, to be designed by Brunelleschi.

It is not surprising that such an evocative accumulation of so many centuries,

involving some of the greatest names, not solely in Florentine but in European history and art, and epitomising the established image of Florence, possesses vast prestige and sufficient glamour to overshadow utterly, almost annihilate, any subsequent achievements in the church, as in the city. What hope has, say, the funerary monument of Caroline of Saxony of attracting attention in San Lorenzo? She was the first wife of the Grand Duke Leopold II and died in 1832 – not a period when Florence or Florentine art stirs the faintest general interest, although her now dusty sarcophagus happens to be at least historically remarkable. It is probably the last truly princely memorial of *pietre dure* craftsmanship. With a crown reposing on a gilded cushion on a slab of what looks like lapis, it gives off diminished but distinct echoes of the magnificent sarcophagi in the Chapel of the Princes.

The fact is that we all know that post-Renaissance Florence never produced artistic figures to approach Donatello and Michelangelo, nor literary ones to approach Dante and Boccaccio. However enlightened and well-meaning, the later grand dukes, Medici or Habsburg, lack compelling personalities, and much of the story of their Tuscan kingdom is one of economical and political decline.

Fine though the buildings, statues and paintings that went to the adornment of Florence in the years from 1600 onwards might be, they could not fundamentally alter the ancient, basic lineaments of the city, even though the exterior of the Chapel of the Princes added a fresh distinctive dome to the skyline – and one other large, handsome dome, that of the church of San Frediano, was later to be built, without somehow contributing significantly to the essential look of the city, partly perhaps because it rises far away from the centre.

Florence in the seventeenth century could not begin to resemble or rival Rome, even had it been fortunate enough to possess native geniuses of the calibre of Bernini and Borromini. And although some splendid, showy churches were built in seventeenth-century Florence, none of them had the effect that Longhena's Santa Maria della Salute had in Venice: of being at once dominant and integrated so brilliantly into the civic panorama that it became thenceforward fundamental to visual concepts of the city.

In the long-hallowed, medieval-Renaissance perspective of Florence, the Chapel of the Princes marks an end and even a nadir, signalling that the vigorous, heroic days of Florentine art are finished for ever, much as it marks (positively crows over) extinction of the republic. A moral might be drawn there, and very probably often has been, between the loss of republican liberty and the consequent decline of artistic standards, as evidenced by that florid, overweening and yet faintly vacuous interior.

In a less narrow, prejudiced and old-fashioned perspective, however, the Chapel of the Princes signals no end but a beginning — of grandiose stylistic ideals, vigorously assertive and astonishing. Aspects of the chapel are as impressive as they are unprecedented, and oddly haunting. If nothing previously executed in Florence prepares one for it, in itself it serves as a preparation for other, subsequent chapels, less sheerly opulent on occasion but arguably of more subtle design, where sculpture may play a greater part than in the Chapel of the Princes as it has been left. Not least does the subordination of painting there announce future decorative schemes where the role of painting would be equally subordinate, sometimes barely impinging on the spectator.

To clear the mind as one enters the chapel and prepares to consider it — not treat it as an irrelevant or tasteless ante-room to the sublimity of Michelangelo's chapel — it is well to remind oneself that there is no correlation between the disappearance of the Florentine republic, vanished decades before the chapel was even conceived, and any presumed decline in the calibre of Florentine art. History constantly refutes such simplistic equations, providing instead instance after instance of autocracy and even tyranny coinciding with and often positively fostering great art and artists. Whether one chooses to respond to or disapprove of the emerging features of the 'second' Florence, neither political sympathy nor morality should play any part in the choice.

'Ornate' or some similar adjective is usually invoked to describe the Chapel of the Princes, and it is thoroughly justified. What we have to realise, however, perhaps taking a deep breath in so doing, is that the chapel is nothing like as ornate as it was originally planned to be. It is, to some extent, as incomplete as is Michelangelo's scheme in the adjoining area. Since it is more patently a scheme of decoration, and of collaboration, and by artists highly talented without being supreme geniuses, it is bound to suffer gravely from its incompleteness.

The most damaging and obvious lack is that of all but two of the gigantic bronze statues of the Medici grand dukes which were meant to occupy each of the niches above their tombs. The empty spaces are aesthetically desolating and also lend themselves, unfortunately, to reflections on the vanity of human wishes. And then the focal point of the chapel, the altar — a badly needed reminder that this is a sacred, Christian building — is found on examination to be a cobbled-together affair, conventional-looking, incorporating a few competently executed panels of mid-nineteenth-century *pietre dure* in a painted framework of wood. What was envisaged, and designed, was a huge inlaid marble tabernacle, the cupola of which would have soared up to meet the vault overhead. The effect would have been more solid and sumptuous than that of the tabernacle in Santo

Spirito, and also much more appropriate to its environment. As for the segmented vault of the dome itself, now decorated with Benvenuti's quite effective nineteenth-century religious paintings, that was intended to be every goldsmith's vision of heaven, a blaze of lapis lazuli starred with rosettes of gilded metal.

Cold and very sombre, despite its magnificence, is the first impression the chapel makes today. Strange if exotic bluish tones which have crept into many a colour photograph of it are quite misleading. Its overall tone is compounded of greens and reds, the green of dried seaweed and the red of dried blood. While the octagonal and not particularly interesting ground plan is easily perceived, it takes time — and some care in advancing over the glassy surface of the marble floor — to absorb the worthwhile details, which are really more than details: high on the walls the big, Buontalenti-style shell-framed cartouches, flanked by flaming urns and, below, the massive, sculpted porphyry sarcophagi, one for each grand duke, slightly varying in design but each supporting at its centre a patterned cushion on which rests a gem-set grand-ducal crown. At intervals along the dado are embedded tautly designed and exquisitely crafted *pietre dure* interpretations of the escutcheons of the major (diocesan) Tuscan cities, looped and garlanded and conceived as displayed on so many banners of white marble, hung against backgrounds of dark green marble edged with rust-red. Any one of these is absorbing to study; and for all the opulence of the materials, and the pride of territorial possession, those aspects are transcended by the validity of the series of panels as works of art.

Perhaps the shield of Siena, divided simply into equal fields of white and black, has an inherent severity that would survive in any medium, but it stands out the more effectively in the slightly rusty polychrome splendour of the chapel, and around its white and black target-like core are inlaid tiny fronds and small slabs of moss-green and mauvish *pietre dure* which complement it beautifully. Although other coats of arms, such as those of Pisa, Fiesole and Florence itself, have exactly the same pattern of decorative surround, the colours of their *pietre dure* inlay tend to be more monotonous.

A new Florentine art form has come into existence in these polished panels. It is one possessing its own complex intellectual-cum-sensuous appeal. With hardness and precision, and an overriding sense of pattern and design, are combined the literally colourful properties of the materials themselves, exploited by skilful cutting and by subtle juxtapositions. At times, the effect is of a colour's very essence seized and perceived — in perhaps a minute mineral chip — as though at the bottom of some deep pool of water. At other times, a gamut of textures, semi-translucent and opaque, marbled, mottled and veined, and ranging through the spectrum in tone, sets up an almost rippling surface

effect of colours played off against each other in a rare crystalline patchwork of the greatest artistry, every patch of which is a jewel.

It would be absurd and unhistorical to deplore the products of *pietre dure* – more spirited and far more sheerly ostentatious displays of which were soon to be created in forms of furniture and reliquaries – as somehow not properly Florentine. It was Grand Duke Ferdinando I who in 1588 brought into official existence the Opificio (Workshop) of *pietre dure*, which has continued to practise down the centuries, and an attentive visitor to the Chapel of the Princes will note that one section of the inlaid pavement bears the Workshop's monogram and the date 1962.

By his action the grand duke showed himself a true Medici, with a taste for the jewelled, the rare and the highly wrought inherited not only from both his parents but from his Medici ancestors, going back to Lorenzo 'the Magnificent' and to the less charismatic yet significant figure of Lorenzo's father, Piero, with his documented fondness for precious stones, marbles and minerals. Before stigmatising the lavish museum of *pietre dure* represented by the Chapel of the Princes, the *quattrocento* enthusiast (with possibly, if Anglo-Saxon, a touch of the puritan in that very enthusiasm) must consider whether the chapel would not have enchanted as well as astounded Piero de' Medici.

Perhaps the closest parallel to the chapel, in funereal splendour and family pride, is to be found in Spain, in the Chapel or Pantheon of the Kings at the Escorial. It had been a project of Philip II (who died in 1598) but it was begun only subsequently and its construction is approximately contemporaneous with the work that went on in the Chapel of the Princes during the earlier seventeenth century. It was completed and inaugurated only in 1654, under Philip IV. There is contrast as well as similarity between the two buildings, but in passing one may recognise how very far the Florentine merchant family of Medici had risen in two centuries, to be erecting a chapel that can be compared with one built by the kings of Spain and which includes the sarcophagus of an emperor, Charles V, once liege-lord of the rulers of Florence.

At the Escorial the royal Pantheon is located in the Crypt and descent to it, down a steep marble staircase, brings apposite thoughts of burial. The Pantheon itself is an elegant, circular space of partly pinkish marble and a good deal of gilt, with small, sculpted, gilded angels holding candles at intervals around the wall. But in this restrained yet graceful setting the mortuary function of the chapel is insisted upon in a way almost as practical and prosaic as that of any secular mortuary. The kings of Spain and their wives are buried in coffins of identical design, placed one above the other in recesses that read as shelves, identified only by gilded metal name-plates. There are no images of them, and

the sense of humanity levelled in death is strong, especially as the tiers of coffins flank the altar with its figure of Christ on the Cross.

Returning to Florence and stepping back, as it were, into the Chapel of the Princes, one is immediately struck by the most effective and novel aspect of the scheme, the colossal statues of the grand dukes in bronze, standing in living guise and full regalia above their massive sarcophagi. Flawed as the existing appearance is, through the concept being left so incomplete, it still retains something of powerful originality – thanks to the achievement of Pietro Tacca, sculptor of the two statues that are *in situ*, of Ferdinando I and Cosimo II. If in the mind's eye one fills the empty niches with statues of comparable quality, the chapel begins to assume much of its intended dignity, and also aesthetic calibre. The slightly oppressive expanses of the *pietre dure* walls are, or, rather, would be, enlivened by the bronze statues all around, especially if those were, as intended, gilded. The part that gilded metal could play in setting off as well as obviously enriching panels of *pietre dure* was to be repeatedly demonstrated by Florentine artefacts of all kinds, culminating in the large and superb cabinet commissioned by Grand Duke Cosimo III in honour of his son-in-law, the Elector Palatine. More of a small monument than a piece of furniture, and with a gilded figure of the Elector in a niche at its centre, that extraordinary, extravagant yet artistically triumphant object descends from the Chapel of the Princes.

The way the chapel evolved is complicated and not entirely clear. In addition to the no longer young Buontalenti, other architects and artists contributing to its evolution, such as Matteo Nigetti and Alessandro Pieroni, were active, gifted men (Nigetti will occur again in these pages), but have scarcely become household names outside Florence. Another figure involved is partly interesting because of his heredity and his amateur status, Don Giovanni de' Medici, the child of Grand Duke Cosimo I's old age, by profession a soldier.

More than one proposal was put forward about the design of the statues of the grand dukes, and it seems that the preferred medium for them was marble. It was Tacca himself (according to the reliable seventeenth-century Florentine pioneer art historian Baldinucci, who was more scrupulous and much more scholarly than Vasari) who decided on bronze, doing so against considerable opposition. Indeed, he was apparently not among the sculptors first selected for the work, although he had executed the colossal plaster models that temporarily occupied two at least of the niches.

Tacca chose bronze primarily because he was a master at handling it. He had also perfected a process for its casting and assembly, and a method for ensuring successful

gilding of the large quantities of metal. Perhaps, too, he could anticipate the sumptuous contrast of the two media, of the tall shapes of gilded metal gleaming like great candle-sticks in the niches of dark *pietre dure*. And perhaps he was aware of an earlier funerary achievement where lifelike figures of gilded metal are seen against a setting of stone, the wonderful groups of Charles V and Philip II kneeling with their families on either side of the high altar in the main chapel of the Escorial. They are the work of a sixteenth-century Italian sculptor, Leone Leoni, assisted by his son Pompeo, who had settled in Spain. If Tacca needed to argue the case with a Medici patron for choosing bronze for the statues of the grand dukes in the Chapel of the Princes, he could not have cited a more splendid and flattering precedent.

Not in prayer, and very much not moribund, the pair of statues Tacca finally cre-ated – of father and son – are at once incarnations of royal authority and recognisable portraits. Ferdinando I may be lightly idealised, slimmed down physically, but Cosimo II is almost uncouthly portrayed, with his bulbous nose prominent. The whole idiom flies in the face of that of Michelangelo's '*Capitani*' in the adjoining chapel. Tacca delights in all the fluidity and texture of damask robes and ermine capes, and conveys a sense of animation through his sensitive response to every fold of the formal costumes.

To the statue of Grand Duke Ferdinando I he gave a touch of delicate if not neces-sarily appropriate poetry, refining beyond anything naturalistic or obvious by having Ferdinando gaze meditatively at the thin wand of the lily-topped sceptre, which he bal-ances gracefully, slanting across his body, in slim, sinewy fingers. Thus might some saint be sculpted gazing on the Crucifix. Proudly yet half poignantly, Ferdinando seems to brood on a ruler's destiny, and possibly there is just a hint of his unforeseen, eventual ele-vation to the Grand Dukedom of Tuscany. As an intensely stylish image of royalty per-sonified, though also patently of a person, Tacca's *Ferdinando I* is a masterpiece. In itself it indicates something of the creative energy alive in the Florence of its day (see Plate 30).

W HEN FERDINANDO I died in 1609, he was succeeded by his eldest son, the nine-teen-year-old Cosimo II. The young grand duke was not a physically impressive figure, as Tacca's statue in the Chapel of the Princes indicates and other representations confirm. Nor was he a very forceful ruler. He suffered from tuberculosis and became increasingly ill during his short life and comparatively short reign. He died early in 1621.

It is altogether understandable that history generally has not had much to say about an undominant ruler who barely lived to maturity and who might seem to symbolise or

prelude the gradual decline of a dynasty and its kingdom. The tranquil years of Cosimo II's reign offer little in the way of interesting or disturbing events in Florence, for which his subjects may well have been grateful. A sense of continuity and stability inherited from the previous reign would be the more welcome in seventeenth-century Europe, often at war and witnessing such dramatic deaths of kings as that by assassination in 1610 of Henry IV of France, husband of Cosimo's cousin Maria de' Medici. It was not a negligible achievement that Tuscany remained peaceful; and outwardly at least it appeared still prosperous. Besides, there were some business initiatives undertaken, outside Europe. A Florentine commercial mission was set up in Persia in the same year as Henry IV was assassinated.

Wonderful Persian artefacts — round shields of steel, intricately inlaid

Gasparo Mola: Helmet and Shield of Grand Duke Cosimo II, *Museo nazionale del Bargello.*

with mother of pearl — subsequently arrived in Florence as gifts to the grand duke, to persuade him to join in political alliance against the Turks. Exotic as is a Persian shield surviving in the Bargello, it is hardly more exotic — and certainly no more ornate — than the buckler and helmet executed for Cosimo in Florence (now also in the Bargello), where lace-like patterns of chased and gilded copper are spread over the areas of burnished steel, and a snarling gilt dragon writhes on the helmet's crest. Such artfully fantastic armour suggests not war and bloodshed but peace and theatrical pageantry.

Cosimo II may have left virtually no impress on the pages of history but he does not deserve to be dismissed as a ruler indifferent, indolent or intellectually dim. Like two of his younger brothers, Cardinal Carlo de' Medici and Prince Don Lorenzo, he had a pronounced interest in the arts, and unlike them he had the entire family palace of the Pitti at his disposal as well as the family collections, much increased during his reign by gifts

and his own patronage. Towards the end of his life, as he must have feared if not indeed realised it was, he rapidly devised and had richly furnished what a contemporary diarist described as '*una bella galleria*' (no mere small cabinet room) of paintings and sculpture in the Pitti, and his taste in pictures ranged from esteemed old master examples to small-scale landscapes by both Italian and Northern painters of his own day. To some extent, the taste for landscape was new in Florence, and new too was the painting of such scenes on *pietre dure*, and also the realisation of them in *pietre dure* compositions. Cosimo had all the Medici villas recorded in coloured 'views' which were to be incorporated in panels of *pietre dure* mosaic on luxurious pieces of ornamental furniture.

Tastes like these may easily reinforce the stereotype of a sick man indulging in sensuous visual pleasure (though nobody has yet explained what would be wrong in his so doing), but there are other aspects to Cosimo II's character. While the fabric of Florence was not affected by them, its 'image' at the period certainly was. Religious and even superstitious as the grand duke might be (he moved back into newly arranged quarters at the Pitti Palace on the feast-day of the Medici patron saints, Cosmas and Damian), he deserves to be remembered — and saluted — for proto-scientific interests serious enough for him to have invited to the city from Pisa the son of a sixteenth-century Florentine musician, the mathematician and astronomer, earlier his tutor, Galileo Galilei.

Galileo, 'who of late', wrote the English poet, John Donne in 1610, 'hath summoned the other worlds, the stars to come nearer to him', dedicated to Grand Duke Cosimo II his *Siderius Nuncius*, published that year, in which as messenger he conveyed a message from study of the stars through the newly invented telescope. Among his discoveries were four new 'planets' (satellites in fact) around the planet Jupiter, and those he christened the 'Medicean stars' in honour of the grand duke and his three brothers. Thus the Medici family found a positive place — ultimate recognition of their status — in the modern, scientifically established heavens. Not even the painted and verbal hyperbole of Vasari had envisaged that apotheosis.

The patronage and protection given by Cosimo II to Galileo more than repaid the compliment. And during the grand duke's brief lifetime, the challenge to church authority implicit or explicit in Galileo's discoveries and polemical publications (he had in him a good measure of Florentine contentiousness) did not lead to open papal condemnation of him. Cosimo's son, Ferdinando II, continued the patronage and seems to have been more profoundly and practically absorbed than his father by scientific matters, but he could not entirely protect Galileo when the famous clash came. Still, Galileo escaped with his life.

Façade of the Viviani house, Via Sant' Antonino.

Nor did Florence forget him. Under the last Medici grand duke, Gian Gastone, a monument to Galileo went up in Santa Croce, thanks chiefly to his devoted disciple and biographer, Vincenzo Viviani, who had left a bequest for that purpose. Viviani set up his own remarkable monument to Galileo — one of the most bizarre and truly 'baroque' productions to be seen in Florence. The façade of his modest-sized house (in the narrow Via Antonino, not far from Santa Maria Novella) was turned into a sculpted *éloge* of Galileo. Over the doorway, between curling, twisting cartouches, is set the astronomer's bust, by the brilliantly accomplished, endlessly active sculptor Giovanni Battista Foggini. The remarkable feature, however, is the virtual blanking out of the walls immediately on either side, where windows might be presumed, by long tablets or scrolls of stone, scalloped and curved top and bottom, on which is inscribed detailed praise of Galileo and gratitude to Louis XIV of France (who had given Viviani financial aid). As décor

it might have been devised in cardboard for some official funeral ceremony, and from such an occasion the concept perhaps derives. Viviani's originality was to have temporary-seeming ornament transferred to a medium solid and durable. His interests included architecture, and by making the façade of his house a memorial — almost, a museum — in Galileo's honour, he added something admittedly small yet permanent to the appearance of Florence.

The 'tablets' were placed in position in 1693, at the end of a century which had been one of science and philosophy, as much as of baroque show and of fervent piety, the century of Descartes as well as of Galileo, and of the founding of the Royal Society in England. In Florence a Royal Society-style Academy, the Academy of Prince Leopoldo de' Medici (the youngest son of Cosimo II), known generally as the Academy of the *Cimento* ('Experiment' or 'Trial'), came into existence in 1657, five years before Charles II granted the first charter to the Royal Society.

Cosimo II had 'won' Galileo for Florence, in an earnest though civilised competition with Venice, where Galileo was promised the great gift the republic traditionally provided — that of freedom. Had he opted for Venice the loss would have been Florence's but he himself might have found a stronger bulwark against papal wrath.

With the creation of new churches and new chapels, and new decoration of old ones, and the growing population of priests, monks and nuns, and with a fresh though hardly unprecedented wave of religious feeling fashionably washing through the city, Florence in the seventeenth century can superficially seem plunged in a single mood of emotional, pietistic gloom. Darkened canvases by the one painter of the period widely known, Carlo Dolci, heavily encrusted altars and the mournful, proto-Victorian pious repressiveness associated with Cosimo II's mother and widow, ruling as regents for the time of his son Ferdinando II's minority, have loosely combined to convey an unalluring 'picture' of the period. Extremes of Roman Catholic religious feeling are often antipathetic to northern, Protestant temperaments, however fine its artistic manifestations. And for some reason, a succession of grand duchesses in Florence who supposedly 'interfered' in government and who sought to lead good if narrow lives — rather than be frivolous and dissipated — seems to attract particular condemnation, arguably more sweeping than if they had been men. One may suspect that wearing ugly black costumes and becoming fat are among their crimes.

In fact, a good deal about the 'picture' is inaccurate or at least confused. The paintings themselves, notably when cleaned, are often the opposite of gloomy, though they may be intense. Sometimes, the most sacred of religious objects, a reliquary or small

shrine, is of dazzling, Fabergé-style opulence and refinement but with a greater degree of aesthetic energy.

Above all, Florence had in Galileo a new and secular patron saint, of European renown, one more hero added to its cultural pantheon, long before he was honoured by a monument in Santa Croce. The cult (as it may be called) of Galileo in Florence, like the Accademia del Cimento there, points to an enlightened intellectual climate coexisting with the religious one. It was, after all, a Prince of the Church, Cardinal Leopoldo de' Medici, brother of one grand duke and uncle of another, who was the Accademia's patron. As in the Renaissance, cultivation of 'advanced', speculative learning did not necessarily imply a lack of belief in Catholicism, still less in Christianity. As for the Catholic Church's full recognition of the correctness of Galileo's astronomical observations and deductions, that took rather longer to be formally admitted,

Cosimo Merlini: Reliquary Cross of the Grand Duchess Maria Maddalena, *Museo dell'Opera del Duomo.*

but the pope accepted the results of a commission of the pontifical academy of sciences, which had so concluded, in 1992.

The piety of Cosimo's II's mother, the Grand Duchess Cristina, and of her daughter-in-law, the Grand Duchess Maria Maddalena, is not in doubt. Artistically attractive evidence of it is contained in two differently designed but equally sumptuous objects they commissioned. Maria Maddalena presented to the Duomo a tall, enamelled and gold cross, almost etiolated in its filigree elegance, and bristling with globular jewels like so many frozen, green-tinted dewdrops, a masterpiece which the court goldsmith, Cosimo Merlini, designed to display the relic of a thorn from Christ's crown of thorns (now in the Museo dell'Opera del Duomo).

The Grand Duchess Cristina had a miniature, temple-shaped reliquary of silver, rock crystal and semi-precious stones (originally in her own chapel in the Pitti Palace, now in the Treasury at San Lorenzo), which shelters a fragment supposedly from the column at which Christ was flagellated. Under the silver and crystal dome, two figures in silver flagellate a larger one of Christ, whose body is carved out of glowing, pale, flesh-coloured cornelian. It is a challenging conceit. The reliquary might at first sight pass as a luxury table ornament, and there is either extreme sophistication or simplicity in the piety which can take pleasure in such a *recherché* and materially rich interpretation of so poignantly naked and painful a subject. But Cristina was shrewdly selected by Galileo to be the addressee of a piece of thoughtful writing in which, broadly, he sought to reconcile, though also distinguish between, Scripture and scientific knowledge, a bold essay well received at the court in Florence and which became his *Letter to the Grand Duchess Cristina*.

The piety of Cosimo II was also to be richly commemorated. It is literally enshrined in an object of almost desperate lavishness, offering heaven what might cruelly be described as a bribe — sadly and vainly, as things proved: the brilliantly coloured, bejewelled *Ex Voto* mosaic of *pietre dure*, in which he kneels on a cushion of lapis lazuli, superbly clad, though comical as ever in physiognomy, pleading or grateful to be restored in health (see Plate 34). It is perhaps the most vividly personal and sumptuous of all seventeenth-century Florentine artefacts, but it was not intended for the city. Cosimo planned it to be part of a magnificent altar-frontal, destined as a gift for the altar of St Charles Borromeo in Milan, should he be cured. It never reached Milan, for his prayers were not answered.

Perhaps only because the relief was to go abroad (that is, outside Tuscany), the composition incorporates a *pietre dure* view of Florence, locating Cosimo there and identifying him as the city's ruler. Through a wonderful window-frame of inlaid, pinkish-mauve jasper is seen the unique, quintessential and of course religious Florentine combination of Giotto's Campanile and the Duomo with Brunelleschi's dome. There are even indications, executed in bluish stone, of the hills north of the city. Inevitably, however, the façade of the Duomo has to be shown bare.

It was Cosimo's son, the Grand Duke Ferdinando II, who would initiate proposals, very soon frustrated, for at last clothing the Duomo with a worthy façade. But some public building contributions to Florence were made by Cosimo, and others would probably have followed had he lived longer. As it is, subsequent developments of the Pitti Palace and the hospital of Santa Maria Nuova have helped to obscure the steps he took for their enlargement and improvement, employing his preferred architect, Giulio Parigi.

Externally, Parigi's additions to the central block of the palace are not immediately apparent, being in the same stone and rusticated style as the original *quattrocento* building. That Cosimo might wish for some expansion of his home was perhaps the natural consequence of a numerous family (he had eight children), as well as of grandiose ideas for making it more impressive as a palace. At the hospital of Santa Maria Nuova, where the first arcades of the main façade were begun by Parigi, to be continued under later Medici grand dukes, Cosimo II's initiative is commemorated by a bust of him, chronologically the first of the grand-ducal series of busts on the portico, but it has probably not done much to keep his memory alive.

On the one public building Cosimo gave to the city, a granary situated at a street juncture east of the Palazzo Vecchio and not far from the Arno, his bust can also be seen. Parigi is usually credited as the architect of this by no means uninventive building, in the traditional form of an open, ground-floor loggia with storeroom(s) above. The upper portion is elaborately treated, divided into three strongly defined areas, pierced by windows circular, rectangular and, on the main floor, big and arched and framed between pilasters. But in Florentine fashion it is not a building very noticeable at street level, and in purpose it has steadily come down in the world, having dwindled from being a theatre to a cinema.

In every sense, Cosimo II's granary is an isolated building. It is in the palaces and, particularly, the churches that stylishness and show asserted themselves most forcibly in seventeenth-century Florentine architecture. Sometimes, as at the old church of San Simone (properly Santi Simone e Giuda), tucked away in a small piazza near the Teatro Verdi, in the ancient heart of Florence, the exterior gives no hint of what awaits one inside. The shock of delight is the greater on discovering within this simple, single-nave church a ceiling richly carved and coffered, a harmony of green and gold, designed by a highly gifted, long-lived and ubiquitous native architect, Gherardo Silvani (born in 1579 and not dying until 1675).

Silvani's name keeps cropping up in connection with buildings of all kinds, and his capable son, Pier Francesco, continued the activity, though he survived his father by only ten years. There was more than a touch of Buontalenti's creative capriciousness in the elder Silvani's treatment of the features of palace façades, with windows, balconies and doorways of deliberately unexpected, intriguing design, often incorporating staring bats' heads, even bats' wings.

These never overdone yet arresting and characteristic aspects of Florentine palaces of the period, handsomely enough designed in themselves, are there to be remarked on.

Doorway of the Palazzo Castelli-Fenzi, Via San Gallo.

Two of Silvani's finest façades, those of the Palazzo Coroni (Daneo) and the Palazzo Bartolomei are even in the same street, the main thoroughfare of Via Cavour, more familiar and visited as the site of the Palazzo Medici-Riccardi.

Elsewhere in the city the now sometimes rather grimy façades of palaces by Silvani suddenly appear, and it would be difficult to miss the large Palazzo Castelli-Fenzi in the parallel Via San Gallo, if only because of the pair of gargoyle-like satyrs sculpted grimacing and almost yelling abuse, on either side of the portal, and who support the balcony above. Less obtrusive though more refined is the fantasy treatment of what are or should be pilasters below the two figures, fancifully conceived as dissolving into long ribbons and cords and tassels, lightly modelled in stone. A final breath seems there exhaled from the long-past, delicate, graceful carving of Desiderio da Settignano.

As it happens, the two satyrs are the work not of Silvani but of a contemporary sculptor, Raffaele Curradi, and the doorway is the sole enlivening note on a rather ponderous if grand façade. Yet they are licensed by Silvani's own vocabulary and his use of animal masks and heads, found sometimes glaring out above an entrance archway or roaring below a window-sill. At the Palazzo Castelli-Fenzi the grilles of each heavy ground-floor window rest on the shells of tortoises. And there, even the distinctly idiosyncratic though now nostalgically charming relief featuring a locomotive, inserted over the doorway in the nineteenth century to commemorate the introduction of the Florence–Livorno railway line, is less incongruous than it would be over, say, a *quattrocento* doorway.

Yet it is a church – an entirely new one – that is the greatest and most sustained monument to the stylish vigour of Florentine architecture and decoration in the seventeenth century: the church of San Gaetano. Accessible and central, and in fine condition, its exterior recently restored, it suffers only from the restricted 'medieval' space of the Piazza Antinori where it rises in all its scenic splendour like a tree peony in a prison cell. Getting away from it sufficiently to appreciate the intended impact of its beautifully proportioned, ebullient yet dignified façade, approached by a broad flight of steps, is hardly possible. It has to be studied, as it is normally photographed, from an angle, though in terms of space what it really deserves is a piazza resembling that of Santa Croce.

There is considerable rightness in the fact that the construction of Santi Michele e Gaetano (commonly known as San Gaetano), down to the ultimate decoration of the façade, occupied most of the century and involved a number of outstanding architects and sculptors, and additionally some painters. It was begun by Nigetti in the reign of Grand Duke Ferdinando I and taken over by the elder Silvani, whose son finished the façade. Among sculptors who contributed to the interior was Foggini, who would have opportunities in other Florentine churches for more extensive demonstrations of his virtuosity, as architect in addition to sculptor.

San Gaetano was effectively finished only in the reign of Ferdinando I's great-

grandson, Cosimo III, the penultimate Medici grand duke, in the last decade of the seventeenth century, when statues were placed in position on the façade. But the 'seal of approval' had already been stamped on it shortly before, with the establishment over the central, circular window of the colossal, boldly sculpted Medici arms, topped by the grand-ducal crown and supported by winged *putti*. In the rolling contours and swagger of this decorative device, the work of Carlo Marcellini, who also sculpted busts of Cosimo III, there seems fully justified celebration of Florentine *seicento* achievement in the arts. The church is also, as the prominent inscription on the façade records, a monument to a Medici patron, Cardinal Carlo de' Medici, younger brother of Cosimo II and uncle of Ferdinando II.

Inside, as well as out, San Gaetano provides the most obvious, the most cogent and the most complete answer to any lingering questions about whether post-Renaissance Florence produced any truly worthwhile architecture. Admittedly, there were to be few other churches of its scale and accomplishment, but San Gaetano represents by no means the end of an artistic pilgrimage through the 'second' city. Rather, it stands chronologically less than halfway along that route. Its façade bears the date 1648, and it was judged to be in a sufficiently finished state to be consecrated the next year.

The importance of San Gaetano begins with its façade, a masterpiece of classical design by Gherardo Silvani, simple but subtle in its two tiers of pilasters that lead logically up to the jagged outline of a dominating pediment (see Plate 31). Stripped of its sculpture, it would still make a noble effect. It is, one may say, the ideal façade of its period in Florence: going back to gather hints from Buontalenti's façade of Santa Trinita and absorbing the idiom of proposals then current for the façade of the Duomo.

The very fact that San Gaetano *has* a façade is an achievement, considering that neither the Duomo (at the time) nor San Lorenzo (ever) was to be so fortunate — and nor was the very handsome, later seventeenth-century church of San Frediano. And although Silvani's façade is in itself a more than satisfactory, satisfying statement, the sculptural element on it does not detract from but reinforces its style of tremendous yet animated dignity. The tonal contrast of some white statuary against the brown stone mass of the architectural members is exactly right and helps prepare one for the interior.

No luxurious show of *pietre dure* as in the Chapel of the Princes — no colouristic display as such at all — but the visual equivalent of a bracing douche of icy water is what one experiences on stepping into its austerely grand, half-funereal, though far from gloomy nave. It seems a harmony achieved entirely out of black and white: the black or anthracite-grey of the darkest *pietra serena* used for the architecture, and the whitest of stucco and

Justus Sustermans: The Florentine Senate Swearing Loyalty to Grand Duke Ferdinando II,
Ashmolean Museum, Oxford.

marble for the profusion of statues and bas-reliefs which adorn the walls. It is tempting
to say no other religious interior in Florence is similar, though a hint of the austere con-
trast is already adumbrated in Michelangelo's sacristy.

At first sight, one is hardly conscious that there are also paintings in the church.
There is no high altarpiece but instead, more typically, a bronze crucifix, by another
sculptor of the period, Francesco Susini. Painted altarpieces are to be found on exami-
nation, in the deep side chapels. And that the boldest and most brilliant of those (a
Martyrdom of St Lawrence) is by Pietro da Cortona, not strictly a native artist and active
largely at Rome, has its significance. Mid-seventeenth-century Florence possessed no
decorative painter to rank with Silvani or Foggini in architecture and sculpture. Carlo
Dolci's distinction lay in the direction of portraiture and intensely felt, intensely finished,

Ferdinando Ruggieri:
Catafalque for the Obsequies of Grand Duke Gian Gastone de' Medici,
Biblioteca Nazionale Centrale.

often small-scale religious pictures. The painter most capable of exuberant and delight-ful fresco decoration was the gifted Giovanni da San Giovanni who died in 1636, leaving unfinished frescoes in the Pitti Palace for Grand Duke Ferdinando II. A fresh talent was sought, from outside Florence. Pietro da Cortona came from Rome, on several occa-sions, to create new and superb fresco schemes in the palace.

The underlying theme of those decorations is the familiar one of the glory of the house of Medici, but specific impetus was given to it by the fact that Cosimo II's heir, Ferdinando II, had now assumed power as grand duke and was celebrating his marriage to Vittoria della Rovere, daughter of the Duke of Urbino. In reality, it proved a marriage to justify little celebration, and the happiest aspect of it lay in the works of art it instigated.

Ferdinando II reigned until 1670. Whatever the presumed problems for a boy ruler whose physical eclipse between the formidable black bulk of his mother and his grand-mother had been vividly evoked in a ceremonial composition by the great court portraitist, the Flemish-born Justus Sustermans, Ferdinando emerged as a cultivated, able, popular and largely successful prince. In Sustermans' composition (see p. 409), which shows homage being paid to him by the Florentine Senate, Ferdinando looks a pale shrimp of a child. One would not be too sure of his survival. But there was to be a splen-dour about 'his' Florence – not all of it due to him personally. San Gaetano symbolises it. And the splendour lingered on, as far as the physical city was concerned, well into the reign of his son, the third and last Cosimo, lighting up what is otherwise an increasingly gloomy tale of a moribund kingdom, an exhausted dynasty and a fluctuating future for Tuscany under foreign control.

Indeed, stylishness and lavishness clung to the Medici grand dukes to the very end. A vast construction, more triumphal than mournful, and fully baroque in its ostentation and elaboration, was erected in San Lorenzo in 1737 for the obsequies of the last male ruler of the line, Grand Duke Gian Gastone. It was only temporary, of course, but fortu-nately its design was recorded in an engraving which conveys much of its sumptuous effect. That effect is more striking in comparison with the very meagre décor for similar ceremonies a few years earlier, at the death of Cosimo III. As farewell not only to the Medici as rulers but to a whole era of opulent display in Florence, there could scarcely be a more fitting flourish.

Some of the problems that arise from attempts to study and savour other great monuments, artistic milestones on the road that conducts one eventually to that final catafalque, must be faced before stepping further.

Apart from those of the Palazzo Pitti, the majority of the palace interiors of the period are rarely, if at all, accessible to the 'ordinary' visitor. Inevitably, emphasis falls therefore on ecclesiastical buildings, many of which are usually (though not always) open once, at some given time in a week — possibly for a service. And perhaps such emphasis is in any case not wrong. The churches and chapels of the period are certainly stylish enough, and varied enough, to make for stimulating sightseeing. Perhaps they are evidence of the increasingly repressive, pious atmosphere fostered by a succession of grand duchesses and culminating in the gloomy near-fanaticism associated with the penultimate Medici grand duke, Cosimo III. But they seldom convey that sense.

Gloom and repression are the very opposite of the moods they suggest. From the visual evidence, Florence would appear to have been celebrating the Catholic religion fervently, yet with exuberance and optimism. The future life anticipated by their architecture and art promises to be graceful, expansive and sumptuous. Heaven will be animated by flurries of slim, pale, angel shapes and decorated in colour schemes featuring a good deal of white and a great deal of gold.

But such heaven does not always lie around one in Florence with total visual immediacy, even when physically accessible. Sometimes it can be disconcerting to find the extent to which a Renaissance or earlier interior has been redone in lavish style, without entirely concealing the previous architecture, as at Santissima Annunziata. An individual seventeenth-century chapel created there may well be more aesthetically satisfying, and certainly more truly *sui generis*, than the main body of the church, which rather too patently suggests a lily not merely gilded but regilded. Elsewhere, as in the church of Ognissanti, the initial impression is of such a heterogenous mingling of stylistic idioms and assembly of competing objects (including a fresco by Botticelli) that one might retire disheartened, without discovering that away in the right transept is a small chapel dedicated to St Peter of Alcántara. It is a homogenous fusion, typically of architecture and sculpture, with painting contributing only a subordinate share, a pretty, early eighteenth-century creation of almost boudoir rococo style, which seems to whisper of religious aspiration in seductive, hedonistic tones evocative less of Cosimo III's Florence as con-

Opposite: *Chapel of St Peter of Alcántara, Ognissanti.*

ventionally conceived than of the northern European kingdom of some sophisticated prince-bishop – or even of Louis XV's France.

On occasion too, as could hardly not occur in Florence, of all cities, the fame and prestige of some great Renaissance achievement fatally and for ever overshadows a neighbouring achievement no less valid and great in its own terms, but created at a much later date. No more striking and sad example exists than the tale of two chapels in the church of the Carmine (Santa Maria del Carmine).

For a majority of people, whether or not they manage to visit Florence, the Carmine means solely the Brancacci Chapel and its frescoes by, supremely, Masaccio. Until comparatively recently, the eager, programmed pilgrim would enter the church, hasten blindly down the nave and turn abruptly right to become absorbed by the frescoed walls of that chapel. Now that the frescoes have been restored, the chapel is boarded off from the rest of the church and must be approached through the adjoining cloister, after payment of a fee. Thus there is no longer any inducement to visit the church itself, and even less likely is it that the chapel in the left transept, facing the Brancacci one, will be troubled by visitors. Indeed, anybody straying there may gaze – freely – undisturbed for hours on end, while from the crowds pent up in the Brancacci Chapel, arriving and departing at regular intervals, drifts a steady, respectful, polyglot hum. There could scarcely be more excitement if the Renaissance was being born daily, behind the high screens – and in the process being filmed.

All that the other, silent chapel, the chapel of St Andrew Corsini, has to offer is itself as a large-scale, luminous and imposing work of art, a combination fused mainly out of architecture and sculpture: a magnificent, thoroughly baroque harmony but devoid of associations of heroic stylistic birth, or re-birth, naturalism or conquest of space or pioneering genius (see Plate 32). Talented native artists – Foggini and the younger Silvani – worked to achieve the Corsini Chapel (see further, pp. 426–7). And to it, unusually in Florence, a painter of at least equal talent, the Neapolitan Giordano, contributed the finishing touches, filling the cupola of the chapel with a colourful, literally heavenly vision, of the saint's apotheosis.

One reason that there are no crowds marvelling daily over this monument of all the major arts is simply that it has not been put on the average visitor's 'map' of Florence. That hints at another, grave problem. Later Florentine artistic achievements rarely receive much attention in popular guide-books, even those that are reputedly good and reliable. The names of the artists have often gained little or no general currency. The history of the construction of a chapel or church may well be extremely complicated, and

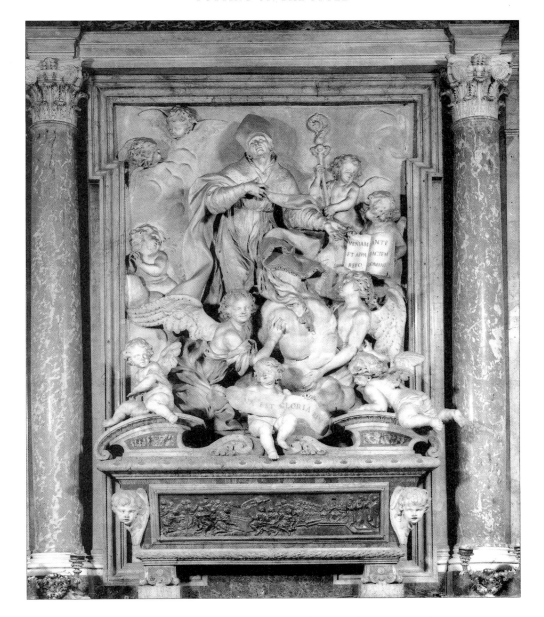

Giovanni Battista Foggini: Relief of the Apotheosis of St Andrew Corsini,
Corsini Chapel, Santa Maria del Carmine.

the work have gone on for decades, from one century into another, so that its style can-
not neatly or easily be characterised.

Above all, there is a widespread assumption — encouraged by the bias of most of the

writing in English at least – that the best days of Florence were over by 1600. Whatever followed has to be, is sometimes openly treated as, inferior, artistically, as in other ways. Florence was notoriously not the 'home' of the baroque, and it is inconvenient for the tidy pattern-making desired by art history that it should have produced any baroque monuments at all – still less any of rococo tendency. The chapel of Saint Peter of Alcántara, admittedly a mild aesthetic experience and definitely of no major historical importance, remains a very well-kept secret. Scholarship itself is still in the process of reassessing, virtually rediscovering, the shape of the 'second' Florence. That may make difficulties for the amateur eager for knowledge, but it also allows, positively encourages, the unfettered exercise of the amateur's eye. It can be a relief to stumble upon the chapel, or the palace façade, the sculpted group or the reliquary, around which there has accumulated no mass of received opinion.

And, even when every problem on the way has been rehearsed, the fact is that the rewards of a journey, however hurried, are great and worthwhile. By good fortune and good sense, the one palace that really matters is extensively accessible, the Palazzo Pitti. Because the building went on being inhabited by the grand dukes as long as Tuscany lasted as a political entity, and was subsequently used by the kings of Italy, it is (among other things) a museum of the artistic tastes of successive generations, and of styles from baroque through neo-classical to mid-nineteenth-century. Each doubtless has its own appeal, but undeniably the double burst of brilliance of decoration – upstairs and downstairs, as it were – which Grand Duke Ferdinando II instigated in the 1630s is the most stylish.

In the painter Giovanni da San Giovanni (born near Arezzo in 1592) Florence nurtured an artist of wonderfully varied ability, capable of working on copper, canvas or wall, and in very varied moods from grim to whimsically light-hearted, with often a concomitant lightness in handling paint. His eye for the individual took in his own features, and he has left a small, memorably acute self-portrait (in the Uffizi), frescoed on a tile with astonishing immediacy and directness. Fresco was a happy medium for him. Cosimo II had given him a first grand-ducal commission of that kind, but the impending marriage of Ferdinando II with Vittoria della Rovere (1637) led to his being commissioned to fresco a cycle of allegorical scenes in a high, cool, 'summer' room (see Plate 33) on the ground floor of the Palazzo Pitti (now the large room encountered early on in a visit to the Museo degli Argenti).

Although Giovanni da San Giovanni's death meant the cycle had to be finished by others, something of his spirit and perhaps also his concept survived, for there is an over-

all fanciful, rustic charm in each brightly coloured country scene, set in an elaborate, illusionistic architectural framework, rising to the white and gold ceiling with its own big, cloud-borne, central marriage allegory. The theme of the wall frescoes is flatteringly Medicean-cum-Florentine, dealing with the flight of the Muses from Parnassus to Florence, where they are welcomed by Lorenzo 'the Magnificent'. Although the theme is serious, its interpretation is in decorative terms. Cheerfulness if not flippancy keeps breaking in, even into the allegorical scene of Lorenzo's death (by Francesco Furini), and the visitor looking round is more likely to be enchanted than edified by the summer green of the trees, the wide expanses of blue sky, and the occasional bird or beast.

No similarly frescoed room is to be seen in Florence. Although at the Pitti the rooms beyond are frescoed from floor to ceiling with professionally executed illusionistic décor, the effect is stately but uninteresting. In Giovanni da San Giovanni's room there is a piquant contrast between the formal grandeur of the feigned architecture and the lively, busy and airy landscape compositions perceived as opening out on all sides beyond it. This is decoration not so much for a town palace as for a country villa, and Giovanni da San Giovanni might have found some precedent for his treatment in Pontormo's fresco in the Medici villa at Poggio a Caiano.

Upstairs at the Pitti – on the *piano nobile* – a complete suite of rooms crystallises the easy but utterly accomplished and luxurious style required by the Grand Duke Ferdinando II to provide a suitable environment for a reigning Medici in the mid-seventeenth century. These are the rooms of the Planets (Venus, Apollo, Mars, Jupiter and Saturn) whose decoration was entrusted to the highly esteemed Pietro da Cortona (see Plate 36). After the death of Giovanni da San Giovanni, it had been none too tactfully supposed in Florence that Pietro da Cortona might leave Rome to come to finish the ground-floor scheme. The opportunity to 'immortalise himself' in Florence, as the grand duke's agent in Rome persuasively phrased it to the painter, became the much more attractive and important task of creating new work: the ceiling and cornice decorations which give the Planets' suite its sumptuous character.

All that has diminished the tremendous, beautifully preserved effect of what Pietro da Cortona achieved over a period of years is the fact that every room is now hung, and hung tightly, with paintings – and they are paintings often great both aesthetically and physically. To halt and look up from their serried rows, to concentrate and absorb the richly wrought, highly allusive though buoyant world overhead of Pietro da Cortona's fertile imagining, calls for distinct effort. In Ferdinando II's day the walls were chiefly hung with tapestries, and more than one room had its large *baldacchino* of red velvet fringed

with gold. For these are state rooms, and on their ceilings (the walls, it is noteworthy, left out of the scheme) is a succession of visions illustrating the ideal planetary progress of a Medici prince and future ruler: from love, to protection of the arts, experience of war and eventual heavenly triumph. It is, as it were, a painted mirror and a horoscope for Ferdinando's heir, Cosimo III, born of a loveless union in 1642, contracting one yet more disastrous marriage, and generally failing to meet most of the prognostications.

The fault was scarcely Cortona's. If anything could have inspired the prince (and Cosimo was by nature intelligent and enquiring), these ceilings should have done so. Rubens-like in his artistic optimism (the Pitti ceilings half recall Rubens's Whitehall ceiling), with a personal vision of the world as ever-alluring and ever-exciting, Pietro da Cortona is no dull pedagogue or dreary propagandist for the divine right of rulers. He had an instinctive ability to give pictorial force and form to abstractions and allegory. He came to Florence in 1641 as the painter already of the huge ceiling of the *salone* of the Palazzo Barberini in Rome, with its celestial celebration of a Barberini pope, Urban VIII. Less overwhelming but possibly more sympathetic are the several heavens of the Pitti apartments: airy spaces in which ceilings seem eventually to dissolve in milky skies. Besides, in those rooms Cortona was not content with feigned architecture but modelled the upper portion of the walls to make an exceptionally deep frieze of gilded figures and white stucco medallions, alternating with painted lunettes – creating a décor of astonishing, unparalleled richness that manages to be also elegant and, oddly, almost chaste, despite its splendour.

Florence had Pietro da Cortona only on loan, as it would, more briefly, have Giordano and the Venetian painter Sebastiano Ricci. With no native artist of Cortona's all-round genius, there could be no subsequent suite of rooms in a Florentine palace to equal those in the Pitti. But then no other palace in the city could claim a need for such near-royal adornment, since no other was occupied by the ruler. Before Cortona's work was completed, Ferdinando II had sold the old Medici family palace in the Via Cavour (then Larga) to the Marchese Riccardi. When the Riccardi decided to have decorated the *galleria* they had added to the palace, they commissioned Giordano to paint on its ceiling an apotheosis of the Medici dynasty.

The prospect of one more apotheosis may not now sound very inviting but Giordano seems to have entered on the task with even more than his usual high spirits. It is true that not even he could make the central scene of the group, with the mustachioed Ferdinando II on clouds, other than faintly comic. But to the mythological subjects along the sides of the ceiling he brought vivacity and silvery grace, truly decorating a room

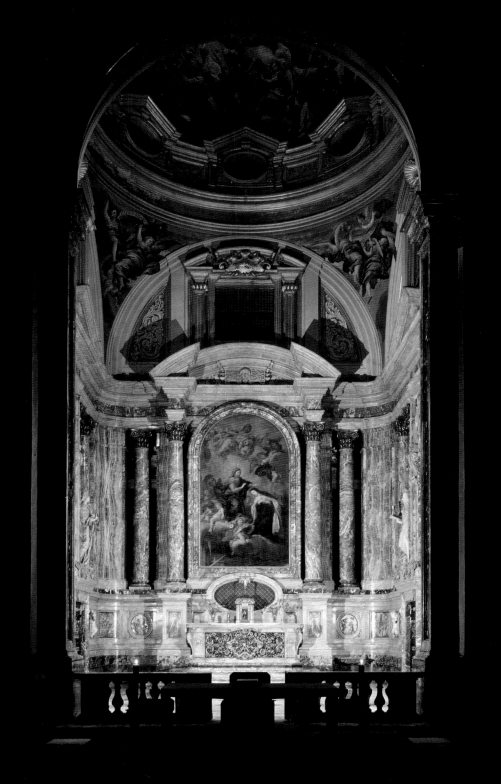

PLATE 40

Ciro Ferri (and others): *The Sanctuary and High Altar*, Santa Maria Maddalena dei Pazzi

PLATE 41
Giovanni Battista Foggini (and others):
Cabinet of the Elector Palatine,
Museo degli Argenti, Palazzo Pitti

PLATE 42
Zanobi Del Rosso: *The Kaffeehaus*,
Boboli Gardens

PLATE 43
Massimiliano Soldani Benzi: *Reliquary of St Alexis*,
Treasury of San Lorenzo

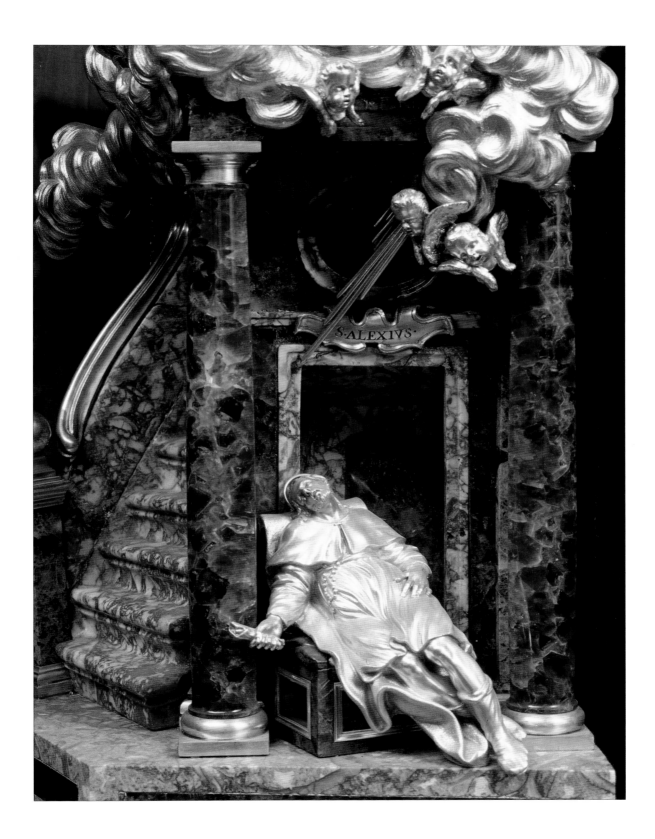

PLATE 44
Bernardo Fallani: *The Casino della Livia*,
Piazza San Marco

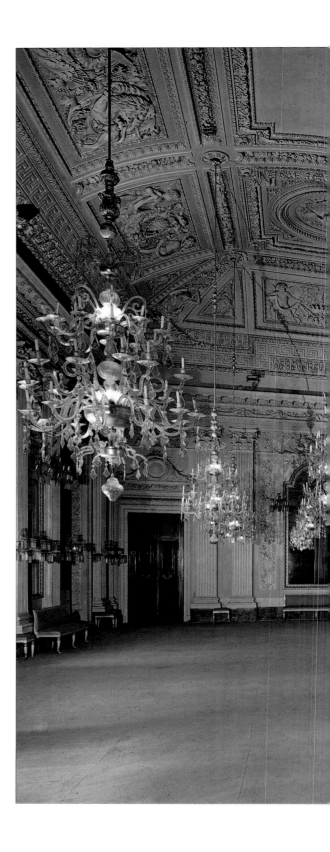

PLATE 45
Gaspare Maria Paoletti (and others):
The 'Sala Bianca', Palazzo Pitti

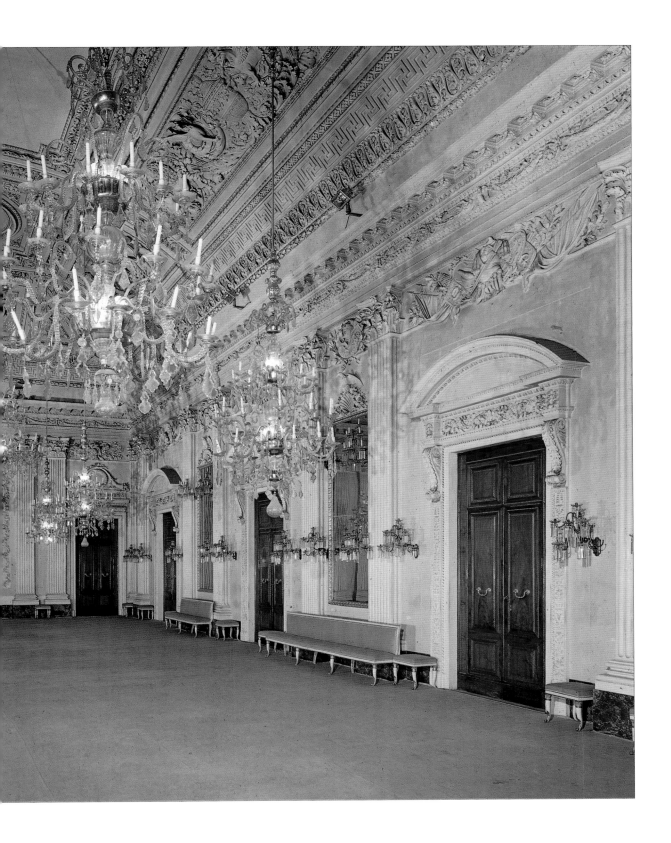

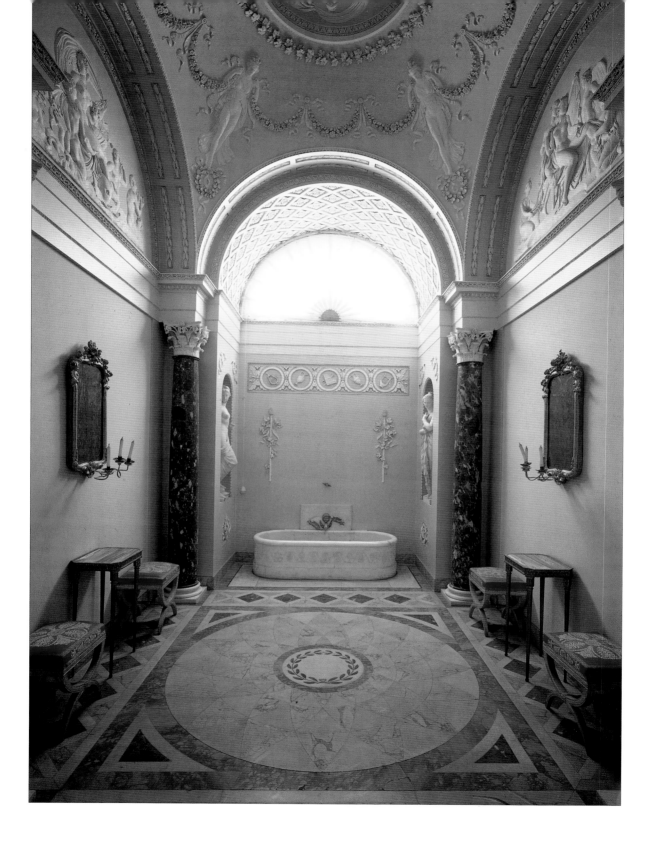

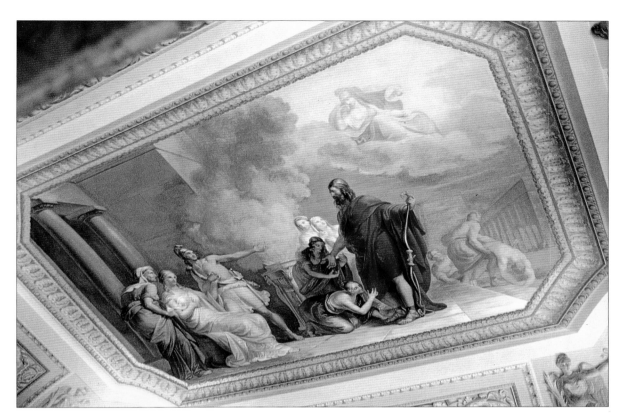

PLATE 47

Gaspare Martellini: *The Return of Ulysses*, Ulysses Room, Palazzo Pitti

OPPOSITE: PLATE 46
Giuseppe Cacialli: *The Bathroom of Napoleon*,
Palazzo Pitti

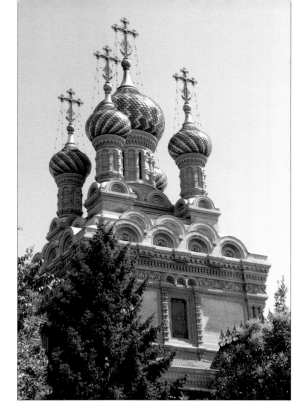

PLATE 48

Mikhail Preobragensky: *The Russian Orthodox Church*, Via Leone X, Viale Milton

PLATE 49

Charles Mant (and others): *'Monument of the Indian'*, The Cascine

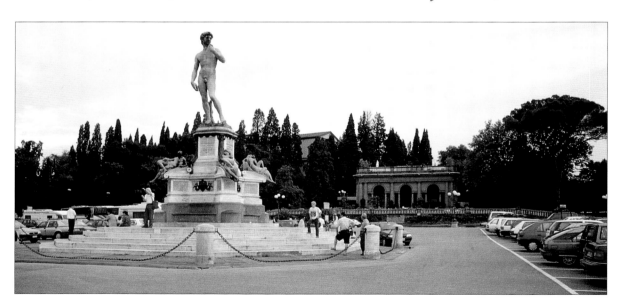

PLATE 50

Giuseppe Poggi: *The Piazzale Michelangelo*

which is already something of a quintessence of seventeenth-century decorative art in Florence (see Plate 35).

An airy atmosphere greets the visitor to this space, reached with no hindrance or formalities up a staircase from the courtyard and through an ante-room on the first floor of the palace. It is void of furniture but hardly empty, since in addition to Giordano's animated ceiling it is almost alive with gold and white *boiseries*, and its long windows are effectively duplicated on the opposite wall by equally long mirrors, themselves painted with playful figures and flowers, in a taste which might seem dubious but which yet is acceptable in this environment. The *galleria* was intended for serious, studious purpose, to display gems and coins, for which the richly carved wall cupboards served as storage, but it would make a suitable setting for an intimate concert of light-hearted music.

The services of Cortona to Florence would have extended from interiors to the outward face of the city had his creativity been the sole criterion. But, unfortunately, money too was involved. He was a gifted architect, and when the Oratorian fathers held a limited competition for the builder of a new church, '*tutta alla moderna*', he was chosen. The grandeur and cost of his proposal seem to have frightened the fathers, and the church was finally built by Pier Francesco Silvani, to become part of the impressive complex of San Firenze, one of the great, unmissable architectural achievements of later Florence. So the loss proved less than it might have been. More perhaps to be mourned is Cortona's never-executed design for the façade of the Palazzo Pitti, which would have given it a majestic, flamboyant, main portal (see p. 420). And he also was asked — by Ferdinando II's highly cultivated brother, Cardinal Leopoldo — to submit a design for the façade of the Duomo.

Entirely new palaces continued to be added to Florence during the seventeenth century, but none was grander or more assertive in thrusting itself forward, and sideways, on to the permanent cityscape than the Palazzo Corsini. Its expansion along the Arno seemed unending. It was '*con molta magnificenza*' that the Marchese Filippo Corsini, whose family was hugely wealthy from banking activities based in Rome and who was a councillor of state under Grand Duke Cosimo III, wished to develop the palace further towards the end of the century. Cosimo issued a decree in 1690 recognising the magnificent concept and the improvement to the city's adornment, as well as the economic fact that the expansion would employ 'many poor workmen'. His decree ordered the compulsory sale of a house on a site adjoining, so that the new palace could develop as the marchese desired. And right up to the last year of the reign of Gian Gastone, Cosimo's son, the interior of the palace was being decorated and improved. By then the Corsini had

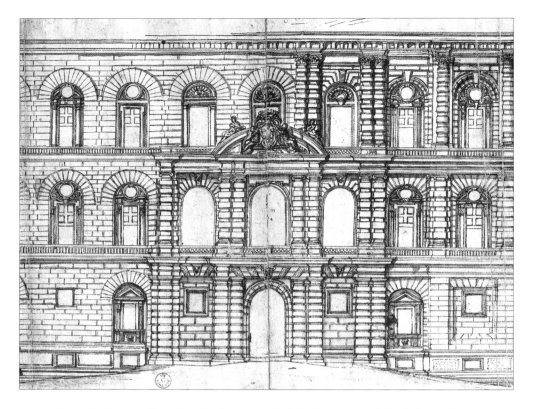

Pietro da Cortona: Drawing for Proposed Main Entrance of the Palazzo Pitti,
Gabinetto Disegni e Stampe, Galleria degli Uffizi.

a fresh claim to grandeur: one of the family had become Pope Clement XII. A statue of him was erected on a staircase inside.

Seen, as it usually is, from the river side, the Palazzo Corsini forms a massive, uningratiating presence. It is in the city yet hardly of it, at least stylistically. Pier Francesco Silvani seems to have had the chief hand in its design, which brings echoes of Roman baroque in the U-shape of the façade and the balustrades crowned with urns and statues. Somehow, they sit oddly on the building, almost as alien to it as they are to the idiom of Florentine architecture. But the very grandeur typifies the architectural aspirations of noble families of the period.

Far less pretentious as a 'statement' and much smaller in scale, at once novel and yet distinctly local (especially in its grey and white combination and contrast of stone), is a palace right at the river's edge on the Oltrarno, the 'Palazzo delle Missioni', built beside the Ponte Santa Trinita and begun in 1640 (see Plate 38). Not properly a palace but a

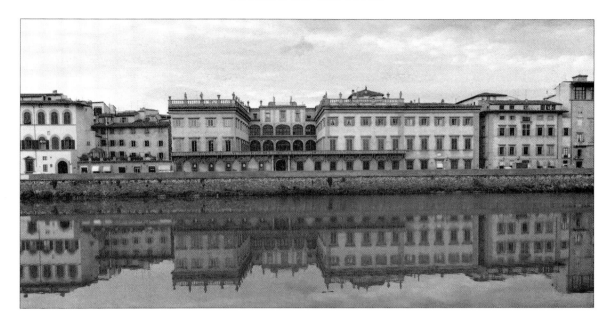

View of the Palazzo Corsini from the Arno.

house for the priests attached to the nearby church of San Jacopo sopr'Arno, it has its unusually decorative and decorated façade facing into the narrow, sloping Piazza Frescobaldi. Its architect, a certain Bernardino Radi, is obscure even by the standards of *seicento* Florence, but one could wish he had had more opportunities to build there, if this building represents his style.

The compulsive charm of it lies in the stark contrast between its flat, chalk-white façade and the array of applied or sculpted features, all in deep-toned grey stone: elaborately framed windows, varied in shape at each level, and oval niches for busts (of four Medici grand dukes), a handsomely carved entrance doorway and strong definition of the horizontals and verticals of the building by trimming in the same crisp grey stone.

The effect is original and unashamedly picturesque. The site did not permit too grandiose a building in bulk, but Radi has lavished every inventive refinement on the single frontage, probably breaking a few architectural rules in so doing. Yet, despite its unusualness, it remains quintessentially Florentine. Buontalenti would surely have approved of it, and without stretching the imagination excessively one can conceive that it might also have gained the approval of Brunelleschi. His treatment of the interior of the Pazzi Chapel, with its alternations of grey and white, has here been borrowed, exploited and applied to an exterior.

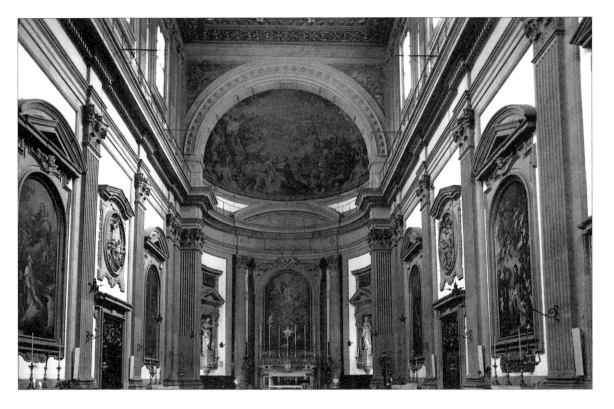

Pier Francesco Silvani and Gioacchino Fortini: Interior of San Filippo Neri, *San Firenze complex.*

It is not the exteriors but the interiors of the churches and chapels that exude the strongest allure in the last hundred years of Medici rule – always with the exception of San Firenze, or at least the visitable portion of it, the church of St Philip Neri. That is the left-hand building of a magnificent complex otherwise, strangely, turned into a court of justice – as though St Paul's were taken over by the Old Bailey. San Filippo Neri offers the uncommon experience in Florence of a post-Renaissance façade matching, perhaps even outdoing, a serenely beautiful, contemporaneous interior. The giant Corinthian pilasters framing its one doorway echo the similar giant ones down the nave. Within, the effect is more silvery and luminous than at San Gaetano, the obvious parallel. The grey stone pilasters seem paler, and the décor less austerely grand.

Only its lack of a finished façade handicaps the church of San Frediano in Cestello from claiming its place as a perfect jewel of the period. The prominent, dignified outline of its cupola gives a rare, Roman tinge to the Florentine skyline, but the blank brick wall above which it rises is incongruous and looks off-putting. Such a church may scarcely

seem worth a visit, especially as its location tends to appear distant, although in fact it is little further away than the church of the Carmine.

Matteo Bonecchi:
Allegorical Female Figure,
San Frediano in Cestello.

San Frediano even has a generous sweep of piazza before it, which makes the absence of façade the more painful. Perhaps, however, its dusty, slightly scruffy exterior only increases the delightful surprise of its interior, quite un-Florentine in feel, painted in elegantly pale tones, spacious and largely free from sculpture but filled and flooded with light (see Plate 37). If it ever had to be adapted to secular use, it would make an excellent ballroom.

Its colour scheme of white pillars and pilasters with palest pistachio-green-cum-grey walls has about it something more Northern than Southern, at least on first encounter. A few pastel-coloured frescoes, restricted to the area of the cupola, increase rather than diminish that impression. They certainly do not mar the exhilarating sense of pervasive luminosity. Large-eyed women, of allegorical import, are depicted in the pendentives by a competent decorative painter, Matteo Bonechi (died around 1750), and the side chapels, as graceful as the body of the church, have some frescoes and altarpieces of the period. But the very restraint of the décor is part of the appeal, letting the building function as a great vessel to hold light. Its green and gilt organ loft above the entrance, and the mustard-yellow *baldacchino* suspended over the high altar, are like two grace-notes, enhancing that luminous air.

Stylishness without ostentation is exemplified by San Frediano, the design of which is by a Roman architect, Giulio Cerutti, although construction was carried out from 1687 by a local man, Antonio Ferri. Just as stylish but far more sumptuous — indeed, out-standingly so — is the choir-chapel of Santa Maria Maddalena dei Pazzi, a Renaissance church which has to be sought out in its monastic setting, being as concealed from public view as San Frediano is insistently visible.

The Florentine Carmelite saint, of the ancient, once anti-Medicean Pazzi family, was canonised in 1669, sixty-two years after her death. She had lived in a convent adjoining and owning San Frediano (hence representations of her in that church) but her body

was early moved to the Cistercian monastery in Borgo Pinti. In 1670 Cosimo III succeeded his father as grand duke, and though not the sole patron of the choir-chapel, he was involved in its evolution. And in its alliance of ecstatic if simple piety and polished opulence it can claim to be something of a monument not only to the saint but to him and his tastes.

Ubiquitous and notably harmonious richness of material is one's lasting impression of a chapel that in its gleaming depth and soaring height virtually reduces the rest of the church to the status of an ante-room or corridor. Although there are chapels down each side of the nave, the eye is drawn towards that superb central space, its walls sheathed in mellow, warm-toned marble, tawny yellow and mottled, brownish red, glowing with the sheen almost of well-waxed wood. The pillars, the altar, the balusters of the communion rail and the (partly renovated) floor are all of marble, and general richness is increased by the elaborately wrought grilles and panels of gilded bronze, glittering at their richest where inset in doors of jet black.

To Pietro da Cortona's Roman pupil, Ciro Ferri, is due the concept of the chapel, although – as so often – its evolution and the contributions of other artists to it make for a lengthy story. Ferri himself also provided, under specific pressure from the grand duke, the main altarpiece (of Santa Maria Maddalena dei Pazzi receiving a gold chain from the Virgin), a tepid piece of work dragged out of him and tacitly rebuked by two rapidly produced paintings on the side walls of the saint enjoying comparable visions, from the fluent brush of Luca Giordano. But much can be forgiven Ferri's picture for the sake of his architectural scheme and its memorable, subtle tonality (see Plate 40). His preliminary designs envisaged, incidentally, a dome not painted (as it was) but ribbed and coffered in a manner borrowed from his master's treatment of the dome at Santi Martina e Luca in Rome. That would have added a final, suitably refined richness to the scheme.

No other great baroque chapel in Florence itself may have quite the spectacular impact of that of Santa Maria Maddalena dei Pazzi, since none has the advantage of being seen and approached down a long nave. But extraordinary effects – occasionally grander, in their way, and occasionally more startling – were achieved by the virtuoso sculptor-architect Giovanni Battista Foggini, Florence's best alternative to Bernini, of whose work Foggini certainly took account, without allowing himself to be inhibited by it.

Foggini deserves his own 'trail' through the city, and the progress would take one

Opposite: *Giovanni Battista Foggini:* The Feroni Chapel, *Santissima Annunziata.*

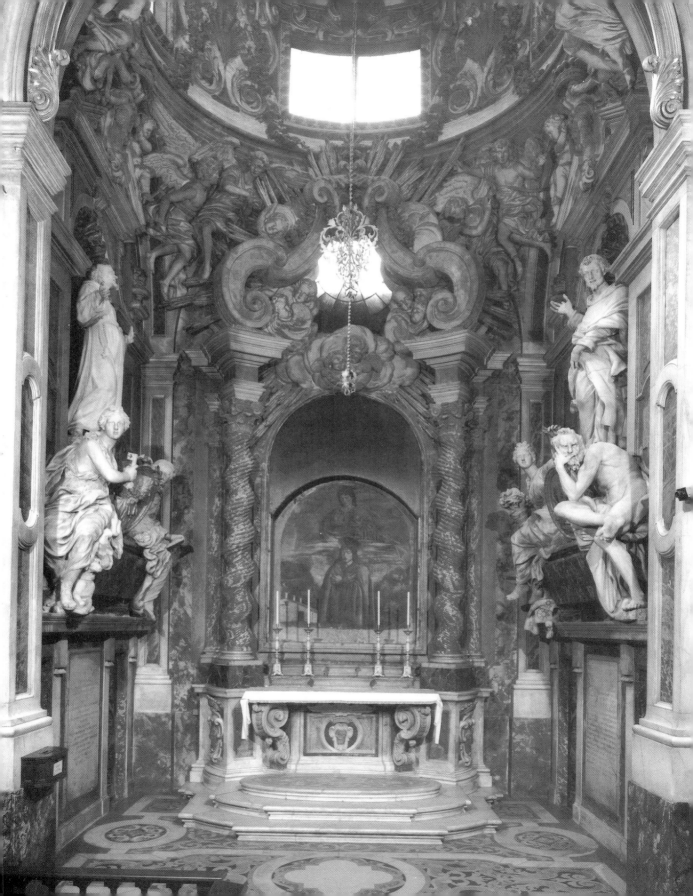

back and forth, in style and in type of building, as well as up and down the streets, and uphill too: from his exuberant sculptural contribution to the big, new rooms added to the Palazzo Medici (now Medici-Riccardi) to the comparative sobriety and tonal chasteness of the décor in his elegant small church of Santa Maria di Candeli; from the dignity of his bas-reliefs in the chapel of St Andrew Corsini in the Carmine (see Plate 32) to the writhing forms and encrusted, grotto-like effect of the Feroni chapel in Santissima Annunziata. Perhaps the most astonishing, original and sheerly elegant of all his achievements is the white and gold interior of the small, drab-looking church on the Oltrarno, San Giorgio alla Costa (see Plate 39), open only at very limited times, but, when it is, worth every step of the considerable climb to its unobtrusive side door.

Foggini had been born in Ferdinando II's reign, in 1652. He died in 1725, two years after Cosimo III, in the reign of the last Medici grand duke, Gian Gastone. It would be too facile to see him, in parallel, as the last great native sculptor-cum-architect, since there were other gifted figures on the scene, but he held a very special position at Cosimo III's court, as 'primo scultore' and also 'architetto primario'. His was partly an organisational role. He had his workshop and collaborators, and the degree of his personal involvement in, for example, the Feroni Chapel (see p. 425), a typically collaborative affair, may be a matter for scholarly debate. But there, as in the grander, calmer and earlier Corsini Chapel, it is the marriage of sculpture with architecture that is so remarkable. The Feroni Chapel is perhaps more sculptural than architectural: a positive cave inhabited by swirling, dramatically projecting figures, modelled in stucco or carved in marble, arched over by a ceiling every solid inch of which is alive with tightly woven patterns of cherubs and garlands of roses and cherubs' heads, and curving abstract shapes blending suggestions of foliage and of clouds. Where so much is in movement, the strong twist of the marble pillars that frame the altarpiece area, unusual in a Florentine context, seems particularly apt.

The Feroni Chapel was inaugurated in 1693. Although a year later Foggini was still concerned with sculpture for the Corsini Chapel, construction of the existing building – for that is what it amounts to – had begun in 1675. It is the grandest, and yet the most inviting, and arguably the finest of all chapels of its period in Florence, physically large and as proudly imposing as its status as the chapel of the wealthy Corsini family would suggest. Francesco Feroni was wealthy too, but a self-made merchant (one ennobled by Cosimo III). The Corsini Chapel proclaims long-established lineage, in addition to vast wealth, and plays the unbeatable trump card of a family saint (St Andrew Corsini, Bishop of Fiesole, was canonised, after much Corsini pressure, in 1629).

The predominantly red and white stripes of the Corsini coat of arms – on a huge

scale — crown the entrance to the chapel, taking visual precedence over God the Father floating below. Pairs of the Corsini arms are set at the base of each of the three great stirring, sculpted reliefs of the saint by Foggini (assisted by a German sculptor active in Florence, Balthasar Permoser). And perhaps it is more than chance that the predominant colours throughout the chapel appear to be red and white. Sumptuous in its scale and in its very disposition of space, beautifully judged in its proportion of sculptural elements to architecture, the chapel leaves a final impression of sumptuousness in chromatic terms. Against a general tonality of grey and white, the tall, polished pillars and horizontal slabs of red marble, of a red between salmon-pink and deep coral, and itself flecked with white, are not merely rich but intensely stylish.

How confident the age still was, one is bound to feel, constantly encountering its stunning and seemingly ever-varied solutions to the church or the chapel interior. The polarities between the magnificent achievement of the St Andrew Corsini Chapel and the no less magnificent one of Santa Maria Maddalena dei Pazzi, each for Florentine saints but male and female, would be sufficient subject for discussion: one a shrine cool, stony, dynamic, expressive of action, the other warm, amber-toned, more lulling and more contemplative in mood.

If all this creative effervescence is to be called 'theatrical' (thus tacitly denigrated), then it is a pity that later periods did not tread the boards and don the motley. Away from the church and the palace there are a few further Florentine surprises in store for the unprejudiced eye.

A modest glass doorway in the Borgo Ognissanti can be pushed open, and one is standing in the vestibule of the hospital founded by a member of the local Vespucci family in the fourteenth century, later enlarged and taken over to become, as it has remained, the Ospedale di San Giovanni di Dio. It contains an upper chapel, designed by Carlo Marcellini early in the eighteenth century, but the far more unusual feature is Marcellini's dramatic, slightly curved double staircase, opening out from the vestibule, ascending to a landing dominated by a large sculpted group, with San Giovanni di Dio its central, standing figure.

So ingeniously has Marcellini disposed the space that in photographs the effect is of a tremendous vaulted area, suggestive of the foyer of a grand theatre, an effect increased rather than diminished by the pair of neo-classic statues, on plinths flanking each flight of stairs (actually of Faith and Hope). In reality, the scale of the building is comparatively small, though that only makes Marcellini's staircase, like the whole *mise-en-scène*, more striking and attractive.

427

Carlo Marcellini: Atrium of the Ospedale di San Giovanni di Dio, *Borgo Ognissanti.*

Marcellini is another accomplished architect-cum-sculptor of the period who has failed to become well known. What he could achieve as a sculptor can be studied conveniently in Santa Maria Maddalena dei Pazzi, for his are the vividly composed, gilded bronze medallions of mystic events in the saint's life that punctuate the marble dado around the chapel.

Yet one more such all-round artist, Girolamo Ticciati, sculpted the animated group of San Giovanni di Dio on the landing of the Ospedale. And Ticciati was responsible for a much bolder sculptural project, characteristic in every way of its age, but found too bold for later tastes: the large visionary marble group of St John the Baptist, ecstatically posed, ascending heavenwards in a great burst of rays and clouds, which in 1732 was placed over the altar in, of all buildings, the Baptistery. Photographs – for it survived *in situ* to be photographed – convey a thrilling effect, less incongruous than might be

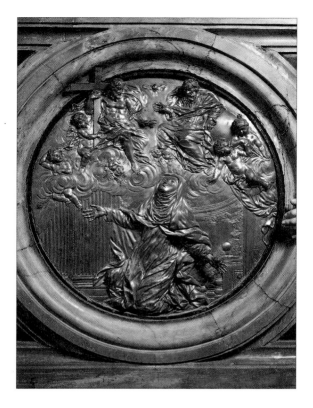

Carlo Marcellini: Bronze Medallion *(detail of the high altar),*
Santa Maria Maddalena dei Pazzi.

supposed. Eventually, the group was removed (in 1912), and the curious visitor to the Museo dell'Opera del Duomo may notice in the courtyard the shrunken, weathered, inglorious remains of Ticciati's confident, scenic concept (see page 9).

The period deserves to be left on a happier note, if on a very much smaller scale, with one last illustration of its religious emphases and its artistic refinement. Possibly Foggini had a hand in the designing of an original and exquisitely executed reliquary (a Medici 'treasure', to be seen in the treasury of San Lorenzo), that of St Alexis, carved by Massimiliano Soldani Benzi, an expert sculptor in metal and a superb medallist.

Several Florentine reliquaries of the time create miniature 'baroque' figure compositions out of what had once been ornamental objects. Few or none equals the sheer richness of this scene, with its mottled, yellowish marble staircase, its glassy, amethystine pillars and its almost clotted mass of gilt-bronze clouds from which cherubs gaze down on the gilded figure of the sleeping saint (see Plate 43).

St Alexis is the very pattern of Christian humility, a Roman patrician who gave up wealth to live as a beggar and, according to the legend, spent his last years as a servant, unrecognised, in his father's house, sleeping in a corner under the stairs. Not many Florentines pursued similar careers. And while the reliquary conveys pious sentiment, it could scarcely be more opulent as a work of art. The opportunity to create a house has resulted in an interior designed as elaborately as it is realised, in ebony and semi-precious stones. Humble as the corner chosen by the saint may be, however uncomfortable his box-like substitute for a bed, the seat itself is carved out of lapis lazuli. Perhaps crystallised there is something of the paradox and the fascination of Florence under its last Medici rulers.

C OSIMO III STROVE for his kingdom in circumstances which increasingly justified whatever depression he suffered and whatever quantity of prayers he bombarded heaven with. His brilliantly gifted heir, Grand Prince Ferdinando, of wide-ranging culture, a connoisseur of the visual arts and an outstanding musician (for whose theatre Handel composed his opera *Rodrigo*), predeceased him and died dissipated and childless, after an unhappy marriage. His second son, Gian Gastone, was also intelligent (as is sometimes forgotten) but equally flawed in temperament, over-borne by his father, and he also endured a miserable, childless marriage. Cosimo's one daughter, Anna Maria Luisa, married the Elector Palatine, outlived him and returned a childless widow to Florence. 'Quiet and solitary' was how the court of Gian Gastone, who was by then a bed-ridden debauchee, seemed to the German traveller Johann Georg Keyssler, in 1730.

The European powers (England among them) were busily arranging and rearranging the future of Tuscany, a problem which had preoccupied but defeated Cosimo III in his last years. For a time he mooted a highly imaginative proposal, almost an act of reparation, it might seem, whereby Florence would revert to its ancient republican status. But in a general swapping of kingdoms and principalities, Tuscany was eventually allotted to the Duke of Lorraine.

Cosimo's surviving son and daughter, mutually antipathetic, each made their significant contribution to the future welfare and prestige of the Tuscan state. Gian Gastone won the political concession that, although destined to belong to the House of Lorraine, the state should not be absorbed and would retain its independence. Outliving her brother until 1743, Anna Maria Luisa inherited no power but the vast property — the

works of art of every kind, the furniture, the books, the jewels – which the Medici family had assembled in the course of four centuries. And she bequeathed all of it to the new grand duke and his successors, on condition that nothing was to be removed from Florence or from the duchy. 'These things', her will stipulated, were for the ornament of the state, the benefit of the people and an inducement to the curiosity of foreigners.

Thus she dowered the city as a unique, permanent, inalienable museum for mankind. As such, and under a new, foreign regime, Florence prepared to enter the new, less glamorous but more 'modern' world.

The Enlightened City and the New Troubles of Italy

I N 1783 PIETRO LEOPOLDO, the Grand Duke of Tuscany, always much concerned with improvements in all spheres to the city, as also to the state, proposed a new practical measure for Florence: lighting of the streets with oil lamps. It is no bad symbol of his reign and his aims — and generally of his century — even if one has to admit that nothing came of that particular proposal.

Unfortunately, it may serve symbolically in other, less happy ways, for it indicates the comparative absence in the Florence of today of physical traces of Pietro Leopoldo's long, conscientious, civilised and beneficent rule. It was not there but in Pisa that — eventually — a statue was erected, showing him as a calm, royal, classical figure, clad in a toga, standing on a plinth inscribed with his name and the words: 'forty years after his death'. Mozart's classical-Roman opera, *La Clemenza di Tito*, had been written in 1791 to celebrate his coronation at Prague, and the statue could almost be of him as the clement Emperor Titus. Pietro Leopoldo was in many ways a very un-grand grand duke, at least by Medici standards, although a Habsburg prince and a future Holy Roman Emperor. As Peter Beckford reported in 1787, 'State and magnificence make no part of the expence [sic] of the Grand Duke of Tuscany . . .'

It was not to be expected that his reign would see the building of splendid new churches and chapels, and there were sufficient ex-Medici palaces and villas to accommodate the grand-ducal family (though not the grand duke's mistress). A hospital, an observatory or a theatre was more likely to be judged as needed and of use to the community. The priorities of Pietro Leopoldo's government lay in trying to reform and revitalise Tuscany so that it became an efficient, financially solvent, commercially viable, civilised state. It may not make for exciting history that under Pietro Leopoldo the death penalty was abolished, as was torture, but such enactments must have been welcome to his subjects, as must also have been suppression of the Inquisition.

In fact, he himself angrily reintroduced the death penalty in the upheavals of 1790,

after he had left Florence, but that hardly damages him as a pattern of the ideal eighteenth-century ruler – ideal perhaps at any period. And, broadly, his successors – facing, without properly understanding, a more disturbed and volatile European situation – inherited something of the same goals of prudent administration combined with a lack of personal ostentation. Considering the peculiar assignment they had been given as Austrian archdukes, and younger sons, called on to go and govern a colony or a separate province, one where they were always alien, they seem extraordinarily committed to the welfare of their subjects and the improvement of their state – and also extremely responsive to their peculiar position as inheritors, almost custodians, of Medici monuments, Medici possessions and Medici traditions. For the first of the Habsburg grand dukes a new coat of arms was devised, and appropriately it incorporated the Medici *palle*.

Florence may never have cared much for its Habsburg rulers, nor they for Florence. They were the opposite of stylish or charismatic in appearance and personality, and more dutiful than instinctive in their attitude to the arts. Their importance in Europe as rulers was negligible, and their capital was famous chiefly as a museum, one whose colossal prestige would be consolidated only in the nineteenth century. By then, however, their tenure was growing precarious. Italian nationalism had awoken, and the Austrian presence on any Italian territory seemed provocatively unjust.

While Florence was becoming a museum city the Habsburgs were highly honourable curators of it and by no means unprogressive in their attitude towards it. In 1848, a famous year of revolution throughout Europe, the Grand Duke Leopold II honoured with his presence a quite novel festival held in Florence: that which inaugurated the railway station at the Porta al Prato (the gate through which several Medici brides had made their entry to the city). At the same time the line was opened to connect that station to the central one near Santa Maria Novella, the Stazione Maria Antonia, named after the grand duke's second wife. A vast, impressive and elaborately decorated nave, as of some secular cathedral, formed the main hall of the station, and through its tall, open archways passengers could get their first glimpse of Florence, with the campanile of the church of Santa Maria Novella rising near at hand.

Although styles in station architecture have changed drastically, and so has the name of the station, the location has not. Perhaps it would take an excessively sentimental or nostalgic eye to see in the station of Santa Maria Novella of today – itself a daring yet accomplished and skilfully designed, still valid monument of modernism, dating from 1934 – any echoes of the Habsburg grand dukes. Yet the coming of the railway to Tuscany, and the creation of a main station at Florence which is dramatically central in

location, emotionally if not literally (offering immediate visual contact with the old, medieval city symbolised by the brick campanile of Santa Maria Novella), are very much part of the overall Habsburgian concept of a state well organised, efficient and up-to-date, not least in terms of having good communications.

Land reclamation and new roads were among the priorities of Pietro Leopoldo (he took a personal interest in the challenging project, which came to fruition, of cutting a road through the mountains north from Pistoia to the capital of the ex-Este duchy, Modena), and it is hardly too fanciful to suppose that had the iron road of the railway been invented in his lifetime he would have favoured its introduction into Tuscany. In any case, there exist links and memorials less frail and tenuous to mark the years of Habsburg rule in Florence, though they tend to be unassertive or at least largely unremarked by the average visitor.

The one monument that is the opposite of unassertive, the grandiose triumphal arch which still stands, colossal and isolated, in what is today the Piazza della Libertà, has connotations of the 'folly' and – for all its impressive appearance – is something of a monumental irony. It looks incongruous in Florence, partly because of its Roman imperial style, and it would look yet more incongruous were it not sited well away from the city centre and now given a softening environment of fountains and trees. Asked to guess whom it was erected to commemorate or welcome, one might well without knowledge name Napoleon.

It is, in fact, of a surprisingly much earlier period. The brainchild of (it would seem) a chief representative of the new regime, Emmanuel de Richecourt, it was planned to be ready to welcome the first post-Medici ruler, Francis Stephen of Lorraine, who arrived in the city in January 1739. Despite the quantity of workmen employed on it – 400 is the usual figure given – it was far too elaborate in its combination of sculptural groups, bas-reliefs and architecture to be finished in time. In Renaissance fashion, recalling the décor of many a Medici *entrata*, recourse was had to wood and canvas to give the arch an appearance of completion. Work proceeded on it, however, after the entry of the new grand duke and continued for more than a decade.

The arch was designed by an architect from Lorraine, Jean-Nicolas Jadot (who had previously had a hand in the striking if eccentric church of Saint-Jacques at Lunéville), but Florentine sculptors were involved in its execution. Surmounting the arch is a frisky, prancing equestrian statue of Francis Stephen. That provides a stylistic clue to dating the monument, for it is a typically 'baroque' piece of work to crown architecture in a neo-classic idiom, and was the contribution of Vincenzo Foggini, son of the famous sculptor.

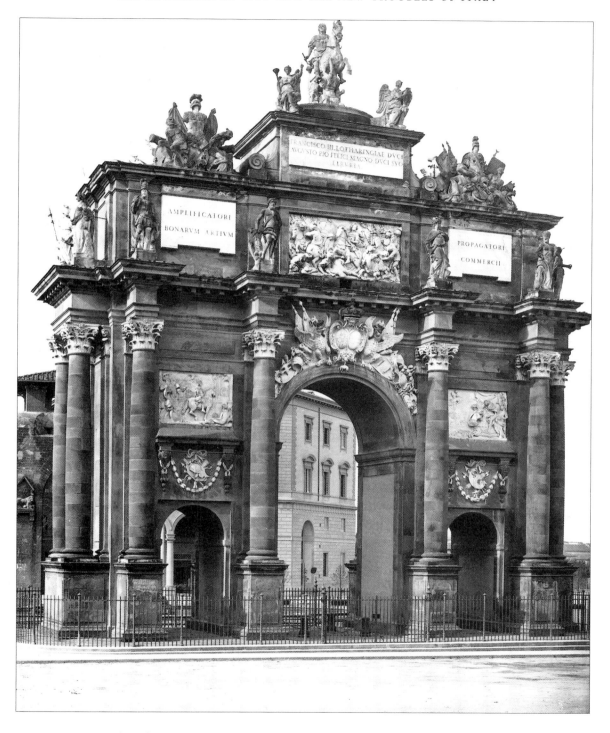

Jean-Nicolas Jadot: Triumphal Arch of Francis Stephen of Lorraine, *Piazza della Libertà.*

The arch itself, with its echoes of antique examples and anticipations of, for instance, the Arc de Triomphe in Paris, seems to be the first of its kind to be built, as opposed to designed, in post-classical times. It goes further, in its fulsome way, than had any Medici public monument and much further, probably, than the grand duke commemorated by it would have wished. On the actual day of his arrival in Florence he and his wife passed through it in their coach, before entering the Porta San Gallo (and an engraving of the period gives no hint of its incomplete state, while suggesting a dense, excited crowd assembled to welcome the new ruler).

Presumably through the Porta San Gallo, but possibly on that occasion going around the triumphal arch, the grand-ducal couple departed from Florence only a few months later. They were never to return. More important affairs summoned them back to their northern kingdom or kingdoms. Francis Stephen had married Maria Theresa, daughter and only child of the Emperor Charles VI of Austria, and at his death in 1740 she inherited his dominions. Her husband was to become the Emperor Francis I. Tuscany represented, at best, a very minor portion of their possessions and concerns — concerns which led to an outbreak of war (the war of the Austrian succession), concluded in 1748 with the Peace of Aix-la-Chapelle. In the previous year the empress had given birth to her third son, Peter Leopold, who would succeed his father as Grand Duke of Tuscany on the emperor's death in 1765.

Meanwhile, for a quarter of a century, Tuscany was administered by a regency, and all the Florentines were to see of their grand duke of the new dynasty was his image on horseback prancing atop the triumphal arch outside the Porta San Gallo. The elation it conveyed was not widely shared. And although Tuscany was not itself drawn directly into Austria's war, it was compelled to subscribe heavily to the expenses. Already in October 1739 a French visitor, the Président de Brosses, recorded the general air of dissatisfaction felt in Florence at the replacement of the Medici as rulers by the House of Lorraine. Yet one intelligent Florentine made a perceptive comment to him, partly foreshadowing the more satisfactory future under Pietro Leopoldo: 'any master will find the secret of contenting us providing he resides in Florence, protects the sciences and has a taste for the arts, since it is a grave defect here to lack those qualities'.

For several years, effectively until the Peace of Aix-la-Chapelle, it was not settled beyond all doubt which dynasty should provide the masters of Tuscany — a matter on which Tuscan views were not sought, however strongly they might be felt. Quite how the House of Lorraine had first been awarded the grand duchy may have remained a puzzle and an irritation to the Florentines. It was through a form of territorial musical chairs

sanctioned by the major European powers. Poland had been assigned to the Elector of Saxony, so the King of Poland received in compensation the duchy of Lorraine, and in turn the Duke of Lorraine, Francis Stephen, was assured of the succession of Tuscany on the death of the childless Gian Gastone de' Medici.

During the earlier period of the Lorraine regency, a Medici lived on in Florence, the widowed Electress Anna Maria Luisa, Gian Gastone's sister. Although living in retirement, of an opulent, Medicean kind, in the Palazzo Pitti, she had not retired from her position as head of the family. Her return from Germany had meant the return, incidentally, of the most sheerly sumptuous piece of Florentine furniture – more sculpture than 'furniture' – the great cabinet of ebony, gilded bronze and inlaid *pietre dure* which Cosimo III had commissioned for her as a sort of commemoration of her marriage (see Plate 41). In her last years in Florence she was much preoccupied with the family church of San Lorenzo and particularly with the Chapel of the Princes.

As far as the exterior is concerned, it was she – suitably enough – who added the final touches to its appearance, though even there her intentions were not entirely carried out. Her architect was Ferdinando Ruggieri, responsible for the huge, imposing, pilastered façade of the San Firenze complex and also the designer of the exuberant catafalque in San Lorenzo at the time of the death of Grand Duke Gian Gastone.

Ruggieri (assisted by his brother Giuseppe) prepared a model of the cupola of the chapel. Its drum was to be pierced with distinctly 'mannered' windows, curved at the top and pulled out of the rectangular in flattened *appliqué*-like framing, in a manner recalling Buontalenti – and that is the form in which they were executed, as is visible today. What the cupola had always lacked was a lantern (a fact emphasised by that on the nearby cupola of Michelangelo's sacristy), and Ruggieri designed one in a style deliberately echoing the Brunelleschian lantern of the Duomo, though with a slimmer, oddly more 'Gothic' silhouette. Combined, as it was planned to be, with ribs dividing the dome into segments, it would have given much greater dignity and definition to the rather amorphous bump of the cupola, but it was never built.

The cupola's massive shape retains its unfinished look, though a lively flourish, mitigating its mass, was given by the addition of a campanile in yet another style, not easily described but thoroughly non-Florentine with an angular, pointed cusp suggestive of a northern or central European campanile (see p. 438). That was the most substantial contribution made to San Lorenzo by Anna Maria Luisa. It is the ultimate monument of Medici patronage – built in the time of the succeeding, foreign dynasty – and it bears prominently both the date of its inception (1740) and the name of the commissioner.

Ferdinando Ruggieri: Campanile of the Chapel of the Princes, San Lorenzo.

Few campanili anywhere are so inscribed, and this one may be thought to proclaim a certain defiance, as well as pride, at that precise period and in such changed circumstances in Florence. Religious, not secular, it certainly speaks out as rebuke, if not challenge, to the rhetoric expressed in Jadot's triumphal arch for Francis Stephen of Lorraine as Grand Duke of Tuscany.

Pietro Leopoldo was not the destined Grand Duke of Tuscany, and that itself is perhaps a minor irony of history. When the matter of the Habsburg imperial succession was finally fixed, it was agreed that the second son of the emperor should be the Tuscan ruler, and the second son of Francis Stephen and Maria Theresa was the Archduke Karl. It was only on his premature death in 1760 that Pietro Leopoldo became

the heir to Tuscany. Francis Stephen died in August 1765, and within a month the new grand duke, aged barely eighteen, arrived in Florence.

The regency had ceased, and very soon — sooner than his widowed mother in Vienna had advised or thought prudent — Pietro Leopoldo began actively to reign. Enlightened, earnest, reforming, he was also very much the ruler, despite advisers and councillors. Cosimo I de' Medici would have seen in him a successor with a different style yet in his own autocratic mould. And Pietro Leopoldo's reign lasted for twenty-five years, ending in 1790 when, on the death of the Emperor Joseph II, his childless elder brother, he succeeded as the Emperor Leopold II of Austria.

He could not have left Florence at a more critical juncture. The French Revolution had broken out in the previous year (and his youngest sister was Marie-Antoinette, Queen of France). Already in 1790 the fresh regency he had established for his son, Grand Duke Ferdinando III, faced unrest and riots in Florence, ostensibly over the high price of grain but with rumblings ominous for the future. Reactionary policies seem anyway to have followed his departure, and the established regimes of Europe were soon experiencing the twin shocks of the fall of the French monarchy and the rise of Napoleon.

As Austrian emperor, Pietro Leopoldo had to be a rather different figure from the enlightened ruler of small, peaceful Tuscany. He too began to face violent, unprecedented events, affecting him politically and personally. He came back once to Florence, in 1791, to oversee the installation of Ferdinando as grand duke, and in the following year, still comparatively young, he unexpectedly died.

Almost inevitably, in the aftermath of a decade which included the invasion of Tuscany by Napoleon's troops, the flight of Ferdinando III and the transformation of the Grand Duchy of Tuscany into the kingdom of Etruria (before being turned back into a grand duchy for Napoleon's sister, Elisa Baciocchi, to reign over as grand duchess), the quarter-century of Pietro Leopoldo's rule would probably have seemed to the survivors of it a golden era. In reality, regardless of any retrospective, excessive sense of *douceur de vivre*, his was a rule of active, enlightened autocracy, which preserved peace in Tuscany and brought it the benefits of good, stable government.

As an advertisement for the success of the regime of a 'philosopher-prince' — very much an ideal of the eighteenth century — it was among the finest in Europe. Frederick the Great of Prussia might be a much more gifted, indeed near-creative personality, with aims similar in principle but openly aggressive in practice. And in Italy a salutary contrast appeared between the steadily reformed, re-invigorated Tuscany of Pietro Leopoldo and the Republic of Venice, no less steadily declining in the very same years.

It was an age of unashamedly bourgeois, homely monarchs, such as George III of Great Britain, Louis XVI of France and Charles III of Spain, whose daughter was married to Pietro Leopoldo. His practicality and comparative simplicity aligned him with them, though he had a better brain. Somewhat melancholy and sceptical in temperament, scientifically inclined in his pursuits (his chemistry cabinet-cum-desk is preserved in the Museo di Storia della Scienza), he was a constantly visible presence to his subjects as, in effect, one of them. He walked, rather than went by carriage, between the Pitti Palace and the Uffizi — going presumably not along Vasari's corridor but through the streets. The letters of the English Resident (that is, representative), Sir Horace Mann, the friend and constant correspondent of Horace Walpole, provide a mass of minor but profuse evidence about Pietro Leopoldo, including such characteristic incidents as his visiting the theatre in an ordinary chaise, without attendants. As early as 1766 he opened the Boboli Gardens to the public. And one of the significant additions he made to the gardens was not a piece of sculpture but a building, a slim, semi-Turkish-style kiosk, the 'Kaffeehaus' (retaining its exotic, Teutonic name in Italian usage), a place of leisured retreat and refreshment for himself and his family, away from the cares of governing (see Plate 42).

Nothing could be more redolent of its period. Such a small, elegant, essentially light-hearted pavilion might have been put up contemporaneously for the sovereign in the gardens of Versailles or those of the sultan's palace at Istanbul. A blend, in a way, of lighthouse and observatory, the Kaffeehaus stands strategically sited, isolated, halfway up the steep incline of the Boboli Gardens, just where any climber might welcome a pause. Its flimsy, curved balconies, echoing its curved façade, face out towards the city and offer what is still a marvellous panoramic view over Florence. And by an imaginative piece of policy, it functions today as a public café. Its cool, intimate, gracefully frescoed interior is by no means spoilt by the discreet installation of a bar, and its opened windows invite one on to the balcony beyond. The double purpose for which it was built, of refreshment for mind and for body, retains and has indeed gained in enlightened validity.

The building itself, designed by Zanobi Filippo Del Rosso, manages to be gently whimsical and partly playful in appearance, without being trivial. It seems a more sensible adjunct to the gardens than yet one more group of sculpture. Although its current colour scheme of cream and terracotta may differ from the original one (which appears to have been predominantly green), it effectively defines the pavilion's architectural features and beckons attractively as it is discovered amid its setting of hedges and trees. As a monument to Pietro Leopoldo it may be modest, but it serves — or it should — as a reminder of the civilised values exemplified by his reign.

Pasquale Poccianti: Façade of the Meridiana, *Palazzo Pitti.*

At the extreme other, southern end of the Pitti Palace something similar, more extensive, yet still modest, can be seen in the low, one-storey, orange-toned pavilion of the Meridiana (now the Costume Museum), which began under him as a suite of only six rooms. Although he inhabited the Pitti, where there was hardly any lack of space, he had added – in neo-classic style – what might almost pass as a large-scale conservatory. It is at once dignified – with steps and portico, and lion statues flanking the steps, added later by Pasquale Poccianti – and also unassuming. Despite the touches of formality, and the sweep of gravel in front of it, the structure gives off an air of privacy. It was built to have no street façade, and even now has to be sought out, under the metaphorical shadow cast by the huge mass of the adjoining palace. Its architect was Gasparo Paoletti, working in virtually a new, never wholly common style in Florence. Paoletti was to be designated 'Maestro di architettura' when Pietro Leopoldo created the Accademia di Belle Arti. The concept of the Meridiana was, interestingly, to appeal to the succession of different rulers in Florence, up to and including the Italian royal family. As a result, its scale was enlarged and, more unfortunately, its interior character was drastically altered.

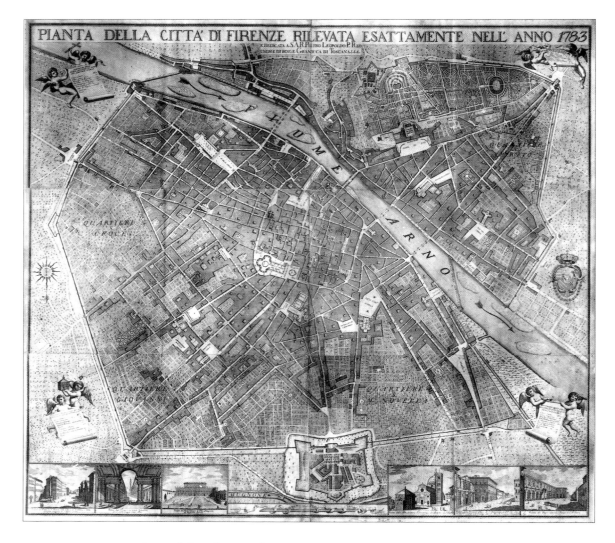

Map of Florence dedicated to Grand Duke Pietro Leopoldo, 1783, Museo di Firenze com'era.

The Florence perambulated by Pietro Leopoldo was admirably mapped in a new, very big and detailed plan of 1783, 'exactly drawn' and published with a dedication to him and including on it six neat little views of various sites in the city. The choice of them seems more than casual, and its emphasis is markedly non-medieval and non-religious. Admittedly, and not surprisingly, the Piazza del Duomo, with the Baptistery and Giotto's Campanile, forms the subject of one view, and the more up-to-date churches of San Giovannino degli Scolopi and Santa Trinita are features in two other scenes. The remaining three, however, show the Uffizi from the river side; the Pitti Palace, 'home of

442

the reigning sovereign'; and finally the impressive façade of the 'royal' hospital of Santa Maria Nuova.

It was in the same year that a new set of regulations was issued concerning medicine in Florence as a matter of public health, crowning the reforms and expansion of the hospital during Pietro Leopoldo's reign. And on the wall in the very short nearby street leading to the hospital, now the Via Folco Portinari, there can be found a small yet revealing tablet, which bears the date 1785. Its inscription brings together the names of Portinari, founder of the hospital in or around 1286 (the exact date is given variously), of his housekeeper Mona (Madonna) Tessa, credited traditionally with inspiring the idea, and of Pietro Leopoldo, reigning as grand duke five centuries later. Past and present concerns for the welfare of Florence meet and coincide in that linking of names across a vast gap of time, and what had once been initiated by a citizen of the medieval Florentine republic is now — dutifully, almost, it might seem, humbly — brought to completion by an Archduke of Austria who is also the Grand Duke of Tuscany.

Of Florence in the years immediately preceding Pietro Leopoldo's reign a vivid and extensive view is provided by the numerous engravings of sites in the city, and of the environs, based on drawings by the native topographical artist Giuseppe Zocchi (1711–67), which are now displayed *en masse* in the Museo di Firenze com'era (see p. 444). The publication of one set of these in 1744, *Scelta di XXIV vedute . . . di Firenze*, was itself a sign of new interest and probably a stimulus for vistors (comparable books of prints of views of Venice had been appearing there since 1703). The dedication of the *Scelta* provided a reminder that the city was a Habsburg possession: it was dedicated to Maria Theresa, mother of the future Grand Duke Pietro Leopoldo.

Judged aesthetically, Zocchi may be no more than a poor man's Canaletto, content more often to record than interpret, observant of great buildings though no passionate poet of bricks and mortar. Yet he not only brings mid-eighteenth-century Florence before us in much architectural detail but peoples its streets and piazzas, and its river, with a sprinkling of society at all levels. There are carriages and horsemen, fishermen, fine ladies, children and dogs (in considerable quantity). There are also workers and the needy. At most of the church porches, so carefully noted, lie no less carefully noted figures of beggars and cripples.

Slightly untidy, definitely leisurely and tranquil with the air of a backwater, Zocchi's Florence looks as if it is waiting for a reforming ruler, or at least for one who resides there. At the same time, despite the hinted indications of poverty and hardship, it has its quiet charm, as well as historical interest. Zocchi shows a city with, for instance,

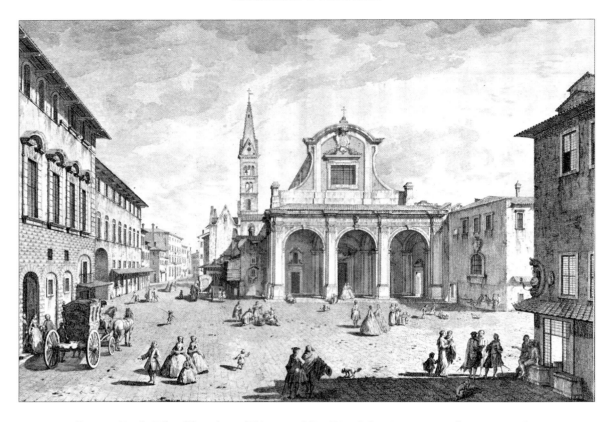

Giuseppe Zocchi: The Church and Piazza of San Pier Maggiore, *Museo di Firenze com'era.*

Giambologna's *Hercules and the Centaur* in its original position, not yet removed to the shelter of the Loggia dei Lanzi. The ancient church of San Pier Maggiore appears with the handsome arcaded portico Nigetti had added to it for the Albizzi in the late 1630s, and Zocchi's must be one of the last depictions of the complete exterior, before collapse and demolition reduced it to the fragmentary remnant of today, a dilapidated though still handsome portico with no church but a street behind it. The loss of San Pier Maggiore was an unavoidable one that occurred during Pietro Leopoldo's reign, but it is not one likely to have been mourned by him.

He was more concerned with reducing clerical privileges, suppressing ecclesiastical foundations and creating new secular institutions, sometimes taking over old buildings for the purpose. He founded an 'Imperial and Royal' Museum of Physics and Natural History, drawing on the rich Medici collections of such material and adding, 'regardless of expense', machines and instruments obtained from London and Paris. He established

the Accademia di Belle Arti in the restored complex of the old hospital of San Matteo and the adjoining convent of San Niccolò (now Via Ricasoli), with duties to instruct students and also its own collection of works of art for study purposes. Suppression of churches and convents often brought Renaissance and earlier altarpieces into the public domain, and a strong sense of historical continuity and of the value of preserving the past – a museum sense – informed much of what was done in Florence under Pietro Leopoldo.

The Uffizi was drastically reorganised, with a director at its head. A new room was built by Paoletti, in neo-classic style, to house the famous Niobe sculpture group, which Pietro Leopoldo had had transferred from the Villa Medici in Rome to Florence. If not precisely a catalogue, an illustrated volume was published in 1778 of the paintings in the possession of Pietro Leopoldo, 'Archduke of Austria, Prince of Hungary and Bohemia and Grand Duke of Tuscany', delimiting his collection (chiefly hung in the Pitti) from the public one of the Uffizi, yet making it widely known through the medium of engraving. A few years later (1781) came a history of the Grand Duchy of Tuscany itself. In the same year as Pietro Leopoldo had arrived in Florence there was published by the ducal printer, Gaetano Cambiagi, the first edition of a popular, often to be reissued new guidebook, *L'Antiquario fiorentino ossia Guida per osservare con metodo le rarità e bellezze della città di Firenze* (1765), the very title of which sounds a didactic note.

Thus the city became geared to visitors, attracting larger numbers of them as the century advanced, while its modernisation was primarily addressed to its inhabitants. The British were frequent visitors, and Horace Mann's duties included entertainment of the more interesting or socially prominent of them. But there could be no termination to the progress of improvements for Florence, and even in the apartments of the Pitti, Pietro Leopoldo had probably not brought everything into desired order by 1790 when his elder brother's death caused his departure to Vienna. New rooms in the palace, like the Sala delle Nicchie (niches), designed to house some of the other classical antique statues brought from Rome, were soon completed by his son Grand Duke Ferdinando III in a rather tepid neo-classic style, reminding one of the passage of time since Pietro da Cortona had worked for the Medici, and anticipatory of occupation of the palace by Elisa Baciocchi. In an intermediate style, recognisably eighteenth-century, but perhaps particularly Pietro Leopoldian, is the long 'Sala bianca', the ballroom, encrusted in chaste white stucco, which two Lombard stuccoists, Grato and Giocondo Albertolli, executed for him in the later 1770s. No paintings, only mirrors, intervene on the blanched, pilastered walls, increasing the cool effect (see Plate 45). The sole other decoration is

equally cool and comes from the glittering, plain glass chandeliers and wall lights. Very grand yet uncluttered, and tonally very consciously austere, this chill, frosted décor creates a thoroughly winter environment, and to its function as ballroom are added associations of a wonderful, indoor ice rink.

Under Pietro Leopoldo the green public spaces of the city increased. The old Medici territory of dairy farms, the Cascine, stretching west along the bank of the Arno, was made more accessible by him, it seems, although the evidence is somewhat ambiguous. Already in 1732 Joseph Spence (*Letters from the Grand Tour*) could speak of the Cascine as 'made for the pleasure of the Great Duke [i.e. Gian Gastone] and his subjects', describing ecstatically its woods and groves and meadows as 'most like a paradise'. During Pietro Leopoldo's reign it was certainly thrown open to everyone on special occasions, not least annually on Ascension Day, more popularly known in Florence then as the 'Feast of the Cricket' when the wretched insects were captured and caged by children, a fate hardly better than the previous practice of massacring them as supposedly a threat to crops. In any event, Pietro Leopoldo undoubtedly enhanced the appearance of the Cascine by having built the deliberately plain though harmonious and still surviving 'palazzina' in the middle of it, an act which set in train other, subsequent additions to the park. The semi-rural environment and the grand duke's own taste resulted in a very low, central arcaded block, ornamented only by medallions of agricultural themes, which has about it more of a glorified farmhouse than of the palatial. In fact, its architect, Giuseppe Manetti, had earlier submitted more than one design for it, all judged unsuitably grandiose, and what was finally built in 1787 (by a different architect) was much pared down from Manetti's original proposals.

In Pietro Leopoldo's peaceful times the area around the Fortezza da Basso could also be converted into a pleasant, park-like space. And Jadot's isolated triumphal arch outside the Porta San Gallo, commemorating Leopoldo's father's entry to Florence in 1739, was assimilated into the landscape. A tree-lined avenue or avenues sprang up nearby, designated by a modish French word, 'Parterre'. A touch of internationalism was given to the Tuscan capital that now had both a 'Parterre' and a 'Kaffeehaus'.

Within what were then the city limits, it is around the familiar, traditional Medici quarter of San Marco that positive evidence of Pietro Leopoldo's reign remains most concentrated. Close at hand is the adapted complex of the Accademia di Belle Arti (to which would eventually be consigned Michelangelo's *David*). The façades of both the church and the convent (now museum) of San Marco were taken in hand in the late 1770s and early 1780s, that of the convent so tactfully that it is hardly noticeable. Indeed, none

of the work was intended to be obtrusive. Far from being 'modern', the major alterations and additions are in a neo-sixteenth-century Florentine style. If the pastiche façade of San Marco is somehow thin and unconvincing – and it is – the small but prominent palace that completes the piazza, the so-called Casino della Livia, is a brilliant piece of homage to sixteenth-century style, notably perhaps to Buontalenti, realised so successfully that its actual date is difficult to believe.

Although less boldly fanciful in detail than Buontalenti's nearby Casino Mediceo, the Casino della Livia is something of a chip off the block of that building. Part of the attraction lies in its almost miniature yet refined quality, emphasised by its being located on a corner of the piazza, and though built to serve as a grand-ducal office it seems to deserve its *cachet* as the house in which Pietro Leopoldo installed his mistress, the actress Livia Malfatti Raimondi (hence its name). With arched and rusticated doorway, reliefs in roundels, balcony and upper storey almost entirely of windows, its façade has a toy-like, if not stage-like, air, even while it provides a positive anthology of typical Florentine motifs (see Plate 44).

Some of the elusiveness or unassertiveness of the physical evidence for Pietro Leopoldo's reign in Florence is explained by the fact that the Casino della Livia, like other buildings associated with him, lacks any novelty of style. Refusing to be rococo or neo-classical, it fits into the familiar urban ethos so discreetly that one is not prompted to enquire about its instigator. Much the same applies to the altogether far grander complex of the Ospedale di Bonifacio (now the Questura), standing at no very great distance away in the Via San Gallo. The tremendously dominant, long, arcaded ground floor of the restructured hospital (reorganised to concentrate in one hospital care of special categories of the sick, such as the incurable and the insane) is in a seventeenth-century idiom, recalling the arcaded portico of the hospital of Santa Maria Nuova. But there busts of the Medici grand dukes who were benefactors are proudly displayed on the main façade, and it is possible to step back into the surrounding piazza to appreciate the effect. There is no comparable space in the Via San Gallo. Perhaps partly for that reason, the bust that was put up at the Ospedale di Bonifacio was placed over the main door within the portico (see p. 448). Spattered with bird-droppings, and in any case a rather shrivelled, unimpressive affair, a bust of Pietro Leopoldo remains *in situ*, with an inscription which records the 'compassion and munificence of the Prince', giving the date 1787. What neither the bust nor the inscription records is the identity of this prince. That seems a typically Pietro Leopoldian and certainly un-Medicean gesture of unassertiveness, and such gestures have cost his reputation quite dear.

Giuseppe Salvetti: Portico of the ex-Ospedale di Bonifacio, *Via San Gallo.*

The complex of Santa Maria Nuova has continued to be an active, important, ever-expanding medical centre. Pietro Leopoldo's personal, practical, humanitarian hospital (its humane treatment of insanity largely unprecedented in Europe at the time and to be credited to its then director, Vincenzo Chiarugi) has become the chief police station of Florence. The majority of its visitors today (foreign students and so on) are probably unaware of the purposes for which it was re-established and enlarged in the late eighteenth century, though explicit wall tablets do commemorate both Pietro Leopoldo and Chiarugi.

A somewhat similar fate has perhaps happened to the city as Pietro Leopoldo's capital: improved by him and under him in a reign of twenty-five years, yet always unostentatiously and undramatically. Florence was not even to be his burial place, as it might sometimes have seemed likely it would be during the lengthy period of his beneficent, peaceful rule; and the cliché about a person 'passing away' has sadly pointed application to the Grand Duke of Tuscany who was probably the greatest of them all.

Pietro leopoldo had not ruled without advisers both Austrian and Florentine. Of them all, none was longer-lived than Francesco Maria Gianni, born in Florence in 1728, a devoted but extremely opinionated and unpopular servant of the state, and of the grand duke, whose last years were passed in quasi-exile in Genoa, where he died at the age of ninety-four in 1821 – the same year as Napoleon died.

Gianni's life thus embraced the extreme limits of Gian Gastone de' Medici's reign and of the restoration in 1814 of Ferdinand III, Pietro Leopoldo's second son, as grand duke, following the collapse of Napoleon's attempts to dominate Europe. It was a long period of time by any standards but, more importantly, it was a period of unique change, threat and disturbance, for established systems of government and for those who were governed. For centuries Florence had enjoyed peace, even though its prosperity had fluctuated. Peacefully, the Habsburg dynasty had succeeded that of the Medici, and as a civic capital Florence might have expected to enter the new, nineteenth century with no sense of discontinuity. Even violent revolution in France did not – on the face of it – presage interruption to the calm tenor of Florentine life and benevolent, *ancien régime* rule of it.

Napoleon changed all that, and yet ultimately he failed to consolidate his control of kingdoms any more than of events. His dream-Italy, partitioned out among his family, with his infant son superbly designated the 'King of Rome', dissolved, leaving only sporadic physical traces of inordinate, perhaps insane ambition. If Grand Duke Ferdinand III had any spark of humour – which is doubtful – he should have smiled at finding on his return to the Pitti Palace in 1814 that it had been equipped with an up-to-date, characteristically Napoleonic convenience, a bathroom (see Plate 46), of exquisite, neo-classical elegance, specially designed for the emperor who never arrived to take a bath in it (and a comparable one had also been built for the empress).

Most of the more grandiose and public proposals for an 'improved' Florence, as part of Napoleon's empire, did not come to fruition. Among them was the project for a Foro Napoleonico, designed by Giuseppe Del Rosso, son of Zanobi who had built the Kaffeehaus in the Boboli Gardens. That space was going to be made by destruction of houses and churches in the area of the city north of Santissima Annunziata, and at its centre was intended to stand a colossal statue of the emperor. Attractive as the plan might have seemed in its scale and its flattery, it was actually rejected in Paris, on the grounds that more essential works were needed in Florence.

The point is illustrated by a foundation which did get built, the neo-classically plain hospice for paupers, constructed out of two suppressed convents (along the Viale Giovine Italia). It bears a proud inscription: 'Napoleon the Great, Emperor of the French

and King of Italy, erected, inaugurated, generously endowed this hospice in the eighth year of his reign, memorable for the auspicious birth of the King of Rome, hope of the world '('*speranza del mondo*'). The boy who received that glamorous if vainglorious title had been born in 1811 and was to die in 1832.

By a quirk of fate, the more grandiose Napoleonic proposals for Florence antici-pate later nineteenth-century native ones, when the aim was to invest the city with the look and feel of a great capital, with wide boulevards and huge piazzas, robbing it of some of its old individuality. Amid so much modernising, accompanied by dutiful commem-oration of the past, some significant personalities were left literally on the periphery. The piazza named for Pietro Leopoldo lies in an anonymous, semi-industrial area to the north of the main city. One of the roads running into it is the Via Francesco Gianni, so at least ruler and minister are there united.

The rapid, fluctuating succession of events that precipitated Florence into the nineteenth century was bewildering – more bewildering than violent, by the standards of the French Revolution in France or of the sixteenth-century siege of the city by the Medici pope, Clement VII, and his allies. It is a matter of historical record which has left few monuments of any kind there, apart from changes inside the Pitti Palace. Neo-classic, Napoleonic Florence can be glimpsed in only occasional, somewhat out-of-the-way façades, while the most imposing semi neo-classic of palaces, Palazzo Borghese, was remodelled in that style for Prince Camillo Borghese, husband of Napoleon's notorious sister Pauline, seven years after the restoration of Ferdinand III.

The grand duke himself attended the evening of its inauguration, which was celebrated with both a ball and a pageant. He is mentioned in a contemporary account (published in the *Gazzetta di Firenze*) as complimenting his host on the new, magnificent long gallery, which might, in other circumstances, have served to receive Napoleon and which might equally have drawn a compliment from him.

IN 1799 (on the feast, as it happens, of the Annunciation) Tuscany had been invaded by French troops. Ferdinand III retreated to Vienna. A few months later the French withdrew, needed elsewhere as an attacking force. Florence, with its unprecedented experiences down the centuries of constitutions of every shape and colour, now turned to the past for a form of government. There came into renewed being that never very effective body, the Florentine Senate, exercising power in the name of the absent grand duke. Napoleon's victory over the Austrians at Marengo in 1800 signalled the hard facts

of realpolitik, and those were driven home by French reoccupation of Tuscany later the same year.

Only perhaps to the historian of constitutional curiosities can it be of much interest to follow the fresh, almost monthly variations of government in Florence, where the average citizen must have found it difficult if not impossible to keep up with the facts about who was supposedly in charge of the city and the state. A regency appointed from Vienna replaced the senate. A four-man commission replaced the regency, to be replaced under the French by a triumvirate. Then, in 1801, by the terms of the peace treaty of Lunéville between France and Austria, and that of Aranjuez between France and Spain, Tuscany was assigned as a new kingdom, the kingdom of Etruria, to the Bourbon dynasty of the Dukes of Parma.

A king now reigned in Florence – the penultimate novelty, King Lodovico. He had little time to do much reigning, however, as he died in 1803. The government reverted to being a regency, nominally headed by his widow on behalf of her very young son, Carlo Lodovico. Nor did Florence have long to savour that refinement, for the kingdom of Etruria soon disappeared for ever from the map of Europe. Napoleon annexed the Tuscan territory and created his sister Elisa its grand duchess.

Once, in the days of Luca Landucci, it had caused astonishment in Florence that a woman, the wife of the *Gonfaloniere* Soderini, should go and live in the seat of government, the Palazzo Vecchio. Now, in the period from 1808 to 1814, a woman actually occupied the Palazzo Pitti and exercised rule from there. Florence, one can conclude, had seen and experienced every possible permutation of governmental system, with a wide range of contrasting personalities to embody each system. While Ferdinand III could only look on, as it were, from northern Europe, the first and last Grand Duchess of Tuscany to reign ruled in her own right – or rather, under the aegis of her brother. When he fell, she too would fall.

In 1814 an apparently enthusiastic Florence welcomed back as grand duke Ferdinand III (he at least had the advantage of comparative familiarity). The arts, which the Grand Duchess Elisa had busily employed in adapting and decorating the interior of the Pitti, obediently reflected the new situation. Indeed, they convey it more concisely than paragraphs of explication.

On the ceiling of the very room in the palace which had been destined for Napoleon's bedroom (adjoining his bathroom), an effusively flattering, allusive composition was soon painted – in sub-French, neo-classic manner – depicting *The Return of Ulysses* (see Plate 47). For Napoleon the subject envisaged had been equally classical and

flattering, though more clearly heroic: the *Repose of Hercules*. Perhaps it is easier to accept Napoleon as Hercules than the Grand Duke Ferdinand III as Ulysses, though in fairness to the latter it must be said that he returned to Florence as a well-meaning if not always wise ruler. And the final decade of his reign, ended in 1824 by an infection caught on inspection by him of an area of reclaimed marshland, coincided with a notably peaceful era throughout Europe altogether, at least by comparison with the previous two decades.

Like other occupied cities, Florence had suffered artistically during the years of French domination, when some sixty paintings had been removed from the grand duke's collection in the Pitti to swell the Musée Napoléon (the Louvre) in Paris. Fortunately, as one English visitor was to remark in print (Henry Coxe, *Picture of Italy . . .* , 1815), the French could not carry off the palace ceilings. Florence would probably have suffered more than it did, in fact, had the Director of the Uffizi not made a vigorous defence of any spoliation of that collection. Florence was fortunate also in regaining most of the looted works, following Napoleon's overthrow. It even acquired a further, subsequently very famous painting in the strange, uncertain years of interregnum. The exiled Ferdinand III responded favourably to the opportunity of purchasing a Madonna and Child by Raphael, which became known as the 'Madonna of the Grand Duke' – a sobriquet it deserves, though perhaps few of its many later admirers could identify the grand duke concerned.

Art could not be expected to do much to make memorable the brief royal Bourbon regime in Florence, though attempts were set in hand to fill the empty frames left on the walls of the Pitti by the French rape of paintings. A Roman-born sculptor, Giuseppe Belli (*c.*1733–1812), who had executed a bust of Ferdinand III, received the commission for a bust of the boy Carlo Lodovico of Bourbon, heir of King Lodovico, who was presumed for a while to be the future king of Etruria.

Around the Grand Duchess Elisa a far more appealing, more patently glittering, more positively cultural atmosphere came into existence, though some of the glitter and prestige derived from her imperial brother in Paris. To his sun she remained very much the moon. The most ambitious of her projects for the redesign of apartments in the Pitti were set in train with the never-realised hope of a stay in Florence by the emperor and his Austrian empress, Marie-Louise (herself later to reign in Italy as Archduchess of Parma). The architect on the spot was a Florentine, Giuseppe Cacialli, a pupil of Paoletti, nominated Crown Architect in 1808. His were no simple or solely aesthetic tasks, for every proposal had to be referred to Paris. Italian painters, including one accomplished local neo-classic practitioner, Pietro Benvenuti, the painter of the effective scenes in the dome

of the Chapel of the Princes, were involved in the proposed schemes of decoration, but those schemes too needed approval in Paris — and final decisions on them had not been reached when the events of 1814 overtook them and the Napoleonic system they were in part intended to glorify.

A distinct flavour of the stylish settings Cacialli envisaged — more formal though no less elegant than his bathrooms for the imperial couple — can be enjoyed in the so-called 'Music Room' of the Pitti, which was designed to be one of the emperor's reception rooms. To create this beautifully proportioned space two smaller rooms had been combined, and its ceiling was eventually frescoed with an allegorical glorification of the empire that triumphed, that of the Habsburgs. But the graceful, restrained saloon itself, with a pillared

Luigi Cambray-Digny: Façade of the Palazzina de' Servi, *Via Gino Capponi.*

colonnade at each end, is what takes the eye. To the British visitor its idiom looks familiar, for it recalls that of the Adam brothers, and one might almost expect to encounter Cacialli's room on a tour of Syon House or, perhaps more aptly, Kenwood.

The interior of the Palazzo or Palazzina de' Servi' (now part of the University of Florence) sounds from descriptions as though it has retained its neo-classic décor of 1810 intact, and the façade of this building (which has to be sought out in a leafy courtyard off the Via Gino Capponi, only a few yards away behind the church of Santissima Annunziata) is a very rare instance in Florence of a complete neo-classic exterior.

Perhaps the building — today somewhat disfigured by lines of utilitarian piping, grilles and the occasional air-extractor — is more of an oddity than entirely successful, though its long colonnade of Ionic pillars possesses undoubted dignity, even if it appears awkwardly related to the upper, wreath-decorated portion of the façade from which it protrudes. Built in local stone, and by a local architect, yet one clearly of French descent, Luigi Cambray-Digny, this 'palazzina' has a sense of being alien in Florence. The façade

could be that of a *mairie*, or even a barracks, in provincial France at the period. Official-looking as it seems, its purpose is not easily obvious, and nobody would guess that it was designed as the residence of an archbishop. The archbishop was, however, a Napoleonic nomination – as extraneous to native tradition as his residence.

Much slighter yet perhaps more effective in design, and certainly equally unusual, is a severe neo-classic façade which occurs, suddenly inserted, as it were, in the largely *cinquecento* vista of Borgo Pinti. In this almost masonic-temple-style façade is – or, rather, was – the entrance to a new scholastic establishment, the Liceo Regio, which typically made use of the suppressed convent attached to Foggini's church of Santa Maria di Candeli on the street corner. Its architect was Giuseppe Del Rosso, in an idiom very different from that of his father's Kaffeehaus. There is nothing playful or lighthearted about the appearance of this lyceum. Twin Ionic columns guard the way in, rather as might a pair of stern janitors. Del Rosso had little space on the street to give character to his building but that seems to have aided concentration, and about what he was able to articulate there is a crisp, geometric clarity.

A younger architect of that interesting period, an interim one – stylistically as well as politically – won the commission from Prince Borghese to remodel his mother's large family palace in the Via Ghibellina. Gaetano Baccani was born in 1792, lived until 1867, and was to contribute considerably to the appearance of Florence, moving from the semi-neo-classical manner of the Palazzo Borghese to the romantic and the neo-Gothic. What is perhaps his most familiar and striking addition to the city is the brick campanile of Santa Croce, an exercise in the idiom of Florentine Gothic so successful that it often passes as authentic, although its design is from the late 1840s and its completion came only two years before Baccani's death. Seldom can such a prominent pastiche (borrowing from the campanile of the Badia and the tower of the Bargello) have become an acceptable, integral aspect of a great city's skyline.

Perhaps it is significant that Baccani's Palazzo Borghese fails to be uncompromisingly neo-classic. Walking casually along the Via Ghibellina, one might not even notice at first that the thoroughly traditional, rusticated façade at street level is in effect a platform for upper storeys in the grandest neo-classical style. In fact, as frequently happens in Florence, the palace is really too grand for its constricted site. Its central feature of a long loggia of Ionic columns attached to the wall, with winged genii modelled in stucco above and the Borghese arms splendidly flaunted at the summit, virtually detached from the cornice, rises too steeply to be easily appreciated in the street. And despite its assertive, unapologetic, neo-classic features, the building is a hybrid. To a fashionable,

Frenchified modern style have been married elements of the old Florentine style of domestic architecture, and the marriage is not entirely harmonious.

Some sign of the bifocalism of the period, or a hint of the historicism soon to be pervasive in Florence, comes from the masque performed in that newly built, neo-classic environment on the evening of its inauguration in 1822. Its performers represented Lorenzo 'the Magnificent' and the artists of his day, and their costumes were specifically stated by the *Gazzetta di Firenze* to be based on those in the frescoes of Ghirlandaio.

The Palazzo Borghese had no successors in Florence, but the Ghirlandaio-costumed masque of Lorenzo de' Medici points to the new, growing awareness of the *quattrocento* city and its artistic achievements, which we tend to think of as

Gaetano Baccani: Façade of
the Palazzo Borghese, *Via Ghibellina.*

'Victorian'. When that culture was reinstated and re-appreciated, it was as if the wheel had come full circle for the image of Florence. To outward appearances, the city was settling down for a sustained and peaceful future under the tolerant, not inactive rule of Leopoldo II, who succeeded his father as grand duke in 1824.

'His manner was about as bad and as unprincely as can well be conceived,' wrote Thomas Trollope, elder brother of the novelist, in his recollections of utterly unglamorous balls given at the Pitti during Leopoldo II's reign. According to him, when strangers complimented the grand duke on the prosperity and contentment of his subjects, he invariably replied, 'They are quiet' ('*Sono tranquilli*').

There was more to Leopoldo II, as there had been to his grandfather, Pietro Leopoldo, than his 'unprincely' manner might suggest. His interests were scientific and practical, and he deserves to be remembered not least for his serious, personal concern with reclamation of the swamps of the Maremma. He had too some enlightened, liberal ministers, including a future prime minister of united Italy, Bettino Ricasoli. But '*Sono*

tranquilli' was not applicable to Italians generally, or eventually to the Tuscans. As in the sixteenth-century 'troubles', attempted foreign domination of Italy was the focus of unrest, and the Grand Duke Leopoldo II, however mild and well-intentioned, represented an aspect of that. One warning arose from 1848, that year of revolt all over Europe, but of especially stirring significance in Italy. For a brief, dizzy period Rome was declared a republic with Mazzini one of its triumvirs. The pope (Pius IX) fled to Gaeta, where he was joined by Leopoldo II, forced by popular uprising to leave Florence. A few months later he was able to return, with the support of Austrian troops, much as Pius IX returned to Rome with the support of a French army.

Yet in 1859, barely ten uneasy years after resumption of his reign (and two years after receiving the pope on an official visit to Florence), Leopoldo II was compelled to leave Florence for what proved the final time. In the following year Florence and Tuscany voted by a plebiscite to join the kingdom that in 1861 became the Kingdom of Italy. To a large extent, the 'troubles' of nineteenth-century Italy came to a happy end.

From them Florence had emerged physically unscathed. In many ways the city of 1861 was the city familiar today. A certain amount of fairly sensitive improvement — widening of streets, tidying up of certain key areas, such as the south side of the Piazza del Duomo — had been going on in the 1840s and '50s. Somewhat earlier, in the 1820s, after Ferdinand III's restoration, Baccani had contributed to the Piazza del Duomo the sober, pillared Palazzo dei Canonici, which owes nothing to its Gothic-Renaissance surroundings, though from its façade giant statues of Arnolfo di Cambio and Brunelleschi survey 'their' Duomo. A mood of romantic historical consciousness seems already at work in their placement, and Florence would soon be evoking by statues and buildings its prestigious past. For better or worse — probably the latter — a neo-Gothic marble façade was executed for Santa Croce, the rigid, sterile façade only too visible today across the huge expanse of piazza. By 1861 that was nearing completion.

A timely piece of legislation in 1861 required each street to bear the same name throughout the length, and that must have provided a neat opportunity for rebaptising any area awkwardly recalling the Habsburg regime. The Piazza Maria Antonia (named after Leopoldo II's second wife) thus became, and has remained, the Piazza della Indipendenza.

The Florence of that date had not yet had thrust on it the dubious honour, conferred in 1865, of being the capital of Italy. Politically, that seemed to someone like Ricasoli a poisoned cup, and aesthetically one might make a rather similar judgment, for the new status gave impetus to drastic changes to the city's character. Not all those were

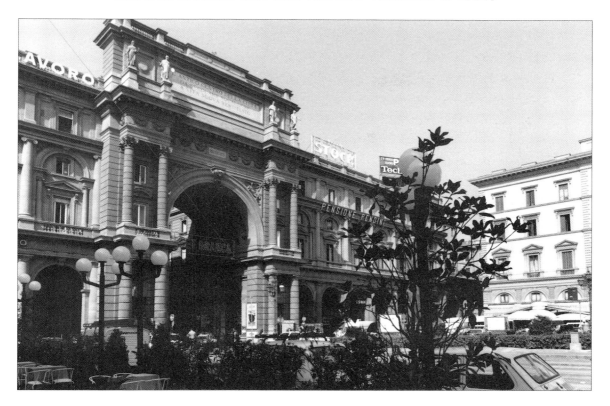

The Piazza della Repubblica.

deplorable, though few advantages could compensate for the vacuous, large-scale ugliness of the Piazza della Repubblica, a triumph of boastful banality achieved on the site of the centuries' old market-place in 1895, by which time Rome had long replaced Florence as the capital of Italy. That central urban eyesore remains unfortunately an inherent part of the image of the city today, though there are far pleasanter, more interesting and often less frequented nineteenth-century memorials where one can take farewell of Florence.

FLORENCE AS CRADLE AND CAPITAL

As the visitors streamed steadily into later nineteenth-century Florence, often on tours organised by Cook's, benefiting from the advantage of the new, popular medium of photography, able to buy reproductions at the shop of the photographer brothers Alinari (founded 1854), and possibly carrying their own cameras, reliably guided by the marvellously detailed publications of Baedeker and probably fired, especially if British, by the eloquent pages of Ruskin's *Mornings in Florence*, they anticipated in many ways the far larger, more heterogeneous and more restless influx of visitors to the city at the end of the twentieth century.

Yet there were differences. Those visitors of the nineteenth century were, whether or not they realised it, pioneers. It was they who effectively established, virtually consecrated, the major points on the artistic itinerary of even the most whirlwind traveller of today. They were pioneers also in constituting largely a new type of visitor, the bourgeois or middle-class one, venturing abroad with no social contacts there and little or no knowledge — especially in Italy — of foreign customs and foreign languages. Increasingly, they travelled in a new form of transport, the train, and in a comparatively new style, often *en famille*. They went with the purpose of improving their cultural education by seeing famous medieval and Renaissance monuments — not to mingle with the natives, involve themselves in politics or aspire to be received by whoever was the ruler.

There was a novelty about even the sex of those pioneering visitors, for many of them were women (that is, 'ladies'), who might actually be travelling without male escort and who had their own standards and expectations inspired by modesty. As late as 1913, on the verge of the First World War, Baedeker's *Northern Italy* provided the quiet but necessary word of advice about cafés in Florence and added to its mention of the well-known Doney's in Via Tornabuoni, 'recommended to ladies'.

The subject of women in nineteenth-century Florence would be a rewarding one. The city seems to have been a particular haven and show-case for women, who ranged

from the foreign literary figures of Elizabeth Barrett Browning and Ouida to the distinguished native holder of a salon, Emilia Peruzzi, and including more humbly several keepers of hotels and *pensioni*. 'English landlady', the 1913 edition of Baedeker thought it worthwhile noting of the Hôtel Regina & Victoria on the Lungarno Vespucci. The hotel's very title is a convenient reminder that Florence had witnessed the arrival finally of the supreme bourgeoise of the century, Queen Victoria (who never visited Rome or Venice). In the spring of 1888 her 'magnificent reception' was reported in the English newspapers, and with much emotion did Princess May of Teck, the future Queen Mary, read how 'God Save the Queen' was played in the Piazza del Duomo. It was doubly moving for her and her family, as they had themselves spent several memorable and enjoyable months in Florence.

The Teck family had artistic enthusiasms not shared by Queen Victoria. Princess May's mother had rushed through the Pitti Palace on a wave of excitement: 'Titians! Raphaels! Andrea del Sartos! Van Dycks! Rubenses! – gloriously beautiful!' Queen Victoria went there to return the visit that the King of Italy, Umberto, and his queen had paid her (having come to Florence for her visit). The rooms she saw were the royal private apartments, furnished in sumptuous if stuffy late nineteenth-century taste, of a kind fortunately preserved and visible in the palace still. Although Queen Victoria dutifully visited some of the sights that had appealed so much to Prince Albert as a young man in Florence forty-nine years earlier (and the prince had greatly admired both the exterior and the interior of the Pitti), she was probably more at home, in every way, in a silk-upholstered drawing-room, crowded with knick-knacks, furnished in an international palatial style from which any suggestions of Florentine environment were excluded. Modified forms of such furnishing awaited visitors to the grander hotels, and as usual the queen typified a majority of at least her own subjects.

Of course, the new form of travel and the new forms of information created by the nineteenth century were not specific to Florence. But they happened to coincide with a new, intense focus upon it as the 'cradle' of the Renaissance, an altogether earlier period of the Renaissance than had attracted popular interest previously. Besides, it could be argued that the newly developed image of Florence, along with the city itself, suited the bourgeois traveller better than the perennial, daring glamour of Venice or the much grander and more complex cosmopolitan environment of Rome. There is a sense too in which an earnest, moral and vaguely, even anxiously, religious age would feel more 'at home' in a city symbolised by Fra Angelico than in one symbolised by Titian.

Ghiberti's 'Paradise Doors' provide a potent example of the Florence that was

effectively re-discovered. Like Florence generally, they had not excited great interest during most of the eighteenth century. Goethe was merely one traveller who had passed through the city without comment. The historian Gibbon is unlikely to have experienced much emotion at seeing any works of *quattrocento* Florence, while earlier in the century Ghiberti's doors had markedly failed to impress a French traveller, the Président de Brosses. To Dostoevsky, by contrast, they were so wonderful that, as he told his wife in a burst of Russian exuberance, if he ever became rich he would buy and hang in his study photographs of them – photographs that should be, if possible, as large as the originals. Skilled modern photography has made Dostoevsky's dream a virtual reality. But it was only in 1773 that a large-scale publication of the doors had first appeared, '*incisa in 34 fogli aperti*'. Before that, there was probably no demand for reproduction of them.

By 1868–9, when Dostoevsky was living in Florence, his enthusiasm as such was no novelty. The works of Masaccio, Donatello and Luca della Robbia had also been re-discovered, and the crucial role of Florence in the story of Renaissance art had become a commonplace. Nothing better sums up that revolution of taste than the resurrection of Botticelli. 'A kind of hero-worship' was how John Addington Symonds described his cult (in *Renaissance in Italy: The Fine Arts*, first published in 1877), noting how in the previous century, and at the beginning of the nineteenth, preoccupation with his art would have passed as 'a mild lunacy'. Today, Botticelli's *Birth of Venus* is probably at least as familiar throughout the world as Leonardo's *Mona Lisa*, and almost certainly more appreciated. It continues to enjoy every vicissitude of fame, its central figure of Venus still being borrowed for advertisements in most countries, and her face imprinted on innumerable T-shirts for sale on Florentine market stalls.

The revolution of taste which brought back to a central place in cultural consciousness the art of fifteenth-century Florence, and that of earlier centuries as well, is in itself a vast subject, with wider European ramifications. It has a particular piquancy where Florence is concerned because the city which attracted so many visitors for its past associations was by the mid-nineteenth century fast turning itself into a modern one, to become in 1865 the capital of the new, largely united Kingdom of Italy. And it had, as Florence had not had for many decades, a new and vigorous group of painters working there – Italian but not all of them Tuscan by birth – known, none too helpfully, as the 'Macchiaioli' (painters of the '*macchia*' or patch).

Although English-speaking scholars have given a certain amount of attention to this group in recent years, the actual paintings are not easily seen, and hence are not familiar, outside Italy. They definitely failed to be collected by the British at the time, and the

omission has not subsequently been repaired. There were a few links, partly of friendship, between some Italian and British artists, notably between Giovanni Costa, a painter on the fringe of the Macchiaioli, and Lord Leighton. But the orientation of the group was, in both personal and artistic terms, directed much more towards France. Theirs was a rather gentle form of realism, with much sub-Corot-style emphasis on the countryside and on placid interiors. It was an intended break with too-carefully painted scenes of classical history and mythology – in style as much as subject matter. Although the pictures constituted a revolution of sorts, and occasionally illustrated some topical battle scene on Italian territory, the overall effect of them is quiet, peaceful and limpid in the sense of light and air, compared with the stirring, semi-martial lives of many of the painters.

For them, the movement of the *Risorgimento*, with hopes of Italy becoming at last one kingdom, was a thrilling cause. Only unevenly and almost obliquely did that cause enter '*macchia*' pictures. One has to glance carefully at, for example, the small genre painting of a girl seated sewing at a window by Odoardo Borrani (a privately owned but often reproduced and exhibited picture) to absorb its significance, to which its title contributes much.

It shows a Florentine interior, with sunlight falling on a typical tiled roof, visible through the window. The girl is patiently sewing the red, white and green flag of Italy, but that action itself only becomes meaningful when 'read' with the picture's title: *The 26th April 1859*. We have to know, too, that the date is the eve of the retreat from Florence, under popular pressure, of the last grand duke, Leopold II. For all the revolutionary implications of its theme, however, the painting's mood and style are calmly bourgeois. This is far from being some Italian variant of Delacroix's famous painted manifesto, *Liberty on the Barricades*. The girl's role remains a domestic one. For some man is reserved the duty of publicly brandishing the flag as incitement to demonstrations in the streets of Florence on the following day.

Borrani himself was one of those who did more than paint or brandish flags. Like others of the Macchiaioli, he joined the Tuscan artillery and fought for Italian liberty. Costa was another, even more consistently 'engaged' artist, closely involved with Garibaldi, fighting at Mentana in 1867 and among the first to enter Papal Rome when it fell to the troops of United Italy in 1870.

Patriotic and artistic fervour were unusually, militantly, combined among artists in nineteenth-century Florence. There was little tradition of that kind in the city – indeed, it is not characteristic of artists in general anywhere. Only during the French Revolution

Odoardo Borrani: The 26th April 1859, *collection Giuliano Matteucci, Viareggio.*

perhaps was there a precedent. For generations the citizens of Florence in particular had been passive in the face of every change of government, and the actual events there, leading to a plebiscite by which Tuscany joined the kingdom that became Italy, were

peaceful. There was to be no re-play of the bloody strife of Guelphs and Ghibellines, and no repetition of the Pazzi conspiracy. Yet it seems appropriate that the café where the artists gathered, along with entirely political personalities, should be called the Caffè Michelangiolo (in what is now the Via Cavour), for he at least had been a staunch patriot and prepared to serve the republic in military defence against Medici aggression.

In some ways, mid-nineteenth-century Florence was livelier, busier, more a centre of great, truly epoch-making events and celebrations than it had been for centuries. To its sense of past history was now added history in the making. It saw the entry of the future king of Italy, Vittorio Emanuele II, though some of the acclaim he received on arriving in April 1860 had to be shared, to his annoyance, with his Prime Minister, Cavour. The following year the king inaugurated a huge *Italian* Exhibition in Florence (the adjective was emphatic), a conscious but proud echo of the great exhibitions held previously in London and Paris.

The exhibition had its fine arts section, and among the paintings on display were two that represent the closely allied streams of present and past awareness in the city. Borrani's *The 26th April 1859* had been painted in fact only in 1861, possibly for the exhibition. It stood for the contemporary world and would take on greater relevance when Florence became the capital of Italy as so far united. The *clou* of the fine arts section, however, was a no less emotive scene, from deep in the past of the city, *The Expulsion of the Duke of Athens*, by Stefano Ussi. Significantly, that picture was bought for the state and is thus part of the Gallery of Modern Art in the Palazzo Pitti. Ussi's composition is a typical, academic affair (no *macchia*-style work), technically competent though aesthetically feeble. But its subject was of tremendous resonance within Florence. It recalled, with whatever topical application, St Anne's Day in 1343 when the city had expelled its foreign, one-time ruler, a day the republic had gone on celebrating as long as it existed.

Ironically, the average foreign visitor probably responded with more enthusiasm and knowledge to Ussi's subject (and perhaps also to its 'finished' appearance) than to Borrani's. Few visitors had come to enjoy the modern achievements of Florence, in any sphere. Indeed, some of the changes seemed painful. The lineaments of the old city were being altered rapidly and drastically. Expansion was thrust on it in a dynamic, 'progressive' way, of a kind which had never been carried out so extensively before. The gains and the losses were both substantial, and it could be argued endlessly about which eventually predominated. What is beyond argument is that the changes were irreversible.

The scope of the alterations took various forms, at once minor and major, subtle

and sensitive, but on occasion also coarse and ruthless. On the one hand, a street might be widened to provide a more effective vista, without much harm to the urban fabric. On the other, the city walls were simply destroyed, as was the ancient, if shabby, profoundly evocative secular heart of the city, the Mercato Vecchio, where in triumphal mood the colossal, classical arch erected there was inscribed in 1895 with words which boom out emptily over the huge aesthetic desert of the piazza (then the Piazza Vittorio Emanuele), announcing that from age-long decay the old city centre has been restored to 'new life'.

Those who had known the quiet, snug-seeming Florence of the Austrian grand dukes must have blanched and mourned when they saw such deathly evidence of the '*vita nuova*' imposed on their familiar city. To someone like the Irish novelist Charles Lever, long resident in Florence and an unabashed champion of the last grand duke, Leopold II, the old times were 'surrounded with a charm of existence words cannot picture'. Lever left Florence in 1867 and died five years later, so he was spared seeing many of the most radical physical alterations to the city.

The arch in the Piazza Vittorio Emanuele may actually have looked better when it was crowned by a group of allegorical sculpture, *Italy Enthroned* (removed in 1904), and when it served to frame the equestrian statue of the king which occupied the middle of the piazza (subsequently banished to a less central location). Yet in some ways these nationalistic flourishes came too late, for by 1871 the city had ceased to be the capital of Italy. That fateful choice, however (made while Papal Rome aggressively resisted, with French military support, integration into the new kingdom), was what gave impetus to a hectic pace of 'improvement' and expansion. In the name of progress, cruel liberties were taken with medieval republican Florence that might seem, in a pejorative sense, politically motivated.

It was as though the city, which had suffered or enjoyed virtually every conceivable form of government down the centuries, had to be stamped with one apparently final image: as the capital not of some petty kingdom (as it had been briefly of Etruria) but of a proud, revitalised and leading nation in Europe, the Kingdom of Italy.

That Italy had come together and gained '*vita nuova*' demanded celebration. In becoming the capital in 1865, Florence was pushed into unaccustomed, strong, political limelight. At once its physical inadequacies for such a role were exposed. Like some pauper suddenly revealed as heir to a throne, the city now required dressing up in suitably sumptuous robes, and metaphorically a couturier of great energy and vision was available in Giuseppe Poggi. In three months he conceived and presented a comprehensive urban plan for Florence which would transform it into a city equivalent to other European cap-

itals. And the impetus for that expansion continued to roll on, decades after the capital itself had been established at Rome.

The ministries (often housed in existing Florentine palaces — that of Finance, for example, in the Casino della Livia) had departed, as had the ministers and government officials. The population of the city declined. Florence was left awkwardly making — and paying for — grand gestures which lacked any functional significance, and some of Poggi's more ambitious ideas were reduced to a trivial level. The imposing loggia he built as an adjunct to his boldest and most successful innovation, the Piazzale Michelangelo (see Plate 50), was soon demoted to use as a café, whereas he had intended it to be a museum of Michelangelo's work. And even about the central sculptural 'homage' to Michelangelo enshrined in the bronze version of the *David* (a gift from the Italian government to Florence), flanked by bronze replicas of the four allegorical figures from the Medici tombs, there is an uneasy air of inflation and indeed conflation, for the monument has no real artistic validity. It is, in fact, a thoroughly misconceived piece of nineteenth-century pastiche, big and yet ultimately hollow, which it is impossible to imagine perpetrated by later periods (however grave their aesthetic sins). We might, oddly enough, better respect an historico-romantic but original statue which represented Michelangelo himself, brooding over the Piazzale and the panorama of the city.

Such a thought must have occurred to many a visitor, especially after remarking, say, the statues of famous Tuscans in the niches along the portico of the Uffizi. It is almost galling to discover that a proposal was made for a statue of Michelangelo on the Piazzale named after him. A talented if wayward sculptor of the nineteenth century, Giovanni Dupré (Italian-born but of French descent) conceived the idea and would have executed the statue, but his proposal was not accepted. For some hints of what Dupré would have made of the commission, one may study the statue of Giotto that he contributed to the Uffizi series.

The life of Poggi, creator of the Piazzale Michelangelo, was to be a remarkably long as well as busy one. Born in Florence in 1811 (at a time, that is, when Elisa Baciocchi was reigning as Grand Duchess of Tuscany), he did not die until 1901. The grateful city has kept his name alive doubly, and in a particularly suitable location. From what became in 1911 the Piazza Giuseppe Poggi, at the Gate of San Niccolò, there winds sinuously up the hillside towards San Miniato the wide, tree-lined Viale Giuseppe Poggi, which brings one to his inspired creation of the Piazzale Michelangelo, the broadest of terraces, set at the half-way stage between the gate below and the church above. Although the whole area has been so picturesquely improved, with its vistas, its boulevards and its ramps of stair-

Giuseppe Poggi: Piazza Beccaria.

case, treated almost as though it were a park or the grounds of some palace, it has not lost its countrified feel. It still lies very much at a distinct distance from the city. San Miniato still retains its age-old seclusion on the heights overhead, and its tranquil, meditative spell is intact.

Back down in Florence, one can follow Poggi's traces. His hand is openly shown in the scenographic grandeur of the elliptical Piazza Beccaria, which he conjured up from the space outside the old Santa Croce Gate, in an idiom more appropriate to Rome or Turin, to form a focal point for broad avenues conceived presumably in emulation of Paris and Vienna. At a time (1865–74) when the Mercato Vecchio was still in existence, the centre of Florence was free from, and perhaps seemed likely always to be free from, such alien architectural rhetoric. The Piazza Beccaria was then physically extraneous to the city's core, and only steady urban expansion eastward has effectively absorbed it into the city of today. Yet it continues to strike an aloofly assertive note. That its palatial,

The 'English' Cemetery.

pilastered façades are largely un-Florentine in style is really part of its message. An old provincial town had to be rapidly adapted to becoming a modern, cosmopolitan capital city, and in that process the Piazza Beccaria was the first important and possibly the most flamboyant step.

Much more unobtrusively, and naturally, did Poggi contrive to make a complete island site out of the Protestant or 'English' cemetery, which dated back to 1828, and lay just beyond the city walls. Even today, it has preserved its extraordinary, insular detachment. It is a sort of mortuary Sark, or perhaps a San Marino, small in extent, serenely self-contained and intimate, where one may wander along steep, stony paths and past sentinel-like cypresses, oblivious to traffic noises or other indications of the outside world.

Even if there were no good literary reasons for a pilgrimage – if Clough, Landor, Fanny Trollope and Elizabeth Barrett Browning were not buried there – it would still be worth a visit. Unlike the centre of Florence, it is seldom or never crowded – apparently visited hardly at all. The only crowd there consists of the tombs amid the hedges or under the trees: ranging in date and fashion from the neo-classic stoicism of a graceful urn on a fluted column to the extravagant grief of a sorrowing widow, a fully three-dimensional

figure, sculpted kneeling in completely detailed, nineteenth-century costume, inclusive of the myriad, cleverly carved marble bobbles that fringe her shawl.

More perhaps than most visitors to Florence bother to realise, the city they encounter is still very much as the nineteenth century shaped and left it. That does not mean that there has been no further evolution. With eyes attuned for the phenomenon, the visitor can remark the odd, freakish signs of 'Liberty style' architecture, in a few exuberant villas and notably in the tall slice of it that constitutes the narrow façade of the 'Casa-Galleria', which is number 26 of the Borgo Ognissanti. In typically Florentine fashion, that most unexpected stylistic intruder in such a street hardly registers at ground-floor level. Its boldest effects are reserved for its upper storeys, and it is best appreciated in a literal retrospect, from the corner of the nearby Piazza Ognissanti. Then, however alien it may look at first, its idiom of stone stretched and curved into ellipses, its grotesque ornamentation and its general air of playful invention raise thoroughly Florentine echoes, recalling the tricks and quirks of Buontalenti's architecture, still surviving, one may feel, in a building that dates from 1911.

The mid-1930s central railway station of Santa Maria Novella is itself a triumph of modernism worth appreciation, and serious students might like to go on, literally, to the markedly and thus not altogether inappropriately phallic design of the building that has become the 'Cinema Puccini' (begun 1933), in the piazza of the same name. Post-Second World War schemes — often brilliant and daring ones — are to be found, though inevitably they tend to be on the periphery of the Florence perceived by the average visitor. At the end of the twentieth century Florence is, of necessity, still expanding. There is a city of the future conceived and to be studied, and even the most casual of tourists who has endured the rigours of passing through the airport at Peretola must hope for some practical if not stylish architectural solution to be created there — and soon.

For the face of nineteenth-century Florence — whatever its failures, at least conceived on a spacious scale — Poggi was not solely responsible, ubiquitous and hyperactive as he may seem. His is not, after all, the over-conscientious and uninspired neo-Gothic of the finished Duomo façade, itself a project controversial, argued over and competed for as intensely in the nineteenth century as had been any project in the Renaissance. It was not Poggi who was responsible for the huge, sternly frowning Doric temple to commerce (the Borsa Merci) fronting the river on the Lungarno Diaz, a building that refuses to be apologetic — rather, commands attention — though a medieval complex of the Arte della Lana, possibly designed by Arnolfo di Cambio, was destroyed to provide its site.

Nor was Poggi the architect of any of those necessarily heterogeneous religious

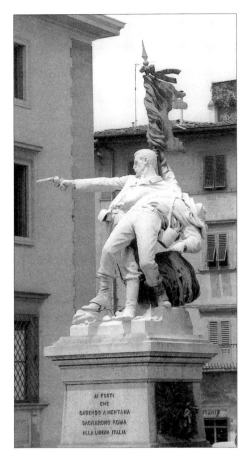

Oreste Calzolari: Monument to
the Fallen at Mentana, *Piazza Mentana.*

buildings that added to the cosmopolitan air of the late nineteenth-century city: the imposing, Islamic-style synagogue (inaugurated in 1882), patently eclectic yet no less patently effective, which gave one more dome, prominent and copper-coloured, to the Florentine skyline; the much more modest Anglican church (dating from 1893); and the thoroughly vigorous 'transplant' from its native land, the Russian Orthodox church (see Plate 48), with its bulbous cupolas clothed in gleaming, polychrome tiles manufactured by the firm of Cantigallia in Florence, begun in 1899, consecrated in 1903.

The nineteenth century had some unexpected and partly exotic, if strictly unimportant, contributions to make to the city in terms of public monuments. It is only a pity that today these additions receive so little attention from either natives or visitors, and the actual circumstances which brought them into existence seem to have largely receded from the common consciousness.

Two of these monuments connect with the year 1870, but that is about their only connection. There could indeed hardly be a greater contrast in idiom between the patriotic, highly melodramatic and stirring rhetoric of Oreste Calzolari's monument to the fallen at the battle of Mentana, in its eponymous piazza, and Lorenzo Bartolini's pensive, neoclassic group of statues commemorating Count Nicholas Demidoff, a private person, though a great philanthropist, in the modest piazza that bears his name.

Florence had — and was to have — nothing comparable to either concept. No ordinary citizen, however rich (and Demidoff, a Russian émigré, was enormously rich), could expect to be commemorated in a civic, secular way after death. Part of the fascination of the form in which Demidoff was eventually commemorated lies in its combination of private and public, of the individual and the community — for the creation of the

View of the Piazza Demidoff.

piazza setting of the monument provided an amenity for Florence. The mood there is one of relaxation and quiet reflection. Not heroism but humanity and goodness of heart are personified in Nicholas Demidoff, and such virtues as Charity and Truth, in female guise, are gathered below the podium on which he is passively seated.

But the monument to Mentana is a passionate, masculine, defiant shout, incarnating an ideal for all Italy, and none the less effective, even irrationally rather moving, despite being executed long after the actual event. It is a war memorial with the additional piquancy of celebrating a defeat, though one that proved temporary, and it lacks any specific Florentine connotations. In that, as in its uninhibited melodrama, it is unlike Calzolari's other essay in evocation of the *Risorgimento* past, the pair of bronze equestrian statues at Fiesole, commemorating the meeting of Garibaldi and Vittorio Emanuele II.

Mentana has probably lost most of its resonance today, at least to non-Italians unless they are historians of the period. It was a famous setback in 1867 for Garibaldi and his volunteers, who were attacking the Papal States, with Rome as their objective, and a famous victory for the united forces of the papacy and the French. Italian was pitted against Italian, and some of the ambiguities arising from the situation were ironically exploited by Disraeli, in his novel *Lothair*, published in 1870.

Calzolari's monument dates from 1902 but in every other way it belongs to the previous century. Clasping a dying comrade, who yet manages to hold aloft his standard, a soldier – in effect, an unknown warrior – discharges his pistol at an unseen enemy, bravely but with a sense of personal doom. He and his fellow-soldiers are martyrs for a cause, and the message of the whole group is that their fight and their deaths were not in vain. On the plinth is a bronze relief showing Garibaldi himself amid the battle (almost in the style of Giambologna), and the inscription on the monument is explicit in its dedication to: 'The brave who falling at Mentana consecrated Rome to liberated Italy'.

Perhaps it is wrong to say the monument lacks all connotations for Florence, since the city remained the capital of the new Italy as long as Rome remained untaken. But in 1870 the Franco-Prussian War broke out. That resulted in the withdrawal of French troops from Rome, and on the last day of the year Vittorio Emanuele was able to enter it as his new capital.

The date 1870 appears on the Demidoff monument, not far distant but on the opposite bank of the Arno. Demidoff had died in 1828. Bartolini was his close contemporary, a Florentine answer or alternative to Canova and Thorwaldsen, and – like them – an internationally famous sculptor in his day. His was a style of neo-classicism merging with a gentle form of 'realism', helping him to be effective as a portraitist. In Santa Croce his refined manner is well exemplified in the calmly conceived funerary monument of Countess Sofia Zamoyska, where the subject is seen in profile, reclining gracefully, as though on a chaise-longue. The Demidoff monument demanded something altogether larger, yet still in a vein more intimate than grandiloquent. Bartolini received the commission in 1830 but had by no means completed it at the time of his death twenty years later, although he had made models for it (now in the Accademia).

Under its bandstand-like shelter of iron and glass, erected to conserve it, the final monument has a slightly sad and quaint air. Stylistically, as in other ways, it looks unrobust, more quiescent than assertive, and almost vulnerable in its exposed setting. In timeless, classical drapery, Nicholas Demidoff clasps a child who might be some penniless Florentine orphan but is in fact his younger son, Anatole, whose mother had

died when he was six. And it is largely to Anatole Demidoff, who became Prince of San Donato, that the monument is due. Even by Russian standards of the period, he was fabulously wealthy, insanely self-indulgent, restless and discontented. He had a passion for art but no clear idea how to direct it. Few people could better serve as compelling illustration of the adage that money does not make for happiness.

Demidoff quarrelled with Bartolini over the monument to his father. It had been his original intention to place it in the park of his colossal villa at San Donato, in the environs of Florence. His next idea sounds typically Russian but was almost certainly inspired by the Chapel of the Princes at San Lorenzo. He planned to have a mausoleum built which should be lined with malachite and topped by a dome of gilded bronze; the monument itself would be installed on a base of lapis lazuli. The Medici grand dukes, from Cosimo I onwards, would have approved. Eventually, after Anatole Demidoff's death, such extravagant private dreams gave place to the restricted, open-air and public setting of the monument on its present site.

The sculpted group gives unusual character to the peaceful location, with its few trees and its few benches. Florence is deficient in pleasant places to pause and sit undisturbed. The Piazza Demidoff offers not only that but space with a view — across the river, towards the ever-familiar yet ever-absorbing panorama that epitomises the old, historical city, with a glimpse of the tower of the Palazzo Vecchio. Nobody could possibly pause, with safety, in the small area of the Piazza Mentana, chiefly in use as a parking lot and traffic corridor, as devoid of distinctive features as it is of benches. To retreat to the Piazza Demidoff, mercifully silent, if a touch forlorn, is to enter a zone of contemplation. The visitor who pauses there has reason to feel grateful for the urge that led to commemoration of Nicholas Demidoff.

And that spot seems a highly suitable one in which to survey and think of bidding farewell to Florence. The story of the Demidoff monument has its strange, slightly pathetic history, which seems to tinge the very figures grouped there. It was a long way from St Petersburg that Nicholas Demidoff had wandered, via Paris and Rome, to die in Florence.

Such thoughts prompt recollection of another, even more unusual, nineteenth-century monument, perhaps the strangest and saddest of all: the 'Monument of the Indian' (see Plate 49), at the far end of the Cascine, the same person who is commemorated by the efficient modern viaduct that crosses conveniently nearby, the Viaduct 'dell' Indiano'.

It is a small copper cupola, supported on columns and suggestive of, hardly bigger than, an elaborate howdah, which arches over the bust of no anonymous 'Indian' but of

the young Maharajah of Kohlapur, Ram Chuttraputti (born in 1849). If not actually visited, it can be taken in visually from a car as one leaves the city.

The maharajah arrived in Florence, still then the capital of Italy, in November 1870, on his way home to India after a stay in London. He had failed to meet Queen Victoria (she was at Balmoral), but was received by Gladstone, then Prime Minister. It may well have been Gladstone who suggested his visiting Florence.

The maharajah reached the city on 29 November, staying at what is now the Grand Hotel, in the Piazza Ognissanti. The same evening he was suddenly taken ill and died. Brahmin rites required cremation of his body at the juncture of two rivers, and the sole convenient site was in the Cascine, where the tributary of the Mugnone flowed into the Arno. Near to that place a monument to him was erected in 1876, designed by Major Charles Mant of the Royal Engineers, containing a bust by an English portrait sculptor living in Florence, Charles Francis Fuller (who himself died before the monument was completed).

Postcards of the 'Monumento dell' Indiano' are among those nowadays on sale, and local taxi-drivers will stop on the viaduct and point it out to the interested passenger. Few visitors to Florence have spent less time there than the unfortunate maharajah. He was to see virtually nothing of the city where he remains so poignantly present in effigy.

I T WAS POSSIBLY reflection on all that the maharajah had thus missed, as much as on life's brevity, that caused my sympathetic taxi-driver to sigh, as we stared at the monument one rainy late spring afternoon, 'Povero indiano.' And, for no very clear reason, I found myself sighing too.

Perhaps it was because I also was leaving Florence, though less finally. Unlike the poor maharajah, I had lived to see a good deal of it. But there was finality even in putting up the rain-spotted window and being driven away from 'the Indian', from the associations of nineteenth-century Florence and of those of many previous centuries there, away altogether from the past: towards the airport at Peretola and the writing of this book.

MEDICI FAMILY TREE

(in simplified, abbreviated form)

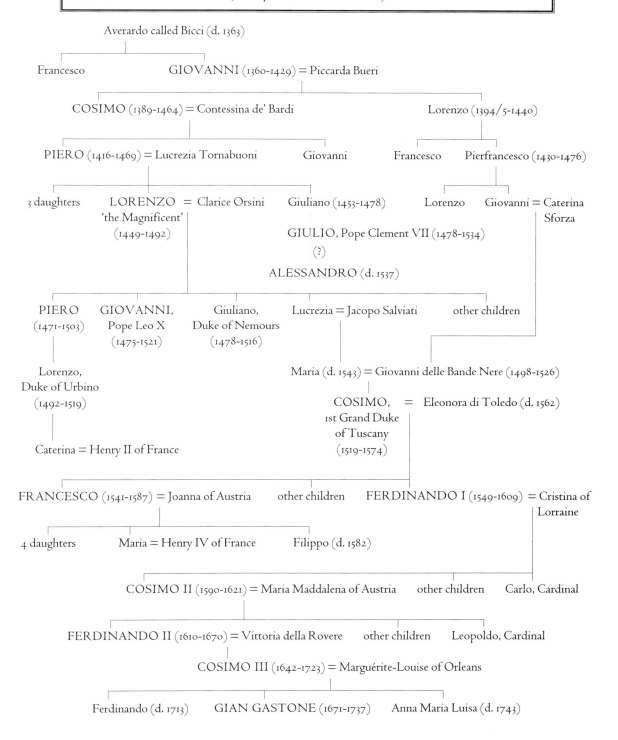

Books for Further Reading

As the heading above makes clear, this is not a bibliography as such. It omits, for example, periodical literature, much of it gratefully utilised in the writing of this book, though it does include some major exhibitions. Rather than a list of sources consulted, it is therefore a list of books, of a deliberately varied kind, for the interested reader seeking more information. Not entirely but partly omitted are art books, especially in the popular, familiar area of the Renaissance, where any complete itemising of monographs on painters alone would be impractical and not strictly relevant here.

To make the material more easily comprehensible, I have subdivided it, broadly in accord with the chapters of this book. For works in English, the place of publication is assumed to be London unless otherwise stated.

General

EXHIBITION

Firenze e la sua immagine: cinque secoli di vedutismo, Florence, 1994.

BOOKS

H. Acton & E. Chaney (eds.), *Florence, A Traveller's Companion*, 1986, repr. 1987.

G. Andres, J. M. Hunisak & A. R. Turner, *The Art of Florence*, New York, 1988; London, 1991.

P. Bargellini, *Vedire e capire Firenze*, Florence, 1961.

P. Bargellini & E. Guarnieri, *Le strade di Firenze*, Florence, 1977–87.

E. Borsook, *The Companion Guide to Florence*, 5th, revised edn, 1988.

A. Busignani & R. Bencini, *Le chiese di Firenze*, Florence, 1974.

R. Caggese, *Firenze dalla decadenza di Roma al risorgimento d'Italia*, Florence, 1912–21.

L. Capellini & D. Cardini (eds.), *Firenze. Guida di architettura*, Turin, 1992.

C. Cresti, *Le fontane di Firenze*, Florence, 1982.

R. Davidsohn, *Geschichte von Florenz*, Berlin, 1896–1927.

C. L. Dentler, *Famous Foreigners in Florence 1400–1900*, Florence, 1964.

E. Detti, *Firenze scomparsa*, Florence, 1970.

G. Fanelli, *Firenze* (*Le Città nella storia d'Italia* series), Bari, 4th edn, 1988.

L. Ginori Lisci, *The Palazzi of Florence. Their History and Art*, trans. J. Grillo, Florence, 1985.

M. Gregori & S. Blasio, *Firenze nella pittura e nel disegno dal Trecento al Settecento*, Milan, 1994.

J. R. Hale, *Florence and the Medici. The Pattern of Control*, 1977.

C. Hibbert, *Florence: The Biography of a City*, London & New York, 1993; paperback edn, Harmondsworth, 1994.

E. Hutton, *Florence*, 1952.

F. King, *Florence, A Literary Companion*, 1991.

K. Langendijk, *The Portraits of the Medici, 15th–18th Centuries*, Florence, 1981–87.

M. McCarthy, *Stones of Florence*, London New York, 1959.

N. Machiavelli, *History of Florence*, anon. trans., New York & London, 1901.

J. Macleod, *People of Florence, A Study in Locality*, 1968.

A. M. Massinelli & F. Tuena, *Treasures of the Medici*, English edn, 1992.

A. Mori & G. Boffito, *Firenze nelle vedute e piante*, Florence, 1926.

N. Ottakar, *Firenze. Cenni di storia e di cultura fiorentina*, Florence, 1945.

W. & E. Paatz, *Die Kirchen von Florenz*, Frankfurt am Main, 1940–54.

A. Panella, *Storia di Firenze*, Florence, 1949.

F. T. Perrens, *Histoire de Florence depuis la domination des Médicis jusqu'à la chute de la république*, Paris, 1888–90.

G. Pieraccini, *La stirpe de' Medici di Caffagiolo*, Florence, 1924.

Y. Renouard, *Histoire de Florence*, Paris, 1967.

G. Richa, *Notizie istoriche delle chiese fiorentine . . .*, Florence, 1754–62.

F. Schevill, *History of Florence from the Founding of the City through the Renaissance*, New York, 1936; London, 1937.

G. Spadolini, *Firenze mille anni*, Florence, 1977 (*A Short History of Florence*, trans. R. Learmonth, Florence, 1992).

T. C. I. Guide, *Firenze e provincia*, Turin, 7th edn, 1993.

M. Vanucci, *Storia di Firenze dalle origini ai giorni nostri*, Rome, 1992 edn.

T. Verdon (ed.), *Alla riscoperta di Piazza del Duomo in Firenze*, I: *Dal Battistero al Duomo*, Florence, 1992.

D. Wigny, *Au coeur de Florence*, Paris & Louvain-la-neuve, 1990; Italian edn, *Firenze*, Milan, 1991.

L. Zeppegno, *Le Chiese di Firenze*, Rome, revised edn, 1991.

Chapters 1 – 8

EXHIBITIONS

La città del Brunelleschi, Florence, 1979–80.

Omaggio a Donatello, 1386 –1986, Florence, 1985.

Capolavori di scultura fiorentina dal XIV al XVII secolo, Florence, 1986.

L'età di Masaccio, il Primo Quattrocento a Firenze, Florence, 1990.

Eredità del Magnifico, Florence, 1992.

Maestri e Botteghe: Pittura a Firenze alla fine del Quattrocento, Florence, 1992–93.

Renaissance Florence: The Age of Lorenzo de' Medici, 1449–1492, London, 1993.

BOOKS

C. Acidini Luchinat (ed.), *The Chapel of the Magi: Benozzo Gozzoli's Frescoes in the Palazzo Medici Riccardi, Florence*, New York & London, 1994.

L. B. Alberti, *On painting*, trans. & ed. J. R. Spencer, New Haven & London, revised edn, 1966.

F. Ames-Lewis, *The Library and Manuscripts of Piero di Cosimo de' Medici*, New York, 1984.

——(ed.), *Cosimo 'il vecchio' de' Medici, 1389 –1464*, Oxford, 1992.

F. Antal, *Florentine Painting and Its Social Background*, 1948.

C. Avery, *Florentine Renaissance Sculpture*, 1970.

——*Donatello: catalogo completo delle opere*, Florence, 1991.

A. B. Barriault, *Spalliera Paintings of Renaissance Tuscany. Fables of Poets for Patrician Homes*, University Park, 1994.

E. Battisti, *Brunelleschi. The Complete Work*, 1981.

L. Berti & R. Foggi, *Masaccio: catalogo completo dei dipinti*, Florence, 1989.

A. Beyer & B. Boucher (eds.), *Piero de' Medici 'il gottoso' (1416–1469): Kunst im Dienste der Mediceer*, Berlin, 1993.

A. Billi, *Il libro di Antonio Billi*, ed. F. Benedettucci, Rome, 1991.

E. Borsook & J. Offerhaus, *Francesco Sassetti and Ghirlandaio at Santa Trinita, Florence: History and Legend in a Renaissance Chapel*, Doornspijk, 1981.

G. Brucker, *Florentine Politics and Society 1343–1378*, Princeton, 1962.

—— (ed.), *The Society of Renaissance Florence, A Documentary Study*, New York, 1971.

—— *Renaissance Florence*, Berkeley, Los Angeles, London, 1983 edn.

M. M. Bullard, *Lorenzo il Magnifico: Image and Anxiety, Politics and Finance*, Florence, 1994.

C. Caneva, *Botticelli: Catalogo completo dei dipinti*, Florence, 1990.

F. Cardini (ed.), *Lorenzo il Magnifico*, Rome, 1992.

E. Carli, *Arnolfo*, Florence, 1993.

A. Chastel, *Art et Humanisme au temps de Laurent le Magnifique*, Paris, 1959.

C. M. Cipolla, *The Monetary Policy of Fourteenth-Century Florence*, Berkeley, Los Angeles & London, 1982.

K. Clark, *Leonardo da Vinci*, ed. M. Kemp, 1988.

B. Cole, *Giotto and Florentine Painting*, New York, 1976.

D. Compagni, *Dino Compagni's Chronicle of Florence*, ed. & trans. D. E. Bornstein, Philadelphia, 1986.

R. Davidsohn, *Firenze ai tempi di Dante*, Florence, 1929.

L. De Angelis (ed.), *La Civiltà Fiorentina del Quattrocento*, Florence, 1993.

C. Dempsey, *The Portrayal of Love: Botticelli's Primavera and Humanist Culture at the Time of Lorenzo the Magnificent*, Princeton & Oxford, 1992.

R. Fremantle, *God and Money, Florence and the Medici in the Renaissance*, Florence, 1992.

G. C. Garfagnini (ed.), *Lorenzo il Magnifico e il suo mondo: Convegno internazionale . . .*, Florence, 1994.

R. A. Goldthwaite, *The Building of Renaissance Florence, An Economic and Social History*, Baltimore & London, 1990 edn.

C. Gutkind, *Cosimo de' Medici, Pater Patriae, 1389–1464*, Oxford, 1938.

F. Hartt, G. Corti & C. Kennedy, *The Chapel of the Cardinal of Portugal 1434–1459, at San Miniato in Florence*, Philadelphia, 1964.

R. Hatfield, *Botticelli's Uffizi Adoration: A Study in Pictorial Content*, Princeton, 1976.

D. Herlihy & C. Klapisch-Zuber, *Les Toscans et leurs familles*, Paris, 1978.

G. Holmes, *Florence, Rome and the Origins of the Renaissance*, Oxford, 1986.

—— *The Florentine Enlightenment 1400–1450*, rev. edn., Oxford, 1992.

W. Hood, *Fra Angelico at San Marco*, New Haven & London, 1993.

H. W. Janson, *The Sculpture of Donatello*, Princeton, 1957.

P. Joannides, *Masaccio and Masolino: A Complete Catalogue*, London & New York, 1993.

M. Kemp, *Leonardo da Vinci. The Marvellous Works of Nature and Man*, rev. edn, 1988.

D. V. Kent, *The Rise of the Medici: Faction in Florence 1426–1434*, Oxford, 1978.

R. Krautheimer & T. Krautheimer-Hess, *Lorenzo Ghiberti*, Princeton, 1982 edn.

G. Kreytenberg, *Orcagna's Tabernacle in Orsanmichele, Florence*, New York, 1994.

L. Landucci, *A Florentine Diary . . .*, trans. & ed. A. de Rosen Jervis, London & New York, 1927.

R. W. Lightbown, *Donatello and Michelozzo*, 1980.

—— *Sandro Botticelli, Life and Work*, 1989.

L. Macci & V. Orgera, *Architettura e civiltà delle torri: Torri e famiglie nella Firenze medievale*, Florence, 1994.

A. Manetti, *The Life of Brunelleschi*, trans. C. Enggass, ed. H. Saalman, University Park & London, 1970.

P. C. Marani, *Leonardo: Catalogo completo dei dipinti*, Florence, 1989.

L. Martines, *The Social World of the Florentine Humanists 1390–1460*, Princeton & London, 1963.

—— *Lawyers and Statecraft in Renaissance Florence*, Princeton, 1986.

D. Marzi, *La Cancellaria della repubblica fiorentina*, Rocca San Casciano, 1910.

L. M. Medri, *Il mito di Lorenzo il Magnifico nelle decorazioni della Villa di Poggio a Caiano*, Poggibonsi, 1992.

A. Molho, *Florentine Public Finances in the Early Renaissance 1400–1433*, Cambridge, Mass., 1971.

P. Murray, *An Index of Attributions made in Tuscan Sources before Vasari*, Florence, 1959.

R. Offner & K. Steinweg, *A Critical and Historical Corpus of Florentine Painting*, New York, 1931–79.

I. Origo, *The Merchant of Prato*, 1957.

A. Padoa Rizzo, *Paolo Uccello: Catalogo completo dei dipinti*, Florence, 1991.

A. Pizzigoni, *Brunelleschi*, Bologna, 1993 edn.

J. Pope-Hennessy, *Paolo Uccello*, rev. edn, 1972.

—— *Luca della Robbia*, Oxford, 1980.

N. Rubinstein, *The Government of Florence under the Medici (1434–1494)*, Oxford, 1966.

—— (ed.), *Florentine Studies: Politics and Society in Renaissance Florence*, 1968.

J. Ruda, *Fra Filippo Lippi: Life and Work, with a complete catalogue*, New York & London, 1993.

H. Saalman, *Filippo Brunelleschi: The Cupola of Santa Maria del Fiore*, 1980.

—— *Filippo Brunelleschi: The Buildings*, 1993.

A. Schiaparelli, *La casa fiorentina e i suoi arredi nel secolo XIV e XV*, Florence, 1908.

J. Schuyler, *Florentine Busts: Sculpted Portraits in the Fifteenth Century*, New York & London, 1976.

E. Staley, *The Guilds of Florence*, 1906.

R. Steinberg, *Fra Girolamo Savonarola, Florentine Art, and Renaissance Historiography*, Athens, Ohio, 1977.

L. Tintori & E. Borsook, *Giotto: The Peruzzi Chapel*, New York, 1965.

M. Trachtenberg, *The Campanile of Florence Cathedral*, New York, 1971.

R. Trexler, *Public Life in Renaissance Florence*, New York, 1980; paperback edn, Ithaca & London, 1991.

Vespasiano da Bisticci, *The Vespasiano Memoirs*, trans. W. George & E. Waters, 1926; reprinted as *Renaissance Princes, Popes, and Prelates*, paperback edn, New York, 1963.

M. Wackernagel, *The World of the Florentine Renaissance Artist*, trans. A. Luchs, Princeton, 1983.

D. Weinstein, *Savonarola and Florence. Prophecy and Patriotism in the Renaissance*, Princeton, 1970.

G. Zippel, *Niccolò Niccoli*, Florence, 1890.

Chapters 9 – 11

EXHIBITIONS

Al servizio del Granduca, Florence, 1980.

Disegni di architetti fiorentini 1540 –1640, Florence, 1985.

From Studio to Studiolo, Florentine Draftsmanship under the first Medici Grand Dukes, Oberlin, 1991–92.

Moda alla corte del Medici: gli abiti restaurati di Cosimo, Eleonora e Don Garzia, Florence, 1993.

BOOKS

C. Avery & S. Barbaglia, *L'opera completa del Cellini*, Milan, 1981.

L. Berti, *Il Principe dello studiolo, Francesco de' Medici e la fine del Rinascimento fiorentino*, Florence, 1967.

—— *Pontormo e il suo tempo*, Florence, 1993.

C. Booth, *Cosimo I, Duke of Florence*, Cambridge, 1921.

F. Borsi, *Firenze nel Cinquecento*, Rome, 1974.

H. C. Butters, *Governors and Government in Early Sixteenth-Century Florence, 1502–1519*, Oxford, 1985.

B. Cellini, *The Life . . . Written by Himself*, trans. J. A. Symonds, ed. J. Pope-Hennessy, 1949.

E. Cochrane, *Florence in the Forgotten Centuries: 1527–1800*, Chicago, 1973.

C. Conti, *La prima reggia di Cosimo I de' Medici . . .*, Florence, 1893.

L. Corti, *Vasari: Catalogo completo dei dipinti*, Florence, 1989.

J. Cox-Rearick, *Dynasty and Destiny in Medici Art: Pontormo, Leo X and the two Cosimos*, Princeton, 1984.

—— *Bronzino's Chapel of Eleonora in the Palazzo Vecchio*, Berkeley, Los Angeles, Oxford, 1993.

A. M. Cummings, *The Politicized Muse, Music for Medici Festivals, 1512–1519*, Princeton, 1992.

M. Fantoni, *La Corte del Granduca: Forme e simboli del potere mediceo fra Cinque e Seicento*, Rome, 1994.

A. Fara, *Bernardo Buontalenti: L'architettura, la guerra e l'elemento geometrico*, Genoa, 1988.

F. Gilbert, *Machiavelli and Guicciardini: Politics and History in Sixteenth-Century Florence*, Princeton, 1965.

H. S. Hager (ed.), *Leonardo, Michelangelo and Raphael in Renaissance Florence from 1500 to 1508*, Washington, D. C., 1992.

M. B. Hall, *Renovation and Counter-Reformation: Vasari and Duke Cosimo in Sta Maria Novella and Sta Croce, 1565–1577*, Oxford, 1979.

H. Hibbard, *Michelangelo*, 2nd edn., 1985.

Michelangelo, *The Letters of . . .*, trans. & ed. E. H. Ramsden, 1963.

A. C. Minor & B. Mitchell, *A Renaissance Entertainment, Festivities for the Marriage of Cosimo I, Duke of Florence, in 1539*, Columbia, 1968.

A. Natali & A. Cecchi, *Andrea del Sarto: Catalogo completo dei dipinti*, Florence, 1989.

R. Ridolfi, *The Life of Francesco Guicciardini*, trans. C. Grayson, 1967.

N. Rosselli del Turco & F. Salvi (eds.), *Bartolomeo Ammanati, Scultore e Architetto, 1511–1592*, Florence, 1995.

C. Roth, *The Last Florentine Republic*, 1925.

L. Satkowski, *Giorgio Vasari, Architect and Courtier*, Princeton, 1993.

G. Spini, *Cosimo de' Medici e l'indipendenza del principato mediceo*, Florence, 1945; repr., 1980.

J. N. Stephens, *The Fall of the Florentine Republic 1512–1530*, Oxford, 1983.

C. de Tolnay, *Michelangelo*, Princeton, 1943–60.

G. Vasari, *Le Vite de' più eccellenti Pittori Scultori ed Architetti . . .*, ed. G. Milanesi, Florence, 1878–81.

—— *I Ragionamenti e Le Lettere . . .*, ed. G. Milanesi, Florence, 1882.

—— *Lives of the Artists, A Selection*, trans. G. Bull, Harmondsworth, 1987 edn.

W. E. Wallace, *Michelangelo at San Lorenzo: The Genius as Entrepreneur*, Cambridge, 1994.

Chapters 12 – 13

EXHIBITIONS

Artisti alla corte granducale, Florence, 1969.

Gli Ultimi Medici. Il tardo barocco a Firenze 1670 –1743, Florence, 1974;

Twilight of the Medici: Late Baroque Art in Florence 1670 –1743, Detroit, 1974.

Painting in Florence 1600 –1700, London, 1979.

La Galleria Palatina: Storia della quadreria granducale di Palazzo Pitti, Florence, 1982–83.

Il Seicento Fiorentino. Arte a Firenze da Ferdinando I a Cosimo III, Florence, 1986–87.

Splendori di Pietre Dure. L'Arte di Corte nella Firenze dei Granduchi, Florence, 1988–89.

BOOKS

H. Acton, *The Last Medici*, 1958; rev. edn, 1980.

F. Angiolini, V. Beccagli & M. Verga (eds), *La Toscana nell'età di Cosimo III*, Florence, 1993.

C. Avery, *Giambologna*, Oxford, 1987; paperback edn, 1993.

F. Baldinucci, *Notizie dei professori del disegno . . .* , ed. P. Barocchi, Florence, 1974–75.

A. Banti, *Giovanni da San Giovanni: pittore della contraddizione*, Florence, 1977.

M. Campbell, *Pietro da Cortona at the Pitti Palace*, Princeton, 1977.

G. Cantelli, *Repertorio della pittura fiorentina del Seicento*, Florence, 1983.

C. Cresti, *L'architettura del Seicento a Firenze*, Rome, 1990.

E. L. Goldberg, *Patterns in late Medici Art Patronage*, Princeton & Guildford, 1983.

M. Gregori (ed.), *Cappelle Barocche a Firenze*, Milan, 1990.

K. Lankheit, *Florentinische Barockplastik. Die Kunst am Hofe der letzen Medici (1670–1743)*, Munich, 1962.

M. Mosco (ed.), *Itinerario di Firenze barocca*, Florence, 1974.

G. Pratesi (ed.), *Repertorio della Scultura Fiorentina del Seicento e Settecento*, Turin, 1993.

S. Vasetti, *Bernardino Pocetti e gli Strozzi: Committenza a Firenze nel primo decennio del Seicento*, Florence, 1994.

Chapters 14 and Epilogue

EXHIBITION

Anatole Demidoff, Prince of San Donato, London, 1994.

BOOKS

G. Artom Treves, *The Golden Ring, The Anglo-Florentines 1847–1862*, trans. S. Sprigge, London, New York, Toronto, 1956.

P. Bargellini, *Caffè Michelangiolo*, Florence, 1944.

P. Bellucci, *I Lorena in Toscana, Gli Uomini e le opere*, Florence, 1985 edn.

A. Boime, *The Art of the Macchia and the Risorgimento*, Chicago & London, 1993.

F. Borsi, *La Capitale a Firenze e l'opera di G. Poggi*, Florence, 1970.

N. Broude, *The Macchiaioli: Italian Painters of the Nineteenth Century*, New Haven & London, 1987.

C. Cresti, *La Toscana dei Lorena. Politica del territorio e architettura*, Milan, 1987.

D. Durbé, *La Firenze dei Macchiaioli: un mondo scomparso*, Florence, 1985.

A. Lensi, *Napoleone a Firenze*, Florence, 1936.

D. Mack Smith, *Cavour*, 1985.

H. Peham, *Leopold II*, Graz, 1987; *Pietro Leopoldo, Granduca di Toscano*, Italian edn., Florence, 1990.

U. Pesci, *Firenze capitale (1865–1870)*, Florence, 1904.

F. Pesendorfer, *Die Habsburger in der Toskana*, Vienna, 1988.

T. Signorini, *Caricaturisti e caricaturati al Caffè Michelangiolo*, ed. B. M. Bacci, Florence, 1952.

G. Spadolini, *Firenze capitale: gli anni di Ricasoli*, Florence, 1979.

T. Trollope, *Social Aspects of the Italian Revolution*, 1861.

M. Vanucci, *Firenze Ottocento*, Rome, 1992.

A. Wandruszka, *Leopold II, Grossherzog von Toscana, König von Ungarn und Böhmen, Römischer Kaiser*, Vienna-Munich, 1964–65.

Index

Numbers in *italics* refer to page numbers of black-and-white illustrations; colour plates are indexed in **bold** as **col.pl.** followed by their plate number.